A Guide to
DUTCH ART
in
AMERICA

PETER C. SUTTON

THE NETHERLANDS-AMERICAN AMITY TRUST, INC.

WM. B. EERDMANS • GRAND RAPIDS J. H. KOK • KAMPEN

Published by special arrangement with the NAAT in the Netherlands by J. H. Kok of Kampen,
The Netherlands, and in the United States and all other countries by Wm. B. Eerdmans Publ. Co.
of Grand Rapids, Michigan.

This volume is dedicated to the memory of Thelma McC. Zearfoss, deceased wife of Herbert K.
Zearfoss, Founding Member and Treasurer of The Netherlands-American Amity Trust Inc.

*The expenses connected with the research, travel, drafting and editing of Dr. Peter Sutton's
manuscript were covered by grants from:*
 The National Endowment for the Humanities
 The Quaker Company of Conshohocken, PA and the Netherlands

*Publication of this volume was made possible by donations from the following patrons and con-
noisseurs of Dutch art:*
 Mr. Edward W. Carter of Los Angeles, California
 Mr. Joseph T. Dawson of Corpus Christi, Texas
 Gerald and Linda A. Guterman of New York City
 Mr. George M. Kaufman of Norfolk, Virginia
 Mr. Bernard G. Palitz of Newtown, Connecticut
 Mr. Robert H. Smith of Arlington, Virginia
 Mr. Eric Martin Wunsch of New York City

*The following persons and corporations also contributed generously to the publication (as of June 23,
1986):*
 Agfa—Gevaert
 Gavin Anderson & Co.
 ARCO Chemical Company
 Artifex Development Corp.
 Begg, Inc. Realtors
 Dr. Herman L. Bosboom
 Bryn Mawr College
 Etheridge Printing Company
 The Hannon Company
 James H. Hardie
 Industrial Comm. of the Neth.
 to the U.S.
 Ellen S. Jacobowitz
 KLM, Royal Dutch Airlines
 Kluwer Publishing Company
 The Hon. J. W. Middendorf II
 MIP Equity Fund
 Nationale-Nederlanden, U.S. Corp.
 Netherlands Embassy
 Planax North America Inc.
 RABO BANK
 Tanguy Enterprises International
 Wynant D. Vanderpool, Jr.
 Willard Wichers
 Woodner Foundation
 Herbert K. Zearfoss

Special thanks go to Willard (Bill) Wichers, a founding member of the NAAT, who has served as
volunteer Project Officer for *A Guide to Dutch Art in America* since it was commissioned by the
Board of Directors almost six years ago. Mr. Wichers has been involved with every aspect of the
project, working closely with the author, Dr. Peter Sutton; the publisher, William B. Eerdmans;
and the NAAT Board of Directors. Throughout this long gestation period Mr. Wichers showed
extraordinary devotion to and aptitude for the book, along with exemplary patience and good
humor in the face of delays, complications and uncertainties. So the publication of this book is,
among other things, a testimonial to Bill Wichers and the special place he has occupied for 30
years in relations between the United States and the country of his forebears.

Art reveals the creativity of a people and perhaps even its identity. I therefore hope this *guide* will pave the way for the enjoyment of Dutch art in the United States.

Beatrix

Queen of The Netherlands

A Message from J. W. Middendorf II, Chairman

One of the great moments in all art history occurred in the 17th century after the Low Countries successfully defended their freedom and increasingly became more prosperous and began creating new cultural values. Of the several thousand Dutch artists working during what came to be known as the Golden Age, several, with Rembrandt van Rijn at their head, emerged as truly great artists for all time. For realism, beauty of line, and quality of texture, the paintings of this Golden Age—lasting at least until the death of Rembrandt—have never been surpassed. In the ensuing centuries those giants among artists have stayed the course. Indeed, their works have grown in stature and popularity.

The Netherlands-American Amity Trust (NAAT), the originator and co-publisher of *A Guide to Dutch Art in America,* was founded six years ago to promote and amplify the traditional friendship between the great Dutch and American nations. Since then, the NAAT has steadfastly adhered to that central theme. Through its multi-faceted program, the NAAT has contributed to greater mutual understanding and appreciation between our two peoples in the cultural, diplomatic, and economic fields. The publication of this book is another milestone in the history of NAAT's accomplishments. There have been earlier milestones, such as NAAT's sponsorship and exchange of curators between the Toledo Museum of Art and the Lakenhal Museum in Leiden; the establishment of a fellowship fund for American and Dutch graduate students; and the two visits to the United States in 1982 by Her Majesty Queen Beatrix and His Royal Highness Prince Claus, to which the NAAT made a significant contribution.

On behalf of the NAAT I wish to commend the author of this book, Dr. Peter Sutton, for his exceptional professional skill and dedication, as well as for his faithfulness to his original vision of this book. In the following pages he has undertaken to describe the glories of Dutch art in all of its richness and diversity. We of the NAAT are happy and proud to be the sponsor of this unprecedented work. We trust that it will furnish both pleasure and knowledge to its readers for many years to come.

A Message from Daniel J. Piliero, President

I am happy to add a few words to those expressed by Ambassador Middendorf. *A Guide to Dutch Art in America* has been several years in development, and it has required the dedicated work of dozens of men and women starting with the author, Dr. Peter Sutton, and including all present and past members of the NAAT Board of Directors. So this book epitomizes, in a way, the glories of Dutch art—its extraordinary vitality combined with meticulous attention to detail and unflagging professional diligence.

As a strong supporter of the NAAT during my final years in the Netherlands and since 1983 in the United States, I am proud that it has been

involved with *A Guide to Dutch Art in America* from start to finish. The successful conclusion of this major publication project illustrates the special contribution which the NAAT, as a private organization, can make to greater mutual understanding and appreciation between the Dutch and American peoples. With the support of private individuals and the corporate world, the NAAT will continue to serve as a focal point and a reminder of the enduring value of Dutch-American friendship.

CONTENTS

PREFACE

Dutch art has for centuries contributed so much to Western European culture, it is so well represented in this country, and the relationship between the United States and the Netherlands has been so warm and fruitful, that a book of this kind would seem a matter of course. Yet no publication of its kind has ever been issued and no tool like it exists.

The need for a guidebook enabling all those interested in Dutch art to find out at a glance which paintings and drawings by particular artists or which works of applied art of various periods are to be found in the major American public collections is so obvious that it comes as a surprise to discover that none has ever been written. Until now anyone wishing to know where Dutch art from past centuries or the not-so-distant past could be seen or studied had to rely on memory or hearsay, or had to consult the countless catalogues and publications of the far flung individual museums. Since a fundamental goal of American collecting has been to educate people about all cultures, Dutch art, like the art of so many other nations, is found in virtually every city and town across the country.

The great pioneering collectors' enthusiasm for Dutch art combined with the sensitivity and insight of countless individuals has brought a most remarkable array of paintings, drawings, prints and objects of applied art to this country. Famous masterpieces have been assembled alongside other works of great quality and interest. Anyone wishing to acquaint himself with Dutch art can do so without leaving the United States, and anyone living elsewhere wishing to study it must come here. To mention but one example, in New York there are more paintings by Vermeer than in any other city in the world. Indeed Dutch art is so well represented here, that one can trace virtually its entire development through the fine examples preserved in American museums.

Now we have a guide that tells us where to find the art that we seek and that gives us a lively but professional analysis of the historical significance of these treasures. We are all grateful to Peter C. Sutton and the Netherlands-American Amity Trust for having written and published this illuminating guide. Undoubtedly similar books on the arts of other cultures will soon follow its example.

EGBERT HAVERKAMP BEGEMANN
The John Langeloth Loeb Professor
of the History of Art,
The Institute of Fine Arts,
New York University

ACKNOWLEDGMENTS

An effort such as this, which is at once broadcast and narrow in its focus, incurs a multitude of debts. The museum directors, curators, registrars, interns, art handlers and photographic folk to whom this author is beholden are legion. Rather than inventory this debt imperfectly, I thank you collectively; the enthusiasm and cooperation that you have shown me during my visits and in correspondence attest to the strengths and hospitality of your institutions. What I owe to our federal, corporate and private sponsors is clearly manifest in this volume; to our various benefactors, my heartfelt thanks. My debt to several individuals, however, must not go unspecified. In the first stages of the project, I was expertly advised by Cynthia Kortenhorst-von Bogendorf Rupprath and Ellen Jacobowitz. Charles Tanguy supervised the early administration of the book. Throughout the preparation of the manuscript, Martha Small was the most correct, indefatigable and cheerful of assistants. More than any other individual, Otto Naumann helped shape early drafts of the manuscript with both his excellent connoisseurship and broad acquaintance with American collections. Egbert Haverkamp Begemann, Joe Rishel, and Frits Duparc served as wise critics and patient advisers. Holly Elliot edited swiftly and deftly; Bill Wichers gently supervised the book's production; Joel Beversluis oversaw the design and typesetting with care; and Mary Lynn Riesmeyer and Jacqueline Y. Sutton proofread with eagle eyes. Finally, for their tender endurance, this book is dedicated to Bug and Page.

THE COLLECTING OF DUTCH ART IN THE UNITED STATES

"**I** *doubt much whether there is any nation of Europe more estimable than the Dutch in proportion [to their size]. Their industry and economy ought to be examples to the world. They have less ambition, I mean that of conquest and military glory, than their neighbors, but I don't perceive that they have more avarice. And they carry learning and arts, I think, to greater extent."*

(John Adams, September 15, 1780)

Americans have long loved Dutch art. Whether the captains of industry in hot pursuit of Old Masters, avant-garde advocates of *de Stijl,* or simply modest collectors of Delft tiles, all are united by their admiration for the quality of Dutch art. The museums and public collections of the United States attest to these tastes, housing many of the finest works ever produced by Dutch artists. Indeed, in the relatively brief period of the last century, American collectors, connoisseurs, museum directors and curators have assembled treasures of Dutch art to rival those of any other country in the world, including the Netherlands. This guide offers the first extended account of these astonishingly rich holdings.

The American enthusiasm for things Dutch stems in part from a sense of a shared heritage. Even before the Dutch Republic granted *de jure* recognition to the United States on April 19, 1782, inaugurating what was to become the fledgling nation's longest continuous diplomatic ties, John Adams could write to his wife Abigail from Amsterdam with heartfelt admiration for the Dutch people and their achievements. Adams' regard brought concrete rewards, in the form of important wartime loans and trade agreements from the Dutch Republic. The American people's identification with the Dutch and their historical struggle for religious, political, and economic independence from Spain was later codified by the historian John Lothrop Motley, whose *The Rise of the Dutch Republic*, first published in 1853, called William the Silent the "George Washington of the sixteenth century." There were, of course, many parallels between Dutch and U.S. history to inspire this American author: the war of liberation waged by a federation of separate territories each with its own local pride and sense of independence; the popular celebration of commerce, industry, mercantile values, and free enterprise; the social mobility, the absorption of foreign peoples and ideas, and the spirit of intellectual and religious tolerance; the emphasis on domesticity, middle-class home life, thrift, simplicity and self-reliance. Even foreign observers were struck by these similarities. Writing in 1860, the

great French art critic who helped revive interest in Vermeer and Frans Hals, Thoré-Bürger, characterized the Netherlands in the seventeenth century as "a new society, strange, . . . absolutely incomparable to the rest of Europe, not unlike the young American society today, protestant and democratic." Of course, it was convenient for Thoré and his contemporaries to exaggerate the egalitarianism and Protestant convictions of the Dutch, as many as 40 percent of whom are estimated to have remained Catholic around 1650. Yet for the purple passaged Motley, the Dutch revolt was a spiritual, indeed racial, imperative, "the opposition of the rational elements of human nature to sacerdotal dogmatism and persecution." "To all who speak the English language, the history of the great agony through which the Republic of Holland was ushered into life must have peculiar interest, for it is a portion of the records of the Anglo-Saxon race, essentially the same, whether in Friesland, England, or Massachusetts."

The perception of a common moral and ideological heritage undoubtedly influenced early American collectors of Dutch art. The naturalism and secular subject matter of much Dutch art appealed to a people conditioned by Ralph Waldo Emerson's emphasis on the familiar and Walt Whitman's poetic catalogues of everyday themes, situations, and objects. As early as 1814, George Murray, reviewing the annual exhibition in Philadelphia at the Pennsylvania Academy for *The Portfolio*, extolled the naturalism of Dutch art and its supporting system of patronage. "The Dutch and Flemish schools, for faithful representation of nature, have never been excelled. Who were here the connoisseurs? Who the patrons of the artists?—Merchants and other wealthy citizens—men of plain and simple manners, possessing taste without affectation." The reviewer went on to encourage American artists and collectors to follow the Dutch example. In those early years of the nineteenth century, however, good Dutch art was scarce on this side of the Atlantic. To be sure, there were collectors, like Richard Codman (died 1803) and his son Charles Russel Codman of Boston, who owned Dutch pictures but not in such numbers as their Italian works. In the early decades of the nineteenth century, the New York dealers Pierre Flandrin and Michael Paff regularly offered Dutch paintings for sale. Merchant princes such as Robert Gilmore, Jr. (1774–1848), of Baltimore, who was educated in Amsterdam and was a friend of Cornelis Apostool, director of the Koninklijk Museum, later the Rijksmuseum, and Gilmore's friend Charles Graff of Philadelphia collected Dutch paintings in numbers. But many of these works carried spurious or exceedingly optimistic attributions. In 1830 Gilmore stated without exaggeration in a letter to Graff that his collection was "equal if not superior to most in this country," but modestly added that "one good picture of a London cabinet would be worth the whole." Lamenting the sad state of American connoisseurship, a reviewer for the *New York Tribune* wrote in 1855, "It is safe to affirm that there is not another land under the sun which contains so many worthless, smoky and dirty old daubs as this, nor another

that offers so good a market to the busy manufacturer of such impostures."

Among those New Yorkers whose collections included Dutch Old Master paintings, though often of dubious merit, were Luman Reed (died 1836), his partner in the wholesale grocery business, Jonathan Sturges, Philip Hone, and Gideon Nye. All of these men exhibited their works to the public, either in their own residences or in such institutions as the New York Gallery of Fine Arts, the American Art Union, or the National Academy of Design. While all of these collections were subsequently dispersed, a portion of the collection assembled by the Philadelphian Thomas Jefferson Bryan has been perserved in the New York Historical Society. The collections originally included more than one hundred Netherlandish pictures, counting among their number commendable works by Terborch, van den Eeckhout, Ochtervelt, Dirck Hals, and Jan Baptist Weenix. Before deeding his art to the Historical Society in 1867, Bryan exhibited it to the public on the second floor of his own home at Broadway and Thirteenth Street in New York, where an admission fee of twenty-five cents was charged. True to the Transcendentalist belief that art refines, educates, and improves, and the allied notion that museums are not repositories of plunder but moralizing institutions, the collection was called the Bryan Gallery of Christian Art. A sort of missionary zeal attended early nineteenth-century attempts to raise the public taste.

Dutch art had no antebellum champion to rival James Jackson Jarvis, whose extensive collection of Italian primitives may still be viewed at Yale. Nonetheless, in the post–Civil War era Netherlandish paintings were collected in increasing numbers not only by individuals but also by institutions, including the Pennsylvania Academy of Fine Arts (which had 107 Netherlandish pictures by 1870), Hartford's Wadsworth Atheneum, and the Boston Museum of Fine Arts. The last mentioned like the Metropolitan Museum of Art in New York, the Philadelphia Museum of Art, and the Art Institute of Chicago, was founded in the 1870s. There were still collectors, such as Judge Crocker of Sacramento, with little apparent concern for quality, but more discriminating buyers emerged, attended by higher market prices and a new concept of art collecting. No longer was art at the service of moral improvement but could, in good conscience, enhance life. Even the architecture of the new museums looked less ecclesiastic than palatial. Among the new collectors of Dutch pictures were Henry G. Marquand, George A. Hearn, and William K. Vanderbilt in New York, Stanton Blake in Boston, Samuel B. Beresford and James Batterson in Hartford, and James E. Scripps in Detroit. Toward the end of the century, the lawyer John G. Johnson of Philadelphia assembled a vast collection of paintings, which is exceptional for remaining virtually intact today. It attests to a new desire for historical comprehensiveness, an inspiration that also evidently guided Henry Walters of Baltimore in his pursuit of precious objects and the decorative arts. Other collectors bought outstanding works of Dutch art as part of an effort to recreate for

themselves princely surroundings to rival the residences of European aristocracy. One thinks above all of P. A. B. and Joseph Widener, whose mansion at Elkins Park, Pennsylvania, housed the collection that now forms the core of the National Gallery of Art in Washington, but there were also ambitious collectors like Benjamin Altman, one of the major benefactors of the Metropolitan Museum of Art. For the tough Pittsburgh industrialist Henry Clay Frick the ideal of refinement was London's Wallace Collection and its select gathering of masterpieces; to Frick's enduring credit he succeeded in attaining a supreme level of quality. Some collectors, like Charles P. Taft of Cincinnati, sought through their art to ennoble modest surroundings, while others, notably the incomparable Isabella Stewart Gardner, turned over their homes, their fortunes, indeed their whole lives to their passion for collecting. At the opposite extreme was J. Pierpont Morgan, who dispassionately amassed his collection as one might run a burgeoning business enterprise, by aggressive, en bloc purchase and careful organization. It would be utterly unjust, however, to assume personal detachment on the part of the many financial benefactors of America's museums and their all-essential purchase funds. The generous moneys of Libby, Hanna, Ryerson, Wilstach, Van der Lip, Kress, Ahmanson, et al. have immeasurably enriched the quality of art in our nation's public museums.

Individuals have shaped not only our art institutions, but also in many cases (to name only a few, Gardner, Barnes, Taft, Walker, Crocker, Frick, Morgan, Johnson, Lehman) the complexion of whole collections, or large parts thereof. Nonetheless, there is no standard profile of a collector or even of a Dutch painting collector. Art collecting, moreover, is hardly a natural result of prosperity; rich folk have always found other costly diversions. Collectors, of course, share some universal motivations—the desire for possession, the love of beauty and invention, the joy of artistic discovery. Yet we no longer share the certainty expressed by the author of the 1928 handbook of W. A. Clark's collection, now preserved in the Corcoran Gallery in Washington, that the Senator from Montana's love of Dutch paintings was inspired by their "sincerity, their truth, their wholesome realism." Dutch art's fidelity to nature, as noted repeatedly in this guide, is but one half of its attraction, the complementing factor encompassing symbol and allusion.

The Dutch record of fact, nonetheless, is forever compelling. Edward Carter's splendid new Los Angeles-based collection of Dutch still lifes, landscapes, marines, and architectural paintings—indeed all painting types exclusive of conspicuous figures (e.g., history or genre)—attests to a love of adroit mimicry and the painter's craft. However, such specialized tastes have generally not been the rule with major collectors in the U.S. Instead, owners of great Dutch art, like Norton Simon of Pasadena at present, have also usually owned outstanding works by artists of other schools, quality alone establishing criteria for acquisition. This time-honored policy now guides the newly enriched J. Paul Getty Museum in

Malibu, easily the most promising art collecting institution now active in the marketplace. The fact that Dutch seventeenth-century paintings have dominated recent Getty acquisitions speaks well of the quality of the Dutch art still available and, by extension, of the extraordinary achievement and fecundity of Dutch painters.[1]

1. On the history of art collecting in the United States, see H. Tietze, *Meisterwerke Europäische Malerei in Amerika* (Vienna, 1935); René Brimo, *L'Evolution du Goût aux États-Unis* (Paris, 1938); Russell Lynes, *The Taste Makers* (London, 1949); Aline B. Saarinen, *The Proud Possessors* (New York, 1958); W. G. Constable, *Art Collecting in the United States of America* (London, 1964); Joshua Taylor, *The Fine Arts in America* (Chicago, 1979), pp. 140-47. For a particularly useful account of early American collectors of Dutch art, see chapter 2 of Henry Nichols Clark, "The Impact of Seventeenth-Century Dutch and Flemish Genre Painting on American Genre Paintings 1800-1865" (Ph.D. dissertation, University of Delaware, Newark, 1982).

EXPLANATORY NOTE

This guide reviews noteworthy holdings of Dutch art in public museums, institutions and collections as well as private collections open to the public. For convenience, the individual entries are arranged not by region but alphabetically by the city in which the collection is situated. While the rare examples of Dutch architecture in the United States are excluded, both the visual and decorative arts are discussed at length and extensively illustrated. The bulk of the text, however, is deliberately devoted to paintings. In part this reflects the actual of Dutch art collecting in this country; outside of the major institutions, there are surprisingly few significant holdings of the decorative arts of the Netherlands. However, it also reflects the fact that paintings are more likely to be on regular display than more fragile works on paper, namely prints and drawings.

The book thus is designed with the museum visitor in mind. Not only is its attenuated shape integral to that design but also its many small illustrations. Though scarcely adequate for detailed study, these will assist the itenerant viewer in recognition and as *aides-mémoire*. In place of a dry list of highlights, the book offers a running text which seeks to relate individual works to the larger context of the artist's oeuvre, his age, and Dutch culture. Critical judgments of quality and attribution are also offered. Though written for the average literate viewer, it presumes by its very focus on Dutch art a degree of specialized interest. The Dutch art historian or specialist may also find useful the section at the back of the book with an abbreviated list arranged by artist of all the paintings in the collections under review. Since the volume is intended primarily as a handbook, considerations of length have not permitted full citations in this final section but most titles and vital information are provided in the text.

ALLENTOWN ART MUSEUM

Fifth at Court Street
Allentown, Pennsylvania 18105 (215) 432-4333

Housed in a converted Presbyterian church dating from 1906, to which an extensive modern-styled wing was added in 1975, the collections of the Allentown Art Museum include European and American painting, sculpture, and decorative arts. Their holdings of Northern European art are modest and mostly composed of the Samuel H. Kress Collection, opened in 1959. Exceptional among the cities who received a Kress gift, Allentown has never had a Kress store, but is situated near the family home in Cherryville. A catalogue by F. R. Shapley of Allentown's Kress collection was published in 1960 and is still available. Updated entries for the paintings appear in Colin Eisler's *Paintings from the Samuel H. Kress Collection: European Schools Excluding Italian* (1977). The museum maintains an active exhibition schedule and in the past has mounted loan shows of Dutch art, notably *Seventeenth-Century Painters of Haarlem* (1965).

Although many pictures from the Kress gift have been downgraded in recent years—the *Fisherboy*, for example, is clearly not by Frans Hals, the large *Still Life* is not by Frans Snyders, and the *Westphalian Landscape with Waterfall* is only the work of a Ruisdael follower—the collection still claims a small group of notable Dutch paintings. Particularly strong are the portraits. A pair of fine three-quarter-length pendants by Paulus Moreelse depict a man and his wife who recently have been identified as *Dirck Strick* and *Henrica Ploos van Amstel* (figs. 1, 2). Strick's coat of arms in the upper left, indecipherable with the naked eye, was revealed by infrared photography. A pupil of the portraitist M. J. van Mierevelt, Mooreelse also painted history subjects and was active as an architect. His meticulous handling of costume is well illustrated here. Nearly as painstaking but less intractable is the execution of the *Portrait of a Young Woman* (fig. 3) dated seven years later, and improbably attributed to Rembrandt. The seated woman with the wispy blond hair—one of the young Rembrandt's favorite models—

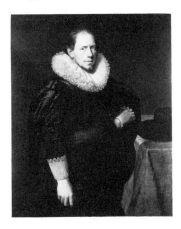
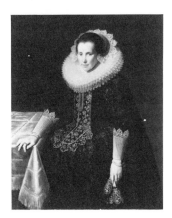

1 2

3

has unfortunately been burdened with several unsupportable identities over the years, including Rembrandt's sister, his wife Saskia, and an unknown love who presumably entered his life prior to his first marriage. The last theory is based on the work's connection with a presumed pendant, Rembrandt's *Self-Portrait* in Glasgow. In truth, we know nothing certain beyond the fact that Rembrandt painted this less-than-mysterious-looking young woman about a half dozen times in the early 1630s. Another notable portrait from these years is the so-called *Portrait of Cornelis Coning* dated 1630, which only recently entered the collection. The identification is based on the sitter's resemblance to Hals' portrait of Coning in the group portrait of St. George Militia Company of 1639. Despite some supporting voices (Grimm's most notably), the consensus of opinion among experts (Slive et al.) is probably correct in rejecting the work as Hals'. The painting nonetheless remains a forceful image which leaves one wishing he knew more about Hals' followers and imitators.

Another relatively recent acquisition is the *Still Life with Fruit* dubiously assigned to Cornelis de Heem, the only Dutch still life in the collection. A beautiful little panel, *Mother and Child (fig. 4)*, exhibits a remarkably assured touch and colorful palette. Though unsigned, it has long been attributed to Thomas de Keyser, whose style is usually slicker. Dated 1628, two years after that artist's marriage, the scene has been assumed to depict de Keyser's own

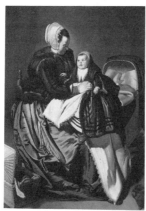

4

family. Whoever its author, the painting is of special interest as one of the earliest domestic genre paintings. A second notable genre scene is Adriaen van Ostade's so-called *Village Lawyer* dated 1655, one of a series of works by the artist which seem to depict a local official or professional (lawyer, notary public, etc.) assisting a peasant with a document. A quick look through any notary's ledger from these years offers a vivid reminder—numerous *X* 's or scrawled marks of testators and complainants—of the commonness, despite advances in education, of illiteracy in this "Golden Age."

HIGH MUSEUM OF ART

Peachtree Street N.E.
Atlanta, Georgia 30309 *(404) 892-3600*

The original collections were housed in the residence of Mrs. Joseph M. High, who in 1926 presented her home on Peachtree Street to the Atlanta Art Association, specifically to house a museum and art school. In 1955 the High Museum expanded into an adjacent building. Joining in 1962 with the Atlanta College of Art, the Atlanta Symphony and the resident theatre company, the High Museum formed the Atlanta Art Alliance, which was housed in the Atlanta Memorial Art Center. As the collections grew, however, this space too proved inadequate and in 1983 the High Museum dedicated a striking new building designed by Richard Meier. For its white enameled surfaces, splayed walkways and spacious atrium, the structure has been received with acclaim as one of the most handsome new museums in the country. A good catalogue of the *European Art in the High Museum* by Eric Zafran appeared in 1984.

The collections of Western European art benefit from a Kress collection, including several good Italian Renaissance paintings. Other strengths are the eighteenth and nineteenth century American paintings and decorative arts. The small Dutch collection includes portraits by Anthonie Palamedes and J. de Langhe, a winter scene by Barent Avercamp, a depiction of the nurturance of the infant Jupiter attributed to Nicolaes Berchem, and still lifes by Hendrik van Streek and Dirk de Horne (*fig. 5*). The latter depicts dead game, fowl and vegetables on a simple stone ledge.

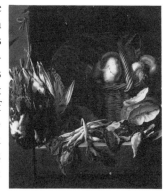

5

MUSEUM OF ART

Art Museum Drive
Baltimore, Maryland 21218 *(301) 396-7101*

The museum was founded in 1914 and is housed in a classical styled building opened in 1929 and designed by John Russell Pope. It adjoins the Wurtzburger Sculpture Garden. A wing designed to house the famous Cone Collection of modern art, especially distinguished for its works by Matisse, was opened in 1955, and further additions designed by Bower, Lewis and Thrower were opened in 1982. Exhibition catalogues and publications on special aspects of the collections appear regularly but only the Italian paintings (1981) have been fully catalogued.

The Dutch collections of the museum are not so extensive as those of the Walters Gallery nearby but often surpass them in quality. Surely the finest of the Dutch paintings in the museum are the two female portraits by Frans Hals. The earlier of the two is an unidentified *Portrait of a Twenty-Eight-Year-Old Woman,* dated 1634 and viewed three-quarter length. She wears an elegant black dress with elaborate white lace cuffs, headdress, and broad millstone ruff. In her right hand, like so many other sitters of the period, she casually dangles a pair of gloves by the finger tips. Her warm, hospitable expression is immensely appealing, yet one's greatest admiration is reserved for the supreme artistry of Hals' technique. His handling of the subtleties of tone in this simple black, gray, and white composition never falters; the deftness of his touch intimates every quality of texture and surface, from the starchy intricacy of the lace to the smoothness of her cheek, delighting the eye. It has been plausibly suggested that the pendant to this handsome portrait is a considerably smaller portrait of a man, also dated 1634, in the museum in Budapest. The connection between the two, it is argued, was long overlooked because the latter work's original format (known through an old copy) was substantially cut down in the past.

While the companionship of these two works must for the time being

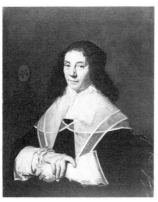

remain only a probable hypothesis, there is no question that the half-length *Portrait of Dorothea Berck (fig. 6),* dated 1644, is the pendant to *Portrait of Joseph Coymans* of the same year now in the Wadsworth Atheneum in Hartford. Married to Dorothea in 1616, Joseph was Lord of Bruchem and Nieuwwaal and a member of a family of fabulously wealthy merchants and bankers. The year after these portraits were painted, the Coymans' bank did in excess of four million guilders worth of business, more than any other bank in Amsterdam. Dorothea Berck of

Alblasserdam (her coat of arms at the upper left alludes to her name [Berck=birch] by a cinquefoil of birch leaves) also came from a distinguished family; her father had served as the Dutch ambassador to England, Denmark, and the Venetian Republic. While one perceives an element of dignity in her pyramidal pose and firm gaze, little in her appearance, costume, or expression betrays her elevated social station. Indeed, looking on her gives vivid new life to the familiar observations regarding Dutch modesty and frugality. Together the pendants are some of the finest examples of Hals' mature portrait style to be found in this country.

While the painting *Old Man in a Beret* is no longer accepted as the work of Rembrandt, the late *Portrait of Titus,* the artist's son, of 1660(?) still has its defenders despite its alternately thin or heavily restored paint surface. This curiously doting image shows the grinning young man leaning back in a chair with his hand supporting his chin. The pose is not unlike that of an earlier portrait of Titus dated 1655 in the museum in Rotterdam, but now the pensive adolescent has nearly reached simpering adulthood. The date on the work cannot be deciphered accurately, but Titus would have had to be about the same age as when he posed for the small head study now in Detroit. If genuine—and the possibility seems remote—the present work would be one of the last of the series of images Rembrandt painted of his son. Titus was to precede his father in death, passing away in 1668 at the age of only twenty-seven. Two noteworthy portraits by Rembrandt pupils are Govaert Flinck's *Portrait of a Man* dated 1639 and Ferdinand Bol's *Portrait of a Young Woman,* reputed to be Anna Maria van Schuurman (1607–1678), dated three years later. Of special interest for the reconstruction of the chronology of the artist's oeuvre is the *Family Portrait* of 166(7?) by the Terborch pupil Caspar Netscher.

Without question the most important Dutch history painting in the collection is Cornelis Cornelisz van Haarlem's *Venus and Adonis (Fig. 7)* of 1619. The goddess Venus embraces the handsome young hunter Adonis as they sit by a table covered with a rich still life. The dogs attending Adonis in the lower left not only serve to identify him as a hunter but also foretell his demise, since, against Venus's constant entreaties, he persisted in hunting wild game and was ultimately killed by a boar sent by the vengeful Mars, who loved Venus himself. According to van Mander, Adonis was a symbol of reckless youth which ignores good counsel. The large and placid figures contrast with the attenuated forms of the artist's earlier *Christ as the Man of Sorrows* (1597) in Philadelphia and reveal Cornelis's growing classicism. Although it has sometimes been assumed that these developments signal a loss in the vitality of his art, they seem rather to

7

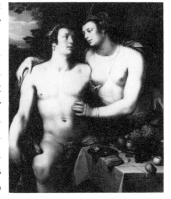

mark a renewal of stylistic innovation. A later manifestation of this classicizing impulse, albeit on a far smaller scale and in a very different context, is the *Diana and Her Nymphs in an Italianate Landscape* by Cornelis van Poelenburgh. Poelenburgh characteristically defies categorization as either a landscapist or a history painter, happily exploiting the realms of both and exposing the shortcomings of such generic terms.

More readily identifiable as pure landscape is Jan van Goyen's *View of Rhenen* of 1646, the same date to appear on another view of this city by the artist, now in the Corcoran Gallery in Washington. The walled city of Rhenen with its towering medieval church of Saint Cunera was a great favorite of Dutch landscapists, inspiring works not only by van Goyen but also Hercules Seghers, Albert Cuyp (see his drawing in the Fogg Museum), Anthonie Waterloo, and many others. Other notable landscapes include Salomon van Ruysdael's *River Landscape* of 1643 and a Jacob van Ruisdael *Landscape with Waterfall* (compare Harvard's painting), a handsome but less than inspired variation on one of the master's preferred compositions. Of the few other seventeenth-century Dutch paintings that may be mentioned are Hendrik van Vliet's *Interior of the Oude Kerk in Delft* of 1656, which reveals the architectural painter's knowledge of perspective as well as his usual labored execution, and Mattheus Wytmans' *Still Life with Fruit*; the latter should be compared with the *Violinist* by this rare artist in the Walters Art Gallery.

While the museum has no eighteenth-century Dutch paintings nor any decorative arts by Dutchmen, it owns several Hague School pictures by Josef Israëls, Anton Mauve, and Jacob Maris. Like the *Breeze from the Sea* of 1868 by the last mentioned, the two landscapes by Jongkind, the handsome *Moonlight on a Canal* of 1856 and *The Seine at Passy,* are on long-term loan to the museum. Van Gogh's still life of a battered *Pair of Shoes (fig. 8)* dated 1887 is from a series of still lifes he executed while in Paris between March 1886 and February 1888. Other shoe still lifes from this period are found in the Van Gogh Museum in Amsterdam and the Fogg Museum in Cambridge. As with other great Dutch still life painters, it is a testament to the artist's power of observation that he is able to interest the viewer in the most

8

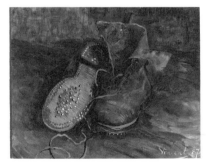

common of objects. Van Gogh's *Restaurant Rispal at Asnières* also probably dates from 1887. The *Landscape with Trees and Figures,* which like the *Shoes* is in the Cone Collection, may date from his stay in Saint-Rémy (May 1889–May 1890) or Auvers (May–July 1890). The museum's holdings of modern Dutch art include Theo van Doesburg's *Interior* of 1919 and Mondrian's *Composition V* of 1927, as well as two works by Karel Appel.

THE WALTERS ART GALLERY

600 North Charles Street
Baltimore, Maryland 21201 *(301) 547-9000*

The Walters Art Gallery was formed by William T. Walters, a nineteenth-century railroad magnate, and his son and successor, Henry Walters. The range of this collection was prodigious, including remarkable holdings of paintings, sculpture, illuminated manuscripts, incunabula, textiles, ceramics, gold and silver objects, ivory, jewelry, and porcelain. Indeed, one cannot help but be impressed by the catholicity of their interests and the exceptional quality of many objects, especially the early medieval art. While the father's tastes ran to more conservative patterns of collecting older art, the son developed an eye for contemporary European painting while living in France during the Civil War, a result of his father's secessionist sympathies. The gallery is composed of the original building, constructed in 1907 but only bequeathed to the city with its collection in 1931, and a modern-styled addition opened in 1974. The new addition allows the display of a vast body of material long hidden in storage. While the exceptionally good collection of Italian paintings was catalogued in 1976 in exemplary fashion by Federico Zeri, the approximately seventy Dutch paintings have never been adequately studied and remain relatively little known. Furthermore, the old catalogue of paintings has now long been out of print. Nonetheless, the curatorial staff has improved documentation and exposure of the Dutch collections. One welcomes, for example, the didactic labels and "in house" exhibitions of the Dutch collections.

The seventeenth century is far better represented than the fifteenth and sixteenth centuries or the Dutch collections of later periods. Moreover, many of the very early works are in problematic condition. For example, the two side wings depicting the *Donors and Their Children* of a lost altarpiece once assigned to Jan van Scorel and now dubiously attributed to Cornelis van Gouda were formerly joined together to give the false impression of a group portrait and now betray extensive losses. Better preserved but somewhat abraded is the large and important panoramic landscape by Maerten van Heemskerck depicting the *Abduction of Helen* (fig. 9) of 1535–36. Heemskerck worked under Scorel before becoming an independent master in Haarlem. He departed for Rome in 1532 shortly after painting the *Portrait of* 9

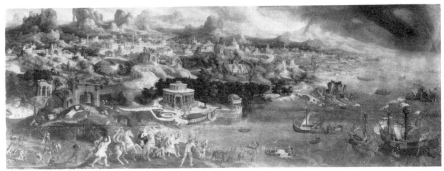

the Artist's Father now in the Metropolitan Museum of Art and remained in Italy for four years studying the art of the southern Renaissance and sharpening what must have been his extensive knowledge of classical literature. The present canvas (Heemskerck was one of the first Netherlandish artists to paint chiefly on this support) is one of the last works he executed before returning home. Its large scale and rich and varied design testify to his admiration for Italian mural painting. In the foreground appears the abduction of Helen from Venus's temple at Cythera, an event that precipitated the Trojan War. In the fantastical landscape beyond, one can identify the Seven Wonders of the World. The full meaning of the artist's elaborate symbolic program evades us. However, we note that in the Renaissance, Helen's abduction was not regarded so much as a rape as a joyful act of love. Another name for Helen's abductor Paris was Alexander; all the Wonders date from the reign of another ruler of this name, Alexander the Great. Perhaps the work is a celebration of love or of the superhuman accomplishments of the ancient world as exalted by classical literature. In any event, the painting effectively conveys the grandeur and heroism of antiquity. For this and similar achievements Heemskerck is regarded as the most gifted of the second generation of Romanists.

Surely the most beautiful Dutch history painting in the collection is the excellently well preserved *Parable of the Tares of the Field* (see Matthew 13:24, 27, 37) of 1624 by Abraham Bloemaert *(fig. 10)*. At first glance one might mistake the work for a purely pastoral landscape with its picturesque cottage and tree house. Yet one soon notices that the two slumberers in the foreground are nude (an allusion to Adam and Eve?) and the sower in the distance is clearly discernible as the devil spreading the tares and the thistles. The parable's allusion to the Last Judgment may be supported by other potentially symbolic details in the work; the goat in the foreground is a traditional Christian symbol of the damned, especially in scenes of the Last Judgment when the sheep (the believing) will be separated from the goats (the unbelieving; see Matthew 25:13–46). Further, the peacock may also take up this eschatological theme since, in addition to its familiar association with pride, it is a symbol of immortality because legend relates that its flesh never decays. The peacock's many eyes are also often interpreted as an allusion to the all-seeing Church. An interesting comparison to this painting

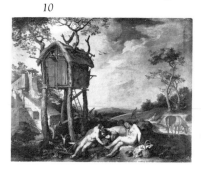

10

is provided by Simon de Vlieger's later version of this theme in the Cleveland Museum. There the parable unrolls in a far more naturalistically conceived landscape, but the juxtaposition of the unwary sleepers in the foreground and the diabolical sower in the distance is maintained.

Other notable history paintings in the Walters include a depiction of *The Vision of Cornelius, the Centurion* dated 1664 by the

Rembrandt pupil Gerbrand van den Eeckhout. The story from the Acts of the Apostles (10:3) relates how Cornelius, a Roman official but a devout and God-fearing man, had a vision of an angel who instructed him to send men to Joppa to summon Peter. When Peter, who had been foretold of the calling in a vision of his own, came to Cornelius, he preached to and baptized the convert and his people. Doubtless the gleaming cistern in the lower left is an allusion to the baptismal font. This type of symbolic allusion to past or future episodes that resolve the narrative was a regular feature of Dutch history painting. Though less common in the case of cabinet-sized paintings, another practice was the execution of series of paintings dealing with successive events in a story, as in David Colyns' two panels at the Walters. Colyns, a little-known Amsterdam painter of biblical themes, first depicts a landscape with Joseph being thrown into the well by his brothers. ("And Reuben said unto them, Shed no blood, but cast him into this pit that is in the wilderness, and lay no hand upon him; that he might rid him out of their hands, to deliver him to his father again" [Genesis 37:22]). The second panel is a continuation of the tale. It depicts Joseph revealing the cup found in Benjamin's sack to his brothers (Genesis 44:12–17). The cowering brothers kneel to plead for Joseph's mercy while he stands with his attendants beneath the portico of a noble building, robed as the powerful overlord of Egypt. Clearly, moral lessons could be drawn from such dramatic reversals. Inventory references suggest Colyns also executed series involving more than two pictures.

Several interesting Dutch portraits are owned by the Walters, including the pendant *Portraits of an Unknown Young Man and Woman* dated 1647 by Hendrik Bloemaert, eldest son and student of Abraham, and a *Portrait of a Sixty-Seven-Year-Old Man,* dated two years earlier, by Jacob Gerritsz Cuyp, which deserves more regular display. Also usually found in the depot is a large *Family Portrait in a Landscape* by an unknown master whose charming awkwardness suggests provincial origins, and a stunning little portrait of *Two Boys in a Landscape (fig. 11)* assigned for lack of a better name to Herman Mijnerts Doncker. The freshness of this little panel matches the disarming openness of the boys' faces. Pieter Nason's so-called *Portrait of Maria van Schuurman* of 1663 (see also Bol's portrait at the Baltimore Museum of Art) has recently been cleaned and now shows her elaborate lacework to advantage as well as the gentle lady's "warts and all" complexion. Among the

11

Walters Gallery's small group of Dutch miniatures are a pair of handsome portraits by Cornelis van Poelenburgh of *Jan Pellicorne* and *Susanna van Collen.* Better known as a painter of italianate landscapes, Poelenburgh painted a number of miniatures after his return from Italy. The present pair were commissioned from the artist as engagement portraits shortly before the couple's marriage in 1626. The

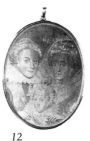

12

sitters are depicted in costume of a type of romantic hero and heroine (Granida and Daifilo?) made popular by the arcadian plays of Hooft and Vondel. A merchant and art collector, Pellicorne, and his wife were later portrayed in the actual dress of the period by Rembrandt in a pair of full-scale portraits now in the Wallace Collection in London.

An especially interesting portrait group is that of the ill-fated *Frederick V, Elector Palatine, Elizabeth Stuart, and Frederick VI* on the small, oval-shaped, gold medallion (fig. 12) engraved by Simon de Passe (c. 1595–1647). The couple is depicted before their brief reign as king and queen of Bohemia. Frederick's Protestant armies were routed by Catholic forces on a snowy mountain near Prague a few months after his coronation (1619). Driven into exile, he sought the protection of his Orange-Nassau relatives in The Netherlands, and the couple subsequently became known as the "Winter King and Queen." Precious portrait medallions of this type often were made in gold or silver (compare de Passe's silver portrait medallion of *King James I, Queen Anne, and Charles Prince of Wales* in the Boston Museum) and were engraved with the same tools used to incise printing plates. They frequently were worn as necklaces or pinned to clothing (note the link at the top). Occasionally the medallions were also inked and used to make prints. Thus their form relates them less to cast medals or painted miniatures than to metal printing plates.

The finest of the gallery's small group of Dutch still lifes is surely the *Vanitas Still Life* by Adam Bernardt, a little known painter whose few works all depict books and globes. In this case both a terrestrial and celestial globe appear, as well as a book open to a chapter entitled "Namen der Ey-landen." These details seem to suggest that the transience implicit in the familiar symbol of the hourglass applies to the whole world. Other objects in the composition allude to the vanity of power and wealth. Wealth is embodied in the string of pearls, while power is conveyed by the open book turned to the heading "Afkomst en Historie der edele Graven van Hollandt, Zeelandt ende Vrieslandt van d'eerste tot de laetstetoe" (Origin and History of the Noble Counts of Holland, Zealand and Friesland, from the First to the Last), and the document at the lower left prominently inscribed "Eersters Schepens deser Stadt Leyden" (First Aldermen of the City of Leiden). Since it began in quantity around 1620, the production of *vanitas* still lifes had centered in Leyden, where the university was a stronghold of Dutch Calvinism.

The Walters has few noteworthy Dutch landscapes: a Salomon van Ruysdael of 1633, a *River Scene* dubiously assigned to Job Berckheyde, and works by Pieter de Neyn and Gillis Rombouts. No greater in number but of somewhat higher quality are its genre scenes. An unusual effort for Jan Lievens, Rembrandt's early colleague, is his *Man Playing a Lute*, a work related to the Utrecht Caravaggisti's large-scale, half-length musicians and

revelers in fanciful costume. No less theatrical is the dashing garb of the *Violinist* in satin-trimmed doublet with slashed sleeves by Mattheus Wytmans, a later Dutch painter of genre, portraits and still lifes. Here the musician is seated in a gardenlike setting with statuary and urns decorated with images of the gods and patrons of music, art, and poetry. Doubtless he is preparing for a duet with the young woman depicted in a painting in the Gemäldegalerie in Dresden which has rightly been identified as the work's pendant. In this companion piece a woman wearing a loose-fitting chemise and sporting feathers in her hair seems to study her part in a music book. A statue of Abundance in the distance may allude to the ampleness of the young lady's charms. Evidently her fetching attributes have not been lost upon the violinist who tunes his instrument to his partner's key in an amorous as well as musical sense.

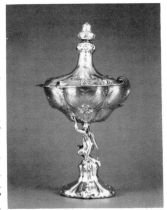

13

In addition to a small group of Dutch bronzes and sculptures in wood, the Walters owns a few Dutch ivories, including a tiny snuff box decorated with a diminutive scene of the Judgment of Solomon. Far and away the finest piece of silver is a covered cup (*fig. 13*) of 1639 by Johannes Lutma of Amsterdam (1584?–1669), the leading exponent of the grotesque "shell" style of Dutch silver. Undulating and drooping motifs, remarkably similar to modern art nouveau forms, of fanciful mask-like faces decorate the cover and body of the cup. A graceful female forms the stem. Lutma, we recall, was portrayed by his friend Rembrandt in an etching. One could imagine that the goldsmith's art made a favorable impression on the painter, who often lavished considerable attention on the burnished and complicated surfaces of metalware in his history paintings and occasionally even used gold grounds in his panel paintings. Another notable piece of Dutch metalware in the Walters is a coconut cup with silver mount of 1598 by Cornelis de Bye. See also the pair of flintlock-pistols made for the stadtholder Johan Willem Friso by Gerrit Penterman of Leeuwarden around 1700.

Among the nineteenth-century Dutch paintings are two works by the Dordrecht portrait and history painter Ary Scheffer: *Christ Weeping Over Jerusalem* and *Dante and Beatrice*. The leader of the romantic school in Holland, Scheffer was more admired in France than Delacroix was. He taught art to Louis-Philippe's children and drew critical praise for the sentimental conceptions of his subjects. Disdained during the years following the rise of Impressionism, Scheffer's emotional art has recently regained some of its lost favor but doubtless will never recapture the fame it had during the artist's lifetime.

UNIVERSITY ART MUSEUM

2626 Bancroft Way
Berkeley, California 94720 *(415) 642-0808*

In 1963 the recommendation of a university survey to build an art museum coupled happily with a gift from the modern artist Hans Hofmann of forty-five of his own paintings and funds to build a gallery to house them. The striking building that emerged seven years later was the result of a national competition won by the architects Richard L. Jorasch, Ronald E. Wagner, and Mario Ciampi. Touted as the largest university art museum in the world, the structure is a sort of Cubist's vision of the Guggenheim Museum, a splintered helix with radiating galleries. The greatest strengths are in twentieth-century American paintings and a growing Asian collection, but older European masters are also represented (Rubens, Savoldo, Carracciolo).

The best Dutch painting in the collection is a large composition by the Haarlem painter Pieter de Grebber depicting *Moses and the Daughters of Jethro (fig. 14)* (Exodus 2:15–21). Moses is seen seated by the well as the women draw water. By defending the women against shepherds who would have driven them from the well and by assisting them in the watering of their flocks, Moses won the favor of the Midian Jethro, who gave him his daughter Zipporah in marriage. In all likelihood Zipporah is the central woman who seems to be the focus of Moses' rapt gaze. De Grebber's classicism lends the scene a solemnity and grace that befit its monumental scale. Often overlooked in surveys of Dutch painting, this alternative Haarlem tradition epitomized by de Grebber ran concurrently with the more dramatically baroque approach to history painting practiced by Rembrandt and his school.

Another lesser Dutch history painting in the collection, attributed to Pieter de Witte but closer in style to Jacob de Wet, is called, not a little vaguely, "The Questioning," but may be Tamar's revelation to Judah. The drawings collection includes works by Nicolaes Berchem, Jacob Backer, a memorable drawing of a *Man with a Sculpture* dated 1771 by Nicolaes Muys, and a pretty gouache landscape by Anton Mauve *(fig. 15)*. The prints include impressions by Bol, Breenbergh, Everdingen, Lievens, Paulus Moreelse, Adriaen van Ostade, and Rembrandt.

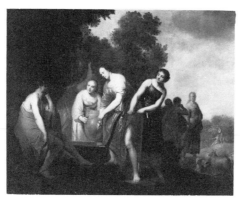

14 15

BIRMINGHAM MUSEUM OF ART

2000 Eighth Avenue N.
Birmingham, Alabama 35203 *(205) 254-2565*

The Birmingham Museum of Art opened its doors to the public in 1951 in Birmingham's City Hall. Eight years later a permanent museum was constructed, the green marble and travertine Oscar Wells Memorial Building. Two new wings have been added in 1966 and 1980. A major strength of the collections is an outstanding Kress Collection of fifteenth and sixteenth century Italian paintings; however, here too are found Mexican and Pre-Columbian art, German and French porcelain, English and American silver, Wedgewood (the Beeson Collection), old master prints, and modern paintings. The Dutch paintings claim several good quality pictures, including a winter landscape by Ruisdael, *St. Mark Sharpening his Quill* misattributed to

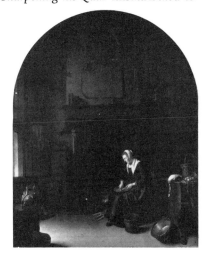

Jan Lievens but more closely associated with the style of Jacob Toorenvliet, and a kitchen interior with a woman scraping carrots *(fig. 16)*. While the latter is attributed to the Dordrecht painter Hubert van Ravesteyn, its painstaking technique has less in common with the kitchen interiors of south Holland artists (Sorgh and his circle) than with their Leiden counterparts, followers of Gerard Dou such as Slingelandt and Koedijk. An extensively illustrated *Handbook* of the collections was published in 1984. 16

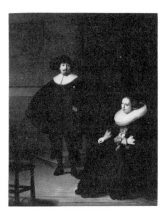 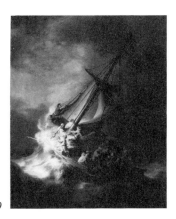

18 19

Leiden to the bustling commercial city of Amsterdam, Rembrandt would execute his full-length portrait of a fashionable *Lady and Gentleman in Black* (*fig. 18*). Once again the image is formal but slicker and more meticulous. Both the technique and the composition, with the elegantly dressed figures— one standing and one seated—viewed in an orderly interior, recall the art of Thomas de Keyser, the most stylish Amsterdam portraitist of the period. Works like this and the severely elegant *Portraits of the Preacher Johannes Elison* and his wife *Maria Bockenolle* painted in the following year and now hanging nearby in the Boston Museum, were the staple of Rembrandt's early success. An interesting feature of the Gardner Museum's painting is the fact that x-rays reveal that Rembrandt painted out a child who once stood between the couple. Hanging on the same wall and painted in the same year (1633) is Rembrandt's violent *Christ in the Storm on the Lake of Galilee* (*fig. 19*), presenting a very different side to the baroque master's art. Buffeted by the tempest, the tiny bark keels over dangerously and threatens to fill with water. Those few terrified apostles who are able rush to the stern of the boat where Christ had been sleeping to plead for salvation. He subsequently would grant this deliverance but not without an admonition against the weakness of their faith. The dramatic lighting, diagonal design, and agitated figures present the young Rembrandt at his most theatrical. Drama not only

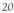

20

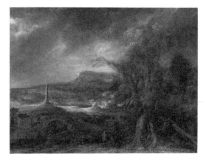

filled Rembrandt's history paintings in the 1630s, it also infused his rarer landscapes. Hardly more than a dozen pure landscape paintings by Rembrandt survive, and nearly all are imaginary views with great valleys, steep escarpments, gigantic trees, and fantastic buildings or ruins. The master reserved a more naturalistic approach to nature for his drawings and etchings. The Gardner Museum's *Landscape with an Obelisk* (*fig. 20*) of 1638(?) is an imaginary landscape very much

ISABELLA STEWART GARDNER MUSEUM

280 The Fenway
Boston, Massachusetts 02115 *(617) 566-1401*

Like the Frick Collection in New York, the Gardner Museum is a splendid treasure house that, in all respects, testifies to the personal tastes and achievements of one highly discriminating collector, Isabella Stewart Gardner (1840–1924). While many friends and experts, notably Bernard Berenson, advised her, the building on the Fenway and its contents remain her personal document. She acquired the art, designed the building, superintended its construction, and installed the collections. During her lifetime, Fenway Court, a palazzo built in 1903 in the Venetian style, was visited by many outstanding artistic figures of the day. It was opened to the public in the year following Mrs. Gardner's death and was supported with an endowment to maintain flowers in the enchanting central court and to provide for frequent concerts. Few places in Boston are more inviting on a grim winter afternoon. A catalogue of paintings by Philip Hendy was first published in 1931 (reissued 1974) and a general guide to the collections appeared in 1935.

The arrangement of the collection is permanent and not a little eccentric. Mrs. Gardner's expressed purpose in organizing her museum was to provide "a source of enjoyment—and only secondarily that it should be instructive." Consequently one must crane one's neck to catch a glimpse of the early Rembrandt *Self-Portrait* hung over a doorway or jostle with fellow visitors for space to view treasures in more than one cul-de-sac. But the enjoyment of experiencing these masterpieces interspersed with furniture and decorative art objects in Mrs. Gardner's own intimate domestic setting offsets the inconvenience of an installation with little chronological or didactic intent. It must be stressed that the Gardner Museum is distinguished above all by its collection of Italian art. Thus, while the present comments will touch only on the Dutch paintings, we trust that the reader will not be so parochial as to pass over such masterpieces as Titian's *Rape of Europa,* arguably the greatest painting in America, in a search for the Dutch room.

Mrs. Gardner's collection of Dutch paintings is small but select, including three Rembrandts and a special rarity, a Vermeer. Two of the Rembrandts and a Terborch now considered to be a workshop piece were in the famous Hope Collection and were purchased through Berenson from the dealer Colnaghi in September 1898. Acquired two years earlier, Rembrandt's *Self-Portrait* of 1629 is the largest self-portrait he had yet undertaken and offers a particularly formal image of the youthful painter. Eschewing for once the emotional expressiveness of many of his first self-portraits, Rembrandt looks out at us with a studied composure that belies his dashing costume, a grandly feathered beret and cloak festooned with a gold chain. A product of Rembrandt's early Leiden period, this work reflects his close association in these years with Jan Lievens. Four years later, having moved from his native

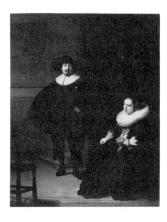

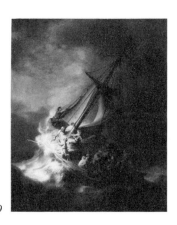

18 19

Leiden to the bustling commercial city of Amsterdam, Rembrandt would execute his full-length portrait of a fashionable *Lady and Gentleman in Black* (fig. 18). Once again the image is formal but slicker and more meticulous. Both the technique and the composition, with the elegantly dressed figures— one standing and one seated—viewed in an orderly interior, recall the art of Thomas de Keyser, the most stylish Amsterdam portraitist of the period. Works like this and the severely elegant *Portraits of the Preacher Johannes Elison* and his wife *Maria Bockenolle* painted in the following year and now hanging nearby in the Boston Museum, were the staple of Rembrandt's early success. An interesting feature of the Gardner Museum's painting is the fact that x-rays reveal that Rembrandt painted out a child who once stood between the couple. Hanging on the same wall and painted in the same year (1633) is Rembrandt's violent *Christ in the Storm on the Lake of Galilee* (fig. 19), presenting a very different side to the baroque master's art. Buffeted by the tempest, the tiny bark keels over dangerously and threatens to fill with water. Those few terrified apostles who are able rush to the stern of the boat where Christ had been sleeping to plead for salvation. He subsequently would grant this deliverance but not without an admonition against the weakness of their faith. The dramatic lighting, diagonal design, and agitated figures present the young Rembrandt at his most theatrical. Drama not only

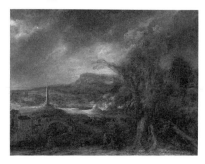

20

filled Rembrandt's history paintings in the 1630s, it also infused his rarer landscapes. Hardly more than a dozen pure landscape paintings by Rembrandt survive, and nearly all are imaginary views with great valleys, steep escarpments, gigantic trees, and fantastic buildings or ruins. The master reserved a more naturalistic approach to nature for his drawings and etchings. The Gardner Museum's *Landscape with an Obelisk* (fig. 20) of 1638(?) is an imaginary landscape very much

BIRMINGHAM MUSEUM OF ART

2000 Eighth Avenue N.
Birmingham, Alabama 35203 *(205) 254-2565*

The Birmingham Museum of Art opened its doors to the public in 1951 in Birmingham's City Hall. Eight years later a permanent museum was constructed, the green marble and travertine Oscar Wells Memorial Building. Two new wings have been added in 1966 and 1980. A major strength of the collections is an outstanding Kress Collection of fifteenth and sixteenth century Italian paintings; however, here too are found Mexican and Pre-Columbian art, German and French porcelain, English and American silver, Wedgewood (the Beeson Collection), old master prints, and modern paintings. The Dutch paintings claim several good quality pictures, including a winter landscape by Ruisdael, *St. Mark Sharpening his Quill* misattributed to

Jan Lievens but more closely associated with the style of Jacob Toorenvliet, and a kitchen interior with a woman scraping carrots *(fig. 16)*. While the latter is attributed to the Dordrecht painter Hubert van Ravesteyn, its painstaking technique has less in common with the kitchen interiors of south Holland artists (Sorgh and his circle) than with their Leiden counterparts, followers of Gerard Dou such as Slingelandt and Koedijk. An extensively illustrated *Handbook* of the collections was published in 1984.

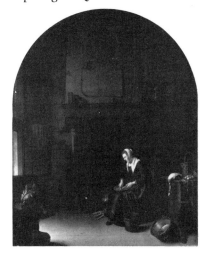

16

INDIANA UNIVERSITY ART MUSEUM

Indiana University
Bloomington, Indiana 47401 *(812) 337-5445*

The Indiana University Art Museum moved in 1981 to an impressive new triangular shaped space designed by I. M. Pei. The new building triples the gallery space and accommodates the extensive Fine Arts Library of the University as well as all the customary departments of a large university museum with a strong art history department. Appropriately, the collections, though limited in size, are broad ranging, including a notable classical collection as well as representative Near Eastern, Oriental, Indian, African, Oceanic, Pre-Columbian, as well as western European and American collec-

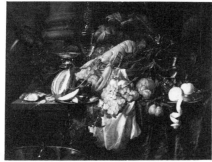

tions. The finest of the Dutch paintings include a *Tavern Scene* dated 1661 by that underestimated Ostade pupil, Cornelis Bega, a half-length *Portrait of a Lady* of c. 1657–58 by Gerard Terborch, Pieter de Grebber's prayerful *Young Daniel* and a luscious *Still Life with Lobster* (fig. 17) by Pieter de Ring. An extensively illustrated *Guide to the Collections* was published in 1980.

17

in Rembrandt's manner but probably by his close follower, Govaert Flinck. Indeed, it bears remnants of the latter's signature. The mysterious obelisque, seemingly of immense height, appears in the middleground illuminated by a burst of sunlight escaping from the storm clouds overhead. The darkened foreground is dominated by a huge gnarled tree under which pass a barely perceptible couple, reminiscent of but not identifiable as the Holy Family on their flight from Egypt. The ominous emotionalism of this view bespeaks an attitude toward nature that was perceived by later writers as roman-

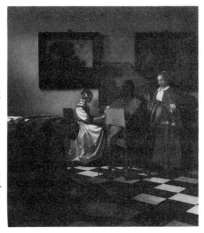

tic and was much admired in the last century. Perhaps the most famous *21* "romantic" landscape by Rembrandt is *The Mill*, now at the National Gallery in Washington. It is interesting to note that Mrs. Gardner sought unsuccessfully to purchase this picture from Lord Lansdowne's collection before it was acquired for the Widener Collection, whence it later went to Washington.

While she therefore had disappointments, Mrs. Gardner knew unusual triumph in acquiring one of Johannes Vermeer's thirty-odd surviving works. *The Concert (fig. 21)* depicts three figures— two women and a man—making music at the back of a whitewashed room with tiled floor. As always in the Delft master's interiors, the silvery light filters in from a source in the upper left and gently bathes the figures with diffuse highlights. The repoussoir of the foreshortened table and bass viol lying on the floor in the foreground couple with the pattern of the tiles to create a sense of deep spatial recession. Indeed, here and in a related picture in Buckingham Palace the perspectival effects are more pronounced than in any other works in the master's small oeuvre. The space functions conspicuously as a conduit to the scene. Yet as so often in Vermeer's art there is also an effect of exclusion in motifs like the figure of the man seated with his back to the viewer and in the self-containment of the players themselves. One detail of the picture worth noting is the appearance of Dirck van Baburen's *Procuress (fig. 29)*, now on view nearby in the Boston Museum of Fine Arts, on the rear wall of this scene. Other works by Vermeer, such as the *Woman with a Balance* in Washington, suggest that he might comment on a scene through the use of a painting within his painting. Some writers have assumed that in this context, Baburen's scene of mercenary love is an admonition. After all, in Dutch genre, music is often a prelude to love. Little in the cool demeanor of the musical trio, however, would suggest disposal to temptation. Thus we are uncertain whether the motif operates symbolically; if one assumes it does, the challenge is to gauge the specificity of its illusion. Stated prosaically, these are some of the questions that contribute to the much-celebrated mystery of Vermeer's art.

MUSEUM OF FINE ARTS

465 Huntington Avenue
Boston, Massachusetts 02115 (617) 267-9300

The first effort to form a public museum of art in Boston was undertaken as early as 1859 with the offer of the Jarvis collection of Italian paintings now in New Haven. Although this project was abandoned, eleven years later the museum was the first in the nation to be incorporated. On July 4, 1876, the centennial anniversary of the Declaration of Independence, a new building designed by the Boston architects Sturgis and Brigham and erected in Copley Square was opened to the public. Despite several enlargements, the inadequacies of the original building soon became apparent, and at the turn of the century plans were under way for a new and larger structure on Huntington Avenue designed in the Beaux-Arts style by Guy Lowell. The new building was opened in 1909. Two years later Mrs. Robert Dawson Evans provided the funds for the erection of a building facing the Fenway to contain the painting galleries. These subsequently were united with the Huntington Avenue building by a central wing, also financed by Mrs. Evans. The newest addition, a substantial, modern-styled, three-story wing to the west of the existing building, was designed by I. M. Pei and opened in July 1981. The new space forms a galleria with a high glass barrel vault offering natural illumination. Like Pei's National Gallery additions, the building is restrained, elegant and superbly finished in detail. With this enlargement the Boston Museum has embarked on an exciting new era of expansion, reinstallation, and exhibition. The Evans Painting Wing, presently closed for renovations, will reopen in late 1986. These changes promise to increase both the museum's mass appeal and ability to satisfy the discreet museum-goer. The new *Summary Catalogue* by Alexandra Murphy listing and illustrating all 1638 European Paintings in the collection appeared in 1985. The Dutch enthusiast may also wish to consult the December 1979 issue of *Apollo,* which included an article by John Walsh and Cynthia Schneider on "Little Known Dutch Paintings" in the collection. A museum *Bulletin* has been published since 1903. For an extensive history of the museum, the reader is directed to W. M. Whitehill's two-volume work of 1970.

The Boston Museum of Fine Arts is one of the foremost museums in the United States. Its collections are encyclopedic: the Asiatic art is, quite simply, the best in the Western Hemisphere, the Egyptian and classical collections are rivaled only by those in New York, the textiles are world renowned, and the print collection surpasses all others in this country. Moreover, the museum maintains an active schedule of exhibitions of singular importance, including the recent Dutch show, *Printmaking in the Age of Rembrandt.* While not so distinguished as some aspects of the European collections, notably the nineteenth-century French paintings, the Dutch collections are both impressive and broad ranging. Their full quality,

long obscured by the relegation of worthy pictures to the depot, was revealed through the installations and writings of John Walsh, the author's predecessor as Baker Curator and a noted Dutch specialist.

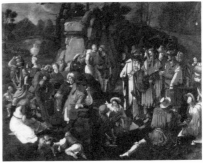

22

Surely the most significant early Dutch painting in the museum, indeed the most important single work by the artist in this country, is the *Moses Striking the Rock (fig. 22)* of 1527 by Lucas van Leyden. The painting may have been purchased by Camillo Borghese (1550–1620), later Pope Paul V, and was recorded as hanging in the Villa Borghese as early as 1657. Van Leyden's reputation justifiably rests on his production of 172 highly innovative engravings, an excellent sampling of which is owned by the Boston printroom. Initially influenced by Dürer as well as Italian artists, van Leyden soon fashioned his own style, mixing Northern and Southern printmaking techniques. His prints are often more pictorial than Dürer's, employing restricted but richly varied tonalities, which subtly enhance the illusion of space, light, and air. Although not without decorative impulses, van Leyden brought an unprecedented degree of naturalism to the art of engraving. His prints were eagerly sought by Italian collectors and artists, on whom they had a substantial influence. Indeed, van Mander could report triumphantly in his biography of the artist in his *Schilderboeck* (1604), that Vasari, his great Italian forerunner in the chronicling of artists' lives, thought van Leyden superior to Dürer.

Paintings by van Leyden, as we have suggested, are far rarer than his prints; only two other paintings, in the museums in Leiden and Leningrad, are conceived on as grand a scale as the Boston painting. Like these works, the *Moses* dates from the later part of van Leyden's career when he turned increasingly to painting in pursuit of more monumental effects. Like the picture of 1531 in Leningrad, the *Healing of the Blind Man of Jericho*, the Boston painting shows van Leyden's growing concern for themes dealing with man in nature and the relationships between figures and space. The interpretation of the literary source (Exodus 17:3–6) is unusual in depicting the distribution of the water rather than the more dramatic moment of the miracle itself. More than thirty exotically clad figures appear in a rocky landscape with a high horizon. For all the richness of the anecdotal detail, the figure-eight-shaped composition has less spatial integration and hence a more ornamental quality than the later work in Leningrad. Although these trends can readily be explained in terms of van Leyden's move toward a more unified treatment of space (in this regard he was an important forerunner of the baroque), they can also in part be explained by a different conception of the work. The Boston picture is not executed in oils but in distemper on canvas, a technique known as "tuechlein," that has resulted in the loss of much of its tonal range, unfortunately leaving a dark and

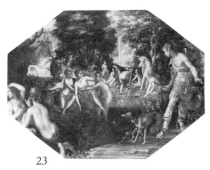

23

muted overall appearance. This practice was adopted in murals intended as substitutes for tapestries and produced in centers such as Malines, which van Leyden is said to have visited. Thus the artist might have felt the decorative qualities of his design were appropriate to this medium. Part of this interest in ornamental design, however, reflects van Leyden's admiration for Italian mannerist painting. His graceful, movemented art appealed to Northerners because it seemed to discard the last vestiges of medieval art's static restraint. It was van Mander who celebrated and codified the Mannerist aesthetic, calling for the study of nature but also for its embellishment and elevation through art. Nature was to be reformed, style and virtuosity cultivated.

The chief center of international Mannerism in the last decades of the sixteenth century in Holland was van Mander's Haarlem; however, Utrecht also had its practitioners, including Abraham Bloemaert and Joachim Wttewael. The latter had lived in Padua from 1586 to 1588 and evidently came in contact with the art of the Venetian masters and Tuscan Mannerists like Zucchi and his followers. Upon returning to Utrecht in 1592, he produced cabinet-sized paintings of religious and allegorical subjects in a highly stylized manner. As witnessed in Boston's *Diana and Actaeon* (fig. 23), Wttewael's figures often are posed with exaggerated elegance, their flesh tones pearly, seemingly suffused with opalescence, and their landscape settings fantastically lush, the leaves appearing as lace or embroidery. The unfortunate Actaeon, here depicted virtually "surpoint" in his studied attitude of surprise, happens on Diana, the goddess of the hunt, and her nymphs as they bathe. For this transgression he is transformed into a stag and killed by his own hounds. The story often was interpreted allegorically in this period as an admonition against the weakness of the flesh; Actaeon had succumbed to the temptation of the senses because he permitted his eyes to look upon the naked goddess—the ever-vigilant guardian of virginity—and her chaste entourage. His punishment (he seems already to sprout antlers) was quick and severe. The diverse poses assumed by the squirming nymphs fulfill van Mander's prescription that the figures in a history painting be "varied as to position, movement, activity, design, character and expression." This stress on invention and variety was a basic tenet of Mannerism, and, unlike most Dutch artists, Wttewael embraced this style long after the turn of the century. The present work is dated 1612, the year after he helped found the Utrecht guild, and the painting in Washington of 1624 seems still more *retardataire* in its adherence to Mannerist forms.

In the first two decades of the seventeenth century, Mannerism in Holland was replaced by a new style and approach to narration. Although these changes owed much to the art of that extraordinary German expatriate

who worked in Rome, Adam Elsheimer, the principal innovator among Dutch artists was the Amsterdam painter Pieter Lastman, the teacher of Rembrandt. The group led by Lastman is often referred to collectively as the "Pre-Rembrandtists," but there was nothing provisional about their art nor did they merely serve as antecedents to Rembrandt's greatness. Lastman not only introduced a new formal vocabulary but also promoted a new approach to sources,

24

both literary and pictorial. His painting of *The Wedding Night of Tobias and Sarah* *(fig. 24)* is dated a year earlier than Wttewael's picture but has already replaced its busy design of elegant, vaguely erotic figures with a simple composition of a few stolidly conceived characters. Just as his broad, curiously vulcanized little figures eschew the refinements of Mannerism, his approach to storytelling is deliberately straightforward. The source in the Apochrypha (Tobit 8:1–5) relates how Tobias insisted upon marrying Sarah despite the fact that she was plagued by a demon who had killed seven would-be husbands on their wedding night. Following the advice of his guardian angel, Raphael, Tobias took the liver and heart of the fish he had been instructed earlier to catch and put them in an incense burner in the bridal chamber, whereupon the demon was driven off and bound "hand and foot" by Raphael. Tobias then rose and said to Sarah, "Get up, my love, let us pray and beseech our Lord to show us mercy and keep us safe." Most earlier representations of the story depicted the couple praying, but Lastman shows the more dramatic earlier moment of the story while adhering to the text more faithfully than any artist had before him. Tobias kneels over the fire with the burning fish parts as Sarah looking on suspensefully lifts herself up in bed. Overhead Raphael grapples with the exorcised demon. While Lastman's dramatic nocturnal lighting effects owe much to Elsheimer, his conception of the subject as a night scene, like the nuptial flowers strewn on the floor, point to the fact that this is the couple's wedding night. Indeed virtually all aspects of the work are deliberately explanatory and contribute to a clear and succinct exposition of the story. Gone is the Mannerists' circumlocutory approach to narration which had often made it hard to even locate the central protagonists (see, for example, Wttewael's painting in Providence).

Lastman's art, its dramatic impact, and textual fidelity were much admired by later Dutch artists. Rembrandt paid homage to his teacher not only by copying his works but also by returning to the latter's compositions long after he had left Lastman's tutelage. Indeed, a drawing of the Tobias and Sarah theme in the Metropolitan Museum in New York, which is thought to be by a Rembrandt pupil working after one of his master's sketches, is based on the Boston painting, and Rembrandt himself may have

been thinking of the apprehensive Sarah when he conceived the pose for his famous painting of his common-law wife *Hendrickje Stoffels in Bed* (National Gallery, Edinburgh). Lastman's legacy was even passed on to Rembrandt's pupils, such as Ferdinand Bol. Bol's representation of *Judah and Tamar* of 1644 in Boston is indebted to a painting executed by Lastman about thirty years earlier and engraved by Jan van Noordt. While Bol's broad manner imitates Rembrandt's painterly style, his conception of the Old Testament theme stems from Lastman. Tamar was the daughter-in-law of Judah. After her husband had died and his younger Brother, Onan, had refused to impregnate her (a deed for which he too was slain by the Lord), Tamar was to remain a widow in her father's house until the third and youngest son was old enough to marry her. Faced with this prospect, she disguised herself as a prostitute and, seating herself by the side of the road, was propositioned by her own father-in-law. Before complying, Tamar required that Judah give her his ring, staff, and bracelets as security for payment (see Genesis 38:13–26). When she became pregnant and was accused of adultery she produced these objects and was vindicated. In Bol's painting as in Lastman's, the two main characters of the story are shown seated next to each other and the crucial attributes of their pledge displayed prominently. Thus textual fidelity is observed and both the context of the story and its denouement intimated.

Old Testament themes such as this were depicted nearly as frequently by Dutch history painters as New Testament subjects. In part this may have been because the Dutch identified with the struggles of the "chosen people" of the Old Testament in their own war for freedom against the Spanish. Amsterdam was perceived as the new Jerusalem, a city that by the harsh standards of its age was distinguished for its tolerance. It harbored many oppressed peoples, including twenty thousand Jews by the end of the century. Moreover, the new interest in Old Testament subjects also probably reflected the Reformation's rejection of the typological interpretations of these subjects favored in the Middle Ages; that is to say, Old Testament themes had not been viewed historically but were interpreted merely as prefiguring events in the New Testament. With the stress placed by Luther and Calvin on "the Word alone" and exegesis, or the interpretation of the Scriptures as a succession of literal, historical events with independent interpretable Christian meanings, the Old Testament became a welcome source of new subjects. Further, it is noteworthy that the tolerant Dutch nation produced a conspicuously ecumenical art. The seventeenth-century Dutch history painter's choice of subjects rarely betrays his religion; although Roman Catholic, Lastman's repertoire of biblical themes differed little from that of the Protestant Rembrandt.

Boston's Rembrandts include an early work with a disputed attribution depicting an *Old Man* (fig. 25), which, like the *Man with a Gold Chain* (fig. 66) in Chicago and other works depicting the same model, has been assumed with little reason to portray Rembrandt's father. While his identity

25

26

remains unknown, the elderly man's expression and attitude of deep thought (some have assumed that he is praying) has prompted the suggestion that he represents the repentant Saint Peter. The effect of this forcefully expressive image depends not so much on the artist's technical ability nor some imponderable capacity to sympathize with his model as on the success of his original conception of the subject. The importance of the thorough formation of the concept or idea before the artist proceeds to execute his work was stressed by van Mander and other seventeenth-century Dutch art theorists. The writer Houbraken even relates an anecdote concerning a painting competition between three artists that was won by the painter who "eerst een vast denkbeeld vormde van zyn gansche werk, eer hy verf op't paneel bracht" (first formed a visual idea of his entire work before applying paint to panel). It has been suggested that Rembrandt's painting of the *Artist in His Studio (fig. 26),* which shows a painter (perhaps the young Rembrandt himself) dressed in a long robe standing back from a large easel silhouetted in the foreground, represents the artist in this crucial act of conceptualization. Hidden from the viewer, the painting is the *tabula rasa,* the receptor of his thought. Rembrandt not only brought a formidable intellect and imagination to his work, he also made thought a central theme of his art, as seen in the many figures in his paintings who strike expressions of silent absorption or reflection. Boston's late *Evangelist (John?) Writing* offers a case in point. Although the picture has suffered—until the late 1930s the unfortunate saint wore an overpainted beard—it still presents a particularly powerful and strangely private image of introspection (compare the related paintings of saints in Washington, San Diego, Malibu, and the Metropolitan Museum in New York).

Perhaps the finest Rembrandts in the museum present a far more formal side to the painter and originate from a much earlier and arguably more ambitious point in his career. The life-size painting of *The Preacher Johannes Elison* and his wife *Maria Bockenolle* of 1634 is one of only two known full-length pendant portraits by Rembrandt. The other pair in the Rothschild

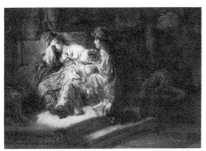

Collection in Paris is also dated 1634. Although educated in Holland, Elison was a Protestant minister in Norwich, England, and seems to have enjoyed some reputation as a preacher in the Dutch Reformed Church of England. His son, Jan Elison the Younger, moved to Amsterdam where he married a Dutch woman and prospered in business. While his parents were visiting

27 him in 1634, he commissioned the twenty-eight-year-old Rembrandt, then already the best as well as one of the most sought-after portraitists in the city, to paint their likenesses. Seated facing each other in large sturdy arm chairs, the couple are posed with an appealing simplicity. Yet their black and white costumes are rendered with the fastidious craftsmanship that characterized fashionable Amsterdam portraiture in these years. Elison is portrayed beside the sacred books of his calling, placing his left hand on his chest, a rhetorical gesture of sincerity encountered elsewhere in preachers' portraits. Clearly Rembrandt satisfied his patron, since the latter stipulated in his later wills that the portraits remain in the family. Together with a pair of oval portraits of a *Man in a White Collar* and a *Woman with a Gold Chain* in Boston, which are also dated 1634, these large and well-preserved paintings offer excellent examples of the type of decorous portraiture that formed the basis of Rembrandt's early success in Amsterdam.

Boston offers a good sampling of works by the Rembrandt School, the best of which are history paintings. In addition to the Bol mentioned above, there are important paintings by Carel Fabritius and Aert de Gelder. *Mercury and Aglauros (fig. 27)* was previously thought to be a representation of Danaë by Rembrandt. It also long carried an attribution to Govaert Flinck until Frits Duparc rightly recognized its stylistic connection with Fabritius's early *Raising of Lazarus* in Warsaw and the recently rediscovered *Mercury and Argus,* now on the New York art market. Although his works are exceedingly rare (the accepted *oeuvre* in the newest monograph includes only nine paintings), Fabritius is often considered the most innovative of all of Rembrandt's pupils because of his pioneering role in the formation of the Delft School. However, the Boston painting shows few of those qualities—a lightened palette and perspectival effects—that Fabritius is presumed to have transmitted to Vermeer; rather, like the two paintings mentioned above, it attests to Rembrandt's influence in its dark tonality, thick paint application, dramatic lighting and conception of the subject. The impact of Rembrandt's art of the 1640s will be apparent to many, but it took no less well-read an observer than Panofsky to recognize the rare theme from Ovid's *Metamorphoses.* Aglauros, a daughter of Cecrops, was poisoned with jealousy by the goddess Minerva and refused to conduct Mercury to her sister Herse, with whom he had fallen in love. Even rejecting Mercury's offer of gold, the incident depicted here, Aglauros was turned into stone by the god. While often obscure to the modern viewer, the stories from Ovid were well

known to Dutch artists. Indeed, the *Metamorphoses* was translated and issued in illustrated editions more often than any other classical book and earned the sobriquet "the painter's Bible." Van Mander devoted a large section of his *Schilderboeck* to the "Interpretation of the Metamorphoses," which he believed contained important moral lessons.

While Fabritius soon departed from his teacher's style, Aert de Gelder continued to work in a Rembrandtesque manner well into the eighteenth century. His *Rest on the Flight into Egypt* has been dated as late as c. 1685–90. The motif of the Joseph reading from a large book (the Scriptures?) originated in Italy with the Carracci but probably was introduced in the North by Rembrandt. The Virgin's gypsy headdress may be designed merely to evoke the exotic nature of the history piece. The painting can be compared with the artist's slightly earlier painting in Providence. While not of the quality of either of these two works, de Gelder's other painting in Boston, the *School Master*, is of interest for adopting large-scale Rembrandtesque figures (the central pedagogue recalls Rembrandt's late *Homer*) to a theme usually treated by earlier Dutch genre artists (Dou, the Ostades, and Steen) on a more intimate scale.

Life-size genre figures had been a specialty of the Dutch Caravaggisti in the 1620s. Followers of the immensely influential Italian artist, Caravaggio, these artists like the earlier Mannerists were part of a broad international movement, but asserted their own independent manner. Caravaggio is best remembered for dramatic naturalism achieved through a radical new use of chiaroscuro, or the juxtaposition of intense values of light and shadow. Less well understood is his contribution to genre painting. His early scenes of androgenous youths playing music, young gallants with fortune tellers, and gaming soldiers doubtless had an impact on his Dutch followers, not only in their choice of piquant subject matter but also in elements of design and lighting. The green doublet with slashed sleeves and feathered beret sported by the young *Boy Singing* (fig. 28) of 1627 by Hendrik Terbrugghen is only pseudo-Burgundian. It certainly was never worn by a self-respecting Dutch burgher, who, as we have seen, would have clothed himself in severe black and white. Rather, it is evocative of theatrical attire. While it is usually unclear whether these and the many other picturesque young revelers and musicians painted by the Utrecht Caravaggisti are actors, street performers, or merely exotic characters donning studio props, their numbers attest to a taste for these gay and spirited images. Perhaps their unrestrained jollity seemed a refreshing compensation for the constraints of the Dutch burgher's industrious life. Whatever their effect, the large, half-length format and bright illumination of these works probably descend from Caravaggio, while the genre type

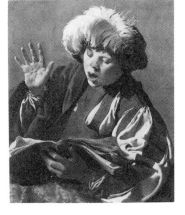

28

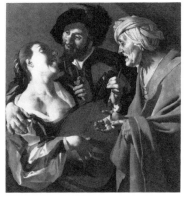

29

owed its popularization and refinement to his Utrecht followers. The most gifted of these, Terbrugghen, employs cooler color harmonies and a softer light, achieving effects closer to natural daylight than his Italian predecessors.

Dirck van Baburen, Terbrugghen's Utrecht colleague, probably never met Caravaggio; he was still a student in Utrecht when the master died in 1610. However, his assimilation of the caravaggesque movement's ideas is illustrated in his splendid *Procuress* (fig. 29) of 1622, one of the short-lived master's best works. Here in a particularly engaging depiction of the ancient theme, a lascivious fellow in a gaily striped outfit snuggles up to a receptive lady playing a lute. The payment he offers—a large coin—appears to be disputed by a beturbaned old crone dressed as a gypsy. Although gypsy women often appeared as fortune tellers with young couples, here the transaction is of a different and more predictable sort. The painting's mercenary love subject was already recognized when the work was known to the great painter Vermeer. It figures in his mother-in-law's inventory as a "Koppelaarster" (Procuress). Furthermore, the painting appears in the background of two of Vermeer's paintings, one of which now hangs just down the street in the Isabella Stewart Gardner Museum. The painting's subject was also one that Vermeer treated in his early years and its palette (yellow, blue, and white) and bright, clear light probably would have appealed to the Delft painter. Indeed, the art of Vermeer seems to have owed much at its inception to the Utrecht Caravaggisti.

Although he was born and lived the greater part of his life in Flanders, Adriaen Brouwer played a central role in the development of low-life genre painting in Holland. At an early stage in his career he traveled to Haarlem, where he entered the circle of Frans Hals. Bringing with him knowledge of the peasant painting tradition that originated in the southern Netherlands with Pieter Brueghel the Elder and survived well into the seventeenth century (see the museum's two excellent works by Joost Cornelisz Droochsloot), Brouwer fashioned an art that incorporated on a small scale Hals' lively

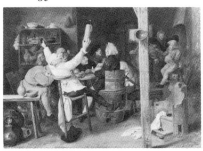

30

brushwork and portrayal of character with a wholly unapologetic new vision of the peasantry. As witnessed in Boston's *Tavern Interior* (fig. 30) of c. 1625, Brouwer depicted the coarse vitality of the lower classes with a remarkably assured touch and great empathy. The allergorizing intent that had been a primary concern in earlier Dutch low-life scenes by such artists as David Vinckboons (see the *Battle with*

Death) and Adriaen van de Venne (see his two paintings in Springfield) recedes in importance as the life of the peasant becomes the central theme. No longer is the rough carousing a mere pretext for moralizing; the viewer is brought face to face with the reality of the crude visage of the peasantry. Brouwer's many followers, including outstanding Dutch artists like Adriaen van Ostade (whose *Merry-Making Peasants* is one of the best low-life scenes owned by the museum) and David Teniers in Flanders, painted many fine pictures but ultimately sacrificed their mentor's power for a more comfortable and comforting image of the peasant. Brouwer's originality was not lost on his contemporaries; no less discriminating collectors than Rubens and Rembrandt owned his works.

Boston's only work by one of the guardroom painters is a merry company by Jacob Duck (on loan and long misattributed to Pieter Codde), but they have one of several versions of Terborch's early *Cavalier in the Saddle*. This painting is remarkable for showing the single motif of a horse and rider viewed from behind. Better known than his early scenes of bivouacking soldiers are Terborch's elegant, small-scale portraits (see his three-quarter-length *Portrait of a Woman*) and high-life genre scenes. High-life and domestic genre is well represented in Boston by two *fijnschilder* paintings by students of the Leiden painter Gerard Dou, Pieter van Slingeland's *Couple at Music* of 1688 and Dominicus van Tol's *Woman Holding a Fowl in a Window*. Both works adopt the high finish for which Dou was so admired, and the latter, by Dou's nephew, takes over the "niche" motif that he popularized. The polished execution and elegant manner of Eglon van der Neer owes more to Terborch and the latter's student Caspar Netscher. This refined style was much admired in the courts of Europe toward the end of the century and won van der Neer appointment to the positions of painter to the Dutch governor of Orange in France, to Charles II of Spain, and later to the Elector Palatine, Johann Wilhelm, at Düsseldorf. The couple in van der Neer's richly decorated *Dutch Interior* in Boston seem to have portrait features and serves to remind us of the fluid boundaries between genre and portraiture in Dutch art. The painting within the painting, previously over-painted with a demure landscape, depicts Venus and Cupid, undoubtedly alluding to the love shared by the couple.

Paintings within paintings were a standard device used by genre painters to comment on their scenes. Gabriel Metsu's handsome early painting of 1654 of the time-honored *Usurer* (fig. 31) theme depicts a woman holding a paper with a legal seal as she dries her eyes with a handkerchief. Her tearful entreaty draws little sympathy from the stern old usurer, who, weighing coins, sits surrounded by a strongbox and additional bills. On the back wall, at a strategic point between the two figures, appears a painting of a nude figure holding up a large bag or sack (of coins?) which has been tentatively identified as an allegorical representation of Avarice. In Nicolaes Maes' *Eavesdropper* (the work's anecdotal title "The Jealous Husband" probably reflects a later interpretation of the theme) the commentary is offered by the

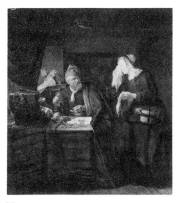

central figure of an older man who turns to the viewer as if to hush the audience as he overhears the amorous scene unfolding in the distance on the right. Elsewhere in Maes' works of this period the idleness of servants is ridiculed. Here the man holds what appears to be a bell chord in his left hand. Presumably he intends to startle this dallying maidservant out of the arms of her lover. The eavesdropper theme, usually employing a woman as the central figure and always treated in this anecdotal fashion, was one of Maes' favorite subjects.

31

Better preserved than this painting is the *Pancake Baker*, a work attributed uncertainly to Maes but achieving commendable freshness with an agile, fluid touch.

Both Metsu's *Usurer* and Maes' *Eavesdropper* came from the nineteenth-century Boston collection of Stanton Blake, whose Dutch paintings had been acquired in 1880 from the collection of Prince Demidoff of San Donato Palace in Florence. Other works from this well-known collection included Simon Verelst's *Still Life with Dead Birds* and Jan van Huysum's *Vase of Flowers* (fig. 32), truly a tour de force of this decorative, late seventeenth-century still-life painter's style. While the exacting observation of the blossoms in this work is at the service of the colorfully ornamental effect of the whole, the *Vanitas Still Life* in a niche by Cornelis Norbertus Gysbrechts piles up a diverse array of objects, all of which potentially allude to the transitoriness of man's existence. Even the *tromp l'oeil* motif of the tear in the upper right corner, seemingly exposing illusionistic stretchers behind the canvas, prophesies the decay of the painter's own artistry. The care Gysbrechts and more gifted artists like his forerunner Pieter Claesz (the museum owns three still lifes by the master, a pair of panels dated 1642 and a *Breakfast Still Life* of 163[9]) took in painting textures and surface details typifies the Dutch-

32

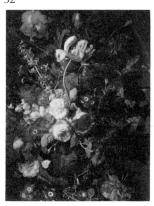

man's love of factual accuracy. The same concern motivates Pieter Saenredam's meticulously spare record of the *Interior of St. Odulphus* in his native Assendelft and Emanuel deWitte's more pictorial but no less accurate view of the south aisle in the *Interior of the Nieuwe Kerk in Amsterdam* of 1677. Indeed, the naturalism of Dutch art assumed many forms, from the slick surfaces of Werner van den Valckert's early portrait of a man in a ruff removing his glove, to Frans Hals' magnificently freely painted late portrait of a man, whose long hair and dressing gown already seem inspired by the fashion of

the court of Louis XIV. Although virtually textbook examples of opposing styles, these two works successfully serve the same end; namely, to provide an image of compelling truth to life.

The search for the accurate representation of nature was preserved perhaps most vigorously in the field of landscape. All the basic features of Holland's terrain were recorded by Dutch painters. Indeed, specialists developed in the categories of panoramas, dune and canal scenes, wooded landscapes, marines, even winter scenes and twilight views. The emergence of landscape as an independent genre is largely an achievement of the seventeenth century when the Dutch developed the first great school of naturalistic landscape painting. Yet for all their naturalism, Dutch landscapes are not direct transcriptions of reality but imaginatively reformed images of nature. Dutch artists made sketches from nature; we are told that Adriaen van de Velde, whose *River Landscape* is owned by Boston, traveled into the countryside weekly for this purpose. However, they only composed in paint after they had returned to the studio. Through these practices nature was edited and reformed; rather than a "mirror of nature," Dutch landscapes are assemblages of naturalistic motifs. The artists found support for these approaches in contemporary art theory. Following Italian Renaissance and ultimately antique concepts, van Mander argued that art should improve on natural appearances by creating ideal images from the best features of a variety of models, a notion taken as an article of faith by later writers such as van Hoogstraten and Gerard de Lairesse.

One can readily perceive the invention of the artist at work in the vestigial Mannerist conventions of a painting like Roelandt Savery's *Landscape with Animals*. Far less obvious are the workings of van Goyen's imagination in his *Fort on a River* of 1644 or the *River Scene with Church Spire* of 165(5?), works that achieve their natural appearance from cohesiveness of design, unifying effects of atmosphere, and a rich palette of earth colors—browns, grayish greens, and painterly yellow highlights. The supreme artistry of Jacob van Ruisdael is still better disguised. We note, for example, that the point of view in his lovely *View of Haarlem with Dunes* is higher than any actual promontory on the outskirts of the city. As in his other *haarlempjes*, the imagined, elevated perspective is designed to enhance the sense of an

immense panorama and towering sky. Similarly, his magnificent *Rough Sea (fig. 33)* shows keen observation of the effects of stormy winds at sea and doubtless reflects studies Ruisdael made on the estuary of the river IJ outside Amsterdam (see also Ludolf Bakhuysen's *View Across the IJ toward Amsterdam*). Yet his arrangement of the ships, dramatic distribution of light and shade, and sense of color obviously reflect artistic considerations beyond mere reportage.

33

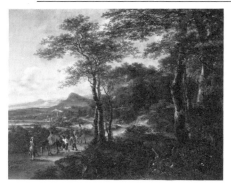

34

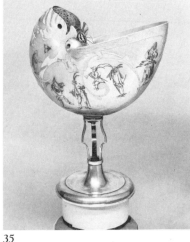

35

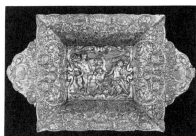

36

The Dutch artist carried his naturalism with him even when he journeyed south on the trip prescribed by art theorists to examine the great achievements of the Italian Renaissance and antique art. One would hardly mistake Jan Both's large and impressive *Landscape with Banditti Conducting Prisoners (fig. 34)* for the work of an Italian artist. To be sure, it captures the warm amber light familier to all those acquainted with the late afternoon sun in the Italian campagna; however, the specificity of the artist's treatment of the foliage and mountainous landscape forms betrays his origins. The same is true of the *Italianate Landscape with Goats* by Adam Pynacker. The latter's works are rare in this country and employ a more silvery tonality and larger and more decorative foreground motifs than the designs of his forerunner Both. Quite a different approach appears in the works of the later, third generation of Dutch italianate landscapists, such as Johannes Glauber, Aelbert Meyering and Jacob de Heusch. Glauber's *Classical Landscape* abandons all reference to the contemporary Italian landscape to enter the rarefied, literary world of Poussin, Dughet, and late Claude. The popularity of this cool arcadian classicism among the late seventeenth century Dutch landscapists, marks the decline of the indigenous, naturalistic school in favor, once again, of more international movements.

The decorative arts in Boston include a number of noteworthy objects. Among these are an engraved medallion by Simon de Passe portraying King James I, Queen Anne of Denmark and Charles, Prince of Wales (compare de Passe's portrait medallion in the Walters Art Gallery, Baltimore) and a nautilus cup *(fig. 35)* decorated with Commedia dell'Arte figures after J. Callot and bearing the coat of arms of Admiral J. G. Tengnagel, burgomaster of Kampen, 1659, its silver stand by Johannes de Vignon, The Hague, 1700 (compare the nautilus cups in Toledo and New Haven). Other silver objects include two engraved beakers of 1637 and 1642 and a teapot by Florianus van der Hoef, Haarlem, 1752. However, the finest piece of silver is without question a newly acquired layette basket *(fig. 36)* by Adriaen van Hoecke (1636–1716).

Layette baskets were traditionally used to hold the infant's clothes prior to the christening. The basket bears the monogram of Count Willem Adriaen van Nassau, Lord of Odijk, and the arms of his wife, Elizabeth van der Nisse. It was probably commissioned for the baptism of their son, Cornelis, on June 8, 1667.

A lovely small terra cotta sculpture depicting a naiad *(fig. 37)* is attributed to the renowned sculptor, Adriaen de Vries. The collections also include several boxwood and ivory carvings as well as seventeenth

37

and eighteenth century Dutch ceramics, including a white ewer from Delft similar to vessels depicted in Johannes Vermeer's paintings. Its silver lid is marked A. Brunsvelt, Leeuwarden, 1653. A *chine-de-commande* dish made for the Dutch market is decorated with a depiction of the "Vryburg," a Dutch ship that visited China in 1756 under Captain Jacob Ryzik. Boston also owns seventeenth and eighteenth century Dutch pewter, porcelain and glass. Though rarely on view, a large *kast* is preserved in storage.

Though often overshadowed by the collections nearby at Harvard, Boston's Dutch drawings include many outstanding sheets, including three Rembrandts. Especially charming is the study of a *Sleeping Dog (fig. 38)*. In the field of prints, the collections are second in this country to none. The prizes of the collection include such works as the unique colored print by Hercules Seghers of a *Rocky Landscape with Church Tower* and an extensive selection of Jan and Esaias van de Velde's prints, but to inventory highlights would scarcely convey the depth of the collections. These are only plombed in the print room's numerous boxes or on the special occasion of such pioneering shows as *Rembrandt as Experimental Printmaker* (1968) and *Printmaking in the Age of Rembrandt* (1983), exhibitions which have secured the renown of their organizer, Clifford Ackley, as the preeminent Northern print curator in this country.

Boston is deservedly famous for its early enthusiasm and abiding love of the art of J. F. Millet and the Barbizon School; a major exhibition devoted to the Museum's several score of Millets was mounted in 1984. It is hardly surprising, therefore, that the Hague School was also a favorite of Boston collectors. Josef Israëls is represented by a half dozen canvases and Anton Mauve by five paintings as well as watercolors and drawings. Characteristically, most are genre scenes depicting sailors' families, peasants or landscapes with shepherds and farm animals. Other Hague School

38

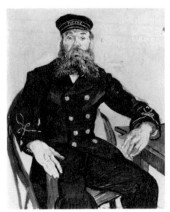

39

artists here represented include the three brothers, Jacob, Matthijs and Willem Maris, and Johannes Bosboom and B. J. Blommers. Johan Barthold Jongkind's nocturnal *Dutch Port*, dated 1868, displays the artist's proto-Impressionist technique. With nearly forty Monets, Boston would be reckoned one of the leading centers in the country for the study of Impressionism even in the absence of Gauguin's greatest masterpiece, *D'Ou venons nous*, and four outstanding canvases by van Gogh. No less powerful than his landscapes, *Houses at Auvers* and *The Ravine*, are the latter's portraits depicting Madame Roulin, "Berceuse" (compare Chicago's version), and her husband, the *Postman Roulin* (*fig. 39*). Van Gogh gave the modest postillian an admirable dignity, likening his great bearded head to that of Socrates (see the related drawing in Los Angeles).

BOWDOIN COLLEGE MUSEUM OF ART

Walker Art Building
Brunswick, Maine 04011 *(207) 725-8731*

The collections of the Bowdoin College Museum were begun as early as 1811 when James Bowdoin III bequeathed seventy European paintings and two portfolios of drawings, the latter valued at $7.75. Some of these drawings, including a splendid pen and ink *View of Waltensburg* by Pieter Brueghel the Elder and fine pen and wash landscape drawings by, among other Dutch artists, Philips Koninck (*fig. 40*), still stand out among the highlights of the collection. The Walter Art Building that now houses the museum was designed by Charles Follen McKim of the famous firm of McKim, Mead and White and dedicated in 1894. McKim took as his architectural models Florentine Renaissance prototypes, the Loggia dei Lanzei and Brunelleschi's Capella dei Pazzi. As part of the decorative scheme, McKim commissioned four leading American artists (Kenyon Cox, John La Farge, Abbott Thayer, and Elihu Vedder) to paint murals for tympanums under the central dome. Underground additions designed by Edward Larabee Barnes doubled the museum's size in 1975–76 while preserving its original architectural integrity. The collections are wide ranging as befits a college museum. Noteworthy aspects include ancient Mediterranean art, especially Assyrian reliefs and Greek red figure vases, Italian Renaissance medals in the Molinari Collection,

American nineteenth-century paintings, drawings (Winslow Homer), and decorative arts. An extensive *Handbook of the Collections* was published in 1981 and the drawings ably catalogued by David Becker in 1985.

40

While there are no masterpieces among the Dutch paintings, deserving of note are several good quality paintings by some of those able "minor masters" for which the Netherlands is so renowned. In the painting of naturalistic ecclesiastic architecture, Hendrik Cornelis van Vliet was less innovative than his gifted Delft colleagues Gerard Houckgeest and Emanuel de Witte, but he was capable of a handsome work like the *View of the Choir of the St. Jacobskerk in The Hague* (*fig. 41*). Beyond the *tromp l'oeil* curtain on the right is the tomb of Admiral Jacob van Wassenaer, executed by Bartholomeus Eggers after designs by C. Monincx in 1667. Thus we are provided with a *terminus ante quem* for van Vliet's painting. Although it is hardly fair to compare van Vliet's art to

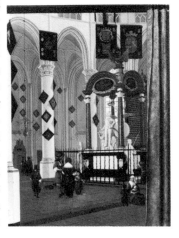

41

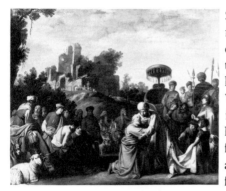

42

43

Saenredam's hauntingly severe poetry (the diamond-shaped memorial escutcheons too often crowd or clutter the whitewashed columns and the color and light can go hard and decorative), his command of space often was compelling. What van Vliet was then to his more gifted forerunners, so Nicolaes Moeyaert was to Pieter Lastman—an able but occasionally unspirited follower. Where Lastman sought to clarify and animate biblical and mythological narratives by focusing on a crucial dramatic gesture, Moeyaert could lapse into compositional formulas and stock poses. An inspired example of his work is the *Meeting of Jacob and Joseph in Egypt* (fig. 42) of c. 1636 which is a variation on a theme that the artist had treated in a painting of 1628 in Hamburg. Several drawings from the original Bowdoin bequest are also by Moeyaert, including a *Flight into Egypt* and an amusing little *Tobias Frightened by the Fish.*

Other notable Dutch drawings include Abraham Bloemaert's *Studies of Running Figures* (perhaps a study for figures in the artist's painting, *The Crowning of Teagenes* of 1626 in the Centraal Museum, Utrecht, or for one of his compositions depicting the Annunciation to the Shepherds), an *Oriental Archer* by Jacob Backer (fig. 43), italianate landscapes by Bartholomeus Breenbergh and Jan Baptist Weenix, and of course, the two Rembrandtesque river views by Koninck (see fig. 40). The extraordinary sensitivity of the latter two owes much to their broad but assured technique. Usually relegated here to the depot, two Dutch paintings nonetheless are of exhibitable quality: *View of Ships on a Stormy Coast* signed and dated 1634 by Abraham Willaerts (fig. 44) and Godfried Schalken's *Portrait of a Woman.*

44

BROOKLYN MUSEUM

200 Eastern Parkway
Brooklyn, New York 11238 *(718) 638-5000*

First opened in 1897, the Brooklyn Museum was designed by McKim, Mead and White. Nearby are the Brooklyn Botanical Garden and Prospect Park. Originally conceived as a "Museum of Everything for Everybody," the building formerly housed twenty-eight departments, from art to zoology. A papier-mâché squid once pursued an octopus across the ceiling of the hall now devoted to the museum's world renowned Egyptian art collections. It was only in the 1930s that all but the art-related collections were dispersed to other Brooklyn institutions. In addition to its Egyptian holdings, the museum is best known for its American paintings and decorative arts as well as period rooms, pre-Columbian, African, and American Indian art. The modest Dutch painting collection benefited from the Michael Friedsam Estate left to the Metropolitan Museum of Art which in part was transferred to Brooklyn. A handbook of the collections was first printed in 1967.

Although the Dutch collections are not especially distinguished, they include several noteworthy paintings. One of the best portraits, despite its abraded condition, is Frans Hals' *Portrait of a Man Holding a Portrait Medallion*. The practice of representing the sitter's hand poking illusionistically out of a simulated frame (compare the Metropolitan Museum's *Portrait of Petrus Scriverius*) was a technique popularized by Mannerist portrait engravers. A relatively early work, the painting's technique may be compared with that of Pittsburgh's *Portrait of van der Morsch*, dated 1616. Other portraits include Thomas de Keyser's *Portrait of Gertrude van Linborch* of 1632, portraits of unknown men by Adriaen Backer and Gerard Dou, the latter virtually a miniature, and a handsome pair of small three-quarter-length pendant portraits of c. 1660 by Gerard Terborch which are on loan to the museum. The so-called *Burgomaster Hasselaer and His Wife (fig. 45)* is not by Gerard Dou but by an able artist from his immediate circle, possibly Adriaen van Gaesbeeck. Even the painting of a hermit in the background is based on Dou.

Like the Hals, the best genre painting in the collection unfortunately has been abraded, but Terborch's *Woman Pouring Wine* of c. 1650 already anticipates something of the psychological subtlety that he would develop in his genre paintings produced over the next decade. Filling his pipe, an officer eyes a young girl with a sidelong glance as she pours a glass of wine. A painting in the museum in Montpellier, France, is presumed to be the Brooklyn picture's pendant. It depicts the same girl

45

gaily pouring wine but now facing left, where the soldier companion has passed out on the table, no doubt a victim of the tobacco and liquor. Other genre scenes include the *Peasant at a Window*, which displays one of Adriaen van Ostade's favorite compositions, *Garden with Figures* by a follower of de Hooch, and *Street Musicians* and the *Village Doctor* by two different followers of Jan Steen. Virtually the only Dutch still life is *Flowers, Snake, and Butterflies*, again a work of a follower, in this case of Rachel Ruysch. The only history painting is the poorly preserved *Raising of Lazarus* presently assigned to the circle of Lastman and possibly by Jan Tengnagel.

The landscapes are of greater interest. Particularly charming is a small painting by Albert Cuyp showing the *Artist Drawing in a Landscape (fig. 46)*, proof, if their paintings were not sufficient, that Dutch artists followed their theorists' directive in drawing directly from nature. Meindert Hobbema's *Hamlet in the Wood* is a good, representative example of the artist's mature style, but the *Ruins of the Castle Kostverloren*, also assigned to the artist, cannot be accepted. The arcadian landscape with nudes said to be by Poelenburgh is also misattributed.

In the period room from Jan Martense Schenck's house built about 1675 in Brooklyn's Flatlands not only is the architecture reminiscent of Dutch prototypes, but some of the furnishings are of Dutch manufacture, including the tiles, brass andirons, and large oak and inlaid ebony *kast*. The decorative arts collections also include several other pieces of delftware, including a tea caddy dated 1698.

46

Several of The Hague School artists, including Israëls, Mauve, Jacob Maris, Mesdag, and W. Roelofs, figure among the nineteenth-century paintings and drawings. Here too we find Jongkind's *Le Tuileries à Honfleur* of 1865. One of the most memorable twentieth-century paintings in the collection is Kees van Dongen's large full-length *Portrait of William S. Davenport*. Brooklyn also owns a chair by the De Stijl designer Rietveld.

ALBRIGHT-KNOX ART GALLERY

1285 Elmwood Avenue
Buffalo, New York 14222 (716) 882-8700

One of the happiest weddings of old and new American museum architecture occured in 1962 when an elegant modern wing, funded by Seymour H. Knox, was added to the austere and distinguished Greek revival gallery that had been constructed more than a half century earlier through the generosity of John J. Albright. One can scarcely imagine a more fitting

47

structure for this institution, which prides itself above all on its twentieth-century American and European art. In spite of its emphasis on modernity, the gallery is one of the oldest in the United States; its governing body, the Buffalo Fine Arts Academy, was founded in 1862. Some Old Master paintings are on view (mostly eighteenth-century French and English works and notably for our purposes, Salomon Ruysdael's *River View (fig. 47)* dated 1642, as well as a selection of Oriental, African, and Pre-Columbian art. But its great strengths are the nineteenth-century American painters, European Post-Impressionists and early twentieth-century French, Spanish, and Italian masters. In addition to a stunning pair of Gauguin canvases, there are two van Goghs, the more memorable of the two being *La Maison de la Crau (fig. 48)*, a view of an old mill that was one of many

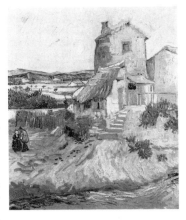

48

views of Arles and its environs that van Gogh painted in the fall of 1888. The structure itself, popularly known as the Jonquet Tower of *tabatière*, still survives and proves that the artist took liberties with his subject to enhance the building's height and the monumentality of the site. A large, late and rigorously abstract Mondrian *(fig. 49)* is one of the gallery's proudest possessions. The gallery's admirably thorough catalogue of *Painting and Sculpture from Antiquity to 1942* by Stephen Nash et al. (1979) is still available.

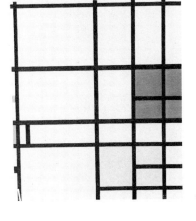

49

FOGG ART MUSEUM

Harvard University
32 Quincy Street Cambridge, Massachusetts *(617) 495-2378*

With the Yale University Art Gallery in New Haven and the Art Museum at Princeton, the Fogg Art Museum is the finest university museum in the country. All three of these great institutions are committed to the educational use of their collections. Yet in assembling and preserving their respective "teaching collections"—a notion that in this country has all too often been used to defend the collecting of dismayingly mediocre objects—these museums have recognized the didactic value of quality in art. Perhaps reflecting the region's traditionally Puritan anti-visual bias, the Fogg was founded only in 1891, well after the art gallery in New Haven, and long exhibited a curiously academic disdain for museum cosmetics. The walls were scuffed, the labels shabby, and the lighting subterranean. However, with the opening of the new Sackler Museum in 1985, the old Fogg was given a splendid facelift and its glorious collections have never looked better. Perhaps Harvard's greatest strengths are its East Asian collections (the Chinese bronzes are world renowned) and its spectacular collection of drawings. Indeed the latter can hardly be rivaled in this country by any other institution short of the Metropolitan Museum of Art and the Pierpont Morgan Library in New York. The collections of European paintings from the seventeenth to nineteenth centuries are also excellent. Harvard has long loved Dutch art; as early as 1857, Francis Calley Gray (class of 1809) bequeathed his extensive print collection including seventy-two etchings by Rembrandt.

The museum was first housed in Hunt Hall (1895) and moved to its present site on Quincy Street in 1927. The Sackler Museum, designed in controversial fashion by James Stirling, now houses the classical, Egyptian, Oriental, and Islamic collections, as well as temporary exhibition space. Many of the United States' most distinguished art historians and museum professionals studied at the Fogg. Pioneered by Charles Eliot Norton and Paul J. Sachs, this great pedagogic tradition has been carried on by the Fogg's more recent directors, Agnes Mongan, the noted historian of Dutch art, Seymour Slive, and now Edgar Peters Bowron. Like his great predecessor on the faculty, Jakob Rosenberg, Slive has sharpened many a student's appreciation of the art of the Low Countries. The staff of the Fogg regularly produces scholarly exhibition catalogues and publications on aspects of the museum's collections; William Robinson is presently preparing a catalogue of the Dutch drawings. In the absence, however, of a current handbook or general catalogue, the reader is directed to the May 1978 issue of *Apollo* (on sale at the museum) which was devoted to the collections.

The chief strengths of the collection of Dutch drawings at the Fogg are its Rembrandt and Rembrandt School drawings and its landscapes. One of the best early seventeenth-century sheets, however, is Hendrik Goltzius's *Allegorical Composition with the Artist's Motto* of 1612. The elaborate symbolism of this work is typical of Mannerist art. In the foreground on the left a

nude engraves a plate while an angel with a
torch looks on, an allusion to *Fama* (Fame).
The woman at the right, *Capriccio,* holds a
whip and a spur, incentives to artistic achieve-
ment. Behind on a table is Goltzius's personal
emblem: a wreathed and winged head of a boy
poised above the caduceus of Mercury, patron
of artists, which in turn surmounts a pile of
riches. Other drawings by Goltzius of this de-
vice (one of which dated 1609 is in the E. B.
Crocker Gallery in Sacramento) actually are

50

inscribed with his motto: *Eer Boven Golt* (Honor above gold), a play on his
own name. The presence of the caduceus may suggest that while honor
should indeed be valued above gold, an artist might acquire riches through
honest commerce, symbolized by Mercury's attribute.

One good source of income for an artist in seventeenth-century Holland
was printmaking, and both Goltzius and his gifted pupil Jacques de Gheyn
II, excelled in this field. The latter's large and highly finished drawing of *A
Crossbowman Assisted by a Milkmaid (fig. 50)* served as the final model for a
major engraving. The scene depicts the young man pointing directly at the
viewer a weapon that by the seventeenth-century was thoroughly antiquated.
The subject again doubtless has emblematic and quite possibly literary
meanings. One theory holds that it is a humanistic interpretation of Tyl
Uylenspieghel with the central figure about to deflate our pomposity. Other
writers have emphasized the amorous features of the work. The poem
inscribed on the engraving after this drawing has the young girl enjoining
the young man to take careful aim and hit the target in the center with her
help: *Et bene virgo docet.* The young man, strengthened by his success in
love, will take aim at us all.

Like the undulating contours of the elegant crossbowman, the alle-
gorical content of the work attests to Mannerist artifice, but the landscape
beyond reveals the greater freedom and truth to nature that we associate
with the Baroque. The naturalistic Dutch landscape tradition is represented
in Cambridge by drawings by, among others, Esaias and Jan van de Velde,
Pieter Molyn, Jan van Goyen, Lambert Doomer, and Albert Cuyp. Of
exceptional beauty and rarity is Jan van de Velde's *Landscape with Watermill.*
Cuyp's panoramic drawing of *Rhenen on the Banks of the Lower Rhine* is an
unusually large, finished work which, like his other drawings of this type, is
topographically accurate. With its prominent tower of St. Cunera's Church,
the site was a great favorite of Dutch artists and was represented by van
Goyen, Saenredam, and even Rembrandt. The latter's *Winter Landscape (fig.
51),* which came to the Fogg with the famous Charles A. Loeser bequest, is
one of the great master's most impressive drawings. With only a few deft
strokes of the pen and the subtlest use of washes, Rembrandt brilliantly
conveys the impression of a snow-covered landscape on a still winter day.

Although not pinpointed, the scene is thought to represent the countryside on the Amstel River between Kostverloren and Ouderkerk, the area where the famous etching of *Six's Bridge* was conceived. Rembrandt often sketched in this

51 region in the 1640s and early 1650s. Doubtless the tranquil countryside that he depicted offered him a restful break from his busy life in Amsterdam.

Jacob van Ruisdael, as usual, expresses a far more dramatic and tumultuous view of nature in his *Landscape with Waterfall* (*Color Plate 11*). This surely is the Fogg's greatest Dutch landscape painting and one that invites comparison with other similar scenes of mountain torrents in the museums in Baltimore, Cleveland, and Philadelphia. The collection also includes a pair of tranquil *Coastal Scenes* by Jacob's uncle, Salomon van Ruysdael, and a stormier *Seacoast* by Simon de Vlieger. These marines are supplemented by a strong group of drawings of boats and seascapes by Willem van de Velde II. The best cityscape in the collection is a lovely *contre jour* cityscape by Gerrit Berckheyde (*fig. 52*).

The Fogg's Dutch still lifes include a *Still Life with Lobster* by Jan Davidsz de Heem and two handsome dead game still lifes by Jan Vonck and Jan Weenix. Paintings of genre themes are relatively underrepresented, although a work by Michael Sweerts deserves note. Scenes of everyday life figure more prominently among the drawings. The splendid cache of Rembrandt drawings boasts a brilliant sheet of *Three Studies of a Child and One of an Old Woman* (*fig. 53*) as well as a wash drawing of a *Woman in a Canopied Bed with a Child* thought to be a study of the artist's wife Saskia and one of their children. As Slive has noted, drawings of the life of women and children seem to have been considered a special category of Rembrandt's art. The large collection of drawings amassed by Jan van de Capelle, the independently wealthy seventeenth-century Dutch marine painter, and recorded in

52

53

the inventory of his estate (1679), included a portfolio of 135 drawings of "het vrouwen leven" by Rembrandt.

One of the strongest features of the Fogg's Dutch collections is portraiture. The so-called *Portrait of a Preacher* by Frans Hals was owned by the king of Poland in the eighteenth century and offers a particularly vital early example of the artist's work. It may be compared with the *Portrait of a Man* dated 1625 in the Metropolitan Museum. Although traditionally identified as a preacher because of the bearded sitter's skull cap, such headgear was also worn by people of other professions in Hals' portraits. Noteworthy portraits of women in the collection include works by Bartholomeus van der Helst and Gerard Terborch, masters respectively in large and small of portraying the prosperous Dutch bourgeoisie. An interesting comparison is offered by the two family portraits by the Rembrandt pupil Nicolaes Maes and Jacob Ochtervelt. The latter is the earliest (1663) of Ochtervelt's seven known family portraits and depicts the soberly clad group in an appropriately restrained manner. The charming antics of the child in the foreground and the accents of color in the chairs and de Hooch-like vista at the left serve to enliven the scene, but the atmosphere remains reserved. It is a far cry from the opulence of Maes' *Family Portrait* of a c. 1680 where the sitters are clad in elegant drapery and posed with a studied insouciance. Here not only the costumes and poses but also the rich colors and sumptuous painting of stuffs reflect an international style of portraiture which became increasingly fashionable in Holland after c. 1670. Doubtless Maes would have been exposed to this style when he visited Antwerp in the early 1660s. He subsequently gave up his early Rembrandtesque manner and genre themes (compare, for example, his works in St. Louis and Philadelphia) and concentrated on the more lucrative field of portraiture. Thus the Fogg portrait well illustrates Houbraken's statement that "Maes very soon gave up Rembrandt's way of painting, particularly when he discovered that young ladies would rather be painted in white than in brown." Indeed, the complete success of this style by the end of the seventeenth century is reflected in Houbraken's judgment that Maes painted better portraits than any artist working before or after him. For his own part, Ochtervelt quickly grasped these changes in taste as can readily and progressively be seen in his later portraits in Hartford (1664?), Budapest (1670), and the Norton Simon Museum.

If Maes shed Rembrandt's chiaroscuro, he also forsook his teacher's probing examination of character; Maes' sitters become virtually interchangeable in their expression of well-heeled contentment. By contrast, the Fogg's so-called *Self-Portrait* and *Portrait of a Man,* long attributed to the youthful Rembrandt but now thought to be by followers show an interest in intensely individual facial expression. The former, like Rembrandt's early self-portrait hanging nearby in the Gardner Museum, shares the master's delight in fanciful costume; the miller's twenty-three-year-old son is depicted wearing a steel gorget, silk scarf, and earring. The model for the *Portrait of a Man* is

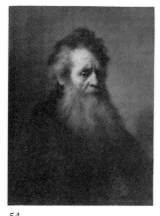

54

the same as in the Boston Museum's so-called *Man (Saint Peter?) in Prayer,* who was long incorrectly thought to be Rembrandt's father. The patriarchal aura of the *Portrait of an Old Man (fig. 54)* dated 1632 and bearing Rembrandt's signature is still stronger, yet no effort has been made to connect the model with Rembrandt's family, and even the master's authorship is in doubt. As Slive has observed, the painting "shows unmistakable traces of the soft, silvery touch [Jan] Lievens developed around 1630." While arguments have been made for a collaborative effort, most specialists would now assign this picture wholly to Lievens. It testifies to the close ties of the young Lievens and Rembrandt in those years, an intimate working relationship that has been compared with that of Braque and Picasso in the formative years of Cubism.

Related to Rembrandt's portraits and *tronijen,* or "head studies," is his *Head of Christ.* This painting is one of a series of small oil sketches painted in the late 1640s and early 1650s that show Rembrandt exploring his own distinctly unhieratic image of Christ. The model was the same throughout. His expression varies but always conveys compassion and composure. Not only did these studies influence Christ's appearance in Rembrandt's mature biblical scenes, they had a lasting impact on Westerners' image of Christ's physical appearance. Rembrandt's interest in biblical subjects is represented at the Fogg by an early drawing of the *Supper at Emmaus,* and two later sheets, the *Angel Gabriel Appearing to Zachariah* and a masterfully succinct *Pilate Washing His Hands.* A pen and ink drawing of *Jacob's Dream* is by Ferdinand Bol; other Rembrandt school drawings include, in addition to anonymous sheets, works by Juriaen Ovens, Salomon Koninck, Lambert Doomer, and Nicolaes Maes. Of the handful of Dutch religious paintings in Cambridge, Cornelis van Poelenburgh's *Rest on the Flight (fig. 55)* is of special interest and quality.

55

Late seventeenth- and eighteenth-century Dutch art is scarce (passable paintings by Adriaen van der Werff, Jacob de Heusch, and Pieter Mulier the

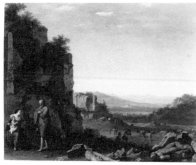

Younger, and a handful of drawings). The nineteenth century fares much better, largely owing to the generosity of Grenville L. Winthrop. Winthrop collected widely but is now perhaps best remembered for having owned the most distinguished collection of Ingre's works outside France. In addition to his extraordinary holdings of French, English, and American nineteenth-century drawings, Winthrop owned a handsome

group of Jongkind paintings, watercolors, and drawings, works by The Hague School artists Israëls, Mauve, and Maris, as well as two excellent van Gogh drawings, *The Blue Cart* (fig. 56) and the *Peasant of Camarque,* both executed in August of 1888. The sitter in the latter drawing is identified in van Gogh's letter as Patience Escalier, cowherd, gardener, and "a sort of man with a hoe." The large size and careful execution of this reed

56

pen drawing distinguish it as one of the artist's finest portrait drawings. Doubtless conscious of the legacy of Millet, van Gogh makes of Escalier an iconic yet compellingly human image of the peasant who one imagines silently working his plot of land, a field not unlike *la moisson* (the artist's own title) in *The Blue Cart.* From the same year as these drawings is a painted *Self-Portrait* and, dating a year earlier, a still life of *Three Pairs of Shoes,* which may be compared with the work in the Baltimore Museum. A good Mondrian drawing figures among the early twentieth-century collection.

KRANNERT ART MUSEUM

University of Illinois
500 Peabody Drive
Champaign, Illinois 61820 (217) 333-1860

Designed by a student of Mies van der Rohe, Ambrose Richardson, the modern styled Krannert Art Museum serves the students of the University of Illinois and the twin cities of Champaign and Urbana. The collections are general in composition with strengths in American art and European painting—Murillo, Teniers, Tiepolo, and notably, eighteenth- and nine-teenth-century French artists. A semiannual *Bulletin* includes articles on dis-tinguished objects in the collections; some of the best paintings were also exhibited at the dealer Wildenstein's gallery in New York and nine univers-ities in the 1973–75 exhibition *Paintings from Midwestern University Collec-tions*. The present author's "provisional catalogue" of the museum's painting collection (1979) is unpublished.

In addition to the Krannert family, for whom the museum is named, Merle J. Trees was one of the collection's major benefactors. Among his gifts to the collections are some of the best Dutch paintings, including Frans Hals' *Portrait of Cornelis Guldewagen (fig. 57)*. One of the finest small-scale portraits by Hals in America, the work of c. 1660 depicts a burgomaster of Haarlem and the owner of the Rode Hert (Red Hart) brewery. A wooden beer keg from this brewery appears in the *Man with a Beer Jug* attributed to Hals in the Portland Museum. Guldewagen's wife was depicted by Jan de Bray in a pendant to the Krannert painting preserved in the Pescatore Museum, Luxembourg. While the *Portrait of a Man* once assigned to Rembrandt in Champaign-Urbana can no longer be accepted as by the master, any of his pupils, or even his immediate circle, the *Portrait of Lady Godolfin* of 1635 is monogrammed and dated by Cornelis Jonson van Ceulen, and Bartholomeus van der Helst's *Portrait of Mevrouw van Daems* of c. 1642–43 has found general acceptance. As late as 1935 the latter work was accompanied by a pendant, whose present location is now unknown, depicting the sitter's husband, who was a member of the mercer's guild in Amsterdam.

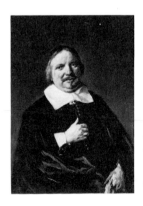

Jacob van Ruisdael's *Ford in the Woods* is a characteristic if somewhat routine later work by the master, dating around 1670 or some years later. The scene of *Riders by an Inn* usually given in the past to Nicolaes Berchem in fact bears his son's signature. Far and away the finest Dutch still life in the collection is Abraham van Beyeren's *Banquet Piece (fig. 58)*, which compares favorably with similar compositions in San Francisco, To-ledo, Philadelphia, and elsewhere. It includes the time-honored motif of the artist's reflection in a large silver ewer. While the museum's painting of

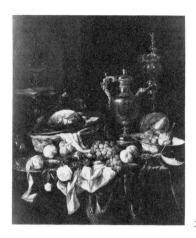

58 59

the ancient theme of *Mercenary Love* once assigned to Cornelis van Haarlem is now recognized as only a copy of the Dresden original, two other genre scenes deserve note. The *Night Scene with a Woman Paying a Maid Servant* may be a late work by that great Delft master of lighting effects Pieter de Hooch; however, it has probably been cut down at the bottom and right edges. Also long assigned to de Hooch, the *Woman Carrying a Jug in a Courtyard* (fig. 59) once actually bore a monogram (no doubt cleaned off or overpainted by a deceitful restorer) of the painter Hendrick van der Burch, whose identity and painting style has only recently been clarified. Archival discoveries suggest that van der Burch was Pieter de Hooch's brother-in-law. In addition to the personal connection, his signed works and core of attributed paintings attest to his admiration for de Hooch's orderly, light-filled courtyards and interiors. Here, as elsewhere in his work, van der Burch's hand is detectable in the looser technique and penchant for flecked highlights.

The nineteenth century paintings include minor works by Jongkind and J. H. Maris.

WILLIAM HAYES ACKLAND
MEMORIAL ART CENTER

University of North Carolina
Columbia and Franklin Streets
Chapel Hill, North Carolina 27514 *(919) 933-3039*

Completed only in 1958, the Ackland Art Center is the result of the gift of
the Tennesseean William Hayes Ackland, who bequeathed a substantial sum
to establish a museum in a major southern university to promote the arts.
The courts awarded the money to the University of North Carolina, which
has spent it judiciously under the supervision of several notable directors
and curators, most recently Evan Turner, now director of the Cleveland
Museum. The collections that have been assembled are broad ranging,
offering, in the true goal of such institutions, a level of quality that belies the
faintly apologetic cognomen "teaching collection." The collections encom-
pass works from Egyptian, Indian, and classical antiquity to contemporary
art. At present the original structure (which actually houses Ackland's
remains in a sarcophagus on the premises) is being enlarged and renovated
to accept the growing collections. A selected *Catalogue* was published in
1971 and a *Handbook* appeared in 1983 to celebrate the museum's twenty-
fifth anniversary.

 The Dutch collections are small but include several interesting works.
A recent acquisition is the large painting by Matthias Stomer of *Christ before*

Nicodemus, the first Dutch caravaggesque
painting in the museum, which also boasts
Valentin de Boulogne's breathtaking *Saint
John the Evangelist.* Dramatic nocturnal light-
ing effects also distinguish Salomon Kon-
inck's *Mocking of Ceres (fig. 60),* which
reflects a greater debt to Rembrandt and
Elsheimer. Doubtless Koninck knew Hen-
drik Goudt's print after the Elsheimer
painting of this subject now in the Prado,
Madrid. Searching at night for her daughter,
Proserpine, Ceres is shown at the doorway
of an old woman who offered her a refresh-

61 60

ing drink. The saucy boy who mocks the
goddess at the left was turned into a lizard-
like creature for his arrogance. The painting
by the little known Horatio Paulyn (often
confused because of identical initials with
Hendrik Pot) depicts the *Idolatry of King
Solomon (fig. 61)* and may be compared with
Bronkhorst's depiction of this theme at Bob

Jones University. Here the idol clearly depicts Eros, who points his arrow of love directly at Solomon, a reference to the king's ruinous appetite for women. One of the most noteworthy Dutch paintings in the collection is Emanuel de Witte's *Interior of the Oude Kerk, Amsterdam (fig. 62)*, one of the artist's later, shadowed compositions which, despite some evidence of abrasion (the darks in the master's works from these years are exceptionally fugitive and can easily be overcleaned), attests to the power of this great architectural painter who ended his life in suicide. Nicolaes Maes' *Portrait of a Gentleman* presents no problems of attribution. It must be said, however, that the *Mountainous Landscape* attributed to Esaias van de Velde is only by a follower, as are the *Still Life with Pewter Jug* assigned to Jan Davidsz de Heem, the *Boy Lighting His Pipe* called Godfried Schalcken, and the *Landscape with Satyrs and Nymphs* given to Cornelis van Poelenburgh (here another name could be found). The Jan van Goyen *River Landscape* is now considered an outright forgery. Later Dutch paintings include a lovely early Jongkind *Barnyard Scene* in Dinard in Northern France with water carts and a coastal view dated 1866.

Although no noteworthy Dutch decorative arts are found in the collection, Chapel Hill claims a selection of prints and several good drawings including a late Pieter Molyn *Landscape with Peasants,* a scene of *Figures with Classical Ruins* by Jan Baptist Weenix, and a bacchanalian *Mythological Scene* dated 1692 *(fig. 63)* by Willem van Mieris.

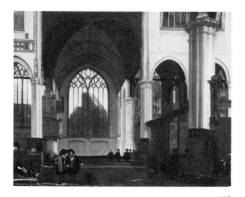

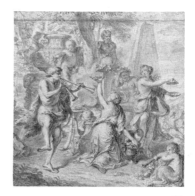

62 63

ART INSTITUTE OF CHICAGO

Michigan Avenue and Adams Street
Chicago, Illinois 60603 (312) 443-3600

Forerunner of the present Art Institute was the Chicago Academy of Design established in 1866. The institution's name was changed in 1882, and in 1893 it moved to its present site following the close of the World's Columbian Exposition. The building by Shepley, Rutan and Coolidge that had served at the exposition as the Congress of Religions remains the core of the Art Institute's complex of buildings. Numerous structural accretions have appeared as the collections have expanded; the most recent is the Morton Gallery, which houses the superb collection of twentieth-century European art. The Institute represents one of the great synoptic collections of the history of art in this country, including classical Greek and Roman art, Pre-Columbian, African, and excellent Oriental collections, as well as a world famous collection of European and American paintings, prints, drawings, and decorative arts. The greatest single aspect is probably the French Impressionist and Post-Impressionist painting collection, but the European collections are in general exceptionally strong. With the pressure of a lively exhibition schedule and the constant search for additions to the collections, catalogues of the permanent holdings have fallen out of date; the last painting catalogue appeared in 1961. However, an admirably fluent handbook by the late John Maxon appeared in a revised edition in 1977, a colorful selection of *One Hundred Masterpieces* is available, and the periodical *Museum Studies* devotes scholarship to the permanent collection. New catalogues are planned under the able leadership of the director, James Wood (formerly at the St. Louis Museum), and the paintings curator, Richard Brettel. A great loss to the institution was the recent death of Harold Joachim, long one of the preeminent prints and drawings curators in this country.

Chicagoans early loved Dutch art. A Willem van Mieris entered the collections by 1890, and the painting department's first major acquisition in 1892 was Jan Steen's *Family Concert* dated 1666 (*fig. 64*). Two years later Charles L. Hutchinson, who served as president of the Art Institute for forty-

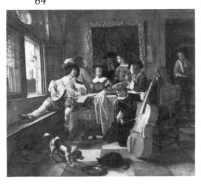

64

three years, was able to secure with the aid of Martin Ryerson (still the Institute's single greatest benefactor) thirteen major works from the sale of the former Demidoff Collection in Florence. Among these were several outstanding Dutch paintings, including Rembrandt's splendid *Girl at an Open Half-Door* (*see fig. 67*) of 1645 and Adriaen van Ostade's so-called *Golden Wedding* of 1674. In 1922 the bequest of Mr. and Mrs. W. W. Kimball brought not only a group of fine

English paintings to the collection but also Rembrandt's early *Portrait of a Man in a Plumed Beret.* At Mr. Hutchinson's death three years later, several Dutch paintings from his own personal collection came to the Institute. Shortly thereafter the Helen Birch Bartlett Memorial collection was granted, securing Chicago's reputation as one of the greatest repositories of Post-Impressionism in the world, including not only Seurat's *Grande Jatte* but some of van Gogh's greatest masterpieces. Important later benefactors of the Dutch collections included Charles H. and Mary F. S. Worcester, whose own tastes ran to German and Italian art but who set up an endowed purchase fund which made possible the acquisition of Terbrugghen's great *Denial of Saint Peter.* Similarly, the Potter Palmer fund made the purchase of the great Ruisdael *Ruin of Egmond* possible in 1947. In 1954 Max and Leola Epstein gave Hals' *Portrait of a Lady.* The staff continues to take an active interest in acquiring Northern baroque art; in 1981, for example, a major early Frans Snyders was purchased.

The early Northern Netherlandish collections are unequal to the quality of Chicago's later Dutch works, but include paintings attributed to a follower of Cornelis Engelbrechtsz, attributed to the Master of the Virgin among Virgins, and two works assigned to Jacob Cornelisz van Oostzanen, only one of which, the fragmentary *Virgin and Saint John,* approaches the master's style and quality. Easily one of the most significant of the few sixteenth-century Northern works in the collection is the monumental *Judith* (fig. 65) by Jan Sanders van Hemessen. The powerful nude twists in space holding aloft in one hand the sword and grasping with the other the sack that will carry away the gruesome prize of Holofernes' head. Authentic works by the master are particularly rare in this country. Dutch Mannerism is little represented outside the Printroom (see Pieter Witte's [called "Candido"] *Supper at Emmaus*), but the Caravaggisti include not only the major Terbrugghen mentioned before but Johan Moreelse's pendants *Democritus* and *Heraclitus,* representations of the Greek philosophers who, respectively, laughed and wept at the world. The subject enjoyed great popularity in the North (more than eighty artists treated the theme), especially among Utrecht painters. Very likely its attraction was related to the appearance of Karel van Mander's treatise (1604) on the accurate depiction of emotions, which devoted fully five pages to the challenge of distinguishing between laughing and weeping, gaiety and sadness; prior to the publication of van Mander's book, the two philosophers had not figured in Dutch art.

65

Other Dutch history paintings include Bartholomeus Breenbergh's *Resurrection,* an outstanding and appropriately bizarre *Witches' Sabbath* by the versatile Cornelis

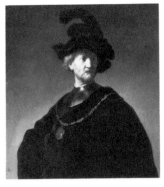

66

Saftleven (compare Richmond's painting and see also the artist's drawing preserved here), and a group of works by Rembrandt and his school. The master's painting of *Christ* is accompanied by an oil sketch by Jan Lievens of *Christ Washing the Apostles' Feet,* Barent Fabritius's unusually good *Rebecca Welcomed by Abraham,* a perplexing painting tentatively assigned to Willem Drost and uncertainly identified as *Samuel and Eli (Benjamin's Departure from Jacob?),* and Samuel van Hoogstraten's *Resurrection of Christ* of 1656, a work that already attests to the artist's departure from his teacher's manner (compare the early work mentioned below). The generous cache of Rembrandt drawings in Chicago also includes sheets depicting *Joseph Interpreting Dreams* and a great fat reed pen sketch of *Noah's Ark.* Drawings by the Rembrandt School feature works by Barent Fabritius, Aert de Gelder, Jan Victors, Gerbrand van den Eeckhout as well as works by other known and unknown followers.

Among the outstanding masterpieces in the collection is Rembrandt's early *Man with a Gold Chain (fig. 66)* of c. 1630–31. The model for this work recurs repeatedly in the master's youthful work (see the paintings in Boston, Cambridge, The Hague, Cassel, and Leningrad) and has been identified, without foundation, as Rembrandt's father. The swashbuckling panache of the costume—an extravagantly feathered beret, ample black cape, steel gorget, and courtier's chain—belie the sitter's sunken eyes and cheeks, his firmly set but tellingly toothless jaw. Though scarcely achieving the world-weary expression of the Metropolitan Museum's later *Aristotle,* something of that great mature work's contrast of the mere trappings of high office and the inner repose of true stature is already captured in this memorable early work. The authorship of Rembrandt's later *Young Girl at an Open Half Door(fig. 67),* dated 1645, has been questioned by as prescient a Rembrandt specialist as the late Horst Gerson, but his doubts and tentative

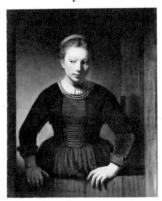

67

reattribution to Jan Victors must be rejected. The girl, clad in the uniform of Amsterdam's Municipal Orphanage, gives a sidelong look as she stands parallel to the picture plane behind an open half-door. Her calm monumentality surpasses Victor's melodrama or self-conscious illusionism (compare the latter's *Girl at a Window* in the Louvre) offering a lower class but hardly less noble counterpart to other paintings by Rembrandt, such as the *Portrait of Agatha Bas* (Her Majesty the Queen of England, Buckingham Palace), which uses

a similar framing device to enhance the immediacy of the subject. Other notable portraits in the collection include a fine image of an alert-looking *Young Woman* dated 1627 by Frans Hals, a lesser quality *Portrait of an Artist* dated 1644 which is attributable to Hals but abraded, a *Portrait of a Lady* by Paulus Moreelse sporting a costume with bristling lace collar datable to c. 1620, a haunting portrait of an elegant, heavy-lidded woman formerly and perhaps correctly attributed to Dubordieu (compare his work in the Rijksmuseum), a pair of good early half-length pendants by Nicolaes Maes, and an elegant small *Portrait of a Man,* possibly a lawyer or judge (see the statue of Justitia in the background), signed by Casper Netscher and dated 1680. An image of a *Youth in a Turban* has been wrongly assigned in the past to Rembrandt and to Aert de Gelder, no doubt because of the rich freedom with which the headgear is painted; but its attribution by Bauch to Hoogstraten in the early 1640s is more convincing. There is no uncertainty, however, about the attribution of the *Woman with a Veil and Feathered Hat* to Aert de Gelder, probably of the 1680s. Its bold frontal composition and dazzling technique make it one of the most memorable images in the collection.

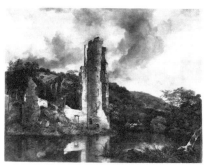

68

Chicago has no early Dutch landscapes but boasts several excellent examples of the mature "classical" phase, notably Jacob van Ruisdael's *Ruins of the Castle of Egmond (fig. 68).* Typical of the artist's work of the 1650s is the stress on mass and color. Gone are the gauzy forms of van Goyen. While the ruins of Egmond Castle near Alkmaar could readily be visited in Ruisdael's day (there even exist modest remains today), Ruisdael probably exaggerated the towering structure of the ruin and surely fictionalized the large hill that rises behind it. The intent, of course, is to monumentalize the scene. In addition to the site's political associations (the prince of Orange had destroyed the castle to prevent the Spanish from using it as a stronghold), the ruins naturally had associations with transience and decay, but also could carry positive connotations. In seventeenth-century prints as well as poetry, ruins often were sites for pleasurable bucolic retreats and, ironically, could suggest the durability of man's work. Two works by Ruisdael's peerless pupil Meindert Hobbema reside in Chicago. The greater and better preserved is the lovely *Watermill (fig. 69),* a subject that Ruisdael had treated by 1653 (see the painting newly acquired by the J. Paul Getty Museum). Ruisdael's treatment of the theme stressed the turbulent power of undershot mills, while the milder Hobbema, who made a specialty of the theme, explored the mill's quiet and placid beauty.

69

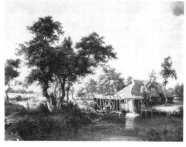

70

A good early (1630) still life by the well-known Pieter Claesz is accompanied by a later *Flower Still Life* dated 1658 by the little-known Adriaen van der Spelt (*fig. 70*). Had the latter painted nothing else (in truth his works are exceedingly rare), van der Spelt would be remembered for his illusionistic skills in painting the *tromp l'oeil* satin curtain in this work. The trick, of course, is enhanced by the low relief and the imagined distance between the curtain and the picture plane. Paintings of Dutch Interiors by Metsu and other seventeenth-century genre painters illustrate the practice of hanging protective curtains in front of paintings. One of Chicago's genre scenes, *The Terrace,* by an unknown Delft painter of mid-century (*fig. 71*) also attests to the Dutchman's appetite for illusionism; no doubt reflecting the perspectival achievements of Fabritius and de Hooch, this sunny work not only offers a view of a couple on a terrace but interjects the illusion of a mullioned window through which the scene is viewed. Delft's architectural painters (works by both Emanuel de Witte and Cornelis de Man are here preserved) also experimented extensively with the illusion of space in their church interiors.

In contrast, Pieter Codde's earlier genre scene, known as *The Assembly,* dated 1632, seeks naturalistic effects less through the impression of interior space than through the scrupulous rendering of stuffs and surfaces, fine rustling satins and starched linens. Very likely the subject of the painting is a wedding party. During such gatherings all the silver and gold vessels (often presents from earlier celebrations) owned by the family were put on display and used in a succession of elaborate toasts to the newlyweds. Often they began with the smallest cup and ended with the tallest flute. The man kneeling before the couple drinks from a particularly precious covered cup, called an *overdekte bokaal.*

71 72

The finest Dutch genre painting in the collection is Jacob Ochtervelt's *Music Lesson* of 1671 (*fig. 72*). Although compositionally based on Vermeer's *Officer and a Laughing Girl* in the Frick Collection, New York (*see color plate 12*), this painting of perhaps a dozen years later transforms the Delft artist's simple, convivial chat into an elegant balletic exchange. The lighting system, the use of the male figure as a *repoussoir,* even the inclusion of an identifiable map (C. J. Visscher's "Germania Inferior") on the back wall, are essentially the same, but Ochtervelt strives for something more elevated— an aristocratic world of attenuated proportions, the sway of studied grace, and just a hint of insouciance. The counterpart to this late high-life subject is Adriaen van Ostade's bumptious *Golden Wedding,* dated three years later. Ostensibly an image of peasant life (compare his earlier treatment of the theme in the painting in Toledo), its view of the lower classes as prosperous, light-hearted folk expresses a social ideal that must have been as reassuring to a well-to-do patron as Ochtervelt's elegant musicians. Other Dutch genre paintings in the collection include Steen's great *Musical Company* dated 1666 (the hunt scene on the rear wall—an allusion to animal passion and its control?—is based on a print after Rubens' painting in Rennes), Terborch's badly rubbed *Music Lesson,* a large but rather dull Isack van Ostade of 1643, an exceedingly poor little interior wrongly assigned to Eglon van der Neer, and a far superior domestic scene by Willem van Mieris burdened with the apochryphal title the *Happy Mother,* its date 1703, hitherto unnoticed.

Supplementing these works are Chicago's genre and figure drawings. A particularly charming early sheet is Avercamp's study of a *Mail Sled.* Like the artist's other sketches and paintings of sleds drawing everything from beer kegs to itinerant stone sharpeners, this work attests to the ice-borne commercial and communication network provided by the frozen waterways of seventeenth-century Holland. The era's unusual cold scarcely hampered business or pleasure. Cornelis Dusart's late drawing of a *Hurdy-Gurdy Player* (*fig. 73*), dated 1695, provides an equally picturesque image. However, the tattered gaiety of this hunched figure with his rasping instrument ought not obscure the fact that street performers were among the poorest and most

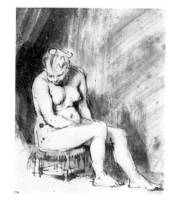

73 74

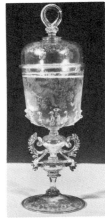

abused members of Dutch society. Surely one of the most memorable figure drawings in the collection is Rembrandt's *Seated Nude* (fig. 74), a powerful pen sketch of the studio model seated on a low stool, the bold strokes of wash, her heavily deposited form and downturned gaze adding to the weight of expression.

The decorative arts collections claim a few pieces of seventeenth- and eighteenth-century furniture, silver, and delftware, including a bottle with a screwtop by Samuel van Eenhoorn and a jar by Pieter Adriaensz Kocks. Rarely exhibited but in many cases of noteworthy quality are the holdings of Dutch glass. Of special interest is a winged goblet with cover

75

(fig. 75) and engraved decorations of c. 1650–75 attributed to W. Mooleyser, a fine stippled wineglass signed and dated 1749 by Frans Greenwood, and a so-called friendship glass dated 1795 (fig. 76) showing two male figures amicably bending toward one another under the motto "Vryheid, Gelykheid, en Broederschap" (Liberty, Equality, and Fraternity), a commemorative reference to Dutch and French relations. After the collections in Corning, Toledo, and the Metropolitan Museum of Art, Chicago's Dutch glass holdings are among the most extensive in this country.

76

The art of the eighteenth-century Netherlands is as scarce

here as elsewhere in this country, but, true to the pattern of American collecting, the later Impressionist works abound. While The Hague School somewhat surprisingly is little in evidence (two mediocre Josef Israëls), Jongkind is well represented, the finest of his three canvases being the blustery *Entrance to the Port of Honfleur* (also known as the *Windy Day*) dated 1864. No serious student of van Gogh can afford to bypass Chicago, which

77 claims fully ten paintings as well as outstanding drawings by the artist. Here we meet the artist's wonderfully delicate image of tilting gaslamps on the *Belvedere Overlooking Montmartre*, a work probably painted during his stay in Paris in 1886, as well as a *Still Life with Grapes* infused, as it were, with a halo of blue light, and one of van Gogh's intense *Self-Portraits,* the latter two probably executed about this time or a year later. The *pointillist* manner of the *Self-Portrait* attests to the artist's admiration for the style perfected by Seurat. In a letter with a sketch for his painting of *Bedroom at Arles* (fig. 77), van Gogh wrote to Theo of the work having a simplicity "à la Seurat." Chicago's version of this famous composition is perhaps not the first painted version (which generally is considered to be the painting in Amsterdam), but lacks nothing to convey its image of an abstemiously bare though

colorfully bright and well-scrubbed room—the very emblem of healthful poverty. It was shortly thereafter that Gauguin arrived in Arles, a visit that soon degenerated into conflict, and van Gogh began his series of portraits of the Roulin family (related works in Boston, Philadelphia, and the Metropolitan Museum of Art in New York). Van Gogh had begun his first version (Kröller-Müller Museum, Otterloo) of the so-called *Berceuse* (fig. 78) before the famous mental attack that resulted in his mutilating his own ear. He subsequently recorded producing four replicas in the following months, of which

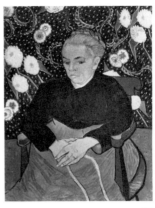

78

Chicago's painting is one. The powerfully iconic effect of this maternal image (note the rope she holds to rock the cradle) is enhanced by the huge floral pattern of the wallpaper behind. According to his letters, van Gogh envisioned a sort of secular triptych in which the *Berceuse* would be the centerpiece with wings depicting sunflowers (see the painting in Philadelphia). Van Gogh's landscape attained a splendid urgency and vitality in these years, as witnessed in Chicago's masterful reed pen drawing of 1889 of a *Grove of Cypresses,* the foliage transformed into licked curlicues, coiled tongues of fire. Yet there are also grimly private images of an inexplicable power, such as the *Drinkers,* in which van Gogh, confined to the asylum, suddenly turned once again to Daumier for inspiration, depicting gaunt drinkers at a table before a landscape studded with industrial smokestacks. The meaning that this singular work, an isolated statement among van Gogh's last works, had for the artist may never be fully understood.

CINCINNATI ART MUSEUM

Eden Park
Cincinnati, Ohio 45202 *(513) 721-5204*

Even before the Cincinnati Art Museum was inaugurated in 1886, the city was one of the first and most active art centers west of the Alleghenies. As early as 1812 an art school had been established, and by 1854 the Ladies' Fine Arts Academy (later a casualty of the Civil War) had sought to establish an art gallery. When the museum opened atop Mount Adams, the highest of the city's hills, it was hailed as the "Art Palace of the West." Originally designed in the massive Richardsonian Romanesque style, the original structure is now partly disguised by additions dating from 1907, 1910, 1928–30, 1937, and 1962–65. The earliest of these—the Schmidlopp Wing—added an exterior Greek portico which now serves as the main entrance. The permanent collections are far ranging and international, including Egyptian, Greek, Etruscan, Roman, Nabataean, Near Eastern, Indian, Oriental, European, and American art. The Dutch paintings and prints are numerous and often of exceptional quality. A *Handbook* published in 1975 is available.

Reflecting the collections' strengths in Dutch portraiture and landscape, the two finest Dutch paintings in the museum are Frans Hals' outstanding *Family Portrait* and Albert Cuyp's *View of Herdsmen on the Banks of the Maas.* Hals' *Family Portrait* (fig. 79) has been dated about 1635 by Slive. He notes that it stands in the venerable tradition of small-scale, full-length family portraits first popularized by the Haarlem/Amsterdam artists Thomas de Keyser, Pieter Codde, and Jan Miense Molenaer, and which later evolved into the eighteenth century's "conversation piece." Rembrandt's lone effort in this genre is the painting in Boston's Gardner Museum dated 1633. Hals places the family on the terrace of what surely is an imaginary villa with an equally fanciful vista of a garden and stately buildings. The background may, as Slive argues, have been painted by Pieter Molyn with whom Hals seems to have collaborated on other occasions. While the vines clinging to

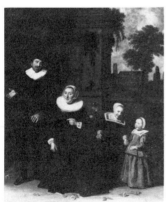

the masonry in the middle distance probably allude to steadfast love, and the roses strewn upon the ground can alternately symbolize love or the transience of life, the painting's central theme is not merely a likeness of individuals but a celebration of the joy and health of family life. The children are a vision of enchantment, their parents complete contentment. Indeed, the unrepressed gaiety of the group—so different from the staid and decorous demeanor of family portraits later in the century—is a delight to behold.

79

Although good of its kind, Mierevelt's *Portrait of a Man* dated 1630 seems mechanical by comparison, and, similarly, the so-called *Portrait of Titus,* Rembrandt's son, attributed here uncertainly to Nicolaes Maes, pales beside Hals' vital characterization of childhood. Terborch's *Portrait of a Man, Aged Twenty-Two,* dated 1656, probably once was a compelling image of youth but now, alas, is in poor condition. The other noteworthy portrait-like work in the collection is the *Young Girl Holding a Medal,* incorrectly assigned to Rembrandt. The work of a follower

80

or student, perhaps Govaert Flinck, the subject seems somewhat too old to wear a christening medal of the type seen in the *Titus* portrait. Rather, with her pearls and exotic costume, she, like so many of the half-length figures Rembrandt and his pupils dressed in studio props, seems to assume a historical or at least pseudo-historical identity. The roles, on the other hand, of *Vertumnus and Pomona (fig. 80)* in Ferdinand Bol's large and ambitious picture—the only major Dutch history painting in Cincinnati—are easily recognized. A favorite subject not only of Rembrandt's students (see Govaert Flinck's painting in Rochester) but of Dutch painters generally, the theme appealed because of its implicit collusion with the viewer; onlookers share with the painter the knowledge that Vertumnus is a man disguised as an old woman attempting to seduce the beautiful Pomona. Apart from the erotic dimension of the theme, it naturally had the dramatic interest, so richly mined by Shakespeare and other playwrights, of the dilemma of seeming and being.

Cincinnati's Dutch landscapes include a fine *Winter Landscape* by Aert van der Neer that is preferable to the Taft Museum's picture by this artist, a late but majestic Ruisdael *Landscape with Woods, River and a Castle* (surely an imaginary scene despite the label's presumption of a site in Westphalia), a good, small *Landscape with Watermill* by Hobbema, and a tranquil *View on the river Vecht* by Jan van der Heyden. These Northern views are balanced by Jan Both's *Italian Landscape,* dated 1645, and the gloriously sunny *View on the Maas (fig. 81)* by that italianist *manqué,* Albert Cuyp. This part of the American Midwest is particularly rich in outstanding works by Cuyp, claiming as it does fine examples in Indianapolis, Cleveland, and Toledo. It must be said, however, that the artist's style is not yet fully understood if a work like the *Two Horsemen* hanging nearby in Cincinnati's Dutch galleries can still carry assignment to Cuyp. Certainly this is a work by that great epigone Abraham

81

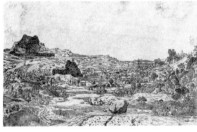

82

Calraet, whose imitations of Cuyp's works have been confused with the master's paintings for at least two centuries not only because of their stylistic resemblances but because of the accident of shared initials.

For sheer rarity, to say nothing of their haunting beauty, the print collection's two landscape etchings by Hercules Seghers (fig. 82) must be singled out for special mention. Seghers was probably the most gifted imaginary landscapist of his age in the North, enjoying the admiration of no less discriminating a collector than Rembrandt, who not only was influenced by his highly personal style but even reworked one of his plates. Reproductions of Seghers' colored, moon-like landscapes, even in costly facsimile volumes, rarely convey his rich subtlety of hue. Unfortunately, the extreme sensitivity of these works to light limits their periods of display.

Cincinnati's collections are weak in Dutch still life, a lacuna that until recently had been filled by a splendid Cornelis de Heem which was on loan but is now sold. Better in quality are their genre scenes, notably a late (c. 1675) *Music Party* by Gerard Terborch. Although the picture is not in the best of condition, it displays the psychological subtlety for which the artist is renowned. The young gallant's glance strays from his music to fix on his lovely female accompanist, who concentrates perhaps too deliberately on her music. The figure of the woman is repeated in a similar and doubtless contemporary painting in Waddesdon Manor (British National Trust). Ironically, Waddesdon Manor also houses the original, of which Cincinnati's *Skittles Players,* wrongly attributed to Pieter de Hooch, is a copy. Another change of attribution (first suggested by Susan Donahue Kuretsky of Vassar) must be urged for the collection's so-called Ochtervelt, which is better assigned to Pieter van Slingeland. Good low-life genre prints by Adriaen van Ostade and Cornelis Dusart have found their way into the collection. The single noteworthy piece of Dutch furniture, a massive seventeenth-century oak chest (fig. 83), is perhaps best mentioned in the context of Dutch genre,

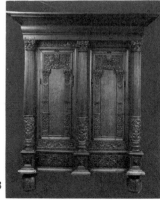

83

since artists like de Hooch often furnished their interiors with a *"kast"* of this type (see his painting in Cleveland).

More than a dozen nineteenth-century Dutch paintings are preserved in Cincinnati. In addition to landscapes and figure pieces by Hague School artists (Josef Israëls, Anton Mauve, and Willem Maris), the collections include paintings by J. M. ten Kate and Petrus van Schendel. The last mentioned specialized in finely executed nocturnal scenes with artificial lighting (see his *Girl Reading by Lamplight*

dated 1870) which seems ultimately de-
scended from Godfried Schalcken. Both the
early and later art of van Gogh is represented.
The *Head of a Peasant Woman* dates from the
era of the famous *Potato Eaters,* and the very
late (though ironically only postdating the
former by six years) *Undergrowth with Two
Figures* is of 1890. Cautioning oneself all the
while that we bring to such a picture the
foreknowledge of van Gogh's violent end, one
nonetheless finds the slender figures, sur-

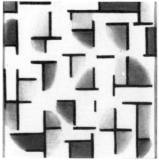

84

rounded by a forest of thick trees and dwarfed by the high horizon (were it
not for the painterly touch one might think of Klimt), strangely brittle and
vulnerable.

Two important early twentieth-century Dutch works in the collection are
the charcoal drawing executed by Mondrian in 1912 called *Scaffolding* and
a later painted *Composition (fig. 84)* by another leader of the "De Stijl"
movement, Theo van Doesburg. The printroom owns one of M. C. Escher's
illusionistic woodcuts, the *Day and Night,* in which geese and the fields
beneath them imperceptibly intermingle, changing from black to white and
back again. Lastly, like Pittsburgh, Cincinnati owns a painting by the COBRA
artist Corneille.

TAFT MUSEUM

316 Pike Street
Cincinnati, Ohio 45202 *(513) 241-0343*

The Federal-style Charles Taft home was built in 1820 for Morton Baum, mayor of Cincinnati. From Baum it passed to Nicolas Longworth, a congressman, and thence to the Taft family. In 1908 William Howard Taft accepted the Republican presidential nomination from the building's portico. However, it was Charles Phelps Taft, the half-brother of the twenty-seventh president and the publisher of the Cincinnati *Times Star,* and his wife Anna Sinton who amassed the collections seen here and who donated the building to the city. The house was formally dedicated as a museum in 1932. Well maintained, the elegant mansion draws visitors to admire its Chinese porcelains, French enamels, English furniture, decorative arts, watches, and jewelry. But its greatest strengths are its Old Master and nineteenth-century paintings. The selection of English and Dutch pictures is small but superb. There is a room-by-room catalogue (n.d.).

Although its identification (stemming from a sales reference of 1825 when the picture sold with a companion, now unlocated) with Michiel de Wael, one of the sitters in Hals' group portrait of the St. George Militia of 1627, has rightly been questioned, Frans Hals' *Portrait of a Man* is an excellent example of his manner of the early 1630s. Equally fine are the pair of pendants—a *Man Seated Holding a Hat,* and his mate, a *Seated Woman Holding a Fan*—that Hals must have executed about a score of years later. Our inability in this case to identify the couple seems particularly disappointing given their genial expressions and the brilliant execution. The woman's image is surely one of the most engaging female portraits by Hals in this country. Hardly less distinguished is Rembrandt's *Portrait of a Fashionably Dressed Young Man (fig. 85),* dated 1633. Here the subject, wearing an elaborately tailored costume replete with bows at the waist to hold up his breeches, appears to have suddenly risen from his chair to extend his left

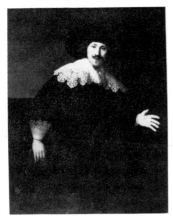

hand expressively. This introductory gesture doubtless was intended for his mate, the richly clad *Young Woman Seated Holding a Fan,* also dated 1633, now preserved in the Metropolitan Museum of Art in New York. Unfortunately, the subtle dialogue of this charming pair, separated as it is by the Appalachians and so many miles, is lost. We nonetheless can admire the youthful Rembrandt's assurance in animating his sitters. His achievement is set off by Ferdinand Bol's adequate but uninspired portrait in the collection. In passing we should also note that

the attribution to Rembrandt of the painting of a *Man Leaning on a Sill* is uncertain, the *Portrait of an Elderly Woman* is surely a later pastiche of Rembrandt's art, and the *Laughing Child with a Flute* is only a copy of a lost Hals.

A group of good quality Dutch genre paintings are to be seen at the Taft. The best is Jan Steen's splendid little painting of one of his favorite subjects, *The Doctor's Visit (fig. 86*; compare the other versions of this theme in the Johnson Collection, Philadelphia, and the Metropolitan Museum). As if the young lady's swooning, the doctor's comically apoch-

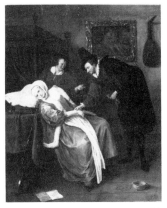

86

ryphal costume, and the painting of classical lovers on the back wall were not enough, the inscription on the piece of paper on the floor leaves no doubt about the painting's subject. "Hier baet / geen Me[de]sijn / want het is / minne pÿn" (No doctor avails here because it is lovesickness). Another theme popular from the 1630s onward among Dutch genre and particularly guardroom painters, was the sleeping soldier tickled by a woman as his amused companions look on. Terborch's version of this theme at the Taft probably dates from the mid- to late 1650s. Sadly, it has suffered from abrasion but must once have been an outstanding work. It is assumed to have a companion (Hottinger Collection, Paris) depicting a woman drinking with a man and attended by a page. Pieter de Hooch's so-called *Music Lesson* in the same room is a good later (c. 1667–70) example of the painter's art with a rather daring color scheme juxtaposing intense red and orange. Attention also should be drawn to two fine little genre paintings by Adriaen van Ostade, *Old Toper* of 1651 and *Carpenter's Shop* of 1656.

The landscapes include a *View on the High Road* signed by Jacob van Ruisdael, a lesser quality landscape by Aert van der Neer, and a truly outstanding, major *Wooded Landscape (fig. 87)* by Meindert Hobbema (the staffage possibly by another hand). The *Harbor with Fishing Boats* assigned to Salomon van Ruysdael is the only Dutch seventeenth-century marine in the collection.

The Hague School pictures, several of which are major examples, also

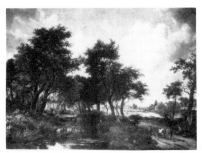

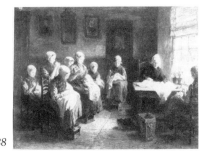

87 *88*

include views of Dutch quays and harbors. Jacob Maris's large and imposing *View of Rotterdam* is a noteworthy painting, as is Josef Israël's *Sewing School at Katwijk (fig. 88)*. Anton Mauve's *View of Cattle* led away from the viewer to the horizon by a drover is one of the artist's numerous examples of this theme most of which seem to have been executed in Laren. The Taft's collections of Dutch nineteenth-century paintings, like those of other collections formed in this country at the end of the nineteenth and the early decades of the twentieth century, attest to the strong attraction that Hague School art had for American viewers.

CLEVELAND MUSEUM OF ART

11150 East Blvd.
Cleveland, Ohio 44106 (216) 421-7340

The Cleveland Museum of Art is one of America's great, encyclopedic museums, presenting to the viewer the full range and achievement of the history of art. Like the city's excellent library and symphony, the Cleveland Museum and its rich and varied collections are a testament to an extraordinary era of civic pride that swept up America's Midwestern cities in the last quarter of the nineteenth century and the first decades of this century. One could argue that not since the Roman Empire has there been such a welling up of private and corporate support for cities and their cultural institutions. A site for a gallery dedicated to art was reserved in Wade Park in 1892, but it was not until 1913 that funds were made available for the incorporation of a museum. The museum itself was formally opened three years later in a classical-style building designed by the architects Hubbell and Benes with the consultation of Edmund B. Wheelwright of Boston. Additional galleries and a new wing designed by Hays and Ruth were dedicated in 1958, and further additions, principally to accommodate the museum's educational services and special exhibitions spaces, were integrated by Marcel Breuer and Associates with the existing structure in 1970. Funds for the construction and support of the museum initially bequeathed by Hinman B. Hurlbut, John Huntington, and Horace Kelly have been supplemented since the museum opened by substantial purchase funds, notably those of Mr. and Mrs. William H. Marlatt, John L. Severance, Elizabeth Severance Prentiss, and Leonard C. Hanna, Jr.

These ample funds have enabled Cleveland to compete with the greatest and wealthiest museums of the world in the pursuit of outstanding art in virtually every field. In addition to important purchases, the collections have been supplemented with great works of art bequeathed to the museum by many of the same benefactors who provided purchase funds. In addition to its envious history of generous private support, the Cleveland Museum has benefited from a strong tradition of professionalism and scholarship among members of its own staff and administration. The present director, Evan Turner, and his predecessor, Sherman E. Lee, typify this tradition, as did the late Wolfgang Stechow, who served the museum, and specifically the Dutch collections, so ably as the advisory curator of European art. Stechow wrote many of the entries on the Dutch paintings for the comprehensive new catalogue *European Paintings of the Sixteenth, Seventeenth, and Eighteenth Centuries* (1982). Additional publications include an extensively illustrated *Handbook* published in 1978 and a highly literate *Bulletin* that has been published continuously since 1914.

In seeking the dual goals of comprehensiveness and high quality in the collections, the leaders of the Cleveland Museum have scarcely slighted the

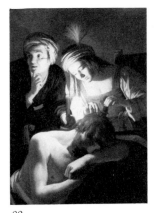

89

Dutch School, though in tabulating sheer numbers of masterpieces, the visitor might award preeminence to the Italian, French, or Spanish collections. Some of the earliest Dutch treasures proper are a small panel depicting the *Adoration of the Magi* by the charming fifteenth-century Haarlem painter Geertgen tot Sint-Jans and a fine group of prints by Lucas van Leyden, the latter including an engraving of the *Return of the Prodigal Son* and a woodcut of *Samson and Delilah*. Both of these history themes enjoyed popularity with later Dutch artists, including Rembrandt. When the Caravaggio follower Gerard van Honthorst (known to his Italian colleagues as Gherado della Notte, "Gerard of the Night") painted Samson and Delilah (*fig. 89*) he no longer depicted the stealthful act in a daylight landscape as van Leyden had, but concentrated the scene upon a few large figures dramatically illuminated in the darkness by a central candle. Together with the excellent works by George de la Tour, Valentin de Boulogne, and Jusepe de Ribera in Cleveland, Honthorst's *Samson and Delilah* speaks eloquently of the international impact of the art of Caravaggio, whose own haunting *Martyrdom of Saint Andrew* was acquired in 1976. The old woman who fearfully attends Delilah in Honthorst's work is absent not only from the van Leyden but also from the Old Testament's account of the story, which mentions only male accomplices (Judges 16:18–21). Doubtless she was added by Honthorst and his immediate forerunners in the nocturnal treatment of this theme, such as Rubens, not only for the expediency of having her hold the candle but also because she recalls the serving woman who accompanies Judith beheading Holofernes (see Judith 13), a related episode from the Bible much loved for its emotional drama by Caravaggio and many other baroque history painters. Two other figures who were related in the thinking of the day were the scholarly but lachrymose Saint Jerome and the weeping philosopher, Heraclitus. In its entry for Cleveland's Terbrugghen, the new painting catalogue intelligently discusses the analogies that were drawn between the two in seventeenth-century literature. However, despite the repetition of the same figure in

90

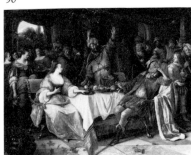

another work by the artist depicting Heraclitus with his counterpart, Democritus, the philosopher who laughed at the world, the fact that the Cleveland painting exchanges Heraclitus's globe for Jerome's skull would seem to certify that it is the saint and not the philosopher who is depicted.

One of the finest Dutch history paintings in Cleveland is the scene of *Esther, Haman, and Ahasuerus* (*fig. 90*) by Jan Steen.

Ahasuerus, king of the Medes and Persians during the Babylonian captivity of the Jews, took Esther, a Jew, as his queen. The king's evil minister, Haman, had plotted to destroy the Jews with a decree of execution issued in the king's name. Esther arranged a banquet where she exposed Haman's plot and pleaded for the life of her people. Ahasuerus is shown rising in fury to send Haman to the same gallows that had been prepared for Mordecai, the king's loyal Jewish minister (Esther 7:1–10). In Christian art, Esther's intercession with Ahasuerus was commonly interpreted as a prefiguration of the Virgin's intercession with God for mankind's salvation. Since the Dutch identified with the children of Israel in their struggle for freedom from Spanish rule and religious oppression, the story of Esther enjoyed great popularity in seventeenth-century Dutch art, literature, and drama. Indeed, here, as so often in Steen's paintings, the subject seems to be conceived theatrically, not only in the exotic costumes and emphatic gestures but also in the staging of the scene. The curtained setting with columns and open wings recalls the stage of the Amsterdam Schouwburgh.

The three Rembrandt drawings in Cleveland (the museum owns no certain history paintings by the artist) take a less theatrical approach to their biblical themes. One depicts the still figure of *Christ before Caiaphas* with a babbling crowd who mock their despondent captive. The stolid soldier who stands at the center with a helm and lance recalls figure motifs from Rembrandt's famous *Night Watch,* suggesting a date of around 1642. A similar date is usually proposed for the drawing of *Tobias healing Tobit's Blindness,* a particularly fresh work showing the point in the apocryphal Bible story when the son administers the miraculous fish parts to his father's eyes under the watchful supervision of his guardian angel and his elderly mother, Anna. The beturbaned woman standing silently at the right doubtless is Tobias's new wife, Sarah. While works such as this have a marvelous spontaneity, they hardly prepare us for the rough power of a reed pen drawing like *The Meeting of Christ with Martha and Mary after the Death of Lazarus (fig. 91).* This sheet has been identified as one of the rare drawings dating from near the end of Rembrandt's career, or c. 1662–65. The two sisters, superimposed on one another with the broadest and bluntest of strokes, kneel before Christ. In the Bible Mary is described as falling to the Lord's feet with the words "Lord, if thou had been here, my brother had not died." The mournful figure of the standing Christ is also faithful to the biblical account (John 11: 30–36): "He groaned in the spirit . . . [and] wept" at the news of Lazarus' death. Behind Christ appear the apostles with heads bowed in sorrow. At the right are the weeping Jews who attend the sisters; one old man in a high cap takes out a kerchief to dry his cheeks. Despite his expression of sadness, Christ is clearly not in despair. To Martha's objections to

91

his opening the tomb, Christ replied, "Said I not unto thee, that, if thou wouldest believe thou shouldest see the glory of God?" This entire complex didactic exchange preceding the raising of Lazarus is executed in the crudest of shorthand, but the drawing succeeds in conveying the narrative succinctly and with great tenderness. Even more interestingly, it shows Rembrandt's mind at work.

In contrast to this drawing, the two oval panel portraits by Rembrandt in Cleveland are both from his early years in Amsterdam. Once wrongly thought to be a self-image by Rembrandt, the *Portrait of a Youth* of 1632 is a typical example of the confident young artist's portrait style. The *Portrait of a Lady* of 1635 has unfortunately been damaged and overpainted in the face and collar. The assumption that the work is the pendant to a portrait of a gentleman in the Townsend Collection, Indianapolis, has been doubted by Stechow. Of the two other putative Rembrandts, the so-called *Portrait of a Jewish Student* has been identified with no compelling reason as Spinoza, and like the *Old Man Praying* has been doubted by the Rembrandt specialist, Horst Gerson. While the former painting has some claims to being autograph, the latter indeed seems questionable, despite its relationship to the very late series of saints and images of Christ (compare the many other paintings from this group in America, in Boston, Chicago, Malibu, Glens Falls, New York City, San Diego, and Washington). There is no reason, however, to doubt the assignment of the handsomely preserved *Portrait of a Lady in a Ruff* of 1638 to Frans Hals or to question Terborch's *Portrait of a Standing Lady,* which sadly is separated from her mate in the National Gallery in London. It can be debated, as tradition claims, Govaert Flinck's rather dour *Portrait of a Woman* of 1646 in fact portrays the great woman author and scholar of Oriental studies Anna Maria van Schuurman (1607–1678). It seems likely, however, that Dirck van Santvoort's *Portrait of a Girl with a Flute,* which Cleveland's new catalogue relates to two other paintings of the same size and same sitter holding a mirror and fruit, is part of a Five Senses series.

Reviewing this assembly of portraits one is struck again by the exceptional importance of portraiture to the Dutch in their Golden Age. In a

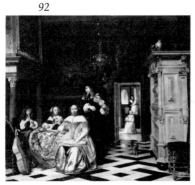

92

century when portraiture flourished as never before, nowhere was it so popular as in The Netherlands. Portraits were not merely essential for the support of Holland's burgeoning community of artists, they fulfilled important artistic and social needs. The Dutch people desired visual records of themselves, be they factual or merely flattering. While we ought rightly to question our ability at the remove of three centuries' time to read the intangibles of character in these faces, we may be sure

that portraiture served to realize the Dutchman's self-image and legitimize his ambition to actual or imagined social roles.

Pieter de Hooch's masterful *Music Party* (fig. 92) of 1663 well illustrates this function. The elegantly attired players who make music around the table covered with a rich oriental rug all bear portrait features and almost certainly are members of a single family. Although they have not been positively identified (there is some evidence to suggest that they may be the family of Adam Oortmans, owner of the Zwaan Brewery in Amsterdam), the sitters almost certainly are members of the wealthy merchant class in Amsterdam, whose patronage de Hooch surely coveted after his move to that city in 1660/61. The musical party, whose costly instruments include a viola de gamba, an alto recorder, a small cittern, and a violin, are surrounded by the material evidence of their success. The room is furnished on the left with a marble columned fireplace and on the right with a splendidly crafted chest of unstained oak surmounted with porcelain and lacquered boxes. Despite the intimate proportions of the room, the floors are tiled with marble and the back wall covered with an expensive tapestry. Music was a common feature of family portraits and probably alludes to the ideal of familial harmony. Moreover, the painting of the sacrifice of Isaac over the mantlepiece might also prompt thoughts of family loyalty and obedience. The Protestant emphasis on marriage and the importance of the family pervades Dutch portraiture. Paintings like the de Hooch, which anticipate the eighteenth century's "conversation piece," and the numerous pendant and rarer double portraits of married or betrothed couples reflect a deep societal need for marital and familial imagery in the era that saw the rise of the private, nuclear family and the waning of the old extended kinship circles.

Willem Kalf's elegant *Still Life* (fig. 93) is dated the same year as the de Hooch. Surely the rich objects depicted—Italian glassware, finely worked Dutch silver (the central vessel with supporting putto, Stechow notes, recalls the style of Christian van Vianen), and a porcelain bowl of Chinese design filled with imported fruit—would have appealed to wealthy Amsterdamers like those depicted in the portrait. The rich atmosphere and veiling shadow of Kalf's work contrast with the scrupulous clarity of Ambrosius Bosschaert's

Flower Still Life, which bears the earliest date, 1606, in the artist's oeuvre. Typically the composition includes blooms from different seasons, indicating that they were composed from separate studies. This was a common practice, as was the habit of including a tiny self-portrait in the reflection of metalware objects, like the silver pitcher in the handsome *Banquet Piece* by Abraham van Beyeren (compare, for example, Pieter Claesz's painting in Vassar). Similar banquet pieces by van Beyeren are in Toledo, Worcester, Champaign-

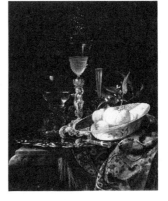

93

94

Urbana, Philadelphia, and San Francisco. Despite the quality of the Kalf, Bosschaert, and van Beyeren, they remain something of the exception in Cleveland, where there are relatively few Dutch still lifes or genre scenes. The latter include only Jan Baptist Weenix's fanciful *Hunting Party with Ruins* (the Temple of Vespasian) and a poor, even dubious, Codde *Guardroom Scene.* Animal painting is represented only by Abraham Hondius's *Cat and Monkey,* illustrating Aesop's familiar fable known by way of engravings of La Fontaine or even Roemer Visscher's *Sinnepoppen.*

These lacunas, however, are offset by an outstanding collection of Dutch landscapes. Among the earliest is a pen and wash study of a gnarled *Hollow Tree* by Roelant Savery, the Flemish-born artist who worked for Emperor Rudolf II at Prague before moving to Amsterdam and later Utrecht, and a black chalk drawing *Hilly Northern Landscape with a Hut* by Esaias van de Velde *(fig. 94).* While the former still exhibits a calligraphic impulse reflecting Savery's Mannerist training, the latter offers a more direct, unprepossessing approach to nature which is typical of seventeenth-century Dutch naturalism. The art Esaias produced in the early decades of the seventeenth century and specifically between c. 1618 and his untimely death in 1630 had a formative influence on many of the greatest landscapists of the age, including Jan van Goyen and Salomon van Ruysdael. Like Esaias, both of these artists began their careers with additively composed designs which devoted attention to detail and the local application of color, but subsequently developed freer manners stressing a unifying tonality and a limited palette. While both artists departed from Esaias's style in new and influential ways, they remained in his debt, especially in their river scenes. Van Goyen's *View of Emmerich across the Rhine* of 1645 was painted fifteen years after Esaias's death but still employed compositional devices—a view of a diagonally receding river with the spatial effect enhanced by both the silhouette on the near shore of a barge and herdsmen and the overall effect of atmosphere—that descend from Esaias. The *River Landscape with Castle* dated the previous year by Salomon van Ruysdael employs a similar design and technique. But particularly in mature works such as these, the two artists' hands can readily be distinguished. Van Goyen remains a draftsman at heart even in his paintings, while Salomon van Ruysdael, by whom we know not a single drawing, is a painter's painter composing with the brush. The building in Ruysdael's painting is a free adaptation of the Castle Loevestein which lies near the confluence of the Maas and Waal rivers opposite the town of Woudrichem. Although the castle enjoyed renown as the site of the imprisonment of the famous jurist Hugo Grotius (whence he famously escaped hidden in a bookcase), Ruysdael felt no compulsion to record the building or its actual location exactly. Here, as in several other landscapes by Ruysdael, he has varied both the original architecture (known through engravings) and the

site of the castle. Such disregard for topo-
graphical accuracy was typical of the lyrical
mood that pervaded Dutch landscape before
mid-century.

Among the highlights of Cleveland's
Dutch landscapes are Lambert Doomer's
sensitive drawings of river and harbor views.
Though hardly so well known, he shares
qualities with Holland's greatest landscapist,
Jacob van Ruisdael, who is here represented

95

by four excellent paintings, affording a review of his career from its first
years to later maturity. In addition, the printroom owns some of Ruisdael's
rare etchings. A remarkably precocious artist, Ruisdael seems to have begun
his activity as an etcher in 1645; he started dating paintings the following
year when he was only eighteen years old. The year 1646 that appears on
Cleveland's *Landscape with a Windmill* (fig. 95) and a handful of other
works by the artist is important not simply because it is Ruisdael's earliest
date but because it confirms his contemporaries' recognition of his youthful
promise, since the Haarlem painters' guild only admitted to their ranks
persons under the age of twenty when they showed exceptional talent.
Although not without the signs of tentativeness, the work and its monumen-
tal windmill are remarkable for anticipating motifs and compositional
elements of Ruisdael's maturity. The artist painted a close variant of the work
a few years later, now in Buckingham Palace, and employed a mill as the
focal point of several later masterpieces, notably the *Mill at Wijk* in the
Rijksmuseum. The *Wooded and Hilly Landscape at Evening* in Cleveland has
been dated to the early to mid-1660s, offering an example of the intimate
side to Ruisdael's mature works. Although the woman, child, and dog
walking into the painting in the middleground are small in relation to their
surroundings, they are more than mere staffage; their human presence
provides an inviting means of access to the calm twilight landscape. The
monumental *Landscape with a Dead Tree* probably dates only a few years
later but presents a far grander, more dramatic image of nature. Here
humanity is outscaled, virtually insignificant. A rushing stream and denuded
birch tree contrast with a sunlit castle and mountains in the distance.
Grandeur of an order of magnitude unknown in real nature invests this
scene with an imagined beauty and power of which Ruisdael alone was
capable in Dutch landscape painting. The last and presumably the latest of
Cleveland's Ruisdaels is the *Landscape with a Church beside a Torrent*
(compare Dayton's Ruisdael). Here as elsewhere in the artist's images of
northern cascades, the influence of van Everdingen's Scandinavian scenes is
unmistakable. Also apparent, though hardly conspicuous, is a certain dwin-
dling of the vitality of the artist's design and coloring, an abatement that
seems to characterize Ruisdael's final phase.

Not only for its style but also quality, *A Wooded Landscape with a Road*

96

and Figures by Ruisdael's follower Meindert Hobbema may be compared with related scenes by that artist in the Frick Collection and the Philadelphia Museum. The italianate landscape tradition is also well represented, though somewhat ironically best shown in the works of two artists who probably never set foot on Italian soil. To be sure, there is an interesting work by the early and influential Herman van Swanevelt (see also the artist's etchings preserved here) and a fine painting of 1657 by Berchem, but the pride of the collection is Albert Cuyp's dazzling *Travelers in a Hilly Landscape with a River* (fig. 96). The hushed, almost spiritual aura of this masterpiece arises not so much from the genre figures' recollection of the motif of the Holy Family's Flight into Egypt (compare Cuyp's painting in the Carter Collection, Los Angeles) but from the splendid glow of the sky. A close variant of the design is in the Mauritshuis, The Hague, but the picture surely qualifies as one of the best Cuyps in America. The other outstanding italianate painting is Adriaen van de Velde's *Landscape with a Sleeping Shepherdess* of 1663, a work of pleasing serenity. Adriaen van de Velde was the son of Willem van de Velde the Elder, the ships' draftsman and painter of sea battles, and the brother of Willem the Younger, the most famous of all Dutch marine painters (see Cleveland's *Seascape with Man-of-War Firing a Salute* of 1690). Adriaen produced some religious scenes (although scarcely a prerequisite, he was Catholic) and a few portraits, but the majority of his oeuvre consists of pastoral landscapes. These owe much to works of Paulus Potter and Philips Wouwerman, whose *Dune Landscape* is here preserved. Human activity in Adriaen's scenes is usually more important than in the works of Ruisdael or his other contemporaries among Holland's landscape painters; here the sleep of the shepherdess contributes to the bucolic calm. Cleveland owns one of Adriaen's many preparatory figure drawings, a handsome sketch for a picture formerly in the Steengracht Collection of a woman searching for fleas. Chalk drawings of this sort anticipate eithteenth-century French tastes. Unfortunately, however, an early owner of the drawing found the woman's efforts at hygiene unseemly and disguised her activity by adding a spindle, which she now handles in the most improbable fashion.

97

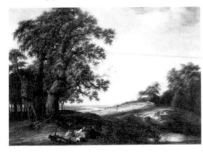
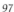

The tiny sower silhouetted on the hill in the distance of Adriaen's *Sleeping Shepherdess* calls to mind the subject of the extraordinarily lovely and rare Simon de Vlieger in the collection. The *Parable of the Sower* (fig. 97) dated 165(?) is one of this marine specialist's few wooded views and a truly exceptional painting in the naturalistic landscape tradition, not only for its sheer quality but also its illustra-

tion of a biblical parable (see Matthew 13:24–30 and compare Bloemaert's painting in the Walters Art Gallery, Baltimore).

Adriaen van de Velde was reported to have been the pupil of Jan Wijnants in Haarlem. While Wijnant's date of birth is still a matter of conjecture, he cannot have been appreciably older than Adriaen and probably had only limited impact on the formation of his art. Most of Wijnant's works represent hilly dune landscapes with sandy

98

roads. Wholly unexpected, therefore, is Cleveland's *View of the Herengracht in Amsterdam (fig. 98)*, Wijnants' only known cityscape. As Stechow has shown, the picture must date from 1660–62. Wijnants did not settle in Amsterdam until 1660 and the fenced-off lot behind the figures loading a barge on the left was the site on which four houses were built in 1662 by the famous architect Philips Vingboons. In these years the cityscape was only just emerging as an independent genre of painting separate from more established art forms, such as landscape, topographical views, and urban genre. Among specialties of Dutch painting, therefore, cityscape was a late bloomer. Precedents for the new painting type are found in the market scenes of Sybrant van Beest and Hendrik Sorgh. An early center of cityscape painting was Delft. This orderly little town with its regular grid pattern of streets and canals was the home around 1650 of the architectural painters Gerard Houckgeest and Emanuel de Witte (see his late, imaginary church interior in Cleveland), and in the following decade of Carel Fabritius, Pieter de Hooch (see his *Courtyard* in Toledo), Jan van der Heyden (see his *View in Delft* in Detroit), and, of course, the incomparable Jan Vermeer, who all made important contributions to the development of cityscape painting proper. Wijnants' work in Cleveland is an isolated statement, thus of limited influence; but its early date indicates he too must be considered one of the pioneers of this new painting type, which first celebrated the beauty of the urban scene as the central theme of a work of art.

Apart from a large seventeenth-century chest, the decorative arts are little represented in Cleveland, and Dutch visual arts of the eighteenth century are scarcely more abundant: a painting of the *Village of Eemnes* dated 1778 by Jordanus Hoorn and drawings by Jacob de Wit, Jacob Cats, Hendrik Meyer, and Dirk Langendijk. The Romantic era is represented by two works by Ary Scheffer, including *The Shades of Francesca and Paolo Appearing to Dante and Virgil* of 1851. Somewhat surprising in the light of the collections nearby in Toledo, Cincinnati,

99

100

and Detroit is the paucity of Hague School art—a single Israëls painting. A lone Jongkind gouache of Arnhem dated 1864 is also here preserved.

The van Goghs are more numerous and all the paintings relatively late works. The *Two Poplars* was painted in October 1889 out-of-doors and presumably also outside the walls of the asylum of Saint-Rémy where van Gogh was then residing. The slender trees wriggling skyward are silhouetted against a move-mented hillside. The *Road Menders at Saint Rémy (fig. 99)* was executed two months later. It depicts pavement repairs with great blocks of stone and rubble. Dominating the scene are huge roadside plane trees receding into the distance; van Gogh himself referred to the painting in a letter as "The Large Plane Trees." The road gang and the tiny women in their native dress are all but dwarfed by the massive trunks and gnarled limbs. An autograph replica of the painting is in the Phillips Collection, Washington. Still a later work executed in June of 1890 is the *Portrait of Mademoiselle Ravoux.* One of three portraits that van Gogh painted of the young sitter, the work depicts the blond, thirteen-year-old daughter of an innkeeper in Auvers-sur-Oise. With her pointed nose and chin and intense expression, Adeline Ravoux seems acutely alive. Van Gogh, however, would be dead scarcely a month later.

A fuller span of Mondrian's career is here presented, ranging from his early drawings of *Peasants in a Field,* which grew directly out of nineteenth-century Dutch art, to the *Bos Oele,* dated 1907, of his early maturity, and one of his lovely *Chrysanthemum* studies, to the culminating geometric rigor of the *Composition with Red, Yellow and Blue (fig. 100)* of 1927. Departing from this well trodden road running from the representational to the abstract, is Karel Appel's *Des Animaux* of 1957 which seeks instead the express route of emotion.

THE CORNING MUSEUM OF GLASS

Corning Glass Center
Corning, NY 14831 *(607) 937-5371*

The Corning museum of Glass owns one of the richest and most distinguished collections of European and American glass in existence. Its holdings of Dutch glass attest to the extraordinary achievements of Netherlandish craftsmen in the seventeenth and eighteenth centuries, when the earlier Venetian monopoly on fine glassmaking was at last challenged. While the use of a diamond point for engraving on glass was probably invented in Venice, it became a specialty in the Netherlands. Amateurs even engraved as an elegant pastime. The engraved glasses often were for presentation, to commemorate an event or to express fraternal or patriotic sentiments. As such they are unique and often bear a signature and date.

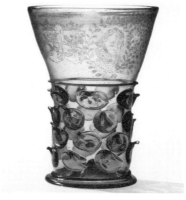

101

Among the finest seventeenth century pieces in Corning are: an engraved roemer (*fig. 101*) with coats of arms of the Seven Provinces with the portraits of Prince Maurits and Frederik Hendrik from the first half of the seventeenth century; a tall flute glass scratch engraved with a portrait of Willem III of c. 1670; a bun-footed beaker with rustic decorations engraved by Willem Mooleyser (compare Philadelphia's goblet) and dated 1685 (*fig. 102*); a calligraphed roemer with the patriotic motto "To the welfare of the fatherland"; and a bottle (*fig. 103*) diamond engraved by B. Boers in 1697. The eighteenth-century pieces include several wine glasses, including one dated 1746 with diamond-stippled decorations by F. Greenwood; another with a depiction of Flora by

102

103

104

Jacob Sang and dated 1764; and a third of 1795 decorated by the famous David Wolff with stipple-engraved figures commemorating Batavian independence. Here too is a reverse foil engraving on glass by J. Zeuner, dated 1775, depicting a portrait of E. F. Alberti (*fig. 104*).

DALLAS MUSEUM OF ART

1717 North Harwood
Dallas, Texas 75201 *(214) 421-4187*

Until January 1984, the Dallas Museum of Fine Arts was housed in modestly scaled, unprepossessing quarters on the edge of town in the state fairgrounds. It was appraised by its present director, Harry Parker, as a poor second to the fat lady and the ferris wheel. The new building designed by Edward Larrabee Barnes is a vast modern-styled structure situated downtown and offering huge increases in both gallery space and services. As befits a museum that in the future will devote itself primarily to modern and contemporary art, the new building included commissions from Claes Oldenburg, Ellsworth Kelly, and other leading artists. The new Decorative Arts Wing houses the Wendy and Emery Reves Collection opened in 1985. Unfortunately, not only is the collection itself uneven but also the installation foolishly attempts to recreate the donors' home in the south of France, the

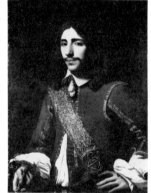

Villa La Pausa originally built by the designer Coco Chanel. The glitzy results remind us why indulgence on this scale has become rare in American museums. Dallas' present collections are strongest in regional American and twentieth-century painting, but include a broad if not yet deep sampling of the art of other cultures. An extensively illustrated publication of *Selected Works* (1983) appeared for the opening of the new building.

105

The older Dutch art includes a pleasant *Portrait of Woman in a Landscape* wrongly attributed to Jacob Gerritsz Cuyp, a *Hermit Saint* signed by that great chronicler of artists' lives, Arnold Houbraken, a scene of a *Young Girl Plucking a Duck* dubiously assigned to Barent Fabritius, a very handsome *Portrait of an Officer* (*fig. 105*) by Michael Sweerts (lent by the Hoblitzelle Foundation), and a selection of prints by Rembrandt and other Dutch artists. Among the more modern Dutch works is a loosely executed scene of a *River Bank in Springtime* of 1887 by van Gogh, the *Sheaves*

106

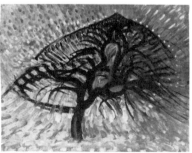

of Wheat (from the Reves Collection) painted by the artist in the last month of his life (July 1890), Mondrian's *Blue Tree* (*fig. 106*) of c. 1909–10 (one of a series of tree studies that owed an obvious debt to van Gogh's vibrantly expressive art), as well as one of the artist's late and especially rhythmic abstractions, the *Place de la Concorde* of c. 1938–43.

DAYTON ART INSTITUTE

Forest and Riverview Avenues
Dayton, Ohio 45401 (513) 223-5277

The Dayton Art Institute was founded in 1919 and moved to its present building, donated by Julia Shaw Carnell and designed by Edward B. Greene, in 1930. The facade is inspired by the Villa Farnese and the monumental staircase by the Ville d'Este near Rome. A new wing housing the Art School was added in 1965 and a modern-styled entryway and annex was recently completed. Mrs. Carnell admired Oriental art, which like American art is well represented here. Of special interest are the collections of baroque painting formed for the most part under the directorships of Thomas C. Colt and Bruce H. Evans. Important benefactors in these areas have been Mr. and Mrs. Elton F. MacDonald. *Fifty Treasures of the Dayton Art Institute* was published on the museum's fiftieth anniversary in 1969, and a *Selected Checklist* of works of art appeared in volume thirty-four (May 1976) of the Institute's *Bulletin.*

Dayton's leaders and benefactors happily have not shied from large, animated baroque pictures. Forming an excellent counterpart to their strong Italian collection (see especially the works by Guercino, Strozzi, Saraceni, and Preti), the Dutch paintings include two good examples of the Utrecht Caravaggisti's art: a young laughing *Violinist (fig. 107)*, dated 1626, by Hendrik Terbrugghen (another superior version is in a private collection in New York); and a recently acquired *Merry Flea Hunt (fig. 108)* by his colleague Gerard van Honthorst. Another version of the latter work is in the museum in Basel, but it omits the two cavaliers at the left. Both of these works adopt the life-size scale, half- to three-quarter-length compositions, dramatic lighting, and momentary effects associated with Caravaggio. The Rembrandt pupil Ferdinand Bol, on the other hand, has portrayed a *Young Man with a Sword (fig. 109)* full length as well as life-size. As with so many of Bol's works, this painting was wrongly assigned to Rembrandt and still is mistakenly

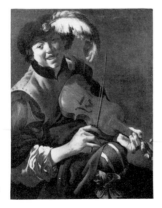

107

108

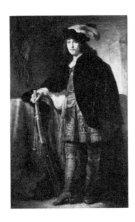
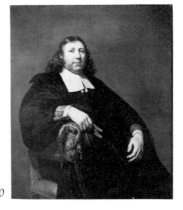

109 *110*

assumed to be Bol's self-portrait (compare the half-length self-portraits by Bol in Springfield, Toledo, and Los Angeles). The subject's marvelous costume is no less fanciful than that of Terbrugghen's *Violinist.* The black velvet cape, feathered beret, tall boots, and gilt sword doubtless are inspired by his teacher's exotic props. The pose, lighting, and technique are wholly Rembrandtesque. Full-length single figure portraits are rare in Rembrandt's oeuvre (see the pictures in Boston, the Rothschild Collection in Paris, and Cassel) and all date from the 1630s. Undoubtedly Bol's painting, which probably dates from around 1650, was influenced by his experience of these works and Rembrandt's etchings of "Orientals"; however, the artist reveals his own personal style in the work's greater elegance and decorative grace. Other notable portraits in the collection include the *Portrait of Geertje van der Graeff,* dated 1641, by Jacob Willemsz Delff, the grandson of Mierevelt and a respectable practitioner of the latter's formularized manner, and a particularly handsome *Portrait of Dammas Guldewagen (fig. 110)* by the very able Haarlem painter Jan de Bray.

Still life is not a strong feature of the collection, but Abraham van Beyeren's *Fish Still Life* (compare the Johnson Collection's painting in Philadelphia) reminds us that this painter took as much delight in the gleam of fish scales as the glint of precious metalware. A pair of small landscapes dated 1620 by Roelant Savery are inhabited on the one hand by beasts and the other by fowl. These works, however, scarcely approach the quality of the *Waterfall before a Castle (fig. 111)* painted by Ruisdael around 1670, the finest Dutch landscape in the collection. Although highly composed by Ruisdael's standards, the work offers a fresh response to nature and a notable delicacy of execution. A landscape dubiously attributed to Jan Asselijn includes a scene of the *Rest on the Flight into Egypt.* The most interesting Dutch history painting in the collection, however, is a large, well-preserved panel depicting *Moses and the Brazen Serpent (fig. 112),* dated 1640, by Adriaen van Nieulandt. Like Nicolaes Moeyaert, van Nieulandt continued to paint history and biblical scenes in the manner of Lastman and the Pre-

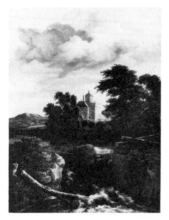
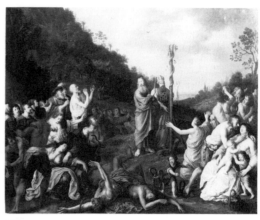

111 112

Rembrandtists long after this style had been overshadowed by other devel-
opments. Another rare painting is the vaguely Rembrandtesque half-length
scene of an *Old Man Reading,* signed and dated 1637(?) by Simon Kick, the
Amsterdam painter better known for his guardrooms and soldiering scenes.

Although Dayton has little in the way of Dutch decorative arts or
sculpture, its print collections include etchings by, among others, Rembrandt,
his pupil Jan Georg van Vliet, Adriaen van Ostade, and Cornelis Bega. Works
by Karel Appel figure among the modern paintings.

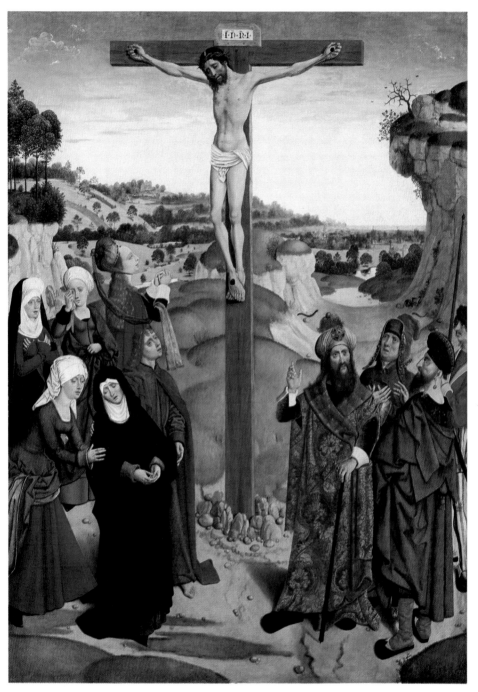

1 *Master of the Tiburtine Sibyl*, Crucifixion, *c. 1485*
 Tempera on panel; 56½ x 40⅜ in. (143.5 x 102.6 cm.)
 Detroit Institute of Arts, Detroit, no. 41.126

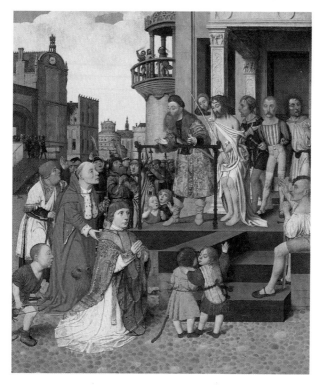

2 *Jan Mostaert,* Christ Shown to the People, *c. 1520*
Oil on panel; 22 x 18 in. (55.6 x 45.8 cm.),
St. Louis Art Museum, St. Louis, Missouri, no. 207:1946

3

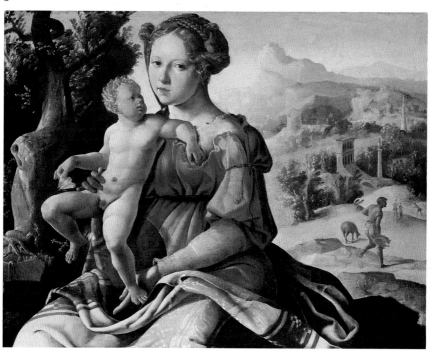

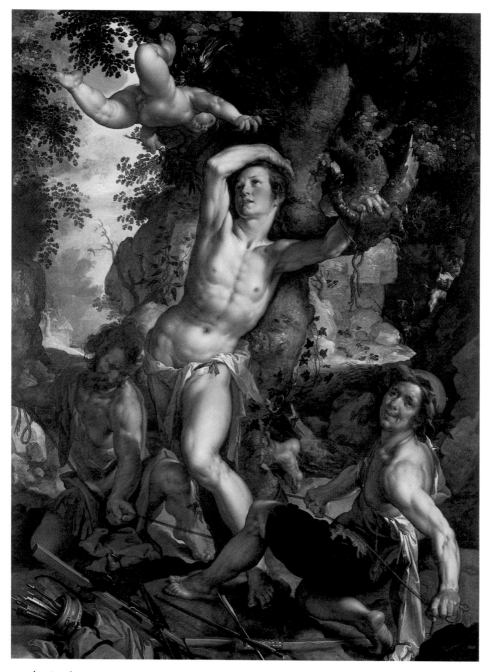

4 *Joachim Wttewael,* The Martyrdom of St. Sebastian, *1600*
 Oil on canvas; (168 x 123 cm.)
 The Nelson-Atkins Museum, Kansas City, Missouri, no. F84-71

3 *Jan van Scorel,* The Rest on the Flight into Egypt,
 Oil on panel; 22¾ x 29½ in. (57.8 x 74.9 cm.)
 National Gallery of Art, Washington, D.C., The Samuel H. Kress Collection, no. 1398.

5 *Christoffel van den Berghe*, Flower Still Life, 1617
 Oil on copper; 14⅞ x 11½ in. (37.8 x 29.2 cm.)
 John G. Johnson Collection, Philadelphia, no. 648

6 *Frans Hals, Shrovetide Revelers, c. 1615*
 Oil on canvas; 51¾ x 39¼ in. (131.5 x 99.7 cm.)
 Metropolitan Museum of Art, New York, Bequest of Benjamin Altman, 1913, no. 14.40.605

7 *Hendrik Terbrugghen*, St. Sebastian Attended by St. Irene, 1625
 Oil on canvas; 59 x 47¼ in. (149.5 x 120 cm.)
 Allen Art Museum, Oberlin College, Oberlin, Ohio, R. T. Miller, Jr., Fund, no. 53.256

8 Jan van Goyen, Skating near Dordrecht, 1643
 Oil on panel; 14¾ x 13½ in. (37.5 x 34.3 cm.)
 St. Louis Art Museum, St. Louis, Missouri, no. 223:16

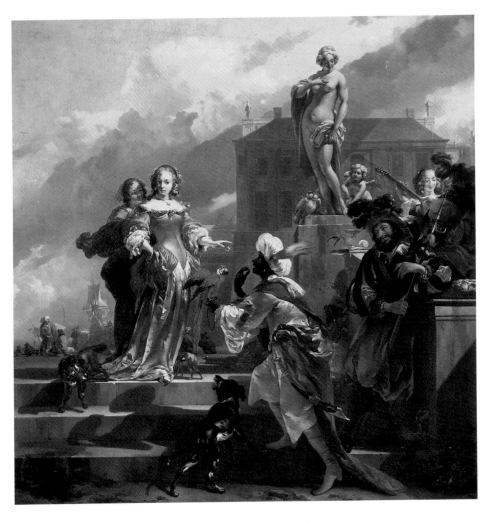

9 *Nicolaes Berchem,* A Moor Presenting a Parrot to a Lady
 Oil on canvas; 36⅞ x 35 in. (94 x 89 cm.) mid 1660's
 The Wadsworth Atheneum, Hartford, Connecticut, Sumner Collection, no. 1961.29

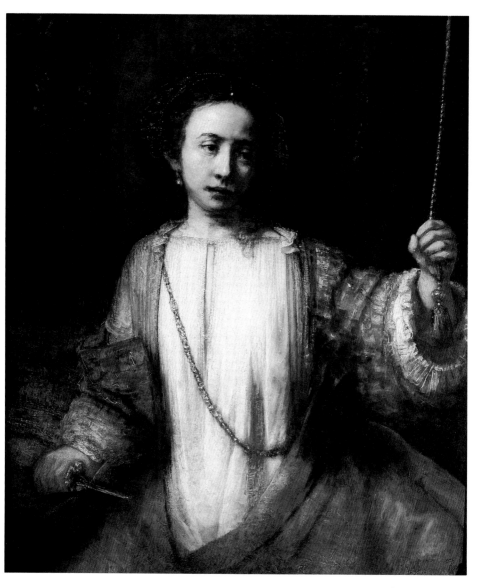

10 *Rembrandt van Rijn, Lucretia, 1666*
 Oil on canvas; 41⅜ x 36⅓ in. (105 x 92 cm.)
 The Minneapolis Institute of Arts, Minneapolis, MN
 The William Hood Dunwoody Fund, no. 34.19

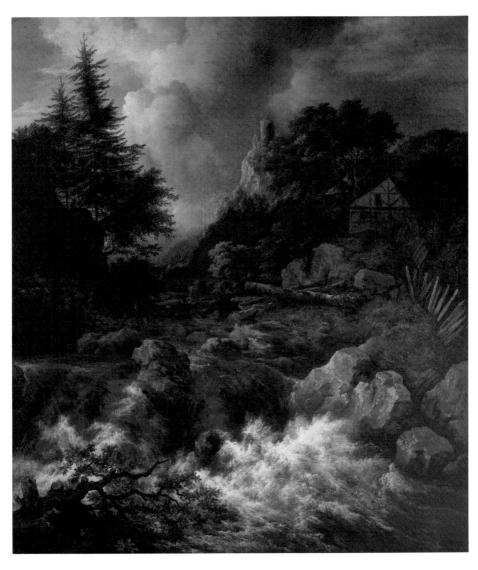

11 *Jacob van Ruisdael,* A Waterfall, *c. 1665*
 Oil on canvas; 38⅗ x 33¾ in. (98 x 85.7 cm.)
 Fogg Art Museum, Cambridge, MA, Gift of Miss Helen Clay Frick, no. 1953.2

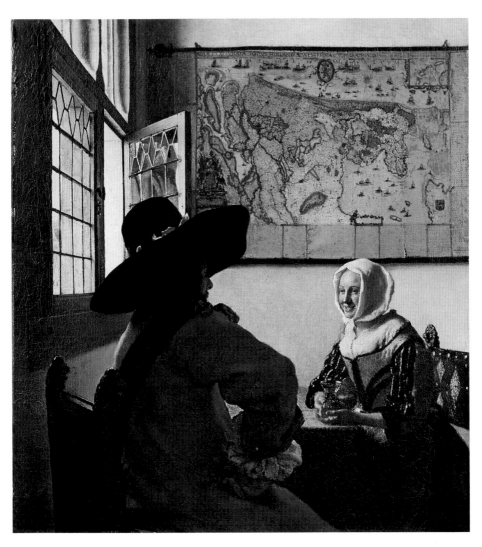

12 *Johannes Vermeer,* Officer and Laughing Girl, *c. 1658*
 Oil on canvas; 19⅞ x 18⅛ in. (50.5 x 46 cm.)
 The Frick Collection, New York City, no. A936

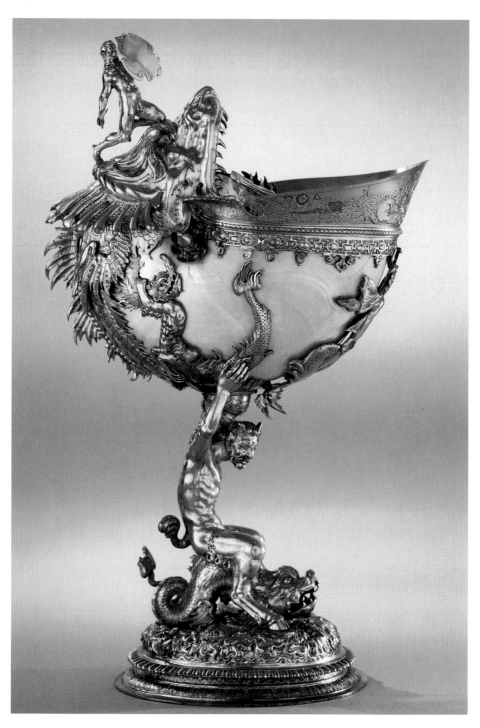

13 *Jan Jacobsz van Royestyn,* Nautilus Cup, *1596*
 Silver gilt and nautilus shell, height 11⅜ in. (28.8 cm.)
 The Toledo Museum of Art, Toledo, Ohio, Gift of Florence Scott Libbey, No. 73.53

14 *Dutch Tiles, Sea Creatures, Rotterdam, first quarter of the seventeenth century*
 Philadelphia Museum of Art, Philadelphia, Gift of Anthony N. B. Garvan

15 *Dutch Tiles, Star Tulips, Rotterdam, early seventeenth century*
 Philadelphia Museum of Art, Philadelphia, Gift of Anthony N. B. Garvan

16 *Josef Israëls*, The Cottage Madonna, *c. 1867*
Oil on canvas; 53 x 39¼ in. (134.6 x 99.7 cm.)
The Detroit Institute of Arts, Detroit, Michigan, no. 59.117

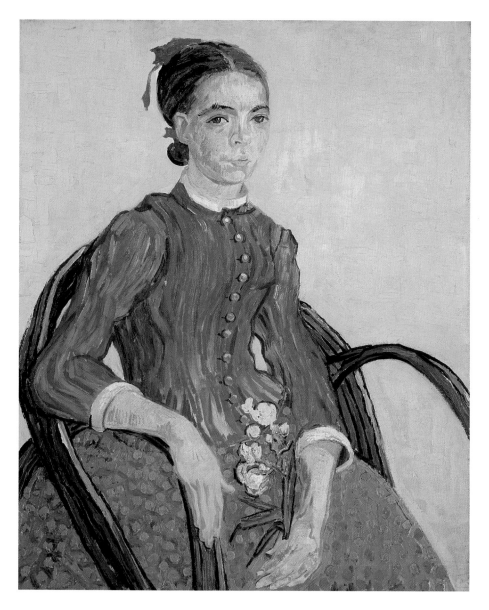

17 *Vincent van Gogh,* La Mousme, *1888*
 Oil on canvas; 28⅞ x 23¾ in. (73.3 x 60.3 cm.)
 National Gallery of Art, Washington, D.C., Chester Dale Collection, no. 1963.10.151

18 *Piet Mondrian*, Broadway Boogie Woogie, *1942–43*
Oil on canvas; 50 x 50 in. (127 x 127 cm.)
Collection, The Museum of Modern Art, New York, Given Anonymously

DENVER ART MUSEUM

100 West 14th Avenue Parkway
Denver, Colorado 80204 *(303) 575-2793*

Founded in 1893, the Denver Art Museum brought its diverse collections together for the first time in 1971 in a new building designed by Gio Ponti of Milan and James Sudler Associates of Denver. The unusual modern-styled structure is constructed of gray glass tiles and vaguely recalls a medieval fortress, with narrow slit windows and the suggestion of crenelated battlements. The collections are varied, with notable strengths in American Indian, Asian, Pre-Columbian, and Mexican art, while the best paintings are early Italian (Kress and Guggenheim pictures), French Impressionist, early modern and contemporary works. A handsome guidebook, *Major Works in the Collection,* was published in 1981.

Denver owns very few Dutch paintings. An interesting picture of the sorceress *Minerva (fig. 113)* was formerly attributed to Rembrandt and now is tentatively reassigned to his follower Willem de Poorter. A painting of about the same period (c. 1630–35) owned by the Mauritshuis in The Hague depicts the same subject in a comparable design but with a different style; it too was called Rembrandt but now carries a tentative attribution to Hendrik Pot. The Denver painting is too soft in execution for Pot but not broad enough for de Poorter; however, both the technique and figure type share points of resemblance with the works of the Rembrandt pupil, Isaac de Jouderville. Another provisional reattribution may be considered for *The Letter,* once generously assigned to Gerard Terborch, but, to judge from the costume, too late for that artist; the work bears some similarities to paintings by David van der Plaes; however, once again, the reassignment cannot be verified. The *Still Life with Peacocks and Other Fowl* by Melchior d'Hondecoeter or a follower (the painting is a smaller version of a composition dated 1682) takes up one of this renowned bird painter's favorite themes. The painting illustrates the Dutch proverb that is loosely translated "Each bird sings according to its beak," or as we would say in English, "To each his own." Like the genre painter Jan Steen, only in the guise of still life, Hondecoeter perpetuated the sixteenth-century Netherlandish tradition of illustrating sayings and proverbs. The greatest Dutch painting in the collection, however, is Mondrian's abstraction *Blue, White, and Yellow* of c. 1930, a particularly powerful mature work *(fig. 114).*

113

114

DETROIT INSTITUTE OF ARTS

5200 Woodward Avenue
Detroit, Michigan 48202 *(313) 833-7900*

The forerunner of the Detroit Institute of Arts, the Detroit Museum of Art, was opened to the public in 1888 in a Richardsonian-style building in downtown Detroit. Three additions were made by 1904 and six years later the present site on Woodward Avenue was purchased with the intent to expand further. In 1919 the downtown structure and its holdings were presented to the city, but the private corporation that created the museum was retained as the Founders Society. At that time the museum's name was changed to the Detroit Institute of Arts. A new building, which survives as the central section of the existing structure was designed in an Italian Renaissance style by Paul P. Cret and Zantzinger, Borie and Medary and opened in 1927. Further additions, opened in 1966, included a spacious modern-styled south wing with new galleries and special exhibition space designed by Harley, Ellington, Cowen and Stirton and Gunnar Birkerts and Associates. A north wing occupied in 1971 was designed by the same architects.

The expressed purpose of the Detroit Institute is to provide an overview of man's accomplishments in the field of art by assembling works of all ages, from prehistoric to modern. The achievements are impressive. Included in the collections are outstanding art works from the Egyptian, Assyrian, Persian, Greek, Etruscan, Roman, Chinese, Japanese, Indian, Islamic, African, Oceanic, and New World cultures as well as extensive collections of Western art. As broadly as Detroit has cast its nets, nearly half the gallery space is devoted to European art. The Dutch collections are both large and rich. An early supporter of the Old Master and particularly the Dutch collections was the newspaperman James E. Scripps, who in 1889 made a gift of forty-three European paintings, including good pictures by Salomon van Ruysdael, Jan Both, Jan Steen, and Emanuel de Witte. His widow added a substantial gift twenty years later. To a significant degree, the European collections at Detroit reflect the tastes and patterns of collecting established by W. R. Valentiner, the Institute's first director. A man of extraordinary energy and curiosity, Valentiner was not only a specialist on Dutch art, producing books on Rembrandt, Hals, de Hooch, and Maes as well as numerous articles on other Dutch topics, but also a pioneer in the formation of America's museums, working successively for the Metropolitan Museum in New York, the Detroit Institute, the Los Angeles County Museum, the Getty Museum in Malibu, and the North Carolina Museum of Art at Raleigh. Under Valentiner's guidance the beneficence of important collectors like Mr. and Mrs. Edsel B. Ford was first cultivated, support which later brought the museum master-pieces like Terborch's *Lady at Her Toilet (fig. 124)*. Additional noteworthy benefactors of the Dutch collections included the Whitcombs, Booths,

Kellers, Fishers, and Haasses, the last mentioned providing Ruisdael's world-renowned *Jewish Cemetery (fig. 121)*. The bequest in 1970 of the famous Robert H. Tannahill Collection not only brought the Institute superb French nineteenth-century paintings, graphic arts, and African sculpure, but also fine paintings by van Gogh. The museum's publications include a *Checklist* of paintings published in 1970, an *Illustrated Handbook* issued the following year, and a handsomely illustrated volume covering *Selected Works* as well as recent acquisitions (1979). A literate *Bulletin* and catalogues of special exhibitions, such as

115

Gods, Saints and Heroes: Dutch Painting in the Age of Rembrandt (1980), appear regularly. Susan Donahue Kuretsky is preparing the catalogue of the Dutch paintings.

Precious little fifteenth-century Northern Netherlandish art survived the iconoclasm of the following century, consequently works connected with the early Haarlem School are of great interest. The hand of the Master of the Tiburtine Sibyl was first identified by Max J. Friedländer, who gave the master his lengthy appellation and defined his oeuvre on the basis of a painting in Frankfurt of the *Tiburtine Sibyl Announcing the Birth of Christ to Emperor Augustus*. The *Crucifixion (fig. 115; pl. 1)* in Detroit, which probably dates from c. 1485, is now attributed to the Sibyl Master. The slender mourners—the three Marys and Saint John on the left and Joseph of Arimathea and his exotic entourage on the right—have some of the angularity of figures by Dirck Bouts, with whom the Master of the Tiburtine Sibyl is believed to have studied in Louvain. But they also exhibit the gentle naturalism associated with the early Haarlem School and Geertgen tot Sint-Jans. The poses of several members of the group on the left are borrowed from Bouts, and the man on the right seen in three-quarter lost profile is taken from Albert van Ouwater, Geertgen's teacher, to whom the Detroit painting was once assigned. The relationship between the figures and the richly articulated landscape space also calls to mind Haarlem painting. The panel should be compared with the large *Marriage of the Virgin* by the Tiburtine Sibyl Master in the Johnson Collection in Philadelphia.

Sixteenth-century Dutch art is underrepresented in Detroit. A sculpture of *Hebe (fig. 116)* the goddess of eternal youth and the cupbearer to the gods, was attributed to Adriaen de Vries before being reassigned to Hubert Gerhard. This piece of c. 1590 shows how Northern artists interpreted the techniques and formal vocabulary of Italian sculptors, such as Giovanni da Bologna, developing their own Mannerist style. A late

116

117

118

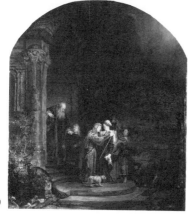

119

form of Mannerism employing sturdier, more amply proportioned figures is seen in Joachim Wttewael's drawing in Detroit (fig. 117) illustrating Christ's words "Suffer the little children to come unto me" (Mark 10: 13-16), dated 1621, a preparatory drawing for a painting of the same year, now in Leningrad. Although a relatively rare subject in Northern Netherlandish art, the theme was treated by Cornelis van Haarlem and Rembrandt in his famous *Hundred Guilder Print.*

As we have noted elsewhere, Pieter Lastman and the Pre-Rembrandtists brought a new narrative clarity to history painting in the first decades of the seventeenth century. Comparing Wttewael's drawing with Lastman's painting dated 1611 of *David Handing the Letter to Uriah (fig. 118),* we are struck by the latter work's simplicity. One readily identifies the main characters of the story, who are no longer obscured by crowds of ornamentally posed, subsidiary figures. King David wished to marry Uriah's wife, Bathsheba, who already was pregnant with David's child. He hands the kneeling Uriah the letter that will send him into battle and to his death. The scribe who stares up wide-eyed at the king knows, like the viewer, the deadly contents of the letter. Lastman paints the single gesture—the handing over of the letter—that confirms David's sinfulness as an adulterer and murderer. The dramatic possibilities of the story evidently appealed to the artist since he returned to it in a painting dated eight years later (Groningen Museum).

Rembrandt much admired his teacher's history paintings. Like Lastman, he sought a clear and dramatic visualization of the narrative. In his masterfully conceived little painting of the *Visitation (fig. 119),* for example, we see the meeting of the Virgin and her aged cousin Elizabeth before the latter's home in the hills outside the city. The lighting and architecture serve to

focus attention on the two main figures. An-
ecdotal details, though not specified in the
text (Luke 1:39–41), enrich the story. Old
Zacharias, Elizabeth's husband, is assisted by
a young boy as he hastens downstairs to greet
Mary; a young black servant removes Mary's
cape; and at the right, partially hidden by the
crest of the hill, Joseph is just arriving with
the donkey in tow. With its fanciful architec-
ture and exotic trappings—the peacock, the
black, and the figures' costumes—the scene
is designed to evoke a distant time and place

120

appropriate to the Bible. Yet it is his tender interpretation of the miraculous
exchange between the two women that reveals Rembrandt's greatness. Upon
hearing Mary's salutation, Elizabeth's baby (Saint John the Baptist) leapt in
her womb. Rembrandt not only conveys the intimacy but also the wonder
of the moment. His only depiction of the Visitation, the painting may in
part be based on Dürer's woodcut of the theme. However, personal associa-
tions could also have been attached to the subject. Elizabeth bears a strong
resemblance to Rembrandt's mother, who died in 1640, the year the painting
was executed. Moreover, Rembrandt's wife Saskia was pregnant during the
first half of the year with their daughter Cornelia, who died two weeks after
birth.

The finest Rembrandt School history painting in Detroit is Jan Victors'
Death of Lucretia. However, it seems a poor melodrama when compared
with Rembrandt's powerful versions of the theme in Washington and
Minneapolis. Claes Moeyaert's *Laban Searching for His Idols,* dated 1647, is
based on a painting Lastman executed twenty-five years earlier. Better
preserved and of greater interest are two fine italianate Dutch paintings,
Cornelis van Poelenburgh's *Nymphs and Satyrs in a Landscape with Ruins* and
Karel Dujardin's beautiful *Return of the Holy Family from Egypt (fig. 120)* of
1662. An artist who is often linked with Paulus Potter because of his skills
in painting animals, Dujardin spent several years in Italy in his youth and
returned there at the very end of his life. Although clearly based on
recollections of mountainous southern scenery, this work was painted in
Holland and betrays the influence of Adriaen van de Velde. Its strongly
classicizing impulse, especially evident in the figures, anticipates late sev-
enteenth- and even early eighteenth-century styles, as witnessed in Pieter
van der Werff's *Repentent Magdalen* in Detroit of 1711. The still life details
(note Joseph's tools) and the rendering of surfaces is a virtuoso performance,
but this is a hard and chilly beauty.

Detroit's Dutch portraits are very strong. Frans Hals' *Portrait of Hendrik
Swalmius* of 1639 would in itself be enough to distinguish the collection, so
vivid is this likeness of the Haarlem preacher. Hendrik's brother, Eleazer,
was also a preacher in Amsterdam. The brothers evidently could recognize

skill in a portraitist because when Eleazer had his own image painted two years earlier he chose no less an artist than Rembrandt (Antwerp Museum). The other Hals in the collection is a half-length *Portrait of a Woman,* dated 1634, which is the pendant to a painting in the Timken Art Gallery, San Diego. A pair of eighteenth-century watercolor copies in the museum in Dayton, Ohio, identify the sitters as Mons(ieur) Mers and his wife Catherine Vulp, while inexplicably assigning the pair to Hals' lesser colleague Johannes Verspronck. The Haarlem painter Verspronck never imitated Hals' open brushwork, but Hals' own son, Jan Hals, known as "Jan de Gulden Ezel" (Jan the Golden Ass), attempted a semblance of his father's free touch, as witnessed in his *Portrait of a Man* dated 1644. The similarity in both style and the two artists' monograms inevitably tempted many later dealers who were eager to fetch a Frans price to alter Jan's mark from "JH" to "FH." But a close examination of the two styles quickly exposes the superficiality of the resemblance. Jan's brushwork is vacant bravura while Frans' lively technique always defines form.

Other Dutch portraits at Detroit include a pretty but characteristically shallow *Portrait of a Girl with Feathered Hat* by Honthorst, good works by Nicholaes Elias and Aert de Gelder, and a particularly handsome and well-preserved man's portrait dated 1654 by Bartholomeus van der Helst. Surely, though, the most intense and engaging Dutch portrait in the collection is Rembrandt's *Man in a Plumed Hat and Gorget,* one of the artist's finest portraits from the mid-1630s. Formerly thought mistakenly to be a self-portrait, the painting inspired numerous copies. Copyists naturally are more prone to replicate an image of one of the world's most famous artists than an anonymous sitter. The copyists probably were also attracted by the power of the image, which is as gripping as the man's firm hold on the hilt of his sword. The face, with his knotted brow, dark, piercing eyes, and partly open mouth has a momentary animation which is complemented by his dashing costume, the strong illumination, and rich technique. This is Rembrandt the portraitist at his most baroque. A striking emotional contrast is offered by the artist's late study of *Titus,* the costume of which has prompted the suggestion that Rembrandt posed his own son as an angel preparatory to painting a biblical subject, perhaps Matthew and the Angel. As we have seen,

Rembrandt executed many *tronijen* (head studies) like this and the *Christ* also owned by Detroit (compare the versions at Harvard and in the Johnson Collection, Philadelphia), the purpose of which seems to have been to probe emotions.

The baroque fascination with strong emotions was not restricted to figure painting; it also found expression in, among other forms, the Dutchman's concern with mood in landscape. Surely one of the great

examples of the emotional power of landscape painting, indeed one of the greatest of all Dutch paintings, is Jacob van Ruisdael's famous *Jewish Cemetery (fig. 121)*. Grandly tragic, the image stirs thoughts of transience and regeneration; nature is made metaphor. The earlier of two versions of the subject (the later, smaller painting is in the museum in Dresden), the picture focuses on a group of tombs which still may be seen in the Jewish burial grounds at Ouderkerk. The ruins are inspired by Ruisdael's drawings of the Abbey Church of Egmond and the Gothic Buurkerk at Egmond-Binnen. The rest of the scene, however, is pure operatic imagination. The rushing stream in the foreground, the crumbling church in the distance, the blasted and broken trees in the foreground speak of the passage and ravages of time. At the same time, the rainbow, the birds circling in the sky, and the dramatic streaks of sunlight that part the thunderclouds overhead offer the possibility of hope. Little wonder that this emotionally charged painting and its Dresden version were favorites in the romantic era. Writing of the latter painting in his essay "Ruysdael als Dichter," Goethe observed, "Even in their ruined state the tombs point to the past beyond the past: they are tombs of themselves."

While we have no knowledge of who commissioned these paintings, it has reasonably been suggested that they might have been ordered by the families of prominent Jews buried at Ouderkerk. We note the inclusion of a family making a visit to a tomb in the middle ground of Detroit's painting. The prominently lighted tomb of white marble with prismatic cover closest to the center of the foreground is that of Dr. Eliahu Montalto, a famous Portuguese physician who attended the duke of Tuscany and later Maria de Medici. Unlike Rembrandt, Ruisdael is not known to have had contacts with the Jewish community, but he apparently took a degree in medicine in 1676 in Caen, France, and was inscribed in the list of Amsterdam doctors; a contemporary observer claims he performed successful surgical operations in Amsterdam. Conceivably, Ruisdael felt a special sympathy for Montalto or the other outstanding Jewish refugees interred here. Whatever the circumstances of the work's conception, it transcends mere individuals and the parochial concerns of this world, speaking instead to the great questions of finality and renewal, the primal drama of death and life.

Detroit's several other Ruisdaels offer familiar views of windmills and watermills, canals and torrents, but none approaches the quality or interest of the *Jewish Cemetery*. Furthermore, most have condition problems, abrasion being a common ailment among the landscapes in the collection. A small panel depicting a *Landscape with Windmill* and a second, larger scene of a *Watermill*, on loan from Mrs. L. T. Lewis, stand out among the remaining Ruisdaels. An especially attractive early seventeenth-century *Landscape with the Plundering of a Coach* by the Middleburg painter Jacob van Geel reveals Flemish influences in both form and theme. If offers an interesting comparison with the slightly later painting of highway robbery by Esaias van de Velde or a follower (Pieter Post?). Gone is the ornamental treatment of foliage,

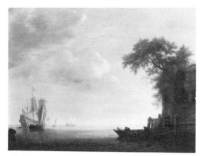

122

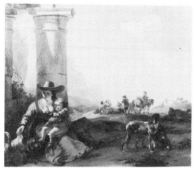

123

replaced by a more naturalistic handling of the landscape. The deadly banditti in both works remind us of the hazards of seventeenth-century travel. A lovely *Dune Landscape* dated 1631 by the Esaias pupil Pieter de Neyn proves that at his best this lesser-known painter approaches the quality of van Goyen and Salomon van Ruysdael. Both of these great landscapists are represented in Detroit by mature riverscapes, dated 1651 and 1643 respectively; a pleasant *Winter Landscape* by van Goyen is also here preserved. An artist who is often mistaken for these painters or, more rarely, Ruisdael, is Wouter Knyff, whose handsome *River Scene* of 1648 like a number of Detroit's better landscapes stems from the original Scripps gift. Another Scripps painting is Simon de Vlieger's *Calm Sea on the Banks of the River Maas (fig. 122)*, dated 1642, easily the most beautiful marine in the collection. In this mature work, de Vlieger demonstrates his renowned mastery of the expressive effects of a still stretch of water as well as less expected gifts as a colorist: a flaming, autumnal tree arches over the fishermen in their boat on the right.

A special strength of the landscape collection is the Dutch italianate group, including two fine works by Jan Both, the large *Ford with the Halt of Travelers* and a smaller but superior scene of a *Pass in the Apennines*. The two works were doubtless inspired by recollections of the breathtaking mountain scenery Both traveled through on his journey to Italy. A work that is equal parts landscape and genre, reality and fantasy, time past and time present is Jan Baptist Weenix's *Italian Peasants and Ruins (fig. 123)*, certainly one of the greatest Dutch paintings in the collection. This bright and colorful canvas depicts a nursing mother seated on a roadside near the half-buried columns of classical ruins with a landscape with shepherds at the right. The scene, like Both's painting, at first seems only to depict a view of seventeenth-century life in the Italian campagna, but there are also intimations here of a timeless Arcadia. In addition to the ruins, note the figures in classical undress among the herders. Jan Baptist Weenix, as we shall see, played an equally important role in the development of Dutch still life. Other Dutch italianate landscapes in the collection worth mentioning include a large *Wooded Landscape with Cattle* wrongly attributed to Nicolaes Berchem, and a good, Both-like painting by Willem de Heusch. Also in this vein is Jan Hackert's *Forest Landscape with Stag Hunt,* a blandly decorative picture by one of the most conventional late seventeenth-century purveyors of the Dutch italianate style. One last foreign view by a Dutchman deserving note is

the *Brazilian Landscape* of 1665 by Frans Post, one of the artists in the service of Johan Maurits of Nassau-Siegen, governor of Brazil under the Dutch West Indies Company and creator of the famous Mauritshuis in The Hague. It was Post's job to record the flora and fauna of the New World. More than mere travel documents, these works capture the exotic flavor of their subjects. In the foreground of the steamy tropical scene the artist typically includes several picturesque creatures—an iguana, an armadillo, and a python swallowing its prey.

Cityscapes and architectural views, a special favorite of the urbanized Dutch painters, are fairly well represented in Detroit. Vestiges of sixteenth-century perspectival formulas and the spatial recipes of the Antwerp artist Jan Vredeman de Vries are still evident in the exaggerated order of Bartho-lemeus van Bassen's *Baroque Interior with the Return of the Prodigal Son*. A more natural effect of space is achieved in Jan van der Heyden's *View of the Oude Kerk in Delft* of c. 1655. The site chosen by the artist is not without interest; in the 1650s Delft was the center of innovation in cityscape and architectural painting as well as in the related study of perspective and optics. The *Perspective Box* wrongly attributed to Samuel van Hoogstraten in Detroit attests to the era's interest in the illusion of space. Among Delft artists who made perspective an innovative feature of their art we count Gerard Houckgeest, Emanuel de Witte, Carel Fabritius, and, of course, the genre painters de Hooch and Vermeer. A late and somewhat overscaled work, de Witte's *Interior of a Church* nonetheless shows the master's concern with dramatic contrasts of light and shade and the expressive use of atmosphere. Although often assumed to be a church in Amsterdam, the structure is probably in large part imaginary. On the other hand, Gerrit Berckheyde's *View of the Grote Kerk in Haarlem* dated 1695 attests to continuing interest through the end of the century in topographically accurate cityscapes. The church of St. Bavo's, one of the most imposing structures in Holland then and now, was painted repeatedly by Berckheyde and his contemporaries. Much rarer were images of the small *Village of Den Briel with the Sint Catharina Kerk,* as depicted by the Delft painter Daniel Vosmaer. Surely, though, the most unusual city view in the collection is the charming little *Cityscape with Ox and Dog,* a collaborative effort between van der Heyden and Adriaen van de Velde. The latter painted the animals, while van der Heyden contributed the setting with its glimpse on the right of the Sint Elisabethsgasthuis, one of Amsterdam's hospitals.

Compared to landscape and genre, Dutch still life is less well repre-sented in Detroit. Pieter Claesz's *Breakfast Still Life* is a large, rather decorative late work; van Beyeren's *Kitchen Still Life* of 1664 is more interesting than pleasing—a departure from the artist's elegant subjects of later years. On the other hand, the *Still Life with Dead Swan* by Jan Baptist Weenix is a bold and attractive composition that attests to the artist's important role around 1650 in the conversion of the Flemish game piece into a native Dutch still life type. Hunting in these years in Holland was the privilege of the upper

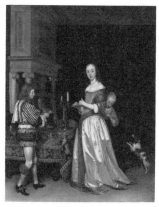

124

classes and regulated by law. Virtually all the birds and animals in Weenix's picture—the swan, partridges, bitterns, and rabbit—were game restricted to the aristocracy. Thus, to the viewer at mid-century such hunting booty would have seemed exceptionally luxurious. A highlight of Detroit's still lifes is the presence of two excellent but quite different works by Willem Kalf, the greatest repesentative of the classical phase of Dutch still life painting. The first depicts a small *Kitchen Still Life* with groceries, utensils, and a woman in the shadows. Small-scale kitchen and barn still lifes of this type were produced in South Holland in Kalf's native Rotterdam as well as in Middelburg by such artists as Herman and Cornelis Saftleven, H. M. Sorgh, P. J. Duifhuizen, and Frans Rijkhals. Kalf seems to have produced these unpretentious works alongside his better known *pronk* (elegant) still lifes, a superb example of which is owned by Detroit. Kalf was a consummate master of the rich but understated still life. The silver platter, the Ming design bowl, the *roemer* glass overturned on the deep pile table carpet, and the tall *pokel* goblet were the last word in prestige supplies. Yet the painting eschews ostentation, seducing by calculated restraint and Kalf's masterful command of light, color, and texture.

Unquestionably the most beautiful genre scene in Detroit, indeed one of the finest in the country, is Gerard Terborch's *Lady at Her Toilet (fig. 124)*. A page wearing an elaborate striped jerkin and tights holds a chalice and ewer as a maidservant ministers to an elegant women's dazzling satin gown. The servants, the richly appointed interior, and the finery suggest an exceptionally even fictionally prosperous household. No less rich is the splendid execution. Typical of Terborch is the suggestive treatment of the woman's abstracted expression and hand gesture. Is she simply removing her jewelry to wash or does she finger her ring with some deeper purpose? Terborch leaves such questions tantalizingly unanswered. By the same token, he refuses to disclose the contents of the sheet held in rapt attention in the *Young Man Reading*, a late work by Terborch in Detroit. Nevertheless, as with the artist's numerous other paintings of readers, the image engages us by its compelling truth to an ordinary everyday event, the missive fresh from the post, the news hot off the street. A far cry from Terborch's rarefied world of ambivalent gesture is the explicit domain of Jan Steen. In his slugfest known as *Gamblers Quarreling* the moral lesson is actually inscribed in the picture, referring the reader to *Prov[erbs] C[h]ap[ter] 20*, which admonishes, "Wine is a mocker, strong drink a brawler...." Steen's moralizing approach to genre was descended from painters like Pieter Brueghel, whose art is readily recalled in Steen's *Fair at Oegstgeest*. Like lesser peasant painters, such as Droochsloot (see his *Village Festival*), but with greater fidelity to the art's

125

126

original vitality and moral intent, Steen perpetuated the sixteenth-century tradition of depicting the kermises, weddings, fairs, and the other festive diversions of the lower classes.

Additional genre scenes in Detroit's generous sampling include: domestic subjects by Pieter de Hooch, the charmingly naive Jacobus Vrel, and the rare painter Hercules Sanders; market scenes by Quirin van Brekelenkam and Egbert van der Poel; and images of the artist's studio by Michel Sweerts and an anonymous but able artist wrongly identified in the past as Frans van Mieris. Depicting a young man holding a plaster bust in his hand, the Sweerts serves to remind us of the common practice of drawing from these aids even in the studios where painters were committed to working from life. The expression "naar het leven" could as readily be applied to copying casts as drawing from the live model. The other artist's studio is probably a self-portrait and shows the young painter surrounded by the tools of his trade. Surely one of the loveliest genre scenes in the collection is Ludolf de Jongh's *Hunting Party in the Courtyard of a Country House*, which, like the paintings by Wouwerman in the collection, points again to the popularity of hunting subjects. The orderly space of the courtyard and the beautiful effect of light entering through the archway at the left probably reflect the contact between de Jongh and his fellow Rotterdamer de Hooch. Yet another fine later seventeenth-century "high life" scene is Michiel van Musscher's so-called *Sonata*, signed and dated 1671. The elegant company make music on a terrace, a subject derived from Flemish artists but also treated by earlier Dutch artists like Eeckhout, Barent Graat, and de Hooch. The scene of dallying *Courtship* long assigned to Musscher's contemporary Caspar Netscher is more likely by the Rotterdamer Joost van Geel.

Dutch decorative arts are scarcely represented in Detroit, although a fine chest *(fig. 125)* of c. 1700 inlaid with tortoise shell, a clock of c. 1725 by Pieter Klook, a delftware garniture, and a set of silver tumblers by Adam Loofs or Loots (active c. 1682–1710) deserve note. Highlights of the Dutch drawings include

127

works by Jacques de Gheyn, Esaias van de Velde, Bloemaert, Breenbergh, van Goyen, Molyn, Isack van Ostade, Philips Koninck, and a charming *Shepherd Boy in a Hat (fig. 126)* by van der Does. Eighteenth-century Dutch painting is little in evidence: Pieter van der Werff's *Magdalen* and a painting of *Huis Oudaen, near Breukelen,* dated 1780, by the little known Christian Zepp providing the only examples. The representation improves with the nineteenth century. In addition to works by Jan Weissenbruch and Anton Mauve, the collection includes Jozef Israël's famous *Cottage Madonna (fig. 127),* one of the artist's celebrations of the virtues of the peasantry and motherhood. Like J. F. Millet only with more emotion, Israëls sought to elevate peasant subjects to the scale and importance of religious and mythological art. Throughout much of the twentieth century such images have been dismissed as mawkish and patronizing, but in their own time and long after their sentiment was perceived as authentic, indeed moving. With the recent reappraisal of nineteenth-century academic art, The Hague School led by Israëls, though scarcely restored to its original popularity, has regained respectability.

The Barbizon and Impressionist painters in France surely never doubted the quality of Dutch art nor the attraction of Holland as a subject; witness Charles-François Daubigny's *Mills at Dordrecht,* painted shortly after his visit to that city in September 1871. Van Gogh traveled the opposite route, first to Paris, where in 1887/88 he painted his powerful *Self-Portrait with Straw Hat,* and later to Arles and Saint-Rémy, where he made his own close studies of Millet. The latter's influence is clear in *The Diggers* of 1889/90. Indeed, like other works of this period, it was once wrongly thought to be a copy of Millet. Yet the brilliant colors and thick, broken application of paint are wholly van Gogh's inventions. In addition to this image of work, he offers us a scene of leisure in a view of pleasure boats on *The Bank of the Oise,* a placid subject one readily associates with Renoir or Monet, but here translated into van Gogh's own inimitably searing and bristling style.

KIMBELL ART MUSEUM

1101 Will Rogers Road West
Fort Worth, Texas 76107 *(817) 332-8451*

The Kimbell Art Museum was made possible by Kay Kimbell, an immensely successful Fort Worth entrepreneur who made his fortune in grain, oil, insurance, real estate and supermarket chains. Leaving his entire interest in these ventures to the Kimbell Art Foundation, he ensured the support of the future museum. The founding director, Richard F. Brown, had the great good sense to engage the renowned Philadelphia architect Louis I. Kahn to design the Kimbell Art Museum. Kahn's building, completed in 1972, is one of the most successful museum designs, indeed one of the most beautiful buildings built in the U.S. in recent years. A low structure conforming to and integrating the terrain of a nine-acre park, the building has simple, elegant lines. The interior is equally rich and spare, subtly introducing natural light. Brown and his able successor, Edmund P. Pillsbury, have lost no time in putting their connoisseurship and the ample Kimbell funds to work in filling these elegant spaces with masterpieces. With the exception of the Getty Museum in Malibu, the Kimbell is probably in a better position to purchase great works of art than any other institution in the United States. The collections range from ancient to modern art. They include not only Western European but also South and East Asian collections as well as African and Pre-Columbian art. The Dutch works are few but of good quality. An exacting catalogue of the collection appeared in 1972 and a handy guide in 1981.

Part of the original Kimbell bequest, *The Rommel Pot Player (fig. 128)* is the best of more than a dozen variants (see, for example, the smaller work attributed to Judith Leyster in the Art Institute of Chicago) of a lost original by Frans Hals. The scene depicts a laughing musician playing a crude instrument composed of a pig's bladder stretched over a stoneware jug half-filled with water. His ludicrous tune has drawn a crowd of delighted children. Like Hals' other large early painting of celebrants at a table, in the Metropolitan Museum of Art in New York, this work

128

probably depicts revelers at Shrovetide, the celebration held three days before Ash Wednesday. Wearing a floppy hat with a fool's fox tail, the rommel pot player may illustrate the Dutch proverb inscribed on a print of the same subject by Jan van de Velde, "Many fools run around a Shrovetide / To make a half-penny grunt on a rommel pot." From Hals' exuberantly crowded early art we turn to the master's more restrained, mature style, in the *Portrait of a Man* of c. 1643–45. The sitter fixes us with his heavy-lidded gaze, his

129

face highlighted by the crisply starched, white chevron of his collar, his upswept mustache reiterated by the brim of his hat. The sitter's identity, as with many of Hals' subjects, is unknown. The abstracted object in his left hand has been read variously—a glove, a swatch of cloth, a sheaf of grain (the attribute of a grain merchant or brewer?), even a bouquet of tail-feathers from a grouse—but its vagueness has so far defied interpretation. Surface bravura for its own sake is uncharacteristic of Hals, as is a certain flatness in the modeling of this work, raising the possibility that it may be by a follower. Other portraits in the collection include knee-length companion pieces by Terborch; compare Terborch's other pendants from the later 1660s in the Lehman Collection at the Metropolitan Museum of Art and the Corcoran Gallery in Washington, which both depict the subjects full length. The present works evidently are autograph replicas of a pair of full-length portraits in the Museum at St. Omer and in the Sorbonne, Paris. As with many of Terborch's later works, the Kimbell paintings betray the work of studio assistants in the accessories.

Without question the finest Dutch portrait in the collection is Rembrandt's *Portrait of a Young Jew (fig. 129)* of 1663, a work of extraordinary sensitivity and compassion. Wearing a yarmulke, the unidentified sitter may be the same model who served for Rembrandt's late images of Christ. Among the Kimbell's small collection of prints are fine impressions of Rembrandt's etchings of the *Landscape with Cottage and Haybarn* of 1641, the so-called *Faust in His Study* (the image was identified only ten years after Rembrandt's death as an "alchemist"), *Saint Jerome Reading in an Italian Landscape,* and a rare late state of the *Three Crosses (fig. 130).* Begun in the early 1650s, the plate for this last etching was extensively reworked around 1660–61 when Rembrandt, in characteristically experimental fashion, changed his entire conception of the theme. Whereas the earlier, lighter states had concentrated

130

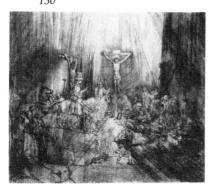

on the witnesses' various reactions to Christ's death, now the figure of Christ is the focus of the veiled and darkened scene. The print seems to revert to the earlier moment in the story when, according to Saint Luke, "from the sixth hour there was darkness over all the land unto the ninth hour. And about the ninth hour Jesus cried with a loud voice saying . . . 'My God, my God! Why hast thou forsaken me?'" Rembrandt's decision to depict Christ at the moment of his most abject despair is con-

sistent with the intensely personal, spiritual concerns of his last works.

131

The panorama is one of the most characteristic Dutch contributions to the history of landscape. No terrain is more typical of The Netherlands than a broad, watery plain coursed by rivers and mottled by the light and shade of a towering sky. The air is moist, the horizon seemingly limitless. Pioneers of this distinctive landscape type were Goltzius and Hercules Seghers, but Salomon van Ruysdael, Jacob van Ruisdael, and Jan van Goyen also served to refine and popularize it. Despite some rubbing in the sky, van Goyen's *View of Arnhem* looking southeast toward the Rhine is a good example of the artist's panoramas; compare his other panoramas from the later 1640s in the Corcoran Gallery (1646) and the Smith College Museum of Art (1647). Salomon van Ruysdael's broad *Landscape with the Ruins of Egmond Abbey (fig.131)* of 1644 also reveals a fine sensitivity to light and atmosphere but adopts a more traditional diagonal composition with a single "wing" of trees on the left, a standard motif used to enhance spatial recession. The single wing formula also appears in a red chalk drawing of a *Landscape with Windmill* attributed to Albert Cuyp, yet another early purveyor of the panoramic view. The Kimbell's collections also illustrate the impact of seventeenth-century Dutch landscape on French and English painting of the following century: Fragonard's *Pond* of c. 1761–65, for example, is clearly influenced by Jacob van Ruisdael's art, and Gainsborough's *Suffolk Landscape,* though now more fully absorbed, also attests to the legacy of that great Haarlem painter and his fellow townsman Jan Wijnants. The only Dutch still life in the collection is a luxurious *Flower Still Life* attributed to the eighteenth-century artist, Jan van Huysum. The rich pastel hues and high finish of this work would seem typical of this influential painter; however, a certain hardness in the touch has recently led some to doubt the picture (compare the paintings in Boston, Kansas City, Malibu, and the Carter Collection in Los Angeles).

HYDE COLLECTION

161 Warren St.
Glens Falls, New York 12801 (518) 792-1761

The Hyde Collection was the creation of Mr. and Mrs. Louis Fiske Hyde. Mrs. Hyde, née Pruyn, had inherited a fortune made in mining, lumber, and paper manufacturing. Although the couple lived most of their lives in Glens Falls, where Mr. Hyde ran the Pruyn Paper Company, they met and were educated in Boston. A classmate of Mr. Hyde's at Harvard was Bernard Berenson, and the couple were advised in their collecting by W. R. Valentiner. In assembling and installing their collection in Hyde House—a stucco structure of 1912 in a Florentine Renaissance style—the Hydes probably were most influenced by the example of Isabella Stewart Gardner's collection on the Fenway in Boston. Although hardly of such a high standard, the collection includes several respectable Dutch works, notably an important Rembrandt. The collections were opened to the public in 1963; *The Hyde Collection Catalogue* by James K. Kettlewell appeared in 1981.

The tiny collection ranges from Greek sculpture to works by Picasso and Matisse. The strengths are in Italian, French, Dutch, and American art. A handsome early black chalk drawing of a *Landscape with a Fence and Sandy Road in the Dunes (fig. 132)* by Pieter Molyn is datable to 1626 on the basis of its close resemblance in design to a painting of this year in the museum in Braunschweig. Such works constitute an important first step in the development of the realistic landscape in Holland. A later expression of this idea is Jacob van Ruisdael's painting *Dune Landscape,* an intimate study that is unusual for its nearly square format. Rembrandt is represented by an etched *Portrait of the Artist's Mother* (Cornelia van Zuytbroeck) of 1631, a quick pen sketch of an unidentified history subject depicting *Two Men in Oriental Costume,* and the monumental late painting of Christ *(fig. 133).* Related not only to the artist's series of small head studies of a Jewish model traditionally identified as Christ (see, for example, the painting in the Fogg Art Museum),

132

133

but also to the half-length *Christ* dated 1661 in the Metropolitan Museum of Art, New York, the work has a singular impact. Notwithstanding condition problems, the painting is a memorable, deeply spiritual statement. It has been related both to the series of half-length apostles and evangelists which Rembrandt is believed to have undertaken in 1661 as well as to the *Saint Paul* in Washington and the Saint Bartholomew in San Diego, both of 1657. Not without interest is the provenance: It was owned by Cardinal Fesch (Napoleon's minister in Rome), later passed to Count Davidoff in Petrograd and was sold to the Hydes, through the good offices of Valentiner, by the Soviet government in 1933.

134

Other Dutch paintings include a *Vanitas* dubiously attributed to Evert Collier, with musical instruments, globe, books, and other objects. Among these is a bookmark inscribed with the famous dictum "Vita Brevis Ars Longa" (life is short, art long). A Frans Hals School piece, a copy of a van Mieris, and a crude forgery of a Vermeer betray the collection's limitations, but the visitor's patience is rewarded by such works as van Gogh's splendid reed pen drawing of a *Corner of a Field* (fig. 134) of April 1888. In the distance we catch a glimpse of the Romanesque church of St. Trophîme at Arles, but the principal interest is the fruit tree in the foreground with its angled, shooting limbs and the nervous, spiky grass of the field. With good reason, the collection's catalogue draws attention to van Gogh's admiration of Japanese woodcuts in these years.

BOB JONES UNIVERSITY MUSEUM OF SACRED ART

Wade Hampton Blvd.
Greenville, South Carolina 29614 *(802) 242-5100, Ext. 270*

This collection is extraordinary for several reasons, but primarily because it is composed entirely of paintings with religious subjects, depicting scriptural events, or biblical characters. Bob Jones University is a nondenominational, coeducational institution which promotes strict fundamentalist Christian beliefs and evangelistic practices. As the school describes itself in its publications, it is a "Christian liberal arts university standing without apology for old-time religion and the absolute authority of the Bible." The Collection of Sacred Art is used as part of the religious curriculum. Moreover, the collection represents the special enthusiasm of Dr. Bob Jones, Jr., an ordained Baptist minister who not only is Chancellor of the University but has overseen the collection's growth and installation. In the 1950s and 60s, when Old Master history paintings were plentiful and inexpensive, Dr. Jones bought freely from E. & A. Silberman in New York and Julius Weitzner in London. The construction of the first museum was begun in 1951, and a new Fine Arts Building was erected in 1956. When these spaces too were outgrown, the old dining hall was converted to a museum with twenty-eight galleries in 1968. These are elaborately, indeed theatrically installed, with colorful fabrics on the walls, decorative carpets and "period room" appointments. Even background music is provided. At the opening of the new museum the effect was described by the director of Harvard's Fogg Museum, John Coolidge, as having "a marvelous lack of timidity." If the surroundings then are a bit tarted up, the collections themselves nevertheless include many excellent paintings. The Dutch paintings were catalogued along with the other Northern paintings in 1962, and in 1968 a Supplement appeared. A new catalogue is in preparation. One also may consult *Baroque Paintings from the Bob Jones University Collection,* a catalogue of an exhibition by David Steel held at the North Carolina Museum of Art in Raleigh and Colnaghi's gallery in New York in 1984.

Although to many in our secularized society the collecting of only religious art may seem an unduly pious pursuit, it nonetheless acknowledges one of the great achievements of Western and specifically Dutch culture. As a Christian people, the Dutch were exceptionally well versed in the Bible; biblical events considered obscure today were common knowledge. Unlike Southern art, nearly as many Old Testament themes were depicted as New Testament subjects. Clearly the Dutchman identified with the struggles of the Jews of the Old Testament, not merely as their Medieval predecessors had, as prefigurations of New Testament stories or typological events (which is to say having both a literal and symbolic meaning), but as recognizable human experiences. Although he often dressed his figures in "pseudo-historical" costumes, the Dutchman most often conceived of biblical events

as happening in the here and now and biblical personages as real people. Clearly this was not, as the nineteenth century would have had us believe, solely the result of the country's conversion from Catholicism to Protestantism. Estimates made as late as 1670 suggest that only one third of the Dutch population belonged to the Reformed Church, another third comprised members of various dissident Protestant sects, and the remainder were Catholic. The many Catholics (who counted among their number such famous Dutch artists as Pieter Lastman, Jan Steen, and Johannes Vermeer) and their tolerant treatment drew comment from Sir William Temple and other foreign observers. Although the public practice of Catholicism was officially outlawed, as late as 1700 there were twenty *schuilkerken* (hidden [Catholic] churches) in Amsterdam. The textual fidelity and humanism of Dutch religious art, moreover, was not restricted to artists of the Calvinist faith. Protestant and Catholic artists alike eschewed narrow denominational concerns in the choice and treatment of their religious subjects. Both literary and pictorial sources were consulted in the interpretation of themes. Dutch seventeenth-century religious art thus expresses the special ecumenical spirit of the Dutch people themselves.

A review of the sixteenth century Northern Netherlandish pictures in the collection readily reveals that there are many paintings of problematic condition and authorship. The triptych with the central scene of the *Miraculous Feeding of the Multitude,* for example, is poorly preserved and probably not by Lucas van Leyden. Similarly, Jan van Scorel's *Christ and the Samaritan Woman,* though powerful in design, is of uncertain origin. *Jonah under the Gourd Vine at Nineveh* is a copy of Philip Galle's print after Scorel's pupil Maerten van Heemskerck, and the large wings from an altarpiece attributed to Heemskerck are probably only by a Dutch or lower Rhenish follower. On the other hand, the small *Christ as the Man of Sorrows* (not an "Ecce Homo") may be an autograph work by Heemskerck. Later sixteenth-century Dutch pictures include a brisk little oil sketch of the *Flight into Egypt* (engraved by Jacques de Gheyn II) and a large scene of *Saint John Preaching in the Wilderness* by Karel van Mander. While the attribution of the *Salvator Mundi* to the Haarlem Mannerist Hendrik Goltzius cannot be sustained, the assignment of the *Christ Healing the Blind Man (fig. 135)* dated 1619 to his fellow townsman Cornelis van Haarlem presents no problems whatsoever. In this work from the artist's later career, van Haarlem reaffirms his admiration for the Italian Renaissance's

135

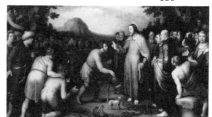

ample human form but tempers the exaggerated animation of his more Mannerist earlier works. In the crowd on the right is a portrait of the shell collector, Jan Govertsz, who was also portrayed in a famous portrait by Goltzius.

An especially large group of pictures

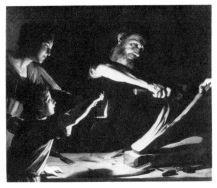

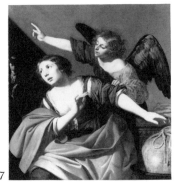

136 137

in the collection are by or related to the Utrecht Caravaggisti. Here again attributions are slippery. The scene of *Esau Selling His Birthright* labeled as Terbrugghen was considered by the late Benedict Nicolson, a Terbrugghen specialist, to be a composite design by an imitator of the two other *Esau* compositions. The *Christ among the Doctors* is an outright copy of Dirck van Baburen (better versions in Oslo and with the dealer Bruno Meisner, Zurich) while the *Saint Sebastian Tended by Irene,* also called Baburen, is one of three versions, the original of which may have been by the French Caravaggist Trophime Bigot. Another work that has been associated with Bigot is the lovely image by candlelight of the youthful *Christ in the Carpenter's Shop (fig. 136)*, catalogued in Greenville, not without reason, as by Gerard van Honthorst. (A very similar painting was stolen some years ago from the Convent of S. Silvestro, Montecompatri). No firm attribution can be offered in this case, but the quality of this charming work will be evident to all.

If the representation, therefore, of the pioneers of Caravaggism in Utrecht is spotty, some of the able but lesser known figures in this circle are shown to advantage. Much influenced by Honthorst was Jan van Bijlert, whose painting of *Mary Magdalen Turning from the World to Christ (fig. 137)* is fully signed and above suspicion (compare van Bijlert's works in Norfolk and Houston). Under the guidance of an angel, the Magdalen shuns a symbolic globe and pearls for a spotlit crucifix. Jan

138

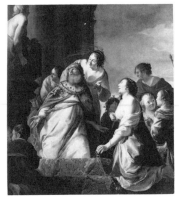

Gerritsz van Bronckhorst was born in Utrecht and, like van Bijlert, is mentioned in Rome in 1621 before returning to Holland to settle in Amsterdam. Surely one of his best works (see also the lovely *Aurora* in Hartford) if not his masterpiece is the large *Idolatry of Solomon* (1 Kings 11: 8) *(fig. 138)*, dated 1642, in Greenville. Solomon was punished by God for sacrificing to the false gods of his foreign wives (the Bible mentions seven hundred wives and three hundred concubines!). Here Solomon is

depicted on his knees before an idol sur-
rounded by some of the wives who "turned
away his heart." The subject was included
by Lucas van Leyden in two biblical print
series depicting the powers of women. An-
other outstanding Utrecht School painting
is the *Flight of Lot and His Family from
Sodom (fig. 139)* by Matthias Stomer, the
pupil of Honthorst, who appears in Rome
in 1630 and later worked in Naples and
Sicily. Although his wife has not yet turned
to salt, the elderly Lot is obviously bewil-
dered at being led from his home at night

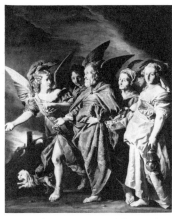

139

by winged visitors. Characteristically, Stomer's touch is dryer and his colors
more acrid than Honthorst's, but the effect achieves a hard sort of beauty.
One final work that can be mentioned with the Utrecht School is a half-
length figure of an *Evangelist* (possibly Matthew, although he serves no angel
as amenuensis) attributed to Jacob Backer, a very able Amsterdam artist
whose reputed but unproven ties with Rembrandt are far less obvious than
his links with the international Caravaggesque and classical style of painting.

Although related to studies made by Rembrandt, the small *Head of
Christ* is not likely to be by the master, but numerous other good Rembrandt
School pictures fill the collection. A particularly attractive work reflecting the
influence of Rembrandt's small and carefully handled history paintings of
the early Amsterdam period is Willem de Poorter's *Jeroboam's Idol Worship
Rebuked (fig. 140)*. De Poorter studied with Rembrandt in these years and
shared his taste for heightened emotion, dramatic lighting and meticulous
still-life detail (note the vessels and faggots at the left). The subject
(1 Kings 13: 1–4) is King Jeroboam rebuked by a prophet, Iddo (or Jadon,
according to the longer account in *Josephus*), for worshiping false gods. The
regent's stiff gesture probably is more than a simple command to quiet the
noisy prophet since the scriptures state that his arm "dried up, so that he
could not pull it in again." Gerbrand van den Eeckhout entered Rembrandt's
studio a decade later than de Poorter, studying there in the late 1640s. His
painting of *Joseph in Prison Interpreting the Dreams of the Butler and Baker* of
1643 shows the influence of Rembrandt's contemporary art not only in the
painterly technique but also in the general theme of an exposition with
listeners. Joseph predicted both the restoration of the butler's position of
favor in Pharoah's household and the baker's execution. Later he would
again use his interpretive powers to gain influence with Pharoah himself.
Joseph's expository gesture here recalls the manual rhetoric of the many
moving speakers of history depicted by Rembrandt. Drawings related to this
work are preserved in Chicago and the British Museum.

Other Rembrandt School paintings in the collection include Govaert
Flinck's oil sketch for his large chimney piece dated 1658 in the Amsterdam
Town Hall depicting *Solomon's Prayer for Wisdom*. While Salomon Koninck's

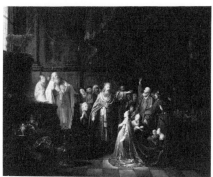

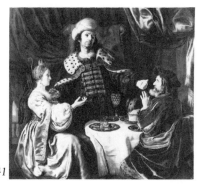

141

140

Saint Matthew and the Angel is rather dull and overscaled, Jan Victor's *Esther Accusing Haman (fig. 141)*, dated 1651, is one of this capable painter's finest works (compare Lievens' treatment of the theme in Raleigh and Steen's in Cleveland). Particularly attractive are the details of surfaces, still-life elements, and costume (the resolute Esther's marvelous crown!). The popularity among Rembrandt School artists of this subject and others like the Dismissal of Hagar seems to descend from Lastman's example. It is also possible that these themes were assigned by Rembrandt to his pupils as exercises in expression and invention. A large and impressive canvas depicting *Christ before Pilate (fig. 142)* is believed to be by the rare and little-known Rembrandt follower Constantin Renesse; old attributions to Barent Fabritius, Nicolaes Maes, and Cornelis Bisschop were apparently refuted by the discovery of Renesse's monogram, but one writer has recently disputed this reading as a misunderstanding of a pseudo-Hebraic inscription. Although elements of the handling and design depend on Rembrandt (compare the etchings of *Ecce Homo* of 1635 and *Christ at Emmaus* of 1654), the heightened palette and assured touch are those of an accomplished and independent master.

Flourishing concurrently with Rembrantesque history painting was the

142

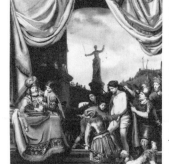

Haarlem classicist tradition. To some extent these developments are anticipated by works like Cornelis van Haarlem's *Christ Healing the Blind Man (fig. 135)* of 1619, which, as we have observed, exhibits a new monumentality and repose. But it was Pieter de Grebber who pioneered this art in the following decades. His *Adoration of the Shepherds* at Greenville shows his affinity for the Flemish painter Jacob Jordaens, with whom de Grebber worked on decorations at the Dutch princely residences, but in its use of large, classical forms also attests to his international stylistic

orientation. Symptomatic of the present lack of understanding of de Grebber's art is the misattribution of the *Annunciation* to his hand, a work that is only a copy of a painting in a German private collection.

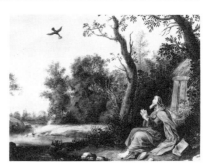

143

Of the numerous other Dutch religious paintings in the collection, some align themselves with major artistic movements while others are more independent statements. *Elisha Refusing Naaman's Gifts* (not *Balak Imploring Balaam,* as was once thought) depicts the Syrian general offering gifts to Elisha for curing the former's leprosy. It clearly is a work from the Pre-Rembrandt circle but its assignment to Jan Pynas is wrong; more plausible is the recent suggestion of Jan Tengnagel, but the little-known Lastman follower François Venant must also be considered. Aert van der Neer's early *Arrival at Emmaus* devotes much of the scene to a landscape reminiscent of Esaias van de Velde's art. The same is true of Raphael Camphuysen's lovely scene of *Elijah Fed by the Ravens* (fig. 143) dated 1629. A popular subject for religious staffage in Dutch landscape, the subject here is more than a mere pretext for the painting of nature. The artist was obviously touched by the story itself, which, ironically, may only be the result of a mistranslation; the town near the brook of Cherith where Elijah took refuge (1 Kings 17: 5–6) is called Oreb, meaning "raven" in Hebrew. Just as these artists combined landscape with religious subjects, Benjamin Gerritsz Cuyp's *Saint Peter Delivered from Prison* employs the same coarse but vital figures and broad touch that he used in his peasant genre scenes. Still another combination of Dutch specialties is the *Decapitation of Saint John the Baptist* by an artist who continued to paint in Poelenburgh's style well into the eighteenth century, Gerard Hoet; this work unites the sacred theme with a scrupulous painting of architecture, a colonnade with groined vault. Perhaps the most surprising application, though, of the specialist's art to a religious theme is the *Still Life with Instruments of the Passion* (fig. 144) by an anonymous seventeenth-century Dutch still-life painter. Here all figures are omitted, only the attributes of Christ's suffering are depicted and these in a naturalistic

144

rather than hieratically emblematic fashion. Yet, paradoxically, the spiritualism of this remarkable work is no less eloquent.

The decorative arts in the collection were gathered initially as "background" elements to enhance the paintings which, of course, are the primary interest of the museum. Nonetheless, a number of interesting pieces of furniture (cassoni, creden-

73813

zas, cabinets, ecclesiastical seatings, etc.) have been gathered, mostly of early Renaissance designs and Italian origins, although some Netherlandish and an occasional Dutch piece are exhibited: a sixteenth-century inlaid chest, choir stalls, and a sea captain's chest. Joseph Aronson's catalogue of the furniture was published in 1976.

WADSWORTH ATHENEUM

600 Main Street
Hartford, Connecticut 60103 (203) 278-2670

The Wadsworth Atheneum is one of the oldest museums in the United States, having begun in 1842 with the construction of a Gothic Revival building, the gift of Daniel Wadsworth, which still forms part of the museum today. The Atheneum boasts one of the finest collections of Northern European paintings to be found outside America's larger cities. Furthermore, these collections were begun before those of the museums in New York, Philadelphia, Boston, Chicago, and other large U.S. cities. The Atheneum's nineteenth-century benefactors included Dr. Samuel B. Beresford (1805/6–73), a distinguished Connecticut physician, and James G. Batterson (1823–1901), a wealthy building contractor who cultivated a wide range of cultural and scientific interests. Both men actively collected Dutch paintings. In the early years of this century the growth in the collections centered mainly on the decorative arts but turned to the painting collection when the income from the bequest of the Hartford banker Frank C. Sumner became available in 1927. The same year saw the appointment as director of A. Everett ("Chick") Austin, a figure of great personal style who was an artist and actor. Austin showed great vision in the collecting of works of several baroque artists before their importance was widely acknowledged. He purchased an impressive number and variety of Dutch pictures during his tenure as director (1927–43), but his successor, Charles C. Cunningham, was a still stronger advocate of seventeenth-century Dutch and Flemish painting. Cunningham expanded the collections with the dual aim of filling areas of omission while maintaining the collections' high standards of quality. In many respects these initiatives of the Atheneum's benefactors and directors helped shape patterns of collecting in other larger American museums. The catalogue by Egbert Haverkamp Begemann et al. of the Atheneum's paintings from The Netherlands and the German-Speaking countries; Fifteenth–Nineteenth Centuries appeared in 1978.

Late sixteenth-century Mannerism is the earliest style of Dutch painting encountered in Hartford. The three founders of the much-discussed-but-little-understood Haarlem Academy, which was established to study from life ("om nae't leven te studeren") were Karel van Mander, Cornelis Cornelisz van Haarlem, and Hendrik Goltzius; only the last mentioned is unrepresented in the Atheneum's painting collection. Van Mander, a Flemish emigrant who earned the title "The Dutch Vasari" for his Schilderboeck (1604), is represented by an Adoration of the Magi in which the scene appears amidst towering, arched ruins of exposed brick. Undoubtedly the setting was recollected from his stay in Italy in the 1570s. Its complexity and artifice are typically Mannerist, as are the exaggerated grace and nervous forms of the figures. The Prodigal Son Wasting His Substance (fig. 145) of 1604 by

145

Cornelis Cornelisz van Haarlem presents a later phase of Mannerism when the figures gained in fleshy substance and lost correspondingly in contorted action. But the studied elegance and acrid palette of the work still point to his Mannerist origins. Like other highly secularized depictions of the Prodigal Son theme, this work played a role in the early history of genre painting. Still a later work that attests to the survival of Mannerist sensibilities at least through the late 1630s is the *Neptune and Amphitrite*, by the long-lived Abraham Bloemaert. The boisterous scene depicts the triumphal return of Amphitrite to the Greek sea god and the celebration of sporting tritons, nereids, and putti after she had been discovered in her hiding place by a dolphin.

Some of the first Dutch artists to alter the forms and narrative conventions of the Mannerists were a group of painters known as the "Pre-Rembrandtists," who were active in Rome in the early decades of the century where they were associated with Rembrandt's teacher Pieter Lastman. Despite their rather unfortunate name, their art was in no way provisional or less than fully formed. The Atheneum's *Adoration of the Magi (fig. 146)* of 1617 by Jacob Pynas is one of the finest examples of Pre-Rembrandtist art in America and one of the artist's earliest dated pictures. Comparing this tiny copper panel with van Mander's earlier treatment of the theme, we perceive a greater formal restraint coupled with an increase in narrative clarity. The fervor of the kings' adoration and the fact that they have traveled from afar is made explicit; one of their number is in the act of dismounting while the royal entourage is still seen weaving through the classical landscape toward their special destination. Among Pynas's important historical contributions was his successful incorporation of multi-figure historical subjects into landscapes inspired by the influential German painter Elsheimer, whose work he encountered in Rome.

A tour of the Atheneum's painting collection cannot help but impress

146

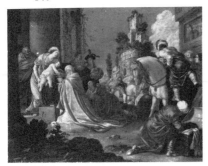

upon the viewer the seventeenth-century Dutchman's interest in and absorption of artistic developments in Italy. The monumentality and dramatic lighting of Caravaggio clearly influenced the scene of *King David with Angels* attributed to Terbrugghen (a replica of the version in Warsaw), the *Young Bacchus* attributed to Caesar van Everdingen (but possibly by Jacob van Campen), as well as the exceptionally beautiful and important *Burying the Dead* by Mi-

chael Sweerts. Part of a series illustrating the Seven Acts of Mercy (four of the six known paintings are in the Rijksmuseum in Amsterdam), this painting ultimately derives its central motif from Caravaggio but owes its setting more to the Bamboccianti (see below). Classicism in Dutch mythological and allegorical painting is represented by Cornelis Poelenburgh's airy *Feast of the Gods* (fig. 147), no doubt the

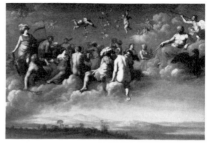

147

celebration of the marriage of Peleus and Thetis, and Jan Gerritsz van Bronckhorst's *Aurora*. Such works are often considered merely diluted forms of Italian art; however, they actually form part of an indigenous classical tradition in Dutch history painting. More representative of the unreformed realism that modern viewers usually associate with Dutch art are the Atheneum's history paintings by two Rembrandt pupils, Gerbrand van den Eeckhout's *Daniel Praising Susanna's Innocence* and Jan Victor's *Joseph Telling His Dreams*. In van den Eeckhout's exotically staged picture, the youthful David exposes the inconsistencies in the stories of the two elders who accused Susanna of adultery. As the first elder is led away, David denounces the second to the group of judges while Susanna weeps at the right.

The Atheneum's strengths in italianate Dutch art are also evident in its genre paintings. While the early indigenous Dutch genre style is adequately represented by Pieter Codde's scene of elegantly clad men and women sharing an idle moment in their music party, the best genre scenes in the collection probably are those of Jan Miel, Jan Baptist Weenix, and Nicolaes Berchem. Like his fellow Bamboccianti, Miel specialized in scenes of Roman street life. His *Carnival in the Piazza Colonna, Rome* is filled with crowds of masked and gaily costumed celebrants. At the center we note men dressed in the striped attire of the Papal Swiss guards, at the left atop a wagon ride actors dressed as characters from the Commedia dell'Arte, and throughout the square beggars, peddlers, and prostitutes do a brisk and picturesque business. The effigy swinging from the gallows at the left symbolizes the passing of winter, a ritual of the last day of Carnival. Weenix, by contrast, moves us into the sunny Roman campagna, where genre figures sit beneath the remains of an ancient temple, a design that proved to be one of Weenix's favorites. The spiraling sculpture group looming above the simple motif of the parasoled woman peasant teaching her little dog tricks is, of course, Giovanni da Bologna's famous *Rape of the Sabines* which the artist has felt at liberty to transport from its actual site in Florence to this imagined setting. The southern harbor serving as a backdrop for Berchem's splendid scene of a beturbaned *Moor Presenting a Young Lady with a Parrot* (*see Color Plate 9*) is no less a piece of fancy. Although it seems unlikely that the painting illustrates a specific literary episode (e.g., Othello and Desdemona) as once was assumed, the two main figures may personify the meeting of the

Christian West (note the cross on her bosom) and the Pagan East, a theme historically depicted in this guise. On the other hand, it may be nothing more than one Dutchman's ideal of the exotic diversions of Mediterranean life.

While not consistently of the first quality, the Dutch genre scenes at the Atheneum are numerous. Deserving special note, in addition to the Miel, Weenix, and Berchem mentioned above, are *Couple with a Dancing Dog* by Jacob Ochtervelt, a scene of *Card Players* by the nephew and pupil of Gerard Dou Dominicus van Tol, and a *Sick Woman* tentatively but probably correctly assigned to Gabriel Metsu. One must do without works by those outstanding painters of everyday life, Brouwer, Steen, Terborch, and de Hooch, but Hartford offers samples of high life, low life, professions, even the exotic foreign life that were the staple of Holland's genre artists. Similarly, Hartford's collections are not representative of the true heights of Dutch landscape painting, but are varied and often distinguished. To be sure, Ruisdael's *Bleaching Grounds near Haarlem* is not his happiest treatment of this theme, but one is pleasantly surprised to encounter works like the lacy *Winter Landscape* by the Mannerist Carel Liefrinck the Younger, Frans Post's steamy *Brazilian Landscape,* and the *Thistle in the Dunes* formerly attributed to Jacob van Ruisdael but now correctly reassigned to the little-known painter Reinier van der Laeck. The names might not be so familiar as those of van Goyen and Hobbema, but the works attest to the Dutchman's versatility. Once again italianate Dutch artists excel; Dirck van der Lisse's *Pastoral Landscape* is a poor man's Poelenburgh, but Jan Asselijn's *Ruined Archway* and Adam Pynacker's tranquil image of *River Barges by an Italian Shore (fig. 148)* are truly outstanding examples of the style of the second generation of the Dutch italianate artists, exhibiting a fine responsiveness to Southern light and scenery. Pynacker's quiet inlet on the Mediterranean coast is one of that painter's most satisfying images. Karel Dujardin and Jacob van der Does offer little pastoral scenes of the Italian campagna, while the eighteenth-century artist Isaac de Moucheron in a series of three canvases from a decorative series depicts Italy as a rarefied, but it must be said, rather vapid world of classical villas and formal gardens.

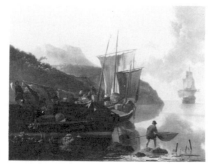

148

149

Townscape painting, a field that in a sense is a subdivision of landscape, is represented by an exacting though somewhat lifeless image of the *Town Hall* in Haarlem by Gerrit Berckheyde, a view of the *Fish Market in Amsterdam* by Emanuel de Witte (compare Jan de Bondt's *Fishmarket* genre scene), one of Daniel Vosmaer's numerous

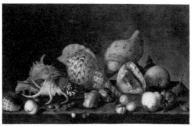

scenes of the aftermath of the calamitous *Explosion of the Powder Magazine* *150* *in Delft* in 1654, and a little street scene (fig. 149) by the enigmatic Jacobus Vrel, a charming naive painter about whom nothing certain is known. One eighteenth-century follower of the Dutch cityscape painters of the Golden Age was Caspar van Wittel, called Gaspare Vanvittelli. Van Wittel never returned from his trip to Italy, and works like his *View of Florence* in the Atheneum served to refine the tradition of *vedute* painting in Italy. Another eighteenth-century landscape deserving note is the scene of *Cattle and Shipping on the Maas,* by Albert Cuyp's great admirer Jacob van Strij. Many a van Strij has passed for a Cuyp and occasionally still does.

The Dutchman's famous and admirable curiosity about his own world took many forms, from controlled empirical research to impetuous collecting for its own sake. Like the craze for tulips, the collecting of shells became for some a mania; however, Balthasar van der Ast's loving record of the surface and patterns of the shells in the Atheneum's *Shell Still Life* (fig. 150) is so precise as to enable modern conchologists to identify the shells individually. The painting bespeaks the rigor of the scientist as well as the aesthetical selectivity of the artist. Similar motivations seem to dictate Margaretha de Heer's inclusion of a rhinoceros beetle in her *Still Life with Insects and Shells* and Simon Pietersz Verelst's use of special *Double Daffodils* in his flower still life. Yet the Dutchman's exacting vision might just as readily be turned to the most quotidien of objects, such as the leavings of a simple meal in the *Still Life with Ham* (fig. 151) by Jan Jansz den Uyl the Elder. This painting played a crucial role in the identification of the artist because it is the only work in his oeuvre to bear both his signature and symbol, a tiny owl (*Uyl* in Dutch) engraved on the silver beaker. *151*

Symbolism plays a more central role in Gerard Dou's *Still Life with Hourglass.* This precisely executed little picture is the companion to a *Still Life with a Money Bag Lying on a Book* in the Armand Hammer Collection, Los Angeles. While the Hartford painting has been interpreted as a *vanitas* image, a more compelling theory recently has proposed that it expressed the idea that "Time is fleeting, but art is long." The notion that study (the pen case and inkwell) and art (the print) can resist the ravages

152

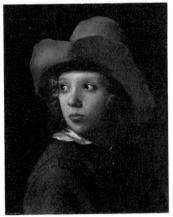

153

of time (the hourglass) is the message of the present work, while its pendant alludes to the financial rewards that are the benefit of study (the money bag placed on the book). Dou, one of the highest paid artists of his day, indeed better paid than even his teacher Rembrandt, knew well the incentives of financial gain.

Some of the greatest strengths of Hartford's Dutch collection are in portraiture. The *Portait of Joseph Coymans* painted in 1644 is a splendid example of the mature work of Frans Hals. Hals portrayed several members of the wealthy Coymans family of bankers and merchants. A pendant to the present work, the *Portrait of Dorothea Berck, wife of Joseph Coymans,* is in the Baltimore Museum of Art, and the portraits of the couple's daughter, Isabella, and her husband have also been identified. In addition, the National Gallery in Washington owns a painting of a fashionable young man previously identified as Balthasar but possibly portraying another member of the Coymans family. Family portraiture in the guise of genre is represented in Hartford by Gerbrand van der Eeckhout's elegant scene of *Children Playing with a Goat on a Terrace* of 1667 and Jacob Ochtervelt's *Family Portrait* (possibly the Elsevier family) *(fig. 152)* of 166[4?]. There is also a fine little equestrian portrait by Philips Wouwerman. One of the Atheneum's best early purchases was the *Portrait of a Young Man with Ruff,* thought initially to be by Bartholomeus van der Helst but now correctly reassigned to the earlier but no less successful Amsterdam portraitist Thomas de Keyser. The sitter looks over his shoulder directly at the viewer. His momentary alert expression is very different from that of Sweert's luminous and dreamy *Boy with a Hat* *(fig. 153).* While the bust-length poses of the two youths have points in common, the slightly abstracted gaze and sensuous features of the Sweerts call to mind the passive and private art of Vermeer. The effect is enchanting and marks this as one of the masterpieces of this "little Dutch master."

Hartford, somewhat surprisingly, has fewer nineteenth-century Dutch works than Belgian (see especially the van Schendels), but claims two pictures worth mentioning. The first is a marine painting entitled *Misty Weather* by The Hague painter Hendrik Willem Mesdag, who enjoyed

extraordinary popularity in his day. This work entered the Atheneum's collection following the first exhibition of Mesdag's work held in America, which was mounted in Hartford in 1903. Better known today is Johan Barthold Jongkind, who is represented here by a youthful work depicting fishing boats at Fécamp *(fig. 154)*. Jongkind journeyed to this town in Normandy with his friend Eugène Isabey in the summer of 1850. This picture, however, was made from sketches and memory after the artist returned to Paris. Other comparable early works by Jongkind are in Williamstown and the Johnson Collection, Philadelphia.

154

SARAH CAMPBELL BLAFFER FOUNDATION

2001 Kirby Drive
Houston, Texas 77019 *(713) 528-5279*

Although the Sarah Campbell Blaffer Foundation is based in Houston, its painting collection circulates throughout the state of Texas in the form of traveling exhibitions. Despite the itinerant nature of the foundation's collection, the quality of the Dutch paintings dictates its inclusion in this guide. The visitor is advised however, to inquire in advance about the location of the shows and to be prepared to travel to outlying cities that otherwise are little known as centers of the collecting of European art.

Established in 1964, the foundation initiated its touring shows in 1975 with an exhibition of *Old Master Paintings*. This was followed by *American Abstract Expressionist Paintings* and most recently *A Golden Age of Painting* (catalogue by Christopher Wright), a show of Dutch, Flemish, and German paintings of the sixteenth and seventeenth centuries which toured the state throughout 1984. The founder of this organization, Sarah Campbell Blaffer, was born in the Texas town of Waxahachie. Though deeply impressed by her experience of the splendid collections of the Gardner Museum in Boston and the Louvre in Paris, she was committed to the idea that a great work of art will have an even greater impact on people in communities where such art is not readily available. Hence it is the citizenry of such cities as Wichita Falls, Waco, Lufkin, and Panhandle who play the glad hosts to these fine pictures.

Though not great in number, the paintings include most areas in which Dutch seventeenth-century painters specialized. Among the earliest works is a large *Merry Company* scene of the 1620s by Dirck Hals. Dirck worked on a far smaller scale than his more famous older sibling, Frans, but also painted with a relatively broad touch and colorful palette. Like the conversation pieces of his Haarlem/Amsterdam collegues, Pieter Codde, Hendrik Pot, Willem Duyster, and Jan Olis, Dirck's genre scenes usually are dominated by elegantly attired young people arranged horizontally across a minimally defined interior space. Often paintings decorate the walls of Dirck's interiors, as they do in abundance here, testifying to his contemporaries' famous appetite for such art. The

155

light-hearted good cheer of these images of Holland's *jeunesse doré* no doubt is stimulated by the contents of the large wine cooler at the lower right. Coarser types and stronger libations are the rule with Adriaen van Ostade, who is well represented here with an excellent early painting dated 1634 depicting peasants in a tavern (fig. 155). The unruly violence of the children at the

left, both the product and delight of their elders' drunken neglect, contrasts markedly with the rigid obedience of the children in Herman Mijnerts Doncker's good, bourgeois *Family Group* of 1644. In an early picture such as this, Ostade still shows his debt to Adriaen Brouwer's vital and singularly brutal image of the lower classes, while his later works depict a tamer, more domesticated peasantry. The refinement of Ostade's later works parallels a general trend in late seventeenth-century Dutch genre best illus-

156

trated in the Blaffer collection by the scene of *Tric Trac Players by a Colonade* (*fig. 156*), falsely signed F[rans] van Mieris and dated 1680. This painting by an admirer, (probably, as the van Mieris expert Otto Naumann suggests, by Frans's son, Willem van Mieris), of the Leiden *fijnschilder* technique, presents an ideal of aristocratic leisure much influenced by the French. As has often been observed, French manners and tastes made inroads in Holland even before Louis XIV's troops invaded the country in 1672. Here the polished technique suits the figures' elegant dress and diversions.

A splendid painting by Philips Wouwerman in the collection depicts soldiers plundering a village, offering a vivid account of the periodic carnage suffered by the Dutch country folk even during these relatively peaceful, prosperous times. Although the majority of Dutch guardroom and soldier pictures depicted soldiers on bivouac enjoying their ease, works by Duyster, Duck, and Kick also show actual fighting as well as officers with booty and pleading captives. Like his Flemish predecessor Sebastian Vrancx and the Dutchman Esaias van de Velde, Wouwerman favored scenes of pitched cavalry battles as in his painting in the County Museum, Los Angeles. Clearly, for all the shine of their Golden Age, the Dutch were not spared the pain of war. Yet looking at the charming scene of winter sport, like Egbert van der Poel's *Skating Scene* (*fig. 157*) of 1656, one can well understand why people tend to think of these as idyllic times. As with Avercamp's paintings of winter activities, van der Poel's record of details, like the elaborate, horse-drawn sleighs (note especially the fanciful, centaur-shaped vehicle at

157

the right), have as much interest for social historians as for art lovers. In Aert van der Neer's painting, the skaters are mere staffage, and the frozen canal and the frost-covered *Landscape with Windmill* become the primary subject. Though executed very thinly with wispy brushwork, the painting conveys the solemn beauty of a winter day in Holland. Especially enchanting is the range of hues—rich umbers, grays,

pinks, and blond yellows—which are typical of van der Neer's winter scenes.

Other landscapes in the collection include a *Landscape with Cornfields* by Ruisdael and a fine painting of *Horsemen in a Landscape* by Albert Cuyp. The castle in the background of the latter work has been identified as Ubbergen Castle near Nijmegen (destroyed 1712), which figures in several of Cuyp's works. Like his uncle Benjamin Gerritsz Cuyp (see below), Albert Cuyp lived and worked in Dordrecht, the town depicted in the large river view in the collection, dated 1647, by Jan van Goyen. In this particularly majestic painting, the town and its prominent windmill, Grote Kerk, and town gates, is depicted from the northeast, while the artist usually preferred the view from the other side. The success of van Goyen's composition is achieved through his distribution of light and shade, his treatment of texture (note the choppy waters) and, most of all, his compelling use of atmosphere. Comparable in its ambitious scale, Ludolf Backhuysen's painting of the *Man-of-War "De Gouden Leeuw" on the River IJ near Amsterdam* (fig. 158), dated 1674, employs a very different style. In this later work there is greater tonal clarity, more color, and an emphasis on structure in the use of a few large motifs. These are formal properties frequently encountered in later seventeenth-century Dutch marine and landscape painting. Unusual even for a later work, however, is the use of an identifiable ship; the large vessel at the left is the *Gouden Leeuw* (*Golden Lion*), the flagship of Lieutenant Admiral Cornelis Tromp, the leading Dutch admiral during the second and third wars with England. Though removed from his post by the grand pensionary, Johan de Witt, Tromp regained power following the murder of the de Witt brothers (August 1672) and the reestablishment of the stadthold-

158

ership. The present work—one of Back-huysen's best—is, therefore, a testament to the restitution of the popular admiral's reputation.

159

Another highpoint of the collection is Johannes Lingelbach's *Capriccio View of Rome with the Castel Sant' Angelo* (fig. 159) dated 1655. Like de Witte's *Interior of a Protestant Church*, Lingelbach's scene is imaginary but uses for romantic effect variations on known structures in Rome; in addition to the Castel Sant' Angelo, we recognize St. Peter's Basilica and Trajan's Column. No less exotic is the scene's evocation of Roman street life, complete with vendors, musicians, cardplayers, shackled oriental slaves, and stevedores. Dutch still life is represented by two later works, an unusual *Banquet Still Life* dated 1650 by Pieter Claesz showing the influence of the

richer and more elaborate Flemish still-life tradi-
tion, and a painting of a great variety of fowl by
Melchior d'Hondecoeter depicting Aesop's fable
The Crow Exposed.

Among the history paintings, Jacob de Wet's
painting of the immensely popular theme the
Expulsion of Hagar is, alas, grievously abraded, but
Benjamin Gerritsz Cuyp's *Annunciation to the Shep-
herds* (based so conspicuously on Rembrandt's
etching of 1633) shows all the painterly breadth
of this neglected artist's technique. A large canvas
depicting *Elijah in the House of the Shunamite
Woman* is usually assigned to Barent Fabritius, an

160

attribution that, ironically, finds support in the uneven quality of the
execution. Far more beautiful is the work of another Rembrandt pupil, Aert
de Gelder's so-called *Allegory of Abundance (fig. 160)*, probably the greatest
single Dutch painting in the collection. Not only is the subject matter
unusual for a Northern painter (the symbolic attributes in the work—the
olive branch, sleeping dog and lamb, and horn of plenty—suggest a fuller
allegorical program, perhaps Peace and Prosperity or a reference to the Dutch
State), the richness of the technique is truly exceptional. It is often observed
that de Gelder, who lived until 1727, adhered longer than any other artist to
Rembrandt's late manner, but it is not yet sufficiently appreciated that
Rembrandt's style was only a point of departure for his own innovations.
Not before Goya was there another painter who explored so daringly the
potentials of his media. Ranging from the thinnest veils of paint dragged
over the surface with a knife, to richly scumbled impastos scratched with
the butt end of the brush, de Gelder's handling of paint not only drew
comment from his contemporaries, like Houbraken, but remains even today
virtually unrivaled in its dazzling variety.

MUSEUM OF FINE ARTS

1001 Bissonnet Street
Houston, Texas 77005 *(713) 526-1361*

The museum is an outgrowth of the Houston Public School Art League and was first housed in a building mixing classical and Spanish elements designed by William Ward Watkin (1924). Wings were added to the east and west by 1926, and in 1953 the Robert Lee Blaffer Memorial Wing was completed. The pioneering architect Mies van der Rohe prepared the designs for Cullinan Hall constructed in 1958. Van der Rohe created an axial plan with splayed wings well adapted to the museum's site. The large interior is spacious and open, thanks to the use of exterior column and girder supports. Van der Rohe's original designs of 1954 were changed little with the addition of the Brown Pavilion opened in 1974. The Dutch collections, created chiefly through the gifts and support of the Blaffers, Goodriches, Hanszens, Becks, and Laurence H. Favrot, are small but select. Although no complete catalogue of the collections exists, an exemplary handbook appeared in 1981.

Houston has several very fine seventeenth-century Caravaggesque paintings. Even more clearly than the strong lighting effects of the works hanging nearby by the Italian artists Orazio Gentileschi and Mattia Preti, the chiaroscuro drama of Matthias Stomer's *Judgment of Solomon* (fig. 161) attests to the legacy of Caravaggio. Stomer depicts the scene at night illuminated by a hidden torch. He has chosen the crucial moment when the king instructs the executioner to carry out his severe but sage decision. The painting has a

161

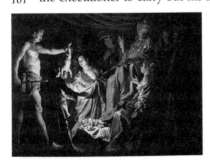

162

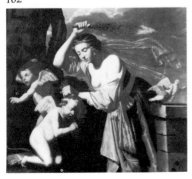

pendant in the Art Gallery of New South Wales in Sydney which depicts *Mucius Scaevola*. While the companion piece addresses a story from Roman history rather than the Bible, as Jean Patrice Marandel has observed in the *Handbook,* the two offer moral parallels in the victory of truth over treachery. Little is known of Stomer's life but he probably trained under Gerrit van Honthorst in Utrecht before traveling to Rome, Naples, and finally Sicily, where he died after 1650. Houston owns a painting (fig. 162) bearing a Honthorst "signature" and the date 1628, but as the late specialist in Caravaggesque painting Benedict Nicolson observed, a Jan van Bijlert signature was recorded on the work as recently as 1951. Like Stomer, van Bijlert was strongly influenced by Honthorst. Here he exhibits his admiration for a later stage in the master's development when Honthorst eliminated the

deep shadows, unrelieved backgrounds, and ar-
tificial lighting of his most Caravaggesque period,
while developing a great clarity of tone, particu-
larly in his modeling of flesh. Van Bijlert's own
style is evident in the figures, especially Venus.
Attended by doves and wielding a switch, she
chastizes "blind" love as "seeing" love flees, a
theme treated in various forms by other Caravag-
gio followers, such as Manfredi. A related subject
is depicted in van Bijlert's probable pendant in
Norfolk, *Mars Bound by Eros and Anteros (fig.
297)*, which employs a similar composition
and is virtually identical in size.

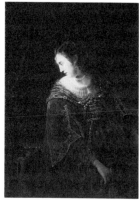

163

Though claiming no certain works by Honthorst, Houston owns a
replica or copy of the artist's well-known *Portrait of the Duke of Buckingham
and His Family* in Buckingham Palace. The museum also displays a good-
quality if somewhat thin *Portrait of a Sixty-two-year-old Woman* dated 1650
by the mature Frans Hals. More striking is the so-called *Portrait of Saskia van
Uylenburgh (fig. 163)*, Rembrandt's wife, by his pupil Ferdinand Bol. Although
Bol could lapse into routine formulas in his portraits, this is a pleasing, even
daring, work that depicts the theatrically lit and heavily bejeweled subject
glancing back over her shoulder into a mirror. The lighting system as well
as the rich technique and costume recall Rembrandt. The sitter's traditional
identification finds some support in the resemblance to portraits by Rem-
brandt of the well-born Saskia (see, for example, the picture in the National
Gallery of Art), but it remains uncertain. (A similar genre-like portrait, also
identified as "Saskia," dated 1642 and attributed to Bol in San Francisco, is
actually by Jan Victors.) Like other seventeenth-century genre scenes with
elegantly clad ladies admiring themselves in mirrors, this work probably
alludes on some level to notions of *vanitas*. Another genre-like scene with
large-scale figures is Pieter de Grebber's *Nursing Mother with Children (fig.
164)* of 1622, the earliest dated work by this innovative Haarlem painter.
Here again everyday appearances, may disguise deeper meanings, possibly a

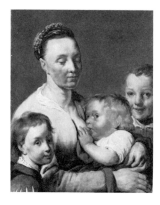

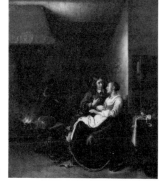

164 165

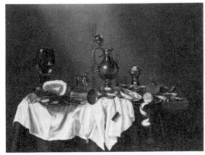

166

caritas, or charity, subject. De Grebber was active at the same time as Rembrandt, but in place of the latter's baroque movement and dramatic lighting, he favored ampler, quieter figures in a bright, clear light. Another practitioner of this more classical style was Nicolaes de Helt-Stockade, whose painting *Diana as the Huntress* in Houston's storage is dated 1654, the year this largely forgotten painter helped found Amsterdam's painters' guild.

Houston's finest Dutch genre painting—and here one uses this latterday term without hesitation—is an attractive scene *Couple Beside a Hearth (fig. 165),* dated 1652, by Jan Miense Molenaer. A figure in the open doorway spies on the amorous couple. The figure types of this work bear a strong resemblance to those of Hendrik Sorgh, while the interest in orderly space even anticipates Delft painters like Pieter de Hooch. Houston has recently acquired a fine early painting by Claude, but seventeenth-century Dutch landscape is represented only by the drawing *Gateway to a Town,* signed by Abraham Bloemaert. Similarly, still life is also restricted to a single example by Willem Claesz Heda, but this is a masterpiece by the Haarlem painter, a mature work *(fig. 166),* dated 1656, painted in his later tonal manner. The composition of silver vessels, Northern and Venetian glassware, and food-stuffs is richer and more colorful (the pink ham, blue delftware, and lemon) than his works of the 1630s, but the muted overall tonality, frontal design, and simple neutral background still show his famous restraint. Heda's works always avoid the sumptuousness of contemporary banquet pieces by de Heem or van Beyeren.

As we have noted elsewhere, the French Impressionists were often attracted to Dutch painting; some even visited Holland (see Monet's *Moulin de Gooyen* of 1871 in Houston's Beck Collection). Doubtless Monet and his colleagues were influenced by Jongkind's landscapes. Houston owns two

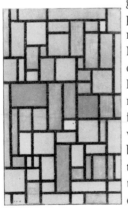

good examples of Jongkind's art, notably a lovely panoramic view, *Dutch Countryside,* dated 1862. Other nineteenth-century works include one of Anton Mauve's countless landscapes with cows and a view of rocks by his gifted cousin Vincent van Gogh. Painted in June or July of 1888, *Rocks* depicts a small rise studded with outcroppings and crowned by a freely executed tree that tilts and trembles in the wind. Theo van Gogh, Vincent's tirelessly supportive brother, seems to have been especially attracted to this powerful, understated work since it was one of the few that he chose to have framed. Early twentieth-century Dutch painting is represented by a brilliant

167

and bouncy image entitled *The Corn Poppy* by Kees van Dongen of a wide-eyed woman in a bright orange hat and, from the same years, an infinitely more restrained *Composition with Gray and Light Brown (fig. 167)*, dated 1918 by Piet Mondrian. The latter is one of Mondrian's earliest and most severe grid paintings. It was executed before he introduced bright primary hues into his geometric compositions. As in Heda's *Still Life*, the restricted palette and highly ordered design bespeak the intellectual rigor that has always been part of Dutch art.

INDIANAPOLIS MUSEUM OF ART

1200 West 38th Street
Indianapolis, Indiana 46208 *(317) 923-1331*

The museum was originally called the John Herron Art Museum and was opened in 1906. The core of the collection of European paintings was amassed between 1929 and 1965 under the supervision of Wilbur D. Peat, the long-time director. Important additions to the Dutch collection were made by Caroline Marmon Fesler and Arthur W. S. Herrington. In 1970 the museum moved from center city to the former J. K. Lilly, Jr., estate, adopted the name Indianapolis Museum of Art, and opened its new building. The Clowes Pavilion, a separate structure connected to the main building by a passageway, was opened in 1972 to house the Clowes Collection on long-term loan to the museum. A useful general catalogue of the collection by Dwight Miller appeared in 1970; the Clowes Collection catalogue by Ian Fraser was published in 1972; and a handbook by Anthony Janson, *100 Masterpieces of Painting,* appeared in 1980. An annual publication, *Perceptions,* has included articles on Dutch topics. The museum continues to actively purchase.

The Indianapolis Museum of Art has several outstanding Dutch pictures, of which the splendid *View of the Valkhof at Nijmegen (fig. 168)* by Albert Cuyp and *Still Life with a Blue Vase (fig. 169)* by Willem Kalf are the most memorable. The latter is dated [16]69 and presents Kalf at the height of his achievement as the consummate painter of elegant, *pronk,* still lifes. In characteristic fashion, the rich objects—a Chinese porcelain vase of Ming design, Venetian as well as Dutch glassware, a watch, and a silver platter with an orange and a lemon peeled in the shape of a helix (virtually the artist's trademark)—have been placed on the corner of a marble table covered with an oriental rug. Faceted with highlights against a dark background and painted in warm, saturated colors, the objects, like spotlit treasures in a jeweler's window, seem especially precious. Yet despite its opulence, the still life is carefully composed and balanced in design, reflecting the elegant classicism that infused so much of Dutch art after mid-century.

169

168

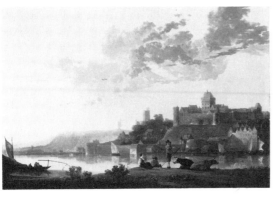

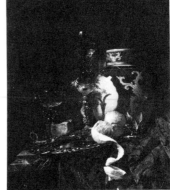

While Kalf's open timepiece could prompt thoughts of the impermanence of luxury, it probably functions in this context primarily to enhance the sense of rich and costly properties. The *vanitas* symbolism, by contrast, is explicit in Indianapolis's little still life of 1629 with shells and a rose by the unknown but skillful painter J. Falk. As if the objects themselves did not speak eloquently enough of life's transience, the work is inscribed in Latin "All that is human is smoke, shadow, vanity and the image of a stage." Symbolic elements in Dutch still lifes could operate alone as the main theme, as one of several meanings, or merely as a footnote or lesser complement to other more central concerns. The potential complexity of this situation is illustrated by the museum's still life of plants, flowers, and animals by Matthias Withoos. Virtually all of the objects in this scene—the thorns, thistles, shaft of wheat, the poppy, the lily, the rose, the lizard, and even the hedgehog—had potentially symbolic and specifically Christian associations; variously they could allude to the Fall and Redemption. The most recent handbook goes to some pains to interpret the entire scene as an elaborate allegory of the apocalypse, although tallying up the associations of individual motifs may not be true to the artist's original intent or emphasis. On rare occasions, Dutch still life might allude to topical events. The compelling illusionism of the *Tromp l'Oeil Still Life* by Evert Collier will not distract the careful observer from the card rack holding two politically important papers: a copy of William III's speech to parliament on October 20, 1696, following an assassination plot involving the French and followers of the exiled King James II; and a copy of *The Flying Post* with the dateline "Turin, May 1," alluding to the accommodation made that year by Savoy with Louis XIV during France's struggle with Spain. Like other successful *trompe l'oeil* artists, Collier depicts objects of limited volume and depth— papers, letters, a comb, a quill pen—so as to minimize the need for painted, "artificial" relief.

The *Valkhof at Nijmegen* depicted by Cuyp (*fig. 168*) had been the site of a palace constructed by Charlemagne which was rebuilt by the Barbarossa and finally destroyed during the French Revolution. To the left is another tower, known as the Belvedere, which was part of the old fortifications; it is depicted with the taller additions made during the remodeling of 1646. This *170*

attractive city on the river Waal was painted by many Dutch landscapists, including van Goyen and Salomon van Ruysdael. Cuyp himself painted this particular scene on more than one occasion; another larger variant is in the collection of the duke of Bedford. Presenting Cuyp at his most brilliant, the Indianapolis painting evokes radiantly warm late afternoon sunlight and shimmering atmosphere. Something of Cuyp's debt to Jan Both can be perceived

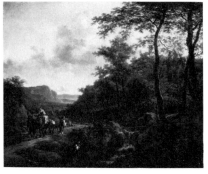

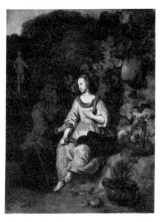

171

from comparison with Indianapolis's glowing *View of the Roman Campagna (fig. 170)*, an outstanding example of this influential painter's work. (Similar paintings by Both are found in Toledo, Detroit, and Boston.) Quite the opposite climate is depicted in Jacob van Ruisdael's chilly *Northern Landscape with a Bridge over a Cascade*; no welcoming radiance here, only stormy turbulence and brooding drama. While Ruisdael's picture was probably recollected from sites along the Dutch and German border, its ultimate inspiration stems from views of still more northerly scenery which he knew at second hand from the work of his colleague Allart van Everdingen, who had traveled to Scandinavia.

While the museum's Frans Hals now appears to be a copy of a lost original and its three paintings formerly called Rembrandt all rightly have come under suspicion, two Rembrandt School paintings deserve note. One is the tiny panel *(fig. 171)* by Gerbrand van den Eeckhout. The painting depicts Vertumnus disguised as an old woman in order to better plead his own impassioned case to the beautiful Pomona, a theme from Ovid much loved by Dutch painters (see Rochester's Flinck). The picture is fascinating for having as much to do with the style of Rembrandt's teacher, Pieter Lastman, as Rembrandt himself. The other painting is a large and impressive historical piece dated 1652 by the often underestimated Jan Victors. The new handbook attempts to identify the subject as Jacob seeking forgiveness from Esau, positing that the viewer himself plays the role of Esau; however, such a reading involves anachronistic modes of perception and probably only betrays our limited acquaintance with Victors' literary sources. Undoubtedly another biblical or mythological subject was intended.

Indianapolis's two best Dutch genre scenes are the well-preserved

172 painting *Woman Playing a Theorbo (fig. 172)* by Jacob Duck—yet another

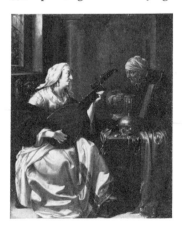

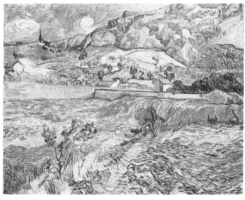

173

image with emblematic *vanitas* associations—and a late *Music Party* by Pieter de Hooch. The portraits by Kalf's teacher, Hendrik Pot (the so-called *Coin Collector*), the ever-fastidious Gerard Terborch, and Nicholaes Maes also deserve mention.

Van Gogh's extraordinary *Landscape at Saint-Rémy* (*fig. 173*), also known as *The Ploughed Field,* is part of a series of canvases depicting the same wheat field executed between June of 1889 and the spring of 1890 when the artist was convalescing at the Saint Paul Asylum after having suffered a nervous breakdown at Arles the previous Christmas Eve. The painting actually depicts the view from his hospital room and was described in letters to his brother Theo and Emile Bernard. An image of remarkable visionary power, the painting speaks vividly of the artist's emotional intensity as well as his gifts as a colorist and composer.

THE NELSON-ATKINS MUSEUM OF ART

4525 Oak Street
Kansas City, Missouri 64111 *(816) 561-4000*

Opened in 1933, the Nelson-Atkins Museum is a classically styled building of Indiana limestone designed by the firm of Wight and Wight. The collections were made possible by the bequest of William Rockhill Nelson (1841–1915), editor of the *Kansas City Star* and one of the great journalists of his day. Forever devoted to improving the quality of life in his city, Nelson himself assembled a gallery of copies of masterpieces, including a full-scale replica of Rembrandt's *Night Watch,* which hung in the basement of the public library and was known as the Gallery of Western Arts. The executors of his estate made good his desire that they purchase art. Particularly during the three Depression years immediately prior to the museum's opening, an astonishing array of European and Oriental treasures were acquired, including notable paintings by Rembrandt, Hals, Hobbema, Dou, W. van de Velde, Claesz, Albert Cuyp, Wou ermans, and van Gogh. With its august central hall supported by a dozen black columns of Pyrenean marble, the structure, made possible by the Mary M. Atkins estate, was the height of museological grandeur when inaugurated. Today the building houses one of the greatest general collections in this country, ranging from ancient Sumerian to the most current plastic and neon art. Surely the greatest strengths are in Oriental art; the Chinese collection (bronzes, statuary, paintings, jades, etc.), like the Indian art, is virtually unrivaled in this country. The Old Master paintings also sustain an exceptionally high standard of quality. An illustrated *Handbook of the Collections* in two volumes, devoted respectively to the Western and Eastern holdings, was issued in a fifth edition in 1973. The present director, Marc Wilson, and his curator, Roger Ward, have recently purchased major works by both Wttewael and Baburen.

One of the earliest Dutch objects in the collection is an exceedingly rare engraving of *The Last Supper (fig. 174)* by the Master I.A.M. of Zwolle, who was active in the latter half of the fifteenth century. As in other early Northern

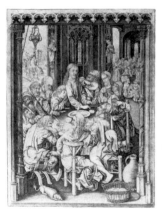

prints, the tortured poses of the figures, the angular drapery, and the shallow space of the architecturally framed composition recall stylistic conventions of Late Gothic carved altarpieces. The Dutchman's naturalistic urge nonetheless is already expressed in still-life details of the basket, earthenware jug, and dog. Early sixteenth-century Northern Netherlandish art is represented by a triptych dubiously attributed to Pieter Cornelisz, son of the Leiden painter Cornelis Engebrechtsz, of *The Resurrection* with wings representing kneeling donors and saints.

174

The Northern Mannerist aesthetic is excellently represented in Kansas City. In addition to prints by Goltzius there are two drawings by Abraham Bloemaert, one of which is a splendidly suave depiction in pen with brown and red washes (*fig. 175*) of the huntress Diana attended by one of her hounds. One of the greatest Mannerist works by a Dutchman in the collection is the bronze by Adriaan de Vries of Hercules, Deianira, and Nessus (*fig. 176*). Hercules was wed to Deianira, who bore him five children. One day while the couple were journeying across a river, the centaur Nessus offered to carry Deianira over on his back. When she accepted, Nesses tried to seduce her and was killed by Hercules. De Vries' complex spiraling composition is based on the famous sculpture group in Florence, *The Rape of the Sabines* executed in 1582 by his teacher, Giovanni da Bologna. A variant of the sculpture also appears in J. B. Weenix's painting in Hartford. As in the Italian sculpture, the design of de Vries' piece is composed of three twisting figures (known to Italian art theorists as *figura serpentinata*) that work, through the subtlest of dynamic balance, in perfect concord in the round. Whereas one must walk around the monumental *Sabines* group in the Loggia dei Lanzi, de Vries' intimate, minutely crafted sculpture seems to have been designed to be held and turned in the hands; compare de Vries' *Vice and Virtue* in the National Gallery of Art, Washington, D.C. Perfectly complementing de Vries' great sculpture is a triumphant new acquisition, Joachim Wttewael's painting of St. Sebastian tied to the tree by the archers (*color plate 4*). Sebastian's writhing, slightly hermaphroditic form is the height of Mannerist refinement.

The seventeenth-century Dutch paintings, though not numerous, are of very good quality. Terbrugghen's *Beheading of Saint John the Baptist* dated 162[2?] was once a splendid picture but, alas, has been cut down substantially at the right. Nearly all of the figure of Salome and Saint John's neck have been lost. Despite this, the canvas compares favorably with the smaller but compositionally related panel of the *Beheading of Saint Catherine* in the Chrysler museum, Norfolk. The costume of the executioner seen in lost

175

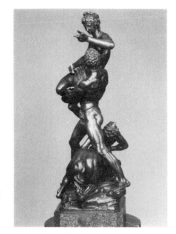

176

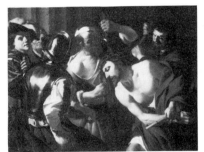

177

profile, with his steel harness, jauntily slit beret, and tied sashes at the waist and knees, is a splendid bit of fancy. Equally colorful are the costumes of Christ's tormentors in the *Crowning of Thorns* (fig. 177) also of c. 1622, by Terbrugghen's colleague Dirck van Baburen. This recent acquisition is an outstanding example of the Caravaggisti's art (see also Boston's *Procuress*) and compares favorably with the smaller version now in Het Catharijne Convent Museum, Utrecht.

The portraits are the strongest features of the Dutch collections. High points are Frans Hals' *Portrait of a Man* (fig. 178) of c. 1650 and Rembrandt's *Portrait of a Young Man in a Black Cap* signed and dated 1666 (not 1667 as sometimes recorded), both excellent later works by the two great masters. The presumed pendant to the Hals (both were in the collection of Count Zamoyski in Warsaw) has also found its way to a Missouri collection, the City Art Museum in St. Louis. Characteristically, Hals has portrayed the husband in a more animated fashion than his reserved but nonetheless sympathetically perceived wife. Rembrandt's sitter has sometimes been thought to be his pupil, the art theorist and painter Samuel van Hoogstraten (see the latter's paintings in Chicago and Springfield). Another image of a Rembrandt pupil is Gerard Dou's *Self-Portrait* at age fifty dated 1663, formerly in the Alte Pinakothek in Munich. It shows the stout painter richly attired, sporting a fur hat and cane, and leaning casually on a table with oriental carpet, a classical archway overhead. This image of leisured prosperity, though a convention adopted in this period even by relatively poor artists in their self-portraits, is not inappropriate for Dou; he was among the highest paid and most sought-after artists of the period. Of approximately the same period as the Dou and the Rembrandt is a *Portrait of a Man* by Terborch (its companion is in Melbourne), which has unfortunately been cut down slightly and somewhat rubbed. Better preserved is Jacob Backer's *Portrait of a Woman* of 1641, one of this able master's best works in this country (compare the painting in the Johnson Collection, Philadelphia).

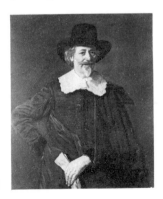

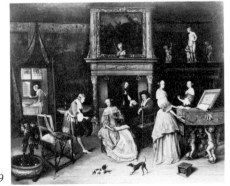

178

179

A truly outstanding group portrait is the *Portrait of a Family* (*fig. 179*) by Jan Steen. Although the tradition of identifying the sitters with the painter's in-laws, the van Goyen family, is probably apochryphal, recent doubts regarding the work's authenticity are unfounded. The elegance of the sitters and the rich interior may seem foreign to those acquainted only with Steen's bumptious peasants, but the work's exquisite touch is surely the master's. Comparable interiors by Steen are dated 1660 and 1661 (in Rotterdam and formerly the Earl of Lonsdale's collection) but the attenuated figure type is more typical of Dutch portraiture and genre of c. 1670; comparable proportions appear in contemporary works by de Hooch and especially Ochtervelt (compare Chicago's painting). Steen characteristically has chosen to comment in his scene through actual inscriptions; beneath the sculpture of Death on the mantle are the chilling words "Disciti Mori" while the inlay of the elaborate clavichord at the right offers a reassuring note: "Musica Pellit Curas" (Music Expels Care). Here again the painting must be reckoned one of Steen's most important works in America.

Several strong landscapes mark the Dutch collections. A large *River Landscape* by Salomon van Ruysdael is dated 1644 (the sadly abused picture in Providence may be compared, but only for its design). Hobbema's *Forest with a Road and Cottages* is a mature work of good quality by the master; comparable forest scenes are in Philadelphia, Minneapolis, Washington, and the Taft Museum, Cincinnati. The *Landscape with a Horseman Greeting a Gypsy* by Philips Wouwerman is a lovely idyll with a greater resemblance to illustrations of Jacob Cats' popular *Spaens Heidinnetje* (Spanish Gypsy Girl), than to the images of wily, thieving gypsies usually encountered in Dutch and Flemish paint-

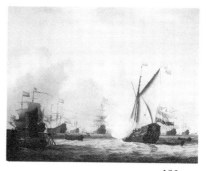

180

ing of the period. By contrast the *Landscape with Cows* by Albert Cuyp seems peculiarly hard for that gentle master of clear light and lowing cattle; however, this may only be a result of the masking varnish. Willem van de Velde's *Marine* (*fig. 180*) of 1668, the best seascape in the collection, shows a man-of-war under full sail saluting in the foreground. One of van de Velde's wispy sketches of ships at anchor is also here. Other landscape drawings include a *River Bank* of 1651 by van Goyen, a *Road along a Canal* attributed to Rembrandt, two sheets assigned to Herman van Swanevelt, and later

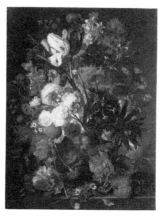

181

drawings by Jacob van der Ulft and Aelbert Meyring.

While the decorative quality of Pieter Claesz's *Still Life* of 1638, sporting its oversized *roemer* glass, is less agreeable than the understated naturalism of his earlier works, the ornamental aspect of Jan van Huysum's *Flower Piece* (*fig. 181*) is a complete success. The complex design, heightened palette, cool light, and rich detail (the luxurious blooms, glistening with dew drops, attract butterflies, bees, and even snails) are a virtuoso performance by the most ostentatious, not to say influential, Dutch still-life painter of the early eighteenth century. With the works in Boston and the Carter Collection, this is one of van Huysum's best paintings in the U.S. A fine drawing by the master is also in the collection. Other still lifes include a platter with seafood attributed dubiously to Pieter de Ring and a *Concert of Birds* (in storage but deserving of at least occasional display) assigned with better reason to Hondecoeter.

The genre paintings include several misattributions: Works assigned to Brouwer and Isack van Ostade are surely wrong. The attribution of a newly acquired Vinckboons is acceptable, but its condition is disappointing. The scene of a *Gentleman Teasing the Pet of a Lady Seated at a Table,* though of high finish, has been listed in the new monograph on the artist as a copy of Frans van Mieris's original in the Mauritshuis. The lone architectural painting in the collection is Hendrik van Vliet's *Interior of the Nieuwe Kerk, Delft,* which offers a glimpse of the tomb of William the Silent by Hendrik de Keyser, probably the single most revered public monument of the day by the most important Dutch sculptor of his age.

The decorative arts collection includes a large clock (*fig.182*) of c. 1700 signed by Bernart Scale of Amsterdam, which, like the seventeenth-century Dutch table in the collection (*fig. 183*), is decorated extensively with marquetry. In addition to prints by Lucas van Leyden, Goltzius, Rembrandt, Adriaen van Ostade, and Ludolf Backhuysen, the prints and drawings department owns notable drawings of history subjects; Rembrandt's reed pen drawing of *Saul and the Witch of Endor Calling Forth the Spirit of Samuel,* Philips Koninck's *Idolatry of Solomon,* and a two-colored chalk drawing of

182

183

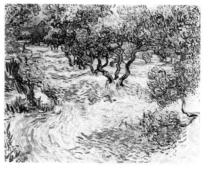

184

Mercury and Aglauros (cf. Fabritius' painting of the subject in Boston) assigned to Salomon de Bray but probably by his son Jan. Rare for an American collection are the two fine pen and wash drawings by Isaac de Moucheron of elaborate architectural windows through which appear genre figures in landscape symbolizing *Hearing* and *Smell* from a Five Senses series. Other eighteenth-century sheets include *Putti around a Fire,* no doubt a study by Jacob de Wit for one of his architectural decorations in grisaille, and a pen and watercolor drawing of a *Market Scene in Utrecht* by Johannes Hubert Prins, who trained to be a doctor, earned some reputation as a cityscapist, and was not the first Dutch artist to drown in a canal.

More distinguished than the rather routine paintings by the nineteenth-century Dutch artists Jacob Maris and Wouter Verschuur, are the two canvases by van Gogh, particularly the whirling, searing *Olive Grove (fig. 184)* executed in Saint-Rémy in the summer of 1889. After the cypress, the olive with its gnarled trunk was van Gogh's favorite tree. The broken strokes of brilliant color in this canvas achieve an exceptionally powerful effect. It is often observed that van Gogh's expressive use of color helped pave the way for the Fauvists, whose art was influential for, among others, Kees van Dongen (see his charming *Female Figure*). Without excessive distortion of history, one could also draw a line of descent to that great Rotterdam-born American painter Willem de Kooning, whose *Woman IV* in Kansas City is one of the definitive statements of Abstract Expressionism.

LOS ANGELES COUNTY MUSEUM OF ART

5905 Wilshire Blvd.
Los Angeles, California 90036 (213) 937-4250

Only thirty-five years ago, Los Angeles, though prosperous and burgeoning in population, had virtually no important public art collection. While comparably sized eastern and midwestern American cities had long since formed a nuclei of great collections, Los Angeles was only beginning to collect. To be sure, Henry E. Huntington had already amassed a splendid collection of English eighteenth-century art to complement his excellent library in San Marino, and the newspaper magnate William Randolph Hearst was buying rapaciously if indiscriminantly; but it is only in the past two decades that Los Angeles has come to own representative, indeed outstanding, collections of Western art. Without exaggeration, one can now say that the greater Los Angeles area—encompassing as it does the Los Angeles County Museum of Art, the J. Paul Getty Museum in Malibu, and the Norton Simon Museum in Pasadena—now offers an array of Old Master paintings to rival those of Boston, Philadelphia, Washington, and Chicago, second only to the peerless collections of New York. This achievement is all the more remarkable when we consider that these collections were formed during a period of unprecedented declines in the availability of such art, coupled with rocketing prices. It is an impressive testament to the dedication, vitality, and, of course, the resources of Southern California's collectors and curators.

The story of this extraordinary growth has modest beginnings. The Los Angeles County Museum of Art was founded in 1910 as part of the Museum of Science, History, and Art in Exposition Park. Its early benefactors included Preston Harrison, Allan Balch (who bequeathed the museum its first Northern European paintings—Petrus Christus, de Hooch, and Holbein), and the Maburys. The collections began to take form only in the late 1940s under the leadership of the ubiquitous director-consultant W. R. Valentiner, who advised Hearst and cultivated such generous donors as George De Sylva and

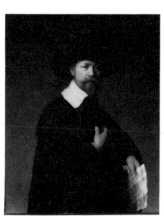

185

J. Paul Getty. In these years the latter gave the museum Rembrandt's great *Portrait of Maerten Looten* (fig. 185). By 1954 the painting collection had grown to such an extent that a catalogue was needed; Valentiner again contributed as a collaborator with the authors, Ebria Feinblatt and Paul Wescher, producing the *Catalogue of Paintings II. Flemish, Dutch and English Paintings, Fifteenth to Seventeenth Century.* Updated entries for many of Los Angeles's Dutch paintings appeared in the exhibition *Dutch and Flemish Paintings of the Northern Renaissance,* La Jolla Museum of Art,

1964; a new catalogue of the collection is in preparation. During Richard Brown's incumbency as chief curator and first director of the County Museum in the late 1950s and early 1960s, efforts were devoted to planning and building a new museum. Opened in 1965, the new complex was composed of three pavilions—the Ahmanson for the permanent collection, the Lytton for exhibitions, and the Leo S. Bing Center for lectures and performances. Although hailed at the outset as an advanced solution to the practical needs of a modern museum, the complex has proven rather disappointing; as of this writing, ambitious expansion and redesign projects are under way.

The collections experienced spectacular growth (documented in the lush exhibition catalogue *A Decade of Collection 1965-75*) in the ten years following the opening of the new galleries. Notable among the acquisitions were outstanding collections of Indian, Nepalese, Tibetan, Near Eastern, Chinese, and American art as well as Western European painting and decorative arts (especially English silver). The principal benefactors of the Dutch collections have been the Howard F. Ahmanson Foundation, Dr. Armand Hammer (Rembrandt's *Portrait of Dirck Pesser*), and the long-term friend and leader of the museum Edward William Carter. The recent exhibition, *A Mirror of Nature: Dutch Paintings from the Collection of Mr. and Mrs. Edward William Carter* (Los Angeles/Boston/New York, 1981–82), offered dazzling proof of the importance of this promised gift. With four Rembrandts, a superb Hals, and numerous other fine Dutch pictures, the County Museum is hardly a whistle stop for Netherlandish enthusiasts but the Carter gift will secure its renown. Since this extraordinary collection devoted to the Dutch specialties—landscape, seascape, town views, church interiors, and still lifes—is not yet part of the county museum or regularly on view, it falls outside the scope of this guide. Suffice it to say that its masterful works by Ambrosius Bosschaert, Avercamp, Porcellis, Cuyp, Both, Saenredam, van der Heyden, and van Huysum would be welcome additions to any collection. The visitor to Los Angeles's permanent collection may wish to consult, in addition to the tenth anniversary exhibition catalogue, the *Handbook* published in 1977.

Although the strength of Los Angeles's Dutch paintings collection is its Rembrandts, virtually all the conventional areas of specialization are represented. An important new acquisition is *The Sleeping Danae Being Prepared to Receive Jupiter* of 1603 by the Haarlem Mannerist, Hendrik Goltzius *(fig. 186)*. Karel van Mander knew the work, then in the collection of Bartolomeus Ferreris of Leiden, and praised the beauty of its composition and the anatomical correctness of its figures in his *Schilderboeck* (1604). Another major though abraded Mannerist work is Joachim Wttewael's depiction of *Lot and His Daughters*. Its theme was a popular history subject among the Haarlem Mannerists; Goltzius, van Mander, and Cornelis van Haarlem all treated the subject. A lovely small landscape *(fig. 187)* with historical figures by Bartholomeus Breenbergh has been identified by Marcel Roethlisberger

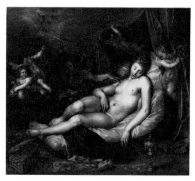

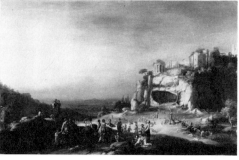

187

186 (*Bulletin,* vol. 23, 1977) as a scene of the gathering of manna. It bears a close resemblance in style and composition to the *Stoning of Saint Stephen* now in the J. Paul Getty Museum. An excellent new acquisition is Pieter Lastman's *Hagar and the Angel,* a painting of 1614 that may be compared with the artist's earlier drawing of the same subject at Yale.

Far and away the most important history painting of the collection is Rembrandt's dramatic early *Raising of Lazarus (fig. 188).* The artist's only known treatment of the theme in oils, this work is probably identical with a painting that hung in the parlor of Rembrandt's home when the inventory of the bankrupt artist's possessions was compiled in 1656. Yet another *Raising of Lazarus* by Rembrandt's youthful colleague Jan Lievens also hung in the parlor. Although there is no proof, it is tempting to identify Lievens' painting with his *Raising of Lazarus* dated 1631 and now in the Brighton Art Gallery, England. As many have noted, this painting and the Rembrandt in Los Angeles are closely related by their bold, theatrical conception of the theme, their use of chiaroscuro, and handling of surface detail. One could well imagine that Rembrandt kept the two paintings as a memento of his early collaboration with Lievens, a particularly productive relationship which, as we have noted elsewhere, even drew the attention of the stadtholder's secretary, Constantijn Huygens. Judging from a drawing dated 1630 in the British Museum, Rembrandt is probably to be credited with the original conception; however, changes in the drawing, which convert the subject to an Entombment of Christ, increase its resemblance to Lievens' painting, providing further evidence of the two artists' close early part-

188 nership. Rembrandt interpreted the theme of the Raising of Lazarus in a very

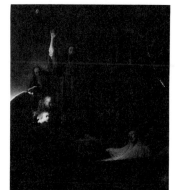

similar manner in a highly finished etching of 1632, in which Christ stands above the tomb with arm outstretched as the bystanders draw back in shock and horror. However, when he returned to the subject in a second print dated ten years later, his concept had changed dramat-ically; gone are the violent emotions and strong contrasts of light, the outward drama has become internalized. In characterizing these changes

Wolfgang Stechow (*Bulletin,* vol. 19, 1973) wrote, "The magician has given way to the spiritual healer."

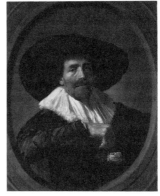

189

The *Portrait of Maerten Looten* (*fig. 185*) is dated 1632, thus postdating the *Lazarus* by only about two years. Its reserve, so different from the emotionalism of the history painting, is characteristic of Rembrandt's early, formal portrait style, but its exceptionally sensitive interpretation of the sitter is hardly routine. Viewed three-quarter length and holding a letter that bears his name, Looten can even support comparison with the magisterial *Portrait of Nicolaes Ruts* (*fig. 245*) dated one year earlier in the Frick Collection, New York. Like Ruts, Looten was a rich Amsterdam merchant. However, his family, who were devout members of the Dutch Reformed Church, lived in Leiden and thus may have first come in contact with the young Rembrandt in his native city. America is rich in portraits from Rembrandt's early Amsterdam years. The Looten portrait, for example, may also be compared with two other three-quarter-length male portraits, dated the same year, in San Francisco and the Metropolitan Museum of Art. Los Angeles also owns a fine oval portrait of a man dated 1634 and recently identified as the brewer *Dirck Jansz, Pesser* of Rotterdam. The so-called *Bust of Saint John* attributed to early Rembrandt and dated 1632 is disfigured by later overpaint and is now believed to be by a student or follower, perhaps Govaert Flinck.

Other Dutch portraits from the 1630s in the collection include one of Jan Anthonisz van Ravesteyn's highly formularized women's portraits (a related painting of the same year is in the Metropolitan Museum of Art) and the incomparable so-called *Portrait of Pieter Tjarck* (*fig. 189*) by Frans Hals. Though unproven, the sitter's identification with Tjarck, a Haarlem silk and cloth dyer, has been strengthened by the recent discovery of an eighteenth-century inscription on the back. Like the majority of Rembrandt's sitters from these years, Tjarck is depicted wearing an austere black and white costume, but he is posed far more casually, with one arm draped over the back of his chair, dangling a rose from his fingers. The flower, the symbol of love, has naturally led some to speculate whether the work is a wedding portrait. Married couples were often portrayed holding roses, and Hals himself once depicted a young woman offering a rose to her husband in a pair of pendant portraits. Characteristic too of the period is the painted portal through which the viewer is seen. In an age that delighted in the *bedriegertjes* (little deceptions) of naturalism, this was a favored illusionistic device. Uncommon, though, is the depth of characterization, dazzling technique, and sheer quality of this picture—all achievements that emerge more beautifully for the recent cleaning.

Additional noteworthy seventeenth-century portraits include works by

Jacob Adriaensz Backer (but perhaps by Flinck), his nephew Adriaen Backer, and two paintings by Ferdinand Bol, including a self-portrait of 1648 (compare the other presumed self-portraits in Toledo and Springfield). A recent acquisition is Gabriel Metsu's *Artist Painting a Woman Playing the Cello,* which has been assumed, with some reason, to be a portrait of the painter and his wife (compare the pendant portraits in Louisville). As in Metsu's *Woman Playing the Viola da Gamba* in San Francisco, the musician may symbolize harmony, in this case presumably either artistic or marital concord. Another artist's portrait, Cornelis Troost's *Portrait of Jacob Campo Weyerman* dated 1725 reveals that this eighteenth-century chronicler of artists' lives (*De Levensbeschryvingen der Nederlandsche Kunstschilders,* 4 vols., 1729–69) was as unattractive as he was plagiaristic; whole sections of his accounts are lifted directly from Houbraken's indispensable *Groote Schouburgh* (1718–21).

Los Angeles's landscapes include two van Goyens from the 1640s, a *Landscape with Deer Hunters* by Salomon van Ruysdael, and two Jacob van Ruisdaels. The early *Dune Landscape* by the last mentioned is the best of the lot. A fine new acquisition is a small italianate *Landscape with Ruins and Travelers* dated 1654 by Nicolaes Berchem. Its pedigree is distinguished, including the well-known Locquet Collection and the former holdings of the counts of Liechtenstein, and testifies to Berchem's high regard in the eighteenth century. Albert Cuyp's *View of the Maas near Dordrecht* has suffered the fate of more than one of his very broad panoramic river scenes. A drawing by the eighteenth-century artist Aart Schouman reveals that the long original canvas was cut in two pieces; the other half is now preserved in the museum

190

in Leipzig. One of the more pleasant surprises of the County Museum's Dutch collections is a major *Battle Scene (fig. 190)* by Philips Wouwerman which has only recently emerged from the basement and a veil of yellow varnish. Dutch cityscapes in the collection include a *View of the Hague* by Gerrit Berckheyde, a poorly preserved Jan van der Heyden, and a *View of the Ponte Rotto, Rome,* dated 1652, by Jan Asselijn.

191

Although not so distinguished as the portraits and history paintings, genre is adequately represented at the County Museum. (Despite the presence of works by Pieter Claesz, W. Heda [by den Uyl?], P. van Maes, and Jasper Gerard, the Dutch still lifes must await the Carter bequest to be truly representative in terms of quality.) Dirck Hals offers an example of the early *Merry Company,* while the guardroom tra-

dition is represented by Pieter Quast's *Girl and Soldier Playing Cards* (the gift of the actor John Wayne). Although best known as a guardroom painter, Jacob Duck also painted street scenes. In his so-called *Street Peddler* (*fig. 191*), the central figure's occupation (quacksalvery? mendicity?) and the picture's meaning have yet to be adequately explained; nonetheless, the panel is one of Los Angeles's best Dutch paintings. Other notable low-life genre paintings are Pieter de Bloot's *Rat Catcher* and Adriaen van Ostade's *Figures at a Cottage* dated 1642. Domestic scenes include Quirin van Brekelenkam's *Woman Scaling Fish* dated 1668 and a late, rather dull Pieter de Hooch. Still another very late work by de Hooch in the collection betrays an alarming deterioration of quality that is probably related in some way to his death in the insane asylum. Although a popular favorite, Gerard Terborch's *Card Players* is in a pitiable state of preservation. Better preserved is a little painting entitled *Lawyer in His Study* which seems to have been a collaborative effort (the work is signed "Av.O/CD") between Adriaen van Ostade and Cornelis Dusart (not Egbert van der Poel). Dusart handled Ostade's estate, completing many of his unfinished works. Somewhat surprisingly, Los Angeles owns several examples of Netherlandish artists working, as it were, in double harness, including a little *Kitchen Interior with Still Life* (*fig. 192*), dated 1643 and signed by both Jan Davidsz de Heem and the famous Flemish genre painter David Teniers, and a much less appealing *Church Interior at Night* by Anthonie de Lorme with figures presumed to be by his fellow Rotterdamer Ludolf de Jongh.

In addition to a few pieces of delftware and an ebonized table of c. 1700, the decorative arts collections include a small bronze bust of a *Crying Baby* executed by Hendrik de Keyser around 1615. Similar figures appear on the sculptor's Tomb of William the Silent in Delft and probably influenced such famous images as Rembrandt's *Ganymede* in the Dresden Museum. Later Dutch works include a *Woman Sewing* by Josef Israëls and two reed pen drawings executed by van Gogh at Arles in 1888. One depicts a *Woman Carrying an Umbrella on the Langlais Bridge* (*fig. 193*) and the other is a drawing of *Postman Roulin* made after the great portrait now in Boston. The museum's modern collections include a fine mature canvas by Mondrian.

192

193

J. B. SPEED ART MUSEUM

2035 South 3rd Street
Louisville, Kentucky 40208 *(502) 636-2893*

Founded in 1925 by Hattie Bishop Speed in memory of her husband, the museum was opened in 1927. The original structure was designed in a strictly classical Renaissance style. The Preston P. Satterwhite wing was opened in 1954, and in 1973 a contemporary-styled wing with garden court was inaugurated. The collections, though not extensive, seek comprehensiveness, offering samplings of Oriental, ancient Greek and Roman, American, and European art, the last mentioned extending from the thirteenth century to the present. The museum maintains an active acquisition policy and during the last twenty years has amassed a very commendable little collection of Dutch seventeenth-century paintings. Although Rembrandt's *Portrait of a Woman,* which was purchased in 1977 on the occasion of the fiftieth anniversary of the museum, must be reckoned the program's crowning achievement, the many outstanding works by lesser-known Dutch artists are the true test of its success. A handbook appeared in 1973 and soon will be reissued, and the museum's *Bulletin* is published regularly.

The strongest feature of Louisville's Dutch paintings is surely its portraits. These include not merely handsome examples of time-honored portrait types, such as Johannes Verspronck's three-quarter-length *Portrait of a Man*

194

dated 1641 and Pieter Nason's oval *Portrait of an Officer,* but more unconventional, truly engaging works such as the *Portrait of a Man with a Lay Figure (fig. 194)* dated 1624 by Werner van den Valckert. A pupil of Goltzius, van den Valckert painted history paintings as well as portraits and militia pieces. The man in this work undoubtedly is an artist and, to judge from his tools, a sculptor. As today, lay figures (*ledepoppen*) or mannequins were commonly used as aides in figure and drapery studies. They were recommended by art theorists and are seen in paintings of Dutch artists' studios by, among others, Adriaen van Ostade.

195

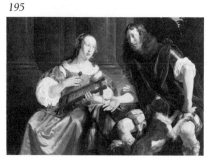

Terborch is known to have owned such a device. As the present work attests, the mannequins often were quite large, some approaching life-size.

Another excellent portrait in the collection is Jan de Bray's lovely *Portrait of a Couple Represented as Ulysses and Penelope (fig. 195)* dated 1668. Historicized portraits, or *portraits-historiés,* seem to have enjoyed some popularity in Holland; compare, for

example, de Bray's own *Portrait of the Artist's Father and His Wife as Anthony and Cleopatra* in the Currier Gallery of Art, Manchester, New Hampshire, and the works by Jan Lievens in Malibu and Gerbrand van den Eeckhout in Toledo. Naturally, in having themselves portrayed as historical figures, the sitters wished to identify with the qualities of the heroic figures from the past. However, it is surprising to discover that one burgher went so far as to have himself and his wife portrayed in a painting (now sadly lost) as the Virgin and the annunciate angel

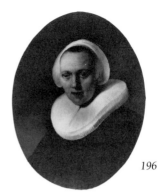

196

Gabriel. Rembrandt's *Portrait of a Woman* (fig. 196) dated 1634, the year in which he married Saskia, is by contrast an eminently straightforward account of the sitter's appearance. The woman looks out with a firm and steady gaze. Her more flamboyant mate, also dated 1634, is preserved in the Norton Simon Museum in California. (See Seymour Slive's account of the Louisville picture in the museum's *Bulletin,* September 1979.) One final portrait deserving note is by Hendrik Sorgh; it is the earliest dated work (1641) by an artist better known for his genre paintings, specifically market scenes.

The best genre scenes in the collection are Jacob Duck's *Stable Interior* (fig. 197), characteristically depicting soldiers and their camp followers taking their ease, and a *Merry Company* scene on copper by Dirck Hals. Albert Cuyp's *Landscape with Ruined Farmhouse* is a good early example of the painter's art and is the finest landscape in the collection. Still life fares less well (a late *Breakfast Still Life* by Pieter Claesz is dated 1653), but architectural painting is excellently represented with a *View in The Hague* (fig. 198) showing the Mauritshuis by Gerrit Berckheyde. Subtle adjustments of light and shade and a compelling suggestion of atmosphere in this work create a naturalistic effect quite foreign to the exaggerated perspective view of Dirck van Delen's *Banquet Hall with a Feast.* The latter work retains sixteenth-century spatial formulas made popular by the Antwerp artist Jan Vredeman de Vries. The little figures in van Delen's nocturnal hall are probably historical, but it is unclear whether they depict the Feast of Belshazzar, the

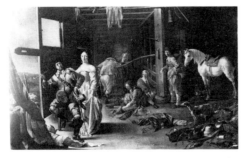

197

198

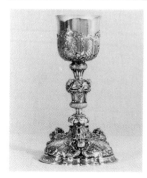

199

Feast of Herod (as in the work attributed to Jan Pynas in the collection), or some other banquet.

The print collection includes etchings by Rembrandt. An eighteenth-century silver chalice (*fig. 199*) by the Utrecht artist Nicolaes Verhaer (1685–1750) graces the decorative arts collection. This work is decorated with medallions depicting the Crucifixion, Resurrection, Adoration of the Lamb, and other scenes from the life of Christ.

J. PAUL GETTY MUSEUM

17985 Pacific Coast Highway
Malibu, California 90265 (213) 459-2306

The J. Paul Getty Museum is the creation of J. Paul Getty, oil magnate and businessman, who, prior to his death in 1976, was one of the wealthiest men in the world. The museum operates under the auspices of the J. Paul Getty Trust, which is the second largest private foundation in this country ($2.2 billion estimated in 1984). In 1983 the trust purchased a 750-acre hilltop in West Los Angeles that will be the site of a tripartite complex, including a center for the history of art and the humanities, a center for art conservation training, and a new museum to supplement the building in Malibu, which will be retained for the antiquities collection. In the meanwhile, the Getty's staff and their ubiquitous contacts seek to buy what remains of the legacy of Western art. The protectors of the "patrimony" of several European nations and the watchdogs of English country houses (that last great reserve of Old Master paintings) are more than a little hysterical on the subject of the Getty's appetites. In truth, even with the riches of Croesus, in today's contracted art market one could never replicate or even equal the collections of America's half dozen greatest museums. Nonetheless, with a yearly budget conservatively estimated at $80 million, the Getty can play the Medici. Though professing never to overpay, they can, at least in theory, bid until the hammer falls; hardly any collector or institution in the world can compete. Moreover, a privilege of wealth is information; when treasures come available, the Getty is likely to be offered them first.

The modest original Getty collection was first opened to the public on the founder's ranch in Malibu in 1953. But it soon required a museum. Dramaticallly situated overlooking the Pacific Ocean, the present Getty Museum was inaugurated in 1974. Although, ironically, Getty himself never saw his creation, one of his enthusiasms was Greek and Roman antiquities. Thus the museum was designed as a setting for these collections. It takes the form of a replica of the Villa dei Papiri excavated at Herculaneum. Getty's greatest love was probably eighteenth-century French decorative arts, of which superb examples are here in abundance. The third feature of the original collections, European paintings, was formerly overshadowed by the strengths of the other two. However, the collection of Dutch paintings, now supplemented by the late Mr. Getty's personal pictures from Sutton Place (according to his own recollection, the first painting Getty ever acquired was a van Goyen) and a series of outstanding recent acquisitions (Ruisdael, Terbrugghen, Steen, de Hooch, P. Koninck, Breenbergh, Knüpfer, Wttewael, Terborch, F. van Mieris, van Huysum, Sweerts, Cuyp, Saenredam) total about seventy-five and achieve an excellent standard of quality and historical importance. The Rembrandts alone refute the accusation sometimes heard that the collections are more academic than outstanding. Moreover, the Dutch art is

likely to further prosper as the Getty looks ahead to an era of expansion (new fields in which the museum will collect include drawings, manuscripts, and photography). The eminently capable new director, John Walsh, is a distinguished scholar of Dutch art, who has published on, among other topics, Porcellis and Vermeer. Publications on the collection include Mr. Getty's *Joys of Collecting* which appeared in 1965 and a good though now outdated *Catalogue of the Paintings* (1972) by Burton Fredericksen. A *Guidebook* (1980) and photo album of *Masterpieces of Painting* (1980) are also available. Exhibition publications appear regularly and a scholarly journal is published annually.

In the painting collection, seventeenth-century Dutch paintings are second in importance only to the Italian (fourteenth through seventeenth centuries). The strongest single group of Dutch works is probably the history paintings, which tend to be large baroque compositions. One exception is Joachim Wttewael's precious little copper *Mars and Venus Surprised by the Gods* (for the subject, see Ovid's *Metamorphoses*. IV, 171ff.), apparently a companion to the Louvre's *Jupiter and Danaë*. When the painting was purchased at auction in 1983, it had been framed by a previous owner in a book, evidently with the intent of making the sensuous image all the more titillating. However, Wttewael's Mannerist nudes hardly require the conceits of the pornographer to express their sexy power. Another early Mannerist painting, though a relatively late work by the painter, is Abraham Bloemaert's *Expulsion of Hagar* of 1628, which takes up a theme made popular in the North by Pieter Lastman. It may be compared with his painting in the Walters Art Gallery, Baltimore, for its design and use of picturesque, rural details, like the treehouse at the left. In their struggle for independence, the Dutch identified with the Jews of the Old Testament. Hagar and her son Ishmael were driven into the wilderness by the child's father, Abraham, but survived to found some of the tribes of Israel. The story offered a biblical parallel to the United Provinces' break with the Spanish Netherlands, perhaps partly explaining its popularity in Holland. However, the appeal was also emotional—the father's reluctant rejection of his child and the lover whom he had taken at God's command. Gerbrand van den Eeckhout's *Hagar Weeping* is probably a fragment of a larger composition depicting the same theme or possibly the later episode of Hagar in the Wilderness. A painting dated 1637 by the Alkmaar painter Willem Bartsius has also been thought to depict the Expulsion of Hagar, however, the woman in the scene would seem closer in age to Sarah, Abraham's elderly wife, than to his concubine Hagar. A somewhat provincial painter but one with a strong artistic personality, Bartsius at times resembles the enigmatic artist known as Pseudo van de Venne.

The little italianate landscapes by the Bloemaert pupil Cornelis van Poelenburgh, by Poelenburgh's colleague in Rome Bartholomeus Breenbergh, and by his follower Dirck van der Lisse are often populated with tiny classical or biblical figures. The Getty owns a group of these artists' works,

including Breenbergh's *Moses and Aaron Changing the Rivers of Egypt to Blood* of 1631, the newly acquired masterpiece by that artist, the *Martyrdom of St. Stephen* (formerly Wolf Collection) of 1637, as well as one of the many scenes of *Diana and Actaeon* by van der Lisse. Bacchanalian revelry animates a second landscape attributed to van der Lisse in the collection (its Poelenburgh monogram has proven false). With large, monumentally conceived figures (compare Berkeley's painting by the artist), the *Homage to Bacchus* by the Haar-

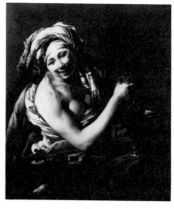

200

lem classicist Pieter de Grebber is, by contrast, an example of history painting proper. Seated at the upper left, the youthful god of wine receives a queue of adoring and surprisingly well-behaved baccantes and putti bearing offerings. Dated 1628, his work may surprise those accustomed to thinking of large, classicized nudes as inhabiting only later seventeenth-century Dutch art.

A friskier and far more engaging bacchante is the subject of the Getty's newly acquired Terbrugghen, dated 1627 (*fig. 200*). Wearing a splendidly exotic but vaguely makeshift turban and off-the-shoulder drapery, the smiling

girl squeezes grapes into a tazza. A pet monkey comically apes her gesture. Another painting thought to be a work by Terbrugghen is the *Shepherd and Sleeping Nymph.* Although outwardly only a scene of bucolic life, the subject may depict the shepherd Daifilo and the shepherdess Dorilea, two characters from *Granida* of c. 1605 by the Dutch poet Pieter Cornelisz Hooft. *Granida* was the first pastoral play in the Dutch language and a great popular success. It has been suggested that the canvas may be a fragment of a larger composition that included Granida, the princess who captured Daifilo's heart. No one, however, has ever sought to identify the nymph and sleeping satyr in Nicolaes Berchem's *Italianate Landscape* (*fig. 201*), a splendid work sometimes said to be dated 1642, the year that the artist joined the Haarlem guild, but probably dated 1647. As in Poelenburgh's earlier *Landscape with Bathing Nymphs,* Berchem's mythological staffage evoke arcadia without referring to a specific classical tale.

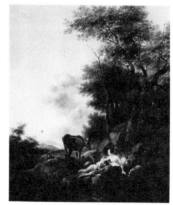

201

202

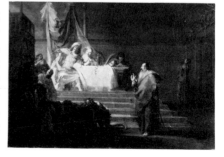

The recent acquisition of Nicolaes Knüpfer's *Solon and Croesus* (*fig. 202*) of c. 1650 (formerly Wolf Collection) brings to the collection a work by one of the most original Dutch history and genre painters but one who is virtually unknown in U.S. collections. Born in Leipzig, Knüpfer was a pupil of Bloemaert in Utrecht and in turn served as one of Jan Steen's teachers. At times his art recalls Elsheimer's and aspects of his loose brushwork have been likened to Bramer's, however, the sources of his original style are hardly obvious. The Getty's painting depicts the Lydian King, Croesus, challenging the Athenian sage, Solon, to name the happiest man he ever met. Despite Croesus's display of his enormous wealth (a pile of treasures in the shadows at the left), Solon replies that he could count no man happy until his life was judged happy at the end; moreover, even humble folk, when blessed with good fortune, could be happier than the richest kings. Dressed in a brilliant pink costume, Croesus points emphatically to his riches, while Solon, clad in a simple brown robe, responds with an understated but clearly admonitory gesture. Knüpfer's inventiveness is not only evident in his treatment of the narrative (compare Honthorst's version of 1624 in Hamburg), but also in his daring figure motifs (the radically foreshortened figure of a soldier in the shadows at the right) and palette.

The strongest group of history paintings at the Getty are the works by Rembrandt and his school. The master himself painted the magnificent *Saint Bartholomew* (*fig. 203*) of 1661, one of a series of works depicting apostles that Rembrandt executed in that year. This powerfully introspective image is discussed elsewhere in connection with other earlier representations of the saint in Worcester and San Diego. Bartholomew's disconcertingly modern appearance has been noted by several authors, but the fact that a mezzotint was made after the work in 1757 eliminates any question of its having been a later (e.g., nineteenth century) pastiche. The sitters in a historicized portrait (*fig. 204*) of 1631 by Rembrandt's early colleague Jan Lievens have recently been identified as Prince Charles Ludwig of the Palatinate (1617–1680), son of the "Winter King" Frederick V (see the medal in the Walters Art Gallery, Baltimore), and his tutor, Wolrad von Plessen. The pedagogue is shown gesturing to the young boy as if explaining a

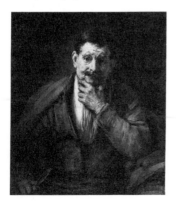

203

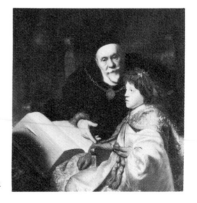

204

passage from the large volume that lies open before them. Previously identified as Eli and Samuel the two figures wear costumes more appropriate to classical than biblical characters, which has led to the supposition that they are represented as Aristotle instructing the young Alexander, an appropriate guise given the political aspirations of Prince Charles Ludwig's family. To its credit, the Getty has recently reunited this painting with its pendant, also of 1631, but painted by Rembrandt's precocious pupil Gerard Dou. It depicts Charles Ludwig's younger brother Rupert in a similar fashion, again instructed by an old man in historical costume. Conceivably, Dou and Lievens obtained these important commissions through the good offices of Constantijn Huygens. Very possibly, they served as gifts to the young scholars' mother, Elizabeth of Bohemia, during their residence in Leiden.

A highly unusual work is the *Adoration of the Shepherds* by the Rembrandt pupil Nicolaes Maes. It is exceptional for being such a straightforward copy of a print source, namely Dürer's 1504 engraving of the Nativity. Usually visual quotations encountered in works by Rembrandt and his pupils are more fully absorbed or at least modified to a different expressive end. Such is the case, for example, in Rembrandt's *Angel Departing from the Family of Tobit* in the Louvre of 1637, which borrows the figure of the angel from a woodcut by the sixteenth-century artist Maerten van Heemskerck. The motif was further altered when Rembrandt's pupil Jan Victors executed his own version of the theme, dated 1649, now at the Getty Museum. While the pedigree of this quotation is easily recognized, it is transformed with each new usage. Victors was an able portraitist and genre painter as well as a history painter. His achievements, however, never approached those of Rembrandt's late pupil Aert de Gelder. The Getty owns two Old Testament paintings by de Gelder, *Abimelech Giving Goliath's Sword to David* and *The Feast of Belshazzar,* or as it is now tentatively identified, the *Banquet of Ahasuerus (fig. 205).* In the latter, a monarch or potentate richly attired in a turban and an ermine mantle slouches drunkenly over a table surrounded by guests and set with a silver platter of brilliant oranges. The former identification of the narrative must be questioned since the sacred gold and silver vessels that Belshazzar ordered for the feast are omitted. Further, the divine writing on the wall denouncing the blasphemous monarch is conspicuously absent. The assumption that the scene depicts the inebriated King Belshazzar at one of the banquet scenes in the Book of Esther depends *205* more upon the knowledge that de Gelder repeatedly represented scenes from the story of Esther (see, for example, the painting in Providence) than upon any details of the painting itself—characters, costumes, action, and so forth. Whatever the subject, the painting attests to the keen interest de Gelder shared with Rembrandt, indeed perhaps more intensely than any other student or

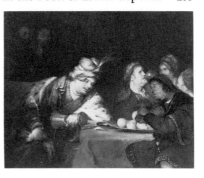

follower, in bringing the human dimension of biblical stories vividly to life. Rarely has the comic but fearful visage of drunken authority been more compellingly portrayed.

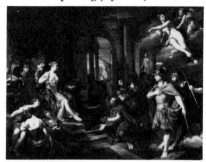

De Gelder's coarse types and free technique ran counter to prevailing tastes at the end of the seventeenth century. More in line with the fashion of the time is the suave *Dido and Aeneas* (fig. 206), formerly attributed to that pardigm of the academic tradition, Gerard de Lairesse, but probably correctly reassigned by Thomas Kren to Jan Verkolje. The cool, studied classicism of this work reappears, albeit in a less accomplished form, in *The Banquet of Cleopatra* by Gerard Hoet, another practitioner of the official classical manner (compare Norton Simon's paintings).

206

207

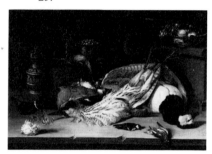

The group of Dutch still lifes at the Getty include several especially interesting works. Ambrosius Bosschaert's *Flower Still Life* is distinguished both for its fine state and early date, 1614. The *Still Life with Dead Birds* of 1624 (fig. 207) by Christoffel van den Berghe is noteworthy not only for its date (the only other dated work by this rare but gifted follower of Bosschaert is in the Johnson Collection, Philadelphia), but as a very early example of the dead game piece; compare Willem van Aelst's much later *Game Piece* of 1674. The *vanitas* still-life tradition is represented with Pieter Claesz's panel of 1634. The artist's reflection, a common *trompe l'oeil* feature of Dutch still lifes, appears in the silver sphere on the table (compare Vassar's Claesz). The *Still Life with Ewer, Vessels, and Pomegranate* by Willem Kalf doubtless is an early work of the type he executed while still in Paris (1642–46). Although Kalf retained his interest in elegant and costly objects, the bright overall tonality

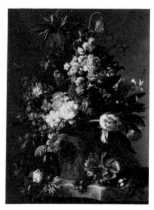

208 *209*

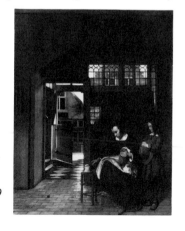

and rather dry touch of this work would later give way to stronger contrasts of light and dark, a richer technique, and more liberal use of color. Recent acquisitions are two splendid flower still lifes by Jan van Huysum, works well suited to the museum's strengths in eighteenth-century furniture. Although both works dazzle, the painting of 1722 (*fig. 208*) is perhaps more stunning.

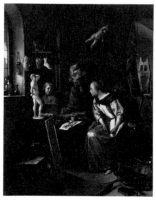

210

The Dutch genre paintings have greatly benefitted from recent purchases. In rapid order the Getty has added: an outstanding early Terborch stable scene painted before the artist devoted himself to high-life subjects; the minutely finished *Alchemist* of 1663 by Cornelis Bega, which, if no other work by this hand survived, would suffice to affirm Houbraken's judgment that the painter was Ostade's best pupil; and masterpieces by Pieter de Hooch and Jan Steen. The de Hooch (*fig. 209*) takes up the popular domestic genre theme of the prayer before the meal (see the van Mieris in the Corcoran and the Steen in Philadelphia), which in this instance is *boterham* or the bread and butter that were the traditional morning repast. The young boy who folds his hands in prayer over the brim of his hat probably attends the school visible across the street under the sign board marked "Schole." This view through the open doorway to the street, virtually de Hooch's hallmark, illustrates the artist's mastery of light and geometric order. Indeed, de Hooch set himself a special challenge in this work by including a glassed foyer, or *voorhuis*, which redoubles the gridwork of mullions. Almost imperceptible at first, a man, no doubt the father, stands silently in lost profile on the far side of the window. In de Hooch's compelling vision of the Dutch home, the menfolk usually stand at a slight remove from the center of domesticity and the activities of women and their children.

Jan Steen's *Drawing Lesson* (*fig. 210*) depicts an artist's studio with the painter instructing a small boy, probably his apprentice, and an enchantingly lovely young girl. It is probably significant that the painting on the easel in the background (the Good Samaritan?) suggests that the artist is a history painter, the highest calling to which an artist could then aspire. The fact that the painter is correcting his students' drawing reminds us that good drawing was considered a prerequisite of painting. Students began by copying prints (Jan Lievens' chiaroscuro woodcut lies on the table) and plaster casts before proceeding to the greater challenge of oils; note the prepared canvas slung in a stretcher—a common studio practice—in the foreground. Among the casts on the shelf is a bull, attribute of Saint Luke, the patron saint of artists. Whether the painting includes additional dimensions of meaning, specifically allusions to the theory of art education, is uncertain. Our suspicions, however, may be aroused by the satin dress and ermine-lined jacket worn

by the young girl, who appears conspicuously overdressed for the untidy business of art. She sharpens her quill, a gesture potentially symbolic of the need for practice in art. More obviously emblematic is the still life at the lower right, which includes a skull, laurel wreath, fur muff, cittern, book, basket, glass vial, and brazier. The smoke of the last mentioned and the skull are traditional *vanitas* symbols, while the other objects could variously allude to art, knowledge, and wealth; thus, collectively they might recall the notion of *ars longa, vita brevis*. To the objection that such scrupulous symbolic analysis overreads what outwardly appears to be a purely descriptive genre scene, we cite another Getty painting by a close friend of Steen's, Frans van Mieris. This work well illustrates the Dutchman's dual concern with symbolism and naturalism. Van Mieris's tiny *Pictura* of 1661 is a representation of the art of painting, which closely follows the description of the personification offered in Cesare Ripa's *Iconologia* (Dutch edition 1644): "A beautiful woman ... with a gold chain around her neck from which hangs a mask, ... she should hold brushes in one hand and a palette in the other and be dressed in a lustrous garment...." In the interest of the natural appearance of the picture, however, van Mieris ignored Ripa's recommendation that the word *Imitatio* (Imitation [of Nature]) appear on the woman's forehead.

Other genre scenes in the collection include a fragment of a *Musical Group on a Balcony* dated 1622 by Gerard van Honthorst, which appears to be the earliest dated illusionistic ceiling executed in the Netherlands. In Italy Honthorst not only studied Caravaggio's art but, as this work executed two years after his return attests, learned much from contemporary Italian fresco decorations. The Getty also owns Jacob Duck's *Interior with Soldiers and Women,* both an indoor and an outdoor scene by the charmingly naive Jacobus Vrel, and a *Family Group in an Interior* assigned to Cornelis de Man but perhaps by Quirin van Brekelenkam. Although genre-like in appearance, Steen's *Satyr and Peasant* cannot, properly speaking, be considered an everyday scene. It illustrates Aesop's fable about the satyr who warily took leave of his dinner with the peasant when he discovered that the latter blew on his hands to keep them warm but also blew on his soup to cool it off. The hoary old satyr is shown delivering a warning to the general amusement of his hosts against those untrustworthy types who blow both "hot" and "cold" with the same breath.

Once weak in early Dutch landscapes, the Getty has recently acquired a charming pair of tiny summer landscapes on copper of c. 1617 by Adriaen van de Venne. One depicts a ballgame in an imaginary, parklike setting and the other a delightful *fête champêtre* with young women playing music in a sheltered arbor as men sneak up to spy on them from all sides. Van de Venne's paintings very often illustrated moralizing expressions or ideas. Undoubtedly the male voyeurs wearing fools' caps and plummeting to earth from their vantage point in the trees on the left embody an admonition. The Getty's other Dutch landscapes include a large Pieter Molyn, Jan van Goyen's *View of the Castle at Wijk* dated 1649, two views of Rhenen by Anthonie Jan van der Croos and Salomon van Ruysdael, the latter's highly characteristic

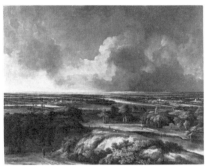
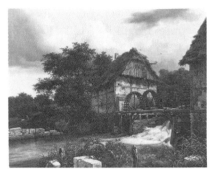

211

though undated *Landscape with Travellers before an Inn,* and a better than *212*
average *Winter Landscape* by Anthonie Beerstraten. An excellent early work
of c. 1644, by Albert Cuyp offers a *View of the Maas,* while one of his mature
paintings (on loan to the Getty) depicts cattle grazing on the river's banks.
Jan van de Heyden's *Tollhouse at Maarsen* (compare Cincinnati's view of
this city) was part of Getty's personal collection. A major recent acquisition
is a large canvas by Philips Koninck of a panoramic landscape (*fig. 211*),
one of the most characteristic Dutch landscape types. Its unusually dra-
matic sky may be by another hand. Two battle paintings deserve special
note; one attributed to Pieter Post depicts *Soldiers Plundering a Village,* while
Johannes Lingelbach's painting shows a *Cavalry Battle.* The latter picture,
which is fully signed, must be a very early work executed by the artist before
his trip to Italy. Nicolaes Berchem's *Italianate Landscape with Nymph and
Satyr* was mentioned above with the other italianate paintings. Berchem is
believed to have accompanied Jacob van Ruisdael on his trip to the Dutch-
German border region. It was there that Ruisdael probably saw undershot
watermills at the estate of Singraven near Denekamp, which in turn inspired
works like the Getty's newly acquired *Two Water Mills and an Open Sluice*
(*fig. 212*) of 1653. The collection's finest Dutch landscape, this masterpiece
and the other new Ruisdael, *Landscape with Wheat Field,* testify to the success
of the ambitious new acquisition program. Like Ruisdael, but with far less
success, Frederik de Moucheron occasionally had other artists paint his
staffage into his landscapes. Indeed, both men collaborated with Berchem.
Moucheron's *Italian Landscape* in the Getty includes figures attributed to
Adriaen van de Velde. Another collaborative effort is Herman Nauwincx's
Italian Landscape with figures by Willem Schellinks (monogrammed by both
artists).

Unusually fresh is the *Portrait of a Twenty-One-Year-Old Woman* dated
1632 by the Amsterdam portraitist Nicolaes Eliasz, known as Pickenoy. Best
remembered for his rather fastidious group portraits of regents and militia-
men, Pickenoy was a contemporary of Thomas de Keyser with whom he
has often been confused. The charming young lady in the exceptionally
wide ruff and gilt stomacher was married to a young man portrayed in a
companion piece now in an English private collection. Probably dating only
a year or two earlier, Rembrandt's so-called *Portrait of the Artist's Father* has
been questioned by some Rembrandt authorities. Although we can readily

dispense with the apochryphal identification of the sitter, the attribution stands firm. The technique and flamboyant conception of the figure wearing a beret with a tall feather and steel gorget—how conventional Pickenoy's formal portrait appears by comparison!—seem entirely characteristic of the young Rembrandt. One of the master's favorite early models, the same sitter posed for, among other works, paintings in Chicago, Boston, and the Fogg Art Museum. Typical of the portraits Govaert Flinck executed while still under the influence of Rembrandt is his *Portrait of a Man* dated 1641. Although formerly attributed to Bol and now assigned to Jacob Backer, the *Half-Length Portrait of a Woman* has less to do with Rembrandt's circle than that fashionable group of Amsterdam portraitists led from the 1640s onward by Bartholomeus van der Helst. The latter's handsome *Portrait of an Officer* is signed and dated 1650. A good, somewhat later *Portrait of a Gentleman in Black,* formerly attributed to Maes, has recentlly been reassigned to Karel Dujardin, whose elegant portraits are perhaps not so well known as his italianate landscapes. Last though hardly least among this group of portraits is the brilliant *Smiling Head of an Old Woman* by the peripatetic Michael Sweerts. Born in Brussels, Sweerts lived in Amsterdam and Italy, traveled to the Orient and died in Goa in 1664. Although often discussed as a Netherlandish painter, he was an artist of such uniquely personal qualities as to defy national or regional classification. Typical of the lack of understanding of his style is the fact that the present work bore an attribution to an unknown eighteenth-century French artist prior to entering the collections. Clad in a simple white kerchief and open-necked collar, the old

woman looks out directly at us with glazed but curiously gay eyes, offering a toothless but disarmingly cheerful grin. The counterpart to Sweerts's poetic *Head of a Boy* in Hartford, this remarkable work attests to an expressive range perhaps surpassed in these years only by Rembrandt.

The Getty Museum began actively collecting drawings only about one-half dozen years ago, but already owns no less than eight sheets by Rembrandt, including a splendid early chalk drawing of a *Female Nude* (fig. 213), traditionally identified as Cleopatra. Other notable drawings are Jan van Goyen's *Village Festival,* Gerrit van Battem's *Frozen Canal,* Adriaen van Ostade's *Tavern*

213

of 1674 and a beautiful group of chalk *Head Studies* by Abraham Bloemaert. Wttewael's genre-like *Lady Assisted by a Gentleman* is one of a series of allegorical drawings on the Dutch struggle for independence; very likely the woman in distress is "Lady Belgica," her gallant savior Prince Maurits. A catalogue of the Getty's drawings will appear shortly.

CURRIER GALLERY OF ART

192 Orange Street
Manchester, New Hampshire 03104 *(603) 669-6144*

Opened in 1929, the gallery, with its attractive central court, was built in memory of Moody Currier, former governor of the state of New Hampshire. With funds left from the Currier estate, the gallery has grown into one of the finest smaller museums in New England. The greatest strengths of the collection appropriately are seventeenth- to nineteenth-century American decorative arts and painting, but the European art also includes several good Dutch paintings. A *Handbook* of the collection was published in 1979.

The Currier owns two good Dutch seventeenth-century landscapes, Jan van Goyen's *View of Fort Lillo on the Scheldt (fig. 214)* of 1643 and the *View of Egmond aan Zee (fig. 215)*. The latter's attribution to Jacob Ruisdael was rejected by the Ruisdael specialist Jakob Rosenberg until the date 1648 and a signature were revealed in cleaning. Despite Rosenberg's change of heart and the conviction of other specialists, this picture appeared to be by a different hand when hung alongside other autographed early Ruisdaels in the monographic show devoted to the artist in 1981–82. Its touch is slicker and overall tonality much lighter. Nonetheless, it is a work of exceptional beauty, well deserving efforts to secure an attribution and no less intriguing for its blasted elm's potential symbolism. The most outstanding Dutch painting in Manchester, however, is the *Banquet of Anthony and Cleopatra (fig. 216)* dated 1669 by the Haarlem painter Jan de Bray (see Franklin Robinson's article on the painting in the gallery's *Bulletin*). The subject refers to the tale that Cleopatra wagered the Roman commander that she could spend more than ten million sesterces on a single meal. The queen of Egypt won her extravagant bet by dissolving one of her pearl earrings in a glass of vinegar and drinking it. As in an earlier version of 1652 in the collection of Her Majesty the Queen of England, the various figures in this scene have portrait features. The central couple seems to represent the same man and

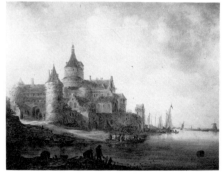

214

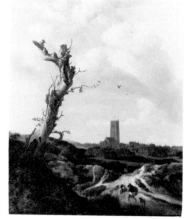

215

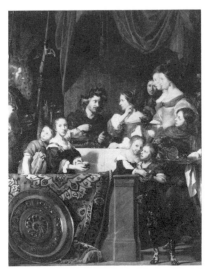

216

woman in the double profile portrait now in a private collection and listed in Jan de Bray's inventory as a portrait of his father and teacher, Salomon de Bray, and the latter's wife, Anna Westerbaen. The male figure on the left carrying a halberd presumably is Jan's self-portrait. The date on the present work indicates that this version was a posthumous portrait of Jan's parents. Historical portraits of this type were common in seventeenth-century Holland; compare, for example, van den Eeckhout's *Continence of Scipio* in Toledo and Jan de Bray's own *Ulysses and Penelope* in Louisville.

BARNES FOUNDATION

300 North Latch's Lane
Merion Station, PA 19066 *(215) 667-0290*

Situated in a twelve acre arboretum, the Barnes Foundation was established in 1922 as a privately endowed educational institution. Its creator was Dr. Albert C. Barnes, the inventor of our grandmother's tonic, Argyrol, famed collector of Impressionist and early twentieth century art and self styled art theorist and educator. The collections are housed in a handsomely reserved building designed by Paul Philippe Cret and dedicated in 1925. The quality of the French paintings is simply dazzling; Cezanne, Renoir, and Matisse are each represented with literally dozens of superb and little known examples. Here too are brilliant masterpieces by Seurat, Manet, Picasso, Modigliani and many other artists of the first rank. Yet a visit to the Barnes is a curiously frustrating experience. In part this results from the installations; masterpieces are hung cheek to jowl with works of dubious merit and authenticity or, strange to say, punctuated with hardware—such as door hinges or antique tools. The eccentric hanging follows no historical overview or grouping by region or school. The higgledy-piggledy effect is deliberate. Like the absence of any collection catalogue or conventional labels identifying the objects on view, the installation is intended to challenge traditional museological approaches to the display of works of art. It reflects the highly personal approach to art of the late Dr. Barnes and his long surviving collaborator, Violette de Mazia. To grasp their method one may read the co-author's several books, including monographic studies of Cezanne and Renoir, or attend the course of study still offered at the Foundation. All of which might sound beguiling in an age of increasing museum professionalism if it were not for the importance of the art involved and the institution's arrogant elitism and carelessness. The Barnes Foundation only reluctantly opened its doors to the public after being threatened with loss of their tax exempt status. Even today the hours are restricted and one must phone in advance for reservations (100 on Friday and Saturday, 50 on Sunday afternoons). Moreover, the installation is not simply eccentric. What audacity it may once have had has long since lost its ability to shock or instruct. In the meantime, the objects have suffered mercilessly. By this I do not refer merely to aesthetic harm—masterpieces by Seurat and Cezanne hung ten feet off the ground— but observable physical deterioration, such as the irreversible light damage suffered by the tapestries, textiles, water colors and other works on paper.

No true art enthusiast would visit the Barnes solely to see the few Dutch paintings, but these are of very good quality. The earliest is an altarpiece of c. 1505, *The Adoration of the Kings (fig. 219)*, which in the past has often been assigned with some reason to the youthful Lucas van Leyden. The painting's style reflects the artist's acquaintance with the Haarlem School tradition of Geertgen tot Sint Jans as well as the art of the Master of the

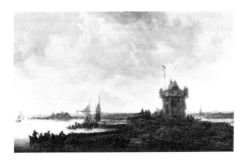

217 218

St. John Altarpiece, who has been assumed to be Hugo Jacobsz, Lucas' father. In fact one of the figures in the left wing reappears in the panel from the St. John altarpiece now hanging only a few miles away in the Johnson Collection in the Philadelphia Museum of Art. Despite this connection with Lucas and his immediate circle the attribution to the master remains uncertain.

Frans Hals' *Portrait of a Man Holding a Watch* dated 1643 is one of several good Dutch seventeenth century paintings in the collection. Although the sitter is unidentified, an inscription on the painting indicates that he was fifty-seven years old. His wife was five years his junior. Her portrait, dated the same year, inscribed similarly and conceived as a pendant, is preserved in the Nationalmuseum, Stockholm. The watch that the man holds is less likely to be an allusion to his professional involvement in the making or collecting of timepieces than a symbol of the brevity of life and the need to use one's time wisely. Several landscapes deserve note. Van Goyen's *Watchtower by a River* (fig. 217), is dated 1651 (compare Boston's painting of the same subject dated 1644) while Salomon van Ruysdael's pleasingly fresh *View of the Rhine near Rhenen* probably dates from the 1660s. An italianate landscape with bucolic figures and romanesque architecture is an unusually fine example of Job Berckheyde's art.

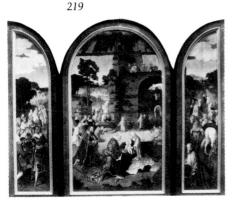

219

The most interesting of several van Goghs in the collection are the *Portrait of an Unknown Peasant with a Pipe* painted in Arles in December of 1888 and a fascinating reclining nude painted in Paris on an oval canvas in the first half of the preceding year (fig. 218). No conventional beauty, the swarthy girl with coarse features and wearing only stockings strikes a seductive pose. In all likelihood she was one of the many prostitutes van Gogh is known to have patronized. A preliminary sketch for the work is preserved in Amsterdam and an inde-

pendent portrait of the sitter in Basel. As the painting's broken brushwork is a reinterpretation of Seurat's pointillist technique, the painting's subject is probably a response to Manet's famous *Olympia* and its well known sources (Goya, Giorgione, *et al*) in the great Western painting tradition.

BASS MUSEUM OF ART

2100 Collins Avenue
Miami Beach, Florida 33139 (305) 673-7530

Situated just off Collins Avenue, a thoroughfare noted for its seedy but interesting art deco hotels, the Bass Collection is housed in the former public library, which was built in 1934. Opened to the public in 1964, this small collection includes paintings, sculpture, prints, drawings, vestments, and tapestries. Some years ago the collection was the focus of controversy when many overoptimistic attributions were downgraded. The out-of-print catalogue of 1973 attests to these mistakes. The paintings' labels now give a more accurate account of what one sees on the walls. To be sure, the works once attributed to Rembrandt, Frans Hals, and Vermeer are not by those masters, but the collection nonetheless includes several respectable Dutch paintings.

The earliest is a triptych of c. 1600 of the Crucifixion with wings depicting donors, by Cornelis Cornelisz van Haarlem. In the center panel

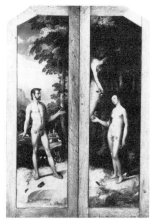

the Virgin swoons as the centurion readies the sponge with vinegar. The tall, slender crosses hark back to a much earlier convention in Dutch religious art practiced by such artists as Jacob Cornelisz van Oostzanen and his circle. Also traditional but less *retardataire* is the division of the male members of the family on the left wing and the female on the right, attended respectively by Saint James and Saint Apollonia. P. J. J. van Thiel, a specialist on van Haarlem, has identified the coat of arms as that of the van Egmond and Bouckhorst families; however, this detail may be a later addition. The outer wings offer a particularly beautiful depiction (fig. 220) of Adam and Eve; the Fall of Man, of course, is a related theme since original sin was redeemed by Christ's sacrifice.

220

221

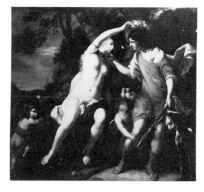

Another handsome Dutch history painting is the large and impressive *Venus and Adonis* (fig. 221) dated 1661 by Rembrandt's pupil Ferdinand Bol. Bol treated this theme repeatedly; indeed, it was one of his more successful compositions. The Rijksmuseum in Amsterdam has just purchased a similar painting, also on a monumental format, which probably slightly predates Miami's work. The expert on Bol Albert Blankert has

also just reattributed a painting in the collection formerly attributed to Govaert Flinck of a *Child Holding an Apple* to Bol. Several cropped motifs in the work, such as the flowers on the right, suggest it has been cut down. One final noteworthy painting is a large canvas of a *Lady Playing the Viola da Gamba with a Dog* by Jan Weenix, which probably was once part of a larger decorative program like the artist's series that includes paintings in Oberlin and New York's Carlisle Hotel.

MINNEAPOLIS INSTITUTE OF ARTS

2400 Third Avenue South
Minneapolis, Minnesota 55404 *(612) 870-3046*

The formation of the Minneapolis Society of Fine Art preceded the founding of the institute in 1911 by twenty-eight years. An art school was established in 1886 and survives on the grounds of the present museum as the Minneapolis College of Art and Design. It was not until 1915, however, that the Minneapolis Institute of the Arts officially opened to the public in a classical-styled building designed by McKim, Mead, and White. While the facade of this original building is still visible today, the south wing added in 1927 has been encased by the extensive, modern-styled additions designed by Kenzo Tange and completed in 1974. The new additions connect the structure to the nationally famous Childrens' Theater.

The most important accession funds for the collection were provided by William Hood Dunwoody, one of the museum's founders, and John R. van Derlip who, in addition to serving as a trustee and benefactor, was the institute's second director and bequeathed many outstanding works, including the van der Helst (*fig. 228*). Van Derlip's tenure as director was followed by the long directorship of Russell Plimpton (1921–56) who oversaw the largest growth in the collections of European paintings and decorative arts. Together with Milliken in Cleveland, Plimpton is considered one of the outstanding Mid-west museum directors of his generation. The museum's greatest single gift—Rembrandt's *Lucretia* (*color plate 10*)—came in the years of his directorship (1935) through the use of Dunwoody funds and the generosity of Herschel V. Jones. The latter's painting and notable print collections were later bequeathed by his widow. During the 1950s under the directorship of Richard Davis, the museum sought to reduce the holdings of paintings to a masterpiece collection. The results are still controversial. While some important, merely unfashionable works were sold shortsightedly (the best of the lot were Italian pictures, but the Dutch paintings included a Pieter de Hooch now in the Thyssen-Bornemisza Collection in Lugano), the funds raised contributed to the purchase of other outstanding works, most significantly Poussin's *Death of Germanicus*. Since this period many Dutch paintings have been purchased or donated (notably the Terbrugghen, Bloemaert, van Everdingen, Dujardin, Esaias van de Velde, van Goyen and Storck), but the great acquisitions under the directorship of Anthony M. Clark, as befitted his expertise, were in the field of Italian art. His successor, Samuel Sachs II, purchased ably in all fields. George Keyes, the present curator, is a specialist in Dutch art who has greatly strengthened the representation of Dutch landscapes and marines. *A Guide to the Galleries* was published in 1970 and a completely illustrated, if sparsely documented, catalogue of *European Paintings* appeared the following year. Keyes' account of the "Paintings of the Northern Schools" in *Apollo* (March 1983) offers an excellent general introduction to this aspect of the collections.

The overall quality of the Italian and French paintings may surpass that of the Dutch. Yet the latter are exceptionally well represented. The earliest Northern Netherlandish painting in Minneapolis is a small panel, *Presentation in the Temple (fig. 222)*, by an unknown follower of the charming fifteenth-century artist Geertgen tot Sint Jans, the founder of the Haarlem School, who, alas, is poorly represented in American collections (see the painting in Cleveland). Like many an early artist whose style is recognizable but whose identity still evades us, this anon-

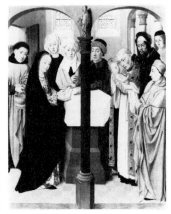

222

ymous painter takes his name from his best known work, the diptych of the *Virgin, Child, and Saint Anne* in the Museum in Brunswick. The Minneapolis panel is one of three surviving altar scenes (the other two are panels of almost identical size found in museums in Glasgow and Amsterdam) of the Life of the Virgin. The small, doll-like figures, so reminiscent of Geertgen's disarmingly tender and unaffected types, are viewed in a shallow space behind a portico with a central column and archways in the immediate foreground. Through the left arch one sees the Virgin with her retinue standing humbly to one side as she places two doves on the altar. These may refer, on one hand, to the dove which under the law of Moses was offered for the purification of the newborn, and on the other, to the Christian symbolism of the dove as the Holy Ghost. Through the right arch we see the clergy solemnly receiving the Christ child, who despite his seeming fragility, will pass back out the door on the left to establish the powerful new Church. With the *Virgin, Child, and Saint Anne* formerly attributed to Jacob Cornelisz van Oostzanen at the Yale University Art Gallery and the pictures by the Master of the Tiburtine Sibyl in Philadelphia and Detroit, this is one of the most important examples in this country of the early indigenous Haarlem School style.

Sixteenth-century Dutch art is represented by an altarpiece, unfortunately in problematic condition, depicting Adam and Eve and attributed to Jan Swart van Groningen, who is perhaps better known as a draftsman. This big and imposing work serves by its rarity to remind us of how few large-scale Dutch sixteenth-century altarpieces survived the *Beeldenstorm* (iconoclasm) that swept over Europe in several successive waves following 1527, or 1566 in the North. Prints, being less conspicuous and more portable, fared better. Minneapolis owns a notable group of engravings and woodcuts by Lucas van Leyden.

Surely one of the most handsome early seventeenth-century Dutch history paintings in the museum is the *Shepherd Boy Pointing at Tobias and the Angel (fig. 223)*. A relatively late work by the long-lived Abraham Bloe-

223

maert, it is less febrile and affected in its animation than his early Mannerist works, like the *Moses Striking the Rock* of 1596 in the Metropolitan Museum of Art. Yet, more than Bloemaert's *Expulsion of Hagar* in the Getty Museum or even *Tobias and the Angel* in New Orleans, it reflects the vestiges of the artist's early interest in Mannerism through its inversion of the primary and subsidiary, indeed incidental, elements of the narrative; although unmentioned in the biblical Apocrypha's account of the story, a shepherd boy looms large in the foreground while one's attention is only drawn to the religious theme in the background by the boy's gesture. Tobias and the archangel Raphael, who assists him in the search for a cure for his father's blindness, stride along together in the distance. Inverted compositions of this sort, much favored by Bloemaert's sixteenth-century Flemish forerunners Aertsen and Beuckelaer, have been interpreted as providing a mere pretext for the painting of genre and still life. However, this essentially modern view seems less likely than the theory that posits that such designs fulfill the Protestant imperative for the direct application of biblical lessons to the secular sphere. Other Dutch history paintings in the collection include a *Denial of Saint Peter* attributed to Honthorst and two works by later italianate artists—a tiny *Annunciation* by Karel Dujardin (compare his masterpiece in Sarasota) and *Mary Magdalen in a Cave* attributed to Johannes Lingelbach but perhaps by the Antwerp painter Anton Goubau. Better known than his religious works are Lingelbach's images of Roman street life, such as Minneapolis's *Piazza del Populo* with a picturesque group of peddlers and peasants with a gentlewoman promenading in their midst.

Without question the most powerful and moving Dutch history painting in the collection is Rembrandt's *Lucretia* (*color plate 10*) one of the greatest masterpieces in America. The faithful wife of the Roman general Collatinus (the story is told by Livy in his *Historiae*) is shown immediately after she had thrust the fatal dagger into her breast. No longer are we shown, as in the Washington version of two years earlier, the suicide itself, rather we face the tragic aftermath, in which the heroine's anguish is wholly internalized. Viewed frontally, Lucretia stands before us with an expression of imponderable sadness yet with dignity. She trusts in the belief that the red stain quickly spreading down her chemise will remove the taint brought upon the family's honor by her rape at the hands of the evil Sextus Tarquinius, a kinsman. Lucretia's faith in her ultimate sacrifice was, we recall, well founded; the news of her suicide brought an uprising which expelled the Tarquins from Rome and established a republic. In choosing to pull the bell cord in her final parting moments—a gesture with obvious theatrical parallels—she not only summons her servants and family but sounds the death knell of the Roman monarchy. The grandly dramatic conception, not to

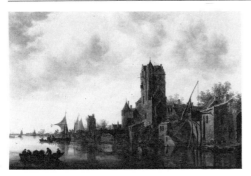

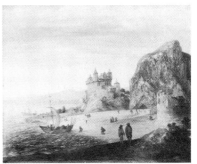

224

225

mention the forceful brushwork and splendid color scheme of greens and golds, show late Rembrandt at his very best.

Minneapolis's selection of seventeenth-century Dutch landscapes and marines has grown considerably in recent years. The acquisition of Esaias van de Velde's *Landscape with Courtly Procession* of 1619 brings to the collection its first work by this pioneering Haarlem realist. His pupil, Jan van Goyen, began his career painting in Esaias's style, before developing his own famous "tonal" manner. Minneapolis's new van Goyen landscape of 1648 *(fig. 224)* represents a still later phase in the artist's development when his colors and radiant lighting effects became more pronounced. Although not an accurate site, the building on the right is the Pellekussenpoort near Utrecht. Among the pleasanter surprises is an enchanting little imaginary *Coastal Landscape with Granite Cliffs (fig. 225)* by the rare Leiden painter Cornelis Liefrinck, a colleague of van Goyen's. The painter's brisk but assured touch and daring palette (note especially the pinks of the rocks) serves to remind us of the remarkable skill and invention of Holland's innumerable "minor masters." A clever recent purchase, Abraham Storck's *Marine (fig. 226)*, also reminds us of the startling capacity of certain Dutch artists of modest, workaday abilities to suddenly create a masterpiece. Outside of Dresden, this is probably the best work by the artist in existence. While the collection's landscape attributed to Molyn has suffered considerably, the large *River Scene with Ferry Boat* of 1656 by Salomon van Ruysdael is well preserved and provides a good example of the artist's mature treatment of one of his favorite themes (compare the somewhat earlier works in Kansas City and Toledo). Equally well preserved is the theatrical *River Scene with a Rainbow* assigned to Allart van Everdingen. Meindert Hobbema's *Country Road* is an honest but routine work by the artist which is outshown by his more ambitious *Wooded Landscape with Watermill and a Hunter (fig. 227)*, one of the artist's finest paintings in this country. The animated staffage doubtless are by another hand. The italianate tradition is excellently represented by Jan Both's *Landscape with Figures*, which, like the pictures in Toledo, Boston, and Indianapolis, was probably painted in the 1640s. Minneapolis's landscape collection offers the welcome opportunity to compare its Dutch works with two early Flemish landscapes by Jan Brueghel and Paulus Brill. Jan perpetuated the imaginary landscape tradition pioneered by

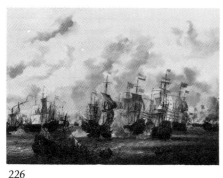

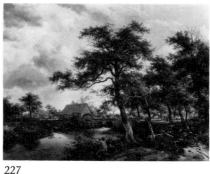

226 227

his father, Pieter Brueghel the Elder, and subsequently rejected by the early
Dutch realists. Brill was an important forerunner of the first generation of
Dutch italianate painters (Poelenburgh and Breenbergh) who, like him,
painted the Italian campagna with contemporary genre figures but with a
brighter, more naturalistic treatment of southern light. Jan Both followed
their example while adding a pervasive golden tonality to his often more
mountainous vistas.

The *Portrait of a Lady* in a millstone collar of 1649 by Albert Cuyp
unfortunately is separated from her bearded husband who now graces the
walls of the National Gallery in London. The painting nonetheless is of
interest because it is one of only a few portraits that can be accepted with
certainty as by Cuyp, the Dordrecht painter better known as a landscapist;
compare the equestrian portraits in Washington and the damaged portrait
in the Johnson Collection, Philadelphia. The style of this relatively early
work recalls the art of Albert's father and teacher, Jacob Gerritz Cuyp. The
chiaroscuro effects and brushwork of Govaert Flinck's *Portrait of a Man*
dated 1654 also reflect the influence of his teacher, namely Rembrandt. Yet
by the time this portrait was executed it had been at least eighteen years
since Flinck had left the master's studio, and one detects an increasing
smoothness and elegance in the technique. The most influential practitioner
of the elegant new portrait style was, of course, Bartholomeus van der Helst,

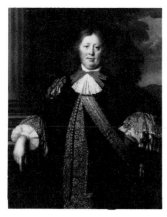

whose fame in his own day exceeded that of
both Frans Hals and Rembrandt. The son of
an innkeeper, van der Helst moved from his
native Haarlem to Amsterdam in 1636 and by
the early 1640s was attracting important com-
missions for guild and militia group portraits.
His great technical flare and flattering manner
soon made him the darling of Amsterdam's
elite regent class. Van der Helst's splendid
portrait (*fig. 228*) in Minneapolis depicts a
stout confident-looking gentleman posing
with studied informality beside a column on
228 the terrace of his country home. The subject

has traditionally been identified as Jacobus Trip (1627–1670). The fabulously rich Trip family were from Dordrecht and made their money in iron and armaments. About the time that this portrait was painted they built the famous Trippenhuis (1662), designed by the architect Justus Vingboons. With its massive, classically ordered facade, it was the only merchant's house in Amsterdam that could rival the grandeur and sumptuousness of Italian palazzi. Jacobus's own grand appearance contrasts markedly with the proud but severe demeanor of his father, Jacob Trip, and mother, Margaretha de Geer, as portrayed by late Rembrandt (National Gallery, London). More than a matter of the respective portraitists' styles, these contrasts seem to typify the increasingly aristocratic tastes of Amsterdam's merchant class, not to say the character of first and second generation wealth generally.

The finest Dutch still lifes in the collection are a large work by Pieter Claesz of 1643 depicting an unfinished meal of seafood and wine and a handsome *Still Life with Earthenware Jug* by Jan van de Velde dated 1658. Van de Velde, who was sensitive to the simple and unpretentious beauty of commonplace objects, owed a debt to his fellow Haarlemer, Claesz, but to the artist's earlier, more intimate side rather than to that luscious and somewhat decorative element of his art represented in the painting in Minneapolis. Notable among the Dutch genre scenes in the collection is Hendrik Terbrugghen's *Gamblers* of 1623. Although the subject of gaming had long existed in Northern art (see, for example, Lucas van Leyden's works), the present work probably descends from a lost picture by Caravaggio, which in turn was developed by Manfredi and, more importantly for Terbrugghen, by the latter's Utrecht colleague Baburen. The subject ultimately recalls the theme of soldiers gambling for Christ's clothes at the foot of the cross but in this case has been thoroughly secularized. The nearsighted old soldier who disputes the call with his saucy younger colleagues was one of Terbrugghen's favorite types. Unfortunately, the subtle color harmonies of this work are distorted by the overpainted light blue sky in the background. Other Dutch genre paintings include a charming scene by Sweerts of a *Boy Copying the Head of a Roman Emperor*; the theme of the youthful artist working from the live model or a cast was much loved by the painter. We already mentioned Lingelbach's italiante genre scene above; the local peasant scene is depicted in the *Barn Interior* of 1644 by Egbert van der Poel. A native of Delft, van der Poel made a specialty in his later years of depicting views of the explosion in Delft in 1654. But in this good, early work he addresses a theme commonly taken up by his contemporary peasant painters, especially those from Haarlem and Rotterdam. As a peasant woman cleans the entrails of a slaughtered pig hanging from a rack on the left, two boys fight over the pig's bladder. Like soap bubbles that can burst, the inflatable bladder was not merely a crude plaything but a potential *vanitas* symbol.

Not to be confused with his namesake, the seventeenth-century poet, Jacob Cats (1741–1799) was the most gifted Dutch draftsman of the latter

229 230

half of the following century; his *View of Heemstede* (*fig. 229*) in Minneapolis is a good example of his drawing style. The Institute's later Dutch pictures include a fresh *View of Lake Leman with Nyon* painted by Jongkind in 1875 and a *Landscape with Olive Trees* (*fig. 230*) executed by van Gogh in the autumn of 1889, while he was confined to the asylum in Saint-Rémy. Olive groves like tall stands of poplars, were some of van Gogh's favorite themes at this time. Here he depicts them beneath the searing and radiating brilliance of the *midi* sun. Minneapolis is also fortunate to own one of Piet Mondrian's mature experiments in what he termed Neo-Plasticism, the *Composition with Red, Yellow and Blue* dated 1922 and given by Mr. and Mrs. Bruce B. Dayton, continuing supporters of the museum. One of a long series exploring with great discipline the expressive possibilities of rectilinear forms and flat, primary colors, this work reveals the lucidity and balance that were the fruits of Mondrian's geometric reductions.

YALE UNIVERSITY ART GALLERY

1111 Chapel Street
New Haven, Connecticut 06520 (203) 436-0574

The Yale University Art Gallery was the first to open to the public in America when, in 1832, it was inaugurated as the Trumbull Gallery to house the work of the "patriot artist" of the American Revolution Colonel John Trumbull. In 1871 an important addition of European art was the acquisition of the James Jackson Jarves Collection of early Italian paintings, still one of the most significant of its kind in this country. Important additions to the Dutch collections included Katherine S. Dreier's gift in 1941 of the Societé Anonyme Collection, which included important works by Mondrian, the Egmont Collection of drawings presented in 1957, and the bequest of Stephen C. Clark in 1961, which brought Yale outstanding works by Hals and van Gogh. The present gallery is composed of two interconnected buildings. The earlier was constructed in 1928 and is based on the design of the Gothic palace at Viterbo, Italy; the later addition, designed by the architect Louis Kahn, is a functional, modern-styled building which continues to serve the collections admirably. A catalogue of the *Selected Paintings and Sculpture* from the gallery was published in 1972, and more comprehensive catalogues of different aspects of the collection have appeared. While the paintings have not been catalogued in full, the Dutch drawings are documented in exemplary fashion in *European Drawings and Watercolors* by Egbert Haverkamp Begemann and Anne-Marie S. Logan (1970). Scholarly articles on the collections appear in the *Yale University Art Gallery Bulletin*.

The finest early Dutch painting in the collection is a scene of the *Virgin and Child with Saint Anne (fig. 231)* formerly assigned to Jacob Cornelisz van Oostzanen but now labeled more accurately, if less specifically, "Haarlem School 1495–1500." The charming, doll-like figures have the slim, angular proportions and high, fragile foreheads that one associates with Geertgen tot Sint Jans. Together with the rare Albert van Ouwater, Geertgen played a pioneering role in founding a school of painting at Haarlem which, though much indebted to Flemish models, would become an independent Dutch style. The three main figures are seated in the foreground on or before a low stone wall. This common conceit alludes to the *hortus conclusus,* or enclosed garden, mentioned in the Song of Solomon and interpreted in Christian iconography as a symbol of the Immaculate Conception. In the landscape beyond appear the holy city of Jerusalem and various episodes from the life of Mary's

231

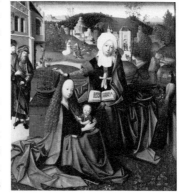

232

parents, Joachim and Anne. Saint Anne was thought at this time to have conceived the Virgin immaculately. In the late Middle Ages this belief made her a figure of great popularity and inspired broader interest in the geneology of the Virgin, since all her ancestors, it was reasoned, would have conceived immaculately. Representations in this period of the Virgin's extended family at times resemble football team portraits, so numerous is the cast of characters.

Maerten van Heemskerck was born in Haarlem about the time this picture was painted. His grisaille panels depicting heroically proportioned *Strong Men* testify to the interest he cultivated in Italian Renaissance and classical art at its source in Rome (see the related panels from this series in Oberlin). A relatively late Romanist, Heemskerck also adopted that most stylish of styles, Mannerism. His taste for Mannerist allegory is well represented in New Haven by a drawing depicting the personification of *The Choleric Temperament* from a series of the Four Temperaments. Although the painting of *The Deluge* once believed to be by Wttewael is now recognized as a partial copy, Yale's collection of late Dutch Mannerism includes fine drawings by Abraham Bloemaert and Jan Muller, as well as the earliest dated sketch (*Hagar in the Wilderness* of 1600) by Pieter Lastman, in which his Mannerist training under G. P. Sweelinck is still very evident.

The allegorical techniques of the sixteenth century were often perpetrated by the first practitioners of the new, more naturalistic style of the following century. Jacques de Gheyn, surely one of the most gifted pioneers of realism, took great care in his still life of 1621 (*fig. 232*) to depict all the objects (books, papers, a skull, plaster casts, etc.) as accurately as possible. Indeed the painting recalls Constantijn Huygens' remark that "in giving form to the human figure and other living creatures [de Gheyn] did not always live up to expectations,... but when it came to inanimate objects such as books or paper or sundry objects of utility, he triumphed over all." Elements like the skull, hour glass, and curious swirling pink aureol with a cherub overhead suggest, however, that the artist had more in mind than mimicry. De Gheyn seems to have been the originator of the *vanitas* still life; his painting in the Metropolitan Museum of Art of 1603 is the earliest of its type. In the Yale painting, however, de Gheyn issues more than a simple warning to beware the brevity of life and to repent. The sheet of paper pinned to the table cloth reads: "SEVARE MODUM, FINEMQUE TUERI,/NATURAM SEQUI" ([to] observe moderation, be mindful of one's end, and follow nature), a maxim perhaps suggested to the artist by his friend the great jurist Hugo Grotius, who published an annotated edition of the quotation's source, Lucan's *Pharsalia,* in 1614. This quote is an exhortation to improvement of

character in the Stoic sense rather than an allusion to transitoriness. Indeed, instead of standing for *vanitas,* the objects probably represent *studium,* the study whereby *vanitas* is conquered. Yale's little drawing by de Gheyn of a *Boy Seated at a Table with a Candle and Writing Tools (fig. 233)* was also long thought to be a *vanitas* image. But here too the allusion may be to the need for study and practice to attain the light of reason (embodied in the candle?). While the meaning of this charming little sheet remains unclear, we recall that van Mander, who expatiated on the value of study and the need to avoid idleness, cited de Gheyn as an artist who wasted time in his youth but always intended to practice his art.

233

234

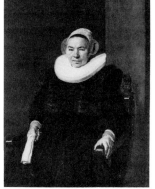

Two outstanding Dutch works in New Haven are Frans Hals' pendant portraits traditionally identified as Heer and Mevrouw Bodolphe *(fig. 234),* both dated 1643. While the names of this seventy-three-year-old gentleman and his wife may be inaccurate (the identification rests upon an old inscription, now lost) their images convey a stern dignity and are justly regarded as among the finest that Hals painted in the 1640s. Like innumerable other pendant portraits of married couples from this period, both sitters hold gloves. Since the feudal times of the Middle Ages, the removal of one's gloves was a token of friendship, humility, and openness. The survival of this tradition is reflected in the fact that virtually no one wears gloves in seventeenth-century Dutch portraiture. For example, in Cornelis Visscher's drawing of a *Portrait of a Young Man* at Yale, the sitter again holds rather than wears his gloves. This carefully worked chalk and pencil drawing is on vellum and, like the artist's other portraits of this kind, doubtless was considered a completed work of art rather than a drawing prep .ratory to a more finished work, such as an engraving or painting in oils.

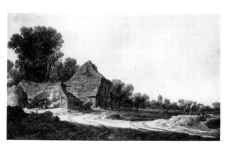
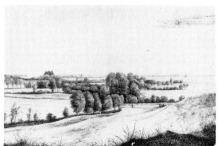

235

236

The two best Dutch landscape paintings in the collection are van Goyen's *Sandy Road (fig. 235)* of 1633, a splendid example of the artist's first mature manner, and Jan Baptist Weenix's lovely *Italian Landscape with Shepherdess*. The paintings are supplemented by several notable landscape drawings, including fine works by Cornelis Hendriksz Vroom *(fig. 236)*, Jan and Esaias van de Velde, van Goyen, and Herman Saftleven. Besides the de Gheyn mentioned above, the drawing collection also includes several interesting genre scenes, notably works by Esaias van de Velde, Jacob Gerritsz Cuyp, Pieter Quast, and Jacob Backer. Karel du Jardin's genre painting of the so-called *Story of the Soldier* stands in the tradition of the Italian street scenes of the "Bamboccianti"; however, in the hands of this later artist the figures have become larger and more monumental. While we can only guess at the content of the story recounted by the young man with a headband in the center, the gesture (roughly translatable in modern slang as "my eye") of the helmeted soldier on the right makes explicit the skepticism read on the faces of the other listeners. Some of the most engaging genre scenes in the collection are the little engraved decorations on the surface of the shell forming the *Nautilus Cup* with silver gilt mount of c. 1660 by Jan Bellekin. Here, in addition to the forms of insects, we encounter the time-honored genre themes of peasants playing cards and undergoing a foot operation, as well as a more risqué view of rustic love-making. An object such as this, combining elegance of form and refined craftsmanship with low-life themes, tells us a good deal about the tastes of the upper middle classes in Holland around the mid-seventeenth-century.

Among the notable nineteenth-century works at Yale are a handsome painting and a drawing of *Honfleur* by Jongkind. Undoubtedly, however, the outstanding Dutch pictures in the collection from this period are the two paintings by van Gogh, an interesting pointillist-styled picture of 1886–87 entitled *Corner of the Park* and the great, haunting *Night Café (fig. 237)* of 1888. Van Gogh wrote of this work, "In my picture of the *Night Café* I have tried to express the idea that the café is a place where one can ruin one's

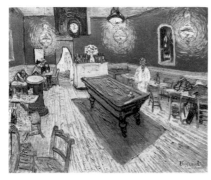

237

self, go mad or commit a crime." Elsewhere he wrote of the work's glaring, strident colors. "I have tried to express the terrible passions of humanity by means of red and green. The room is blood red and dark yellow with a green billiard table in the middle; there are four citron-yellow lamps with a glow of orange and green. Everywhere there is a clash and contrast of the most disparate reds and greens in the figures of little sleeping hooligans, in the empty, dreary room, in violet and blue."

Painted two years before the artist's death, this work presents the painter at the height of his expressionistic powers.

A far cry from van Gogh's emotionally charged paintings are Piet Mondrian's cooly studied experiments in formalism. His mature canvases are divided asymmetrically with straight bands of black running vertically and horizontally and creating rectangular forms which are left a neutral white, painted black or gray, or filled with flat, primary colors. Mondrian only arrived at this severely reductive and highly intellectualized style after many years spent absorbing the ideas of Post-Impressionism, Symbolism, and Cubism. Yale owns three notable examples of his mature work, *Composition* and *Fox Trot B* of 1929 and his diamond-shaped *Fox Trot A* of 1930, which, together with the *Composition Simultanée* (fig. 238) of 1929 by Mondrian's close colleague Theo van Doesburg, are all part of the Societé Anonyme Collection (catalogued 1984). The first American museum of modern art, the Societé Anonyme was founded in 1920 by the writer Katherine Dreier and the painter Marcel Duchamp. Dreier was the first American to visit Mondrian in his studio in Paris and, through her exhibitions and lectures, was instrumental in establishing the artist's reputation in this country. Her donation of the Societé Anonyme Collection to Yale established New Haven as one of the most important centers for the study of early twentieth-century art in America.

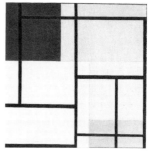

238

NEW ORLEANS MUSEUM OF ART

LeLong Avenue, City Park
New Orleans, Louisiana 70179 *(504) 488-2631*

Opened in 1912, the museum was the gift of Isaac Delgado, a wealthy sugar planter whose name was attached to the institution until 1971. At that time three new wings were added to the original Greek revival building by the Chicago architect Samuel Marx. Though not extensive, the collections are broad ranging both temporally and geographically, including African, Chinese, American Indian, as well as European and American art. Unlike the Italian, the Dutch collections did not have the benefit of the Kress Collection, but they have grown substantially in recent years through gifts, notably that of the late trustee Bert Piso in 1981, and to a lesser extent through astute purchases such as Jan Mytens' *Martini Family* (1979). A new *Handbook of the Collection* was published in 1980.

Although New Orleans has few works by well-known Dutch artists, the collections are sizable. Moreover, the connoisseur's expertise is well tested here. An early work by Abraham Bloemaert, the *Landscape with Tobias and the Angel,* once existed in another version that was cut in half in the eighteenth century; fragments survive in Leningrad and an English private collection. The quality of the Hermitage's painting is superior and suggests that the severed version was the first. However, it is difficult to assess the present work owing to its condition. The *Parable of the Tares and Thistles* by Bloemaert in Baltimore and the Getty's *Expulsion of Hagar* may be compared for compositional similarities, namely the history figures in the foreground and the landscape beyond. Further, Bloemaert's painting in Minneapolis treats the same subject, albeit in a very different design. Far better preserved is Abraham van Cuylenborch's charming *Landscape with Diana and Her Nymphs (fig. 239)* of 1649. The historical theme, the small animated nudes, as well as the motif of the shadowed grotto overhead were favored by the Utrecht painter Cornelis van Poelenburgh, whose art had a strong effect on van Cuylenborch. The influence of the latter's teacher, Carel de Hooch, also

239

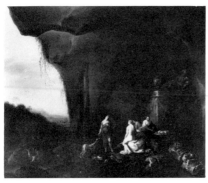

may be felt in the statue of a river god and the classical architectural fragments strewn about. The student/teacher relationship of Dirck Dalens and Moses van Uyttenbroeck is evident in the former's *Landscape with Bacchus and His Followers.* Uyttenbroeck's influence, however, is limited to the tiny figures; the landscape owes more to van Goyen and his circle.

The landscapes proper in the collection include a small and rather abraded *Landscape Near Dordrecht* by Albert Cuyp

and a better preserved and fully signed *Dune Landscape with Gypsies* dated 1650 by the rare artist Jan van Aken. Van Aken, who is better known as a printmaker, here shows himself to be acquainted with the art of both Jacob van Ruisdael and Jan Wijnants; the juxtaposition of the blasted tree in the foreground and road through the dunes to a town silhouetted on the horizon recalls the Currier Gallery's land-scape attributed to Ruisdael. Dirck Stoop's *Rest on the Hunt* is a sunny work in the manner of Wouwerman. The lone Dutch

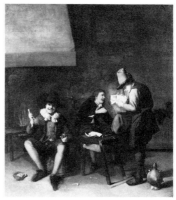

240

cityscape in the collection is Gerrit Berckheyde's *View of the Harbor at Hoorn,* a faithful representation of this port city showing the Hoofdtoren, a familiar landmark, in the center.

Surprisingly numerous are the Dutch genre paintings. In this area the bequest of Mr. Piso, who acquired many of his pictures from the noted Milwaukee collector of Dutch art Alfred Bader, has substantially added to the holdings. One of the earliest is Hendrik Pot's frisky *Bordello Scene* in which a young woman takes payment, a coin, from a procuress. A more demure, early high-life scene is Anthonie Palamedesz's *Musical Company* dated 1637. The entertainments of the lower classes are depicted in the tavern scenes by Cornelis Bega (dated 1663) and the exceedingly rare Andries Andriesz Schaeck (*fig. 240*). Though known only through a half dozen works, the latter was a very able painter. Domestic genre is presented by a mediocre Leiden School *Kitchen Scene* attributed to Pieter van den Bosch, a rather better small painting of an *Old Woman Seated by a Fire* which is probably correctly assigned to Quirin van Brekelenkam, and a handsome scene of a *Milk Vendor in a Courtyard* by Abraham Willaerts. Son and follower of the seascapist Adam Willaerts, Abraham also executed portraits and genre scenes, the latter resembling the style of the Antwerp artist Willem van Herp. The italianate genre tradition is represented by a scene of a *Shepherd Conversing with a Peasant Family* in a southern landscape attributed to Nicolaes Berchem but owing more to the works of Jan Baptist Weenix.

A decorative but oddly memorable picture is the *Fish Still Life on a Beach* signed and dated 1658 by Willem Ormea. Although painters such as van Beyeren, de Putter, and Andriessens painted more compelling fish, the interest of this work is the dramatic contrast of the close view of the catch and the distant view of the sea with fishing vessels. The latter evidently was the work of Adam Willaerts (see his son's painting above), with whom Ormea collaborated on other occasions. The design, juxtaposing the near and far view, is conspicuously archaic at this date, descending from six-teenth-century northern still life. A monumentally scaled *Banquet Piece with Dead Game* signed by Michiel Simons is, for all its labored opulence, an

241

uninspired work, and the *Poultry Yard* by the Hondecoeter follower Cornelia de Rijck is of little interest beyond the fact that the artist was a woman. By contrast, the *Serpents and Insects* (*fig. 241*) by the remarkable painter Otto Marseus van Schrieck is a masterpiece. Little is known of Marseus van Schrieck; however, he traveled with Matthias Withoos (see the latter's painting in Indianapolis) to Rome in 1652 where he joined the *schildersbent* and took the nickname "Snuffelaer." Returning to Amsterdam by 1664, he kept a private vivarium from which he made studies of snakes and other creatures. These were incorporated freely into his paintings, hence we often encounter repeated motifs; for example the two battling snakes reappear in a painting in the Louvre and one in Braunschweig which also includes the toad devouring a moth. The contrasts of the brightly colored motifs against a darkened background, with the predators stalking and killing their prey, gives this artist's work an element of suspense and drama, one might even say a frisson, unusual to still life of the period.

The portraits include Simon Pietersz Verelst's workaday *Portrait of a Woman* and a half-length *Head of an Old Man* dated 1640 by Jan Lievens. By this date Lievens' work had lost some of its earlier power and concentration and began to acquire a sort of outsized flabbiness typical of lesser Rembrandt followers, such as Salomon Koninck. The outstanding portrait in the collection is Mytens' *Group Portrait of the Family of Jacques Martini* (*fig. 242*), commissioner general of armament for the Dutch Republic, dated 1647. This is a superb example of the aristocratic style of portraiture favored by circles at court and high governmental officials in The Hague. The convention of placing sitters in an outdoor, parklike setting is probably imported from the southern Netherlands, where it had been favored by van Dyck and his circle, notably Gonzales Coques. Martini is shown seated with his second wife and surrounded by the children of his first marriage. In the sky at the

242

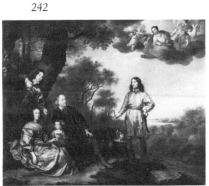

upper right we encounter a curious conceit common to other Dutch portraits of the period; Martini's first wife, Philipate van Sypesteyn, who had died two years before, floats overhead among clouds and putti. Martini gravely turns his glance aloft to the memory of his first wife. His son Ambrosius at the left leans down to offer grapes to the new Mrs. Martini, who also holds a bunch offered her by the young daughter, Magdalena. The grapes

are a symbol of chaste love in marriage, a fitting emblem for this eminently respectable and superbly painted family portrait.

The remaining Dutch collections include a typical two-colored chalk drawing of a so-called *Meat Vendor (fig. 243)* by Toorenvliet, a group of prints (Hendrik Goltzius, Jan Saenredam, Cornelis van Haarlem, Bol, Ruisdael, Cornelis Dusart, Jakob Houbraken, and C. Ploos van Amstel), several eighteenth- and nineteenth-century miniatures in the Latter-Schlesinger Collection of Miniatures, and glassware from the Melvin P. Billup Collection, notably a Newcastle wine glass of c. 1750 with a coat of arms of the House of Orange engraved and stippled in Holland. In the eighteenth century the Dutch imported large quantities of glass from Newcastle, which were then decorated for the home market. The outstanding modern Dutch painting in New Orleans is Kees van Dongen's *Woman in a Green Hat (fig. 244)* of 1905, a good example of his personal interpretation of the raw Fauvist style.

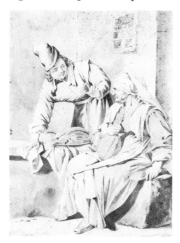
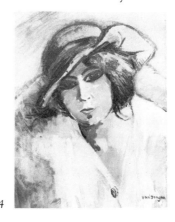

243 244

FRICK COLLECTION

1 East 70th Street
New York, New York 10021 *(212) 288-0700*

Painting for painting, the Frick Collection is quite simply the greatest in the world. Hardly a single work in this dazzling array of Old Master paintings can be considered less than a masterpiece. Indeed, the standards of quality are so consistently high that with a total of scarcely twenty-five Dutch pictures, the collection is an essential stop for anyone with a sincere interest in the art of the Netherlands. The collection and its building on Seventieth and Fifth Avenue were the creations of Henry Clay Frick, a fabulously successful pioneer in the coke and steel industries in Pennsylvania. A precocious entrepreneur, Frick also showed an early love of the visual arts. When, as a young man in his twenties, he applied for a loan, the credit investigator noted prophetically, if blandly, "on job all day, keeps books evenings, may be little too enthusiastic about pictures but not enough to hurt; . . . advise making the loan." Frick the industrialist and financier was a millionaire by age thirty. While he could be fiercely brutal with labor, he will chiefly be remembered for the magnificent art collection he bequeathed to the public in 1919 and which was opened in 1935. An excellent catalogue of *Paintings in the Frick Collection* (2 vols., 1968) by Bernice Davidson is available.

Frick's tastes as a collector were refined gradually. His early acquisitions, most of which were later weeded out, showed an attraction to French academic art, Barbizon School landscapes and the occasional work by a Hague School painter, such as Anton Mauve. Around the turn of the century, his interests turned increasingly to Dutch seventeenth-century art. While a *Portrait of a Young Artist* acquired as a Rembrandt in 1899 is probably the work of a pupil (Barent Fabritius?), notable works by Vermeer, Cuyp, Hobbema, Terborch, and Wouwerman all entered the collection in the next five years. In 1906 he acquired Rembrandt's majestic *Self-Portrait (fig. 246)* and four years later added the master's incomparable *Polish Rider (fig. 247)*, a purchase negotiated by a trusted advisor, Roger Fry. Initially housed in the former Vanderbilt Mansion on Fifth Avenue, the burgeoning collection was moved in 1914 to the new building designed by Thomas Hastings, one of the architects of the New York Public Library. With its spacious rooms, the residence was planned as a setting for Frick's paintings. Frick continued to acquire works in his later years, making a final purchase in 1919 (the year of his death) of Vermeer's *Mistress and Maid,* the third work by this exceptionally rare artist in the collection. It has been rightly observed that the idea to form a collection and bequeath it to the American people was probably inspired in part by the example of the famous Wallace Collection in London, which was left to the British nation in 1894. The two collections have much in common. Yet while Frick had this model of a truly superb

private collection, his achievement also depended on the cultivation of an extraordinary eye. His paintings were not only beautiful but remarkably well preserved. Clearly Mr. Frick cared about condition as well as quality. When on rare occasions later directors of the collection have added to its holdings, they have maintained these high standards; witnesses Rembrandt's *Nicolaes Ruts (fig. 245)* added in 1943, the superb Ruisdael acquired in 1949, or the van Eyck purchased in 1954.

Four excellent but unidentified portraits by Frans Hals are owned by the Frick, offering a review of more than three decades of his art from the late 1620s to the 1660s. The execution of the *Portrait of an Elderly Man* most resembles the officers' banquet portraits of the late 1620s, while the *Portrait of a Man* (erroneously identified in the past as Admiral de Ruyter) points toward the very late style of the group portraits of the Regents of the Old Men's Alms House. The bravura brushwork in the sitter's large double cuffs and slashed sleeves is stunning. The two other Hals have both been linked uncertainly with pendants. The *Portrait of a Seated Woman* dated 1635 was married by one writer to a three-quarter-length figure of a man in the Boymans Museum in Rotterdam, but the match has not taken; despite formal resemblances, the two works cannot, as was claimed, be linked through nineteenth-century sales. The difficulty of identifying pendants, which often have been separated for centuries, is well illustrated by the case of the *Portrait of a Man Holding a Brush* and its putative mate, the *Portrait of a Seated Woman Holding a Fan*, which hangs just up the street in the Metropolitan Museum. While the two paintings are comparable in size, date, and an engaging informality of pose, the similarity of their background is deceptive. In both, the large columns behind the sitters are the work of later restorers. Moreover, these additions appear to be by two different hands. By all accounts, the similarities between the two works, so evident in photographs, were less compelling when the two pictures were brought side by side in 1966. Yet while the old theory identifying the sitters as Hals and his wife, Lysbeth Reyniers, is readily dismissed, specialists hesitate to categorically reject the two paintings' imperfect companionship. Thus an ungratifying uncertainty surrounds the pair.

Little uncertainty, by contrast, attends Rembrandt's splendid *Portrait of Nicolaes Ruts* (1573–1638) *(fig. 245)* dated 1631. This portrait must have been among the first commissions Rembrandt received upon arriving in Amsterdam. The sitter was an Amsterdam merchant who traded with Russia, doubtless the reason for his fur-lined cap and gown. His identity is not only supported by an eighteenth-century copy inscribed with his name but also by a document of 1636 mentioning "a portrait of Nicolaes Ruts by Rembrandt" owned by Ruts' daughter. The fine execution of detail and texture in this excellent, immaculately preserved early panel contrasts markedly with the broad touch of Rembrandt's *Self-Portrait (fig. 246)* of 1658. Arrayed in a magnificent costume similar to those of "Oriental" potentates in his history paintings, Rembrandt poses frontally, seated in a chair and holding a

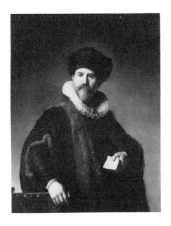
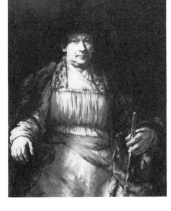

245 246

gleaming staff. Despite the personal bankruptcy that he was forced to declare only two years earlier, he pictures himself as grand and regal. Not only the pose but the painterly execution and rich colors recall Venetian portraiture. Of his approximately sixty painted self-portraits, this work clearly is one of the most powerful.

Rembrandt's third painting in the Frick probably dates from about the same period or several years earlier. The painting known as *The Polish Rider* (*fig. 247*) entered the collection of King Stanislaus II Augustus of Poland in the late eighteenth century, but its earlier history is unknown. This enigmatic painting has been interpreted in numerous ways. One theory holds that it is not an actual portrait but an image of the *Miles Christianus* (Christian Soldier), who had counterparts in the seventeenth century in those mounted soldiers who still defended Eastern Europe against the Turks. To another writer it is historical portrait of Gijsbrecht van Amstel, the mythical founder of Amsterdam. Still another theory suggests that the work is a "spiritual portrait" of the Polish Socinian Jonasz Szlichtyng, who used the pseudonym "Equis Polonus." An anti-trinitarian sect with strong views on the liberty of conscience and tolerance, the Polish Socinians had many sympathizers among religious dissidents in Holland. Rembrandt, it is theorized, had contacts with the Socinians through his relationships with the Mennonites. One new interpretation holds that the painting represents the Prodigal Son riding out after receiving his inheritance and before squandering it in riotous

247

living. Rembrandt showed a particular interest in the story of the Prodigal Son, addressing it on several occasions in his career. Finally, the most recent theory identifies the rider as Tamerlane pursuing Bayazet outside Constantinople, a subject presumably based on a scene from a play by Joannes Serwouter, first performed in Amsterdam in 1657. Whatever the rider's identity, he can be related to a long tradition, particularly in prints, of depicting ex-

otic foreign soldiers on horseback. Moreover, a Polish historian has shown that the rider's dress and military equipment are Polish. Clearly the many and continuing efforts to explain the painting testify to its fascination.

After Hals and Rembrandt, the Dutch artists represented by more works than any others at the Frick are Albert Cuyp and Johannes Vermeer (three paintings each), suggesting a taste for a luminous and elegant style of painting. No murky van Goyens or rude Brouwers here. *Cows and Herdsmen by a River* is an exceptionally beautiful and well preserved example of Cuyp's art which came from the famous Hope Collection, much of which is now in the National Gallery in London. Cuyp's *Sunrise* (fig. 248) depicts traffic and a duck hunt on the river Merwede with a view of Dordrecht in the distance. The third work in the collection, also a river scene, includes a large vessel, apparently a "smalschip," of the type that transported passengers on the Dutch inland waterways. We recall that, prior to and well into the eighteenth century, rivers and canals provided the principal transportation and communication routes in Holland. Although in works of this sort from mid-century he employed a lighter and sunnier tonality, Cuyp was indebted to van Goyen and Salomon van Ruysdael for his interest in river scenes. Van Ruysdael started painting rivers in the 1630s and continued to do so throughout his career. His *Men Dragging a Fishing Net* is a handsome late work with a view of Weesp, a village on the Vecht River southeast of Amsterdam. Yet it is the work of Salomon's gifted nephew, Jacob van Ruisdael, which again takes the palm. Jacob's *Landscape with a Footbridge* (fig. 249) dated 1652 is a truly great and powerfully composed work, the finest Dutch landscape in the collection. Unlike the master's late and far less inspired *View of the Quay in Amsterdam,* the locality cannot be pinpointed, but the work probably was inspired by the scenery around the Dutch-German border in the province of Overijssel which Ruisdael had seen by 1650 when he sketched Schloss Bentheim. Ruisdael's pupil Hobbema has two good works here testifying to his teacher's influence. Two other note-worthy Dutch pictures devoted to landscape in the collection are Isack van Ostade's *Travelers Halting at an Inn* and Wouwerman's *Cavalry Camp,* representative examples of the two artist's work that successfully animate native Dutch scenery with human figures.

Owning three Vermeers, the Frick possesses nearly one tenth of the master's known production. Although some of his works doubtless are lost,

248

249

Vermeer obviously worked very carefully and slowly. Two of Frick's genre scenes depict an interchange between a man and a woman at a table, and the third shows a serving woman delivering a letter. With only two dated works, the chronology of Vermeer's oeuvre must of necessity remain speculative. Nonetheless, the *Officer and Laughing Girl* (*color plate 12*) is probably a relatively early work, dating from the late 1650s. The soldier and girl sit by an open window in the corner of a room with a map on the far wall. Cool daylight streams into the room silhouetting the officer and throwing the scene in relief. The air is clear and the colors bright and saturated. Despite its compelling naturalism, Vermeer's art is highly composed. Reviewing his other paintings we not only discover the same elements (the corner of the room, the window, chair, and even the woman's dress and the map recur) but similar compositions. The orderly design of this early work may owe something to Vermeer's gifted Delft colleague Pieter de Hooch, who painted domestic spaces, both indoors and out, more naturalistically than any other artist had before. Yet the monumental stillness that Vermeer achieved surpassed anything de Hooch ever attained. Indeed, the *Officer and Laughing Girl* appears almost photographic in its truth to life.

This quality was noticed early and fed the supposition that Vermeer used visual aids, such as mirrors, lenses, or the camera obscura. These devices not only assist an artist in composition by framing scenes and clarifying spatial relations, they help define tonal range and enrich colors. Seventeenth-century art theorists recommended their use. Moreover, Vermeer probably was acquainted with such devices; the executor of his estate was Anthony van Leeuwenhoeck, the famous biologist and microscopist. Despite detailed scrutiny of this painting and others, no certain criteria (e.g., scalar discrepancies, principal planes of focus, highlight halation) exist for identifying a painting executed with the aid of such devices. Nonetheless, one can well imagine that an artist with Vermeer's deep commitment to a naturalistic record of the world would have consulted sources that enhanced his understanding of visual experience.

Vermeer's authorship of the painting entitled *Girl Interrupted at Her Music* has recently been doubted, but the picture seems entirely autograph. While it is uncertain whether the girl is actually being disturbed or merely sharing her sheet music with her companion, the couple clearly are absorbed in the subject, if not in the act of making music. The concord and harmony implicit in music often was a prelude to love in Dutch genre, as stated in the motto on a seventeenth-century emblem, "Amor docet Musicam." The painting faintly visible in the background of this picture shows a cupid with its arm raised in the air. The same painting appears in two other paintings by Vermeer. In a painting in the National Gallery in London the white object in cupid's hand has been perceived as a playing card, with the result that the gesture has been interpreted as emblematic: a call for fidelity to one love. Presumably the admonition is directed at the couple in the foreground and, by way of the woman's pointed gaze, at us.

Whether an amorous meaning was intended in Frick's third and latest Vermeer (*fig. 250*) is still more uncertain. Wearing an elegant ermine-lined jacket, the woman seems surprised to receive the letter brought to her by her maid servant. While one can only speculate as to its contents, we note that publishers did a brisk business in those years in manuals on epistolary decorum and style. The writing of love letters—much of it inspired by the French—was the height of fashion. Letter themes, their writing,

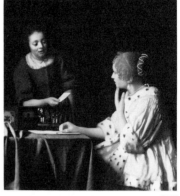

250

delivery, and reading had been popularized by Terborch. By the mid to late 1660s when this work was created, they were some of the most popular "high genre" themes. A woman wearing the same jacket and seated before the same silver inkstand is depicted writing a letter in Vermeer's painting in the National Gallery in Washington. The Washington painting is considerably smaller than the Frick's. The three-quarter life-size scale of the latter is unusually large in Vermeer's oeuvre. Perhaps he found it unsuited to his intimate painting style because he left the background unfinished.

The only later Dutch painting in the collection is a major and appropriately masterful painting by Jacob Hendrick Maris, *The Bridge* (*fig. 251*) of 1885. It depicts a simple, whitewashed footbridge under a leaden sky with two heavily burdened milkmaids on the left bank. The site is believed to be *251*

near Rijswijk, on the outskirts of The Hague; however, like many of his other works, it probably incorporates elements of architectural fantasy. The wonderfully broad and rich execution testifies to the survival of Rembrandt's great tradition of painterly painting. Like the related work in the Johnson Collection in Philadelphia, it is one of the finest works by Maris, indeed by the entire Hague School, in America.

NEW YORK HISTORICAL SOCIETY

170 Central Park West
New York, NY 10023 *(212) 873-3400*

Founded in 1804, the New York Historical Society was conceived to gather and house "material pertaining to the history of the United States, and of New York State in particular." After several early moves, the society acquired its own building on Second Avenue and Eleventh Street. In 1857 it again was relocated to its present site at Seventy-sixth Street overlooking Central Park. As its charter specified, the collections are primarily made up of American and New York State art, with special strengths in the decorative arts and the water colors of John James Audubon. However, for the purposes of this guide and the history of the art collecting in America (see Introduction), the society's long custodianship of the collection of Thomas Jefferson Bryan is of singular interest.

Born and raised in Philadelphia, Bryan was a Harvard graduate who took a degree in law before embarking on a twenty-year sojourn in Paris. Returning to New York in the early 1850s, he brought with him an extensive collection of European paintings, which he installed in his own home as The Bryan Gallery of Christian Art. A handbook of the collection by Richard Grant White was published in 1853. It specified that Bryan's aim had been to offer a chronological survey of the important schools of art. According to Henry Tuckerman, writing in his *Book of the Artists* (1867), the collector took an active part in running the gallery. "A call upon [Mr. Bryan] was like visiting a venerable burgomaster of Holland, or a merchant prince of Florence in her palmy days. He had collected his treasures in the second story of a private building on Broadway, and seated there, a vigilant and enamored *custode*, in an old arm chair, with his snow white hair, gazing round the walls covered with mellow tints, delicious figures, vivid or picturesque landscapes—*chefs d'oeuvre* of pictorial art, hallowed and endeared by memorable names—he seemed to belong to another sphere, and we have wandered from Babel to Elysium in thus entering his gallery from bustling and garish Broadway." After first depositing his collection at the Cooper Union, Bryan deeded it to the Historical Society in 1867. Nearly half of Bryan's original 233 paintings were Netherlandish. While in recent years the Historical Society has sadly been forced by financial pressures to sell many of these works at auction (see especially, sale, Sotheby Parke Bernet, New York, October 9, 1980), a selection from the original bequest is on view in a corridor on the building's top floor and some of the best works (e.g., the Terborch) are on loan to the Metropolitan Museum of Art. Moreover, some of the more important Dutch paintings that were sold, such as van den Eeckhout's *Scipio* (sale, Parke Bernet, New York, May 20, 1971) which now resides in the Philadelphia Museum, have found homes in other American public collections.

Despite his superior connoisseurship, many of Bryan's attributions have unsurprisingly proven wrong. His Rembrandt has long been rejected, but other misattributed works, such as the little *Frozen Canal* wrongly assigned to Hendrik Avercamp, have yet to be reassigned. Two other lovely winter scenes in the collection are correctly assigned to Philips Wouwerman and Jan Beerstraten. The finest Netherlandish landscapes in the collection, however, are by the Flemish sixteenth-century artist Lucas van Valckenborch. The genre scenes include a good quality if somewhat

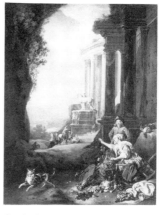

252

thin painting by Dirck Hals of a gentleman and a lady just setting out for a promenade in a garden. The *Artist's Studio* is by a painter only from Dou's circle, but the so-called *"Thieving Cat" (fig. 252)*—a scene of market figures amidst classical ruins—is an excellent example of Jan Baptist Weenix's earliest manner. Ochtervelt's *Lady with Servant and a Dog* is a dark and somewhat labored work by the master, probably from the early 1670s. The map of the Seventeen Provinces on the back wall has been identified as C. J. Visscher's "Germanica Inferior," which also appears in Chicago's *Music Lesson* and other genre scenes by Vermeer and Nicolaes Maes. The motif of tweeking the dog's ear probably descends from van Mieris. Perhaps the finest Dutch painting in the collection is the *Portrait of Moses Terborch (fig. 253)*, now on loan to the Metropolitan Museum of Art, by Gerard and his sister, Gesina Terborch; the former painted the head, hands, and feet, while, as was often Terborch's custom, the latter executed the landscape setting, costume, still life, and assembled creatures. Gesina's style here recalls that of Otto Marseus van Schrieck. The painting probably was a posthumous image of Moses, who died in 1667, its various still-life elements (the skull, the

timepiece, the butterfly symbolic of the human soul, etc.) alluding to the transcience of life. Also found here is a *Portrait of a Young Man* uncertainly assigned to Karel Dujardin. Gerbrandt van den Eeckhout's *Abraham and Melchisidek* of 1670 curiously is signed not only by the artist but inscribed as invented by Isaac Isaacsz; in fact the composition is based on P. Witdoeck's print after P. P. Rubens' painting in Caen. A very fine, later history painting is the *Aeneas and His Son Ascanius Visiting Dido*, uncertainly assigned to Constantijn Netscher.

253

METROPOLITAN MUSEUM OF ART

5th Avenue at 82nd Street
New York, NY 10028 *(212) 535-7710*

The largest and richest museum in the United States, the Metropolitan Museum of Art began in 1870 with fewer than two hundred paintings. Before moving to Central Park in 1880, it was housed in the Allen Dodworth Dancing Academy on Fifth Avenue and later the Douglas Mansion on Fourteenth Street. The original building designed by Calvert Vaux has been enveloped by numerous architectural additions and accretions in as many styles but still serves as the Medieval Hall, its west wall handsomely incorporated into the design of the court of the Lehman Pavilion. The neoclassical Great Hall designed by Richard Morris Hunt was opened in 1902; additions to the Fifth Avenue facade were designed by McKim, Mead and White. A master plan drawn up by Kevin Roche and John Dinkeloo and begun in 1969 has greatly expanded gallery space, adding in scarcely a decade: the Robert Lehman Pavilion, the hall housing the Temple of Dendur (a gift from the Egyptian government), the Andre Meyer Galleries of nine-teenth-century art, the extensive American Wing with three-story atrium, and the galleries devoted to the Rockefeller Collection of Primitive Art. At the same time, many collections have been reinstalled, including Egyptian art, European paintings, and most recently Near Eastern art, while special exhibitions, ranging from discreet little shows of drawings, prints, and photography to that new social phenomenon, the "blockbuster," change constantly. There is hardly a major aspect of the history of art that is slighted in this great treasury; be it Egyptian, Greek, Roman, Chinese, Islamic, Indian, African, Oceanic, Pre-Columbian, European, American, or contemporary art, one may find it here in quantity. The three million objects in the collections are divided among nineteen curatorial departments. At the Metropolitan one may study the Calyx krater by Euphronius, Assyrian reliefs, or Limoges enamels, Islamic art surpassing in quality that of any other institution outside Istanbul, great Renaissance bronzes and jewelry, sculpture from the New Hebrides, spiffy new period rooms in the American wing, elegant costumes and textiles, four thousand musical instruments, Medieval ivories at the Cloisters (in northern Manhattan but administrated by the museum), or simply content oneself with one of the greatest Old Master and Impressionist painting collections in the world.

The Dutch collections include no less than twenty-three Rembrandts, ten Frans Hals, eight de Hoochs, seven Terborchs and, perhaps most remarkable of all, five Vermeers. Important early benefactors of these abun-dant Dutch painting collections include, in roughly chronological order, Henry G. Marquand (1889), George A. Hearn, Benjamin Altman (whose collection donated in 1913 still hangs as a unit), Collis and Archer Hunting-ton, J. Pierpont Morgan, William K. Vanderbilt, and Mrs. H. O. Havemeyer.

The gifts of the Michael Friedsam Collection in 1931 and the Jules Bache Collection in 1949 also added important Dutch works. In recent years the most important single collection of Old Master paintings to come to the Metropolitan was that of Robert Lehman, which included major paintings by Rembrandt and de Hooch as well as important Dutch drawings. The Lehman Collection is administrated separately and hangs in its own spaces, which, somewhat foolishly, are installed to resemble the late Mr. Lehman's apartments. The collection's curator, George Szabo, was the author of the 1975 handbook. The Jack and Belle Linsky Collection acquired and catalogued in 1984 and the recent de Végvàr gift also include important Dutch paintings. Current benefactors are Mr. and Mrs. Charles Wrightsman, who presented the museum with Vermeer's *Portrait of a Young Woman* in 1979 and are the lenders of, among other major works, the Sweerts that is presently on view. Not all of the Metropolitan's paintings, however, are gifts; the trustees' willingness to pursue Dutch masterpieces at the top of the market was amply demonstrated in 1961 when they purchased Rembrandt's *Aristotle Contemplating the Bust of Homer*, then the most expensive picture ever sold. Recently they also purchased a Philips Koninck panorama and a Frans Post landscape. The *Summary Catalogue* (3 vol., 1980) of all European paintings by artists born in or before 1865 was compiled by Katharine Baetjer. A scholarly catalogue of the Dutch paintings, comparable to that of the Flemish (2 vols., 1984), is forthcoming. The Dutch paintings in the Lehman Collection are being catalogued by Egbert Haverkamp Begemann.

Among the outstanding early Netherlandish paintings in the collection are several fifteenth- and sixteenth-century Dutch panels. These include works by the Haarlem School Master of the Brunswick Diptych, the Leiden Mannerist Cornelis Engebrechtsz, and a *Lamentation* by the singularly expressive Master of the Virgin among Virgins. Here too are found the pendant portraits of the *Count and Countess of Egmond* by the Master of Alkmaar and Maerten van Heemskerck's portrait of his father, *Jacob Willemsz van Veen*, dated 1532. Large-scale northern Mannerist history painting of the mid-sixteenth century is represented by Jan Sanders van Hemessen's athletic *Calling of Saint Matthew*, while David Vinckboons sequesters his religious subject, two of Christ's miracles, in a *Wooded Landscape*.

The finest late Mannerist painting by a Dutchman in the collection is Abraham Bloemaert's *Moses Striking the Rock (fig. 254)* of 1596. As in van Hemessen's earlier work, the figures writhe in contorted postures, but now their balletic movements are more exaggerated, the palette unnaturally acrid, the light a chilly incandescence. The artifice of the central woman's pose matches that of the elaborately wrought vessel she holds gracefully aloft on her

254

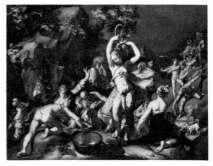

255

shoulder. The subject may be compared with Wttewael's equally mannered treatment of the theme in Washington and Steen's more straightforward account in Philadelphia. The early seventeenth-century history paintings include Jacob Pynas's *Paul and Barnabas at Lystra*, a Pre-Rembrandtist work based on a lost composition by Pieter Lastman. The two apostles standing on the steps at the right express their dismay at being mistaken for gods by the people of Lystra. A relatively recent acquistion is Bartholomeus Breenbergh's late *Sacrifice of Manoah*, dated 1646, which in typical fashion depicts the biblical subject in the Italian campagna. The angel that appears to Manoah and his barren wife announces the birth of their son, Samson, who will deliver Israel from the Philistines. Another especially attractive, small-scale history painting is Leonard Bramer's *Judgment of Solomon*. An underestimated but highly original artist, Bramer achieves extraordinary dramatic effects with a rapid, tenebrous technique; compare Philadelphia's *Presentation in the Temple* by the artist.

One of the most monumental and powerful Dutch paintings in the collection is Hendrik Terbrugghen's *Crucifixion, with the Virgin and Saint John* (fig. 255), monogrammed and dated 162[?]. With the figures placed in a single plane and silhouetted against a starry sky (no Victorian embellishments, the stars are original), this remarkably hieratic image has been likened to earlier German sculpture and the tortured paintings of Grünewald. In truth, the wracked and twisted body of Christ, the shrill juxtaposition of reds and greens in John's robe, and the agonized emotions of the whole are more typical of Gothic than baroque religious painting. It is a testament to Terbrugghen's extraordinary artistic independence that he was capable of adopting elements of an archaizing style to meet special expressive goals. Another fascinating large painting that adopts the clear light and ample forms favored by the Utrecht Caravaggisti is Paulus Bor's so-called *Enchant-*

256

ress. Striking an oddly disaffected expression, the figure sits head in hand before a statue and smoldering altar. The woman is sometimes identified as Circe, but she and her putative pendant, another female mythological figure (Rijksmuseum, Amsterdam), have yet to be satisfactorily explained. Presently on loan to the museum is a half-length painting of the *Clothing of the Naked* by Michael Sweerts, from a series of the Seven Acts of Mercy, which well illustrates the artist's private and poetical interpretation of Italian sources.

The sources for Johannes Vermeer's *Alle-*

gory of Faith (fig. 256), one of only two allegories in the Delft painter's tiny oeuvre, are also in part Italian, though in this case literary rather than pictorial. The female figure who personifies Faith in this work follows the description in Cesare Ripa's *Iconologia* (first Dutch edition, 1644), which describes her attributes as including a blue gown, chalice, book, globe, apple, and a cornerstone (betokening Christ) that crushes a serpent. The mirrored ball that hangs from the ceiling has also been linked to an emblem of 1636 embodying related ideas; it likens the expanse of the world reflected in these small objects to the capacity of the human mind which, though limited, is able to contain the vastness of belief in God. Vermeer's exacting technique in this relatively late work enables us to identify the painting of a Crucifixion on the back wall as a work by Jacob Jordaens and even to identify the specific edition (1618) of the globe published by the Hondius family of cartographers. The motif of the tapestry hanging at the left of the painting was a common feature of Vermeer's compositions; it appears, for example, in Vermeer's other allegory, the *Art of Painting* in Vienna. Some have theorized that the appearance of tapestries and curtains in the left foreground of Vermeer's works is related to the artist's possible use of the *camera obscura*; the hanging presumably would have reduced glare on the lens. A simpler explanation, however, is that the tapestry functions as a traditional *repoussoir*, enhancing the illusion of space so loved by Delft painters.

The largest single group of Dutch history paintings at the Metropolitan are by Rembrandt and his School. An important early work, *The Rape of Europa* of 1632, is on loan to the museum. The master's two small, multi-figured compositions are from his middle and later career, the *Bathsheba* of 1643 (compare the Louvre's later masterpiece on this theme) and the *Christ and the Woman of Samaria* of 1655; however, the life-sized *Bellona* of 1633 was painted in the period of his first arrival in Amsterdam. The name of the Roman goddess of war is inscribed on her shield, but the shield with gorgon's head, the helmet, and the breast plate are the attributes of Athena Promachos. Evidently the two goddesses were linked at this time. The model for Belona is probably Saskia, to whom Rembrandt was betrothed in the year of the work's execution. While it may appear inauspicious to portray one's future wife in so bellicose a role (no doubt the goddess's martial virtues outweighed her destructive associations), Rembrandt's later portrayal of his common-law wife, Hendrickje, as *Flora (fig. 257),* seems more fortuitous. The figure's pose and flowing blouse are probably inspired by Titian's *Flora,* which actually passed through Amsterdam at this time. Yet while the great Venetian emphasized the goddess's amorous identity, Rembrandt stressed her other role as *primavera* or spring. Her leafy bonnet and the flower

257

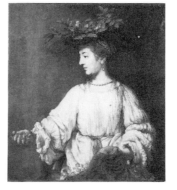

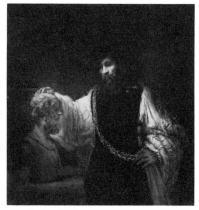

petals she distributes from her dress certify her representation of the most beguiling of the seasons. Like the *Belona*, Rembrandt's so-called *Noble Slav* of 1632 is a relatively early work which shows the young artist's taste for dramatic designs and meticulous technique. It is unlikely to be a commissioned portrait; instead, as in his other early history paintings, it uses the trappings of the Oriental costume to evoke the exotic world of the past. Perhaps the subject will eventually be identified with a specific historical potentate or biblical character.

258 Imaginary dress is again the case in Rembrandt's famous *Aristotle Contemplating the Bust of Homer* of 1653 (fig. 258). The ancient philosopher, Aristotle, is not depicted in historically accurate costume but a fanciful variant of late Medieval attire, with great billowing sleeves and broad-brimmed hat. In conjunction with the sculpture and books, the costume suggests a courtly scholar. Proof of Rembrandt's far-flung renown is the fact that Count Antonio Ruffo of Messina commissioned the work, which was sent to Sicily in 1654. Ruffo specified only that the work depict a "philosopher, half figure"; thus the subject was of Rembrandt's own choosing. The nobleman later asked the Italian painters Guercino and Mattia Preti to execute companion pieces; but in the end these orders too fell to Rembrandt, who sent an "Alexander" in 1661 (probably the painting in the Gulbenkian Foundation, Lisbon) and a "Homer" in 1662 (Mauritshuis, The Hague). Aristotle was Alexander the Great's teacher. Placing one hand on the poet's image while fingering his courtier's chain (note its small medallion portrait of Alexander), Aristotle seems to ponder the competing demands of the contemplative and the active life, the conflict of spiritual and worldly values. Few paintings have ever achieved such a compelling portrait of deep thought.

 Late Rembrandt's increasing internalization of emotion and monumental spiritualism is well illustrated in the *Christ with Pilgrim's Staff* of 1661. The

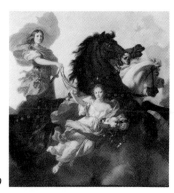

painting is related to a series of half-length images of apostles and evangelists, examples of which are encountered in many American museums, which Rembrandt executed around the beginning of the last decade of his activity. The warm brown tonality and daring brushwork (in addition to the painterly passages, note the highlights scratched into the wet paint) are characteristic of late Rembrandt. This dark manner, however, ran counter to the popular new developments

259 in Dutch history painting epitomized by

Gerard de Lairesse's *Apollo and Aurora (fig. 259)*, dated only a decade after Rembrandt's *Christ*. The rise of this bright and colorful form of classicism signaled a concerted return by Dutch history painters to more international art currents following decades of independence. Many of Rembrandt's later pupils, for example, became converts to this style. Ironically, Rembrandt had no qualms about portraying his colleague and successor; his *Portrait of Gerard Lairesse* of 1665, depicting the painter and renowned critic clad in black and holding a manuscript, hangs in the Lehman Collection galleries. At the time that this portrait was painted, however, Lairesse was still painting in Rembrandt's manner.

Although many of his pupils later rejected Rembrandt's style as old fashioned, the Metropolitan's selection of Rembrandt School history paintings mostly adhere to the master's approach. Gerbrandt van den Eeckhout's *Isaac Blessing Jacob* of 1642, one of the artist's earliest dated works, not only adopts Rembrandt's style of a year or two earlier but also specifically recalls his treatment of the subject in painting and drawing. As the elderly Rebecca watches, Jacob impersonates his older brother Esau to receive Isaac's blessing. Like his father before him, van den Eeckhout made designs for precious metalware; the silver ewer on the table at the right is a piece dated 1614 by Adam van Vianen of Utrecht. Paintings by both Barent Fabritius and Nicolaes Maes in the collection depict Hagar and Ishmael, a subject whose remarkable popularity, especially among Rembrandt pupils, may, as we have suggested elsewhere, indicate that it was a studio assignment. Maes' lovely *Dismissal of Hagar* of 1653 is his earliest dated painting, executed before he turned to domestic genre scenes, of which New York also has good examples. An unidentified adherent to Rembrandt's later manner painted the large and brooding *Pilate Washing His Hands*, sometimes wrongly assigned to Aert de Gelder.

The largest group of Dutch paintings owned by the Metropolitan are portraits. These range from the faithful if somewhat workaday likenesses of the well-to-do painted by Michael Jansz van Mierevelt, Jan Antonisz van Ravesteyn, and later society portraitists, such as Cornelis Jonson van Ceulen the Younger, Adriaen Hanneman, Bartholomeus van der Helst, Nicolaes Maes, Caspar Netscher, and Johannes de Baen, to truly inspired portraits by Hals and Rembrandt. With the conspicuous omission of corporate and civil group portraiture (i.e., a militia company or guild portrait), the Metropolitan can also claim representation of a wide spectrum of the typology of Dutch portraiture. Just as the sitters include a variety of middle- and upper-class individuals, including noblemen, two burgomasters, a historian, a poet, an artist, a brewer, several merchants, and an ebony worker, the portrait types are equally varied in form and type. For example, there are several kinds of pendant and companion portraits. These include Mierevelt's conventional bust-length portraits of 1639/40 identified by their traditional coats of arms as Jacob van Dalen and his wife Margaretha van Clootwijk, Frans Hals' portraits of 1626 with illusionistic oval frames of the Haarlem poet Petrus

260

Scriverius (1575/76–1660) and his wife, Anna van der Aar, Rembrandt's three-quarter length, life-size pendants of 1632 of unknown sitters (possibly members of the van Beresteyn family), and Terborch's full-length miniaturist images of the burgomaster Jan van Duren and his wife, Margaretha van Haexbergen. Here too are double portraits by Dirck van Santvoort and Carel de Moor. Terborch's *Portrait of the van Moerkerken Family,* newly acquired with the Linsky Collection, is again identified by the traditional family crest. It employs the charming conceit of having the mother look at the father's pocket watch, not as a *vanitas* admonition, but possibly as an allusion to the time when the young firstborn son, who is seated between the couple, will become the head of the family. There are also children's portraits (Paulus Moreelse, Ferdinand Bol, Albert Cuyp, and Caspar Netscher), miniature portraits (wrongly attributed to Frans van Mieris and Gabriel Metsu), portraits situated out of doors (Isaac Luttichuys and Pieter Cornelisz van Slingeland) and equestrian portraits (Thomas de Keyser and Albert Cuyp). Cuyp's *Starting for the Hunt* (fig. 260) includes portraits of the highborn Michiel (1638–1653) and Cornelis Pompe van Meerdervoort (1639–1680), their tutor and their coachman; Michiel's death provides a *terminus post quem* for the painting's execution. Portraits can also appear in genre scenes; Brouwer and his colleagues figure in the *Smokers* and Metsu's *Musical Company* of 1659 has been said to portray the artist, his wife, and Jan Steen, although the identification is unconfirmed by known portraits of the sitters.

The Metropolitan also includes certified artist's self-portraits. In a painting from the Altman Collection, Gerard Dou depicts himself in an elegant costume situated in a niche-like window holding his palette and brushes while consulting a large volume, probably as an allusion to the scholarship required of a successful artist (compare Kansas City's *Self-Portrait* by Dou). Rembrandt, on the other hand, dispenses with all but the most conspicuous attributes of his trade, a smock and a beret, in his intensely expressive *Self-Portrait* of 1660. A sitter's attributes in a portrait may assist in the subject's identification; for example, Rembrandt's *Standard Bearer* of 1654 probably represents Floris Soop, one of only three Amsterdam militia company officers of this age who held that post and also collected paintings. Other times the attributes only hint at a vocation or social role. David Bailly's portrait of 1641 in the Linsky Collection has been assumed to be a botanist, not only because the artist portrayed Leiden University professors but also because of the illustrated book of plants that the bearded gentleman holds. Thomas de Keyser's charming portrait of a young girl and a lutenist who has just uncased his instrument is presumptuously titled *The Musician and His Daughter.* And a *Portrait of a Man with a Celestial Globe* of 1624, assigned

alternatively to Werner van den Valckert or Nicolaes Eliasz (called Pickenoy), has been assumed to portray an astronomer. The danger of drawing conclusions about a sitter from accessories is well illustrated by Rembrandt's so-called *Auctioneer* of 1658, which depicts the subject with a volume and bust. Traditionally assumed to be Thomas Jacobsz Haaring, who conducted the sale of Rembrandt's effects in 1658, the image in fact bears little resemblance to known portraits of the sitter. A traditional token of marital fidelity, the pink held by

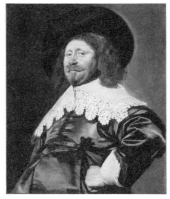

261

the subject in Rembrandt's lovely late *Portrait of a Woman with a Carnation* has a clear meaning; however, the significance of the magnifying glass held by her male companion remains unexplained. Whatever its meaning, the same sitters seem to have posed for Rembrandt's famous *Jewish Bride* (Rijksmuseum, Amsterdam) and the *Family Group* preserved in Braunschweig.

The splendid portraits by Frans Hals in the collection may strike us, albeit subjectively, as supporting what we know of their sitters' lives. With its glossy blacks and jaunty three-quarter-length pose, the *Portrait of Paulus Verschuur* of 1643 looks every inch the confident image of a wealthy Rotterdam cloth merchant and burgomaster. Similarly, the identification of the lionine and not-a-little corpulent gentleman (his girth enhanced by the low point of view), who is supposed on the strength of an old inscription to depict Claes Duyst van Voorhout *(fig. 261)*, is given added credence once we learn that Voorhout owned a brewery called "in den Swaenshals." The festive *Young Man and Woman in an Inn (fig. 262)* of 1623 was titled in the eighteenth-century "Yonker Ramp and His Sweetheart"; however, it is unclear whether the figures are portraits, anonymous genre figures, or, very possibly, a representation of the Prodigal Son wasting his substance. As we have suggested elsewhere (see Hartford's Cornelis van Haarlem), depictions of this biblical subject were important forerunners of the merry company subject in genre.

Frans Hals' role in the history of Dutch genre is well illustrated by his *Merrymakers at Shrovetide (see color plate 6)*. An inscription on a drawing after the painting identifies the subject as "Vastenavond," the pre-Lenten festival cheerfully devoted to foolishness and excess. The two men who snuggle up to the elegant young lady at the festival table were comical characters familiar to all seventeenth-century viewers—the ruddy faced, Falstaffian figure on the left with food necklace is

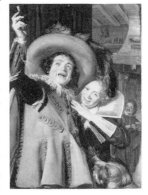

262

Peeckelhaering, while the sly fellow with sausage-festooned beret is Hans Worst. On the table is a bagpipe, traditional instrument of sots and fools, while the raucous figure at the back left also wears fool's attire, a spoon in his cap. Given the figures' associations with theatrical types, the young lady in their midst may, in fact, be a boy; women did not make regular appearances on the Dutch stage until shortly before mid-century. Hals' life-size half-length genre scenes descend from sixteenth-century Netherlandish genre (Aertsen, Beukelaer, Jan Mattsijs, van Hemessen, and others); however, their *joie de vivre* and complementing breadth of execution was unprecedented. The artist's later half-length figures from the 1620s, such as the *Boy*

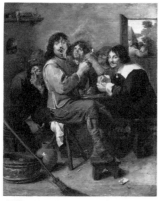

263

with a Lute, owe a debt to the Utrecht Caravaggisti; however, his flashing brushwork was unique. The boy in this scene performs the fingernail test, a popular gesture showing that he has so completely drained his glass that not a drop falls from the inverted vessel onto his nail.

Houbraken's claim that Adriaen Brouwer was apprenticed to Frans Hals while in Haarlem is unsubstantiated, but the shared vitality of the two men's images of low life serves to relate them. A late work by the artist, Brouwer's *Smokers* (fig. 263), of c. 1636, is his finest painting in this country, indeed one of the greatest of all his works. The wide-eyed character blowing smoke in the center is Brouwer himself, and members of the company are said to portray his Antwerp colleagues, Jan Davidsz de Heem and Jan Cossiers. Brouwer's closest Dutch follower, Adriaen van Ostade, is represented by four paintings, including a cottage doorway subject which is of interest for its early date, 1641; but not one of these works shows the artist at his best. While good low-life genre is not wholly neglected as it is in Washington, its representation in New York, with the conspicuous exception of the Brouwer, scarcely approaches the quality of the Metropolitan's high-life scenes. To be sure, Steen offers a frisky *Kermis,* but, except for the new Linsky collection picture, he too could be better served. The painting with the familiar theme of the *Love-Sick Maiden* has condition problems and the *Merry Company on a Terrace* (fig. 264) is a disagreeably outscaled,

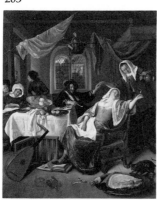

264

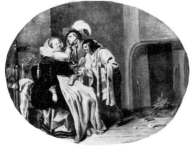

rather blowzy picture, which, alas, is not untyp-
ical of Steen's latest works.

The early merry company and guardroom
scenes also could be better. These include a
routine Dirck Hals dated 163[?], a work assigned
to Pieter Codde but probably by Quast, and a
little oval panel by Jacob Duck called *The Procu-
ress* (fig. 265) but actually depicting a gypsy
subject (the gentleman client would hardly look
so bored if the transaction were of a prurient
sort). The *Evening School* by Gerard Dou, by
contrast, is a very good example of the Leiden

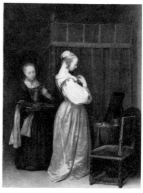

266

painter's work, which may be compared with the Rijksmuseum's famous
painting of the same subject. Another nocturnal scene wrongly attributed to
Dou, the *Serenade,* is surely a late painting by his gifted pupil Frans van
Mieris. The theme of a street scene at night with celebrants or entertainers
in costume probably was inspired by Jan Steen (see his painting in Prague)
and may in turn have influenced the French genre specialist Watteau. Yet
another Leiden genre painter, Quirin van Brekelenkam, is here presented
both by one of his scenes of professions, *The Spinner,* and one of his more
elegant subjects, depicting a gallant sharing a glass of wine and a quiet
moment with a woman in the corner of a light-filled room.

Some of the Metropolitan's finest genre scenes are by Terborch, the
consummate high-life painter. The artist's painting entitled *Toilet* (fig. 266)
is an important transitional work in his oeuvre. Painted around 1650, it is
one of the earliest works to display the elegance that would pervade genre
painting in the second half of the century. While other artists played a role
in these developments (see, for example, Gerbrand van den Eeckhout's
Music Party on a Terrace and his related painting of 1652 in Worcester),
Terborch was its chief innovator. The subject of a lady before a mirror had
been associated with the sins of vanity, luxury, and, specifically, *superbia* at
least since the time of Bosch; little wonder that the serving girl with basin
and ewer wears such a tentative expression. The wealth of suggestion in the
faces and gestures of the figures who inhabit Terborch's mature works
constitute some of the greatest achievements of Dutch genre. In his master-
pieces from c. 1660 we are ushered into the rarefied world of the private
chambers of high-born women, who pen letters, share confidences, or adorn
themselves. The title *Curiosity* given to New York's painting is surely a latter-
day sobriquet; however, the state of mind has rarely been expressed more
compellingly than in the charming figure of the girl who leans over the chair
to spy on her friend's missive. Even the dog seems to take an interest. Of
nearly the same dimensions as Teborch's masterful and comparably elegant
Woman at Her Toilet in Detroit, this work has been assumed to be its pendant.

Comparison of Gabriel Metsu's *Musical Company* (fig. 267) of 1659 and
Terborch's earlier *Couple with a Girl Playing a Theorbo* suggests something of .

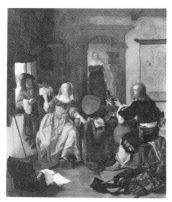

the debt that the Leiden painter owed to his older colleague's elegant new genre style. Yet Metsu was an independent and accomplished artist in his own right. His touch is more fluent, his tonality lighter, and his palette much more colorful than Terborch's. Moreover, he was one of the first to combine the more elegant subjects with an expressive new use of interior space. The *Visit to the Lying In Chamber* of 1661, for example, makes full use of the orderly geometry of the tiled floor, fireplace, doorway, and fur-

267

nishings. While Metsu probably was influenced by the Delft School, he was an innovator in the development of depictions on a horizontal format of high life in spacious Amsterdam interiors. The *Lying In Chamber* depicts a mother and her newborn receiving a formal visitor. The picture was the subject of a poem by Jan Vos and was singled out for praise in Houbraken's account of the artist published in 1721. Gestures in the work recall Terborch, but the theme is essentially new, a creative variation on the sixteenth century's theme of the visit to the wet nurse. The subject subsequently was taken up by many later artists, including Matthys Naiveu (see the painting in Leiden), whose *Newborn Baby* of 1675 is owned by the Metropolitan.

One of the earliest and most charming painters of simple domestic and maternal themes was Nicolaes Maes, whose *Apple Peeler* and *Lace Maker* hang here. Another innovator of these themes was Pieter de Hooch, who is amply represented in New York but with only one mother and child subject, a relatively late, poorly preserved work. The remainder are mostly merry company subjects, depicting officers and ladies socializing by the light of a window or beneath the airy enclosure of an arbor. The finest picture by the artist is the Lehman Collection's painting of a cheerful family gathering in a room decorated with gilt leather (*fig. 268*). The scene on the back wall of Adam and Eve embracing in the first Fall provides a potential admonition, as does the view on the right, where an elegant young man saunters to a

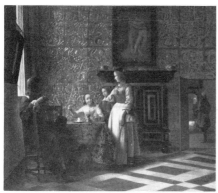

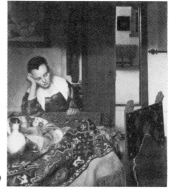

268 269

lighted doorway to receive an old man with a crutch—a motif reminiscent of the theme of Lazarus at the Rich Man's Door. Characteristic but of special beauty is the treatment of the light and atmosphere, the smoke rising from the man's pipe, the gleam of the ebony *kast,* and the suggestion of a secondary reflection on the near wall. Later works by de Hooch in the collection depict an officer paying the hostess (a theme he had treated in his earlier Delft period) and a soldier dressing while a serving girl brings a ewer and basin. The latter painting is only a fragment; early descriptions of the work mention a woman in the bed cropped at right. The canvas's mutilation is likely to have been a brutal form of censorship.

Without a hint of censoriousness, the anonymous author of the catalogue of the Amsterdam sale in which Vermeer's *Girl Asleep* (*fig. 269*) appeared twenty-one years after the artist's death titled the work "een dronke slapende Meyd" (a drunken sleeping girl). It is hardly explicit whether the lovely girl's slumber was brought on by the contents of the wine glass, white ceramic pitcher, and overturned *roemer* on the table. Equally unclear is the meaning of the picture at the upper left, a fragment of a painting of Cupid that appears elsewhere in Vermeer's art but here includes two masks. X-rays indicate that Vermeer first painted a dog in the open doorway and a portrait of a man in place of the mirror in the far room. Whatever the specific meanings of these changes and details, the girl's pose, with eyes closed and head in hand, was associated in earlier prints with the sin of Acedia, sloth and idleness. The most classically beautiful of the Metropolitan's five Vermeers is the *Young Woman with a Water Jug* (*fig. 270*). Like Washington's *Woman with a Balance,* the painting is one of a series of four compositions (the remaining two are in Amsterdam and West Berlin) that Vermeer probably conceived in the early 1660s depicting the single figure of a woman standing before a window in the corner of a room with a table. The perfect clarity and poise of these works is breathtaking. Indeed, one could argue that they represent the ultimate achievement of Dutch genre, the consummate celebration of everyday life. The unaffected delicacy of the gesture of opening the window, the light falling on a starched cowl or glinting metalware, the lush saturation of the colors, are all so brilliantly resolved as to ennoble even so common an activity as pouring out the morning bath.

270

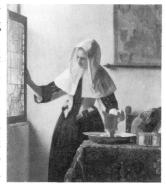

Related to Vermeer's series of single-figure compositions is the Metropolitan's *Woman with a Lute.* The painting has suffered abrasion but, contrary to opinions recently expressed, is autograph. One theory proposes that the woman who tunes her instrument while looking expectantly out the window awaits an absent lover who will accompany

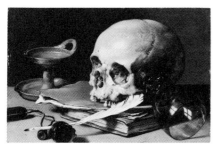

271

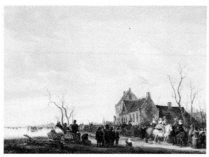

272

her on the viola da gamba here resting on the floor. In assessing this explanation we should consider Bartholomeus van der Helst's contemporary *Musician,* dated 1662 and also owned by the museum, where all the same elements appear, but the woman, who may be a portrait, seems to address the viewer directly. The last Vermeer to enter the collection, the *Head of a Young Woman,* relates to the Mauritshuis' *Girl with Pearl Earring* both in its bust-length format and pose. However, whereas the girl with the turban and parted lips in The Hague expresses an exotic sensuality, here there is a greater refinement and fragility, a febrile, luminous vulnerability. Although she is unidentified, her untailored drapery suggests classical costume; in the same 1696 sale in which the *Girl Asleep* appeared, the painting was described as "een tronie in Antique Klederen" (a head study in antique clothing).

One of the most important if not best-preserved still lifes in the collection is Jacques de Gheyn's *Vanitas* of 1603, the earliest *vanitas* in existence. The symbolism of transience implicit in the skull, bubble, smoke, coins of fleeting wealth, and tulip that soon will fade is now familiar, but here they are united with sculpted images of the philosophers Democritus and Heraclitus (see Chicago's pendants by Moreelse) and visionary details such as the broken wheel in the reflection of the bubble. An excellent later *vanitas* still life dated 1623 (fig. 271) by Pieter Claesz dispenses with the bubble and other supernatural details in the interest of the realistic appearance of the whole, but its warning nonetheless is clear. Other later still lifes in the collection include a Flemish style, horizontally arranged banquet piece by Jan Davidsz de Heem and upright compositions of the more indigenous Dutch type by Willem Kalf (dated 1659) and van Beyeren. Good large examples of the later seventeenth-century decorative traditions of bird painting and the dead game piece are provided, respectively, by Melchior d'Hondecoeter's *Peacocks* of 1683 and Jan Weenix's *Falconer's Bag* of 1695. Later Dutch flower painting is represented by works by Otto Marseus van Schrieck, Abraham Jansz Begeyn, and the woman painters Rachel Ruysch and Margaretha Haverman.

While the Metropolitan could do with an example by Esaias van de Velde or one of his Haarlem colleagues of the early realist approach to landscape, it owns the beautifully understated *Landscape with Cottage* of 1629 by Pieter Molijn. Dated the same year and reflecting Molijn's influence

but less well preserved than the latter's work is Salomon van Ruysdael's *Market by the Seashore,* which employs a diagonal composition and "tonal" palette. A mature work in pristine state by Salomon dated 1650 is the *Landscape with "Drawing the Eel"* (*fig. 272*), which depicts a rural tavern in winter with figures playing a popular if somewhat crude game, the object of which was to pull a slippery eel off a line while riding by on horseback. More conventional not to say refined winter amusements appear in Aert van der Neer's *Frozen River,* dated about a decade later. The collection includes several handsome panoramic landscapes, the earliest of which is probably van Goyen's *View of Haarlem with the Haarlemmer Meer,* dated 1646, which still recalls Hercules Segher's art. The finest of the three panoramas of the typically unidentifiable sites by Philips Koninck is the recently acquired *Extensive Wooded Landscape.* Another new acquisition that applies the panorama formula to sweeping South American terrain is *Brazilian Landscape,* dated 1650, a major work by Frans Post. Jacob van Ruisdael's *View of Haarlem* is less generalized than van Goyen's, but he exaggerates the height of the dunes in the foreground and the tower of St. Bavo's to create a dramatic focal point. Ruisdael's several other paintings preserved here range from an early *Landscape with Village in the Distance,* dated 1646 (which may, however, be by the artist's cousin and namesake, Jacob Salomonsz van Ruysdael), to the late *Mountain Torrent with a Bridge* from the 1670s. The most majestic is the large *Wheatfield* with its centrally receding road, towering sky, and light dappled fields.

The Dutch landscapist who is probably best represented in the collection is Albert Cuyp. An early work from the 1640s is the *Piping Shepherds* which is sometimes thought to be a collaboration between Albert and his father, Jacob Gerritsz. Although *Landscape with Cattle,* which shows in the left distance the Huis ter Merwede near Dordrecht and a villa near Hardenxveld at the back right, has recently been reattributed correctly to Cuyp's 18th century imitator, Jacob van Strij, the *Young Herdsmen with Cows* is an excellent mature example of Cuyp's art. We have already mentioned the equestrian portraits in the *Starting for the Hunt* (*fig. 260*). The staffage in another golden Both-like landscape probably painted by Cuyp in the early 1650s identify the subject as a religious theme; on a rural highway with passing herdsmen, Joseph hastens to lead his new family on the Flight into Egypt. Virtually the only side of Cuyp's art to be neglected are the marines. However, there are lovely marines in the collection by Simon de Vlieger, Jan van de Capelle, and Salomon van Ruysdael. The cityscapes include four paintings by Jan van der Heyden, including views of Leiden, the Park of the Royal Palace in Brussels, and two paintings of the Huis ten Bosch in The Hague. On loan to the museum is the *View of the Keizersgracht, Amsterdam,* with a view of the Westerkerk where Rembrandt was buried in 1669.

The Dutch drawings at the Metropolitan are not so distinguished as the painting collection nor do they rival the towering quality of the Morgan Library's holdings. Nonetheless, there are outstanding sheets like Abraham

273 274

Bloemaert's *Pollard Willows* (fig. 273) and noteworthy drawings by Avercamp, Breenbergh, Poelenburgh, van Goyen, Allart van Everdingen, Adriaen van Ostade, Willem van de Velde, and Jacob Backer. Not unlike the situation in the painting collection, the finest single group of drawings is by Rembrandt. There are biblical subjects, including the great study of *Nathan Admonishing David* (fig. 274), and other sketches of *Tobias and Sarah, Jacob and Rachel,* and *Peter and John at the Gate of the Temple,* striking landscape and street life studies, such as the grimly matter-of-fact *Woman Hanging from a Gibbet,* as well as a *Self-Portrait* in the Lehman Collection. Biblical sheets by the Rembrandt School artists Eeckhout and Hoogstraten are also found here. Among eighteenth- and nineteenth-century Dutch artists represented in the drawing collection are Cornelis Troost, F. C. La Fargue, Christoffel Bisschop, Jacob Maris, and of course, van Gogh.

The Metropolitan's Dutch decorative arts constitute the preeminent collection in this country, although at any given time only a small portion is on view. The seventeenth-century furniture includes two excellent quality cabinets, the large *Beeldenkast* of 1622 (fig. 275) decorated with charming, carved biblical, allegorical, and literary figures, alluding to, among other subjects, the popular themes known from print series of the powers of woman: Delilah holding the shears, Phyllis on Aristotle's back, and female personifications of the Virtues. Here too is a particularly beautiful carved

mirror frame and a long case clock by the mid-eighteenth-century Amsterdam craftsman Gerrit van der Hey. The sculpture collection claims a small bronze of *Neptune* by the sixteenth-century sculptor Johann Gregor van der Schardt and an *Apollo* by Adriaen de Vries (compare the works in Washington and Kansas City). A very large and distinguished silver gilt sideboard with a scene of the Judgment of Paris is thought to have probably been executed by a Dutch or German goldsmith working in London around 1680. Other distinguished pieces of silver which are certain to be Dutch

276 277

include an early coconut cup with silver mount, an especially lovely engraved silver beaker from Enkhuizen dated 1653 (*fig. 276*), a vessel in the form of a rearing horse executed by Johannes de Grebber in Amsterdam in 1658, a Haarlem porringer of 1682, a handsome coffee urn by Tijmon Suyck of Amsterdam dated 1733, a bowl from Leeuwarden of 1737, a teapot of 1743 (*fig. 277*), a silver gilt ewer by Christoffel Radys from The Hague of c. 1740, and several pairs of eighteenth-century candlesticks. A brass tobacco box is engraved with the story of Lazarus. The eighteenth-century Dutch ceramics include: a six-sided polychrome teapot by Rochus Jacobsz Hoppesteyn from the fourth quarter of the seventeenth century, a plate of 1712 with the coat of arms of the House of Habsburg and King Charles VI by Lambertus van Eenhoorn or Lovwijs Fictor; a wall cistern with tea drinkers by the firm of De Drie Vergulde Astonnen, Delft, c. 1705; a black Delftware cruet stand; two plaques representing David and Abigail and Moses and the daughters of Jethro, from the latter half of the eighteenth century; a dish with a calendar representation by De Porceleyne Bijl, Delft, c. 1770; a chocolate pot on a warmer by Het Oude Moriaenshooft, Delft, c. 1765; and a small bird cage, possibly by de Roos. Though not so distinguished, numerous, or well documented as the Garvan tiles in the Philadelphia Museum, the Metropolitan also owns a relatively large group of Dutch tiles (see, for example, *fig. 278*), some of which were donated by W. R. Valentiner. The glass collection includes several stippled wine glasses by Frans Greenwood (one of 1728 decorated with Flora) and by David Wolff—one by the latter dated 1784 with a portrait of Willem V, another with the image of the Amsterdam burgomaster Hendrik Hooft, and still others decorated with *putti* or *chinoiserie* (*fig. 279*). Particularly handsome too is an unattributed flute glass with diamond engraved portrait of Willem III.

Somewhat surprisingly, paintings by the nineteenth-century Koekoek family of landscape and marine painters, who are still much sought after today in the Netherlands, are not plentiful in American museums, but the Metropolitan owns works by Barend Cornelis Koekoek and Willem Hermanus Koekoek. More common are Hague School pictures. New York has

278 279

its share, including representative if not outstanding works by Israëls, Jacob and Matthijs Maris, and a sizable group of paintings by the productive Anton Mauve. Jongkind's *Sunset on the Scheldt* is a copy of a work in Philadelphia but the *Honfleur* of 1868 is autograph. The Metropolitan's nine paintings by van Gogh include several masterpieces, most from his Arles period. The still lifes include an early treatment of *Two Sunflowers* dated 1887, later to become a major theme in van Gogh's decorations for the Yellow House at Arles (compare Philadelphia's painting). The *Oleanders* painted in August of 1888 includes a copy of Zola's *La Joie de vivre* (1884) lying on the table; its meaning may be debated, but in one of van Gogh's still lifes painted in Nuenen in 1885 he juxtaposed Zola's novel with the family Bible. The *Irises* painted in St.-Rémy in 1890 offers a lovely composition of the purple blooms that held such attraction for the artist in his late works; a similar but upright composition of irises is preserved in Amsterdam. The *Flowering Orchard* painted at Arles in the spring of 1888 relates to the drawing in the Hyde Collection, Glens Falls, while the *Cypresses* is one of a series of similar

280

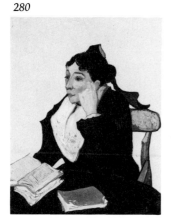

landscape studies. The portraits include the Lehman Collection's *Madame Roulin and Her Baby* (compare Philadelphia's version) and the great *L'Arlésienne* (*fig. 280*). In a letter dated November 6, 1888, van Gogh wrote to his brother Theo, "I have an Arlésienne at last, a figure ... slashed on in an hour, background pale citron, the face gray, the clothes black, black, black with perfect raw Prussian blue." This speedily executed work is probably the sketchier version of the composition preserved in the Musée d'Orsay (Galerie du Jeu de Paume), Paris, while the Metropolitan's

more finished painting may have been executed by the artist as a present for the sitter, Madame Ginoux. Together with her husband, Marie Ginoux operated the Café de la Gare where van Gogh had a room from early May to September 1888 and which served as the subject of several of his paintings (see for example, Yale's *Night Café*).

MUSEUM OF MODERN ART

11 West 53rd Street
New York, New York 10019 *(212) 956-6100*

The Museum of Modern Art was founded in 1929 "to help the public enjoy, understand and use the visual arts of our time." The collections thus are devoted primarily to twentieth-century art but also offer examples of later nineteenth-century (c. 1880 and later) art as immediate predecessors to the modern movement. The museum opened in 1939 and was enlarged in 1964, 1966, and 1984. The most recent additions not only enlarged and renovated the gallery spaces, but added a forty-story apartment building above the structure. In addition to the painting galleries, there is a sculpture garden, which offers a tranquil center-city retreat, world-renowned collections of prints, drawings, photographs, architecture, and design, as well as an extensive film library. The film series, lectures, and symposiums draw a loyal and large following. The paintings and sculpture were catalogued in 1967 by the distinguished art historian and the museum's first director Alfred Barr. A lavishly illustrated introduction to the history of the institution and to its collections, entitled simply *The Museum of Modern Art, New York,* appeared in 1984 on the occasion of the reopening of the expanded museum.

One of the museum's most popular paintings, indeed one of the most famous works ever executed by a Dutchman, is van Gogh's *Starry Night (fig. 281).* In a letter sent from St.-Rémy to his brother Theo, dated June 17–18, 1889, van Gogh mentioned this as a "new study of a starry sky," referring to the fact that in the previous year he had painted a night scene (now in a private collection) while working in the open air under a gas lamp at Arles. That work was one of the first to make an increasingly arbitrary use of color and design. In the museum's painting the whirling, vibrating, night sky with huge, pincer-like crescent of a moon achieves a truly visionary effect. In his letter to Theo, Vincent went on to acknowledge his debt to Delacroix in this effort to escape from the mere representation of nature ("*trompe-l'oeil*

281

exactitude") to the expression of a heightened reality. At the time that van Gogh painted this picture he had already been committed to the asylum at St.-Rémy which was housed in the twelfth-century monastery of Saint-Paul-de-Mausole. The artist's personal record of his confinement includes the Museum of Modern Art's gouache and watercolor *Hospital Corridor at St.-Rémy,* a work probably executed in the frustrating month of October 1889 when van Gogh was unable to paint for

lack of canvas; the artist was dependent upon his brother for the shipment of his painting supplies.

Among the canvases from the early Fauvist generation preserved here are works not only by the great French artists Matisse, Derain, and Vlaminck, but also their Dutch-born colleague Kees van Dongen. Without question the most memorably amusing is his *Soprano Singer* of 1908 depicting Modjesko, a female impersonator well known in Parisian *cafés concerts (fig. 282)*. Viewed in profile, Modjesko sings like a gaudy, full-throated thrush. Com-

282

pensating in part for the painterly exuberance and freedom of the Fauves was the rigor of Cubism and its severely geometric Dutch extension, De Stijl. The Museum of Modern Art boasts the most extensive collection of Piet Mondrian's art in this country. The more than one dozen paintings span his career from an early, relatively naturalistic oil sketch, *Mill by the Water* of c. 1905, to his first reductive and increasingly abstract Cubist canvases of c. 1913–14, to the mature grid-like "compositions" in black, white, gray, and primary colors from the 1920s and 1930s for which he is justly famous, and finally, to the very late works executed in New York in the 1940s when the orthogonal patterns reintroduce representational recollections of the network of city streets and the staccato rhythms of street lights (see, especially, *Broadway Boogie Woogie* of 1942–43, *see color plate 18*). The move to complete abstraction, that is, to an art without reference to objects in nature, had been a search for order, harmony, and balance in the increasingly chaotic modern world. De Stijl was born during World War I, when an unprecedented global conflict seemed likely to destroy civilization, indeed reason itself. The clarity of design, the sharp-edged geometric forms and the simple colors of De Stijl affirmed reason and order in a world gone mad.

The group known as De Stijl took their name and cohesion as an art movement from the magazine *De Stijl* ("The Style"), conceived and published from 1917 to 1931 by Theo van Doesburg, a painter, writer, and architect. While van Doesberg himself played an important role in the birth of nonobjective painting (see *Composition [The Cow]* of 1916–17 and *Rhythm of a Russian Dancer* of 1918) and later was the first to challenge one of the basic tenets of Mondrian's Neo-Plasticism by introducing a diagonal axis into his compositions (see *Countercomposition VIII* of 1924 in the Art Institute of Chicago and the Museum of Modern Art's own *Simultaneous Countercomposition* of 1929), van Doesburg was most influential through his efforts at extending De Stijl's principles beyond painting. He worked, for example, with Cornelis van Eesteren on architectural designs for the ideal private dwelling (see the gouache and ink *Color Composition: Project for a Private House* of 1922, *fig. 283*). The renowned furniture designer Gerrit Rietveld

283

284

(see in addition to his famous red-and-blue armchair of 1918, the sideboard of paint-stained wood of the following year, *fig. 284*) also worked on major architecture projects in a related idiom, such as the Schröder House, begun in 1923 in Utrecht, a model of which is preserved at MOMA. In their utopian search for a universal stylistic harmony, the De Stijl movement entered not only into the traditional realms of painting, sculpture, and architecture, but also city planning, interior design, graphics, film, even music. While van Doesburg's vision of a pervasive cultural program never achieved a truly global impact, he had contacts with the Italian Futurists, the Russian Constructivists, Germany's Bauhaus and new filmmakers, as well as the Dada movement in France and Switzerland, important links that ensured the international and lasting influence of the movement.

Among later Dutch works preserved by the museum are paintings by Karel Appel and G. Lataster, collages by Marcel Polak, and an assemblage entitled *Metallic Gray* by Jaap Wagemaker.

PIERPONT MORGAN LIBRARY

29 East 36th Street
New York, New York 10016 *(212) 685-0008*

Designed by McKim, Mead and White, the Pierpont Morgan Library was completed in 1906. Adjacent to the family's town house, it houses both Morgan's books and art collection. The library was opened to the public in 1924, and four years later an annex was erected. The study and library of the original pink-marble, Renaissance-styled structure are preserved much as they were in Morgan's time. Although the library and collections are usually only available to accredited scholars, special exhibitions for the public are mounted continuously. The collections of the library are some of the most remarkable in the world, including Medieval and Renaissance manuscripts, early printed books, autographs, letters, documents, and musical manuscripts. For the purposes of this guide the greatest interest is the approximately 350 Dutch drawings in the Morgan's outstanding collection of Old Master drawings. The catalogue by Felice Stampfle of the exhibition *Rubens and Rembrandt in Their Century* (1979–80) offers an exemplary account of the best of the seventeenth-century Dutch and Flemish drawings.

The critic John Russell wrote recently, "Big museums are admired and prized and respected, small museums are loved." For that inveterate observer, the two most cherished small museums in New York City were, of course, the Frick and the Morgan Library. While the former has no special exhibition policy, mounting only the occasional tiny though select show, the latter offers regular exhibits renowned for their scholarship and beauty; among recent Dutch offerings was *William and Mary and Their House* (1979). These exhibitions are not so much intimate in scale as in installation, offering the visitor the precious experience—increasingly rare in the exhilarating but often overwhelming era of the "blockbuster" show—of discrete communion with masterpieces. The permanent collection of Old Master drawings, certainly the equal of any in the country, is built upon the core of a collection assembled by the English dealer/collector Charles Fairfax Murray (1849–1919), whose vast holdings were purchased *en bloc* by J. P. Morgan in 1910. In the 1950s a program of acquisitions was begun which has regularly added to the collections, always observing their high standards of quality.

Among the early Dutch drawings are several sheets by the Haarlem Mannerist Hendrik Goltzius. Reflecting the Mannerists' admiration for stories from Ovid's *Metamorphoses, The Judgment of Paris* served as the basis for a large engraving that Goltzius executed before his trip to Italy in 1590. His *Mountainous Coastal Landscape* in part reflects Goltzius' impressions of the alpine scenery that he passed through on his journey but also shows the lingering influence of Brueghel's *Weltlandschaften*. The Dutchman would later reject this convention when, around 1600, he drew some of the earliest naturalistic landscapes of the countryside around Haarlem. Goltzius' unri-

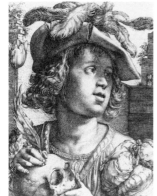

285

286

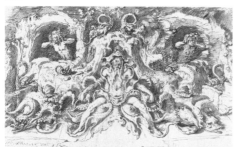

valed virtuosity with the pen is best illustrated in the *vanitas* image of a *Young Man Holding a Skull and Tulip (fig. 285)*. This remarkable drawing, known like his other rare works in this technique as a *federkunststück,* is executed with pen strokes that imitate the swell and taper of engraved lines. While Goltzius was renowned as an engraver, by the date of this work he had given up the practice, in part because of deteriorating eyesight. The decorative invention of the Mannerists is best seen in Jacques de Gheyn II's weirdly fanciful *Design for a Garden Grotto (fig. 286)*, which includes all manner of sea creatures and ghoulish forms. Like Goltzius' *Coastal Landscape* drawing, de Gheyn's *Mountain Landscape* clearly owes a debt to the tradition of Brueghel's bird's-eye views of alpine scenery from the 1550s.

As we have seen, this international current gave way to the indigenous realist tradition of Dutch landscape pioneered by a group of artists active in Haarlem in the early decades of the century. It included Esaias van de Velde and Pieter Molyn, whose landscape art is well represented at the Morgan, as well as Willem Buytewech, who is better appreciated here for his naturalistic figure drawings (see *The Mussel Seller*). Outstanding examples by later practitioners of this naturalistic landscape tradition include works by Jan van Goyen (who depicts both the *Fishmarket on the Beach at Egmond aan Zee* and the *Horse Market at Valkenburg)*, Jan Lievens (a forceful view of *Pollard Willows, fig. 287*), Albert Cuyp, Simon de Vlieger, Philips Koninck, Lambert Doomer (who together with Roelant Roghman probably was the most gifted landscape draftsman in Rembrandt's circle), and, of course, the great luminaries Rembrandt and Ruisdael.

287

288

No less well represented are the italianate Dutch landscapists. Particularly stunning is the *View of the Temple of the Sibyl at Tivoli (fig. 288)*, virtually an obligatory subject for Dutch artists sojourning in Rome, by Bartholomeus Breenbergh, a member of the first generation of expatriots. The power of the design and the sure command of light and shade in this sheet are characteristic of the artist's bold manner. Later generations of italianate artists offer views of other identifiable sites—the *Aqueduct at Frascati* by Jan Asselijn, a panoramic *View of Rome* by Jan de Bisschop, and the *View of Urbino* by Caspar van Wittel—as well as nonspecific, bucolic scenes in the campagna (Nicolaes Berchem, Karel Dujardin, Adriaen van de Velde, and Willem Romeyn). An important and often neglected trend in the Dutch italianate tradition is represented by Herman van Swanevelt's drawings. Van Swanevelt traveled to Italy about the time that the first generation of artists, notably Poelenburgh and Breenbergh, were departing from Italy. The style he developed in landscapes with historical and mythological staffage (see *Joseph Recounting His Dreams*) was less dependent upon observation of actual southern scenery than upon a graceful and diaphanous world of the imagination. His resemblance to Claude (the *Joseph* drawing actually once carried an attribution to the great Italian landscapist) comes as a surprise to those accustomed to thinking of Dutch artists as the limners of bogs and polders.

Highpoints of the collection are the Rembrandt drawings. These include some of his many pen sketches of domestic life—a sheet of views of a woman holding a child, a wonderful drawing *(fig. 289)* of a woman leaning back to counterbalance a fretful infant as she descends a stair, and a sheet of two studies of his wife Saskia sleeping heavily. Some of these works may have been part of the portfolio of drawings of "vrouwenleven met kinderen van Rembrandt" (the life of women with children by Rembrandt) which appeared in the 1680 inventory of the extensive art collection of the marine painter Jan van de Capelle. No less interesting than the beauty of the quotidien for Rembrandt was the novelty of the theater and pageantry. The Morgan owns splendid drawings of *Two Mummers on Horseback* and an exotically clad woman thought to be an *Actor in the Role of Badeloch* (women rarely appeared on the Dutch stage until about 1655), the wife of the hero

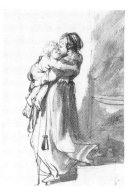

289 290

291

of *Gijsbrecht van Amstel* (1638), the best-known play by Holland's preeminent poet, Joost van den Vondel.

The sources of Rembrandt's art not only arose from direct observation, as in the landscape study of a *Canal and Bridge beside a Tall Tree* or the studio drawing of a *Seated Female Nude* (a relatively recent acquisition), but also from other art. Two of the master's copies from the Mughal School in India (*fig. 290*) are owned by the Morgan. Although Mughal miniatures were not uncommon in seventeenth-century Holland, it was a rare Dutch artist who attempted to record their beauty and incorporate it into his own art. A source closer to home and more orthodox, namely Marcantonio Raimondi's print after Raphael's *Deposition,* has been linked with Rembrandt's *Three Studies for a "Descent from the Cross,"* a promised gift to the library. Other superb drawings of biblical subjects by the master include *The Mocking of Christ* and *The Finding of Moses.* Religious works by unknown Rembrandt pupils depict *Saint Mark Preaching* and the more obscure theme *Lot Defending the Angels;* by known students, we note van den Eeckhout's *Adoration of the Magi* and Samuel van Hoogstraten's *Christ Falling Beneath the Cross.* A popular favorite, and rightly so, is the *Study of a Camel* (*fig. 291*) which, though long thought to be by Rembrandt, now also carries an attribution to van Hoogstraten.

A special strength of the Dutch collection is the figure drawings. These range from Jacques de Gheyn's study for the famous manuel of arms *Wapenhandelinghe van Roers—Musquetten ende Spiessen . . .* (1607) of a *Soldier Preparing to Load His Caliper,* to Buytewech's studies of peasants, to Salomon de Bray's sheet apparently commemorating the birth of *The Twins Clara and Aelbert de Bray* (1646), to the splendid single figure studies by the prolific Cornelis Saftleven, Leendert van der Cooghen, Karel Dujardin, (attributed to) Nicolaes Maes, and Caspar Netscher. Curiously, many more Dutch drawings of low-life genre scenes seem to have come down to us than of high life. This discrepancy is not found in painting, and the reasons for the greater scarcity of drawings of the leisure time of the well-to-do is obscure.

292

Perhaps the ready and relatively inexpensive media of drawing was thought more suitable to images of the lower classes. Whatever the cause, the Morgan's Dutch drawings reflect these trends; there is a goodly number of outstanding peasant genre scenes by Isack and Adriaen van Ostade (*fig. 292*), Philips Koninck, and Cornelis Dusart, but little in the way of high life. There are also relatively few good Dutch still life drawings in the collection. But Jan van Huysum's richly abundant *Flowerpiece* dated 1737 is certainly

one of the finest eighteenth-century sheets. Such is the range of this vast gathering of drawings, however, that any *lacunae* are scarcely conspicuous. Moreover, the viewer cannot help but be dazzled by the consistent quality and interest of this, one of the premier drawing collections of the world.

CHRYSLER MUSEUM

Olney Road and Mowbray Arch
Norfolk, Virginia 23510 *(804) 622-1211*

The forerunner of the present museum was a small memorial museum built in 1905 for the collection of tapestries and paintings owned by Miss Irene Leache and Miss Annie Cogswell Wood, two influential teachers at the Leache-Wood Female Seminary. In 1937 a Florentine Renaissance-style building was constructed to house the Norfolk Museum of Arts and Sciences. Completed with the aid of WPA funds, this structure was designed by Peebles and Ferguson of Norfolk, and Carlow, Browne and Fitz-Gibbons of Norfolk. The Houston wing by Williams and Geoffrey Platt of New York and Finlay F. Ferguson, Jr., of Norfolk was added in 1956. A Centennial wing, designed by Williams and Tazewell and Associates of Norfolk was opened in 1974. A milestone in the institution's history was attained in 1971 when Walter P. Chrysler, Jr., son of the founder of the Chrysler Corporation, presented to the museum a large portion of his collections, much of which had formerly been housed in the Chrysler Museum in Provincetown, Massachusetts. In grateful acknowledgment, the museum's name was changed. The Chrysler Museum's collections are broadly diversified, including ancient Greek and Roman, Oriental, Indian, and Pre-Columbian art, European paintings, drawings, and decorative arts (notably glassware), and American and modern art. *Apollo* magazine devoted an issue to the collections in April 1978, and a new handbook was published by the museum in 1982.

The finest paintings in Norfolk are Italian Renaissance and Baroque works (Veronese, Guercino, Reni, Cavallino, Strozzi), but there are also many fine English, Flemish, and Dutch pictures. The last mentioned happily are supplemented by loans from Walter P. Chrysler's personal collection. The sixteenth century is represented by a small panel of the *Madonna and Child* by Lucas van Leyden and a major Mannerist painting dated 1565 by Maerten van Heemskerck. The latter has been thought to depict Parnassus but

293

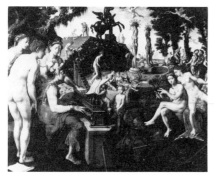

probably represents less lofty Mount Helicon home of the Muses, here represented as nudes playing music *(fig. 293)*. In the distance appears a statue of Pegasus above a fountain. Enchanted by the song of the Muses, Mount Helicon began to rise to heaven but was stopped by Pegasus who stamped the ground. Where he struck the earth Hippocrene, the spring of the Muses, gushed forth. Thus, Pegasus became the symbol of poetry. Characteristic of Heemskerck are the complexly posed nudes and the rich symbolic program.

Although Michalangelo and Raphael doubtless were his ultimate inspiration, he owed more to post-classical Roman and Florentine artists, such as Giulio Romano, Salviati, and Vasari. Early seventeenth-century Dutch history painters also admired Italian art but sought a simpler approach to exposition than Heemskerck and his learned humanistic circle. In the lovely painting by Lastman on loan from Mr. Chrysler, for example, the *Judgment of King Midas* follows Ovid's account of the tale in the *Metamorphoses* (XI, 147–79) very clearly. Pan, seated at the right and holding his pipes, had rashly challenged Apollo to a musical contest. Apollo stands at the center of the composition playing to a rapt crowd of listeners. The judge of the competition was to be the mountain god Tmolus, who sits crowned with an oaken chaplet to the left of Apollo. Tmolus rightly deemed Apollo the winner, but King Midas, overhearing the competition, protested the decision. The king appears at the far right of the painting, pointing out his preference and sporting the ass's ears that were his reward from Apollo for a fool's judgment.

Other excellent Dutch history paintings on loan from Chrysler include a monumental *Death of Seneca (fig. 294)* by Gerrit van Honthorst, a lovely and poetically conceived *Rape of Europa (fig. 295)* by Caesar van Everdingen (a rare theme in Dutch history painting, compare Rembrandt's treatment in a painting now on loan to the Metropolitan Museum of Art in New York), and the characteristically broad and earthy *Adoration of the Shepherds (fig. 296)* by Benjamin Gerritsz Cuyp. The Honthorst is complemented by a work in the permanent collection by a fellow member of the Utrecht Caravaggisti, the *Martyrdom of Saint Catherine* by Hendrik Terbrugghen, a beautiful if abraded work. Yet another Caravaggesque painting is Jan van Bijlert's *Mars Bound by Amor (fig. 297)*, which relinquishes Caravaggio's dramatic chiaroscuro but retains his half-length compositions and large, clearly conceived figures. The work's playful theme complements that of Houston's *Venus Chastizing Cupid,* very possibly a pendant. Other later seventeenth-century Dutch history paintings in Norfolk include two rather dry, late paintings (*Ruth and Boaz,* dated 1672, and *Volumnia Pleading with His Son Coriolanus to Spare Rome,* dated 1674), by the Rembrandt School artist Gerbrand van den Eeckhout, and a tightly executed little panel, *Magdalen in a Landscape,* by Willem van Mieris.

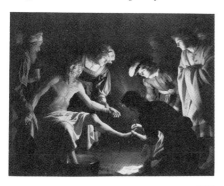

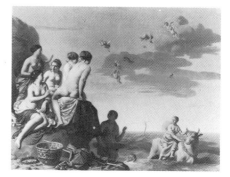

294 295

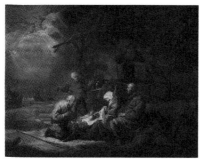

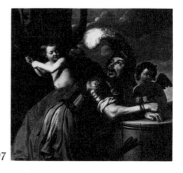

296 297

History painting clearly is the greatest strength of the Dutch collections; yet several other works deserve note. Anthonie Palamedesz' group portrait, dubiously titled *The Wedding Party* but certainly dated 1673, serves to remind us that while the artist is best remembered for his guardroom scenes in the manner of Codde, Duyster, and Duck, he produced at the end of his life a few of the elegant small scale interior group portraits of a type made popular by Gonzales Coques, Metsu, and de Hooch. The collection also includes one of Hondecoeter's large-scale bird paintings, an italianate *Landscape with Figures* by Johannes Lingelbach dated 1667, and a *Wooded Landscape* wrongly assigned to Hobbema. The attributions of the Metsu and the Ostade must also be questioned.

The museum owns a pleasant sheet of figure studies by Adriaen van de Velde, a small group of Dutch prints, and several pieces of Dutch earthenware and ceramics. However, the most distinguished feature of the decorative arts collection are the approximately seven thousand pieces of glass, which together with the collections in Corning, New York, the Metropolitan Museum of Art, New York, and the Art Institute of Chicago, are among the best reserves of Dutch glass in this country. Of particular interest are a group of Newcastle-type goblets with diamond-stippled engraved decorations attributed to David Wolff of The Hague. One of c. 1790 (*fig. 298, left*) bears a portrait of E. F. van Berckel, brother of the first Dutch ambassador to the United States. Another one of these glasses, sometimes called "friendship

298

goblets," depicts two gentlemen and a lady with the inscription of the gallant toast "Vaderlandie Lief en Alle Moie Mÿsies" (to the love of the fatherland and all pretty girls) (*fig. 298, right*).

Norfolk's nineteenth- and twentieth-century collections demonstrate both the lasting impact of Dutch seventeenth-century art (see Delacroix's *Slaughtered Ox,* on loan from W. P. Chrysler, Jr. which is based on Rembrandt) and the ongoing contributions of modern Dutchmen. The latter includes that

299 300

influential forerunner of the Impressionists, Jongkind (see the *View Along the Ourcq* [*fig. 299*] of 1866), the Art Deco sculptor Poels Alb (*The Stork,* 1929), and Kees van Dongen, whose large portrait of *Mlle. Mona Lils* (*fig. 300*) is one of the outstanding pieces in the early modern collection. It captures all the *joie de vivre* and languorous sexuality of the twenties.

SMITH COLLEGE MUSEUM OF ART

Tyron Hall
Elm Street at Bedford Terrace
Northampton, Massachusetts 01063 *(413) 584-2700, ext. 2236*

The curriculum of Smith College included from its founding in 1871 the study of art. Funds were allocated for the purchase of original works of art as early as 1877. The college's first president, L. Clarke Seelye, planned a collection devoted to contemporary American art, selecting as his first acquisition a painting by Thomas Eakins. Today the collection housed in Tyron Hall, a modern design by John Andrews, ranges from antique sculpture to modern color field painting. The greatest strengths of the collection are its nineteenth- and twentieth-century French and American paintings, a

selection of which were exhibited at the National Gallery of Art and nine other institutions in 1970–72. A complete checklist of the collection was compiled in 1979 to celebrate one hundred years of collecting.

The finest Dutch painting in the collection is Hendrik Terbrugghen's *Old Man Writing by Candlelight (fig. 301)*, a very good example of the Utrecht master's dramatic use of nocturnal effects in a half-length figure composition. Noteworthy still lifes are Ambrosius Bosschaert the Elder's *Fruit Dish with Siegburger Jug* and Willem van Aelst's *Still Life*

301

302

with Fish and Vegetables. The attribution of the *Stable Interior with Still Life* to Willem Kalf is uncertain; the painting type descends from Herman Saftleven and bears some resemblance to Frans Rijkhals' art. Of fine quality is Jan Steen's panel, *Drinkers,* while Pieter van Slingeland's *Letter* is in a problematic state but of interest for its recollections of Vermeer. The landscapes include Esaias van de Velde's tiny *Bridge over the Waterfall,* Jacob van Ruisdael's *Landscape with the Church of Beverwijk* and Jan van Goyen's *View of Rijnland (fig. 302)* of 1647. The latter pair, and especially the van Goyen, attest to Dutch artists' love of the panoramic view, a compositional arrangement that manages to evoke even in the unrelenting flatness of the Netherlands' flood plane majestic dimensions and sweeping grandeur.

303

The Dutch drawings are not numerous. A sketch of *Mars and Venus* by Bartholomeus Spranger is an example of the type of Mannerist drawing that influenced Goltzius and his contemporaries. Other sheets are by Jan van Goyen, Jan Lievens, and Rembrandt, whose diminutive but powerful *Women Kneeling in Prayer* is preserved here. One of Piet Mondrian's handsome studies of a *Chrysanthemum (fig. 303)* is another of the best Dutch drawings. Among the finest of a small group of De Stijl works is César Domela's construction *Neo-Plastic Relief No. 9 (fig. 304),* a forceful abstraction arranged on the skew bias.

304

ALLEN MEMORIAL ART MUSEUM

Oberlin College
Corner of Lorain and Main Streets
(Ohio Routes 10 and 58)
Oberlin, Ohio 44074 (216) 775-8665

The Oberlin College Museum was donated by the widow of Dr. Dudley Peter Allen, a Cleveland surgeon. The original Italian Renaissance-style building was designed by Cass Gilbert, creator of the Woolworth Building in New York, and opened in 1917. Additions were made in 1937 and 1977, the latter comprising the Ellen H. Johnson Gallery of Modern Art. The collections are sizable and wide ranging as befits the first university museum west of the Alleghenies. The greatest strengths generally are in the Dutch, German, and Spanish art, nineteenth-century French painting, European prints and drawings, and modern art. The quality of the Northern collections owes much to the purchase fund established by R. T. Miller and the guidance of the great historian of Dutch art Wolfgang Stechow, two factors in the acquisition of the Terbrugghen masterpiece. Stechow was the author of both the *Paintings* (1967) and *Drawings and Watercolors* (1976) catalogues, as well as numerous articles in the museum's *Bulletin.*

Perhaps not surprisingly, one of the collection's strengths is Dutch landscape, an abiding interest of Stechow, who wrote the leading survey of the topic (*Dutch Landscape Painting in the Seventeenth Century,* 1966). Some of the earliest works are a *Rustic Landscape* assigned uncertainly to Karel van Mander of the 1590s and a *Summer Landscape* of c. 1613–15 fully signed by Esaias van de Velde. The staffage in the latter probably represent the meeting on the Road to Emmaus. Although aspects of van de Velde's painting, such as vaguely ornamental figure types, still nod to the international Mannerist art of Coninxloo (compare also the Flemish landscapes in the collection by Paulus Brill and Joos de Momper), the work attests to a new, more direct response to nature. A drawing like David Vinckboons' lovely imaginary *Landscape with the Baptism of the Eunuch* of c. 1602–04 serves to illustrate how very far van de Velde had come. This indigenous Dutch realistic tradition laid the groundwork for such works as Jan van Goyen's *Dune Landscape* of 1647, a mature statement by the master, and Meindert Hobbema's splendid *Pond in a Forest* of 1668, one of this artist's finest paintings in this country.

Unusual for an American collection is the equal, indeed ample, representation of the alternative tradition of Dutch italianate landscape. The drawing collection includes distinguished sheets depicting Italian, or rather italianate, scenery by Bartholomeus Breenbergh, Herman van Swanevelt, Jan Asselijn, and Thomas Wijck. Jan Both is represented only as a printmaker. Both the early (c.1645) and mature (1660s) careers of Nicolaes Berchem may be studied here, respectively, with the *Resting Shepherds* and *Country Farrier.* Influenced by Berchem were Abraham Jansz Begeyn, whose *Ruins of a Castle*

is dated 1665, and Dirck van Bergen; however, the latter's eminently explicit *Bull Mounting a Cow* attests more to the influence of Adriaen van de Velde's bucolic paintings, the other principal model for van Bergen's art. This rich offering of italianate artists again must be credited to Stechow, who was a leader in restoring respectability to these artists after they had been eclipsed in the eighteenth century. In addition to writing articles, he assembled the show *Italy through Dutch Eyes* in Ann Arbor in 1964.

305

Though not so numerous or broad ranging as the landscapes, the quality of individual Dutch works in other areas is often very high. For example, the lone Dutch still life painting in the collection, Jan Davidsz de Heem's *Banquet Piece,* once graced no less distinguished a collection than the Imperial Hermitage in Leningrad. The Hermitage still owns a self-portrait by Michael Sweerts dated 1656, but his later *Self-Portrait Holding a Palette and Brushes (fig. 305)* (the sitter's identity is certified by an etching) has found its way to Oberlin. This sensitive but confident image seems perfectly suited to Sweerts, who, despite an apparently restive nature (born in Brussels, he traveled to Rome, returned home, moved to Amsterdam, joined a religious mission to the Orient, and died in Goa), painted extraordinarily forceful yet poetic images. The history paintings include a pair of monochrome paintings from Maerten van Heemskerck's series of twelve panels depicting the *Labors of Hercules* (four others from the same series are at Yale); see also the master's drawing in the collection depicting *King Ahab Sulking in Bed (fig. 306),* one of six drawings for a series of engravings of the story of Ahab.

Surely, though, the outstanding history painting in the collection, indeed one of the greatest Dutch paintings in America, is Hendrik Terbrugghen's *Saint Sebastian Attended by Saint Irene (color plate 7)* of 1625. The two devout women imperturbably unbind the saint's tethered wrist and gently set about the task of removing arrows from his body, which has turned a ghastly greenish hue. Despite the grisly

306

subject, the work is riveting in its power and beauty. The slumped Sebastian, reminiscent of Christ as the Man of Sorrows, and the beturbaned Irene, who kneels beside him, have sources in Dürer and Italian art. But Terbrugghen's greatness lies not in his capacity to absorb influences but to make of them something new and transcendent.

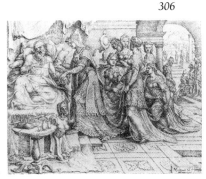

Dutch history painting of almost a

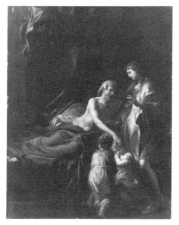 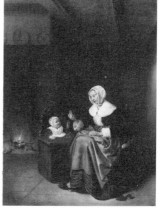

307 308

century later is represented by *Jacob Blessing the Sons of Joseph* (fig. 307) of c. 1720–22 by that underrated classicist Adriaen van der Werff. When the picture was in the collection of the Hohenzollerns, it had a pendant, now lost, of Isaac blessing Joseph. The two biblical themes are related through their shared depiction of a paternal blessing which falls, seemingly erroneously, to the younger son rather than the first born, but which is subsequently justified in inscrutable ways. One interesting technical note: This smoothly executed work painted at the very end of the artist's life is one of the earliest paintings to employ Prussian blue, a pigment that has been used to expose pastiches and forgeries of reputed seventeenth-century paintings.

Allegorical genre is offered in Adriaen van de Venne's depiction of a crippled man in tattered clothing carrying on his shoulders an equally disheveled woman and child. The banderole at his feet is inscribed "'t Sijn ellendige beenen die Armoe moetē draegē" (it is miserable legs that must bear poverty). A companion, now lost, was an allegory of wealth rather than poverty and was inscribed "it is strong legs that can bear wealth"; compare a similar pair of pendants by van de Venne in Springfield. Whether Quirin van Brekelenkam's charming *Mother and Child in an Interior* (fig. 308) (similar maternal subjects by the artist are in Oslo and Braunschweig) or Jan Steen's *Merry Company* bear such explicit messages is unclear; however, they offer potential exemplars of opposing human conduct, the former exemplary in its domesticity and the latter cautionary in its dissoluteness. A drawing of 1689 by Steen's closest follower, Richard Brakenburgh, depicts one of his mentor's favorite genre subjects, *The King Drinks,* and shares Steen's delight in, if not skill in rendering, varied human types.

Only specialists are likely to recognize *The Bakery Shop* (the enormous loaf at the right was baked on Saint Nicholas Day) as a work by Job Berckheyde, a painter better known for his cityscapes and architectural paintings. The only work of the latter type in the collection is Emanuel de Witte's *Interior of the Oude Kerk, Delft* of 1653 or 1655. Eighteenth-century

Dutch art is sparsely but adequately represented by several drawings. These include a fine pen sketch (*fig. 309*) by Jacob de Wit which only recently has been identified as a study for a lost ceiling decoration of c. 1751 of *Zephyr and Flora,* originally installed in the De la Court family's mansion on the Rapenburg in Leiden. The nineteenth-century offerings include Hague School landscapes and figure studies by Israëls, Maris, Mauve, and Weissenbruch. The most interesting is Jacob Maris's *Bridge,* which is related to other versions of the theme in, among other places, the Johnson and Frick collections.

309

NORTON SIMON MUSEUM

Colorado and Orange Grove Boulevards
Pasadena, California 91105 (213) 449-6840

Norton Simon is the most successful American collector of Old Master paintings alive today. Competing not only against other wealthy individuals but also museums commanding vast purchase funds, Simon has bought better paintings in the last twenty-five years than any other collector, curator, or director in this country. The proof of this grand claim is now housed in the former Pasadena Art Museum, founded in 1924 and reorganized and refinanced under Simon's leadership in 1975. Following his takeover, the museum's modern-styled building (designed by Ladd and Kelsey, 1969) was internally remodeled to receive his extensive collections. The holdings include not only outstanding Northern European paintings, but also superb Spanish and Italian works, French art of the seventeenth to twentieth century (notably an outstanding Impressionist collection), monumental Western sculpture, tapestries, excellent prints and drawings, as well as one of the greatest collections of Indian and South East Asian sculpture in the world. No complete catalogue of the collection exists, but a special issue of *Connoisseur* magazine (November 1978) was devoted to its holdings, and a picture book of *Selected Paintings* appeared in 1980.

As the creator of a huge and variegated business empire, Simon not only amassed a fortune but also developed formidable drive and acquisitiveness. Early in his career he learned the value of expert advice, and his practice of seeking out informed opinions before acting on a purchase is legendary. These instincts doubtless were partly behind his purchase in 1964 of the art-dealing firm begun in the last century by the former Lord Duveen. This acquisition provided him with a stock of paintings as well as an extensive archive of photographs and correspondence with collectors. He gained an insider's view of the machinations of the dealing world. The Simon collection began modestly and conventionally enough with a few Impressionist works but soon grew into a broadly representative survey of the high points of Western painting, including stunning works by Giovanni de Paolo, Raphael, Jacopo Bassano, Dirck Bouts, Lucas Cranach, Zurbaran, Rubens, Claude, Tiepolo, Goya, Manet, Renoir, Monet, Degas (a special favorite), and Picasso. Although reputed to be a difficult man, Simon clearly has put his demanding and fiercely acquisitive instincts to better use than many other men of comparable wealth. Inevitably, comparisons favorable to Simon will be drawn with J. Paul Getty's collections in nearby Malibu. In the field of Dutch art, Edward Carter's collection is perhaps stronger in some respects, but not so varied. In truth, one must look abroad for individuals (Baron Thyssen-Bornemisza? Lord Samuel?) who, in our time, have been as avid and uncompromising in their pursuit of great art. The Norton Simon Museum, therefore, is an extraordinary monument to the tastes of one extraordinary man.

Dutch art forms only a fraction of the collections but is fully representative of their quality. An exceptionally rare work is the *Allegory of "Natura"* of 1567, a late painting by Maerten van Heemskerck (compare his earlier *Abduction of Helen* in the Walters Art Gallery and the *Mount Helicon* in Norfolk). The painting depicts an imaginary landscape with tiny figures on a long, narrow format. Characteristic

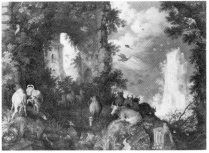

310

of the Mannerist Heemskerck is the learned allegorical program. At the center of the idyllic scene is a statue of Diana of Ephesus, goddess of growth and fertility, inscribed "Natura" (Nature), and surrounded by statues personifying the Four Elements. Representative of a later phase of Mannerism, Cornelis van Haarlem nevertheless perpetuated its allegorical and classical themes, as witnessed in his small copper of the *Marriage of Mars and Venus* dated 1599. An excellent bronze sculpture of c.1575 depicting *Mercury* by Wilhelm Davidsz van Tetrode offers an example of Mannerism's suave forms in three dimensions. Landscape too had its Mannerist practitioners. Roelant Savery's *Landscape with Ruins and Cattle* (fig. 310) exhibits an elaborate lushness that must have seemed slightly *retardataire* when it was painted in 1624; painters in Haarlem, such as Esaias van de Velde, had been painting landscapes for nearly a decade in the newly fashionable naturalistic manner. Yet Savery's artful vision, which earlier had so pleased his chief patron, Emperor Rudolf II in Prague, probably retained an aristocratic appeal. Artists like Wttewael, we recall, found a ready market for their Mannerist works long after the style had run its course.

In spite of these exceptions, the new empiricism—that indefatigable curiosity about the natural world that characterized so many of the seventeenth-century Dutchman's achievements in, among other fields, commerce, science and medicine—quickly infused Dutch art. Perhaps nowhere are these developments so clear as in the still lifes that began to appear shortly after the turn of the century. In the two flower still lifes in the Simon collection by that patriarch of Dutch flower painters Ambrosius Bosschaert the Elder, each rare and costly blossom is observed with unflagging scrutiny. Similarly, in the splendid *Still Life with Fruits and Flowers* (fig. 311) by Bosschaert's brother-in-law, Bartholomeus van der Ast, the individual shells, insects, and sea creatures are studied with clinical exactitude. Though less concerned with the pictorial unity sought by later Dutch artists (compare the *311*

excellent still lifes in the collection by Jan Davidsz de Heem [dated 1654] and the gifted woman painter Rachel Ruysch), these artists were interested in more than verisimilitude and fact gathering; Bosschaert deliberately selects flowers of different seasons, and van der Ast never fails

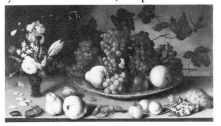

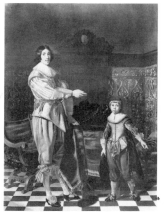

312

to include comparable references to transience and decay—the fallen petal, the spotted fruit, the gnawing beetle.

The Dutchman's meticulous record of the real world included likenesses of his own people; portraiture was one of Dutch painting's greatest accomplishments. Yet this art form has long suffered from the accusation (the effect of which is readily demonstrable in today's art market) that it is only face painting, pandering to vanity, hence of less importance than history, landscape, or other forms of painting. Portraiture naturally is liable to pressures from patron/portraitist relationships that have the force of personality behind them. By the same token, however, these forces lend portraits their peculiar power. More than mere likenesses, good portraits are interpretations of character. They have an identity independent of the artist; the visage, even if unknown, brings an age vividly to life as no other art form. Unlike many modern collectors, Norton Simon has recognized the importance and special attraction of Dutch portraits and owns them in quantity.

Among the earlier examples are a pair of half-length pendants by Thomas de Keyser as well as a charming small-scale, full-length *Portrait of a Man and Boy* (fig. 312) dated 1631 by the artist. Here too is a small oval *Portrait of a Woman* by Gerard Dou and an unusual full-length *Portrait of a Man* by Jan Miense Molenaer, an artist better known for his genre scenes. The compelling immediacy that might be attained even within the strictest conventions of pose and format is demonstrated by Johannes Verpronck's *Portrait of a Lady* dated 1641. The lady with the gay, open smile has traditionally been identified as the wife of the artist Thomas Wijck, but that assumption now is questioned; the couple were only married in 1644. A still more spirited portrait, which, curiously has also been identified with more than one sitter, is Frans Hals' *Portrait of a Man* (fig. 313) datable around 1655–56. Writers have sought unsuccessfully to attach the name of

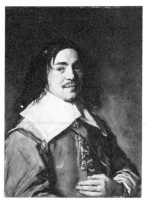

313

the Haarlem painter Vincent Laurensz van der Vinne or Jan van de Capelle to the man. In truth, there is probably no better reason for assuming that this dashing figure in a yellow jerkin is an artist than his "romantic," touseled appearance. No one, on the other hand, would be likely to conclude that the staid *pater familias* in the *Family Portrait* of 1656 by Nicolaes Maes was a painter by occupation. Yet, here again, we have no certain information beyond the fact that the family probably lived in Zwijndrecht, a village opposite Dordrecht, whose Grote Kerk can be

seen across the river visible through the window of this picture. A fascinating contrast with Maes' sober group is provided by the courtly later *Family Portrait* of c. 1671 by Jacob Ochtervelt. The latter is as elegantly ostentatious as the former is self-effacing.

High points of this fine group of portraits are, of course, the trio of Rembrandts. The early oval *Portrait of a Bearded Man in a Wide Brimmed Hat* dated 1633 sold with its less interesting mate as recently as 1960. Fine as the handling is of his tall ruff, the portrait seems routine in the company of the great

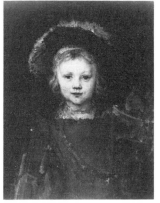

314

Self-Portrait of the later half of the decade. Surprisingly, this work was attributed to the Rembrandt pupil Govaert Flinck in an eighteenth-century engraving by Le Sueur. However, as Gerson has so astutely observed, Flinck was a saleroom favorite at that time, with the result that an astonishing variety of pictures, including Vermeer's *Girl Reading a Letter* now in Dresden, were misattributed to him. Clearly there is no cause to doubt the authorship of this work or that of the charming later *Portrait of a Boy* (fig. 314) usually assumed to be the artist's son, Titus. Decked out in rich finery (Rembrandt's studio props?) the beautiful child is beguiling. In addition to these paintings, the collections offer an outstanding selection of Rembrandt's prints, including impressions of all the landscapes and such famous works as the *Self-Portrait Leaning on a Stone Sill* (fig. 315) of 1639, *The Three Trees* of 1643, and the *"Hundred Guilder Print"* of c. 1649. Painters who were also great printmakers—Rembrandt, Goya, and Picasso—are particularly well represented in the collections.

Several Dutch landscapists fare very well. It is unusual, for example, not only to own a mature work by Salomon van Ruysdael, the well-preserved *Halt before an Inn* of 1643, but also a painting from the artist's early career, the *Dune Landscape with Sandy Road* (fig. 316) of 1628. The contrasts of

315

light and shade in this stormy scene coupled with the daring design (the darkened form of the sandy mound in the foreground dominates all other motifs—figures, a horsecart, cottages, etc.) distinguish this little panel as one of the most pleasing Dutch pictures in the collection. Salomon's nephew, Jacob van Ruisdael, is also shown to advantage with two works, a modestly scaled panel depicting a *Wooded Landscape with a Pool* and the monumental *Three Old Birch Trees* (fig. 317). While the former exhibits all the naturalistic observation for which the Dutch, and Ruisdael as their preeminent land-

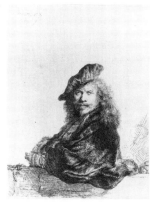

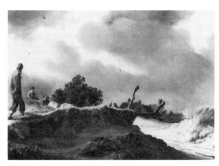

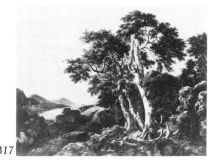

317

316

scapist, are justifiably famous, the *Three Old Birch Trees* has a heroic grandeur that surpasses mere realism. The juxtaposition of the large trees with the distant mountain prospect, reminiscent of sixteenth-century *Weltlandschaften,* lends the work an extraordinary power. The painting's impact was undeniable when it was exhibited at the recent Ruisdael exhibition (1981–82). Other noteworthy landscapes in the collection include an imaginary *Panoramic Landscape* in the tradition of Hercules Seghers by Jan Lievens (see also Lievens' *Portrait of a Man*), a charming *Winter Scene with Figures Playing Golf* by Aert van der Neer, and a *River Landscape with View of Overschie* dated 1642 by Jan van Goyen. In a somewhat oversized canvas of *Evening Meadows with a Woman Milking a Cow* Albert Cuyp falters slightly, but the painting's limitations are only exposed by the consistently high quality of the works that surround it.

Among the genre paintings are two exuberant peasant scenes by the van Ostade brothers, Isack's *Peasants Outside a Farmhouse Butchering a Pig* of 1641 and Adriaen's *Peasants Carousing in an Inn*. One of the artist's favorite themes, Quirin van Brekelenkam's view of an artisan with the tools of his trade in the *Cobbler's Shop* (fig. 318) is an excellent example of his art; note the customer leaning in at the window and compare also his views of other professions, for instance tailors and spinners in Worcester and Philadelphia. In contrast to these images of the lower and working classes, Gabriel Metsu's *Woman at Her Toilette* (fig. 319) depicts a lady of leisure having her hair combed in her boudoir. Like a similar painting (fig. 172) by Jacob Duck in

318

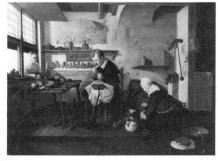

Indianapolis, this delicately painted work may include *vanitas* allusions. In Duck's painting the young woman plays music as she examines herself in a mirror in the presence of an older woman; here the viola da gamba is laid aside in the foreground. The ideas of transience and fleeting beauty are only implied in Metsu's work, while the Duck is more explicit, even including a death's head. Metsu's greater subtlety and refinement, both in

his painting technique and his approach to his subject matter, reflect advances and refinements in the art of Dutch genre painting.

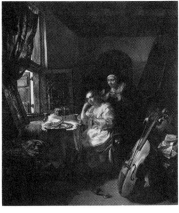

Outwardly, Jan Steen's *Love Letter* would also appear to be nothing more than a piquant little genre scene depicting an old crone delivering a *billet-doux* to a richly attired, rather languorous young woman. Yet, upon closer inspection, we detect the tiny figure of a man on a balcony in the distance. This undoubtedly is King David who awaits the reply

319

to his portentous missive to Bathsheba. Steen depicted this biblical theme in the guise of genre several times (see, for example, the painting in the Richmond Museum), occasionally even inscribing Bathsheba's name on the letter; another genre-like painting in a private collection bears the salutation "Alderschonste Barsabe—omdat" (Most Beautiful Bathsheba—because . . .). More explicitly didactic than many of his contemporaries, Steen often inscribed the meanings or morals of his works into his scenes. For example, in another Steen in Pasadena a young woman in bright red stockings has passed out and is carried uproariously from the tavern door in a wheelbarrow; over the door an inscription from Proverbs chapter 20 appears, "De Wijn is een spotter" (wine is a mockery). Wine is again a central theme in Steen's *Wedding Feast at Cana* where the celebrants proceed with their hilarity paying no heed to Christ, who miraculously changes water into wine. One of Steen's favorite biblical subjects, the Marriage at Cana may have appealed to him not only because it was Christ's first miracle but also because it offered an opportunity to present his inexhaustible cast of human types and anecdotal details. The fourth Jan Steen in the collection, his *Antiochus and Stratonice,* also illustrates this genius for storytelling and characterization.

Other noteworthy Dutch history paintings include a handsome candlelit scene of the *Mocking of Christ* by the Caravaggesque painter Matthias Stomer and another half-length composition depicting *The Denial of Saint Peter* by the italianate artist Karel Dujardin (see his *Hagar and Ishmael in the Wilderness* in the Ringling Museum). The classicizing aspect of the latter work takes a lighter and more bouyant form in an important late *Pastoral Scene* dated 1679 by Nicolaes Berchem. Such a work supports Berchem's reputation as the great forerunner of the Rococo; his gentle, idyllic scenes of shepherds and herdswomen with their flocks often seem to anticipate Fragonard and Boucher. The actual Dutch eighteenth-century paintings of the collection include, in addition to a very late and very curious *Library Interior with a Still Life of Globes and an Atlas* by the cityscape painter Jan van der Heyden, two excellent history paintings in impeccable state by the artist and writer Gerard Hoet, *Achilles Taking Brisais Back to Her Parents* and a *Festival in Honor of Mercury.* This type of academic classicism scarcely reflects modern tastes

320

in Dutch art, affirming instead Simon's com-
mendable willingness to pursue quality even
into unconventional areas of collecting.

The collection's several van Goghs range
from a grim and subdued *Winter Scene,* also
known as *The Cemetery,* painted in 1885, to a
wildly expressive *Mulberry Tree* executed four
years later. Complementing the early Dutch
portraits are van Gogh's outstanding *Portrait
of Patience Escalier* painted in Arles in August
1888 and his *Portrait of the Artist's Mother*
painted two months later. Escalier was a cow-
herd from the Camarque who had become
a gardener but was described by van Gogh as "a sort of man with a hoe"—
a reverent allusion to J. F. Millet's famous icon of the peasantry. While
Escalier was painted from life, Van Gogh's tender portrait of his mother (*fig. 320*)
was based on a photograph, of which he wrote, "I cannot stand the
photograph without any color and I am trying to make a portrait with
harmonious colors, just the way I remember her." Mondrian's late *Composi-
tion with Red, Yellow, and Blue* of c. 1939–42 is also an experiment of sorts
in color. With calculated daring, the artist moves all of the rectilinear color
forms to the edges of his picture, exploring its parameters and limits, while
leaving the center a stark gridwork of white and black. The edge of the
canvas and its implications for the painting as a real object instead of
imaginary window has, of course, profound implications for the theory of
modern art.

A trip to the Norton Simon Museum should be coupled with a visit to
the Huntington Library, Art Gallery and Botanical Gardens situated nearby
in San Marino. The collections of English art are some of the finest in the
world, including Gainsborough's *Blue Boy,* Lawrence's *Pinkie* and Reynold's
Mrs. Siddons; however, included in the Adele S. Browning Memorial Collec-
tion (acquired in 1978) are French and Italian eighteenth-century paintings
and Rembrandt's *Lady with a Plume* dated 1636.

PHILADELPHIA MUSEUM OF ART

26th Street and Benjamin Franklin Parkway
Philadelphia, PA 19101 *(215) 763-8100*

The Philadelphia Museum of Art is the largest repository of Dutch painting in the United States, claiming nearly three hundred works from the seventeenth century alone. The vast collections include ten Jan Steens, nine Jacob van Ruisdaels, outstanding paintings by Saenredam and Terborch, as well as superior works by the later Hague School, Jongkind, van Gogh, and Mondrian. Yet for all its wealth, Philadelphia owns not a single Frans Hals, no Vermeer, indeed no certain Rembrandt. The joy of the collections is in their depth. The museum is unrivaled on this continent in offering excellent works by Dutch painters of lesser renown, artists of the type whom the nineteenth century without derision called "little masters." Witness, for example, the paintings by Christoffel van den Berghe, Cornelis Lelienbergh, Willem Duyster, Jan Pynas, or Frans van Mieris. The study collection and storerooms are filled to bursting with cabinet-sized Dutch pictures in numbers that can only be rivaled by the great depots of European museums. It is a connoisseur's dream and a cataloguer's nightmare. Apart from the omissions (history painting and Dutch italianate art) customarily encountered in American collections formed chiefly in the early decades of this century, the full range and achievement of the art of the Netherlands is here represented.

The Philadelphia Museum of Art was founded in 1875 and took up residence two years later in Memorial Hall, the original Art Gallery of the U.S. Centennial Exposition of 1876 which still stands in Fairmount Park. In the early years benefactors were scarce, but in 1893 the widow of William P. Wilstach, whose money came from saddlery and hardware, bequeathed 150 French and American nineteenth-century paintings. Of greater lasting importance than the original Wilstach paintings, many of which were sold with few regrets, was the W. P. Wilstach purchase fund. The fund's administrators quickly set to work filling cavernous Memorial Hall with big pictures; in the first dozen years monumentally scaled canvases by, among others, Zurbaran, Hondecoeter, Snyders, Ruisdael, and de Vos were purchased. Happily the early advisers had discriminating as well as expansive tastes; many of these works remain highlights of the collection today.

In the early 1920s George W. Elkins and his son William L. Elkins bequeathed their collections of Dutch and European paintings. These passed to the new Museum Corporation then constructing a new museum building on the promontory at the entrance to Fairmount Park, the former site of the city's reservoir. Completed in 1928, this massive neoclassical structure, the largest (and virtually the latest) example of its kind, today appears outwardly much as it did when it opened. Its interior, however, reflects the changes administered during the thirty-year reign (1924–54) of its director, Fiske

321

Kimball. A historian of architecture and interior design, Kimball left his mark indelibly on the institution. It was his desire that great art be viewed in its architectural context. Thus he acquired and installed a Buddhist Temple from China, a sixteenth-century Indian pillared temple hall known as the Mandapam, a room from the Chateau Draveil (1720–25) near Paris, a drawing room designed by Adam for Lansdowne house, and, of special interest for the present reader, a tiny Dutch seventeenth-century interior from Haarlem known as the "Little Boat" (fig. 321). Philadelphia is renowned for its "period rooms." While this type of contextual installation fell out of favor toward the end of Kimball's career, it recently has regained advocates. Much, obviously, is sacrificed by the "modern" practice of hanging works in isolation. The complementary effect of paintings installed with decorative arts is once again appreciated.

Although large parts of the collections have been incorporated into a review of the history of Western art, several discrete collections hang separately. What is sacrificed in chronological order is partly offset by the opportunity to study the tastes of individual collectors. Most notable among these is John G. Johnson, a Philadelphia lawyer who, at his death in 1917, bequeathed to the citizens of the city of Philadelphia nearly twelve hundred Old Master and nineteenth-century paintings. Although Mr. Johnson's love of bargains sometimes led him to acquire works of dubious authorship, his stunning triumphs secure his memory; van Eyck's *Saint Francis Receiving the Stigmata* and Rogier van der Weyden's *Crucifixion with the Virgin and Saint John*, together with the museum's own Rubens, Poussin, and Cézanne, are the stars of the Old Master collection. Johnson loved Dutch paintings and bought them voraciously. Though a connoisseur in his own right, he had the advice of, among others, the great Cornelis Hofstede de Groot and his then young protege, W. R. Valentiner, who together assembled the collection's first catalogue (1914). The most recent (1972) catalogue of Johnson's Flemish and Dutch paintings was compiled by Barbara Sweeny. The *Checklist of Paintings* in the museum's own collection was published in 1965. A completely revised and fully illustrated checklist is being compiled at present. Moreover, the present author's new catalogue of the museum's Northern paintings other than those in the Johnson Collection will appear shortly.

The Early Netherlandish paintings in Philadelphia, as we have indicated, are exceptionally rich. Outstanding among the northern Netherlandish works are a charming large panel with *Scenes from the Life of the Virgin* (fig. 322) by the Haarlem circle Master of the Tiburtine Sibyl (note the simultaneous depiction of several different episodes of the narrative and richness of details like the rabbits in the landscape), an important *Crucifixion* by Jan Mostaert,

and a scene of *Saint John Preaching, with a Scene of Christ and His Disciples* by the Master of the Saint John's Altar. The last mentioned is thought to have been Lucas van Leyden's father and teacher. Two panels in the Boymans Museum in Rotterdam are by the same hand, and the three together formed part of a large altarpiece devoted to the life of Saint John. A small painting of the *Beheading of Saint John* has in the past been assigned to Lucas himself. Although it closely resembles his exotic figure types and distinctive, acrid palette, it now is generally thought to be by a close follower. Lucas's printmaking, however, is

322

well represented in the Printroom with outstanding impressions of such prints as his *Raising of Lazarus* and the recently acquired *Dance of Mary Magdalen (fig. 323)*. Sixteenth-century Dutch art typically is less abundant. A handsome if rather stern *Portrait of an Elderly Woman* has been assigned to Heemskerck in the past but now is usually attributed to the Master of the 1540s (Meister der Vierziger Jahre), an artist from his immediate circle. The strengths of the Flemish and Italian pictures of these years are stronger.

Seventeenth-century Dutch art, on the other hand, is astonishingly plentiful. Certainly one of the greatest paintings in the Johnson Collection is Christoffel van den Berghe's *Flower Still Life (see color plate 5)* of 1617, one of the rare signed and dated works by this gifted but little-known Middelburg painter (compare Norton Simon's painting). As is often the case in these early still lifes, the artist seems intent upon demonstrating his botanical, conchological, and entomological erudition in depicting blossoms from different seasons, shells from different oceans, and an assortment of butterflies and insects. An interesting footnote to this picture was provided by the discovery of ceramic cups of the Wan Li type, exactly like the one depicted at the lower left, in the hold of the Witte Leeuw, a Dutch East India ship that was sunk by the Portuguese off the island of St. Helena in the South Atlantic just four years before this painting was executed. Several writers have commented on the potential for *vanitas* symbolism in the work, not

323

only in the perishable living things but also in the crumbling niche in which they are placed. A fine Pieter Claesz breakfast still life (*ontbijtje*) was purchased by Johnson, but generally he acquired more and better still lifes from the middle and later years of the century. Both of Willem Kalf's still-life manners are represented—his modest kitchen interior type (compare the little panel by Duifhuisen formerly assigned

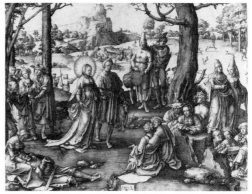

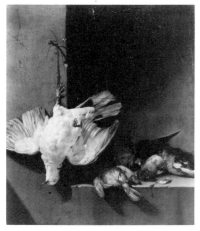

to Sorgh) and far grander *pronk* still-life style. Similarly, van Beyeren is presented with both his banquet and humbler fish still lifes (compare the Alexander Andriessens in the collection), and Hondecoeter is shown not only to have painted simple compositions of dead fowl but also monumental, decorative pieces of live birds, both with exotic fowl and common poultry in parklike settings. Other dead game pieces include exceptionally good works by Hendrik Fromantiou, Cornelis Lelienbergh (*fig. 324*), and Jan Weenix. Late ban-

324 quet pieces by van Beyeren, Kalf, Pieter de Ring, and Cornelis (not Jan Davidsz) de Heem are also noteworthy.

While Dutch artists are notorious specialists, the depth of Philadelphia's collections enables the viewer to examine their unforeseen variety. For example, Jan Steen's strengths not only as a comedian and moralist in genre but also as a history painter and landscapist can here be studied. Similarly, Ruisdael's varied interest in landscape, from the wonderfully simple, early scenes of the dunes around Haarlem (*fig. 325*) to his mature dunescapes, winter scenes, northern waterfalls, panoramas, and marines, are all available. The varied aspects of the landscape careers of van Goyen and Salomon van Ruysdael are well represented with four paintings each. Particularly lovely is Salomon's large panel of 1661 with *Drovers on a Road and Travelers before an Inn* (*fig. 326*). Although none of the sunny landscapes for which Albert Cuyp is best known are found here, his early landscapes in a more "tonal" manner (see the charming *Landscape with Hicking Horse*) as well as his efforts in marine painting and portraiture are represented. Cuyp's follower Abraham Calraet likewise is presented not only as a painter of landscapes with animals but also as a still-life painter. For the connoisseur, there is the opportunity to examine a varied group of works by Govert and Joachim Camphuysen (special interests of Hofstede de Groot) as well as landscapes

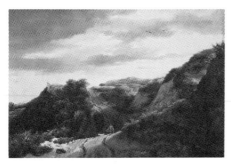

325

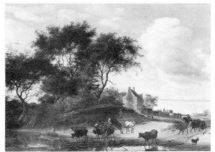

326

by lesser-known artists such as Hendrik ten Oever and Nicolaes Ficke (the latter possibly by Adriaen van Eemont).

Yet the greatest landscapes in the collection are by more familiar names. Besides the Ruisdaels, one must mention Hobbema's impressive *Wooded Landscape with Cottages (fig. 327)* of 1662, an outstanding example of his art and one of the earliest dated works to attest to the influence of his teacher, Ruisdael. Similarly, Paulus Potter's *Landscape with a Stable (fig. 328)* of

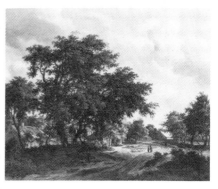

327

1647 is a superb and exceptionally well-preserved example of the painter's fresh and unpretentious style. How vividly the fragile tree and bright little vista at the left convey the sense of an early spring day. No less compelling is the bracing image of winter in Adriaen van de Velde's small *Winter Landscape (fig. 329)*. Other superior landscapes in the collection are Jan Wijnant's *Dune Landscape* and two works by Philips Wouwermans. Vastly outnumbered though they are by native Dutch realist landscapes, the two small italianate landscapes by Nicolaes Berchem and Karel Dujardin are also worthy of note.

An especially lovely and delicate marine is Simon de Vlieger's *Ships in a Calm Harbor (fig. 330)*. Its tranquillity contrasts with the drama of light and movement in the collection's two paintings of rough seas by Willem van de Velde II and Jacob van Ruisdael. Pitching and tossing in stormy waters, the small vessels in these scenes not only remind us of the Dutchman's fame in constructing light, maneuverable ships, but his reputation as a skilled and courageous sailor. Though the Dutch merchant marine fleet was the largest and most efficient in the world at this time, riding out a storm in one of these tiny vessels must have been a hair-raising experience. Other noteworthy seascapes in the collection are by Backhuysen, Bellevois, Albert Cuyp, and Lieve Verschuier.

329

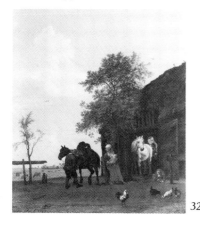

328

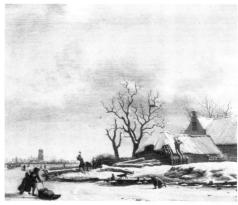

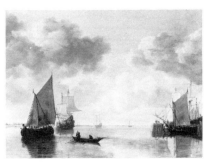

Among the handful of Dutch cityscapes in the collection is Daniel Vosmaer's *View of Delft after the Explosion of 1654.* It shows the devastation that occurred when a powder magazine accidentally ignited, razing a whole section of the town and killing, among others, the artist Carel Fabritius. The painting serves to remind us of two aspects of the history of cityscape painting, namely the important role that

330 Delft played as a center of these developments and the early practice of painting cityscapes as commemorative works, for instance to record a lost edifice or some momentous event such as the burning of the Old Town Hall in Amsterdam. Jan van der Heyden must be reckoned among Holland's greatest cityscapists. His *View of Veere* is one of several paintings he executed of the Grote Kerk in this town in the province of Zeeland. The effect of naturalism is here created by an impeccable balance between the record of minutia, individual bricks and cobblestones, and the overall effect of the design, light, and atmosphere. It is a testament to the artist's powers of invention that he achieves a similar naturalistic effect in his *Landscape with Romanesque Church,* an entirely imaginary composition. Other cityscapes in the collection include Gerrit Berckheyde's *Mill on the Wall of Haarlem with the Gate of the Cross* and a somewhat abraded view of an unknown street by Jacobus Vrel. The architectural paintings include two views of the interior of the Oude Kerk in Delft by Hendrik van Vliet and Hendrik van Streeck.

These rather mediocre later architectural paintings, however, can hardly compare with the achievement of Pieter Jansz Saenredam's *Interior of St. Bavo's in Haarlem (fig. 331)* signed and dated 1631, probably the greatest single Dutch painting in Philadelphia. A view down the center of the choir to the nave, this meticulously conceived work captures all the majesty of the splendid structure, with its towering ceiling and rhythmic procession of whitewashed columns. The staffage (probably by Pieter Post) are dwarfed by the monumental proportions of the church, but the spaces themselves and the colors of the stonework (shades of white, cool pink, and light gray) are

331

in perfect accord. The perspective here, as so often in Saenredam's work, was carefully worked out well in advance of the painting's execution. A finely finished preparatory drawing, now preserved in the Municipal Archives in Haarlem, which also served as a model for an etching to illustrate Samuel Ampzing's *Description of Haarlem* (Haarlem, 1628), not only is a detailed transcription of the architecture but includes a line marking the eye level

of the viewer and the yet-to-be-included staffage as well as the vanishing point to which all the perspective lines converge. The drawing is inscribed "this drawn in 1627. in the great church in Haarlem, from life," thus was executed four years before the painting. Despite Saenredam's fastidious working methods—he even employed measured plans—he would not hesitate to deviate from his preparatory study for a desired effect. Here, for example, the soaring height of St. Bavo's ceiling is deliberately exaggerated.

332

A large group of seventeenth-century Dutch portraits are found in Philadelphia. These include an excellent quality double portrait of a *Woman and a Child* in starched lace and their best finery by Jan Antonisz van Ravesteyn, a pair of pendant portraits by Ravesteyn's Leiden contemporary Pierre Dubordieu, depicting *Pieter de la Court* (father of the famous political economist) and his wife, *Jeanne de Planques* dated 1635, and other noteworthy single-figure portraits by Hendrik Bloemaert, Thomas de Keyser, Jacob Willemsz Delff, Jacob Backer, and Bartholomeus van der Helst (*Michiel Heusch,* dated 1653). Formerly assigned to Bartholomeus, the large double *Portrait of a Man and Woman Seated out-of-Doors (fig. 332)* has been reattributed to the artist's son and follower, Lodewijk van der Helst, but the downgrading has hardly diminished this stout couple's popularity with museum visitors. Another notable double *Portrait of a Man and Woman* that can be easily overlooked is Frans van Mieris's finely executed little panel of 1675 depicting a couple just departing their house for an evening promenade. The lovely, small-scale *Portrait of a Girl Holding an Orange* (dubiously identified as Princess Maria Henrietta of Orange) on copper, formerly attributed to Jan Mijtens and now assigned to Isaac Luttichuys, is exhibited among the museum's large miniature collection.

Until recently a relatively neglected area of the collection was Dutch history painting. Johnson and Philadelphia's other early benefactors eagerly collected Dutch paintings depicting the countryside of Holland and everyday themes but avoided pictures dealing with literary subjects. Evidently such themes did not accord with the nineteenth century's view of Dutch painters as archetypal realists intent only upon recording the "here and now." However, as we have seen, Dutch painters also delighted in representing biblical and mythological themes. Indeed Dutch art theorists promoted history painting as the highest goal to which an artist could aspire. Jan Pynas's *Raising of Lazarus* is the finest example of this particular pre-Rembrandtist's art in America. Not to be confused with his brother, Jacob, who specialized more in Elsheimerian landscapes, Jan, like his more influential colleague Pieter Lastman, was primarily a painter of biblical themes. He also served as one of Rembrandt's teachers. His interest in the human,

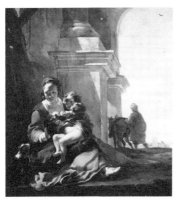

333

psychological dimension of history paint-
ing probably appealed to the young Rem-
brandt. Largely free of rhetoric, Christ's
miracle is here interpreted in very personal
terms. Another gifted painter who, like
Pynas, is today unfortunately better remem-
bered for having been the presumed
teacher of a more famous pupil (in this
case the great Vermeer), is Leonard Bramer.
The *Presentation in the Temple* is a particu-
larly fine example of Bramer's dramatic,
painterly manner. The Johnson Collection
also includes a representation of this theme attributed to Jacob de Wet.
Although the assignment of the *Head of Christ* to Rembrandt is now under
question, at the least it shows a close acquaintance with the master's style,
as does the attractive little *Finding of Moses,* another work that so far has
defied efforts at reassignment. Paintings attributable with certainty to the
artists of Rembrandt's circle include Jan Lievens' early and exceptionally
broadly painted *Old Woman Reading* and, a new acquisition, Gerbrand van
den Eeckhout's *Continence of Scipio* of 1659. Painted the year after the Toledo
Museum's version of this theme, this work adopts the same design but
eliminates the historicized portraits. The celtiberian maiden who has been
returned by Scipio to her darkly handsome fiancé, Prince Aleucus, kneels
in gratitude beside her future husband. Her luminous and pearly beauty
makes the self-denial of the young Roman commander all the more
compelling. An allegory of good government, the Scipio theme was often the
subject of commissions for town halls in Holland.

Another recent acquisition is Jan Baptist Weenix's *Rest on the Flight into
Egypt,* (fig. 333), the first Dutch italianate history painting to enter the
collection. It may be compared with Detroit's painting by the artist which
depicts a secular mother and child also seated before ruins in the Italian
campagna. In the background of the Philadelphia Weenix, Joseph leads the
ass away beneath a monumental arch. In addition to the symbolic apple
and dove held by the Christ child, the suggestion of a cross in the hayloft at
the upper left may prefigure his ultimate sacrifice. One of the Old Testament
figures who prefigured Christ was Moses. The finest Dutch history painting
in the collection is probably Jan Steen's *Moses Striking the Rock,* which depicts
the crowd of thirsting Israelites in all their splendid individualiy, from the
stolid soldier who kneels as he drinks, to the simple family who quench
their child's thirst first, to the elegant lady in satin who drinks from a
precious nautilus cup. Their varied reactions make the miracle all the more
immediate and plausible. A related painting by Steen in Raleigh of the
Worship of the Golden Calf depicts a later episode on the Israelites' journey.
Norton Simon's painting in Pasadena of *The Marriage at Cana* also seems to
reflect Steen's association of Moses' act with Christian baptism, a notion

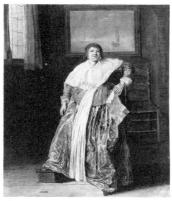

334

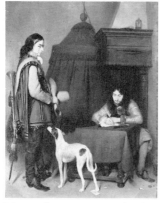

335

supported by Saint Paul's writings (1 Corinthians 10:4); there the source of the water that Christ miraculously turns into wine is a fountain decorated with a figure of Moses holding his rod.

The largest single group of Dutch paintings in the collection is the genre scenes. Johnson, as we have noted, bought these works by the carload. They include both high- and low-life scenes and reflect virtually the full range of genre's development in the seventeenth century. One of the pioneers of cabinet-sized genre scenes was Dirck Hals, brother of Frans. The two panels by Dirck in the Johnson Collection well illustrate his vivacious style. One depicts an elegant young couple seated out-of-doors at a table. Members of the *jeunesse dore* were often portrayed and occasionally satirized by Hals, Buytewech, Esaias van de Velde, and other representatives of the first generation of Dutch seventeenth-century genre painters. The other Hals depicts a rather stout lady comfortably seated in a chair, her foot resting on a footwarmer and a letter in her hand (fig. 334). A similar painting in the museum in Mainz depicts a vaguely distraught woman tearing up a letter. That interior is sparsely furnished save for a stormy seascape on the back wall. In the Philadelphia picture a large painting of a boat on becalmed seas appears. These details seem to suggest that the self-satisfied lady in the Philadelphia picture has received reassuring news, while her Mainz counterpart is a recipient of a discomforting missive.

The theme of the letter proved to be a popular one in Dutch genre, as witnessed in Terborch's so-called *Dispatch* (fig. 335). Here an officer concentrates on the composition of a letter as a messenger with a trumpet stands at the ready. The probability that he is penning a *billet-doux* is supported not only by the existence of a closely related painting in Dijon representing a young woman reading a letter as a rustic courier stands at her side, but also by the appearance of an ace of hearts playing card on the floor in the foreground of the Philadelphia picture. Such potentially symbolic details, like paintings, enabled artists to comment on their scenes. Dutch guardroom paintings abound in Philadelphia. The lovely nocturnal *Soldiers by a Fireplace* (fig. 336 and color plate on cover) is one of Willem Duyster's finest works, as is Jan Olis's *Soldiers Playing Draughts*. Pieter Codde offers a scene of a cavalier with a young woman and old crone (possibly a procuress) which has been

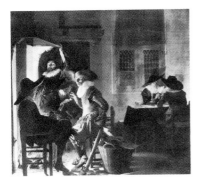

336

politely entitled *The Lovers*. Later soldiering scenes are by Pieter de Hooch, (attributed to) Hendrick van der Burch, and Terborch, the last mentioned depicting a brilliantly painted if rather clamorous scene, dated 1658, of soldiers drinking up as a trumpeter sounds reveille.

Terborch's soldiers' revelry goes uncensured, but Judith Leyster's *Gay Cavaliers* once was the subject of an admonition. An old copy of this work and X-rays confirm that a skeleton with an hourglass originally appeared between the two drinkers only to be transformed by a later hand (no doubt at the behest of a collector with little taste for old-fashioned moralizing) into a stool with a candle. Low-life genre, to which guardroom scenes usually belong, is represented in the Johnson Collection by that pioneering figure from Flanders who was active in Haarlem, Adriaen Brouwer. The *Pancake Baker* is one of the earliest paintings by this rare master. Its coarse power, brutal figure types, and strident colors present an image of low life very different from the work of Brouwer's follower, Adriaen van Ostade. The latter's peasants sing and dance not unlike their social betters (see Ostade's *Musical Company* of the 1650s), indeed seem the very image of rural prosperity as they lean contentedly on their halfdoors or out vine-covered cottage windows.

Although scenes of leisure and revelry were more common, Dutch genre painters also depicted labor and professions. Characteristic of Quirin van Brekelenkam's art is *The Tailor* and *Woolspinner and His Wife*. Typical too is Cornelis Decker's depiction of a *Weaver* (a subject that van Gogh would treat two centuries later) and the *Chaff Cutter and His Family* by Caspar Netscher, one of the earliest and best works by this artist. Domestic scenes such as Nicolaes Maes's lovely painting of a *Woman Plucking a Duck* (fig. 337) also constitute images of work, although here the full glass of wine and pitcher

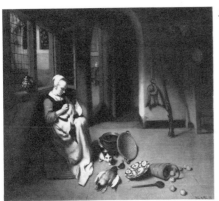

337

338

that appear on the table seen through the open door in the background may discreetly allude to leisure's temptations. The *Village Surgeon*, presently assigned uncertainly to Johannes Natus, deals not so much with a profession, though barber-surgeons could be found in virtually every town, as with a stock comic type not unlike the foggy physician in Jan Steen's splendid *Doctor's Visit (fig. 338)*. The latter painting is certainly one of the greatest genre scenes in the collection. Steen's interest in comic theatrical types relates to his repeated depiction of *rederijkers*. The scene of four mugging *Rhetoricians at a Window*, in which one of their number delivers a recitation, enables us to understand why by the mid-seventeenth century members of these amateur theatrical societies won a greater renown as rowdy, unlettered merrymakers than as thespians. The escutcheon below the window is inscribed with the group's motto "Ieucht nemt in" (Youth is Attractive) and emblazoned with a wine glass and crossed pipes. The work may be compared with Worcester's version of this theme. Other piquant genre scenes by Steen in Philadelphia include the early *Fortune Teller*, the *Skittle Players*, and the *Toast of the Pregnant Hostess*. Philadelphia, in fact, owns more works by the artist than any other museum outside Holland. The museum's *Bulletin* (Winter 1982–Spring 1983) by the present writer was devoted to these holdings. To this wealth of Jan Steens, Johnson even added a representative work by Steen's little-known follower Richard Brakenburgh. Other lesser-known Dutch genre painters also represented by good works in the collection are Bega, Boursse, Diepraem, Dusart, Jan Miense Molenaer, van der Poel, van Tol, and Thomas Wijck.

Philadelphia's strengths in Dutch genre carry over into the eighteenth century and even to some degree to the nineteenth-century collections. Abraham van Strij's so-called *Banker (fig. 339)* is one of the few good works in this country by this talented artist. The landscape painting of cows on the back wall reminds us that Jacob van Strij made numerous imitations of his Dordrecht predecessor Albert Cuyp. Closely resembling but not identical to a painting by Cuyp in the National Gallery, London, the painting within the painting here is not so much the *clavis interpretandi* as the connoisseur's ultimate challenge; is it van Strij or Cuyp?

339

Two other eighteenth-century Dutch genre scenes are by an exceedingly rare painter, Gerrit van Zegelaar. Better represented in this country is the painter of decorative grisailles, Jacob de Wit, whose two *dessus-de-porte* of 1749 and 1750 in Philadephia come from the same house in Haarlem as the large ceiling decoration of *Aurora* now in Sarasota.

Though much inferior to the Italian drawings, which have benefitted from bequests of the art historian Anthony Clark, and others, the Dutch drawings at Philadel-

340

phia have increased in number through the acquisition in 1984 of the European drawings collection of the Pennsylvania Academy of Fine Arts. Among the best sheets is a circular ink and wash drawing, dated 1588, by Hendrik Goltzius (*fig. 340*). Philadelphia's Dutch prints are superior to their drawings, claiming strengths in seventeenth-century landscapes as well as half a dozen notable Rembrandts. The holdings of Dutch ceramics have also greatly expanded in recent years. The museum had previously owned a respectable sampling of both blue and polychrome delftware, including an eighteenth-century garniture, inkstand, butter dish, so-called orange plate, and a *Bliksembord*—literally, a "lightning plate," so titled for its misunderstanding of a Chinese design of a stylized bamboo and waterplant. But it was only in 1979 that the museum began to acquire the extensive collection of Dutch tiles assembled by Francis P. Garvan in the 1920s. This collection constitutes the largest selection in this country of Dutch tiles from the century beginning around 1580. A handsome and scholarly catalogue by Ella Schaap and contributing authors was published in 1984 on the occasion of the exhibition of the entire collection, now in part on permanent display. The collections boast a wide variety of tiles, including floor and decorative wall tiles, some with purely ornamental designs and others with all manner of representational motifs—fruits, flowers, animals, birds, genre scenes, religious subjects, portraits, pastoral themes, soldiers, landscapes, ships, and, some of the most charming, whales, dolphins, and imaginary sea creatures (*fig. 341*). Here too are examples of the large composite tile pictures, depicting decorative urns with flowers (*fig. 342*), animals, commedia del'arte figures, and an enormous commemorative scene, based, like many of these works, on print sources, of the Battle of Ramillies fought in 1706, one of the important military engagements of the War of Spanish Succession. Tiles are

341

342

also installed in the museum's seventeenth-century Dutch period room (*fig. 321*), the finest and virtually the only one of its kind in the United States, from the brewery complex in Haarlem known as *Het Scheepje* (Little Boat). The room is furnished with a large kast, linen press, brass and metalwork of the period. A discussion of its architecture and history was the subject of a museum *Bulletin* (Winter 1984) by Eda Diskant.

The renowned nineteenth-century collections in Philadelphia include a relatively large representation of Hague School artists. The half dozen paintings by Josef Israëls include an early work entitled *The Last Breath* depicting a grieving widow, and a very large but poorly preserved painting of an old man and his dogs called *Old Friends*—a work that was much loved, incidentally, by Vincent van Gogh. The best of the fine paintings by Jacob Maris is an image of *Bridge over a Dutch Canal near Rijswijk,* dated 1872, which relates to a larger painting dated thirteen years later in the Frick Collection, and one of the finest of Maris's many images (the group begun by 1872) of the Schreierstoren in Amsterdam. Here too are works by Matthijs and Willem Maris. Anton Mauve's *Return of the Flock* (*fig. 343*) employs a composition probably descended from Millet, with the shepherd leading the sheep away from the viewer to a high horizon, which the artist repeated with variations in works in Cincinnati, Toledo, New York and elsewhere. Of the six works by Jongkind in the collection, the early *Shipyard* of 1852 (not 1882, as often recorded) is the finest. It depicts an unidentified part of Normandy that Jongkind presumably would have seen during a trip that he took the previous summer with his teacher, Isabey.

Philadelphia has five paintings by van Gogh. These include still lifes ranging from the *Bouquet of Daisies* painted in his Parisian period to one of the seven versions of his famous *Sunflowers* (*fig. 344*) painted in Arles. In all likelihood the Philadelphia version is a replica painted in January 1889 of the version now in Munich. Together with another sunflower painting preserved in the van Gogh Museum in Amsterdam and one of the artist's various versions of the *"Berceuse"* compositions (see Chicago), this work was conceived, according to one of van Gogh's letters, as forming part of "a sort of [secular] triptych." In another later note written from St.-Rémy in 1890, the artist stated that the sunflowers symbolized "gratitude." Since van Gogh hung his sunflower canvases in the room that he decorated for Gauguin, some scholars have speculated that he associated them with artistic friend- 343
ship. While that friendship famously turned sour because of van Gogh's illness, he evidently got on well with the Roulin family, whose members, as we have noted, he painted repeatedly (see Boston's *Postman Joseph Roulin*). Philadelphia owns the *Portrait of Madame Roulin and Her Daughter, Marcelle,* as well as a *Portrait of Camille Roulin*. The former is related to a

344

painting of the same sitters in the Lehman Collection in the Metropolitan Museum of Art, New York. Gauguin's own portrait of Madame Roulin, painted on his visit to Arles, is owned by the St. Louis Art Museum. The Philadelphia drawings also include a fine pen and ink drawing, *Haystacks,* by van Gogh.

With the Louise and Walter Arensberg and the A. E. Gallatin collections, Philadelphia boasts one of the strongest collections of early twentieth-century art in this country. Its holdings of the sculpture of Brancusi and the ironic and influential art of Marcel Duchamp are world renowned. Nearly as distinguished are the extensive group of paintings by Mondrian and other De Stijl artists, such as Theo van Doesburg and César Domela. Of special interest are the group of diamond-shaped canvases, ranging from Mondrian's tightly woven *Composition in Gray* of 1919 to the extremely spare compositions of the late 1920s, both by Mondrian himself (*Composition with Blue* of 1926) and van Doesburg (*Composition 1929*). Domela's *Construction* of painted wood panel and metal strips of 1929 also reiterates these forms by turning the traditional rectangular gridwork design, as it were, on its end.

PHOENIX ART MUSEUM

1625 North Central Avenue
Phoenix, Arizona 85004 *(602) 257-1222*

Situated about one mile from the center of the city in a cultural complex with the city library and the Phoenix Little Theater, the Phoenix Art Museum opened in 1959. A new wing, greatly increasing gallery space, was added in 1965. The collection's strengths are in American and Mexican art but several European paintings are noteworthy. A catalogue of the collection was published in 1965.

The largest group of Dutch paintings are genre scenes. These include representations by Jan Miense Molenaer of *Hearing* and *Touch,* from a Five Senses series (the former personified by a child with a rommel pot, the latter by a child with a cut thumb; compare the Mauritshuis' series), the so-called *Family Gathering* by the Rotterdamer Pieter de Bloot, and Pieter Janssen Elinga's hushed and carefully ordered *Interior with a Girl Playing a Guitar* (fig. 345). The last mentioned closely resembles Janssen Elinga's equally hermetic *Girl Reading* (Alte Pinakothek, Munich) and, like that work,

formerly carried an attribution to the more famous Delft painter Pieter de Hooch. The best Dutch portrait in the collection is Nicolaes Eliasz's (known as Pickenoy) *Portrait of a Woman* of 1631, the best still life, Bartholomeus van der Ast's *Sea Shells* (compare Hartford's painting). Salomon Koninck's so-called *Old Philosopher* is one of the artist's several depictions of an elderly man sharpening a quill, a gesture associated with the need for practice in education. The subject of Jan Steen's late painting of *Theseus with Achelous* (fig. 346) comes from Ovid's *Metamorphoses*. On his return from the Calydonian hunt, the Greek hero Theseus sojourned for a while with the river god Achelous, here seated at the center of the table. While Vondel's Dutch translation of Ovid appeared in 1671, Steen's design has been linked with a print by Martin Bouché illustrating Du-Rijer's French edition of the *Metamorphoses* published in 1677. The later Dutch paintings include works by Jongkind, Kees van Dongen, and Karel Appel.

345

346

MUSEUM OF ART, CARNEGIE INSTITUTE

440 Forbes Avenue
Pittsburgh, Pennsylvania 15213 *(412) 622-3200*

A gift to the city of Pittsburgh in 1890 from the steel magnate Andrew Carnegie, the institute bearing his name was planned as an expansive cultural center complete with music hall and library. The Museum of Art was founded six years later, its art program to be centered around an annual international exhibition which would bring outstanding contemporary art to the city. Indeed, many of the finest works in the collections were purchased from these exhibitions, which continue as an important feature of the institute. A neoclassical building by Longfellow, Alden and Harlow was dedicated in 1895 and an extension added in 1907. The original structure houses exhibition galleries, the ancient and decorative arts collections, as well as the renowned Carnegie Museum of Natural History, where one may pause to admire the skeleton of *Diplodocus Carnegie,* a dinosaur first discovered on an expedition funded by the famous philanthropist. A new wing and sculpture court designed by Edward Larabee Barnes was opened in 1974. It is dedicated to Sarah M. Scaife, who together with her family, was the major benefactor of the museum's strong late nineteenth-century and early twentieth-century French and American paintings collections. Less distinguished are their Old Masters, which nonetheless include some noteworthy Dutch works. A *Catalogue of the Painting Collection* published in 1973 is still available.

Although it has suffered from being transferred from panel to canvas, the portrait by Frans Hals of *Pieter Cornelisz van der Morsch (fig. 347)*, or the so-called *Man with a Herring,* of 1616, is without question the finest old Dutch painting in the collection. The sitter is identified in a water color copy by the eighteenth-century Haarlem artist Vincent Jansz van der Vinne, which is inscribed "Piero, Municipal Beadle of Leiden." In addition to his role as beadle, Pieter Cornelisz van der Morsch (1543–1625) played the part of the

buffoon in performances presented by *De Witte Accolijen,* a Leiden society of rhetoricians. The smoked herring (*bokking*) he holds, once wrongly thought to denote the man's profession as a fisherman or herring merchant, is explained by the expression "iemand een bokking geven," which in Hals' time meant to shame someone with a cutting remark. Thus the painting's inscription "WIE BEGEERT" (who wants it) refers to van der Morsch's readiness to rebuke and ridicule. Studying Hals' vivid portrayal one can well imagine that the sly-eyed sitter had a quick

347

and caustic wit. Other good though far more routine portraits in the collection include female portraits by Jan Anthonisz Ravesteyn (1639), Paulus Moreelse, and Nicolaes Maes (1675).

Although the collections have no outstanding seventeenth-century Dutch landscapes, still lifes, or history paintings, a painting by Jacob Ochtervelt (*fig. 348*) deserves note not only as a good, later (early 1670s) example of this Rotterdam genre painter's art, but also for its subtle use of symbol. Outwardly the picture appears to depict nothing more than an elegant young woman idly playing with the lap dog as her amused maidservant looks on. Yet the placement of one of the circles of the world map on the back wall just above the lady's head recalls the Medieval symbolism of *Vrouw Wereld* (lady world), the embodiment of lust and vice usually depicted as a woman with a globe on her head. Jan Miense Molenaer's *Vrouw Wereld* of 1633 in the Toledo Museum of Art also uses the device of the map to "disguise," as it were, this time-honored symbol with the appearance of an everyday scene. Yet, whereas Molenaer also employs overt *vanitas* imagery (soap bubbles, skulls, etc.). Ochtervelt omits such references in the interest of a more naturalistic overall effect. As the astute iconographer E. de Jongh has observed, Ochtervelt's work represents a later evolution of the *Vrouw-Wereld* type. The view at left to an adjacent room where a couple converse reminds us of Ochtervelt's close ties with Pieter de Hooch, a fellow pupil under Nicolaes Berchem and a lasting influence on his art. It should be noted that the genre scene of a *Lady in an Interior* hanging nearby is only a partial copy of a Terborch in the Metropolitan Museum of Art and cannot sustain its optimistic attribution to Terborch's pupil Caspar Netscher. Similarly, the so-called Rembrandt must be by a much later imitator.

The only eighteenth-century Dutch painting in the collection is a good quality *Portrait of a Man* dated 1727 by the grandson and namesake of the Leiden *fijnschilder* Frans van Mieris the Younger. The following century is represented by the Hague School painters Jacob Maris and Anton Mauve (see also his drawing), George Breitner, and most notably, van Gogh. The

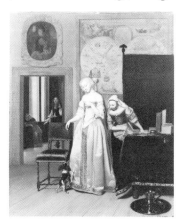

348 349

so-called *Moulin de la Galette (fig. 349)* is, in fact, probably another windmill in the vicinity of Theo van Gogh's apartment on Montmartre; the "Moulin de Blute-Fin" was one of Vincent's favorite subjects in Paris in 1886/87. The other painting by van Gogh is a very late work that can be dated quite precisely July 1890 through references in his letters. The wheat fields around Auver-sur-L'Oise clearly appealed to him. Following his final visit to his family in Paris, he wrote upon returning to Auvers, "I am quite absorbed in the immense plain with wheat fields against the hills, boundless as a sea, delicate yellow, delicate soft green, . . . checkered at regular intervals with the green of flowering potato plants. . . . " Within a month of this writing van Gogh was dead.

Piet Mondrian is represented with an important transitional composition of *Trees (fig. 350)* dating from c. 1912, just the period when the artist was converting from a more naturalistic approach to one stressing greater linear and formal abstraction. His early manner is presented in a charcoal landscape drawing in the collection. Other twentieth-century Dutch artists represented are Kees van Dongen and C. A. Nieuwenhuys. An unexpected but welcome feature of Pittsburgh's collections is the presence of two works by Corneille (Corneille Guillaume Beverloo), one of the founders of the Dutch experimental group "Reflex" and the COBRA movement. Gay and colorful, the *Summer in Havana (fig. 351)* of 1968 is particularly attractive.

350 351

PORTLAND ART MUSEUM

1219 Southwest Park
Portland, Oregon 97205 *(530) 226-2811*

The museum was founded in 1892 and moved to its present building, designed by Pietro Belluschi, in 1932. The collections are broad ranging and claim strengths in Northwest Coast Indian and Eskimo art and, perhaps less expectedly, art of the Cameroons. The painting collections are not extensive but benefit from the supplement of a small group of Samuel H. Kress Collection pictures. A handbook was published in 1971 and is still available.

352

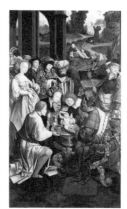

The few Dutch paintings range from a Jacob Cornelisz van Oostzanen, *The Circumcision (see fig. 352),* dated 1517, to a lovely Theo van Doesburg composition of 1916 entitled simply *L'Arbre.* The best Dutch works are still lifes—a Willem Kalf (*fig. 353*) with a porcelain bowl filled with bright oranges and peaches, and an early eighteenth-century *Flower Still Life (fig. 354)* by Wijbrand Hendriks, featuring, in addition to the sumptuous blossoms, a bird's nest on the supporting plinth and a glimpse of a lush, park-like forest beyond. The collection also includes a copy of Honthorst's *Saint Peter in Prison,* a bucolic watercolor by Anton Mauve, and a panoramic land-scape in the manner of Koninck by that great nine-teenth-century French admirer of his Dutch predecessors Georges Michel. Although there are no drawings, a group of prints from the Vivian and Gordon Gilkay Graphic Arts Collection features impressions by Rembrandt and other seventeenth-century printmakers as well as modern and contem-porary Dutch artists. A Dutch clock of c. 1720 is also here preserved.

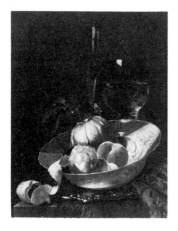

353

354

VASSAR COLLEGE ART GALLERY

Taylor Hall, Raymond Ave.
Poughkeepsie, NY 12601 *(914) 452-7000, ext. 2645*

The gallery is housed in Taylor Hall, a neo-Gothic structure built in 1917. Its holdings began already with the purchase by Matthew Vassar of Elias Magoo's collection of mostly Hudson River School paintings in 1864. The

355

356

357

high points among the Dutch paintings in this good teaching collection include a handsome *Breakfast Still Life (fig. 355)* dated 1641 by Pieter Claesz, a landscape with a *Rest on the Flight into Egypt* by Cornelis van Poelenburgh, Nicolaes Moeyaert's *Sacrifice of Noah,* and a *City-scape with Ruins (fig. 356)* by Daniel Vos-maer. The site of the last mentioned has rightly been identified as Delft after the explosion of 1654. A crumbled wall par-allels the picture plane in the front of the painting's daringly occluded composi-tion. The print collections are noteworthy, including sheets by Lucas van Leyden, Goltzius, Ruisdael, and more than sixty Rembrandt etchings. A pen and ink sketch of *Saint John the Evangelist* by Abraham Bloemaert and a free sheet of sketches of *Two Women* by van Gogh *(fig. 357)* figure among the drawings. *Selections from the Permanent Collections* was pub-lished in 1967, and a complete illustrated list of the paintings (1300–1900) ap-peared in 1983. The gallery also boasts a tradition of mounting small but excep-tionally distinguished exhibitions, nota-bly *Dutch Mannerism: Apogee and Epilogue* (1970), organized by the late Wolfgang Stechow, and *Seventeenth-Cen-tury Dutch Landscape Drawings* (1976), organized by the late Curtis O. Baer with Professor Susan Donahue Kuretsky.

ART MUSEUM, PRINCETON UNIVERSITY

Princeton, New Jersey 08544 *(609) 452-3787*

Founded in 1882, the Art Museum at Princeton is one of the oldest university museums in the country. Its present building was opened in 1966. A major renovation and expansion of the structure is presently under way. The collections, as befits their didactic function, are distinguished in quality and broad ranging, including East Asian art, Greek and Roman antiquities, Pre-Columbian art, Medieval sculpture and stained glass, European paintings, prints, and drawings, and American and contemporary art. The museum maintains an active exhibition program, and the permanent collection is often rotated to complement the art history faculty's curriculum. Unfortunately, no catalogue of the collection exists, but the *Record of the Art Museum, Princeton University* contains articles on the collections.

Princeton's collections are unusually strong in Dutch Mannerist art. An excellent example of Joachim Wttewael's painting is the large *Judith with the Head of Holofernes* (fig. 358). The acrid colors, the figure's deliberately complex pose, and the vague eroticism of the work (note Judith's exposed navel) are all expressions of Mannerist artifice. The work has been dated to the 1590s and may be compared with the artist's *Death of Procris* in St. Louis and *Lot and His Daughters* in Los Angeles. By the seventeenth century, Judith had come to be regarded as a prefiguration of the Virgin Mary. Thus she was a symbol of purity, humility and chastity, while Holofernes embodied the sins of pride and lust. The loan at present of a painting of *Helen of Troy* attributed uncertainly to Hendrik Goltzius offers for comparison another heroine celebrated by the Mannerists. In contrast

358

to these life-size, three-quarter-length images, Cornelis van Haarlem's two paintings of the *Israelites Crossing the Red Sea* (fig. 359) of 1594 and the *Meeting of Jacob and Esau* are long narrow panels in which the narratives are acted out by numerous small scale figures. The Israelites' passage is envisioned as taking place in a misty land of gray skies and billowing water; the biblical characters are also conceived as an exotic lot, dressed in turbans and gypsy garb or pseudo-Burgundian attire. Although still designed in a Mannerist idiom, these works have a new calm and a spatial clarity foreign to the artist's most extreme Mannerist statements from the late 1580s. In these stylistic changes, Cornelis followed Goltzius's lead. Both panels depict Old Testament stories, are close in size, and complement each other

359

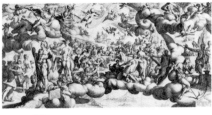

360

in design and color, perhaps indicating that they were conceived as a pair; however, the artist painted other unrelated works on a similar format.

Princeton's prints and drawings collection also claims notable examples of Dutch Mannerism, including Goltzius's highly influential engraving of 1587 after Bartholomeus Spranger's *Wedding of Cupid and Psyche* (fig. 360), engravings by Jan Saenredam and Jan Muller, such as the latter's *Rest on the Flight* of 1593, chiaroscuro woodcuts by Goltzius, and pen and wash drawings by Gerrit Pietersz Sweelinck, and Abraham Bloemaert. The works by the last mentioned not only include religious (*Hagar and the Angel* and *Saint Jerome*) and mythological themes (*The Fall of Icarus* and *The Punishment of Niobe*) but also a nocturnal genre scene with Caravaggesque lighting effects (fig. 361) Bloemaert presumably would have learned from his pupil Gerard van Honthorst.

Princeton's Honthorst (fig. 362)—surely the finest Dutch painting in the collection—is not, however, one of those works for which he earned the sobriquet "Ghirardo della Notte." Rather, it depicts in resplendent daylight, Artemisia, wife of Mausolus, ruler of Caria in Asia Minor, who upon her husband's death in 353 B.C., erected to his memory the famous Mausoleum at Halicarnassus, one of the Seven Wonders of the ancient world. Artemisia was remembered as the paradigm of a widow's devotion to her spouse's memory, not only for this edifice but because she drank her husband's ashes, the solemn ceremony depicted here. It has been argued that this painting was commissioned by Amalia van Solms, widow of Stadtholder Frederik Hendrik, and hung at the Huis ten Bosch. No doubt because of the theme's associations with a widow's fealty to her husband, Amalia also owned a painting by Rubens of this subject. Honthorst's picture is a tour de force in its treatment of stuffs and surfaces—the gleaming urn and Artemisia's satin dress and veil.

None of the other seventeenth-century Dutch paintings in the collection

361

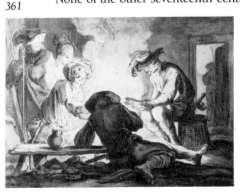

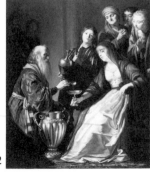

362

equals the Honthorst in quality; however, two works attributed uncertainly to David Vinckboons are of interest—a large outdoor *Fête* with elegantly costumed little figures and a charming smaller scene of nude *Bathers*. Landscapes in the collection include works by Pieter de Neyn, Aert van der Neer, Egbert van der Poel, and two recent acquisitions, a *River Scene with View of Dordrecht* by Salomon van Ruysdael and a *Forest Scene* from Jacob

363

van Ruisdael's later career. The *Shepherdess* dated 1633 by Paulus Moreelse is a typical example of his work (compare the picture in Hartford). Eighteenth-century Dutch art is represented by two decorative works by Jacob de Wit and a painting by Jan Josef Horemans. Far and away, however, the greatest later Dutch picture is van Gogh's *Stagecoach from Tarascan* (fig. 363; on loan from the Henry and Rose Pearlman Foundation) from 1888, for which a pen drawing exists in the Rijksmuseum Van Gogh in Amsterdam. In a letter, van Gogh likened the thick paint application in this work to Monticelli and its palette to Monet. The painting's blaze of color gives the tilting old vehicle a carnival-like gaiety. Princeton's modern collections also include works by Karel Appel.

MUSEUM OF ART
RHODE ISLAND SCHOOL OF DESIGN

224 Benefit Street
Providence, Rhode Island 02903 *(401) 331-3511*

Established in 1880, shortly after the Rhode Island School of Design was founded, the Museum of Art moved to its present building adjoining Pendleton House in 1926. Its galleries include fine examples of Egyptian, Greek, Roman, Oriental, Medieval, as well as later European and American art. The greatest strengths are in classical sculpture, French nineteenth-century painting, and East Asian art. While the far ranging collections are at the service of the faculty and students of RISD and nearby Brown University, they also serve the city of Providence as its principal museum. In addition to producing exhibitions with serious minded catalogues such as *Rubenism* (1977), the museum publishes a *Bulletin*. A catalogue by Deborah Johnson of the old master drawings was published in 1983 and a large *Handbook* of the museum appeared in 1985. The museum's director, Franklin W. Robinson, is a noted scholar of Dutch seventeenth-century art.

Fifteenth- and sixteenth-century Dutch art is little represented in Providence except in prints and drawings. Deserving of note is a *Crucifixion* by an unknown painter who takes his cumbersome name from the panel ("The Master of the Providence Crucifixion"). The work shows the strong though provincial hand of an artist who is thought to have been active in Utrecht around 1450–60. An excellent pen and ink drawing dated 1559 by Marten van Heemskerck depicts the Triumph of David. It served as a model for one of a suite of eight engravings celebrating the powers of patience. A deliberate display of the artist's mastery of monumental, classical form as well as knowledge of ancient art and costume, the work attests to Heemskerck's earlier sojourn in Italy. Early sixteenth-century Flemish interpretations of Italian art are well illustrated in the splendid drawing of *Adam and Eve* by the Mannerist, Jan Gossaert (called Mabuse), while a later, distinctly Dutch form of Mannerism is presented by Goltzius's *Christ on the Cold Stone*

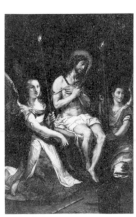

364

with Angels (fig. 364). Whereas Mabuse took Michelangelo as his point of departure, Goltzius consulted much later Italian sources (Taddeo Zucarri), while simultaneously translating his suffering Christ into a more naturalistic, Northern type. This work of 1602, which was engraved, is Goltzius' earliest dated painting. Chiefly remembered as an engraver and draftsman, Goltzius seems to have begun to paint only around 1600. This fact serves to remind us that Dutch mannerism had its origins in prints and drawings, specifically the engravings made by Goltzius after Bartholomeus Spranger's designs. With notable exceptions, such

as the painted oeuvres of Cornelis van Haarlem and Abraham Bloemaert, Mannerism could be said to be primarily a graphic style. Artists such as Jan Saenredam, Jacob Matham, and Jan Muller seem never to have painted, and Jacques de Gheyn and Goltzius painted only for restricted periods. Joachim Wttewael on the other hand produced paintings in a Mannerist idiom as late

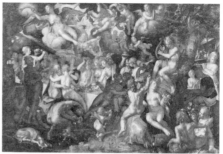

365

as 1630. His large *Marriage of Peleus and Thetis* (fig. 365) of 1610, although rubbed, is of interest because of its subject which proved to be enormously popular with the Haarlem Mannerists. Descended from works like Goltzius's engraving after Spranger's *Wedding of Cupid and Psyche (see fig. 360)*, Wttewael's painting is one of his several treatments of the subject on both large and very small formats. The newlyweds are seen on the far side of the table. Among the gods are Apollo, who entertains the company, Mercury, who acts in his role as server, and Eris, who throws down the fateful apple of discord.

Pieter Lastman's *Saint Matthew and the Angel* of 1613 is part of a series of the four evangelists (other works from the series are in Rotterdam and Dijon) and again shows the simple, more straightforward approach to history painting that we have observed elsewhere in his art. While the arrangement of this work may recall something of the version (now destroyed) of this theme by Caravaggio, the latter's influence on Matthias Stomer's *Christ on the Column* is much clearer. Formerly incorrectly assigned to Carel Fabritius, the *Saint Peter Released from Prison* is by an unknown Rembrandt School artist. It is executed in a very broad, even brutal, manner. With good reason, Frank Robinson has associated the picture with two other Rembrandtesque paintings, Raleigh's *Saint Matthew* and Sarasota's *Lamentation,* which, though not by the same hand, share a similar technique. Aert de Gelder's painting *Esther and Mordecai* is part of a series illustrating the Old Testament heroine's

story (related paintings are in Budapest and Dresden). An interesting painting, sometimes wrongly said to be North Italian, depicts a *Young Huntress* with her companions and a large dog (perhaps a *portrait historié* of a young woman in the guise of Diana?) and may be by the Amsterdam history painter and portraitist Jan van Noordt. One final noteworthy history painting is Adriaen van der Werff's *Expulsion of Hagar* (fig. 366) painted around 1700, of which other versions exist in Dresden, Munich, and Bamberg. This exceptionally popular theme

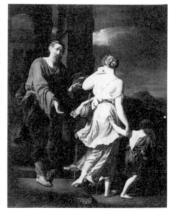

366

367

evidently retained its favor even with late artists such as van der Werff.

Salomon van Ruysdael's *River Scene with Ferryboat* of 1645 is a large canvas with entertaining anecdotal details (the crowded boat with the child who cannot wait for the far shore) but its condition unfortunately has suffered. Like Ruysdael and Esaias van de Velde (see the latter's drawing [c. 1627–28] of a frozen canal), Pieter Molijn had a pioneering influence on Dutch landscape painting in Haarlem. Less well known than his early works of c. 1630 are Molijn's very late imaginary drawings like the *Mountain Landscape (fig. 367)* in Providence dated 1660. Neither Dutch nor Italian in the flavor of the setting, this inspired work of fantasy signals a final resurgence of creativity in the next to last year of Molijn's life. Although one might more readily identify it as the product of imagination, Jacob van der Ulft's drawing of the *Pyramid of Caius Cestius in Rome* takes only minor liberties with the setting. Contrary to Houbraken's report, van der Ulft doubtless visited Italy and distinguished himself as a gifted dilettante who served his native Gorkum as burgomaster. He was preceded in this popular trip south by Karel Dujardin, one of whose paintings of an Italian landscape with ruins is preserved in Providence. Rembrandt, as we have noted, chose to stay at home. A particularly powerful testimony to the master's loving devotion to his own Dutch terrain is the *Landscape with Farm Buildings and High Embankment,* one of the great pen and wash studies from the late 1640s. (Another, perhaps earlier, drawing of the same scene is in the British Museum.) The broad but unfalteringly confident pen work of this landscape drawing is hardly matched prior to a work like van Gogh's splendid *View of Arles* (May 1888).

NORTH CAROLINA MUSEUM OF ART

2110 Blue Ridge Road
Raleigh, North Carolina 27612 *(919) 733-3248*

The state of North Carolina has the distinction of being the first state in the Union to set aside substantial public funds to acquire an art collection. The decision was all the more farsighted and magnanimous for having been voted prior to the funding of a museum building. In 1947 the state allocated $1 million for works of art—a staggering sum in the value of the day— and subsequently voted additional funds to refurbish the old headquarters of the highway department as a museum. Opened in 1956, those makeshift spaces not surprisingly, soon proved inadequate. A new building situated outside of town and designed by Edward Durell Stone was opened in 1983.

North Carolina's unprecedented act of legislative largesse was largely the achievement of Robert Lee Humber, a lawyer who first negotiated a promise of a million dollars from the Samuel H. Kress Foundation and then successfully pressed the state to match the gift. While Humber had no special knowledge of art, he had the able assistance of Carl Hamilton, a noted collector of Italian art. As consultant and adviser to the State Art Commission, Hamilton selected many of the first and best acquisitions. When an unsympathetic state attorney general sought to block the whole venture, the resourceful Humber turned to W. R. Valentiner, then the best-known and most widely respected museum professional in this country, to affirm the value of the works selected for purchase. Valentiner not only offered a positive appraisal of the collections but later agreed to come out of retirement in Rome to serve as the museum's director. He also was the author of the *Catalogue of Paintings* published in 1956 (long out of date, this work is now supplemented by an extensively illustrated *Introduction to the Collections* published on the occasion of the opening of the new museum), and left his important library and papers to the institution. In 1951 the original agreement with the Kress Foundation was altered to allow for the gift to be made in art. The collection that subsequently arrived in Raleigh is certainly one of the finest ever granted by the foundation and fully equal to its promise of cash. Although the vast majority of the works were Italian paintings, two outstanding Dutch pictures were also donated—the Terbrugghen (*fig. 368*) and the Berckheyde (*fig. 376*).

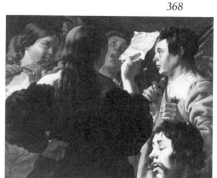

368

Hendrik Terbrugghen's *David Saluted by Women* (1 Samuel 18:6, 7) of 1623 (*fig. 368*) is one of the Utrecht artist's finest works in this country. It depicts the triumphal welcome given the young David by the women of Israel when he

returned with the head of Goliath, here a ghastly shade of green. The subject had been treated earlier in a print by Lucas van Leyden, an artist admired by Terbrugghen, but the painting's half-length composition and dramatic lighting are Caravaggio's legacy. It has been suggested that the head of Goliath is a self-portrait. If that is the case, Terbrugghen would again have followed the Caravaggesque tradition, since the Italian painter is said to have also portrayed himself in his own *David* in the Borghese Gallery, Rome. Another painting attributed to Terbrugghen in the collection, *Young Man with Wineglass by Candlelight,* is also dated 1623. That work uses a hidden light source, a motif more commonly associated with Gerrit van Honthorst than with Terbrugghen. The work has been compared with a night scene of a *Boy Lighting His Pipe from a Candle,* also of 1623, in the Museum in Erlau (Eger); one unlikely theory holds that the pair are all that remains (respectively "Taste" and "Smell") of the Five Senses series. Even allowing for condition problems (the modeling of the head has become lamentably thin), the painting's attribution seems doubtful. It has none of the strength of design or assured touch, for example, of the nocturnal scene owned by Smith College.

Matthias Stomer's *Nativity* owes much to his presumed teacher in Utrecht, Honthorst (to whom the work was once attributed), as well as to Abraham Bloemaert (compare the latter's treatment of the theme in Braunschweig). Here the brilliant chiaroscuro originates not from a hidden candle or taper but from the Christ child himself, who emanates a miraculous glow. The majority of the other history paintings in the collection are by Rembrandt School artists. Govaert Flinck's *Return of the Prodigal Son* was probably executed around 1640, which is to say at least four years after he had left Rembrandt's studio, but recalls the master's style in the arrangement of the figures and the fantastical landscape and architecture (compare Detroit's *Visitation*). The general conception of the theme, albeit much transformed, also recalls Rembrandt's etching of 1636. Flinck went on to win important commissions over his former teacher, notably the decorations for the Town Hall in Amsterdam which remained unfinished at his death in 1660. The *Sacrifice of Manoah* once wrongly assigned to Ferdinand Bol is now more

369 370

plausibly attributed to Gerrit Willemsz Horst, a painter of Rembrandtesque history subjects as well as still lifes. A particularly lovely little painting that stands out for its subtle tonal harmonics and masterful execution is Gerbrand van den Eeckhout's *Expulsion of Hagar (fig. 369)*. Its date, 1666, attests to the lasting fascination that this dramatic and psychologically charged theme held for Rembrandt's pupils. No ready attribution is offered for the large and not insensitive *Saint Matthew and the Angel*, once assigned to Carel Fabritius and now called simply "Circle of Rembrandt," but the work clearly is indebted to Rembrandt's painting of this theme dated 1661 in the Louvre. The largest body of Dutch drawings in the collection are also Rembrandt School products. Many address history themes with pen and wash, including the *Departure of Tobias* attributed to Bol, *Saint Peter Praying for Tabea* by Samuel van Hoogstraten, and *The Angel Appearing to Abraham and His Wife* by Jan Victors.

Without question the most famous, or perhaps infamous, Dutch history painting in the collection is the large *Feast of Esther (fig. 370)*, a broadly painted and garishly colored canvas whose attribution has shuttled back and forth between the youthful Rembrandt and Lievens. At the right the turbaned King Ahasuerus clenches his fists in rage to discover Haman's treachery revealed by Queen Esther. An enemy of the Jews, the king's evil minister reacts with alarm, his darkened form providing a *repoussoir* at the left. One of those works that grew out of the collaboration of Rembrandt and Lievens in Leiden in the late 1620s, this more striking than attractive picture seems, at least since the Leiden exhibition in 1977, to have won a place in Lievens' oeuvre. Its coarse power and combination of Caravaggesque and Lastmanian elements attest to Lievens' daring creativity and help explain Constantijn Huygens' recorded preference for the latter's bold invention over the young Rembrandt's interest in expressing emotion in small, carefully worked paintings. An interesting comparison is offered by Jan Steen's later treatment of the theme in Cleveland. Raleigh also owns a large and ambitious history painting by Jan Steen, *The Worship of the Golden Calf*. The female figure seated in the middle of the composition had appeared earlier in the group of thirsting onlookers in *Moses Striking the Rock* in the Johnson Collection, Philadelphia. Here, however, the atmosphere of pious gratitude is exchanged for sensuousness and lascivity, emotions befitting a scene of pagan worship. The tone is set not only by the salacious looks and frenzied dancing but also the hotter palette and broader touch. The latter were stylistic features of Steen's art after c. 1670. Thus, while their themes are related by the common depiction of episodes on the journey of the Israelites, the Raleigh painting probably dates at least a decade later than the Philadelphia picture.

371

Though small in number, the Dutch

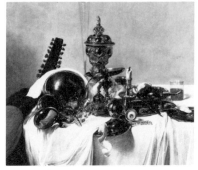

372

still lifes, like the Spanish, are of superb quality in Raleigh. The *Still Life with Flowers, Fruit, Shells, and Insects* (fig. 371) of 1622 by the brother-in-law of Ambrosius Bosschaert, Balthasar van der Ast, is an excellent example of the painter's art. It not only illustrates van der Ast's delight in the minute record of vegetable and animal life (note the grasshopper, lizard, spider, butterfly, caterpillar, and crayfish) but also his practice, particularly in the 1620s, of using orderly horizontal compositions arranged parallel to the picture plane and tilted slightly upward. Coupled with van der Ast's careful drawing and strong local colors, these designs allow for a full account of each object. Jan Jansz den Uyl's *Breakfast Piece* (fig. 372) employs a more dynamic composition. The jumbled remnants of an elegant meal—metal and glassware, a candle, food and drink, and a lute—are arranged on a table covered with a white cloth. In the true spirit of baroque, the artist seems to enjoy the momentary unsettling effect of the *roemer* glass and pewter dish with lemon perched precariously at the edge of the table. Long mistaken for a work of the more famous Willem Claesz Heda, also of Haarlem, this fine painting is now correctly assigned to den Uyl; just as in Hartford's painting, the tiny owl (*uil*) on top of the central *pokal*, serves as a form of signature. In addition to a large *Dead Swan* dated 1657 by Jan Baptist Weenix (compare the painting in Detroit), Raleigh also owns a lovely *Flower Still Life with Dragonfly, Mouse, and Watch* (fig. 373) by the famous woman painter Rachel Ruysch. Refined in color and execution, the work is rich without being precious or excessively decorative. The granddaughter of the architect Pieter Post, Ruysch studied with Willem van Aelst, married the portraitist Jurriaen Paal, to whom she bore many children, and won an appointment as court painter to the Elector Palatine in Düsseldorf. Active into her eighties, Ruysch became one of the most widely respected still-life painters of eighteenth-century Holland. A very

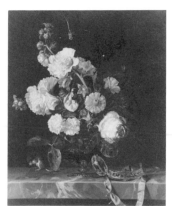

373

formal portrait depicting *Rachel Ruysch in Her Studio* by Constantijn Netscher is also in Raleigh.

An excellent sixteenth-century *Portrait of a Man* by the Scorel student Anthonis Mor (Antonio Moro) has a companion in the Art Institute of Chicago. The persistence into the seventeenth century of the tradition of pendants is well illustrated by the portrait of an unknown forty-four-year-old man and its companion portrait of his thirty-seven-year-old wife attributed to the fashionable court painter Michiel van Mierevelt. Other

noteworthy Dutch portraits in the collection include: an exceptionally handsome and well-preserved *Portrait of Gentleman* by Thomas de Keyser; a half-length *Portrait of a Man,* dated 1644, formerly attributed to Frans Hals but now reassigned to his son Jan; Govaert Flinck's van-Dyckian *Self-Portrait* and *Portrait of the Artist's Wife*, both dated 1646, in which the subjects are depicted standing behind a balustrade with a red curtain overhead; a *Portrait of a Man with a Sword* formerly incorrectly assigned to Ferdinand Bol (compare the painting in Dayton); and a *Portrait of a Man* assigned to that curious and little-known early Rembrandt pupil Isaac de Jouderville.

Another, more gifted Rembrandt student, who in later life became a specialist in portraiture, was Nicolaes Maes. His *Portrait of the Cuyter Family*, dated 1659, depicts the sea captain and merchant Job Jansz Cuyter and his second wife, Dingetje, and their six children standing on the quay in Dordrecht with a view of the Groothoofdspoort. The captain proudly points with a riding crop past the belltower of Dordrecht's well-known town gate to his own ship lying at anchor in the harbor. The portrait is of special interest not only because it is known from a document of 1658 that it served as partial payment for a home Maes purchased from Cuyter, but because it includes elements of both Maes' early and later manner. Around 1660 the artist gave up genre painting to concentrate on society portraits. With its combination of both elegant and unpretentiously anecdotal elements, the painting is a transitional work in his oeuvre.

None of Maes' domestic scenes are found in Raleigh, but the other genre paintings include: a large *Market Scene* dated 1622 by Pieter Cornelisz van Rijck, the Delft follower of Aertsen and Beuckelaer; a scene of an *Old Woman Weighing Gold* (possibly Avarice but certainly a *vanitas* image) by the Rembrandt pupil Willem de Poorter; a boisterous image of a *Peasant Having a Tooth Pulled* of 1629 by Jan Miense Molenaer (compare the artist's full-length treatment of the theme dated the following year in Braunschweig); and two guardroom scenes of good quality, one depicting *Soldiers with Booty* by Jacob Duck and a later work by Ludolf de Jongh (*fig. 374*). The last mentioned depicts a bivouacked soldier awkwardly awakened by a trumpeter's reveille. To judge from the company's amusement and the soldier's ungainly sprawl, the morning followed on a hard night of revelry. De Jongh's painting was once wrongly attributed to another Rotterdam artist, Pieter de Hooch, who executed guardroom scenes early in his career before turning to domestic subjects. Raleigh's de Hooch depicts a *Woman and Serving Maid at a Hearth* preparing a meal. In this later (c. 1670–74) work, de Hooch has long since abandoned the light tonality for which his Delft period interiors are admired but retains their geometric order and such motifs as the *contre-jour*

374

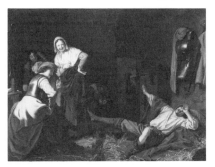

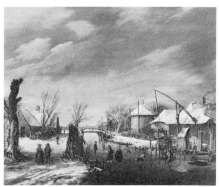

376

375 doorway. Closely related to the Delft interior genre style developed by de
Hooch and Vermeer is *Ladies and Cavaliers Drinking* attributed uncertainly
to Jacob Ochtervelt; the work adopts elements of Vermeer's paintings in West
Berlin and Braunschweig.

Despite an addition at the top, one of the smallest but best landscapes in
the collection is Esaias van de Velde's splendidly fresh little panel *Winter
Landscape with Frozen Canal (fig. 375)* dated 1614. Conceived on quite a
different scale but also distinguished in quality is Jacob van Ruisdael's large
Northern Landscape with Waterfall (compare Philadelphia's *Waterfall*), a later
work by the master. Only one of the two italianate landscapes assigned to
Albert Cuyp seems correct, but the large and somewhat decorative *Deer Hunt
in an Italian Landscape* by Philips Wouwerman is a genuine and important
later work. The only marine in the collection is a large *Calm Sea* by Jan van
de Capelle's student Jacob Esselens; the only cityscape is the excellent *View
of Grote Markt (fig. 376)* in Haarlem by Gerrit Berckheyde. Beneath the great
shadow of Sint Bavo's, merchants ply their wares, maidservants draw water
from a pump, and several well-to-do burghers socialize.

Unfortunately, the exceptional strengths of Raleigh's seventeenth-century
painting collection are not carried through to later centuries. The same state
attorney general who sought to block the purchase of the museum's first
Old Master considered modern art "heinous." The decorative arts also are
scarce, although several pieces of eighteenth-century glassware deserve note,
including a goblet celebrating the twenty-fifth wedding anniversary in 1752
of Jonkheer Gerrit van Martin, Baron de Tour. Some eighteenth- and
nineteenth-century Dutch Judaica (torah finials, etc.) are also preserved here.

VIRGINIA MUSEUM OF FINE ARTS

Boulevard and Grove
Richmond, Virginia 23221 *(804) 257-0844*

Founded by the state's General Assembly in 1934, the Virginia Museum of Art was opened to the public two years later in a Georgian-styled building. Four later additions have been made to the original structure. The most recent is the West Wing, opened in 1985, designed by Malcolm Holzman, and jointly donated by Mr. and Mrs. Paul Mellon and Mrs. and Mrs. Sydney Lewis. The modern styled architecture has striated limestone and polished granite bands on the exterior and a brightly lit marble court inside. The first museum of art in this country to enjoy state sponsorship, Richmond's museum oversees a statewide program of art exhibitions and education. Offering a selection of American and European pictorial and decorative arts, the collections also include crown jewels from czarist Russia, Fabergé objects, and samples of Indian, Nepalese, and Tibetan art. Several good Dutch paintings grace the collection. A catalogue of *European Art* was published in 1966 and the December 1985 issue of *Apollo* was devoted to the museum and its collections.

A *Kitchen Interior* by Cornelis Delff illustrates the persistance into the seventeenth century of the sixteenth-century Flemish tradition of kitchen interiors. Such works usually depict in the foreground a multitude of groceries and still-life objects prepared by kitchen maids, while a smaller subsidiary theme appears in the background, in this case possibly the Prodigal Son. A more accomplished and attractive *Still Life with Fruit and a Parrot (fig. 377)* is by Jan Davidsz de Heem. It too reflects the influence of superabundant Flemish still lifes, but tempers that tradition, expressing its own luxurious if less opulent style. Later flower still lifes include a Jan van Huysum and a pleasant work with fruit and a pineapple—one of the artist's favorite motifs—by Huysum's eighteenth-century successor Jan van Os (*see fig. 378*). The landscapes include a recently acquired *Landscape with Cephalis and Procris* of c. 1620 painted by Alexander Keirincx in his early Flemish

377

378

manner, a *Winter Scene with Skaters* which is an early work by Aert van der Neer, a marine of 1644 depicting a *Thunderstorm near Haarlem* by Jan van Goyen, a *River Landscape* by Salomon van Ruysdael, and a *River Scene with Boat* from the Liechtenstein collection by Hobbema. As so often in his art, Jan van der Heyden's so-called *View in Amsterdam* (*fig. 379*) is a mixture of real and imaginary elements. The large town house at the left is probably

fictional, but the cupola in the distance is that of the new Amsterdam Town Hall. Entirely imaginary, on the other hand, is the lively scene of *Figures with a Goat and a Dog in the Roman Campagna* wrongly assigned to Jan Baptist Weenix. This, in fact, is quite a good and characteristic work by the artist's son, Jan Weenix.

The various old attributions to Rembrandt and Hals, alas, are also wrong, but other Dutch portraits in the collection are

379

genuine and noteworthy. The three-quarter-length *Portrait of a Man* by Thomas de Keyser (*fig. 380*) is dated January 1631 and includes the column, balustrade, and curtain that became part of the standard accessories of elegant portraiture of the period. Stark by comparison is the neutral background against which Terborch sets his small-scale, full-length pendant portraits of a man and his wife. Relatively early paintings by the master, these two works seem to have as much to do with Spanish portraiture (Velasquez) as Dutch (compare Hals' famous *Standing Portrait of Heythuyzen*). A bright and thoroughly charming, genre-like *Portrait of a Little Boy* (*fig. 381*)—the sitter is male despite the dress—was assigned in the last century to Pieter de Hooch before Ludolf de Jongh's signature and the date 1661 emerged. Just as the books and globe in the *Portrait of a Scholar* wrongly assigned to Ferdinand Bol surely refer to the sitter's scholarly profession or pretentions thereof, the obedient little dog that de Jongh's child teaches to perform tricks may allude to the pedagogy essential to rearing well-behaved children.

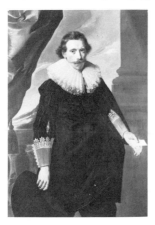

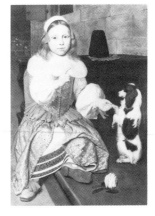

380 381

Far more complicated, as the curator of Amsterdam's Rijksmuseum, P. J. J. van Thiel, has shown, is the symbolism of Jan Miense Molenaer's *Musical Company* (fig. 382) of 1633. Although at first glance the scene seems little more than a merry company on a terrace, the deadly combat of the two men at the left alerts us to other meanings. The overall symbolic program seems to allude to the necessity of temperance in marriage: note

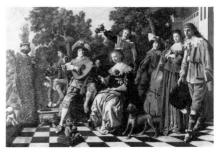

the couple standing at the right. Temperance is symbolized by, among other elements, the figure pouring water into his wine so spectacularly in the center background. Moderation will overcome the disruptive anger (*Ira*) of the combatants at the left, the lust and sensuousness of the monkey embracing the cat in the foreground, and the drunkeness and excess (*Gula*) associated with the gesture of

382

the man looking into his wine jug (a *kannekijker* [literally, "tankard looker"] in Dutch was synonymous with a tippler). Against this multitude of temptations the married couple and their steadfast dog (*Fides*) marshal their restraint and control.

Another scene with the misleading appearance of pure genre is Jan Steen's small picture entitled *The Letter*. As in his related work in the Norton Simon Museum, the true subject is probably *Bathsheba Receiving King David's*

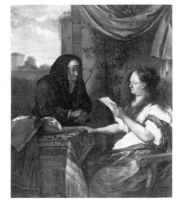

Letter (fig. 383). Other history paintings in the collection include Leonard Bramer's *Betrayal of Christ* and Cornelis Saftleven's *Death the Reaper*, dated 1649. Rare in American collections (compare his painting in Chicago), Saftleven is of special interest for his wide range of subjects. He executed not only religious themes, genre, landscape, portraiture, animal subjects, and other conventional types of pictures, but also illustrations of proverbs and moral and political allegories. The last mentioned constitute a special rarity in Dutch art.

383

MEMORIAL ART GALLERY
THE UNIVERSITY OF ROCHESTER

490 University Avenue
Rochester, New York 14607 *(716) 275-3081*

Founded in 1912 by Emily Sibley Watson as a memorial to her deceased architect son, the Renaissance-styled Art Gallery opened its doors in the following year. At its outset the collection consisted of "two paintings, four plaster casts and a lappet of lace." Mrs. Watson and her husband soon helped to enrich the institution. The museum's major benefactors, the Watsons, not only presented works of art but provided funds that made the expansions in 1926 and 1968 possible. Plans for further additions are now under way. The collections are broad ranging but include strengths in early Chinese painting and sculpture, European Medieval art and American painting. A *Handbook* of the collection was published in 1961 and a *Supplement* in 1968. An exhibition of *Treasures of Rochester* was exhibited at Wildenstein Galleries, New York, in 1977.

Rochester's Rembrandt, a *Portrait of a Young Man in an Armchair (fig. 384)* is in problematic state and bears neither the signature nor the date

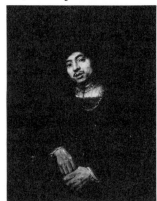

often recorded in the literature: however, the painting is probably correctly assigned to the artist's last decade of activity. The *Portrait of a Man* attributed to Frans Hals also has condition problems; it has been abraded and flattened through relining. However, it also has rightly found its defenders, notably the Hals expert Seymour Slive, who would date it around 1655–60. Other portraits in the collection are attributed to Thomas de Keyser, Dirck van Santvoort, Nicolaes Maes, and Salomon de Bray, the last mentioned offering a charming half-length image of a *Girl with Cherries.*

384

385

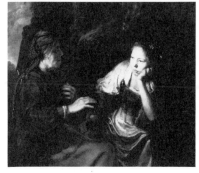

Easily the finest Dutch history painting in the collection is Govaert Flinck's *Vertumnus and Pomona (fig. 385)*, a highly intelligent recent acquisition. The painting illustrates the story told by Ovid about Vertumnus, the god of the seasons, who fell in love with the wood nymph Pomona, who was skilled in agriculture. In his efforts to woo Pomona, Vertumnus vainly assumed many disguises. Finally, he took the shape of an old woman and sang his own praises to the nymph, successfully winning her love

when he at last returned to his own form. In Flinck's painting, Pomona is charmingly conceived as a full-faced and ruddy-complected Dutch farm girl who leans heavily on her hand as she ponders Vertumnus's entreaty. The subject enjoyed enormous popularity with Dutch painters, being treated by, among other earlier artists, Goltzius, Cornelis van Haarlem, Lastman, Bloemaert, and Paulus Moreelse. The Rembrandt School artists who painted the theme included Bol (Cincinnati), van den Eeckhout (Indianapolis and Budapest), Maes (Dublin), Aert de Gelder (Prague), and others. Part of the attraction of the subject surely hinged on the theatrical effect of the disguise and the viewer's special knowledge of the deception. Other popular history painting themes (Amarillis and Mirtillo, Achilles in the House of Lycomedes) also involved men disguised as women. The subject of Judah with Tamar in the guise of a harlot also often shared compositional elements (see, for example, Bol's painting in Boston) with the related Vertumnus and Pomona theme.

Jan van de Capelle's marine offers a hushed view of an inlet on the Dutch coast with a stretch of becalmed sea. Nearly as still and monumental in atmosphere is the scene of *Roman Ruins with Card Players* attributed to Jan Both, a work reflecting that artist's regard for Pieter van Laer's genre subjects. Neither the genre scene of *Woman and Her Maidservant* nor the scene of *Dido Contemplating the Portrait of Aenaes* can be accepted as by Frans van Mieris the Elder; the former is by a later imitator, while the latter is by an able and independent late seventeenth- or early eighteenth-century hand. There can be no question of the certainty of the attribution of the *Pancake Baker* to Jan Steen. The painting takes up a time-honored low-life theme (addressed earlier by among others, Adriaen Brouwer, Jan van de Velde II, and Rembrandt), but treats the baker as a respectable street vendor instead of a coarse peasant. A splendid large *Flower Still Life* (fig. 386) with insects, a snake, and a lizard, dated 1686, by Rachel Ruysch, and a modest little *Still Life with Oysters* by Jan Davidsz de Heem complete the small but commendable representation of seventeenth-century Dutch painters' specialties. The decorative arts, as so often, are thinner in number, but an engraved *Silver Beaker* of 1680 is here preserved and could as readily appear in a Dutch breakfast or taproom composition. A marquetry secretary of c. 1750 also decorates one of the galleries. Later Dutch works include a watercolor of a *Woman Sewing by a Window* by Josef Israëls, a particularly intense *Portrait of a Woman* by Kees van Dongen, and a gouache and watercolor abstraction by Karel Appel.

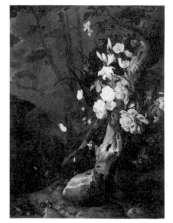

386

CROCKER ART MUSEUM

216 O Street
Sacramento, California 95814 *(916) 446-4677*

In 1869 Judge Edwin Crocker retired from his position as counsel to the Central Pacific Railroad and turned his energies to the expansion and embellishment of the family home. In search of works to fill up the new art gallery—a Victorian Revival building completed in 1872 and designed in the style of a sixteenth-century Italian villa by Seth Babson—Crocker traveled with his family to Europe in 1870. In the midst of the Franco-Prussian War they spent much time in Germany, centered in Dresden with trips to Munich, Düsseldorf, Prague, and Vienna. Their purchases doubtless took advantage of the uncertainties caused by the war, but also were not without impulsiveness. In the brief period of two years, Judge Crocker sent home no less than seven hundred paintings and approximately twelve hundred drawings. Thus he purchased nearly two paintings a day and more than three drawings, a rate of acquisition likely to defeat even the greatest connoisseur. Although Crocker had been preceeded by such famous early American collectors such as Thomas Jefferson Bryan, most of whose collection amassed in the 1850s was given to the New York Historical Society (now largely dispersed), and James Jackson Jarves, whose early Italian paintings are now at Yale, Crocker for a brief period owned the largest private collection in the United States. His widow gave the art gallery and its contents to the city of Sacramento in 1885, then the most important public art museum in the West. The Crocker's home was also subsequently converted to a gallery annex, and the R. A. Herold Memorial Wing was recently added to accommodate the expanding collection. Nonetheless, the core of the collection remains the original Crocker bequest, which is strongest in German and American pictures, mostly of the nineteenth century, and European drawings. A new *Handbook of Paintings* with a complete checklist appeared in 1979 and *Master Drawings from Sacramento* with a checklist of the drawings appeared in 1971. The gallery has mounted small but important European and particularly Dutch art exhibitions in the past, notably *The Pre-Rembrandtists* (1974).

While it must be said that Judge Crocker knew in many instances that he was buying copies, one could wish that he purchased fewer bargains and concentrated more on truly outstanding purchases. The Dutch paintings are characteristic of the picture collection as a whole in their volume and mediocrity. The drawings fare considerably better but perhaps only because of their numbers; here too there is a good deal of dross. Nonetheless, like the greater but likewise notoriously uneven Johnson Collection in Philadelphia, the Crocker Art Gallery is of considerable historical interest as the virtually complete document of one man's taste in the nineteenth century. Beyond this, the collections may also be enjoyed by the art lover in anthologized form.

While the painting of the *Sacrifice of Abraham* called Heemskerck is not by the artist, the collection includes several notable Mannerist and early seventeenth-century Pre-Rembrandtist history drawings. Goltzius's *Judith with the Head of Holofernes* shows the draftsman's admiration for Italian art and was probably executed nearly twenty years earlier than his pen drawing, also preserved here, of his

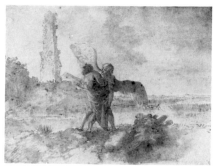

own emblem, "Eer Boven Golt" of 1609 (compare the version at Harvard). *387* A *Mars and Venus* by W. van de Passe is a copy of a print derived from a Goltzius design. Although the collection owns no Lastman or Pynas, it has two good drawings by their able follower Nicolaes Moeyaert—one of a mythological theme, *The Sacrifice of Polyxena* of 1649, and the other, a characteristically obscure Old Testament theme, *Samuel and Saul after the Battle of the Amalekites* (1 Samuel 15:13–31). Another lesser-known Pre-Rembrandtist is the Hague artist Moses van Uyttenbroeck, who rarely appears in documents but was praised by Constantijn Huygens and patronized by Prince Frederik Hendrik. His two drawings of a *Landscape with Shepherd and Shepherdess* (which was engraved) and *Jacob Wrestling with the Angel* (fig. 387 preparatory to a painting) show his strong interest in landscape and bucolic motifs.

In 1618 Adriaen van Nieulandt was mentioned together with Lastman, the Pynas brothers, Moeyaert, and Poelenburgh, in a laudatory poem by Theodore Rodenburgh praising the painters of Amsterdam. His *Landscape with Dancing Satyrs and Nymphs* of 1652 is a late painting but clearly attests to his ties with the other artists mentioned in Rodenburgh's poem; compare Lastman's painting in Norfolk. In contrast to this intimately scaled work, *The Abduction of Proserpine* by Palamedes Palamedesz, the brother of the genre painter and portraitist Anthonie Palamedesz, is a work of monumental proportions in which the short-lived artist (dead at age thirty-one) sought to

388 389

390

391

bring some of his interest in equine subjects (Palamedes specialized in cavalry battles) to a history theme; compare Rembrandt's far greater treatment of the theme in West Berlin. The most inventive painter of history subjects in Palamedesz' native city of Delft was Leonard Bramer, here represented by a pen drawing of *Blind Tobit* (fig. 388), one of the most popular themes from the Apochrypha treated by Dutch artists, notably Rembrandt. The latter is represented by a wonderfully swift drawing of *Saint Peter Liberated from Prison* (fig. 389), usually dated to the artist's early Amsterdam period and one of the outstanding sheets in the collection.

Of better quality than the few odd Dutch still lifes (followers of de Heem) in Sacramento is the fascinating chalk drawing of *Dodo Birds* (fig. 390) by Roelant Savery of c. 1604–05. Savery, we recall, was employed at the court in Prague, drawing and painting exotic animals, like the then soon-to-be-extinct dodo, for the famous *Vivarium* of Rudolf II. He later often included the dodo in his painted landscapes with animals and history paintings, such as *Orpheus Charming the Animals*. Among the Dutch landscapes in the collection (Jan Martszen, Hondius, Klaes Molenaer, etc.), the drawings again excel, notably works by Simon de Vlieger (fig. 391) and attributed to Ruisdael. Peasant genre is represented by paintings by Adriaen van de Venne and Andries Both (Jan's short-lived brother), while a *Lute Player* by an unknown artist (circle of Jan van Bijlert?) belongs to the Caravaggesque genre tradition. Later seventeenth-century Dutch portraiture is represented by works by Maes and (after?) Caspar Netscher.

ST. LOUIS ART MUSEUM

Forest Park
St. Louis, Missouri 63110 *(314) 721-0067*

The earliest art museum west of the Mississippi was the St. Louis Museum of Fine Arts, founded in 1879. The successor to this first structure on Nineteenth and Locust streets was designed by the New York Beaux-Arts architect Cass Gilbert and served as the Palace of Art at the World's Fair of 1904 in Forest Park. The fair building still stands today as the core structure of the museum. Major renovations undertaken by the firm of Hardy, Holzman and Pfeiffer added an annex in 1974. The original building has also recently been refurbished. The elegantly spacious reinstallation at once respects and enhances the central hall and its Roman classical allusions to the Baths of Caracalla. The collections are designed to be as comprehensive as possible, offering art from the Egyptian to contemporary period. The Western art is excellent and offers superb examples of Dutch painting. These have mostly been acquired through purchase, beginning in 1916 when the great van Goyen and the Terborch were acquired. The greatest growth in the Dutch collections came under the directorship in the late 1940s and early 1950s of Perry Rathbone, later director of the Boston Museum of Fine Arts. In these years outstanding works by Mostaert, Maris, Rembrandt, Honthorst, Savery, and van der Ast were purchased. Rathbone's successor, Charles Nagel, acquired not only the Hals, a major purchase by any standards, but also the Wttewael, a painting whose virtues would have been difficult to perceive in 1957. More recent directors, Charles E. Buckley, James Wood (now at Chicago), and James D. Burke, have all nurtured the Dutch collections; the last mentioned is a specialist in Dutch art, notably prints and drawings, and the author of a dissertation on the Dutch italianate landscapist Jan Both. A handbook of the collections was published in 1975 and Dr. Burke catalogued the best seventeenth-century Dutch paintings in the museum's *Bulletin* (Winter 1980).

St. Louis owns three early Northern Netherlandish paintings of considerable interest. The earliest is an *Entombment* by the anonymous Master of the Virgo inter Virgines, a painter and woodcutter whose activity has been localized in Delft and takes his name from a painting of the *Virgin among Virgins* in the Rijksmuseum, Amsterdam. The artist's greatest and most famous work is also an *Entombment*, now at the Walker Art Gallery, Liverpool. Active in Holland in the last quarter of the fifteenth century, the master exhibits a more provincial style than his courtly Flemish or even his neighboring Haarlem contemporaries but is rightly admired for his powerful emotion. His figures are weirdly gaunt and angular, their foreheads distended, jawlines disturbingly delicate, and extremities small and crablike. The elaborate costumes and treatment of the landscape space are also characteristic, the latter appearing as a series of insubstantial, shallow stage partitions,

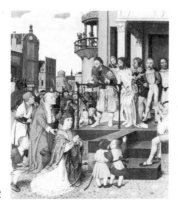

392

above which figures occasionally poke their heads. In spite, indeed because, of his curious awkwardness, he is an artist of singular expressiveness and originality. The early sixteenth-century Haarlem painter Jan Mostaert shares with the Master of the Virgo inter Virgines a sense of humanity which is an important source of the attraction and vitality of early Northern Netherlandish painting. Yet his vision, under the strong influence of Geertgen tot Sint Jans, is much gentler than the Virgo Master's. His figures are more doll-like, one might say, without trivializing, cuter. Mostaert's *Christ Shown to the People (fig. 392 and see color plate 1)* depicts a bearded and richly attired Pilate appealing from a platform in a Medieval town square to an exotic-looking crowd. Among the onlookers is the oversized donor wearing ecclesiastical gowns and kneeling before Saint Jerome in the foreground. Although the dramatic moment of the announcement "Ecce Homo" has arrived, the reactions seem restrained, unemphatic. For Mostaert even Barabas is a sensitive esthete. Something of this gentleness is also evident in Jacob Cornelis van Oostzanen's art, the first important Amsterdam painter. St. Louis owns a fine half-length painting of *Mary Magdalen* of 1519 with her ointment jar. One of the principal characteristics of Oostzanen's figures is their high foreheads and diminutive chins. These delicate oval heads again descend from Sint Jans and call to mind the fragile form of an egg. In a mature work such as this, however, Oostzanen's humanism is tempered by a growing decorativeness, notable in the carpet and treatment of surface detail. This ornamental element would become even more pronounced in his late, more Manneristic works.

The definitive statement, however, of Northern Mannerism is Joachim Wttewael's *Death of Procris*, one of the truly major works by the artist in this country. It depicts the tragic climax of the story of a mutually jealous couple. Suspicious that her husband, Cephalus, had taken a rival, Procris hid in the bushes to spy on him and was killed when he mistook her for a wild beast. Grief stricken, Cephalus later threw himself into the sea. The elegantly

393

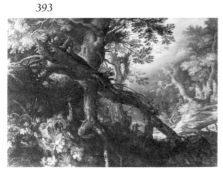

intertwined, pearly-fleshed couple hardly convey the agony of the moment. Rather, in true Mannerist fashion, the story has become a sublimely balletic experience. Mannerist landscape is well represented by Roelant Savery's *Forest with Deer (fig. 393)*. The prey and two hunters are hidden by the dense cover of fallen trees and the richly embroidered foliage. Virtually a textbook ex-

ample of Mannerist composition, the design comprises a dark brown foreground enhancing spatial recession, a green middleground, and an intense blue distance. Other notable Mannerist works include chiaroscuro woodcuts by Goltzius and a recently acquired series of prints of the *Creation of the World* by Jan Muller. Later historical themes by Dutch artists are not numerous, but the printroom claims a fine impression of Hendrik Goudt's engraving after Elsheimer's *Mocking of Ceres (fig. 394)* and a handsome drawing by Andries Both, brother of the more famous landscapist Jan Both, of an *Adoration of the Shepherds.*

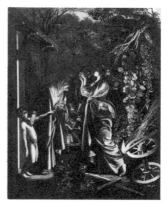

394

Several excellent Dutch landscapes distinguish the collection. The earliest is Hendrik Avercamp's *Winter Landscape with Skaters Near a Town.* Although undated, it is closely related in design to a painting of 1609. Avercamp's winter scenes delight us not only because of his responsiveness to the shapes, textures, and colors of winter—the chill blue-green ice, the light salmon twilight sky, and the stark silhouette of the denuded tree or the more picturesque outline of a tower—but also because of his rich sense of human anecdote. Among the skaters are *kolf* players and an itinerant knifegrinder who no doubt moonlights as a skates sharpener; on the shore a solitary figure bundled against the cold heads home with a marketing basket on his arm. The effect is charmingly direct, never quaint. The other winter scene in the collection is even more enchanting: Jan van Goyen's *Landscape with Skaters near Dordrecht (see color plate 8)* of 1643 appeals more for its masterful treatment of space and atmosphere than for its staffage. Like the much larger and contemporaneous *Landscape and Shepherds* by Albert Cuyp, van Goyen's painting is essentially a panoramic view. Yet rather than emphasize the horizontal expanse of the land, he stresses its vertical aspect. Above the low horizon where soft mists engulf the Grote Kerk, nearly four fifths of the scene is sky. The towering clouds never congeal into patterns but remain a shifting, mottled vapor. Few paintings so brilliantly attest to van Goyen's fame as a painter of atmospheric effects. Very possibly Jacob van Ruisdael was inspired by works such as this when he executed his incomparable *haarlempjes* more than twenty years later. Ruisdael is here represented by one of his waterfalls, a good painting but not of the quality of those owned by Harvard and Baltimore. A recent acquisition is Meindert Hobbema's *View on the Amstel,* a small, early panel by the master, who studied under Ruisdael.

Four excellent Dutch genre scenes are in the collection. Nicolaes Maes' *Account Keeper* of 1656 is a superb domestic genre painting depicting an elderly woman dozing off over her ledgers. A similar composition is in the National Gallery of Canada in Ottawa. Maes painted several pictures of

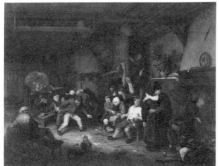

395

servants and housewives asleep at their chores, evidently as admonitions against idleness and negligence. Eyeing the sleeper from the upper left is a bust of Juno, goddess not only of domesticity but also of commerce. In all likelihood the artist included this detail to clarify his cautionary message. Over and above these moralizing concerns the design's orderly geometry and treatment of light were features of Maes' art that anticipate the achievements of the Delft painters Pieter de Hooch and Johannes Vermeer. Adriaen van Ostade's *Peasants Dancing in a Tavern* (fig. 395), dated 1659, also is an outstanding example of this genre painter's mature work. Its frisky subject invites comparison with Chicago's later painting of a similar theme. The happy if coarse strains of a fiddle and hurdy-gurdy also fill Jacob Ochtervelt's *Street Musicians in a Doorway* (fig. 396) of 1665. Here, however, the audience and surroundings are far more elegant. A young woman richly attired in satin directs her maidservant to open the door of his marble-floored foyer so that her child can listen to the music. The child's unqualified delight is enchanting. Ochtervelt specialized in paintings of entrance halls, examining, like his colleague de Hooch, the beauty, perspective, and psychology of thresholds. One of the artist's masterpieces, this work and another painting, again in Chicago, are Ochtervelt's best in this country.

Whether Gerrit van Honthorst's *Young Woman Holding a Medallion* (fig. 397) of 1625 should properly be discussed as a genre painting begs the question of the boundaries of the term; conceivably the work is a portrait. Whatever its classification, the painting's subject is probably a courtesan. If her costume's abundant décolletage and headpiece of feathers (symbols of eroticism and pride) were not enough, the medallion she holds depicts her emblem, a nude in lost profile with the inscription "Wie kent mijn naers / Van afteren" ("Who recognizes my ass / from the rear"). Prostitutes' portraits, often in a flattering and hence commerically advantageous vein, were

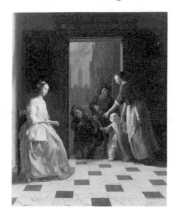

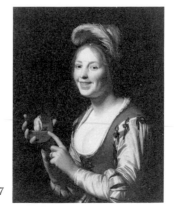

396 397

commonly hung in seventeenth-century brothels to assist visitors in making their selection.

The warranted Dutch portraits in St. Louis are also of very good quality. The earliest is by the Rubens pupil Pieter Claesz Soutman and depicts a *Portrait of a Woman* in an elaborate costume, including an exceptionally wide millstone ruff and embroidered stomacher, which permits a date in the later 1620s. Clothed in the more tractable but nonetheless elegant style, which was fashionable about a quarter century later, Frans Hals' *Portrait of a Woman* is believed to be the companion to a painting held by the Nelson Atkins Museum in Kansas City. Characteristic of the late Hals, the brushwork dazzles in its intimation of the lady's lace and jewelry, but the general effect is one of a modest, unassuming sitter. Far greater pretense is conveyed by the proud stance and finery of Gerard Terborch's *Portrait of Jacob de Graeff* (1642–1690), member of the powerful Amsterdam family and magistrate in 1672. Distantly related to the family, Terborch also knew the patronage of the sitter's two brothers, whom he portrayed in c. 1674, the probable date of this work. A vivid testimony to the increasingly aristocratic attitudes of Amsterdam's regent class, the work is a technical tour de force. St. Louis' Rembrandt is a *Portrait of a Young Man in a Beret* (fig. 398) dated 1662. Since the sitter wears a costume not unlike that worn by Rembrandt in some of his self-portraits, it has sometimes been assumed that he is an artist; however, his identity, like his memorable half-smile, remains an enigma. The identity, on the other hand, of Philips Koninck's portait is established by an engraving in a book of poetry written by the sitter, Heyman Dullaert (1636–1689), and published posthumously in 1719. Like Koninck, who is best remembered for his panoramic landscapes, Dullaert was one of Rembrandt's numerous pupils. Koninck's broad brushwork and warm brown tonality attest to his teacher's influence no less than his sensitive conception of the poet and painter.

The outstanding Dutch still life in the collection is Balthasar van der Ast's *Flower Still Life with Shells* (fig. 399) of 1622. Like other works by the artist, it is painted on copper, a support that permits a higher degree of

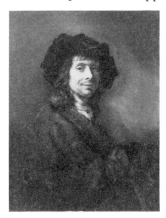
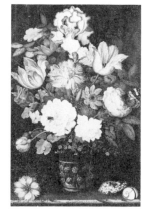

398 399

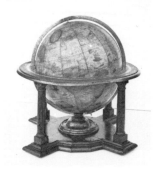

400

finish than canvas or even wood panel. On the metal's slick surface van der Ast could lavish his love of botanical and horticultural detail. Characteristically, his flowers are selected from different seasons and the seashells from both the East and West Indies. Like his painting in Kansas City, Pieter Claesz's *Still Life with Roemer, Oysters, and a Salt Stand* of 1643 is a later work. It is more grandly conceived than his early works and includes richer objects. An actual example of the salt stand, designed in 1624 by the Utrecht silversmith Franssoys Elioet, survives in the Victoria and Albert Museum in London. We also find here one of Willem Kalf's small kitchen still lifes, the counterpart in his oeuvre to the elegant *pronkstilleven*, and an interesting work formerly attributed to Caesar van Everdingen and uncertainly identified as a *Vanitas Still Life*. Although the objects included—an hourglass, old books, mirrored orb, art works, and shells—may allude to the vanity of life, knowledge, and art, a richer symbolic program is also possible. For example, the mirrored sphere that reflects so wide a visual compass appears in seventeenth-century emblems as a symbol of the human mind, which for all its apparent limitations can encompass the vastness of belief in God. Modern iconographers often fail to do justice to the rich variety of meaning in Dutch still lifes of this sort, grouping them indiscriminantly as *vanitas* images (see, for example, Yale's de Gheyn).

The decorative arts include a Dutch or German sixteenth-century inlaid cabinet of rosewood, walnut, and oak, a mid-seventeenth-century extension table, several pieces of glass, including a covered pokal, and delftware. The outstanding Dutch object in the collections is a terrestrial globe *(fig. 400)* by Jodocus Hondius (1563–1611), who founded a famous geographical publishing house in Amsterdam in 1602. An inscription on the globe states that the engraving was begun by Jodocus and finished by his son in collaboration with Adriaen Veen in 1613. Hondius's firm purchased the charts of Gerardus Mercator, the great cartographer, after the latter's death in 1594 and played an important role in disseminating the map-making practice known as the Mercator projection.

St. Louis owns a sizable number of nineteenth-century Dutch paintings, but apart from the van Goghs few are of special interest. The Hague School paintings (including pictures by Israëls, Jacob and Willem Maris, Mauve, Blommers, Bosboom, Weissenbruch, and Mesdag) are autograph but minor. The van Goghs include a very early pen and watercolor drawing of a landscape executed in early spring 1881 at Etten, a painting of the *Hüth Factory at Asnières, Viewed from the Quai de Clichy*, which, like the *Still Life with Apples*, was probably executed in Paris in 1887, as well as two late canvases. The first depicts a steep hillside with very painterly *Vineyards at Auvers-sur Oise* which seems to be mentioned in the artist's letters of June

1890, and the second, also of 1890, shows a *Stairway at Auvers (fig. 401)*. The latter depicts a central view of a road traveled by two young girls in white and, closer to the bottom of the village stairway in the center distance, their counterparts, two older women in dark dresses. Studies exist for these figures, and the composition is known in another smaller painted version in a private collection. St. Louis's twentieth-century collections include

401

Mondrian's *Composition in Red and White* of c. 1938–42. The De Stijl enthusiast will also want to visit Washington University in St. Louis where the Art Museum owns a fine Theo von Doesburg as well as a handful of other earlier Dutch paintings.

MUSEUM OF FINE ARTS

255 Beach Drive North
St. Petersburg, Florida 33571 *(813) 896-2667*

The Museum of Fine Arts is located in Straub Waterfront Park overlooking
Tampa Bay. The Palladian-styled building was opened in 1965. Among the
galleries are Jacobean and Georgian period rooms as well as larger painting
and sculpture galleries. Special strengths of the collections include Indian
sculpture and American art. *Pharos*, a quarterly publication, includes schol-
arly articles on features of the collections.

The seventeenth-century Dutch paintings in the collection include a
"Vanitas" Still Life by Edwaert Colyer and a handsome *Portrait of a Woman*
(fig. 402) by Pieter van den Bos. In the latter work, a restrained image
compensated by charming domestic details, the subject is silhouetted in
severe black and white costume before a light-colored wall. The attributes
include not only a small dog, a straw basket and prayer book on a chair,
but also an engraved portrait on the wall. The engraving depicts a well-
known theologian, Simon Episcopius, leader of the Arminians and opponent
to dogmatic Calvinists. His practical approach to Christianity may well have
been a source of spiritual inspiration to the sitter. Lessons of the spirit are
also the subject of Abraham Bloemaert's *Christ and the Samaritan Woman*
(fig. 403) dated 1626. Like the master's earlier, more manneristically ani-
mated *Moses Striking the Rock* of 1596 in the Metropolitan Museum of Art
in New York, the story alludes to the New Testament's message of the
importance of baptism ("But whosoever drinketh of the water that I shall
give him shall never thirst" John 4:14). Moses' act prefigured the baptismal
salvation of the New Testament, here expressed not only in the words that
Christ spoke to the Samaritan woman at the well but also possibly in the
detail of the butterfly that Bloemaert introduces at the lower right. The
butterfly was a traditional symbol of the soul and resurrection, hence a
possible allusion to the everlasting life that is the promise of Christian
baptism.

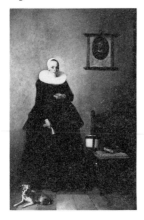

402

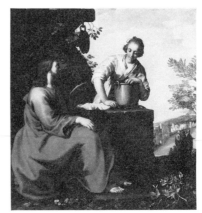

403

Among Bloemaert's many pupils was the gifted Dutch italianate painter Jan Baptist Weenix, whose *Portrait of the de Kempenaer Family* is on long-term loan to the museum. Painted shortly after mid-century, this work already abandons the abstemious appearance of van den Bos's earlier portrait for the new elegance that the Dutch upper classes favored later in the century. The sitters, dressed in colorful satin finery, are viewed in an imaginary classical architectural setting suggestive of a country villa, with the youngest child, Jacobus, riding in a richly decorated red and gold dog cart.

SAN DIEGO MUSEUM OF ART

Balboa Park
San Diego, California 92101 *(714) 232-7931*

Situated in Balboa Park, the San Diego Museum of Fine Arts opened in 1926. It was designed in an ornate Spanish Plateresque style by the local architects William Templeton Johnson and Robert W. Snyder. The museum's main early benefactor was Mrs. Amelia C. Bridges, who had been born a Timken, the steel manufacturing family. When Mrs. Bridges died, her role as prinipal supporter was taken over by two wealthy reclusive sisters, Misses Anne (1867–1962) and Amy Putnam (1874–1958). Most of the European paintings were acquired through funds provided by the Putnam sisters. The Putnam Foundation was formed by 1950. At the death of Anne Putnam, works of art that had been on loan to museums in Eastern cities were recalled and brought together in the Timken Art Gallery (see below), built in 1965 adjacent to the original structure. The strengths of the San Diego museum's collections are its Spanish and Italian paintings; however, it also boasts good Oriental art and American and contemporary painting and sculpture. The Dutch paintings housed in the San Diego museum are not numerous and include misattributions but claim several fine pictures. A catalogue of the paintings collection last appeared in 1960, and the June 1982 issue of *Apollo* was devoted to the museum and the Timken Art Gallery.

The *Young Man with Feathered Cap* dated 1631 is not in a good state of preservation, but is probably correctly identified as an early Rembrandt despite weaknesses in details such as the gorget. More attractive and animated is Frans Hals' spirited little *Portrait of Isaac Abrahamsz Massa* (1586–1643) *(fig. 404)*. Massa was not only a merchant and diplomat to Russia but a historian who kept an important journal, a geographer, and a cartographer of some reputation. He seems, moreover, to have been a personal friend of Hals, serving as a witness to the baptism of one of the latter's children. A painting of the sitter by Hals dated 1626 and now in the Art Gallery of Toronto includes a glimpse of a Northern landscape behind, no doubt a reference to Massa's Russian interests. The present work can be dated 1635 on a basis of an engraving by Adriaen Mathan for which the panel probably served as a modello. Other Dutch portraits in the collection include lesser works attributed to Nicolaes Maes and Gesina Terborch. The putative Terborch known as the *Love Letter*, is a copy of a painting in

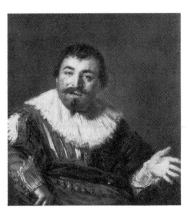

404

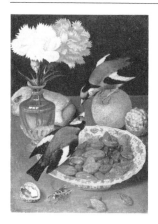
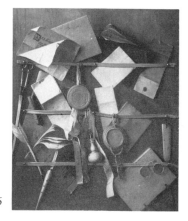

405 *406*

Munich, and the genre scene attributed to Jacobus Vrel is also probably a copy of the work in Antwerp.

Although the collections claim a good, late *Landscape with Waterfall* by Jacob van Ruisdael and a *Village Scene* by the interesting Brueghelian genre painter from Utrecht Joost Cornelisz Droochsloot (compare the works in Detroit and Boston), the quality of the Dutch still lifes is higher. In addition to a charming early seventeenth-century *Still Life with Gold Finches* (fig. 405) attributed to Balthasar van der Ast on the basis of its questionable resemblance to his *Two Parrots* of 1623 in the Fitzwilliam Museum, Cambridge, *407*

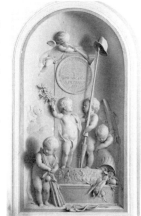

the museum owns a *Trompe-l'oeil Still Life* (fig. 406) attributed to Wallerant Vaillant but closer to Cornelis Gysbrechts. Two other noteworthy works are the splendid later flower still lifes by the great woman painter Rachel Ruysch (dated 1689), and the influential early eighteenth-century painter Jan van Huysum (dated 1740). These luxuriantly refined works are all the more beautiful for their good state of preservation. Another noteworthy eighteenth-century painting is Jacob de Wit's *Allegory of the Treaty of Aix-la-Chapelle* (fig. 407), signed and dated 1748, one of the artist's many decorative works in grisaille which owe their popular name *witjes,* to him. A *Portrait of a Lady* by Kees van Dongen figures among the modern art.

TIMKEN ART GALLERY

Balboa Park
San Diego, California 92101 *(714) 239-5548*

Inaugurated in 1965, the Timken Art Gallery houses the collection of the Putnam Foundation. The modern-styled building of travertine and bronze designed by Frank Hope and Sons is situated in Balboa Park next to its larger neighbor, the San Diego Museum of Art. Unlike the latter institution, which offers temporary exhibitions, traveling shows, and educational courses, the focus of the Timken is on the permanent collection. This comprises a select group of icons, sixteenth-century French tapestries, and, above all, Old Master paintings. Particular strengths are the Spanish, Italian, early Netherlandish, and Dutch pictures. A handbook of the *European Paintings in the Timken Art Gallery,* compiled by Agnes and Elizabeth Mongen, was published in 1969.

The Timken has been called a "treasure-house" in the august tradition of the Gardner Museum in Boston and the Frick Collection in New York. Although smaller in scale and, to be frank, more uneven in quality, the gallery boasts an outstanding little collection of paintings. Single examples are offered of Dutch history painting, portraiture, still life, landscape, architectural painting, and genre. Surely the greatest is Rembrandt's *Saint Bartholomew (fig. 408)* of 1657. The apostle sits in a chair facing the viewer, his head slightly turned and his right hand holding his attribute, the knife with which he was flayed. Before about 1912, when the picture was cleaned, the knife was overpainted with a book, presumably at the behest of an owner who preferred that his subject brood over literary matters instead of a horrific martyrdom. An earlier (c. 1633) version of the theme is in the Worcester Museum and a later one (1661) is in the Getty Museum. Of the three, the present work depicts the apostle with the greatest resolve; cradling the knife, he sternly accepts his end. Like the *Saint Paul,* also of 1657, in Washington,

408

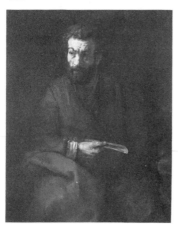

with which it is often compared, the painting seems to have been part of a series of apostles which never was completed or survives only in part. In a particularly good state of preservation, the picture enables us to fully appreciate Rembrandt's broad and powerful late manner.

The outstanding Dutch portrait in the collection is Frans Hals' half-length *Portrait of a Man* dated 1634. As Valentiner first observed, this work is the companion to a woman's portrait in the Detroit Art Institute. The pair are uncertainly identified in eighteenth-century watercolor copies as

"M[onsieur] Mers" and "Catherine V[u]lp," about whom nothing else is known. A slightly earlier work is Pieter Claesz's *Breakfast Still Life (fig. 409)* of 1627, an excellent example of his early "monochrome" style. One of Ruisdael's *haarlempjes* of c. 1670 graces the collection. The angle at which St. Bavo's appears indicates that Haarlem is viewed from a point almost due north,

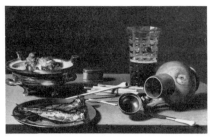

409

but the scene includes bleaching fields located in Overveen, which is farther to the west. Studies of Ruisdael's *haarlempjes* have shown that, despite their naturalism, they are never wholly accurate topographically. Emanuel de Witte also often took liberties with his architectural paintings, although his *Interior of the Nieuwe Kerk, Amsterdam (fig. 410)*, dated the same year as the Rembrandt, appears to be a fairly accurate representation of that building. One of the high points of the entire collection is Gabriel Metsu's *Love Letter (fig. 411)* which depicts a boy delivering a letter to a young lady in a red jacket seated beneath a stone arcade. A pendant to this charming scene, which has the same dimensions and early provenance, is the *Letter Writer* in the Musée Fabre, Montpellier. On at least one other occasion—the famous pendants in the Beit Collection, Ireland—Metsu coupled the themes of the letter written and the letter received. The inspiration for the pairing of these subjects, indeed for the general popularity of letter themes in Dutch genre, stems from Terborch. The present work is especially fresh in execution and clearly superior to a replica in the museum in Oslo.

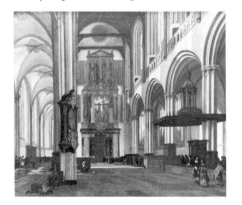

410

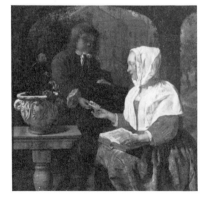

411

FINE ARTS MUSEUMS OF SAN FRANCISCO

M. H. DE YOUNG MEMORIAL
MUSEUM
Golden Gate Park
8th Avenue at Kennedy Drive
San Francisco, California 94121
(415) 558-2887

CALIFORNIA PALACE OF THE
LEGION OF HONOR
Lincoln Park
34th Avenue and Clement Street
San Francisco, California 94121
(415) 558-2881

At the conclusion of the California Midwinter International Exposition of 1894, the Fine Arts Building in Golden Gate Park and surplus funds from the event were turned over to M. H. de Young, publisher of the San Francisco *Chronicle* and director of the exposition, for the purpose of establishing a museum. The cornerstone of the present M. H. de Young Memorial Museum was laid in 1917, and the building was opened two years later. The architect was Louis Mullgardt and the style Spanish Plateresque. Additions were made in 1920, 1925, 1931, and in 1966 a west wing to house the Avery Brundage Collection of Asian Art was completed. The other museum under the aegis of the Fine Arts Museums of San Francisco is the California Palace of the Legion of Honor. The inspiration for this building came from the French government's pavilion at the Panama Pacific International Exposition of 1915, which in turn was a replica of the Palais de la Legion d'Honneur in Paris, formerly the Palais de Salm, designed by Pierre Rousseau in 1786. A great francophile and admirer of the Rodin exhibition mounted in the original 1915 pavilion, Alma de Bretteville Spreckels provided funds to reproduce this temporary structure as a permanent building on a high bluff at Land's End overlooking the California coastline. Completed in 1924, the structure was freely translated from the original by the architect George Applegarth with the assistance of Henri Guillaume. Its truly breathtaking location on a summit in Lincoln Park makes it one of the most beautifully situated museums in the United States. The two museums in San Francisco initially competed as rival institutions, reflecting a long-standing feud between the Spreckles and the de Youngs. Amalgamation of the two museums in 1971 finally brought an end to the contest; the combined collections now rival the best in America. A handbook of the *European Works of Art* appeared in 1966, and Egbert Haverkamp Begemann reviewed the Dutch and Flemish seventeenth-century paintings in *Apollo* (1980).

The Northern European paintings are particularly strong in San Francisco. In addition to fine examples of the art of Rubens, van Dyck, Cornelis de Vos, and other Flemish baroque painters, the collections include excellent Dutch seventeenth-century pictures. One of the finest is Rembrandt's early portrait thought to depict *Joris de Caullery* (fig. 412), which is signed and dated 1632. A document mentions a portrait of a ship's captain by this name who later was a wine merchant and innkeeper and whom Rembrandt portrayed holding a *roer* (translatable either as a "musket" or "rudder"). The gentleman, viewed three-quarter length and wearing a yellow tabard and

metal gorget, is posed forcefully with his arms akimbo. The lighting is vivid and dramatic. The object in the subject's right hand, however, is probably a halberd, a weapon commonly carried only by sergeants in the civic guard. Thus while the sergeant's identity remains uncertain, this emphatic portrait is of special interest because it is the earliest evidence of Rembrandt's contact with Amsterdam's militia, a relationship that culminated ten years later in the commission for the famous *Night Watch* now in the Rijksmuseum in Amsterdam.

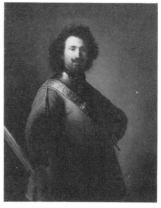

412

The other two paintings assigned to Rembrandt in San Francisco are no longer universally accepted; however, several history paintings by Rembrandt School members deserve special note. Van den Eeckhout's powerful *Saint Peter Healing the Lame* of 1667 reflects his teacher's art both in conception and execution, even though he had long since left the master's tutelage. Van den Eeckhout adhered to Rembrandt's approach only in his religious subjects, adopting a different style for his other themes. The broad technique and dramatic effect of Barent Fabritius's *Dismissal of Hagar* also reflects Rembrandt's art; however, the central figure group reverts to a still earlier source. Barent's conception of the Hagar theme, one of the most popular subjects in Dutch history painting, is based on an early work in Hamburg by Rembrandt's teacher Pieter Lastman. The influential Lastman introduced greater scriptural accuracy and a more intimate variety of human drama into Dutch history painting. Most of his paintings in America are early works (see the pictures in Boston, Providence, and Norfolk), but San Francisco owns one of his late, rather busy compositions, *The Triumph of Joseph* of 1631. Not readily identifiable as a Rembrandt School piece, Ferdinand Bol's *Amarillis and Mirtillo (fig. 413)* attests to a characteristic feature of the art of many Rembrandt pupils, namely their readiness to depart from the master's style once they had left his studio. Bol adopts a classicizing manner in his treatment of a charming episode from Guarini's *Il pastor fido.* The painting 414

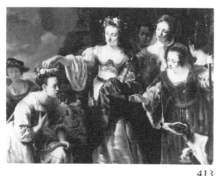

413

depicts the young Mirtillo crowned by Amarillis after he had won a kissing competition while disguised as one of her sister nymphs.

A more comical but nonetheless serious-minded interpretation of a history subject is provided by Jan Steen's *Marriage of Tobias and Sarah (fig. 414)*, an apochryphal biblical theme treated on several occasions by the artist (see especially the painting in Braunschweig). The subject refers to the story of Tobias, who, with the aid of an angel who appears here between the marriage couple, successfully drove out a demon who had killed Sarah's previous six husbands on their wedding night (see Lastman's painting in Boston). The scene depicts the signing of the marital contract mentioned in the Apochrypha, while Tobias's theatrical gesture expresses his faith in divine protection during the less-than-auspicious night ahead. The painter conceives of the scene as occuring in a seventeenth-century Dutch country house. The richly anecdotal gestures of the joking peasants and wedding guests, as so often in Steen's art, attest to his keen observation of his fellow man. Yet for all the smirking and broad comedy, the scene's message doubtless is delivered in earnest—no marriage will survive without faith in God. Together with the paintings in Philadelphia and Cleveland, this work is one of Steen's best history paintings in America. One final biblical scene

deserving mention is the *Annunciation to the Shepherds* by the landscapist Adam Pynacker, a wonderful image of nocturnal commotion.

The genre scenes in San Francisco, though few in number, are among the best Dutch paintings in their collection. The scene of a *Young Mother (fig. 415)* suckling her infant by a window in the corner of a light-filled room is one of Pieter de Hooch's most beautiful interior genre scenes in the United States. Like its splendid outdoor counterpart in Toledo, which depicts a quiet domestic theme but transported to a courtyard, the painting probably was executed in Delft in the late 1650s. In these years de Hooch was at his most innovative, developing an art that emphasized clear, orderly spaces, subtle observations of daylight, and a palette dominated by pure, unmixed hues. His direct style and serene images of Dutch homelife seem to have had a formative influence on his gifted colleague Jan Vermeer, who took these ideas to a splendid and matchless state of refinement. Doubtless the image of the attentive mother nursing her child and the playful note of the young girl

415

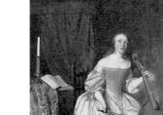

416

imitating her mother's actions by feeding a dog prompted de Hooch's contemporaries to reflect on the simple joys and virtues of domesticity. Gabriel Metsu's *Young Woman Playing the Viola da Gamba* (fig. 416) of 1663 is no less an outstanding achievement in this artist's oeuvre. The exquisite rendering of surfaces—the shimmering white satin dress, the glossy wood of the instrument, and the richly patterned oriental rug—is a virtuoso display perfectly suited to the elegant subject. A portion of Metsu's informed public may have seen in this woman the embodiment of Harmony (compare also the Metsu newly acquired by Los Angeles); in Caesar Ripa's popular *Iconologia* (translated into Dutch in 1644) Harmony is personified by a woman playing a viola da gamba. However, one needed no special knowledge to appreciate the work's harmonious order or the woman's invitation to accompaniment. Music, after all, frequently served in Dutch genre as a prelude to love. Another excellent little musical genre scene is the *Woman with a Cittern*, dated 1677, by Pieter van Slingeland, an able artist whose works are rare in this country.

Highlights among the Dutch portraits in the collection are the introspective *Portrait of a Young Boy* by Michael Sweerts (compare the picture in Hartford) and the excellent small-scale, early *Portrait of a Gentleman in Black* by Terborch. A combination of Spanish and Dutch portraiture, the work and its undefined, light-colored background and darkly silhouetted subject has the look of a miniaturist's Manet. Once attributed to Frans Hals and hailed as a masterpiece, the dashing *Portrait of a Man in White* is now recognized as the work of a clever follower. The so-called *Portrait of Rembrandt's Wife, Saskia, at a Window* of 1642 is now believed to be by Jan Victors instead of Bol. Other portraits in the collection are by Paulus Moreelse, Jacob Backer, and Nicolaes Maes.

Although it houses noteworthy early Flemish still lifes (Jan Brueghel and Jacob van Hulsdonck), the museum's best Dutch still lifes are relatively late works, a brilliant Willem van Aelst *Flower Still Life* (fig. 417) of 1663 and van Beyeren's last dated *Banquet Piece* (1666). In our admiration for the meticulous, opalescent finish of the van Aelst it may be recalled that he was active in Delft at the same time as Vermeer.

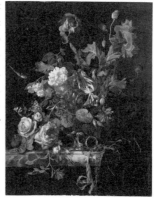

417

While San Francisco could use an example of the painting of Avercamp, Esaias van de Velde, or another member of the early group often called the Haarlem Realists, the collections offer a representative sampling of Dutch landscape. Of special interest is the large van Goyen, dated 1641, depicting a violent thunderstorm (fig. 418), in which boats appear tossed about on an open stretch of water. Complete with lightning, the scene offers an unusually violent image of nature for van Goyen. Contrast is provided by the calm of Salomon

418

419

van Ruysdael's *River Waal with the Valkhof* of 1648, a site that van Goyen represented repeatedly between 1633 and 1654. Another artist who depicted this famous site was Albert Cuyp, whose version now in Indianapolis is discussed elsewhere in this volume. Both Ruysdael and Cuyp showed a greater interest in formal structure and color and took greater liberties with the actual architecture than did van Goyen; however the two paintings that resulted could hardly be more different. While Ruysdael employs a palette inspired by his northern surroundings, Cuyp's sunny colors evoke southern climes. Such is the case even when Cuyp depicts a winter scene, such as San Francisco's delightful little *View of the Maas in Winter.* Here, despite the frigid temperatures, the sky above the skaters and the familiar tower of the church of Dordrecht beyond glows a warm reddish-yellow. Dutch italianate works in the collection include Jan Asselijn's striking *View of the Ponte Molle, Rome (fig. 419),* Jan Both's *Landscape with Herdsmen,* and Nicolaes Maes' *Landscape with Muleteer and Herdsmen.* A cityscape deserving special note is Gerrit Berckheyde's *Singel in Amsterdam* with a view of the large dome of the Lutheran church which still stands today. Other noteworthy marine paintings include works by Simon de Vlieger and Willem van de Velde; the latter, however, was stolen along with three other Dutch pictures in 1978, and its present whereabouts remain unknown.

Highlights of the Dutch decorative arts include a very handsome

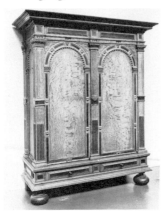

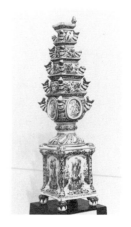

420 421

wardrobe (*kast*) of oak and inlaid ebony dating from the mid-seventeenth century (*fig. 420*) and a pair of large delftware *Tulipiers* (*fig. 421*) of c. 1700.

The nineteenth-century collections include a Mauve, Jacob and Willem Maris, Israëls, Bosboom, and Jongkind's *Pont de la Tournelle, Paris* of c. 1859. Among the modern holdings are works by Kees van Dongen and Karel Appel.

THE JOHN AND MABLE RINGLING MUSEUM OF ART

Tamiami Trail, North
Sarasota, Florida 33578 *(813) 355-5101*

A sense of wonder and fantasy pervades the Ringling Museum, the creation of the entrepreneur and circus magnate John Ringling. Ringling had eclectic tastes but, quite appropriately, was most enamored of the baroque, the style of illusion, theatricality, and heightened emotion. The fun of the Big Top captured by the ornate band wagons in the Circus Museum situated nearby also fills the *Ca' d'Zan,* the pink Venetian palazzo Ringling built in 1929 to house his collections. Amassing an extraordinary total of 625 paintings during a relatively brief five-year period (1925-30), Ringling bought voraciously before financial and personal problems forced him to curtail his spending. He was advised in his collecting by the Munich dealer Julius Boehler, but made many purchases on his own. Inevitably his collection invites comparison with the Frick Museum in New York and the Gardner in Boston, collections that reflect the tastes and personalities of their founders. The Ringling Museum fares far better by such a comparison than one might suspect, principally because of the exceptional strengths of its Flemish baroque pictures. Ringling assembled the greatest collection of Rubens' paintings to be seen in the United States, notably the four large cartoons for the *Triumph of the Eucharist,* the *Achilles Dipped into the River Styx, Lot and His Family Departing Sodom,* the *Scholar Inspired by Nature* (also known as *Pausias and Glycera*), and the *Portrait of Archduke Ferdinand.* Obviously the impresario was drawn to Rubens' expansive vision. No less prescient an observer than Wilhelm von Bode, the great director of the Berlin Museum, congratulated him for overcoming the typical American prejudice against Rubens as bombastic and commended him on his taste for large, impressive pictures. The collection of Dutch sixteenth- to nineteenth-century paintings gathered by Ringling is less important than the Flemish but nonetheless of extraordinary quality. Moreover, since the circus master's death it has been supplemented with several distinguished works (notably the van Aelst, Pynacker, and van Kuijl) purchased by later directors of the museum. The visitor seeking a fuller account of the Dutch and Flemish paintings is directed to the catalogue (1980) by Franklin W. Robinson and William H. Wilson with contributions by Larry Silver. This substantial volume updates W. E. Suida's general catalogue of the collections first published in 1949.

One of the greatest masterpieces in Sarasota is Frans Hals' *Portrait of Pieter Jacobsz Olycan (fig. 422),* a work the famous dealer Duveen was said to have so coveted as to offer Ringling three times what he had paid for it. Olycan was a Haarlem brewer, burgomaster, and member of the States General. Despite having painted nine members of the family a total of eleven

times, Hals managed to endow his sitter with an expression of great immediacy and force. Indeed, the crusty Olycan gazes at the viewer so intently as to appear to scowl. The portrait of his wife, Maritge Vooght, is owned by the Rijksmuseum. While the two paintings may have been pendants, the Sarasota picture's broad, open brushwork points to a later date, suggesting that it may have been executed as a companion piece some years after the picture in Amsterdam. Other Dutch portraits in Sarasota include a *Portrait of a Lady with a Standard* by the early sixteenth-century Haarlem artist

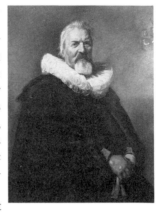

422

and court painter Jan Mostaert, formularized seventeenth-century portraits by Ravesteyn, Nason, Maes, and Netscher, and a pair of handsome and typical pendants depicting a man with a spear and his unidentified wife by the underrated Amsterdam artist who later worked in London, Isaac Luttichuys. A rare painting by the Dordrecht portraitist Paulus Lesire deserves note, as does the magisterial but badly damaged *Portait of a Woman* dubiously attributed to Rembrandt.

One of the tiniest but most precious works in the collection is a little *Winter Scene* on oval-shaped copper by Hendrik Avercamp. Despite its minute scale, the view with high horizon bustles with activity as skaters whiz past the ice-locked hulls of ships. Works by the innovative Herman Saftleven are rare in American museums, hence the recent discovery of his *Sunset Landscape with Herdsmen* in the Ringling Museum's storage depot is a welcome surprise. Yet the high points of the collection's Dutch landscape group are the works by the Dutch italianate painters Adam Pynacker and Johannes Lingelbach. The former's *Landscape with Hunters* (fig. 423) is a late work by the artist showing all his brilliant clarity of vision and gift for precise, calligraphic detail. The Lingelbach in typical fashion presents an imaginary Italian *Harbor Scene* with carefully observed street figures assembled in the foreground with a large statue of Mercury, patron of commerce, in the center distance.

It perhaps will come as no surprise that the first Dutch painting that Ringling purchased was Jan Steen's tumultuous *Rape of the Sabine Women*. Although it cannot be said to be one of the artist's finest history paintings, the picture wants nothing for sheer vitality. And yet a distractive feature of the work is its condition. A common fault of large American private collections that were assembled with some haste, such as Ringling's or Crocker's in Sacramento or to a lesser extent Johnson's in

423

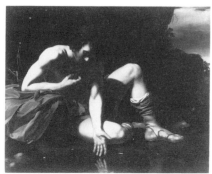

424

Philadelphia, is their uneven state of preservation. One particularly powerful work in Sarasota which is diminished by its condition is the *Lamentation over the Body of Christ* by an unknown member of the Rembrandt School active in the third quarter of the seventeenth century. Like two other similar works formerly thought to be by Rembrandt—the *Saint Matthew and the Angel* in Raleigh and *Saint Peter Released from Prison* at Rhode Island School of Design—this work defies attribution but leaves a haunting impression by virtue of its powerful design; the pitiably lank body of Christ stretched horizontally across the foreground is especially moving. The Ringling Museum owns several notable history paintings by lesser-known Dutch history painters, including the chronicler of artists' lives Arnold Houbraken, the Haarlem classicist Leendert van der Cooghen, and the only recently rediscovered Caravaggist from Gorinchem Gerard van Kuijl. The *Narcissus* (fig. 424) by the last mentioned is his only known work in America and clearly reflects the lessons of Caravaggio's chiaroscuro effects. Speaking no less eloquently of the rewards of contact with Italian and possibly French art, Karel Dujardin's *Hagar and Ishmael in the Wilderness* (fig. 425) is one of the masterpieces of the collection. A popular theme among Dutch artists, the subject depicts the moment when Hagar, the concubine of Abraham who was expelled by his jealous wife Sarah, and her son Ishmael are rescued from thirsting to death in the desert by an angel who points out a fountain.

In fairness to the collection it must be said that this splendid Dujardin is in a very good state of preservation. Equally well preserved are the two outstanding Dutch still lifes in the collection, Willem van Aelst's *Still Life with Dead Game* and Jan Davidsz de Heem's *Still Life with Parrots* (fig. 426).

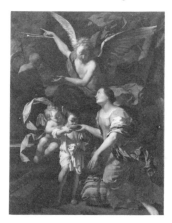

425 426

A specialist in paintings of hunting trophies, van Aelst in his early years usually painted on a more intimate scale but in this large late work adopted a monumental format for one of his favorite designs. Treated on a similarly generous scale, de Heem's still life overflows with rich and exotic objects—food, fruit, shells, metal, and glassware and two gaudy, screeching parrots. It is a testament to the artist's sophisticated powers of composition that his sumptuous and superabundant assembly is in no way crowded or cloying. In many respects de Heem's brash and colorful picture epitomizes the wonderful self-confidence of the Ringling Collection. The same flamboyant spirit also is expressed in the large delftware birdcage (*fig. 427*) preserved in Sarasota.

427

Something of a rarity in American museums, the collection includes large eighteenth-century Dutch history paintings executed as decorative ensembles by both Jacob de Wit (a ceiling actually installed in the master bedroom) and Dionys van Nijmegen. More common are its holdings of works by the nineteenth-century Hague School painters Anton Mauve and Jozef Israëls. However, the latter's "historical genre" scene of *Maria van Utrecht Receiving the Letter from Her Husband Johan van Oldenbarnevelt Announcing His Death Sentence* is notable as an early work in a more academic vein than his better-known peasant paintings. The story of the seventeenth-century Dutch leader Oldenbarnevelt was popular among nineteenth-century Dutch painters. The episode depicted here refers to Oldenbarnevelt's imprisonment and execution after years of service to Prince Maurits and the House of Orange. This grave event in 1619 led to a crisis between the more liberal Remonstrants, who were led by the regent classes of the cities, and the stricter Calvinists, who were loyal to the royal family, who in turn held control of the army. Evidently the young Israëls was drawn to the dramatic event because of its importance for the early history of the Dutch Republic.

SEATTLE ART MUSEUM

Volunteer Park
Seattle, Washington 98112 *(206) 447-4710*

Located in Volunteer Park overlooking Puget Sound and offering a vista of the Olympic Mountains beyond, the Seattle Art Museum was constructed in 1933. The building designed by Bebb and Gould in the so-called *art moderne* style was financed by Dr. Richard E. Fuller, who also gave his own collection of Asiatic art and helped set up an acquisitions program. Today the East Asian collections are some of the finest in the country and have been supplemented with Indian, Islamic, and African art. The small European Old Master collection was greatly enhanced by the presentation in 1952–54 of paintings from the Samuel H. Kress Foundation. Although mostly Italian works, this group of paintings also included half a dozen noteworthy Dutch and Flemish paintings. A group of Northern drawings were left to the museum by Le Roy M. Backus. In addition to the Volunteer Park facility, the contemporary and Northwest art collections are housed in the Modern Art Pavilion annex in Seattle Center (Second Avenue North and Thomas Street).

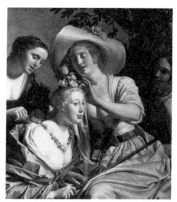

428

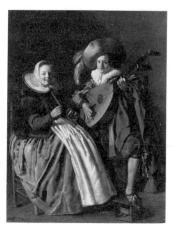

429

Only the Kress pictures have been fully catalogued; see Colin Eisler's *Paintings from the Samuel H. Kress Collection. European Schools Excluding Italian* (1977).

One of the finest Dutch paintings among the Kress group is Gerard van Honthorst's large *Pastorale* (fig. 428), dated 1627. Similar in style to the artist's *Granida and Daifilo*, dated two years earlier, in the Centraal Museum in Utrecht, the work recalls the conception of bucolic history subjects, such as Amarillis and Mirtillo or Daphne and Chloe, but has not been certainly identified with any specific theme. Instead, it seems to be part of the interest that grew up in the 1620s in general arcadian subjects which is demonstrable not only in the works of the Utrecht Caravaggisti but also Moreelse and Bloemaert. Paintings such as Seattle's also have rightly been singled out as forming the basis for Jan van Bijlert's style (compare the latter's paintings in Houston, Norfolk, and Greenville). Another outstanding Dutch genre painting among the Kress paintings is Jan Miense Molenaer's *Duet* (fig. 429) of c. 1629–31. The models for this

430

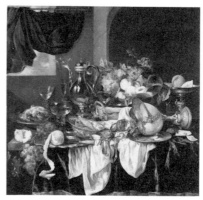

431

work have sometimes been assumed to be Molenaer himself and the painter Judith Leyster, who were married in 1636. However, despite the fact that both artists painted other similar duet scenes in these same years (preserved respectively in the Louvre and the National Gallery, London), there is no proof for the identification, and even the assumption that the figures are portraits is uncertain. An early work by Molenaer, this painting attests to the young painter's assured technique, a style that is at once more controlled and descriptive than Leyster's bravura manner.

The largest single group of Dutch paintings in the collection are the still lifes, which include works by Johannes Leemans, Jacob Rootius, a *"Vanitas" Still Life* of 1650 by Jacques de Claeuw, and *Dead Game Birds in a Niche (fig. 430)* signed by Cornelis Lelienbergh and dated 1665; the last mentioned may be compared with Philadelphia's painting by the artist of the same subject, dated eleven years earlier. Once again, among the still lifes the Kress paintings stand out, with a monogrammed but undated *Banquet Piece (fig. 431)* by Abraham van Beyeren which probably dates from the mid- to late 1650s. Among the precious objects depicted are an overturned nautilus cup, a gold watch, a blue Chinese-style porcelain bowl, a silver coffee pot, and *façon de venise* wineglasses. Not only do some of the individual objects recur in van Beyeren's other works but also some of the same groups of motifs (e.g., the silver platter of peaches nestled in the straw basket), indicating that the artist worked, at least in part, from preparatory studies. The same was

432

true of Emanuel de Witte, whose later *Imaginary Church Interior* in Seattle repeats staffage figures that he had employed earlier in a painting dated 1674 in Cologne. The Gothic-styled church also closely resembles several other works by the painter, one of which (Johannesburg, South Africa) is dated 1678, and may constitute a free interpretation of the Oude Kerk in Delft.

While, somewhat surprisingly, Seattle has no Dutch portraits, the best Dutch landscape is a dramatic *Nocturnal Fire (fig. 432)* by Egbert van der Poel. Van der Poel made a specialty of calamity; in addition to night fires, he repeatedly executed scenes of the famous explosion of the powder magazine in Delft in 1654. The Le Roy M. Backus drawings include a *Landscape with Soldiers* dated 1627 by van Goyen, and other sheets by van de Capelle, Ostade, and one wrongly attributed to Metsu. Several minor pieces of delftware are also preserved here.

MUSEUM OF FINE ARTS

49 Chestnut Street
Springfield, Massachusetts 01103 *(413) 733-5857*

The Springfield Museum of Fine Arts was conceived by James Philip Gray (1835–1904) after he retired to Springfield in 1888 from a prosperous career as a coal and lumber merchant. Although he did not collect art himself, Gray left his entire estate for the purchase of paintings and the erection of a building to house the collection. Nearly all the Dutch paintings in the museum were acquired with these funds. The building, a severe, classical structure, was designed by the local architects Tilton and Githers and opened in October 1933. Handbooks of the collection were published in 1948, 1958, 1963, 1973, and an attractive, newly revised edition appeared in 1979.

While not so rich in Northern painting as the museums nearby in Worcester and Hartford, the Springfield Museum has a solid sampling of Dutch art. Sixteenth-century paintings include a nightmarish *Last Judgment* scene attributed to the follower of Hieronymus Bosch, Jan Mandyn van Haarlem, and a little nocturnal *Adoration of the Shepherds* dubiously assigned to Aertgen Claesz van Leyden. These minor works are supplemented with good quality prints by Lucas van Leyden and Hendrik Goltzius. Far stronger are the seventeenth-century paintings. The earliest are a lively pair of grisailles (paintings in tones of gray or brown) by Adriaen van de Venne, dated 1631. One *(fig. 433)* depicts an elegantly clad young woman holding a wineglass aloft as she dances along on the arm of a disheveled cripple. The other *(fig. 434)* shows a tattered couple who perform a similarly crude dance as the man plays a hurdy-gurdy and the woman overturns a bowl of food raised over her head in the merriment. If the presence of a skeleton in the background is not enough to alert the viewer to allegorical meanings, van de Venne inscribes his messages on little banderoles in the corners of the panels. The former reads "Ellendige Weelde" (Wretched Abundance) and the latter "Weeldige Armoede" (Abundant Poverty), titles that, in their

433 434

word play, specify the symbolic and moralistic intent. Still aligned with the allegorical traditions of sixteenth century genre painters—above all, Pieter Brueghel and his followers—van de Venne is best known for his illustrations of Jacob Cats' popular emblem books. It was van de Venne who engraved the disarming little everyday and not-so-everyday scenes that make the homilies of "Vader Cats" come alive. Moreover, van de Venne was a poet in his own right. It is hardly surprising, therefore, that his works are more literary and consistently allegorical (and in this sense somewhat *retardataire*) than those of his contemporary genre painters. The latter usually commented on their scenes through a subtler technique, which has come to be known as "disguised symbolism." Samuel van Hoogstraten, a seventeenth-century art theorist as well as a painter, described this practice in his treatise of 1678 as "bywerk dat bedektlijk iets verklaert" (accessories that covertly explain something). Yet one hardly need ferret out symbolic elements (e.g., the glass vase of flowers in the window as an allusion to the sacred purity of the Virgin and Child) to comprehend the domestic idyll of Hoogstraten's highly finished painting of 1670, known by the apocryphal title *The First Born* (fig. 435). On the other hand, one could wish for a bit of symbolic assistance in interpreting the curious and much-abraded painting of a *Sleeping Woman* holding a letter, which also is assigned to Hoogstraten, though only for lack of a better name. Another Dordrecht painter, Cornelis Bisschop, painted similar subjects, but the hand is not his either.

Springfield's pleasant series of marines by Jan van Goyen, Willem van de Velde the Younger, and Abraham Storck serve to remind us of the importance of the sea for the Dutch nation. Not only did the far-ranging commercial fleet help to transform The Netherlands into the foremost trading center of the world, but Holland's fishermen safeguarded the nation against famine during periods of disrupted trade, poor crops, war, and even foreign occupation. Moreover, speedy navigation along the rivers and vast network of inland canals ensured a brisk transfer of both goods and ideas; the latter fostered communication which helped make Dutch governmental institutions if not democratic at least relatively accountable. The van Goyen offers

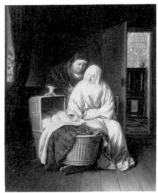

435

a glimpse of the Leiden skyline, and the Storck shows us the Town Hall, the Luthern church, and other monuments of Amsterdam in the distance. The cityscape painter Gerrit Adriaensz Berckheyde, on the other hand, brings us ashore into the marketplace in Haarlem which he had painted on so many other occasions. This particular image of *The Grote Kerk* (St. Bavo's), with people promenading in the open square, is viewed from an archway beside the Town Hall, the corner of which can just be seen at the left. The effect of this arch (which for the sake of the picture's format is

somewhat wider and squatter than in reality) enhances the sense of spatial relief. A traditional illusionistic device, the darkened portal creates a diaphragm or, as it were, a threshold to the pictorial space.

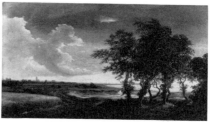

436

Although he painted a few true cityscapes late in his career and often included skylines of identifiable cities (most frequently his native Haarlem) on the horizon, Jacob van Ruisdael preferred the open country side. His *Landscape near Dordrecht* (fig. 436) is an important early work, dated 1648, which combines an open panorama on the left with a group of large, backlighted trees on the right. This type of "single wing" composition had been employed earlier by van Goyen, but the obvious source for the design is Rembrandt's famous *Three Trees* etching of 1643. Ruisdael, we recall, began his career as an etcher and doubtless was impressed by the great master's prints as well as those of Esaias van de Velde and Roelant Savery, who could have inspired his twisted and gnarled trees.

Dutch seventeenth-century still life and portraiture are represented by single examples of each: an elegant *Still Life* by Willem Kalf of a china bowl of Ming design (but like so much of this ceramic ware perhaps of Dutch manufacture) which is filled with fruit and rests beside a timepiece and silver platter on a table covered with an oriental carpet, and a striking *Self-Portrait* (fig. 437) of 1640 by the Rembrandt pupil Ferdinand Bol. Predictably, the painting was attributed to Rembrandt in Boydell's mezzotint of 1767 and entitled "The Orator." Arrayed fancifully in a cape, beret, and gold chain with maltese cross, the dashing artist leans on a cushion resting on a window ledge as he draws back a curtain. Like Berckheyde's arch, the ledge and curtain were time-honored illusionistic devices. (An arch evidently also once appeared above Bol's figure but was painted out by a later hand.) The pose of the right arm resting on the sill was also much favored by Dutch artists, especially for self-portraits. Bol certainly knew both Rembrandt's etched and painted self-portraits, respectively of 1639 and 1640 (National Gallery, London), which employ this pose, but his ultimate sources, like those of his teacher, were Raphael's *Portrait of Baldasare Castiglione* (Louvre, Paris) and Titian's *Portrait of a Man*, formerly said to depict the poet Ariosto (National Gallery, London). Both of these great Italian paintings, astonishingly, were in Amsterdam in these years. The Titian, in which the sitter's broad sleeve is placed parallel to the picture plane, comes closer to the pose repeated so often in the Dutchmen's self-images. Further, it may be

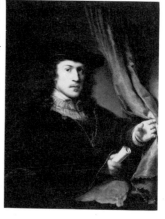

437

significant that the great Venetian's work is now thought by some actually to be a self-portrait, thus vindicating its quotation. Parenthetically, it may be noted that the presence of such remarkable paintings in Holland supports the young Rembrandt's famous retort to Constantijn Huygens' query of why he did not make the prescribed trip south to study the art of antiquity and the Renaissance; Rembrandt replied that Italian art was abundantly available at home.

TOLEDO MUSEUM OF ART

2445 Monroe Street
Toledo, Ohio 43697 *(419) 255-8000*

The Toledo Museum of Art was founded in 1901 under the leadership of Edmund Drummond Libbey, a Toledo industrialist and the museum's first president. The ample funds for art acquisitions left by Mr. Libbey's will provided the means whereby the majority of the museum's European paintings were purchased. In the years between 1926 when Libbey funds first became available and 1939 when the first catalogue of European paintings was published, the principal acquisitions were in Italian Renaissance art and French Impressionist paintings. However, in 1926 and 1933 Arthur J. Secor, the museum's second president, gave the museum his private collection, including many nineteenth-century and several seventeenth-century Dutch paintings. The great period of the collection's growth occurred after the war and owed much to the expert guidance of Otto Wittman, one of America's ablest museum directors. During the past thirty-five years, outstanding examples of Dutch and Flemish seventeenth-century art have been acquired, contributing to Toledo's reputation as a truly world class museum of European art. Even more than the holdings of museums in Worcester or Hartford, the collections testify to the exceptional standards of quality achieved by museums in America's medium-sized cities. A catalogue of the *European Paintings* and a briefer guide were published in 1976. The present Director, Roger Mandle, is a specialist in eighteenth-century Dutch art.

Toledo's lone example of early sixteenth-century Dutch portraiture is the late self-portrait by Jacob Cornelisz van Oostzanen (*fig. 438*), the teacher of Jan Scorel, depicting the painter holding the tools of his trade before an easel supporting a canvas on which a dour lady, assumed to be his wife, is portrayed. As in Oostzanen's other two known self-portraits, the artist glances over his shoulder at the viewer, a pose perhaps derived from Lucas van Leyden's famous self-portrait in Braunschweig. A relatively recent acquisition is Ferdinand Bol's *Self-Portrait* of 1647 (compare his other self-portraits in Springfield and Los Angeles) based on Rembrandt's famous etched self-portrait of eight years earlier. Rembrandt's

438

Young Man with a Plumed Hat, dated 1631, in Toledo was once wrongly assumed to be a self-portrait. Yet another work that is uncertainly indentified as a self-portrait, Bartholomeus van de Helst's handsome *Portrait of a Young Man* of 1655 depicts the subject leaning on a balustrade and pointing rhetorically to his faithful hound. Although the sitter's age and features correspond fairly closely to those of van der Helst in 1655, the costume and the parklike setting admit only to a leisured

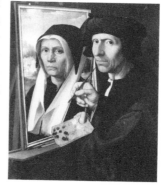

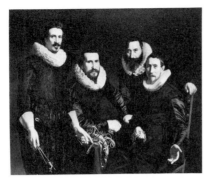

439

gentleman's status—a rank, as we have seen, that was much coveted by many later seventeenth-century Dutch painters—while revealing nothing of the sitter's vocation. Thomas de Keyser, on the other hand, incorporated attributes into his *Portrait of the Syndics of the Amsterdam Goldsmith's Guild (fig. 439)* of 1627 that allude to the profession of those portrayed; among the objects held by sitters and lying on the table are touch needles and a cupel, used, respectively, to assay and extract gold and silver from unpurified ores, as well as silver horse bridles made by guild members. Attired in somber black and white costumes and grouped with studied informality around the table, the sitters (three of whom have been identified) all look out at the viewer with open, earnest expressions, as if mindful of the seriousness of their regulatory duties. While we are quick to recognize de Keyser's work as an example of one of the established traditions of Dutch group portraiture, the portrait elements in Gerbrand van den Eeckhout's *Magnanimity of Scipio* are less apparent. The subject from Livy, a popular theme among Dutch history painters, refers to the continence and self-restraint of the Roman commander, who returned a captive woman to her fiancé and parents, thereby securing the devotion of those that he had vanquished. More than in Eeckhout's three other versions of this subject (the closest in design is in the Philadelphia Museum), the individualized features of the parents and the betrothed couple suggest that they are portraits. Such "historicized" portraits were common in Dutch art and serve to remind us of the fluid boundaries that divide the traditional fields of specialization in Dutch art. An important newly acquired Dutch history painting is Terbruggen's early *Supper at Emmaus,* a work that shows the artist with one foot still in Italy.

Virtually the full range and development of seventeenth-century Dutch landscape painting is represented in Toledo, from the early, additive realism of Hendrik Avercamp's charming skating scene, to the "tonal" effects of van Goyen's river views, to the mature "classicism" evident in the renewed emphasis on structure and color in a work like Meindert Hobbema's outstanding *Water Mill.* While several larger American museums might boast comparable and even superior holdings of the indigenous "realist" school of Dutch landscape painting, few can claim so rich a sampling of the italianate Dutch tradition. In addition to fine examples of the sort of Roman landscapes with ruins executed by the first generation of Dutch italianate painters, above all Cornelis van Poelenburgh and Bartholomeus Breenbergh, Toledo owns an arcadian *Landscape with Shepherds* by Moses van Uyttenbroeck, a late representative of the Pre-Rembrandtists, who in the first decades of the century came under the influence in Rome of the gifted German painter Adam Elsheimer. The art of the second generation of

italianate Dutch landscapists is represented by a beautiful, golden-hued scene of *Travelers in the Italian Campagna* by the chief innovator of this group, Jan Both, and a work by Adam Pynacker, who probably was influenced by Both. Comparable paintings by Both are found in the museums in Indianapolis and Boston. The vivid response Both had to actual as opposed to arcadian or vaguely "historicized" Italian scenery was not lost upon his fellow Dutchmen when he returned home in 1641. Nicolaes Berchem, who later traveled to Italy and who is represented at Toledo by one of his finest early pastoral landscapes, probably owed much to Both. Similarly, Albert Cuyp seems to have learned to paint the warm southern sun from Both and his circle. The Toledo Museum owns two Cuyps: one of a *River Scene at Dordrecht*, which has rightly been characterized as a transitional work documenting his change from an early "monochrome" manner to a mature, warmer and more luminous style; and a later *Landscape with Riding Lesson* in which a building derived from Utrecht's Mariakerk incongruously appears in the background of a splendid southern landscape. Typical of Cuyp are the many pentimenti in the foreground; see, also, the many changes in his equestrian paintings in Washington.

Other noteworthy landscapes include a freely executed winter scene of skaters by Isaack van Ostade and two excellent, relatively late examples of Salomon van Ruysdael's art. Until recently, river and coastal scenes were better represented in Toledo than marines depicting the open sea; an outstanding example of the former is Jan van de Capelle's hushed and majestic view of becalmed ships, an undated painting that may be compared with the picture in Chicago of 1651. An astute new acquisition, however, is Willem van de Velde the Younger's *A Kaag Close-Hauled in a Fresh Breeze* (fig. 440) of c. 1670, one of the great sea painter's finest marines.

The cityscape painter Jan van der Heyden is represented here by one of his several views of *The Garden of the Old Palace, Brussels*, which he must have visited in or before 1673. A work painted more than a century later by the artist's gifted follower Isaak Ouwater depicts the *Prinsengracht in Amsterdam* (fig. 448) and is dated 1782. It was probably painted for the Bouvy family who owned not only an apothecary shop visible in the scene but also the painting itself. Cityscape painting seems to have had its origins in Holland in Delft around 1650. Together with Carel Fabritius, Pieter de Hooch was one of the pioneers of this new painting of urban views. While de Hooch never painted street scenes or buildings for their own sake, he made a specialty of Delft courtyards, those charming little walled enclosures that form an outdoor extension of the intimate life of the Dutch home. The Toledo Museum owns one of de Hooch's finest and earliest Delft period courtyard paintings (fig. 441), a tranquil scene of domestic life. Women draw water and wash clothes beneath a

440

441

skyline dominated by the tower of the Oude Kerk. The triad of primary hues—red, yellow, and blue—in the figures' costumes perfectly complements the subject's timeless simplicity.

Although architecture had an essential function in de Hooch's art, his figures are never mere staffage but serve to link his work with the Dutch genre tradition. Toledo owns fine examples of both "high" and "low" genre. The latter is represented by a scene of nimble peasants dancing in a tavern painted by Adriaen van Ostade in 1652 and another work by the youthful Jan Steen which moves the revelry outside. "High genre" is offered up by its consummate master, Gerard Terborch, whose scene of more elegant diversions is somewhat prosaically titled *The Music Lesson*. As so often in Terborch's work, the psychological interplay of the figures is as refined as his polished treatment of surfaces. The lutenist's gaze strays from his music to the luminous face of his lady accompanist. A painting of 1633 (fig. 442) by Jan Miense Molenaer, husband of Judith Leyster, of a young woman at her toilette serves to remind us of genre's potentially symbolic dimensions. Seventeenth-century viewers probably would have recognized in her the representation of "Vrouw Wereld" (Lady

442

443

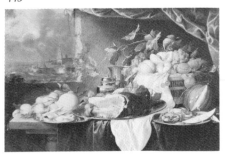

World), a popular allegorical figure in the seventeenth century whose emblematic form—a woman with a globe on her head—is recalled by the strategic tangential arrangement of the seated woman's head and the circle of the map on the far wall. Like the skull on which the girl's foot rests (a detail formerly overpainted by a deceitful restorer) and the bubbles blown by her little companion, she serves as a reminder of the transience and seductiveness of all worldly things. Like Molenaer's *Allegory of Marriage* in Richmond, this *vanitas* image embodies an allegorical program too dense to be adequately discussed within the confines of this review.

Dutch still-life painters were at least as willing to incorporate allegorical elements into their art as other specialists. For example, in Jan Davidsz de Heem's *Still Life with a View of the Sea* (fig. 443)

of 1646, the marine executed in the background by a collaborator (Bonaventura Peeters?) may represent the Ship of Fools sailing through dangerous waters to Cockayne, a land of frivolity and gluttony, symbolized by the sumptuous display of food in the foreground. As with landscape, Dutch still life's full range is represented in Toledo. Balthasar van der Ast's early still life of *Fruit, Flowers, and Shells*, like Avercamp's skating scene, is composed in an additive fashion with each object considered thoroughly and discretely. A typical Dutch empiricist, van der Ast always selected his shells from more than one ocean (compare his picture in Hartford). In addition to a simple breakfast still life by Pieter Claesz, Toledo owns several later, more elegant *pronk stillevens* by de Heem and Abraham van Beyeren, paintings of both dead and live fowl by the prolific still-life and animal painter Melchior d'Hondecoeter, and an exceptionally brilliant *Flower Still Life* by the great Dutch woman painter Rachel Ruysch, who was named court painter to the Elector Palatine in 1708.

For all its many excellent paintings, Toledo is more than merely a picture gallery. Ever mindful of relationships of great works of art of all mediums, the museum's benefactors and leaders have pursued excellence in the decorative arts as well as in paintings. Toledo has assembled some of the finest Dutch silver in this country. One of the most remarkable objects is a nautilus cup (*see color plate 13*) dated 1596 by Jan Jacobsz van Royesteyn from Utrecht. The silver mount and decorations include fantastic sea creatures and other marine motifs. David Bowers's (d. 1690) sleeve tankard with cover (*fig. 444*) of c. 1670–75 is embossed with a scene of a Roman Triumph. The work shows the influence of Christiaen van Vianen of Utrecht. Bowers settled in London and was appointed "embosser in ordinary" to Charles II in 1661. More restrained are a handsome pair of silver toilet boxes (*fig. 445*) dated 1705 by Cornelis van Dijk. These were part of a dressing table service made for the Anglo-Dutch marriage of Maria Magdalena de Jonge and Lord North, whose engraved coat of arms they bear. Here too is a tiny silver pomander (*fig. 446*) probably dating from the early seventeenth century with engraved decorations depicting allegories of the Senses based on designs by Martin de Vos. Often hung from the waist by a chain,

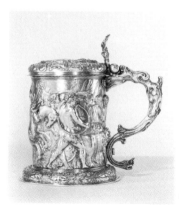

444

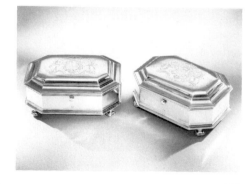

445

446

447

pomanders were filled with powdered spice to combat odors in a society where bathing was not yet a regular custom. A pair of rock crystal plaques bear portraits of the stadtholder Frederik Hendrik and Amalia van Solms based on silver medallions made in 1626. The glass collections also include a very fine engraved *roemer* of 1661 by Carel du Quesne with antic figures reminiscent of Callot. The ceramics include a pair of very good quality tin-glazed vases datable to the early eighteenth century and another vase of c. 1766–75 bearing a portrait of Willem V of Orange-Nassau. Notable pieces of furniture include a walnut veneered cabinet of c. 1740 and a large cabinet organ *(fig. 447)* attributed to Johannes Strümpler of c. 1750–95. The popularity of organ music in the eighteenth century prompted the manufacture of domestic instruments that were smaller than large church organs and appeared as a cabinet when the doors were closed. Holland became the center of European organ construction in the latter half of the eighteenth century.

In addition to the outstanding Ouwater *(fig. 448)* mentioned above, the eighteenth-century paintings include a presentation modello by Jacob de Wit for a ceiling painting commissioned in 1723 by Jan de Surmont for his house on the Amstel in Amsterdam. Flora, the goddess of flowers, is shown in the heavens gesturing to her husband Zephyr, one of the mythical winds. Although the ceiling itself evidently no longer exists, this work may be compared with the ceiling by de Wit preserved in Sarasota.

Like many of his contemporary collectors, Edward Drummond Libbey, the museum's founder, admired The Hague School and even knew their leader, Josef Israëls, personally. All the major figures of this group—Israëls,

448

449

Jacob and Willem Maris, Anton Mauve, Johannes Bosboom, Johannes Hendrik Weissenbruch, George Hendrik Breitner—and several lesser-known followers are represented in Toledo. A later work, Breitner's *Warehouses in Amsterdam (fig. 449)* of 1901, is a particularly memorable cityscape with a broad touch and colorful palette. Among other noteworthy later Dutch paintings are a *View of the Harbor at Honfleur* on the Normandy coast of 1863 by Jongkind and two mature landscapes by van Gogh, a *Wheat Field* painted at Arles (1888) and *Houses at Auvers* (1890), both of which are mentioned in the artist's letters. The houses in the latter picture still exist. An important and relatively recent acquisition is Mondrian's *Composition in Red, Yellow, and Blue* of 1922.

CORCORAN GALLERY OF ART

17th Street and New York Avenue, N.W.
Washington, D.C. 20006

(202) 638-3211

The founder of the gallery that bears his name was William Wilson Corcoran (1798–1888), a banker chiefly remembered for his role in arranging the loan that financed the U.S. government's war with Mexico in 1847–48. Corcoran dedicated his museum to "the encouragement of American genius," and the gallery has become a major center of both old and modern American art in Washington. An important exhibition of contemporary American art is held biennially. The original building (1869), the conception of James Renwick, was soon outgrown and was succeeded by the present structure, designed by Ernest Flagg, which was opened in 1893. Today visitors with an interest in the art of the Lowlands have the Montana copper king and senator William A. Clark (1839–1925) to thank for the small but distinguished collection of Dutch paintings and decorative arts at the Corcoran. Residing in later years in his grandiose mansion on Fifth Avenue in New York, Clark had intended that his collections go to the Metropolitan Museum of Art. In refusing the bequest, the Metropolitan's trustees won our enduring gratitude, since the excellent qualities of Clark's collection, like those of John G. Johnson's in Philadelphia, surely would have been obscured amidst the treasures in New York. In addition to the diverse array of approximately eight hundred objects which Clark bequeathed to the Corcoran, his widow provided for a large wing, designed by Charles A. Platt, to house the collections. It was opened in 1928. A small *Handbook of Dutch and Flemish Paintings* from the Clark Collection was published in 1955, and the catalogue of the exhibition held in 1978 to celebrate the fiftieth anniversary of the installation of the collections included essays on aspects of Clark's Dutch holdings.

As with other late nineteenth- and early twentieth-century American collectors of Dutch art, such as James E. Scripps, John G. Johnson, and Henry Clay Frick, Clark's tastes ran to naturalistic landscape, genre, and portraiture; he showed little interest in Dutch history painting or Dutch

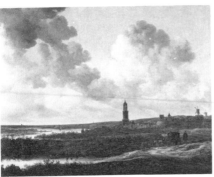

450

italianate art. Yet within the confines of these biases he made some fine purchases. The greatest strengths of his Dutch collection are the landscapes. Clark's van Goyens are among the finest in existence. The *View of Rhenen (fig. 450)* dated 1646, offers a panoramic and particularly majestic view of this city on the Rhine to the southeast of Utrecht. During the Middle Ages, Rhenen and its stout city walls offered pro-

tection to the bishopric of Utrecht. The many Dutch seventeenth-century artists who depicted the historic town and its elegantly tall late Gothic spire of St. Cunera's Church probably associated it with the glories and vicissitudes of the country's past. A coach drawn by four horses moves away from the city toward us, traveling east over the low, rolling hills that form the river's banks. The leaden sky and the rich browns and earth colors of the terrain are typical of van Goyen's works of the early 1640s. The more silvery tonality of the *View of Dordrecht*, on the other hand, suggests that the date, though unclear, probably is 1651 or 1654; the luminous style of this splendid painting is more characteristic of van Goyen's works of the late 1640s and early 1650s. Although van Goyen never lived in Dordrecht, he depicted the picturesque city more frequently than any other artist of the period. On the right is the large square tower of the Grote Kerk and on the far left the Groothoofdspoort. The broad expanse of water in the foreground, which is filled by the dark forms of a heavily laden sailing vessel and several smaller but equally crowded row boats, takes liberties with the actual width of the river at this point. As usual, reality has been adjusted for the pictorial effect.

Van Goyen's influence on his pupil Albert Cuyp is especially clear in the atmospheric effects of the latter's early panel in the collection. Yet the painterly, lemon-yellow highlights on the dunes are the young Cuyp's signature. A far richer palette and tonal range characterize Cuyp's mature *Landscape with Herdsmen* (fig. 451). The pastoral serenity of this sunny landscape is enhanced by the animals' bovine placidity, just as the receding horizontals of the vista at the left are reiterated by the cows' backs. A chillier but more invigorating image is the *Winter Skating Scene* (fig. 452), dated 1645, by Aert van der Neer, that master of twilight views. Here we encounter many of the same antics and figure motifs seen in earlier ice subjects by Avercamp and others. But now the horizon line is lower and the composition achieves a greater unity, two developments typical of Dutch landscapes generally in the intervening period. Stechow has characterized this work as an important link between van der Neer's early and late winter scenes. It is the first in his oeuvre to use a composition showing both banks of the river, more numerous figure groups, and a firmly established foreground zone, all

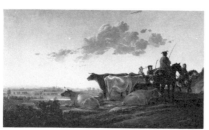

451

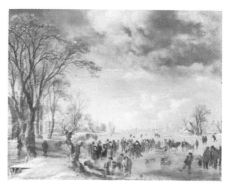

452

qualities typical of his late works. Somewhat surprisingly, this work has more in common with the design of Adriaen van de Venne's early winter scene in Worcester than van Goyen's famous skating scene in St. Louis, indicating a return to more emphasis on structure and local color. Two relatively early works by Ruisdael also grace the collection. Both depict scenes of woods and water and show the master's characteristic powers of dramatic composition, rich treatment of foliage, and such trademarks as the fallen birch tree. One final landscape deserving mention is a scene of *Fishermen Hauling Nets*, dated 1663, by Dirck Hardenstein, which includes a view in the background of the artist's native Zwolle. The design, juxtaposing the near view of the figures and the distant city, recalls earlier compositions by artists such as Arent Arentsz Cabel, to whom the picture was reasonably attributed prior to the discovery in 1954 of the signature. Otherwise known only as a painter of history subjects, Hardenstein shows an unexpected but welcome talent for landscapes.

After landscape, Dutch genre is best represented in the Clark Collection. The drunken peasants who inhabit Adriaen van Ostade's *Tavern Scene* move from their fetid spaces into the open air in Constantin Adriaen Renesse's large-scale painting of *Conviviality near an Inn*. A rural fiddler saws a tune to set all the locals stomping. Chiefly a draftsman, this Rembrandt pupil is today little known as a painter outside of a few surviving genre scenes. His teacher's influence is evident not only in his palette of deep reds and browns and the lighting effects, but also the weird, imaginary landscape in the background. More devout in tenor is the *Prayer before a Meal*, only recently recognized as a work by the pupil of Gerard Dou, Frans van Mieris the Elder. One of the most popular domestic virtue themes in Dutch genre (cf. de Hooch's painting in Malibu and Steen's in Philadelphia), the subject depicts a small boy dutifully saying grace under the watchful eye of a woman about to cut a slice of bread for a meal of *boterhammen* (buttered bread). In this early work, van Mieris's meticulous *fijnschilder* technique is not yet developed fully.

Contrasted with these low-life and domestic scenes are three later

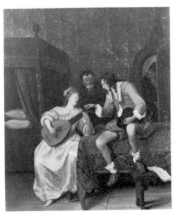

paintings depicting elegant, upper-class subjects. *The Greeting* by Pieter de Hooch shows the sort of leisured, high-life subject and attenuated figure type he developed in his later years in Amsterdam. Of better quality is Jan Steen's so-called *Music Lesson* (fig. 453), dated 1667, which shows a young man jauntily seated on a table covered with a rich Turkish carpet leaning over to tune his lady companion's lute. This picture may depict a scene from Bredero's tragi-comedy *Lucelle*, namely the moment when Asconius tunes Lucelle's lute as

453

the jester, Leckerbeetje, eavesdrops. Whether in fact it illustrates this episode, Steen takes full advantage of the subject's theatrical possibilities. The harmonizing implicit in the young man's gesture seems, by the couple's mutually rapturous gaze, to be as much amorous as musical. The crone in black (a descendant of procuress types) and the leering fool at the door introduce a comic and potentially prurient note, which Steen, in typical fashion, amplifies by the phallic flute projecting from the man's trousers and the bed at the left. While the sexual implications of Dutch genre are often "overread" by modern viewers, Steen's art typically is so frank and candid as to require little exegesis. His naughty allusions had a dual purpose, namely to amuse but also to gently admonish his audience. Among the consequences of romantic dalliance, of course, were lovesickness and pregnancy, maladies very probably suffered by the young lady in a lovely late seventeenth-century Dutch picture called *The Doctor's Visit*, wrongly attributed to Nicolaes Maes (possibly by David van der Plaes). We are encouraged in our diagnosis not merely by the doctor's knowing look and the obscene gesture made by the serving woman in the background, but also by the precedents of so many other treatments of this subject, first made popular by Steen after mid-century. (See his paintings in Philadelphia, New York, and the Taft, in Cincinnati.)

A shadow of its original state, Frans Hals' *Girl with a Flagon* has suffered but still finds supporters for the attribution. Similarly, the *Man in a Hat Holding a Scroll* signed "Rembrandt / 1635" also has condition problems and recently has been questioned by one authority who wrongly sees the style of Jacob Backer, a Rembrandt pupil, in the execution. The motif of the hand holding a scroll has prompted efforts to identify the sitter with various musicians, or, alternately, Constantijn Huygens, but with no basis in fact. The other work in the collection assigned to Rembrandt, an *Elderly Man in an Armchair*, is probably by an artist only in the master's circle in Amsterdam but quite possibly forms a pair with the Metropolitan Museum of Art's *Portrait of a Seventy-Year-Old Woman*. The latter is painted in a comparable style and is of similar dimensions. On the other hand, there can be no doubt of Gerard Dou's authorship in the carefully executed little oval *Portrait of a Bearded Man*. The sitter's earlier identification with Rembrandt's father wisely has been discarded. A final attribution question for the connoisseurs of Dutch portraiture is presented by the pendant likenesses of *Gerhard van Suchtelen* (1640–1722) and his wife *Maria Wedeus* (1640–1730) by Gerard Terborch, but perhaps in part by assistants. In his later works Terborch often left the execution of the settings and accessories to his studio. Not only through his successful portrait business but also as a town magistrate, the artist had contact with the rich, patrician families of Deventer. Gerhard van Suchtelen's father was a burgomaster; Hermana van der Cruysse, Gerhard's mother, also had her portrait painted by Terborch (National Gallery, London).

In addition to paintings, Senator Clark also collected antiquities, sculpture, drawings, furniture, rugs, tapestries, and other decorative arts. Among the last mentioned are Dutch ceramics. In addition to blue and white

of the European paintings is available, and a comprehensive catalogue of the Dutch paintings comparable to F. R. Shapley's *Catalogue of the Italian Paintings* (1979) is forthcoming.

One of the loveliest early Dutch paintings in Washington is the *Rest on the Flight into Egypt (see color plate 3)* by the great Romanist Jan van Scorel. Scorel was born near Alkmaar, studied with Cornelis Buys (who is often equated with the Master of Alkmaar), and traveled to Italy in 1518 where he visited Venice and worked briefly in Rome for the last Dutch pope, Adrian VI. Executed after his return to the North, the Washington painting attests to Scorel's absorption of Italian art, particularly in his monumental foreground figures. The Christ child is derived from types employed by Raphael; moreover, the tiny figure with the windblown garments in the middle distance is a direct quote from the Italian master's *Incendio del Borgo* in the Vatican. Other motifs are borrowed from antique Roman painting. However, the overall conception of the theme and especially the relationship of the figures to the splendid landscape setting is entirely characteristic of Scorel and encourages comparison with his *Magdalen* in the Rijksmuseum in Amsterdam. In addition to its obvious interest in volumetric, classical human form, Scorel's *Flight* reveals Mannerist sympathies in its abrupt change in scale between the foreground and subsidiary figures. A more advanced, indeed rather late, form of Mannerism appears in the *Moses Striking the Rock* dated 1623 by Joachim Wttewael. Here the crowd of attenuated figures who strain to quench their thirst even obscure their savior, Moses, who is only recognized with difficulty among the group by the spring on the right. As one writer has pointed out, Wttewael centers the attention of his scene not on the primary narrative, namely the people's reaction to the miraculous event, but upon the objectification of the concept of water as a life-sustaining force. The foreground is littered with drinking vessels, and the action focuses on the figures and animals gulping down the refreshing liquid; the objects and gestures serve to elucidate the idea of water as a life-giving substance. Thus the biblical episode is treated symbolically rather than in a storytelling manner, an approach that may be contrasted with Jan Steen's later treatment

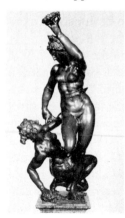

of the theme in the Johnson Collection's painting in Philadelphia. Like his acrid color scheme and stylized figures, Wttewael's tendency to symbolize rather than narrate biblical history is typical of Dutch Mannerism.

Another excellent example of Mannerist allegory is the small bronze sculpture of 1610 by Adriaen de Vries (*fig. 454*). Long thought to depict a *psychomachia*, that is, a conflict between Virtue and Vice, the two intertwined nudes have recently been identified as the personification of Empire Triumphant over Avarice. This was the title given the work in the inventory of 1611 compiled of the

454

NATIONAL GALLERY OF ART

6th Street and Constitution Avenue
Washington, D.C. 20565 (202) 737-4215

In December of 1936 Andrew W. Mellon offered to erect a building on the mall in Washington to serve as a National Gallery of Art. He further offered to donate his collection of 126 paintings and 26 pieces of sculpture as the nucleus of a national collection. Congress accepted his offer the following March, and the National Gallery was established as a bureau of the Smithsonian Institution. Thus the National Gallery survives today more or less as it was conceived, namely as a museum maintained by the federal government with collections created primarily through private gifts. Mr. Mellon's largesse soon prompted others to donate their treasures, notably Samuel H. Kress, who in 1939 presented the gallery with his extraordinary collection of Italian art, and Joseph Widener, who shortly thereafter offered the no less remarkable collection of Old Master paintings and sculpure that he and his father, P. A. B. Widener, had assembled over many years. Important later additions to the collection were made by the Kress Foundation established by Samuel H. Kress, Chester Dale (principally eighteenth- and nineteenth-century French, English, and American painting), Lessing J. Rosenwald (prints and drawings), and others.

Undoubtedly, however, the greatest Dutch works in the collections were given by those captains of industry, Mellon, Widener, and Kress. This fact reflects an essential feature of the National Gallery: its collections were formed almost exlusively by men who sought masterpieces, men who had little patience for the honest, perhaps diverting, but ultimately less than inspired production of minor masters. Hence, in contrast to the museums in Boston and Philadelphia, where the basements burgeon forth countless fascinating and often obscure lesser Dutch pictures, virtually the entire Dutch collection in Washington hangs on the walls. The depot houses a handful of "B-team" pictures and the odd mistake inevitably made in the pursuit of important paintings. While the Dutch collection, therefore, is surprisingly small in number, it is of such exceptional quality as to be surpassed in this country only by that of the Metropolitan Museum of Art in New York.

The Old Master paintings are presently housed on the second floor of the original National Gallery building which John Russell Pope designed in a handsomely austere and conservative classical idiom. Carrying on his father's remarkable generosity, Paul Mellon provided the funds to construct an addition to the gallery, which took the form of the separate East Building opened in 1978 and linked underground with the original gallery. This crisply angled structure, designed by the architect I. M. Pei, complements the old Pope building, combining large, simple forms with highly refined surfaces. It is surely one of the most elegant (and costly) buildings constructed in America in recent years. An *Illustrated Summary Catalogue* (1975)

of the European paintings is available, and a comprehensive catalogue of the Dutch paintings comparable to F. R. Shapley's *Catalogue of the Italian Paintings* (1979) is forthcoming.

One of the loveliest early Dutch paintings in Washington is the *Rest on the Flight into Egypt* (*see color plate 3*) by the great Romanist Jan van Scorel. Scorel was born near Alkmaar, studied with Cornelis Buys (who is often equated with the Master of Alkmaar), and traveled to Italy in 1518 where he visited Venice and worked briefly in Rome for the last Dutch pope, Adrian VI. Executed after his return to the North, the Washington painting attests to Scorel's absorption of Italian art, particularly in his monumental foreground figures. The Christ child is derived from types employed by Raphael; moreover, the tiny figure with the windblown garments in the middle distance is a direct quote from the Italian master's *Incendio del Borgo* in the Vatican. Other motifs are borrowed from antique Roman painting. However, the overall conception of the theme and especially the relationship of the figures to the splendid landscape setting is entirely characteristic of Scorel and encourages comparison with his *Magdalen* in the Rijksmuseum in Amsterdam. In addition to its obvious interest in volumetric, classical human form, Scorel's *Flight* reveals Mannerist sympathies in its abrupt change in scale between the foreground and subsidiary figures. A more advanced, indeed rather late, form of Mannerism appears in the *Moses Striking the Rock* dated 1623 by Joachim Wttewael. Here the crowd of attenuated figures who strain to quench their thirst even obscure their savior, Moses, who is only recognized with difficulty among the group by the spring on the right. As one writer has pointed out, Wttewael centers the attention of his scene not on the primary narrative, namely the people's reaction to the miraculous event, but upon the objectification of the concept of water as a life-sustaining force. The foreground is littered with drinking vessels, and the action focuses on the figures and animals gulping down the refreshing liquid; the objects and gestures serve to elucidate the idea of water as a life-giving substance. Thus the biblical episode is treated symbolically rather than in a storytelling manner, an approach that may be contrasted with Jan Steen's later treatment

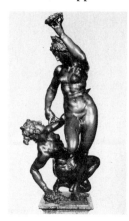

of the theme in the Johnson Collection's painting in Philadelphia. Like his acrid color scheme and stylized figures, Wttewael's tendency to symbolize rather than narrate biblical history is typical of Dutch Mannerism.

Another excellent example of Mannerist allegory is the small bronze sculpture of 1610 by Adriaen de Vries (*fig. 454*). Long thought to depict a *psychomachia*, that is, a conflict between Virtue and Vice, the two intertwined nudes have recently been identified as the personification of Empire Triumphant over Avarice. This was the title given

the work in the inventory of 1611 compiled of the

the jester, Leckerbeetje, eavesdrops. Whether in fact it illustrates this episode, Steen takes full advantage of the subject's theatrical possibilities. The harmonizing implicit in the young man's gesture seems, by the couple's mutually rapturous gaze, to be as much amorous as musical. The crone in black (a descendant of procuress types) and the leering fool at the door introduce a comic and potentially prurient note, which Steen, in typical fashion, amplifies by the phallic flute projecting from the man's trousers and the bed at the left. While the sexual implications of Dutch genre are often "overread" by modern viewers, Steen's art typically is so frank and candid as to require little exegesis. His naughty allusions had a dual purpose, namely to amuse but also to gently admonish his audience. Among the consequences of romantic dalliance, of course, were lovesickness and pregnancy, maladies very probably suffered by the young lady in a lovely late seventeenth-century Dutch picture called *The Doctor's Visit*, wrongly attributed to Nicolaes Maes (possibly by David van der Plaes). We are encouraged in our diagnosis not merely by the doctor's knowing look and the obscene gesture made by the serving woman in the background, but also by the precedents of so many other treatments of this subject, first made popular by Steen after mid-century. (See his paintings in Philadelphia, New York, and the Taft, in Cincinnati.)

A shadow of its original state, Frans Hals' *Girl with a Flagon* has suffered but still finds supporters for the attribution. Similarly, the *Man in a Hat Holding a Scroll* signed "Rembrandt / 1635" also has condition problems and recently has been questioned by one authority who wrongly sees the style of Jacob Backer, a Rembrandt pupil, in the execution. The motif of the hand holding a scroll has prompted efforts to identify the sitter with various musicians, or, alternately, Constantijn Huygens, but with no basis in fact. The other work in the collection assigned to Rembrandt, an *Elderly Man in an Armchair*, is probably by an artist only in the master's circle in Amsterdam but quite possibly forms a pair with the Metropolitan Museum of Art's *Portrait of a Seventy-Year-Old Woman*. The latter is painted in a comparable style and is of similar dimensions. On the other hand, there can be no doubt of Gerard Dou's authorship in the carefully executed little oval *Portrait of a Bearded Man*. The sitter's earlier identification with Rembrandt's father wisely has been discarded. A final attribution question for the connoisseurs of Dutch portraiture is presented by the pendant likenesses of *Gerhard van Suchtelen* (1640–1722) and his wife *Maria Wedeus* (1640–1730) by Gerard Terborch, but perhaps in part by assistants. In his later works Terborch often left the execution of the settings and accessories to his studio. Not only through his successful portrait business but also as a town magistrate, the artist had contact with the rich, patrician families of Deventer. Gerhard van Suchtelen's father was a burgomaster; Hermana van der Cruysse, Gerhard's mother, also had her portrait painted by Terborch (National Gallery, London).

In addition to paintings, Senator Clark also collected antiquities, sculpture, drawings, furniture, rugs, tapestries, and other decorative arts. Among the last mentioned are Dutch ceramics. In addition to blue and white

delftware, the collections include distinguished pieces of early eighteenth-century polychromed faïence inspired by Chinese *famille verte* and Japanese Imari porcelain. Not only the colors but often the decorative motifs—little pavilions on a tea caddy, a petal-fluted border on a dish—had Oriental origins. Influences from other European porcelain centers, especially Meissen and Vienna, are also evident in some of the decorations, colors, and shapes of several of the works. Particularly attractive are a European-inspired armorial dish and a wall plaque with scrolls in high relief.

Kunstkammer of the Holy Roman Emperor Rudolf II of Habsburg. While the recumbent figure in the group is indeed a Vice, she is identified more specifically as Avarice by her money bag and ass's ears inherited from the legend of King Midas. Instead of Virtue, the standing figure personifies Victory, whose attributes are the laurel wreaths in her hair and held aloft in her hand. Like Scorel's painting, the sculpture has earlier Italian formal roots (Bartolommeo Ammannati and Giovanni da Bologna), but this type of political, specifically imperial, allegory was especially common among artists who worked for Rudolf II. Both Bartholomeus Spranger and Hans von Aachen painted allegorical personifications of the victory of empire over the enemies of good rule.

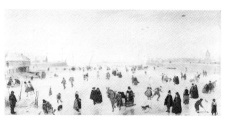

455

Hendrick Avercamp's *Skating Scene* (*fig. 455*) probably was executed around the same time as Wttewael's painting, and both works employ additive compositions that diffuse pictorial interest among many individual details. Rarely, however, have two works had a more different effect. While Wttewael animates his scene with dramatic contrasts of light and shade, and twisting, contorted figures, Avercamp employs a disarmingly direct, even ingenuous approach to his subject. Beneath a high horizon and brilliantly blank sky, brightly colored little skaters whiz about in a broad winter vista, forming silhouettes against the whiteness of the snow and ice. Each figure or group, like the charming horse-drawn sleigh, is fresh and immediate but also exacting in detail. Little wonder that the works of "de Stomme van Kampen" (the mute of Kampen) are as fascinating for social historians as for art lovers.

A good but undistinguished van Goyen of 1644 was purchased recently by the National Gallery, offering for the first time an example of the "tonal" phase of Dutch landscape painting. Later developments in landscape have long been well represented by the magnificent paintings of Ruisdael and Cuyp. In addition to two modestly scaled, lesser examples of Ruisdael's art, Washington owns one of the great forest scenes from his mature period in the 1660s. While many of the motifs in this dramatic work, such as the fallen beech and central cascade, recur in his other paintings, Ruisdael's art was never formularized or mechanical. Rather, his powerful vision of nature is at once specific and monumental. The term "romantic," often used to describe these forest paintings, is misleading and unhistorical. The heroic force of his images has nothing to do with the projection of human sentiments. Rather, it stems from the vital individuality of each tree and shrub.

The landscapes in Washington by Ruisdael's gifted student Meindert Hobbema unfortunately have suffered. The *Wooded Landscape* of 1663 is probably the best preserved. It reflects the artist's debt to his teacher and his

456

taste for more open compositions and forests coursed by roads. Hobbema's view of nature was not as intense as Ruisdael's and proportionally sunnier and cheerier. After his marriage in 1668 and appointment to the well-paid position of wine gauger to the Amsterdam octroi, Hobbema seems to have sharply curtailed his production. The rate of work of the well-to-do Albert Cuyp also fell off in his later years. Washington's Cuyps are some of the finest in the United States, presenting not only an excellent example of his sunny scenes of *Herdsmen Tending Cattle* (fig. 456) but also an outstanding marine and two paintings of horsemen in golden landscapes. One of the last mentioned includes a handsome pair of equestrian portraits as well as numerous pentimenti (passages painted out by the artist himself) which evidently eliminated some sprinting hunting dogs. Perhaps Cuyp felt that this animated detail was ill-suited to a scene in which the tone is set by the stately gait of the elegant couple on horseback in the foreground. Cuyp was a great favorite of the English, who collected his works in quantity at the end of the eighteenth and through the early decades of the nineteenth century. Indeed, many of the greatest Cuyps are still to be found in English country homes. It is hardly surprising, therefore, that J. M. W. Turner chose to copy Cuyp's majestic *View of Sailing Vessels on the Maas at Dordrecht* (fig. 457). The Dutchman's sense of grandeur combined with his subtle responsiveness to light and atmosphere appealed to the English artist just as it did to the connoisseurs and collectors of his day. A new acquisition, Ludolf Backhuysen's *Stormy Sea* of 1668, offers violent counterpoint to Cuyp's calm marine.

Another noteworthy Dutch landscape is Paulus Potter's *Farrier Shop*. Typically, it could also pass for a genre or animal painting. Potter, who died before he was thirty, managed in his brief life to attract the patronage of the House of Orange as well as Dr. Nicolaes Tulp, presiding physician in Rembrandt's famous *Anatomy Lesson*. Undoubtedly Potter's well-stationed patrons were attracted to the unrivaled realism of his monumental animal paintings (see the *Young Bull* in the Mauritshuis) but probably also admired

457

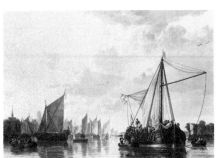

his cabinet-sized paintings of cattle at pasture or stables and smithies' shops. Washington's painting of the last mentioned is signed and dated 1648 and may be compared with the related painting dated one year earlier in the Philadelphia Museum. Contrasting the darkened silhouette of a simple rustic building with a brilliantly clear vista beyond, these works reveal Potter's so-

phisticated understanding of the effects of natural light. Moreover, his observations of the most quotidien of activities, such as the examination of a horse's teeth or the shoeing of an old mare, bespeak a fidelity to nature that seems archetypically Dutch. The varied responses of the Dutch to their landscape surroundings can also be reviewed in the National Gallery's small but distinguished collection of landscape drawings, which includes outstanding sheets by Jacques de Gheyn II, Willem Buytewech, Bartholomeus Breenbergh (fig. 458), Jan Lievens, and, of course, Rembrandt.

458

Precise drawing played a role in the art of the greatest Dutch painter of architecture, Pieter Jansz Saenredam. Washington owns not only an early work by the master but also one of the splendid church interiors from his mature years. Saenredam's *View of Santa Maria della Febbre with St. Peter's Cathedral under Construction*, dated 1629, may initially come as a surprise, since there is no evidence to suggest that the artist ever visited Rome. Moreover, the particular site had been altered considerably by Saenredam's time. The explanation rests in the fact that the young artist seems to have copied the scene from a drawing he owned by the great sixteenth-century artist, Marten van Heemskerck. Clearly Saenredam felt he could learn something from this exercise, yet the final product is more than a mere study in topography. Its immediacy and tonal clarity belies its origins in another artist's conception. While Saenredam probably never set foot in Italy, he traveled out from his native Haarlem to Utrecht, Alkmaar, 's Hertogenbosch, Rhenen, and other Dutch towns, where he made drawings of public buildings and churches. These served as preliminary studies for his paintings. His working method frequently involved an initial sketch made on the site, followed by a finished construction drawing, often completed with the aid of measurements and plans. Only then did this exacting drawing become the basis for his painting; however, many years might pass before the work was realized in oils.

Such was the case with his *View of the Choir of the St. Janskerk in 's Hertogenbosch (fig. 459)*. This work is dated 1646 but its preparatory sketch in the British Museum is dated 1632. While Saenredam usually transcribed his drawings in paint faithfully, he was not above making changes for compositional or visual effects. Here, for example, the height of the choir is stressed more than in the drawing, an adjustment that enhances the architecture's ex-

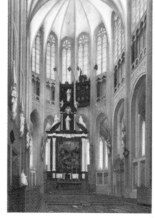

459

hilarating elevation. Another detail of the work that Saenredam changed was the altarpiece by Abraham Bloemaert in the choir. Although this altar had been painted for the church as early as 1620, it had been removed to the southern Netherlands in 1629, hence was not on view in 1632 when Saenredam made his sketch in which the altar is covered with a curtain. Thus, the detail serves as a testament not only to Saenredam's power of detection (he had to seek out an image of the altarpiece) but also to his almost compulsive desire for accuracy in recreating the church's original appearance.

The National Gallery boasts no less than eight single-figure portraits by Frans Hals. Six were given by Andrew W. Mellon, who secured two of them together with many other masterpieces when the Russians sold off works from the Hermitage in the 1930s. While the artist's genre scenes and multi-figure compositions are omitted, the collection offers a review of his activity over fully four decades. A charmingly informal little oil sketch of a *Boy in a Large Hat* is probably the earliest, dating from c. 1628–30. It is followed by his powerful and remarkably assured *Portrait of a Woman* in a millstone ruff, dated 1633, an image that bespeaks both respect and sympathy for the sitter. It has rightly been observed that Hals, unlike many of his contemporaries, was no less a great portraitist of women than of men. The *Portrait of a Man Wearing a Cuirass* depicts the goateed subject with his arm jauntily placed akimbo standing before a window, a motif that appears elsewhere in Hals' art. The seascape beyond may indicate that the model was a naval officer or was involved in other maritime activities. A pose Hals frequently used to enliven or lend an informal air to his subjects depicted the sitter turning around in a chair, over the back of which drapes the sitter's elbow. This pose appears in two works in Washington, an image of a rather portly young man which Walpole and others mistook for Hals' self-portrait, and the so-called *Portrait of Balthasar Coymans (fig. 460)*. This natty fellow with slashed sleeves, high collar, and rakish hat is a member of the wealthy and powerful Coymans family (the coat-of-arms removes all doubt) who were so generous to Hals with their patronage. However, a tampered date on the picture calls

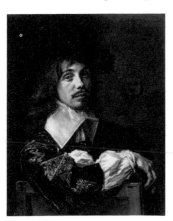

in question his identification with the Balthasar whose parents are depicted in the pendant portraits in the museums in Hartford and Baltimore. Rather, it seems the dandy may have been Willem Coymans, a member of another branch of the family. The possible identification of the sensitively conceived, three-quarter-length portrait of a *Man Holding a Glove* is of special interest because it is now thought to be a representation of the Haarlem genre painter Adriaen van Ostade, whose brilliant-hued *Cottage Dooryard* of 1673 has recently been cleaned

460

by the National Gallery. The empathy Hals seems to express for his subject would certainly be appropriate to a friend and colleague. However, it must be noted that Hals' mastery obviously enabled him to imbue even the most unpromising visage with an element of dignity. We know nothing, for example, of the identities of Hals' two later male portraits from the Widener collection, but looking on these impressive and handsome men, one would readily suppose they were pillars of the community.

A witness at the baptism of one of Hals' children, Judith Leyster (her surname was coined from the name of her father's brewery, *Ley-sterre* or "lodestar") was a friend and admirer of the great Haarlem painter. Her *Self-Portrait* in the National Gallery reflects Hals' influence in the relaxed pose and painterly execution. But Leyster was more than a slavish imitator. Her independence was not only expressed in her art but also in her professional dealings with Hals, whom she successfully sued in the Haarlem guild for the return of a pirated student. A genre painter as well as a portraitist, Leyster played an important role in introducing themes of the domestic life of women into scenes of everyday life. In her *Self-Portrait* she depicts herself with brush and palette seated before a canvas depicting a young reveler who appears in the pendant (private collection, The Netherlands) to her painting in the Johnson Collection, Philadelphia.

One could argue that for consistent quality from picture to picture Washington's genre scenes are the strongest feature of its Dutch collection. While, somewhat surprisingly, only two important still lifes—a G. W. Heda and an elegant composition of fruit, porcelain, and glassware by Willem Kalf— are found in the galleries, there is a group of genre scenes of the highest distinction. Jan Steen's large *Dancing Couple in an Inn* (fig. 461) of 1663 is an excellent example of his mature Haarlem period and one of the rare dated paintings so essential to forming a chronology of the prolific master's oeuvre. Adopting a composition from the Brueghel school, Steen focuses his design on an uninhibited dancer in a feathered beret and his somewhat reluctant female partner. The throng of celebrants who encircle them beneath the inn's vine-covered arbor delight in the ludicrous *pas de deux*. While it is surely not accidental that the traditionally lascivious bird seller is seen mugging between the dancing couple in the center of the composition, such comic and/or moral footnotes only sup- plement the surfeit that is Steen's nar- rative vision. His gallery of universally recognizable types is observed with both humor and sympathy, while his tech- nique is so masterful as to beguile even a jaundiced observer like Joshua Rey- nolds, who grudgingly admitted that Steen was one of Holland's greatest painters.

461

Ultimately, of course, Steen disap-

pointed Sir Joshua since his broad humor and tavern jollity relegated his work to a lower form of art. Something of this bias may linger in the fact that the National Gallery, with the exception of a few prosperous-looking peasants by Ostade, has virtually no representation of the great Dutch genre tradition of low-life painting. High life, on the other hand, is amply represented. Terborch's meticulously executed *Visit* (fig. 462) is one of his finest works in America. It depicts a dapper young man (probably Terborch's student Caspar Netscher) entering a doorway and bowing graciously to a young woman richly attired in satin. To the right another young woman plays a lute at a table beside a second gentleman. The author of the standard monograph on the artist has identified one source for this scene in an emblem of the period depicting a similar situation, with the motto "De overdael en doet gaen baet" (Excess is unnecessary), which is explained in the appended verses as referring to the alluring behavior of idle women, who encourage their suitors' false hopes only to make fun of their disappointments afterward. The obscene hand gestures that the two principal figures exchange give the potentially amorous theme an explicit sexual dimension. Although perhaps surprising to the modern viewer, "naughty" signs frequently appear in high as well as low Dutch genre. Gabriel Metsu's so-called *Intruder* (fig. 463) is another work of extraordinary facility and polish, depicting the headstrong suitor as he barges playfully into the ladies' boudoir to a mixed reception. These representations of the amorous dalliance of the rich owe much to Terborch and anticipate the refinement as well as something of the coquetry of eighteenth-century French genre painting.

With a more painterly technique and lighter palette, Pieter de Hooch moves his scene into the open air of a little courtyard, where a young serving

462

463

464

woman stops to share a drink with good-humored soldiers *(fig. 464)*. The tower of Delft's Nieuwe Kerk appears at the left. De Hooch's walled courtyards constitute an extension of the highly ordered domestic environments of his interiors, an excellent example of which is Washington's so-called *Bedroom*. Whether indoors or out, de Hooch's scenes invariably offer a view, or as the Dutch call it, *doorkijkje*, to an adjoining space, be it a room or neighboring courtyard. These views, virtually the hallmark of de Hooch's art, relieve the sense of closure both

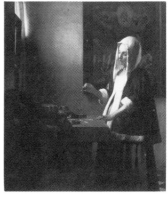

465

pictorially and psychologically. De Hooch's responsiveness to light and sympathy for the quiet joys of domestic life were surpassed only by his prodigiously gifted Delft colleague Jan Vermeer.

One of the greatest masterpieces in America, Vermeer's *Woman Holding a Balance (fig. 465)* offers a simple but enchanting subject: the corner of a room where a woman in a fur-lined jacket holds a scales over a table. The simplicity of this luminous image belies the thought that surely went into its conception and the countless adjustments that created its serene geometry. Despite the work's intimate scale, it achieves a majestic calm, a classical repose. Poised between rest and action, the woman is an enduring enigma. Many have sought to explain the painting's fascination. Long considered a *vanitas* image because of the scene of the Last Judgment on the back wall, the painting has been thought by others to depict a personification of *Justitia* (Justice)—an allusion to the need for temperance and moderation in the conduct of one's life—or of Truth, specifically, the divine truth of revealed religion. Other theories have centered on the probability that the woman is pregnant. When she was thought to be weighing pearls, some theorized that she was attempting to divine the sex of the unborn infant. The fact that the pans of the scales are empty supports the recent notion that Vermeer was making a statement about predestination and free will, then a topical religious debate. As a probable convert to Catholicism, Vermeer would have rejected the Calvinist belief in predetermination; the empty scales thus could refer to the fetus's pure, unblemished soul, whose fate will only be reckoned at the Last Judgment. While this reading accords well with Vermeer's biography as well as with the reverent atmosphere of the picture, it is unlikely to silence the many who will continue the happy task of searching for the "true meaning" of Vermeer. Vermeer's admirers have counted among their esteemed number great critics like Thoré-Bürger, painters such as Bonvin, Pissarro, and Jan Veth, and distinguished men of letters, including Proust and Malraux. All in their fashion have experienced seduction. Looking on the sensuous features and momentary expression of the artist's *Girl with the Red Hat (fig. 466)*, one can well understand their enchantment.

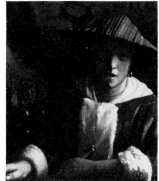

466

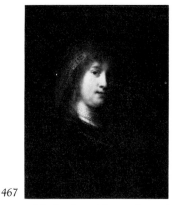

467

While the very dubious works formerly assigned to Vermeer were rightfully removed from his oeuvre in Washington's *Summary Catalogue* of 1975, a number of doubtful attributions to Rembrandt were retained. In fact, fully eleven of the twenty-three paintings assigned to the master in that publication are probably misattributed or under some degree of doubt. One hastens to note that a painstaking reappraisal of the entire Rembrandt collection is presently under way and has already begun to rectify this situation as well as to clarify the visitor's understanding of this great master. Moreover, even with these reduced ranks, the National Gallery is second in this country only to the Metropolitan Museum of Art in its total holdings of Rembrandt's paintings.

One of the earliest is the *Portrait of Saskia* (fig. 467), which must date from his first years in Amsterdam and, like several of the Rembrandts, has been enhanced by a recent cleaning. Wearing a gold chain and looking out candidly from beneath a transparent, gilt shawl, Rembrandt's well-to-do young wife is painted with both pride and tenderness by her husband. The so-called *Turk* is probably a work from the same period and is no less powerful than its three-quarter-length counterpart, the *Man in Oriental Costume*, in the Metropolitan Museum of Art in New York. As with that work, we probably will never know whether this exotic figure was intended to represent a specific historical personage. On the other hand, Washington's so-called *Portrait of a Polish Nobleman* of 1637 is almost certainly a model in fanciful costume and not the likeness of some Slavonic prince who favored Rembrandt with a commission.

The remaining Rembrandts are all works from his later career, dating from the 1650s and 1660s. Like the other version of this theme in Berlin, the scene of *Joseph Accused by Potiphar's Wife* is dated 1655. The story recounts how Joseph, a trusted servant in Potiphar's household, was falsely accused by his employer's wife of having violated her after he repeatedly spurned her attempts to seduce him. Potiphar's wife is shown pointing out Joseph's red robe on her bedpost to her husband. Joseph, the keys symbolizing his trusted status dangling from his belt, stands listening quietly on the far side of the bed. While the practice of reading Rembrandt's personal life into his art has been much abused in the past, there is some reason to suppose that he could have identified with the present subject. During these

years Rembrandt himself was involved in litigation over a breach of promise suit brought by a woman named Geertje Dircx. Thus he too was beset by the accusations of a rejected woman. The matter was resolved when Rembrandt, not a little ungallantly, had the woman institutionalized.

The power and solemnity of Rembrandt's approach to biblical as well as mythological themes are illustrated by two quite similar and freely executed little paintings in Washington: the *Jupiter and Mercury Visiting Philemon and Baucis*, dated 1658, and *The*

468

Circumcision of 1661. In the former, Rembrandt silhouettes Mercury's profile against a hidden light source, thus giving the otherwise mundane-looking god a nimbus. Earlier in his career he had used this technique in a compositionally related representation of *Christ in Emmaus* (Musée Jacquemart-André, Paris) which, like the Washington painting, owes much to a print of *Philemon and Baucis* by Adam Elsheimer, the German history and landscape painter who had such a vital impact on the Pre-Rembrandtists and later generations of Dutch painters.

Rembrandt evidently not only admired Elsheimer's theatrical lighting effects but also his naturalistic treatment of the mythological theme. The Philemon and Baucis story, which involves the disguise of the gods as mortals before they are received into the old peasant's home, was well suited to this approach. While Rembrandt's art was hardly without sources or precedents, no other painter invested history subjects with such vivid humanity. The power of *The Apostle Paul* (fig. 468) seated at his desk, head in hand, with the sword of his martyrdom at the right and his half-completed epistle on the desk before him, rests not in its accessories or even the apostle's monumental attitude of scholarship. Rather, it arises from his curiously sightless expression (perhaps a recollection of the circumstances of Paul's conversion) which lends the figure the look of utter absorption and concentration. No less powerful is his representation of the beautiful and virtuous Lucretia, dated 1664. According to Livy, Lucretia took her own life after informing her husband of her violation by a kinsman. Viewed frontally, she wields the dagger in a pose possibly borrowed from an engraving by Marcantonio Raimondi; however, the dishonored but innocent heroine's poignant expression of resolve and the picture's sumptuous color scheme are Rembrandt's own inventions. A fascinating case of late Rembrandt's evolving conception of a classical theme is provided by the comparison of this work with the *Lucretia* dated two years later, in Minneapolis.

The breadth and monumentality of Rembrandt's later history paintings is also felt in his landscapes and portraits. *The Mill* has recently been the subject of excited reappraisal following a much-needed cleaning that re-

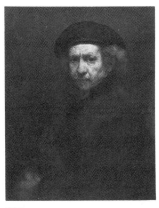

469

vealed many details as well as powerful tonal contrasts previously muted by discolored varnish. The central motif of the mill silhouetted high atop a darkened bluff overlooking water now stands out more dramatically against the brightness of a setting sun. With its broad execution and emotionalism, one can well understand the remarkable appeal that the picture has had for modern viewers conditioned by nineteenth-century romantic art. Indeed, the painting is so emphatic as to seem, at least to some critics, to hyperbolize Rembrandt's style. While the names of several followers, notably Aert de Gelder and Roelant Roghman, have been proposed with little conviction and less persuasiveness, the attribution to Rembrandt is still upheld by many specialists. If the work proves to be by the master, it would be his most ambitious experiment in dramatic landscape painting.

The intense chiaroscuro of this work is also encountered in the impressive late pendant portraits of a *Man with Tall Hat and Gloves* and *Woman with Ostrich Feather Fan* of c. 1660. The latter is one of Rembrandt's most memorable achievements in portraiture, combining great dignity with an air of intelligence and sympathy. The portrait of the alert-looking *Young Man Seated at a Table* of 1662 or 1663 and the *Portrait of a Man in a Tall Hat* of the same period prove that, contrary to a common assumption, Rembrandt continued to receive commissions in his last years of activity. If we detect an element of vulnerability in the proud face depicted in the late *Self-Portrait* (fig. 469) of 1659, it would not be inappropriate; these were hard times, both financially and personally, for Rembrandt. But it cannot be too often stressed that it never was the artist's intention to leave us anything like a modern psycho-history. The assumption that his self-portraits can be read as a serialized personal memoirs is easily discredited; it overlooks the painter's obvious delight in the adoption of personae. Self-portraiture was for Rembrandt less autobiographical than empirical; it enabled him to investigate at first hand that goal of every baroque painter, namely the outward expression of emotion.

Like many American collections, the National Gallery of Art has virtually no eighteenth-century Dutch art and, doubtless owing to the late formation of its collections, no Hague School pictures. But its superb collection of Impressionists includes six paintings by van Gogh. In addition to landscapes, the *Farmhouse in Arles* of 1888 and the *Olive Orchard* of the following year, there are four figure paintings. The *Roulin Baby* of 1888 may be related to other paintings of the subject in Philadelphia, New York, Amsterdam, and a private collection. The half-length *Self-Portrait* of 1889 and the late *Girl in White* standing in a wheat field of 1890 also relate to preparatory studies and autograph variants. The finest of Washington's van Goghs, however, is

La Mousme (*see color plate 17*), which depicts a young girl seated in a chair, holding flowers and wearing a colorful striped and dotted outfit. As Vincent explained in a letter to Theo in July 1888, the term *Mousme* was used in Loti's *Madame Chrysanthème* and refers to "a Japanese girl—in this case she is Provencal—about 12 or 14 years old." Van Gogh went on to describe the colors of the work in detail. A preparatory drawing for the painting in the Pushkin Museum in Moscow also includes color notes in the margin, affirming van Gogh's special concern with the palette of this picture. No doubt the subject reminded van Gogh of his own debt to colorful Japanese prints.

STERLING AND FRANCINE CLARK ART INSTITUTE

South Street
Williamstown, Massachusetts 01267 *(413) 458-8109*

Heir to Singer Sewing Machine money, Robert Sterling Clark was a man of great wealth and greater privacy. Although much of his life was devoted to his two main enthusiasms, art and horses, he trained as a young man to be an engineer and led an expedition in 1908 to explore a remote region of northern China. His collecting began in 1912. Initially he concentrated on Old Masters but later, after marrying his French wife Francine, focused on nineteenth-century French art, the strongest single feature of the collections. A brother, Stephen Clark, from whom Robert Sterling Clark was estranged, was a major benefactor of the Metropolitan Museum of Art and Yale University. Robert Sterling Clark's collections, including not only paintings but also prints and drawings, sculpture, and decorative arts (notably porcelain and silver), were brought together for the first time in a white marble, neoclassical structure designed by Daniel Perry and opened in 1955. Mr. Clark's love of anonymity and the severity of the building soon won it the sobriquet "the tomb of the unknown collector." A large modern-styled addition (1973), designed by Pietro Belluschi and The Architects' Collaborative, now serves as the main entrance. A catalogue of the drawings, by Egbert Haverkamp Begemann, Standish B. Lawder, and Charles W. Talbot, Jr., was published in 1964; a complete *List of Paintings* appeared in 1972; and a selection of *Highlights* of the collection was published in 1981.

The Dutch paintings are few but significant. Two of the finest are a pair of pendant panels by Dirck Hals, younger brother and pupil of Frans, depicting a *Boy and a Girl at Cards* (*fig. 470*) dated 163(1?) and *Two Girls Teasing a Cat*. Such works charmed the Clarks just as they had appealed earlier to eighteenth-century French artists, such as Chardin. Their attraction lies not only in the children's gaiety and amusement but also in the hint of a lesson for a less innocent audience. One dubious theory holds that the pair refer to woman's role as a temptress and subjugator of men. Whatever

470

471

the specific meaning, the pair remind us that in the adult world games are played for higher stakes and cruelty committed in greater earnest. Another Dutch genre painting, Gerard Dou's *Girl at a Window with a Pitcher* (fig. 471), foretells the Clarks' taste for small, highly finished paintings (see the later works by Drölling, Boilly, Meissonier, Gérôme, Boldini, etc.). Two Ruisdaels in the collection also testify to an interest in Dutch landscape that preceded the

472

collector's taste for French Impressionist and American (Winslow Homer) landscapes. A counterpart to the placid *View on the Beach* is Ruisdael's rocky *Landscape with a Bridge, Cattle, and Figures* (fig. 472), a mature work related in design to a poorly preserved painting in Philadelphia.

A recent gift to the collection from a distinguished figure in the field of American museums, Charles C. Cunningham, is a cityscape by Gerrit Berckheyde depicting the *Church of St. Cecelia in Cologne*. Berckheyde was an expert of mass and tone. In place of the surface detail of van der Heyden's works, his architecture stresses the substance of the masonry and the drama of faceted light and shade. Often, as in the present work, he achieved an almost Cubistic effect. Another newly acquired Dutch painting attests to the persistence of the earlier tradition of imaginary architectural painting after the rise around mid-century of a more naturalistic approach. Dirck van Delen's *Church Interior with the Parable of the Pharisee and Publican* (fig. 473) retains the spatial formulas of the sixteenth-century Antwerp artist Jan Vredeman de Vries, but is dated 1653. Church interiors made in Delft at this time by Houckgeest and de Witte were introducing a new sensitivity to light and atmosphere that would influence Berckheyde and his contemporaries. But van Delen remained committed to the cool, linear clarity of the older perspectival recipes. His painting has a splendid logic and impeccable technique. The biblical figures depict Christ's parable of the Pharisee who

473

thanked God that he was such a righteous man, while the publican (tax collector) smote his breast and declared himself a sinner. Stating that "he that exalteth himself shall be abased and he that humbleth himself shall be exalted," Christ judged the publican to be the truly righteous man (Luke 18: 9–14).

Among the Dutch drawings is an attractive sketch of a *Farm under Trees* and a pen and brown ink drawing by Rembrandt of *Christ Finding the Apostles Asleep* (fig. 474).

474

Although somewhat disfigured by gray washes added by a later hand, the latter sheet is a good example of the master's style of the mid-1650s. The subject appears to be unique in Dutch art. Instead of depicting the first time that Christ descended from the Mount of Olives to rebuke the apostles for their lack of vigilance ("could ye not watch with me one hour?"), or the frequently represented third time when he returned to say "Rise, let us be going: behold, he [Judas] is at hand that doth betray me," Rembrandt chose to depict the second time that Christ returned "and found them asleep again: for their eyes were heavy. And he left them, and went away again" (Matthew 26: 43–44). Christ stands with arms outstretched over his slumbering disciples, for whom "the spirit is willing, but the flesh is weak," before leaving them again undisturbed. Unlike other artists, Rembrandt is not attracted by the action and potential drama of the two other episodes. He concentrates instead on the least eventful but, by the same token, most spiritually charged moment; only after descending the second time does Christ know that he is truly alone in his suffering.

A number of good impressions of Rembrandt's etchings are found at the Clark Art Institute and were included in a small show entitled *Rembrandt Fecit*, organized by the graduate program under Julius Held in 1981. The two paintings in the museum long attributed to Rembrandt are now doubted. The *Crucifixion*, bearing Rembrandt's putative signature and the date 1657, has rightly been questioned because of its excessively loose execution. More famous is the *Man Reading*, which also is falsely signed and dated 1645. This dramatically silhouetted work is the best of several versions of a composition that has had many admirers and defenders. Nonetheless, most specialists would now attribute it to a pupil or follower; the most current assignments—a copy after Carel or by Barent Fabritius—both are untenable.

Among Clark's extensive holdings of nineteenth-century art, the Dutch are not so well represented as one might expect. However, we must bear in mind that the bulk of his collection was acquired after The Hague School's

475

reputation had begun to wane. To be sure there are several minor works by Israëls, Mauve, and Weissenbruch as well as a pair of *Amsterdam Street Scenes* by Cornelis Springer; however, these are not of the quality of this period's works from other schools. Consistent with Clark's taste for Impressionism is van Gogh's charming little sketch of the *Terrace at the Tuileries* of c. 1886. Pur-

chased in 1974 after Clark's death, a handsome painting of *Frigates at the Port of Harfleur* (*fig. 475*) is an early work by Jongkind comparable in style to paintings of 1852 in Hartford and the Johnson Collection, Philadelphia. All three paintings appeared in the exhibition *Jongkind and the Pre-Impressionists: Painters of the École Saint Siméon*, organized by Charles Cunningham at the Clark Art Institute in 1977 and characteristic of the small, intelligent type of show for which the museum is so admired.

WILLIAMS COLLEGE MUSEUM OF ART

Main Street
Williamstown, Massachusetts 01267 *(413) 597-2429*

Many visitors to the Clark Art Institute overlook the fact that Williamstown has two art museums. Founded in 1926, the Museum of Art at Williams College was established in Lawrence Hall, which had been erected in 1848. The structure has been expanded several times, most recently in 1983, and houses a broad-ranging collection with strengths in American and Spanish baroque paintings and prints and drawings. A literate *Handbook* of the collections published in 1979 was written by the former director and inveterate guidebook author S. Lane Faison. The Dutch collections are small but include a good early (c. 1640–42) *Stable Interior with Peasants (fig. 476)*

476

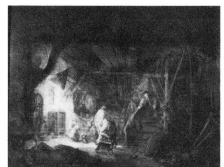

by Isack van Ostade and other paintings by Wybrand de Geest, Aert van der Neer, and Jan Weenix. Some fine impressions figure among the Dutch prints, which include works by Goltzius, Rembrandt, Everdingen, Adriaen van Ostade, and Ruisdael. One of the best Northern drawings in the museum is Hans Speeckaert's *Flagellation of Chirst*, a writhing Mannerist composition that shows a strong debt to Spranger.

WORCESTER ART MUSEUM

55 Salisbury Street
Worcester, Massachusetts 01608　　　　　　　　*(617) 799-4406*

The Worcester Art Museum is one of those excellent medium-sized American municipal museums that one groups with its sister institutions in Toledo and Hartford for the exceptional quality of its collections. The casual museumgoer, whether a foreign visitor or native-born American, may be surprised to discover that in the field of Old Masters these museums often rival their counterparts in far larger cities in the U.S. or Europe. The range and superb quality of objects reflect an acquisitive appetite tempered by discriminating connoisseurship and attest to an extraordinary era of collecting. With the rise in art prices coupled with the shrinking of the market, the most active days of acquisition are passed, but all of these museums continue to add intelligently to their collections. Worcester in recent years acquired not only a major Andrea del Sarto, which was discovered in a local church, but also excellent Dutch paintings by Cornelis van Haarlem, Jacob Duck, and Job Berckheyde.

The Worcester Art Museum was founded in 1896, and the original building was opened two years later. With the growth of the collections, additions were made to the original structure in 1921 and 1933; it was remodeled in 1940 and 1983. The greatest growth in the Dutch paintings collection came in the 1950s and 1960s when special purchase funds were put to fuller use. In 1958, for example, the *Saint Bartholomew* by Rembrandt was acquired with income from funds bequeathed by Charlotte E. W. Buffington, a former trustee of the museum. Notable directors in these years were Francis Henry Taylor, who served both before and after his directorship at the Metropolitan Museum in New York (1940–55), and Daniel Catton Rich. More recent directors have included Richard Stuart Teitze and Thomas Freudenheim. A specialist in Dutch painting and cartography, the able curator is James Welu, who has organized exhibitions of both Dutch (1979) and Flemish (1983) paintings from New England private collections. The

477

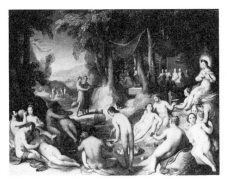

catalogue of the European painting collection was published in 1974, the joint effort of seven specialists; the Dutch paintings were catalogued in exemplary fashion by Seymour Slive of Harvard University.

In 1980 Worcester acquired its first Dutch Mannerist painting, the *Wedding of Peleus and Thetis* (fig. 477) of 1597 by Cornelis van Haarlem. This painting is a tiny variant on panel of a very large canvas by the artist dated four years earlier in the

Frans Halsmuseum in Haarlem. Like that work, it employs a funneling composition with the main banquet scene in the distance and elaborately posed nudes in the foreground. The subject, as we have seen, was especially popular among the Dutch Mannerists (compare Wttewael's later treatment of 1610 in Providence). In the sky at the back left Eros flies away after having thrown down the Apple of Discord, which Paris is seen rashly awarding to Venus below. In addition to the wedding of Peleus and Thetis and the Judgment of Paris, the work also adds references in the foreground to two other popular mythological subjects: Apollo Among the Muses and Mankind Before the Flood, thus conflating four themes into one densely conceived work. The later Pre-Rembrandtists replaced the simultaneous narration of the Mannerists with temporal continuity in exposition. Although Worcester owns no Lastman or Pynas, it has recently acquired the *Laban Searching for His Idols* of 1630 by Willem van Nieulandt the Younger, a late example of the Pre-Rembrandtists' approach to history painting. Based on Lastman's *Laban and Rachel,* dated 1622, in Boulogne-sur-Mer, this work represents the single biblical episode (Genesis 31:17–55) with great deliberateness. When Jacob left the home of his father-in-law, Laban, one of Jacob's two wives, Rachel, stole her father's teraphim. Laban pursued Jacob's caravan, and when he overtook it, accused Jacob of the theft. Unaware of Rachel's act, Jacob invited Laban to search his belongings, whereupon Rachel hid the teraphim in a saddle and sat on it, refusing to rise for her father on the pretext that "the common lot of women was upon her." (Old Testament law forbade men to have any contact with menstruating women.) Unable to recover his idols, Laban eventually made peace with Jacob and returned home. The fact that van Nieulandt's depiction of Laban accusing Jacob is distinguishable from Lastman's representation of the slightly later episode of the story, when Laban confronts Rachel, attests to the Pre-Rembrandtists' concern with narrative clarity. Consistent with these concerns was the Pre-Rembrandtists' penchant for archaeological exactitude; the structure in the background of the van Nieulandt is the so-called Temple of Minerva Medica, a third-century Roman edifice which van Nieulandt etched in 1618. Its presence in the painting, like the exotic pseudo-historical costumes of the figures, is designed to evoke the biblical past.

One of the loveliest Dutch paintings in Worcester is the *Winter Landscape* of 1614 *(fig. 478)* by Adriaen van de Venne. In addition to his activity as a

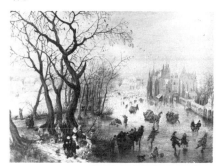

478

painter, van de Venne was a poet and executed illustrations for a fellow versifier, the immensely popular Jacob Cats. Both men were moralists; van de Venne specialized in monochromatic genre scenes illustrating proverbs on human sins and folly (see his paintings in Springfield). However, in his early years he also executed landscapes that recall those of Pieter Brueghel in their use of a high horizon

line, numerous anecdotal details, and varied local colors (compare the pendants recently acquired by the Getty Museum). Beneath the tall, bare trees on the river bank on the left figures stroll with their dogs, hunt, or chop wood, and on the ice stretching back to the fanciful castle in the upper right are swaying skaters, alone or in couples, and horse-drawn

479

sleds. A rare subject in the artist's oeuvre, the painting may originally have been coupled with a summer landscape or could have been part of a series of the four seasons.

While van de Venne's charming little painting captures the gaiety of Northern winter sport, the *Italian Winter Landscape* (fig. 479) by Jan Asselijn conveys a bleaker image of work in an unaccustomedly harsh southern winter landscape. Beneath the shadow of a huge fortress with crenellated battlements are heavily laden pack animals and figures occupied with calves and a saddled ass. Like van de Venne, Asselijn painted very few winter scenes, but the dramatic power of this work could make one wish for more. The picture probably was executed around 1647, shortly after the painter's return from Rome, where he had been a member of the *Bentveughels*, a band of Netherlandish artists who nicknamed him "Crabbetje" (Little Crab) because of his deformed hand. Other noteworthy landscapes include a *Landscape with Two Horsecarts* by van Goyen, which was part of a series of oil sketches on paper mounted on panel executed in 1651, a handsome Salomon van Ruysdael of 1642, and a stormy view of *Boats on the IJ* by Jacob van Ruisdael. One of the earliest of Ruisdael's approximately thirty marine paintings (compare the paintings in Boston and Philadelphia), the work depicts boats buffeted on the choppy waters of this arm of the Zuider Zee with the skyline of Amsterdam, including the East India Company's warehouse, in the distance.

480

The great art historian Erwin Panofsky first identified the central structure in Jan van der Heyden's townscape as the *Church of St. Pantaleon in Cologne*, a building the artist portrayed on at least three other occasions. While the overall structure corresponds fairly closely to the original building, van der Heyden took liberty with aspects of the church, especially the lower stories and facade, inventing Gothic windows, niches, and moldings as well as portions of the towers. The license van der Heyden frequently exhibited in altering actual architecture and topography contrasts

with the degree of fidelity we encounter in the architectural paintings of his gifted forerunner Pieter Saenredam. While Saenredam was not averse to small compositional adjustments, his pictures usually represent the actual site very accurately. This is true of Worcester's masterful painting of the *Interior of the Choir of St. Bavo's Church in Haarlem* (fig. 480) which the artist signed and dated in 1660. Like his other depictions of St. Bavo's, much of the structure appears the same today. Saenredam's detailed technique only hints at his fastidious working methods. Like many of his paintings, the initial conception for this work is documented in a drawing executed more than two decades earlier (c. 1635–36) when he made other similar sketches of St. Bavo's. He later made a still more precise construction drawing (now lost) which was transferred to the panel of equal dimensions before the actual process of the painting was begun. In this way many years passed before the completion of the finished painting. Comparing the methods of Saenredam and van der Heyden serves to remind us of the varied forms that the subjective notion of realism took in Dutch art.

Not long ago the museum acquired a *Bird Still Life* by Willem Gowe Ferguson, a Scotsman who was active in Holland, whose works are often confused with those of Hondecoeter and Willem van Aelst. However, the finest Dutch still life in Worcester is the sumptuous *Banquet Still Life* by Abraham van Beyeren. Van Beyeren painted different types of still lifes as well as a few seascapes in the manner of van Goyen. He is best known, however, for his *pronkstillevens* (*pronk* means "ostentation" or "show") begun around 1653 and depicting banquet tables set with fine foods and precious glass and metalware. As we have suggested, these works seem to reflect The Netherlands' growing prosperity after mid-century as the principal trading and financial center in Europe. Holland's upper-class merchants increasingly imitated the aristocratic ways of the elite regent class, adopting grander and ever more elegant patterns of consumption. To judge from the number of these paintings that survive (see the works in Philadelphia, Cleveland, Toledo, San Francisco, and Champaign-Urbana), there must have been a ready market for images of luxury and prestige supplies. Yet compositions of the humblest objects also still found an audience; at the far end of the social spectrum is Egbert van der Poel's roughly contemporary depiction of

481

overturned and broken crockery in a barn-yard.

A painting whose date, 1652, proves that it was one of the earliest genre scenes to reflect the taste for greater elegance is the *Party on a Terrace* (fig. 481) by Gerbrand van den Eeckhout, the Rembrandt pupil who is better known as a history and portrait painter. The setting, with a stone terrace and balustrade, and the eight fashionably dressed figures in amorous dalliance anticipate works

by Terborch, de Hooch, Ochtervelt, and other later genre painters. The antithesis of this high-life scene is Hendrik Sorgh's coarse *Merrymakers in a Tavern*. A recent cleaning uncovered a peasant pissing against the back wall of this grisly estaminet. More malodorous surroundings are difficult to imagine. Only slightly less rowdy were the gatherings of the *rederijkers* (rhetoricians), societies of amateur poets and dramatists who assembled for read-

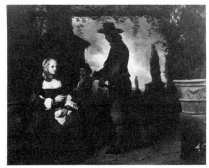

482

ings, dramatic performances, and—to judge from Jan Steen's pictures and satirical plays of the period—loud fellowship and strong drink. In Steen's painting in Worcester a public reading is given at a window by members of an Amsterdam group called "De Egelantiers," who are identified by a coat of arms hanging from the sill bearing their emblem, a flowering eglantine, and their motto, "flourishing in love" (in liefde bloein[en]de). Although not known to have been a rhetorician himself, Steen painted their raucous activities repeatedly; compare the closely related painting in the Johnson Collection, Philadelphia.

A particularly spellbinding little genre scene is Michael Sweert's *Young Couple and a Boy in a Garden (fig. 482)*. Beneath the shade of an arbor, the darkened figure of a man approaches a young woman seated in the light to offer her a bunch of grapes. Behind them a boy in half shadow eats fruit, and in the distance a garden with sculpture appears. As so often with the poetic Sweerts, the work is mysteriously evocative, its meaning impenetrable and unexplained. The *Interior of a Tailor's Shop* by Quirin van Brekelenkam is a more expository though hardly prosaic image—the daily life of an artisan and his two sartorial apprentices, all seated cross-legged on a long table taking advantage of the light of the adjacent window. Like the thirteen other variants of the theme (compare, for example, the version in the Johnson Collection in Philadelphia), this work stands in the venerable genre tradition of depicting professions. Another later example of this tradition is Job Berckheyde's *Baker (fig. 483)*, which takes up a subject treated earlier by Adriaen van Ostade and Jan Steen. The baker blows his horn to alert his customers to the freshly baked bread, rolls, and pretzels displayed in a splendid still life on the window sill. The niche-like window composition descends from Dou, but the stone architecture was a fire precaution required of all bakeries. Worcester also owns a domestic genre scene. The theme of "Gebed voor de Maaltijd"

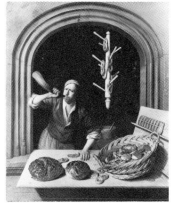

483

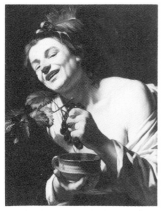

484

(prayer before a meal) was taken up by many Dutch artists, including van Mieris (Corcoran Gallery, Washington), Steen (Johnson Collection, Philadelphia), Brekelenkam (De Lakenhal, Leiden), and Nicolaes Maes (Rijksmuseum, Amsterdam). However, in Maes' *Old Woman Praying* in Worcester, the figure's attitude of devotion is less suggestive of thanksgiving for her supper than of ruminations on transience, thoughts inevitably elicited by the *vanitas* symbols surrounding her—an hourglass, a skull, the snuffed-out candle, roses that soon will fade, books, and a sculpted head (the vanity of art and human knowledge). This work was part of a series of life-size, half- or three-quarter-length genre scenes of old women praying or sleeping which Maes probably painted in the mid-1650s; compare, for example, his painting in Washington.

Some Dutch pictures, especially those of the Caravaggisti, defy categorization as either genre or history painting. One such work is Gerrit van Honthorst's *Smiling Young Man Squeezing Grapes (fig. 484)* of 1622. Typical of the life-sized, half-length figures that Honthorst and the other Dutch followers of Caravaggio made in Utrecht in the 1620s, the work is a boozier, heterosexual version of the Italian master's early images of the young Bacchus and vaguely hermaphroditic youths. The Worcester painting has been called both Bacchus and Dionysus, but Honthorst probably intended his smiling youth to evoke, albeit romantically, tipplers of his own day; the god of wine wears vine leaves, never a plumed beret. Exotic dress of this sort was worn by Caravaggio's revelers and gamblers as well as by professional actors in The Netherlands. The pseudo-historical costume could also alert seventeenth-century viewers to additional levels of meaning. It has been suggested that the painting may be a secularized allegory of Taste from a Five Senses series or, alternatively, a moral lesson on intemperance. Another work that

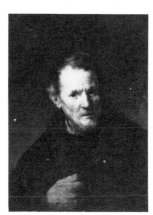

485

straddles several painting categories, namely genre, history painting, and cityscape, is Johannes Lingelbach's *Street Scene with Capriccio of Roman Buildings*. While the figures resemble the Bamboccianti's anonymous peddlars, beggars, and peasants, the subject may be the Feeding of the Hungry from the Seven Acts of Mercy. The setting capriciously relocates the large statue from Rome's Piazza del Campidoglio to the Via del Babuino.

Worcester's later Dutch history paintings include an oil sketch by Ferdinand Bol tentatively identified as the *Incorruptibility of Gaius*

Fabricius and a still more freely executed *Liberation of Saint Peter* by Benjamin Cuyp, the uncle of the famous landscapist Albert Cuyp. Without rival, the greatest Dutch history painting in the museum is Rembrandt's *Saint Bartholomew (fig. 485)*. Viewed bust length and illuminated by a strong light, the saint holds the knife that is his attribute in his right hand while looking directly at the viewer with an agitated expression. His face seems to reflect fear and dread at the thought of his own martyrdom: Bartholomew, we recall, was flayed alive. A relatively early work painted when the young Rembrandt was still fascinated with intensely dramatic emotion, the painting may be compared with the artist's two later treatments of the theme, both of which are preserved in museums in the United States. In the painting of 1657 in the Timken Art Gallery in San Diego, the saint has overcome his emotional conflict and awaits his final test of faith with a new resolve. The last image of 1661 in the Getty Museum is still more internalized; Bartholomew sits absorbed in deep thought, evidently contemplating his destiny. The changes in these paintings are typical in reflecting a progressive deepening of Rembrandt's perception of spirituality and human feeling.

486

Worcester's decorative arts collection includes a tall case clock *(fig. 486)* from the mid-eighteenth century. Paintings by several Hague School artists are also found here, including Israëls, Mauve, Mesdag, and Blommers. Josef Israël's sentimentalized but not overly maudlin *Anxious Family* is noteworthy.

DUTCH PAINTINGS IN U.S. COLLECTIONS

The following is a list arranged alphabetically by artist of all the Dutch paintings in the institutions and collections here reviewed. In addition to the artist's name and dates, the paintings' subjects are briefly indicated by type, i.e., landscapes, portraits, genre. (Note that not all types of paintings produced by a given artist are represented in U.S. collections.) In most cases full titles or descriptions of the paintings are included in the text. Individual works are designated by an abbreviated reference to the collection (see the Key below) and an accession, inventory, or catalogue number. Dated works are indicated by a date in parentheses preceding the citation; undated works are designated by "n.d." Autograph paintings are listed before those which are only attributed or tentatively assigned to the artist ("attr."), works by followers or members of a master's workshop or circle, paintings only in the artist's manner ("style"), and copies, pastiches or forgeries.

KEY TO ABBREVIATIONS

AAM	Allentown Art Museum, Allentown, Pennsylvania.	CAI	Sterling and Francine Clark Art Institute, Williamstown, Massachusetts.
AKAG	Albright-Knox Art Gallery, Buffalo, New York.		
AAMCH	Ackland Art Museum, University of North Carolina, Chapel Hill, North Carolina.	CAM	Cincinnati Art Museum, Cincinnati, Ohio.
AIC	Art Institute of Chicago, Chicago, Illinois.	CAMS	Crocker Art Museum, Sacramento, California.
AMAM	Allen Memorial Art Museum, Oberlin, Ohio.	CGA	Corcoran Gallery of Art, Washington, D.C.
BC	Bass Museum of Art, Miami Beach, Florida.	CGAM	Currier Gallery of Art, Manchester, New Hampshire.
BCMA	Bowdoin College Museum of Art, Brunswick, Maine.	CIP	Museum of Art, Carnegie Institute, Pittsburgh, Pennsylvania.
BF	Blaffer Foundation, Houston, Texas.	CMA	Cleveland Museum of Art, Cleveland, Ohio.
BFM	Barnes Foundation, Merion, Pennsylvania.	CMN	Chrysler Museum, Norfolk, Virginia
BJU	Collection of Sacred Art, Bob Jones University, Greenville, South Carolina.	DAI	Dayton Art Institute, Dayton, Ohio.
		DAM	Denver Art Museum, Denver, Colorado.
BM	Brooklyn Museum, Brooklyn, New York.	DIA	Detroit Institute of the Arts, Detroit, Michigan.
BMA	Birmingham Museum of Art, Birmingham, Alabama.	DMFA	Dallas Museum of Fine Arts, Dallas, Texas.
BMFA	Museum of Fine Arts, Boston, Massachusetts.	FAM	Fogg Art Museum, Harvard University, Cambridge, Massachusetts.

FAMSF Fine Arts Museums of San Francisco, San Francisco, California.

FC Frick Collection, New York City, New York.

HC Hyde Collection, Glens Falls, New York.

HMAA High Museum of Art, Atlanta, Georgia.

HMFA Museum of Fine Arts, Houston, Texas.

IMA Indianapolis Museum of Art, Indianapolis, Indiana.

ISGM Isabella Stewart Gardner Museum, Boston, Massachusetts.

IUAM Indiana University Art Museum, Bloomington, Indiana.

JBSAM J. B. Speed Art Museum, Louisville, Kentucky.

JC John G. Johnson Collection, Philadelphia, Pennsylvania.

JPGM J. Paul Getty Museum, Malibu, California.

KAM Kimbell Art Museum, Fort Worth, Texas.

KAMCU Krannert Art Museum, University of Illinois, Champaign-Urbana, Illinois.

LACM Los Angeles County Museum of Art, Los Angeles, California.

MAB Museum of Fine Art, Baltimore, Maryland.

MAG Memorial Art Gallery, University of Rochester, Rochester, New York.

MIA Minneapolis Institute of Arts, Minneapolis, Minnesota.

MMA Metropolitan Museum of Art, New York City, New York.

MOMA Museum of Modern Art, New York City, New York.

NAM Nelson-Atkins Museum, Kansas City, Missouri.

NCMA North Carolina Museum of Art, Raleigh, North Carolina.

NGA National Gallery of Art, Washington, D.C.

NOMA New Orleans Museum of Art, New Orleans, Louisiana.

NSM Norton Simon Museum, Pasadena, California.

NYHS New York Historical Society, New York City, New York.

PAM Phoenix Art Museum, Phoenix, Arizona.

PAMP Portland Art Museum, Portland, Oregon.

PMA Philadelphia Museum of Art, Philadelphia, Pennsylvania.

PUAM The Art Museum, Princeton University, Princeton, New Jersey.

RISD Museum of Art of the Rhode Island School of Design, Providence, Rhode Island.

RMA John and Mable Ringling Museum of Art, Sarasota, Florida.

SAM Seattle Art Museum, Seattle, Washington.

SCMA Smith College Museum of Art, Northampton, Massachusetts.

SDMA San Diego Museum of Art, San Diego, California.

SL City Art Museum, St. Louis, Missouri.

SMFA Museum of Fine Arts, Springfield, Massachusetts.

SP Museum of Art, St. Petersburg, Florida.

TAG Timken Art Gallery, San Diego, California.

TM Taft Museum, Cincinnati, Ohio.

TMA Toledo Museum of Art, Toledo, Ohio.

UAMB University Art Museum, University of California, Berkeley, California.

VCAG Vassar College Art Gallery, Poughkeepsie, New York.

VMFA Virginia Museum of Fine Arts, Richmond, Virginia.

WAG Walters Art Gallery, Baltimore, Maryland.

WAH Wadsworth Atheneum, Hartford, Connecticut.

WAM Worcester Art Museum, Worcester, Massachusetts.

WCMA Williams College Museum of Art, Williamstown, Massachusetts.

YUAG Yale University Art Gallery, Yale University, New Haven, Connecticut.

ABBREVIATED LIST OF PAINTINGS

Willem van Aelst (1626–1683): still lifes, (1663) FAMSF 51.21; (1674) JPGM 85.PB.236; (n.d.) RMA 58; attr., SCMA 1961.11.

Jan van Aken (born 1614): landscape, (1650) NOMA 81.263.

Hermanus van Aldewerelt (1628/29–1669): portrait, (1664) PMA 72.264.1.

Jan van Amstel (c.1500–1540): history, CMN.

Hendrik van Anthonissen (c.1606–1654/60): landscapes, SCMA 1927.7-1; circle NGA 890.

Cornelis Anthonisz (c. 1499–c.1553): portrait, DIA 38.28.

Karel Appel (born 1921): (1950) MOMA 327.55; (1951) VCAG 55.6.1; (1956) MOMA 183.66; WCMA 72.37; MAB 65.37.1; (1957) PAM 57/100; CAM 67.79; (1962) MAB 64.47; (1967) PAM 76/224; (1969) DAI 75.38; (n.d.) DAI 64.24; PUAM 76-26; SL 27.1975; BMFA 61.198.

Pieter Jansz van Asch (1603–1678): landscape, attr., JC 503.

Jan Asselijn (after 1610–1652): landscapes, (1652) LACM 49:17.7; (n.d.) WAH 1917.1; FAMSF 1952.64; WAM 1969.24; BMFA 52.1831; attr. 61.90.

Balthasar van der Ast (1593/94–1657): still lifes (1622) SL 172.1955; NCMA 52.9.197; (n.d.) TMA 51.381; WAH 1937.491; SDMA 1944.9; PAM 64/250; NSM.

Jan Augustini (1725–1773): portrait, JC 710.

Barent Avercamp (1612–1679): landscape, HMAA; BMFA 60.982.

Hendrick Avercamp (1585–1643): landscapes, NGA 2315; NYHS 1867.368; RMA 59; SL 46.1939; TMA 51.402.

Dirck van Baburen (1595–1624): (1622) BMFA 50.2721; MMA 1975.1.125; NAM; attr. BJU.

Adriaen Backer (1635/36–1684): BM 32.793; LACM 51.38.16.

Ludolf Backhuysen (1631–1708): marines, (1668) NGA 1985.21.1; (1684) MIA 82.84; (n.d.) BMFA 49/1708; BF; JC 592; WAA 1962.442; WAG 37.340; copy, RMA 60.

Johannes de Baen (1633–1702): portrait, MMA 97.41.2.

David Bailly (1584?–1657): portrait, (1641) MMA 1982.60.27.

Alexander Hugo Bakker-Korff (1824–1882): SL 140.1977.

Willem Bartsius (born c.1621): (1637) JPGM 71.PA.20.

Bartholomeus van Bassen (c.1590–1652): DIA 37.59; (with E. van de Velde) FAMSF 51.4.4.

Adriaen Cornelisz Beeldemaker (c.1618–1709): (1653) WAG 367.2003.

Anthonie Beerstraten (active 1639–65): JPGM 78.PB.70.

Jan Abrahamsz Beerstraten (1622–1666): landscapes, NYHS 1867.84; MMA 11.92; PUAM 59-101; BMFA 17.1721.

Cornelis Pietersz Bega (1631/32–1664): genre, (1661) IUAM 73.13; (1663) NOMA 81.264; JPGM; (n.d.) JC 517; CAMS 1872.551.

Abraham Jansz Begeyn (1637–1697): (1665) AMAM 19.6; BMFA 21.105.39; JPGM 122; PUAM 37-245; MMA 71.92.

Jacob Adriaensz Bellevois (1621–1675): marines, JC 588; WAG 37.2499; attr., BMFA 07.499.

Johannes van der Bent (c.1650–1690): WAH 1901.3; JPGM 70.PB.17.

Nicolaes Berchem (1630–1683): landscape & genre, (1649) TMA 55.82; (1654) LACM 81.98; (1656) FAMSF 1952.66; (1657) CMA 68.239; (1679) NSM; JBSAM

70.44; (n.d.) AMAM 59.125; 62.15; JC 610; MMA 71.125; JPGM 71.PB.33; WAH 1961.29; HMAA; attr,, NOMA 81.268; 81.296; circle, DIA 51.232; BM 33.34; style, CAMS 1872.8; PAM 60/47; FAM 1958.116; JC 614.

Nicholas Berchem, the Younger (1649/50–1672): landscape, KAMCU 59-19-1.

Gerrit Adriaensz Berckheyde (1638–1698): arch. ptgs., (1695) DIA 89.30; (n.d.) BMFA 38.1652; NCMA 60.17.69; FAMSF 55.18; CAI 1980.15; WAH 1947.363; SMFA 41.04; NOMA 81.271; FAM 1968.65; JBSAM 79.21; JC 598.

Job Adriaensz Berckheyde (1630–1693): arch. ptgs, landscape & genre, (1676) DIA 37.73; (n.d.) AMAM 56.62; JC 530; WAM 1975.105; attr., WAG 37.2364; follower, DIA 61.78; copy, FAM 1969.60.

Gijsbertus Johannes van den Berg (1769–1817): portrait, (1800) NOMA.

Dirck van Bergen (1645–1690): landscapes, (1682) SAM 70.9; (1682?) RMA 62; (n.d.) AMAM 59.3.

Christoffel van den Berghe (active c.1617–c.1640): still lifes, (1617) JC 648; (1624) JPGM 93.

Adam Bernaerdt (active c.1664): WAG 37.682.

Abraham van Beyeren (1620/21–1690): still lifes & marines, (1655) WAM 1953.1; (1666) FAMSF 51.32.2; (n.d.) MIA 45; SAM 61.146; MMA 1971.254; 71.51; KAMCU 72-2-2; PUAM 59-45; TMA 52.24; 50.247; CMA 60.80; DIA 43.46; 35.21; DAI 51.12; 55.69; JC 637; 639; PMA 24-3-23; attr., JC 638; PAM 58/75A.

Jan van Bijlert (c.1603–1671): history & genre, IMA 58.57; VCAG 66.23.10; BJU; CMN 71.457; HMFA 75.41; NSM; circle, CAMS 1872.405; copy, WAG 37.707.

Cornelis Bisschop (1630–1674): genre JC 485; MMA 1982.60.33.

Daniel de Blieck (active 1648–1673): MMA 71.66.

Abraham Bloemaert (1564–1651): history & genre, (1596) MMA 1972.171; (1624) WAG 37.2505; (1626) SP; (1628) TMA 55.34 (1628) JPGM 69.PA.16; (1629) IMA 58.2; (n.d.) NOMA 79.215; MIA 44; WAH 1964.223; follower, DIA 45.4.

Adriaen Bloemaert (1609–1666): landscape, (1657) AMAM 63.3.

Hendrik Bloemaert (c.1601–1672): portraits, (1647) WAG 37.2495 & 37.2496; (1663) JC 494.

Jan Frans van Bloemen (1662–1749): BCMA 1813.32.

Berardus Johannes Blommers (1845–1914): genre, BMFA 15.878; WCMA 77.88; SL 87.1970; 143.1977; WAM 1941.10.

Pieter de Bloot (1601–1658): LACM 49.11.3; PAM 65/94; attr. JC 552.

Théophile-Emile-Achille de Bock (1851–1904): landscapes, (1891) TMA 25.44; (n.d.) SL 42.1974; BMFA 17.3244; TMA 22.38.

Marten Boelema de Stomme (active 1642–1664): still life, JC 649.

Guilliam du Bois (1620/25–1680): landscape (1652), JC 562.

Ferdinand Bol (1616–1680): portraits, history & genre, (164?) CAM 1957.212; (1642) MAB 38.207; MMA 30.95.269; (1644) BMFA 17.3268; (1647) TMA 80.135; (1648) LACM 55.28; (165?) FAMSF 1937-5; (1657) MMA 57.68; (1659) BF; IMA 57.149; (165?) TMA 26.153; (1661) BC 79.131; (n.d.) SMFA 42.02; HMFA 69.4; BC 63.12; TM 1931.426; WAM 1961.39; DAI 62.18; LACM 55.33; CMN; copies, BMFA 17.3269; PMA 48-95-2; NYHS D-72.

Jan de Bondt (died 1653): WAH 1943.53.

Paulus Bor (c.1600–died 1669): MMA 7972.261.

Johannes Bosboom (1817–1891): arch. ptgs. (1867) TMA 26.78; (n.d.) BMFA 23.520; SL 32.1918; TMA 60.12; attr., WAH 1922.458.

Pieter van den Bosch (1613–after 1663): JC 536; NOMA 81.266; BCMA 1813.47; SP.

Ambrosius Bosschaert, the Elder (c.1573–1621): still lifes, (1606) CMA 60.108; (1614) JPGM 83.PC.386; SCMA 1963.62; NSM (2).

Andries Dircksz Both (born c.1908): attr., CAMS 1872.659; 1872.157.

Jan Dircksz Both (1615/18–1652): landscapes, (1645) CAM 1981.413; MAG 62.29; MIA 46; IMA 55.225; FAMSF 69.30.216; TMA 55.40; DAI 50.29; DIA 89.31; 54.441; BMFA 17.1420; 34.239; follower, WAG 37.241; style, WAM 1940.58; copy, WAG 37.337.

Esaias Boursse (1531–1672): genre, JC 539.

Richard Brakenburg (1650–1702): genre, JC 528; JBSAM 63.11.1-2.

Leonard Bramer (1595–1674): history, MMA 11.73; JC 489; CAMS 1872.560; attr., WAH 1938.604; BJU.

Albert de Bray (active from c.1643): attr., (1676) FAM 1927.210.

Dirck de Bray (active 2nd half 17th century): (1678) LACM 48.9.

Jan de Bray (1626/27–1697): portraits & portraits histories, (1668) JBSAM 75.24; (1669) CGAM 1969.8; DAI 69.32; 57.140; 67.36; attr., WAM 1921.187; BMFA 23.529; MIA 72.78; WAG 37.270.

Salomon de Bray (1597–1664): history & genre, (1636) JPGM 69.PA.23; 69.PA.22; (1662) NSM; attr., MAG.

Joseph van Bree (active c.1675–c.1690): CAM 1884.251.

Bartholomeus Breenbergh (c.1599–c.1657): history & landscapes, (1631) JPGM 70.PB.14; (1637) JPGM; (1646) MMA 1983.411; (n.d.) TMA 65.170; AIC 1967.596; LACM 48.26; attr., DIA 41.61; follower BCMA 1813.44.

Georges Hendrik Breitner (1857–1923): (1901) TMA 76.14; (n.d.) CIP 11.1.

Quirin Gerritsz van Brekelenkam (c.1620–1667/68): genre, (1653) WAM 1910.7; MMA 71.110; (1665) DIA 89.32; (1668) LACM 52.14.1; (n.d.) MMA 32.100.19; NAM 52-52; NOMA 76.306; JC 534; 535; 537; NSM; attr., JPGM 70.PA.20; follower, JC 538; pastiche, RMA 78.

Jan Gerritsz van Bronckhorst (1603–1662): history, WAH 1966.10; BJU.

Adriaen Brouwer (1605/06–1638): genre & landscape, JC 681; MMA 32.100.21; BMFA 56.1185; followers, JC 680; 685; 1694; WAG 37.333; NAM 31-95; copy, WAG 37.2409.

Jan van Bunnik (1654–1727): attr., BM 33.38.

Hendrik van der Burch (1627–after 1666): genre, KAMCU 51-1-1; DIA 28.56; 29.2; FC 18.1.78; PMA E'24-3-51; attr., AIC 48.81.

Richard Burnier (1826–1884): landscapes, (1875) BMFA 22.586; (1881) 1901.18.

Cornelis Buys [Master of Alkmaar] (active c.1490–1520): MMA 32.100.122; 32.100.118; DIA 37.23; NSM; BMFA; attr., JC 351.

Arent Arentsz Cabel (1585/86–1635): WAG 37.678.

Abraham Pietersz van Calraet (1642–1722): animals & still life, PMA 24-3-3; CAM 1946.77; JC 625; 628; 424; attr., NOMA 81.276; PMA 24-3-74; copy, PMA 24-3-91.

Govert Dircksz Camphuysen (1623/24–1672): landscape, genre, still life, JC 557; 558; 559; 560.

Joachim Camphuysen (1602–1659): JC 556.

Raphael Govertsz Camphuysen (1598–1657): history, (1629) BJU.

Jan van de Capelle (1624/26–1676): marines, (1651) AIC 33.1068; (n.d.) MAG 68.99; TMA 56.56; MMA 12.31; 32.100.16; DIA 41.6; follower, FC 06.1.20.

Frederick Jacobus du Chattel (1856–1917): MMA 24.79.

Pieter Claesz (1597–1660): still lifes, (1623) MMA 49.107; (1627) TAG; (1630) AIC 35.300; (1634) JPGM 70.PB.37; (1638) NAM 31-114; (1640) IMA 47.2; (1641) BMFA 13.458; VCAG 40.15; (1642) BMFA 13.459; TMA 50.233; (1643) MIA

47; SL 141.1922; (1644) DIA 40.129; (1647) FAMSF 1960.25; (1650) BF; SAM 54.161; (1653) JBSAM 75.31; (n.d.) LACM 37.21.1; BMFA 56.883; JPGM 70.PA.37.

Jacques de Claeuw (active c.1642–1676): still life, (1650) SAM.

Pieter Jacobsz Codde (1599–1678): genre & portraits, (163?) WAH 1962.447; (n.d.) JC 442; 443; CMA 48.462; AIC 33.1069; attr., JC 455; circle, JC 444; copy, JC 441.

Evert Collier (active 1662–after 1706): still lifes, (1662) MMA 71.19; (n.d.) IMA 62.163; SP; attr., HC 54.

David Colijns (c.1582–1668): (1644) WAG 37.2434; 37.2435.

Adam Colonia (1634–1685): FAM 1939.248.

Jan ten Compe (1713–1761): (1743) RMA 63.

Leendert van der Cooghen (1632–1681): RMA 64.

Corneille [Corneille Guillaume Beverloo] (born 1922): (1955) CIP 55.24.1; (1968) CIP 70.53; (1969) CAM 1971.33.

Cornelis Cornelisz van Haarlem (1562–1638): history & genre, (1594) PUAM 73-74; (1597) PMA 68-182-1; (1599) NSM; (1604) WAH 1941.391; (1619) BJU; MAB 66.1; (n.d.) WAM 1980.14; PUAM 73-75; BC 63.16; follower, RMA 82; copy, KAMCU 61-15-1.

Hendrik Coster (active 1642–1659): portrait, JC 460.

Reinier Coveyn (1636–after c.1665): genre, JC 486.

Anthonie Jansz van der Croos (1604–1663): landscape, JPGM 78.PA.203.

Pieter van der Croos (c.1609–1701): DIA 38.30.

Abraham van Cuylenborch (c.1610–1658): history, (1649) NOMA; (n.d.) MMA 25.110.37.

Johannes Gerritsz van Cuylenburch (born before 1621): genre, RMA 65.

Aelbert Cuyp (1620–1691): landscapes, marines & portraits, (1649) MIA 48; (n.d.) BF; BM 56.191; CAM 1946.90; CGA 26.23; 26.64; CMA 42.637; DIA 33.7; 89.33; 53.355; FAM 1960.742; 1960.743; FAMSF; FC 09.1.30; 05.1.29; 02.1.28; IMA 43.107; JBSAM 63.26; JC 621; 622; 627; 1182; JPGM 83.PB.272; LACM 50.43; MMA 14.40.616; 37.160.13; 1973.155.2; 34.83.1; 25.110.15; 32.100.20; 51.104; NAM 30-24; NCMA 52.9.35; NGA 501; 50; 611; 612; NOMA 81.274; NSM; SL 23.1927; TAG 24; TMA 60.2; 55.41; attr., WAM 1923.212; FAM 1970.63; follower, RMA 66; style, BM 56.1; NCMA; imitator, RMA 66.

Benjamin Gerritsz Cuyp (1612–1652); history & genre, CMN; WAM 1956.82; DIA 43.36; FAM 1961.146; WAG 37.335; BF.

Jacob Gerritsz Cuyp (1594–after 1651): portrait & genre, (1645) WAG 37.589; attr., DMFA; copy, (1621) CIP 34.2.1.

Dirck Dalens, the Elder (1600–1676): landscapes, (1647) DIA 39.594; (n.d.) NOMA 81.279

Johan Danckerts (1615–1681/87): MMA 27.146.

Cornelis Gerritsz Decker (before 1643–1678): genre & landscape, (1651) WAH 1970.34; (n.d.) JC 549 & 583.

Dirck van Delen (1605–1671): arch. ptg. & history, (1630) JBSAM 68.44; (1653) CAI 1981.63; (n.d.) LACMA 55.87.2.

Cornelis Jacobsz Delff (1571–1643): VMFA 76.

Jacob Willemsz Delff, the Younger (1619–1661): portraits, (1641) DAI 36.31; (1655) JC 496.

Olivier van Deuren (1666–1714): attr., FAMSF.

Abraham Diepraem (1622–1670): genre, PUAM 37-241; copies, JC 533; NOMA 81.273.

Willem van Diest (before 1610–1663): marines, (1629) WAG 37.877; KAMCU 61-14-1.

Jacob van der Does, the Elder (1623–1673): (1659) WAH 1951.163A; attr., CAMS 1872.530.

Theo van Doesburg (1883–1931): (1916) PAMP 53.25; MOMA 225.48; (1918) MOMA 135.46; (1919) MAB 51.292; (1929) MOMA 588.67; YUAG; (n.d.) CAM 1967.110.

Herman Mijnerts Doncker (c.1620–after 1656): (1644) BF; (n.d.) attr., WAG 37.2502; follower, CAM 1961.293.

Cornelis [Kees] T. M. van Dongen (1877–1968): (1905) NOMA 63.39; (1908) MOMA 192.55; (1920) TMA 75.55; (1923) PAM 64/228; (1925) NOMA 255.54; (1938) CIP 39.1; (n.d.) CMN; SDMA 1972.22; BM 32.117; HMFA 178-73; NAM 45-41; AIC 1946.48; MAG 66.27.

F. van Doornik (active c.1731): portraits, (1731) NGA 1798 & 1799.

Gerard Dou (1613–1675): genre, portraits & still lifes, (1631) JPGM 84.PA.570; (1663) NAM 32-77; (1670) NGA 1560; (n.d.) CAI 761; BM 32.784; CGA 26.81; CMA 51.325; NSM; MMA 14.40.607; 40.64; 60.71.3; WAH 1937.493; circle, BM 32.783; followers, BM 32.495; NYHS; imitator, BMFA 22.643; copies, HMFA 37-1; JC 545; 548; inv. 432.

Willem van Drielenburgh (1635–after 1677): WCMA 61.19.

Joost Cornelisz Droochsloot (1586–1666): genre & landscape, DIA 54.459; BMFA 04.1613; 04.1614; SDMA 1928.32; attr., WAG 37.366.

Willem Drost (active c.1650–c.1680): portraits & history, MMA 41.116.2; attr., CAM 1954.21; AIC 23.47; 37.463.

Henrick Jacobsz Dubbels (1620–1676): copy, JC 586.

Pieter Dubordieu (1609/10–after 1678): portraits, (1635) PMA W'04-1-63; E'1982-1-1; (n.d.) attr., AIC 1934.386.

Jan Ducamps [Giovanni del Campo]: (1639) WAG 37.646.

Jacob Duck (c.1600–1667): genre & history, MMA 1971.102; NCMA 52.9.38; JBSAM 65.18; CMA 75.79; WAM 1974.337; JPGM 70.PB.19; LACM 58.50.1; IMA 60.189; (with Adam Willaerts) DIA 48.13; attr., JC 683; imitator, RMA 68.

Pieter Jacobsz Duifhuizen (1608–1677): still life, JC 783.

Karel Dujardin (1622–1678): history, portraits & genre, (1662) DIA 89.34; (n.d.) MIA 71.44; NSM; YUAG 1966.84; NYHS 1867.126; RMA 69; RISD 20.230; JPGM 76.PA.40; WAH 1950.184; 1950.185; attr., JC 609; copy, RMA 74.

Daniel Dupré (1752–1817): landscape, WAG 37.565.

Cornelis Dusart (1660–1704): genre, MMA 71.52; JC 529; attr., CAMS 1872.342.

Willem Cornelisz Duyster (1599–1635): genre, JC 445.

Abraham van Dyck (1635/36–1672): history & portrait, WAG 37.2013; WAH 1957.165.

Philip van Dyck (1683–1753): portrait, WAG 37.799.

Gerbrand van den Eeckhout (1621–1674): history, portraits, genre, (1642) MMA 25.110.16; (1643) BJU; (1652) WAM 1922.208; (165[8]) TMA 23.3155; (1659) PMA 1981-1-1; (1662) RMA 79; (1664) WAG 37.2492; (1666) NCMA 52.939; (1667) FAMSF 47.7; WAH 1960.260; (1672) CMN 71.449; (1674) CMN L79.191; (n.d.) IMA 58.89; WAH 1959.255; MMA 26.260.8; BMFA 74.4; JPGM 72.PA.22; wrongly attr., NCMA 58.44.

Jacob Josef Eeckhoudt (1793–1861): history PUAM 53-237.

Adriaen van Eemont (died 1662): landscape, JC 526.

Nicolaes Eliasz [Pickenoy]: portraits, (1631) PAM 64/271; (1632) JPGM 54.PA.3; (1633) DIA 21.214; (n.d.) MMA 06.173.

Pieter Janssens Elinga (died before 1682): genre, PAM 64/235; style, WAH 1965.267.

Cornelis Engebrechtsz (1468–1533): MMA 11.193ab; 88.3.88; follower, AIC 1933.1042.

Jacob Esselens (1626/28–1687): landscape & portraits, NCMA 52.9.205; AMAM 62.40; DAI 46.5.

Allart van Everdingen (1621–1675): landscapes & marines, CMA 74.105; MIA 70.12; JC 587; copy, JC 460.

Caesar van Everdingen (c.1617–1678): history CMN; attr., WAH 1962.438; JPGM 75.PA.64.

Adrianus Eversen (1818–1897): cityscapes, (1867) BMFA 22.631; (n.d.) NGA 2533; CAMS 1872.353.

Barent Fabritius (1624–1672): history & portraits, MMA 1976.100.23; AIC 1967.594; FAMSF; attr., MMA 14.40.629; FC 99.1.96; DMFA 1963.149; WAH 1946.370; BF.

Carel Fabritius (1622–1654): history BMFA 03.1143; follower, JC 479.

Maria la Farque (1732–1782): genre, (1777) JC 709; (n.d.) style, RMA 80.

Govaert Flinck (1615–1660): portraits & history, (1639) MAB 38.200; (1641) JPGM 71.PB.36; (164[5?]) MMA 25.110.27; (1646) CMA 77.117; NCMA 58.4.3; (1654) MIA 49; (n.d.) MAG 83.10; LACM 47.29.12; attr., CAM 1953.126; copies, AIC 1970.1004; LACM 57.49.

Jan Fris (1627–1672): still life, JC 643.

Hendrik de Fromantiou (1633–1690): still life, JC 645.

Barent Gael (1635–after 1681): landscapes, BMFA 27.222; Res 14.

Jakob van Geel (c.1585–after 1638): landscape, DIA 38.15.

Joost van Geel (1631–1698): genre, DIA 67.114.

Geertgen tot Sint Jans (c.1465–c.1495): CMA 51.353; follower, JC 346.

Wybrand Simonsz de Geest (1592–after 1660): portraits, (1630) WCMA 64.13; 64.14.

Aert de Gelder (1645–1727): history, portraits, & genre, (1687) DIA 49.531; (n.d.) JPGM 78.PA.219; 79.PA.71; AIC 1932.1175; BMFA 57.182; 39.45; BF.

Jasper Gerard (died 1654): still life, LACM 55.79.

Jacques de Gheyn (1565–1629): still life, (1603) MMA 1974.1; (1621) YUAG.

Johannes Glauber (1646–1726): landscape, BMFA 1979.287.

Vincent van Gogh (1853–1890): AKAG 66.9.22; 62.2; AIC 1953.178; 1965.1169; 1926.200; 1926.202; 1968.92; 1954.326; 1949.215; 1926.417; 1926.201; 1933.433; BMFA 35.1982; 48.548; 48.549; 52.154; 58.356; CAI 889; CAM 1962.15; 1967.1430; CIP 67.16; 68.18; CMA 58.31; 47.209; 58.32; DIA 22.13; 70.158; 70.159; DMFA 1961.99; FAM 1951.65; 1951.66; HMFA 74.139; IMA 44.74; MAB L.76.24.3; MIA 66; MMA 67.187.70ab; 49.41; 56.13; 62.24; 51.112.3; 1975.1.231; 49.30; 64.165.2; 50.187; MOMA 242.48; 472.41; NAM 37-1; 32-2; NGA 1694; 1695; 1815; 1816; 1817; 2406; NSM (4); BFM (2); MAB 50.303; 50.302; SL 43.1972; 579.1958; 8.1953; 1.935; PMA 63-116-19; 50-92-22; 1978-1-33; 73-129-1; TMA 35.5; 35.4; YUAG 1961.18.34.

Hendrik Goltzius (1558–1617): history, (1602) RISD 61.006; (1603) LACM; circle, BJU; copy, WAG 37.793.

Cornelis van Gouda (1510–1550): attr., WAG 37.247 A & B.

Jan Josephsz van Goyen (1595–1656): landscapes & marines, (1627) MMA 1972.25; (1633) JC 462; YUAG; (1640) LACM 51.29.1; (1641) JC 463; FAMSF 48.7; (1642) NSM; (1643) CGAM 1961.17; WAG 37.375; (1644) BMFA 47.235; NGA; (164[4 or 7]) VMFA 80; SL 223.1916; (1645) LACM 51.29.2; WAH 1923.590; CMA 59.351; (1646) CGA 26.95; MMA 71.62; 45.146.3; MAB 38.209;

(1647) BF; AMAM 41.76; MMA 64.65.1; SCMA 1942.3-1; (1648) MIA 83.84;
(1649) JPGM 78.PB.198; TMA 33.27; (165?) CGA 26.97; (1651) TMA 25.47; DIA
39.5; SMFA 41.05; CGA 26.96; BFM; (1652) WAM 1956.84; (1653) JC 464; AIC
33.1078; (1654) 1969.55; (165[5?]) BMFA 07.502; (n.d.) KAM AP66.4; LACM
51.29.3; DIA 60.229; MMA 32.100.6; 71.61; PMA 24-3-30; FAM 1969.54; follower,
NOMA 58.3; PUAM 64-1; JC 505; style, MMA 65.181.11; JC 469; RMA 81; forgery,
AAMCH 66.9.1.

Pieter de Grebber (c.1600–1653): history (1622) HMFA 71.27; (1628) JPGM
71.PA.67; (n.d.) UAMB; BJU; IUAM 80.36; copy, BJU.

Cornelis Norbertus Gysbrechts (active 1659–75): still life, BMFA 58.357.

Maurits Frederiks de Haas (1832–1895): portrait, BMFA 5.884.

Jan Jansz Hackert (1629–1699): landscape, DIA 50.198; IUAM 60.37.

Johan van Haensbergen (1642–1705): landscape, DIA 89.41.

Dirck Hals (1591–1656): genre, (163[?]) MMA 71.108; CAI 757; (n.d.) CAI 756; BF;
LACM 46.47.2; PUAM 1035; NYHS 1867.149; JC 434; 435; JBSAM 64.31.30.

Frans Hals (c.1580–1666): portraits & genre, (1616) CP 61.42.2; (1623) MMA
14.40.602; (1625) MMA 79.7.34; (1626) MMA 29.100.8; 29.100.9; (1627) AIC
1954.287; (1633) NGA 67; (1634) TAG 22; MAB 51.107; (1635) FC 10.1.72;
(1638) CMA 48.137; (1639) DIA 49.347; (1643) MMA 26.101.11; YUAG
1961.18.23; 1961.18.24; BFM; (1644) WAH 1958.176; MAB 38.231; (1645)
NGA 69; (1650) HMFA 51.3; (165[?]) FC 06.1.71; (n.d.) CAM 1927.399; MMA
14.40.604; 89.15.34; 14.40.605; NSM; FC 17.1.70; 10.1.69; NGA 68; 70; 71;
498; 624; 625; KAMCU 53-1-1; LACM M.74.31; BMFA 66.1054; SDMA 1946.74;
MAG; TM 1931.450; 1931.451; 1931.455; SL 272.1955; CGA 26.99; FAM
1930.186; NAM 31-90; BM 32.821; RM 83; attr., AIC 1894.1023; MMA 32.100.8;
circle, SDMA 1936.22; VMFA 78; follower, CAM 1946.92; BC 4; FAMSF L55.45;
(1630) AAM; BMFA 21.1449; 59.1003; JPGM 70.PA.15; TM 1931.401; KAM
AP65.2; TMA 26.67; style, DIA 48.383; JC 432 & 433; NCMA GL 60.17.67; HC
45; MMA 71.76; copies, CAM 1943.3; 1976.432; 1973.450; VMFA 77; BM
34.496; AIC 47.78; KAM ACF51.1; DAI 65.7; 65.8; imitator, AAM.

Jan Hals (c.1620–c.1650): portraits, (1644) DIA 52.144; NCMA 52.7.42; (1648)
BMFA 01.7445.

Adriaen Hanneman (c.1601–1671): portraits, MMA 89.15.27; NAM 56-89; MIA 50;
YUAG.

Dirck Hardenstein (1620–after 1674): genre, (1663) CGA 26.4.

Matthijs Harings (active c.1615–c.1650): portrait, JC 450.

Margareta Haverman (active 1716–after 1750): still life, (1716) MMA 71.6.

Gerrit Willemsz Heda (active 1642–1667): still lifes, (16[4?]4) WAM 1959.49; NGA.

Willem Claesz Heda (1594–1680/82): still lifes, (1631) WAH 1921.350; (1636)
FAMSF 1942.12; (1656) HMFA 57.56; (n.d.) JC 644; LACM 50.20.1; style, JC
642.

Cornelis de Heem (1631–1695): still life, JC 631; circle, AAM; copy, WAH 1954.217.

Jan Davidsz de Heem (1606–1684): still lifes, (1633) AAMCH 62.11.1; (1643)
LACM M72.67.1; (1646) TMA 55.33; (1654) NSM; (n.d.) MMA 71.78; 12.195;
NGA 1649; MAG 49.63; VMFA 61-15; BMFA 63.267; AMAM 54.21; TMA
55.25; RM 84; FAM 1960.754; follower, JC inv. 421; CAMS 1971.1; copy, WAG
37.867.

Egbert van Heemskerck (1634/35–1704): genre, attr., FAM 1948.53; WAH 1899.2;
1958.71.

Maerten van Heemskerck (1498–1574): history & portraits, (1532) MMA 71.36;

(1535/36) WAG 37.656; (1565) CMN; (1567) NSM; (n.d.) JC 417; AMAM 49.81; 4982; BJU; YUAG; attr., BJU; follower JC 416; CAMS 1872.114.

Margaretha de Heer (active 1640–1660): still life, (1654) WAH 1937.492.

Thomas Heeremans (active 1660–1697): landscapes, (1674) WAG 37.1907; (1682) 37.1863.

Bartholomeus van der Helst (1613–1670): portraits, (1647) MMA 71.73; (1650) JPGM 70.PA.12; (1653) JC 495; (1654) DIA 25.216; (1655) TMA 76.12; (1662) MMA 73.2; (n.d.) MMA 00.17.1; MIA 51; KAMCU 60-1-1; FAM 1969.62; follower, RMA 85; style, VMFA 89; copy, CAMS 1872.514.

Lodewyck van der Helst (1642–c.1684): portrait, attr., PMA 04-1-60.

Nicolaes de Helt-Stockade (1614–1669): history, HMFA 69-22.

Jan Sanders van Hemessen (active c.1524–c.1564): history, MMA 71.155; AIC 56.1109.

Jacob de Heusch (1657–1701): landscapes, FAM 1958.2; attr., BMFA 24.21.

Willem de Heusch (1625–1692): landscapes, DIA 89.37; WAG 37.650.

Nicolaes van Heussen (1599?–after 1630): still life, DIA 31.308.

Jan van der Heyden (1637–1712): arch. ptg. & still lifes, (1711) NSM; (n.d.) MMA 64.65.2; 64.65.3; 71.158; 66.62.5; WAM 1921.181; NGA 2349; CAM 1946.93; LACM 51.17; JPGM 78.PB.200; TMA 72.1; VMFA 64-21; JC 595; 596; DIA 48.218; 38.31; follower, JC 597.

Meindert Hobbema (1638–1709): landscapes, (1658) DIA 89.38; (1662) AIC 22.4460; PMA 24-3-7; (1663) NGA 61; 627; (1664) TMA 67.157; (1665) FC 02.1.73; NGA 62; (1667) IMA 43.108; JPGM 84.PB.43; (1668) AMAM 44.52; (16[?]7) CGA 26.100; (n.d.) MMA 14.40.614; 50.145.22; NGA 60; NAM 31-76; NGA 626; 628; TM 1931.407; CGA 26.101; AIC 94.1031; VMFA 53-25; MIA 52; 53; BM 56.159; DIA 53.361; 67.115; FC 11.1.74; CAM 1940.946; 42.641; CAI 769; circle, CMN; follower, CAM 1940.946; WAG 37.655; CIP 29.2.12; style, BM 23.382; BM 32.822; copy, JC 573; imitator, JC 571; 572; RM 86; BMFA 17.3251.

Gerard Hoet (1648–1733): history, JPGM 69.PA.14; NSM (2); BJU.

Gijsbert Gillisz de Hondecoeter (1604–1653): MMA 71.18.

Melchior de Hondecoeter (1636–1695): still lifes, BMFA 07.501; 21.1451; 26.767; WAH 1899.1; DAM 1962.102; NAM 30-16; TMA 62.69; 49.102; DIA 45.16; PMA 02.1.18; 96.1.12; JC 630; BF; MMA 27.250.1; attr., CMN L77.366; MAB 62.37; WAH 1956.615; JC 629; CIP 29.2.13; 29.2.4; SAM; DIA 72.837; follower NCMA 52.9.44; style, WAH 1958.455; CAMS 1872.509; 1872.670.

Abraham Danielsz Hondius (1625–1695): history, landscape & genre, (1665) WAM; (1688) MMA 1974.368; (n.d.) FAMSF 52.14; CMA 79.82; CAMS 1872.57.

Gerard van Honthorst (1590–1656): history, genre & portraits, (1621) DAI 80.2; (1622) JPGM 70.PB.34; WAM 1968.15; (1625) SL 63.1954; (1627) SAM 62.156; (1653) SCMA 1966.14; (n.d.) CMN; PUAM 68-117; CMA 68.23; attr., BJU; MIA 71.78; circle, WAH 1939.621; WAG 37.3457; follower, TMA 55.60; PUAM 66-25; CAM 1944.111; copy, BMFA Res. 22.6; HMFA 50-11; PUAM 53-236; RMA 87; PAMP 60-28.

Willem van Honthorst (1594/1604–1661): portrait, MMA 51.182.

Pieter de Hooch (1629–1684): genre & portraits, (1663) CMA 51.355; (168[?]) BMFA 03.607; (n.d.) TMA 49.27; MMA 1976.100.25; 29.100.7; 14.40.613; 32.100.15; 58.144; 93.22.2; 1975.1.144; NCMA 52.9.45; TM 1931.395; IMA 67.21; FAMSF 61.44.37; PMA 12-1-7; JPGM 84.PA.47; JC 499; 501; NGA 56; 629; 630; 1925.117; DIA 89.39; CGA 26.103; LACM M44.2.8; BM 34.481; attr., KAMCU 42-1-2; circle, JC 498; copies, CAM 1950.19; TMA 26.79; SL 20.1929; VMFA 97.

Samuel van Hoogstraten (1627–1678): genre & history, (1670) SMFA 52.02; AIC 1969.110; DIA 09.13; AIC 54.297; attr., SMFA 51.11; WAH 1961.643; circle, DIA 35.101.

Jordanus Hoorn (1753–1833): landscape, (1778) CMA 462.15.

Jan Josef Horemans (1682–1759): genre, PUAM 59-102.

Dirck van Horn (act. c.1650): still life, (1650) SCMA 1968.14; HMAA.

Gerrit Willemsz Horst (c.1613–c.1652): history, style, NCMA 56.20.1.

Arnold Houbraken (1660–1719): DMFA 1964.109; RMA 88.

Cornelis Huysmans (1648–1727): landscape, BMFA Res.22.5.

Jan van Huysum (1682–1749): still lifes, (1740) SDMA 1938.243; (n.d.) VMFA 100; NAM 32-168; MMA 1973.155.3; 1973.155.4; BMFA 89.503; JPGM(2); attr., KAM AP70.2; follower SMFA 55.13; AIC 32.962; 32.963; style, 78.PA.67; 78.PA.68.

Josef Israëls (1824–1911): history & genre, (1852) RMA no. 89; (1862) BMFA 18.278; (n.d.) AIC 1974.231; 1944.35; AMAM 19.10; BMFA 87.411; 15.885; 23.535; 24.228; CAI 777; CAM 1981.132; 1956.107; CMA 16.1031; DIA 59.117; 10.12; JC inv. 1009; 1010; LACM 39.12.13; MMA 87.8.13; 17.120.227; PMA 42-60-2; 24-3-10; 24-3-79; 32-45-51; RMA 90; SL 135.1977; TM 1931.460; 1931.428; TMA 14.166; 14.117; 22.23; 22.24; WAB 76.55.4; WAG 37.658; 37.964; WAM 1917.51; 1935.46; WCA 74.14; 64.33.

Dirck Jacobsz (c.1500–1567): portrait, JPGM 54.PB.5.

Cornelis Janssens van Ceulen (1593–1661): portraits, (1617) MMA 1971.2; (1628) MAB 38.196; (1631) IMA 41.49; (1633) IMA 41.35; (1635) KAMCU 59-19-2; (1648) MMA 57.30.1; 57.30.2; (1649) BMA 1954.2; (1657) MMA 41.116.3; (n.d.) PAM 60/70; PUAM 66.211; DIA; attr., SDMA 1966.25.

Govaert Jansz (1578–before 1619): history, attr., DIA 41.39.

Hans de Jode (active 1647): landscape, FAM 1955.169.

Claude de Jongh (active 1633–1663): landscape, (1634) SAM 59.65; (n.d.) YUAG.

Ludolf de Jongh (1616–1679): portraits & genre, (1661) VMFA 63-54; (n.d.) BMFA 17.591; NCMA 52.9.46; DIA 58.169; MMA 20.155.5; follower, DIA 44.79.

Johan Barthold Jongkind (1819–1891): landscapes, (1852) JC inv 1012; NSM; (1856) MAB L.34.48.208; (1862) HMFA 175-73; (1863) PMA 24-3-76; TMA 50.71; AIC 1963.836; (1864) AIC 1968.614; (1865) BM 41.779; PMA 38-22-8; MMA 16.39; (1866) AIC 1933.1129; CMN; AAMCH 64.16.1; (1871) PMA 24-3-84; BMFA 19.95; NSM; DIA 37.22; (1875) MIA 67; (n.d.) BMFA 61.1242; WAH 1950.218; KAMCU 59-10-2; FAM 1943.92; 1943.93; SL 10.1963; HMFA 57-52; MAB L34.48.206; PAM 64/237; 70/37; YUAG; attr., PMA 38-22-7; copy, MMA 06.1284.

Isaac de Jouderville (1613–1640): history & portrait, DAM 1959.114., NCMA G57.57.1.

Frederik Henri Kaemmerer (1839–1902): genre, WAM 1952.31; MMA 87.15.80.

Willem Kalf (1619–1693): still lifes, (1659) MMA 53.111; (1663) CMA 62.292; (1669) IMA 45.9; (n.d.) MMA 71.69; SMFA 42.10; JC 634; 635; 636; JPGM 54.PA.1; PAMP 27.1; DIA 69.358; 26.43; NGA 745; SL 93.1947; attr., SCMA 1962.9.

Godaert Kamper (1613/14–1679): genre, BMFA 46.842.

Johan Mari Henri ten Kate (1831–1910): genre & landscape, PMA 23-59-8; CAM 1947.526.

Alexander Keirincx (1600–1652): landscape, VMFA 84.77.

C. Kelder (late 17th century): portraits, (1684) AMAM 04.1219; 04.1220.

Jan van Kessel III (1641/52–1680): (1663) RMA 92; follower, JC 582.

Jacob Simon Hendrik Kever (1854–1922): genre, TMA 12.510; 14.68.

Thomas de Keyser (1596/97–1667): portraits & genre, (1625) MAG (pendants);

(1627) TMA 60.11; (1629) MMA 64.65.2; (1631) NSM; VMFA 81; (1632) BM 57.142; (n.d.) MMA 29.180.1; NSM; NCMA 23.18.1; WAH 1899.5; attr., (1628) AAM; JC 456; circle, PMA 43-40-41; DIA 31.269.

Simon Kick (1603–1675): genre, (1637?) DAI 55.68.

Cornelius Kicks (1635–1675): still life, PUAM 63-50.

Albert Jansz Klomp (c.1618–1688): MMA 32.100.12.

Wouter Knijff (c.1607–after 1693): landscapes, (1648) DIA 89.36; PMA W'02-1-20; attr., CAMS 1872.11.

Nicolaes Knüpfer (c.1603–1655): history, JPGM.

Jan Kobell, the Younger (1778–1814): landscape, WAH 1898.9.

Barend Cornelis Koekkoek (1803–1862): landscapes, (1833) MMA 87.15.30; (1853) MMA 87.15.45; (n.d.) CAM 1966.446.

Hermanus Koekkoek (1815–1882): landscape, BMCA.

Hermanus Willem Koekkoek (1867–1929): landscape, MMA 1975.443.

Willem Koekkoek (born 1839): cityscape, PMA 23-59-12.

Philips Koninck (1619–1688): landscapes, portraits & genre, (1649?) MMA 11.144; (1665) JPGM 85.PA.32; (n.d.) MMA 63.43.2; FAMSF 43.9.2; SL 402.1923; attr., JC inv. 742.

Salomon Koninck (1609–1656): history & portraits, AAMCH 63.36.1; BJU; BMFA 04.266; attr., PUAM 28–18; style, WAG 37.327.

Evardus Koster (1817–1892): marine, WAH 1900.4.

Gerard van Kuijl (1603–1673): history, RMA 93.

Reinier van der Laeck (died c.1658): landscape, (1645) WAH 1944.35.

Gerard de Lairesse (1641–1711): history, (1671) MMA 43.118.

J. de Lange (died 1696): portrait, HMAA 60.37.

Jan Willemsz Lapp (c.1600–c.1663): landscape, attr., PMA 29-136-148.

Pieter Lastman (1583–1633): history, (1611) DIA 60.63; BMFA 62.985; (1613) RISD 60.093; (1614) LACM M.85.117; (n.d.) FAMSF 44.16; CMN.

G. Lataster (born 1920): (1957) FAM 1958.270; MOMA 14.54.

Johannes Leemans (1633–1688): still life, SAM 64.30.

Willem van Leen (1753–1825): still life, MMA 07.225.470.

Cornelis Lelienbergh (active 1646–after 1676): still lifes, (1654) PMA W'02-1-19; (n.d.) SAM 66.74; attr., CAMS 1872.368.

Paulus Lesire (1611–1656): portrait, (1636) RMA 94.

Aertgen Claesz van Leyden (1558–1617): SMFA 57.36.

Lucas van Leyden (1494–1538): history & genre, (1527) BMFA 54.1432; (n.d.) BFM; NGA 1387; style, JC 413; CMN; copy, MMA 89.15.13.

Judith Leyster (1609–1660): genre & portrait JC 440; NGA 1050.

Carel Liefrinck, the Younger (1559–1624): landscape, WAH 1940.197.

Cornelis Liefrinck (active c. 1626): landscape, MIA 57.

Pieter van Liender (1727–1779): arch. ptg., DIA 54.213.

Jan Lievens (1607–1674): portraits, history, landscape & genre, (1631) JPGM 71.PA.53; (1632) FAM 1930.191; (1640) NOMA 81.294; NSM; (n.d.) WAG 37.2493; FAM 1972.38; JC 487; NCMA 52.9.55; G57.28.1; AIC 34.385; NSM; attr., PMA 61-195-1; follower LACM 46.47.1; copy, JC 473.

Johannes Lingelbach (1622–1674): landscapes & history, (1655) BF; (165?) MMA 71.123; (1667) RMA 95; CMN 71.450; (1668) WAH 1921.341; (1671) 71.23; (n.d.) MMA 71.115; MIA 59; WAM 1976.155; JPGM 69.PB.5; attr., MIA 58.

Dirck van der Lisse (c.1639–1669): history & landscape, WAH 1951.229; JPGM 70.PB.9; 72.PA.12; copy, AIC 1970.1040.

Jan Looten (1616–c.1681): landscape, RMA 96.

Anthonie de Lorme (c.1610–1673): arch. ptg., (1657) VMFA 87; (1660) LACM 47.14; FAMSF.

Isaac Luttichuys (1616–1673): portraits, (1636) MMA 32.100.10; (1663) RMA 97; PMA 68.97.1.

Nicolaes Maes (1634–1693): genre, history & portraits, (1653) MMA 1971.73; (1656) FAMSF 1942.6; 1942.5; SL 72.1950; NSM; (1659) NCMA 52.9.4; (1674) RMA 99; (1675) CIP 64.11.16; (1676) FAM 1966.151; 1966.152; (n.d.) FAM 1957.96; PMA 44-9-4; CIP 64.11.17; MAG; MMA 14.40.612; 32.100.5; 06.1325; 11.149.2; 11.149.3; BMFA 89.504; 10.104; 57.199; 1973.447; AAMCH 65.4.4; RMA 98; AIC 25.715; 25.716; JPGM 70.PA.38; CAMS 1968.26; NGA 63; WAM 1924.14; IMA 44.09; 63.187; 68.29.2; TMA 61.12; 26.60; attr., CGA 26.112; CAM 1946.95; SDMA 1926.120; style, JC 488.

Pieter van Maes (active late 17th century): still life, LACM 49.11.6.

Cornelis de Man (1621–1706): arch. ptg. & genre, AIC 1965.1176; attr., JPGM 121.

Karel van Mander (1548–1606): history, BJU (2); attr. AMAM 59.43.

Jacob Henricus Maris (1837–1899): landscapes, (1868) MAB L.34.48.101; (1879) TMA 22.32; (1881) PMA 24-3-11; (1885) FC 14.1.87; (n.d.) NAM 32-33;; PMA 24-3-12; BMFA 24.231; TMA 25.42; 25.40; MMA 33.136.3; AMAM 42.83; WAG 37.202; JC 1029; 1030; 1031; 1032; TM 1931.456; 1931.458; 1931.433; CIP 16.7.1; SL 34.1974; KAMCU 39-1-3; CAI 802; 803.

Matthijs Maris (1839–1917): genre, (1863) TM 1931.431; (1875) MMA 92.1.49; (n.d.) BMFA 13.467.

Willem Maris (1844–1910): landscapes, PMA 24-4-20; 1978-118-1; TM 1931.408; CAM 1956.108; SL 48.1974; 138.1977; TMA 25.43; 22.33; BMFA 25.118.

Jan Martszens, the Younger (c.1609–after 1647): CAMS 1872.671.

Johan Hendrik van Mastenbroek (1875–1946): (1907) BMFA 23.471.

Master of the Brunswick Diptych (active c. 1480–1500): MIA 43.

Master of the Providence Crucifixion: RISD 61.080.

Master of St. John's Altar (active c.1480–1490): JC 347.

Master of the Tiburtine Sibyl (active c.1480–1495): JC 344; DIA 41.126.

Master of the Virgo inter Virgines (c.1470–c.1520): MMA 26.26; JC 348; SL 4.1935; attr., JC 751; AIC 1933.1049.

Anton Mauve (1838–1888): landscapes & genre, BMFA 17.3238; 17.3248; 22.587; 23.492; 24.222; 24.229; 33.323; 38.1419; MMA 14.40.810; 14.40.811; 14.40.816; 43.86.8; HMFA AL23; RMA 100; PMA 24-4-21; 24-3-13; MAB 76.55.6; WAG 37.661; NCMA; BM 32.842; 21.29; 51.13; AMAM 19.8; DIA 73.60; CAM 1956.117; TM 1931.411; CIP 03.2; 11.6; WCMA 77.8.9; SL 8.1917; 9.1917; 10.1917; WAM 1935.37; TMA 25.53; 25.52; 22.22; CAM 1958.98.

Jacob Frans van der Merck (c.1610–1664): genre, BMFA 74.10; attr., DMFA 1964.106.

Hendrik Willem Mesdag (1831–1915): landscapes, (1896) WAH 1903.4; WAM 1899.3; SL 20.1917; BM 26.604; 21.30; 21.137.19.

Gabriel Metsu (1629–1667): genre & portraits, (1654) BMFA 89.501; (1661) MMA 17.190.20; (1663) FAMSF 60.30; attr., BMFA 83.22; MMA 91.26.11; 50.145.29; 21.134.5; 1982.60.32; TAG 26; NGA 57; NSM; JC 543; JBSAM 70.56.1; 70.56.2; attr., WAH 1922.457; RMA 101; follower, CMN 71.477; style, BM 34.485; copies, WAG 37.33; BM 49.229; JC 507; 508; PUAM 52-171; 53-47.

Pieter ter Meulen (1843–1927): landscape, TMA 22.40.

Theobold Michau (1676–1765): landscape, NAM 34–202.

Jan Miel (1599–1663): genre, WAH 1938.603.

Jan van Miereveld (died 1633): portrait, (1630) CAM 1884.331.

Michiel Jansz van Miereveld (1567–1641): portraits, (1616) BMFA 11.1452; (1619) BMFA 29.975; (1633) NCMS 52.9.49; 52.9.48; (1638) NGA 1648; (1639) MMA 25.110.12; (1640) MMA 25.110.13; (n.d.) MMA 30.95.257; PUAM 79; JBSAM 60.24; follower, JBSAM 63.25.1; style, CAMS 1872.354; BM 29.119.

Frans van Mieris, the Elder (1635–1681): portraits & genre, (1675) JC inv. 310; (n.d.) CGA 26.80; style, MAG; CAMS 1872.641; called, DIA 38.29; copies PAM 81/143; NAM 30-17; HC 55.

Frans van Mieris, the Younger (1689–1763): genre & history, BM 21.447; LACM 56.68.2.

Willem van Mieris (1662–1747): genre & history, (1703) AIC 90.42; CMN 71.476; attr., BF; NOMA 69.36; DAI 50.35.

Abraham Mignon (1640–1676): still life, MAB 57.32.

Claes Cornelisz Moeyaert (1592/93–1655): history, (1628) VCAG 80.17; (1647) DIA 57.17; (n.d.) BCMA 1970.41.

Bartholomeus Molenaer (active c.1640–died 1650): genre, WAM 1919.316.

Jan Miense Molenaer (c.1610–1668): genre & portraits, (1633) TMA 75.21; VMFA 49-11-19; (1652) HMFA 50-35; (1662) BMFA 07.500; (n.d.) SAM 61.162; JC 438; 439; IMA 68.1.2; NCMA 52.9.50; NOMA 81.272; PAM 62/100; 66/70; NSM; circle, CAM 1944.111.

Klaes Molenaer (1630–1676): genre & landscape, SCMA 1956.61; RMA 102; FAM 1924.18; JC 576; style, JC 577; CAMS 1872.629.

Pieter Molyn (1595–1661): landscape & history, (1629) MMA 95.7; (n.d.) JPGM 72.PA.27; PUAM 72-40.

Hendrik Mommers (c.1623–1693): landscape, BMFA 28.858; 28.860; JPGM 109; IMA 68.01.1; attr., WAM 1910.32.

Piet Mondrian (1872–1944): (1913–14) MOMA 153.57; 242.50; (1914) MOMA 633.67; 34.42; (1917) MOMA 1774.67; (1918) HMFA 63.16; (1920) MOMA 257.48; (1921) MOMA 154.57; (1925) MOMA 486.41; (1926) MOMA 179.53; (1927) MAB 51.343; CMA 67.215; YUAG 1942.355; (1931) MOMA 634.67; (1933) MOMA 635.67; (1935) WAH 1936.338; (1936) MOMA 2.37; (1936–42) MOMA 636.67; (1937) MOMA 637.67; (1942–43) MOMA 73.43; (n.d.) MOMA 243.50; 1773.67; NSM; CMA 58.38; NGA 2563; SL 242.1972; DMFA R-66-1; 1975.65.FA; 1982.22.FA; 1982.26.FA; AKAG; MIA 68; CIP 61.1; TMA 78.44; SCMA 1975.23; DAM 1966.185.

Louis de Moni (1698–1771): style, WAG 37.379.

Monogrammist "CMHV": SL 46.1954.

Monogrammist "IS": JPGM 102.

Carel de Moor (1656–1738): portrait, MMA 73.1.

Johan Moreelse (died 1634): history, AIC 97.296; 97.291

Paulus Moreelse (1571–1638): portraits, history & genre, (1625) AAM (pendants); (1633) BMFA 46.559; PUAM 54-130; WAH 1959.25; (n.d.) WAM 1905.125; AIC 1954.292; CIP 64.11.20; MMA 59.23.17; attr., BM 45.9; workshop, MMA 30.95.267.

Willem Moreelse (c.1620–1666): portrait, (1647) TMA 62.70.

Jan Evert Morel (1777–1808): landscape, CAM 1979.131.

Jan Mostaert (c.1475–1555/56): history & portrait, SL 207.1946; JC 411; CAI 946; RMA 104; MMA 1982.60.25.

Frederik de Moucheron (1633–1686): landscapes, BMFA 77.137; (with A. van de Velde) JPGM 78.PA.214.

Isaac de Moucheron (1667–1744): landscapes, WAH 1951.265.

Pieter Mulier, the Younger (c.1637–1701): landscape, FAM 1961.55.

Emanuel Murant (1622–c.1700): landscapes, DIA 31.62; 09.12; CAMS 1872.369; MMA 30.95.260.

Michiel van Musscher (1645–1705): genre, (1671) DIA 64.263; circle, SL 288.1957.

Daniel Mytens, the Elder (c.1590–1643): portraits, (1629) MMA 06.1289; (n.d.) SCMA 1963.60; SCMA 1963.59; JPGM 74.PA.45; VCAG 67.1.2; attr., SL 118.1916; RMA 105.

Jan Mytens (1614–1670): portraits, (1647) NOMA 79.216; (n.d.) JPGM 79.PA.156.

Matthys Naiveu (1647–1721?): genre, (1675) MMA 71.160; (n.d.) BMFA 89.506.

Pieter Nason (c.1612–1688/90): portraits, (1646) JBSAM 60.21; (1647) RMA 106; (1663) WAG 37.71; (n.d.) MMA 71.141.

Johannes Natus (active c.1662): genre, attr., JC 511.

Herman Nauwincx (c.1624–after 1651): landscape, (with W. Schellinks) JPGM 69.PA.6.

Aert van der Neer (1603/04–1677): landscape & history, (1637) NSM; (1645) CGA 26.148; (n.d.) JC 553; WAM 1962.26; NCMA 52.9.57; BJU; NSM; TMA 33.30; 33.31; VMFA 82; DIA 09.17; 89.40; BF; FAMSF; FAM 1943.1356; 1966.146; 1966.147; 1966.148; PUAM 59-134; PMA 24-3-52; CAM 1953.1; TM 1931.468; WCMA 79.1; MMA 17.190.11; 71.60; 32.100.11; circle, WAH 1946.371; follower, PMA W'95-1-7; style, WAH 1905; copy, JC 555.

Eglon Hendrik van der Neer (1634–1703): genre, BMFA 41.935; MMA 32.100.9; imitator, AIC 43.1183.

Martinus Nellius (after 1706): still life, WAH 1958.456.

Caspar Netscher (1639–1684): genre & portraits, (1659) WAM 1955.56; (166?) MMA 89.15.6; (166[7?]) MAB 44.103; (167[2?]) MMA 25.110.60; (1677) WAH 1903.1; (1680) AIC 33.1070; (n.d.) JC 544; MMA 71.67; AIC 25.718; SCMA 1925.4-2; attr., CIP 64.11.20; RMA 107; circle, CAMS 1872.86; copy?, BMFA 94.170; WAG 37.265.

Constantijn Netscher (1668–1723): portraits, history, NCMA 57.10.1; BMFA 61.176; called, NYHS 1867.324.

Albert Neuhuijs (1844–1914): genre, BMFA 23.464; TMA 25.880.

Pieter de Neyn (1597–1639): landscapes, (1631) DIA 52.31; (1637) WAG 37.25.01; (n.d.) PUAM 69-74; JC 465; attr., AIC 33.1070.

Adriaen van Nieulandt (1587–1658): history, (1640) DAI 57.135; (1652) CAMS 1872.508.

Willem van Nieulandt (1584–1635): history, (1630) WAM 1980.7.

Dionys van Nijmegen (1705–1798): RMA 108.

Jan Rutgersz van Niwael (1639–1661): DAI 54.17.

Jan van Noordt (c.1620–1676): portraits, AIC 54.284; WAH 1912.1; copy, WAG 37.387.

Jacob Ochtervelt (1634–1683): genre & portraits, (1663) FAM 1922.135; (166[4]) WAH 1960.261; (1665) SL 162.1928; (1669) WAH 1934.35; (1671) AIC 33.1088; (n.d.) CIP 54.1; NYHS 1867.143; NSM; DAI 60.9; attr., NCMA 52.9.52.

Hendrik ten Oever (c.1659–c.1705): landscapes, JC 561; MFA 52.109.

Tony Lodewijk George Offermans (1854–1911): genre, CAM 1947.524.

Jan Olis (c.1610–1676): genre, (1637) JC 446; (1646) JC 447; JC 448.

Maria van Oosterwyck (1630–1693): still life, CAMS 1872.488.

Jacob Cornelisz van Oostsanen (c.1470–1533): history & portraits, SL 138.1922; PAMP 61.59; AIC 1937.1011; TMA 60.7; IMA 24.1; YUAG; attr., DIA 44.74; follower JC 409; AIC 1935.381.

Willem Ormea (1611–1665): still life, (1658) NOMA 71.38.

Jan van Os (1744–1808): still life, VMFA 100a.

Adriaen van Ostade (1610–1685): genre, (1634) BF; (1641) MMA 71.74; (1642) LACM M.61.42; (1651) TM 1931.420; (1652) 69.339; (1655) AAM; (1656) TM 1931.400; (1657) LACM 49.9.2; (1659) SL 147.1966; (1673) NGA 644; (1674) AIC 1894.1028; (n.d.) MMA 71.148; 06.196; 29.100.198; NSM; CGA 26.150; CMN 61.46.1; BM 34.483; JC 521; 522; inv. 1258; BMFA 45.735; DIA 35.114; PMA 24-3-71; 24-3-72; (with C. Dusart) LACM 53.5.1; style, PUAM 35-69; AIC 33.1088; copies, WAG 37.361; JC 523.

Isack van Ostade (1621–1649): landscape & genre, (1641) NSM; (1643) AIC 1970.1007; (1644) DIA 68.296; (1645) NSM; NGA 645; (n.d.) FC 07.1.91; WCMA 58.4; NCMA 52.9.53; JC 524; TMA 53.76; called, JC 524; copy, MMA 93.2.

Albert van Ouwater (active 1460–1495): MMA 17.190.22.

Isaak Ouwater (1750–1793): cityscape, (1782) TMA 76.13.

Pieter van Overschee (active c.1645–1661): still life, (1645) MMA 22.45.10.

Anthonie Palamedesz (1601–1673): genre & portraits, (1637) NOMA 81.269; (1652) WAM 1920.94; (1654) BMFA 47.1620; PUAM 77–31; (1667) HMAA 1942.13; (1673) CMN 63.15.1; (n.d.) JC inv. 1350; PMA 24-3-53; follower, DAI 56.22.

Palamedes Palamedesz, I (1607–1638): history, CAMS 1872.91.

Horatius Paulyn (born c.1643/45): history, AAMCH 56.1.1.

Evert Pieters (1856–1932): (1899) TMA 12.511; (n.d.) BMFA 25.117; TMA 22.26; IMA 38.26; 25.20.

David van de Plaes (1547–1704): attr., DAM.

Karel van der Pluym (1625–1672): genre & portrait, MMA 71.84; PAM 57/86; FC 16.1.99.

Egbert van der Poel (1621–1664): landscape & genre, (1644) MIA 61; (1648) JC 551; PUAM 29-20; (1656) BF; DIA 09.18; SAM 47.160; WAM 1980.20; attr., SCMA 1961.50.

Cornelis van Poelenburgh (1586–1667): landscape & history, MAB 62.36; WAG 38.226; 38.227; AAMCH 67.25.1; BMFA 51.2776; FAM 1938.81; 1965.523; MMA 71.86; JPGM 70.PC.10; VCAG 65.9; TMA 56.52; DIA 66.6; WAH 1940.24; attr., SCMA 1961.19; circle, RMA 110; follower, BM 29.28.

Willem de Poorter (1608–after 1648): NCMA 52.9.54; BJU.

Jan Porcellis (1584–1632): seascapes, VMFA 79; DIA 52.198.

Jan Frederik Pieter Portielje (1829–1895): portrait, CAM 1956.351.

Frans Jansz Post (1612–1680): landscape, (1650) MMA 1981.318; (1656) WAH 1949.460; (1664) RMA 111; (1665) DIA 34.188.

Pieter Post (1608–1669): attr., JPGM 72.PA.26.

Hendrik Gerritsz Pot (c.1585–1657): genre & portrait, (1633) MMA 15.30.3; (n.d.) BMFA 48.1165; NOMA 81.265; IMA 38.10.

Bernard Pothast (19th cent.): CAM 1967.1186.

Paulus Potter (1625–1654): landscape & genre, (1645) RMA 112; (1647) PMA 24-3-17; (1648) NGA 648; (1650) JPGM 110; follower, JC 618; imitator, JC 712; copy, JC 619.

Antoine Daniel Prud'homme (1745–c.1826): WAG 37.618.

Pieter de Putter (c.1600–1639): style, JC 641.

Louis-Francois-Gérard van der Puyl (1750–1824): portrait, (1787) PMA 51-125-17.

Adam Pynacker (1622–1673): landscapes, WAH 1952.51; BMFA 65.615; RMA 113; TMA 72.31.

Jacob Pynas (active c.1597–c.1648): history, (1617) WAH 1959.103; MMA 1971.255.

Jan Pynas (c.1583–1631): history, JC 471; JBSAM 79.19.

Pieter Quast (1606–1647): genre, LACM 54.137.3; MMA 1973.155.1; attr., PUAM 80.

Abraham Ragueneau (1623–after 1681): portrait, attr., WAG 37.679.

Jan Anthoniesz van Ravesteyn (c.1572–1657): portraits, (1625) JC 451; (1635) MMA 12.202; (1639) CIP 64.11.22; (n.d.) MMA 23.277; CMA 16.1055; RMA 114; attr., (1634) JC 452.

Hubert van Ravesteyn (1638–1691): genre, BMA 1976.303.

Rembrandt van Rijn (1606–1669): portraits, history, landscapes, (1629) ISGM; FAM 1969.56; (1631) TMA 26.64; FC 43.1.150; (1632) FAMSF L55.47; CMA 42.644; AAM; LACM 53.50.3; MMA 64.126; 20.155.2; 29.100.3; (1633) MMA 14.40.625; 32.100.23; ISGM (2); CGA 26.158; TM 1931.409; NSM; (1634) BMFA 56.510; 56.511; 93.1474; 93.1475; LACM M.96.16; JBSAM 777.16; (1635) CMA 44.90; (1637) NGA 78; (1638) MMA 1975.1.139; (1640) MMA 29.100.1; DIA 27.200; (1643) MMA 14.40.651; (1645) AIC 94.1022; ([164]7) NGA 73; (164[?]) MMA 14.40.620; (1650) NGA 666; (165[1?]) NGA 657; (1651) NGA 74; (1653) 61.198; (1654) 49.7.35; (1655) 60.71.14; NGA 79; (1656) NGA 75; (1657) TAG 23; (1658) MMA 14.40.624; FC 06.1.97; NGA 661; (1659) NGA 72; (1660) MMA 26.101.9; (1660?) MAB 38.206; (1661) MMA 49.7.37; NGA 656; JPGM 71.PA.15; (1662) SL 90.1950; (1663) KAM AP77.4; (1662 or 3) NGA 77; (1664) 76; (1665) MMA 1975.1.140; (1666) MIA 62; NAM 31-75; BMFA (166?); (16??) CMA 50.252; (n.d.) BMFA 03.1080; 38.1838; DIA 72.201; 56.183; 53.351; JPGM 78.PB.246; FAM 1964.172; 1969.57; LACM M72.67.2; AIC 1922.4467; MMA 43.125; 14.40.618; 26.101.10; 91.26.7; 14.40.621; 14.40.622; NSM (2); WAM 1958.35; NGA 499; 655; 658; 664; 665; 667; CGA 26.159; FC 10.1.98; MAG 68.98; HC 51; TMA 77.50; attr., JC 480; NGA 662; 660; 659; MMA 17.120.222; IMA; TM 575; (166[1]) CMA 67.16; AIC 19.1970; DIA 30.380; RMA 115; (1634) DIA 28.5; school, RMA 116; JC 474; FAM 1962.97; AIC 54.281; 1954.297; CAI 841; RISD 38.017; follower, VMFA 84; (1633) VMFA 85; (1643) VMFA 86; CAM 1927.415; NCMA GL.58.51; GL.60.17.68; 59.3.1; 59.35.1; NOMA 81.293; JC 478; MAB 51.108; PAM 58/77; (1642) TM 1931.402; (1657) CAI 840; DIA 27.313; 42.151; HMFA 52.17; BMFA 17.3231; 09.184; BJU; (1634) IMA 56.62; (1636) WAH 1961.191; JC 475; style, MMA 1975.373; 89.15.3; 14.40.608; 60.71.15; 60.71.16; 29.100.103; 30.95.268; 50.145.33; 49.7.36; 53.18; 14.40.610; 14.40.601; 14.40.603; 14.40.609; 29.100.102; WAH 1961.645; (1655) WAH 1954.83; KAMCU 49-1-2; NGA 654; imitator, 1872.139; 1872.535; 1872.593; WAG 37.298; copies, FAM 1962.147; JC 476; 477; 481; 482; 483; PMA E'24-3-89; CMN; BCMA 1967.38.9; WAG 37.344; 37.360; FAMSF L56.3; CAM 1973.450; AIC 1970.1010; MMA 15.30.1; 15.30.2.

Constantijn Adriaen Renesse (1626–1680): genre & history, CGA 26.160; BJU.

Marinus van Reymerswael (c.1493–1567): genre & history, DIA 89.62; attr., (1545) NOMA 70.7; copy, JC 394.

Pieter Cornelisz van Rijck (1568–1628): (1622) NCMA.

Cornelia de Rijck (born 1656): NOMA 81.281.

Pieter de Ring (1615–1660): still lifes, IUAM 73.22; JC 632; attr., FAM 1934.119; NAM 33-151.

Willem Roelofs (1822–1897): BM 15.295.

Pieter Roestraten (1627–1698): still life & genre, JC 650; attr. (or Toorenvliet?) JC 437.

Gillis Rombouts (1630–after 1678): WAG 37.2504.

Salomon Rombouts (active 1652–before 1702): landscapes, (1655) BM 71.200.2; (n.d.) BMFA 17.3243; MMA 33.136.6.

Willem Romeyn (c.1624–1694): landscapes, MMA 71.85; JC 608.

Henriette Ronner-Knip (1821–1909): DIA 03.1.

Theodorus de Rooch (1763–after 1793): NOMA 74.375.

Jacob Rootius (1644–c.1681/82): still life, (1674) SAM 65.146.

George Andries Roth (1809–1887): CMA 2958.38.

Jacob Isaacksz van Ruisdael (1628 or 29–1682): landscapes, (1646) CMA 67.19; LACM 75.138; MMA 65.181.10; (1648) SMFA 41.02; CGAM 1950.4; (1652) FC 49.1.156; (1653) JPGM 82.PA.18; (n.d.) DIA 26.3; 37.21; 67.4; 49.532; PUAM 79-46; MMA 89.15.4; 14.40.623; 32.100.14; 25.110.18; BMA 1968.43; BMFA 39.794; 52.1757; 57.4; LACM M.53.3; TM; NSM (2); WAH 1950.498; TAG 25; FAM 1966.32; 1966.168; 1953.2; NCMA 52.9.56; FC 10.1.110; SCMA 1943.16-1; SDMA 1940.74; AIC 47.475; CMA 67.63; 63.575; 62.256; KAMCU 53-1-2; NGA 676; 1551; 1637; SL 44.1974; CAM 1946.98; DAI 53.1; WAM 1940.52; CGA 26.170; 26.169; IMA 44.54; 62.247; PMA 95-1-8; 24-3-60; 24-3-77; 24-3-56; JC 563; 564; 567; 569; 570; MAB 38.199; FAMSF; BF; HC 52; TMA 30.312; CAI 851; 29; JPGM 83.PA.278; attr., PUAM 30-457; follower, DIA 36.28; AIC 22.4470; JC 565; 568; AAM; CAMS 1872.76; style, DM 23; copy, BM 60.140; JC 566.

Jacob Salomonsz van Ruisdael (c. 1630–1681): lanscape, attr., BMFA 22.76.

Rachel Ruysch (1664–1750): still lifes, (1686) MAG 82.9; (1689) SDMA 1979.25; (n.d.) TMA 56.57; NSM; NCMA 52.9.57; MMA 71.174; attr., WAG 37.1817; NCMA G.67.30.1; BM 14.582.

Salomon van Ruysdael (1600/1603?–1670): landscapes & history, (1628) NSM; (1629) MMA 60.55.4; (1633) WAG 37.351; (1642) AKAG 52.2.1; (1643) NSM; DIA 89.43; MAB 38.195; (1644) KAM AP66.5; CMA 73.2; (1645) RISD 33.204; (1648) FAMSF 61.44.36; MMA 06.1201; (164[?]) MMA 15.30.4; JC 466; (1650) MMA 71.98; (1653) TMA 67.15; (1656) MIA 63; (165?) MMA 71.75; (1660) JPGM 54.PA.4; (1661) PMA 24-3-55; (1665) JC 467; (166[?]) TMA 48.77; (n.d.) JPGM 78.PA.196; MMA 71.135; TM 574; FC 05.1.111; FAM 1935.28; 1935.29; 22.1960; LACM 52.24; BFM; PUAM 80-13; RMA 117; NAM F61-72.

Jan Rylaarsdam (born 1911): AMAM 59.123.

Pieter Jansz Saenredam (1597–1665): arch. ptg. (1628) JPGM 85.PB.225; (1629) NGA 1396; (1631) JC 599; (1646) NGA 1395; (1660) WAM 1951.29; (n.d.) BMFA 48.321.

Cornelis Saftleven (1607–1681): history, AIC 45.290; VMFA 19-1-19.

Herman Saftleven (1609–1685): landscapes, (1645) RMA 118; (n.d.) DIA 89.45.

Hercules Sanders (1606–1663): genre, (1642) DIA 09.16.

Dirck van Santvoort (1610/11–1680): portraits, (164[0 or 9]), FAM 1969.59; (n.d.) FAM 1969.59 (pendants); DIA 22.204; MMA 89.15.36; CMA 75.81; MAG; attr., BMFA 93.191; 37.1215; KAMCU 60-2-1.

Roelant Jacobsz Savery (1576–1639): landscapes, animals & history, (1621) DIA 60.216; (1620) DAI 64.48; 64.49; (1624) NSM; (n.d.) WAH 1968.131; BJU; BMFA 67.769; DIA 37.149; IMA 56.74.

Andries Andriesz Schaeck (died before 1682): genre, NOMA 81.278.

Godfried Schalken (1643–1706): genre, history & portraits, AAMCH 66.28.1; WAH 1958.70; MMA 1974.109; attr., BCMA 1944.13.2; follower, BMFA 20.853; style, CAMS 1872.525.

Ary Scheffer (1795–1858): history & portraits, (1851) WAG 37.111; CMA 80.40; (n.d.) BMFA 21.1283; WAG; CMA 77.119; AIC 1969.627.

Willem Schellinks (1627–1678): landscape, JC 613.

Joris van Schooten (1587–1651): portrait, (1635) JC 453.

Petrus Schotanus (2nd half 17th cent.): still life, DIA 58.391.

Otto Marseus van Schrieck (1619–1678): still lifes, NOMA 56.30; MMA 53.155.

Jan van Scorel (1495–1562): history & portraits, NGA 1398; BMFA 50.293; BJU; attr., DIA 35.15; 73.5; follower, JC 415; 414.

Hercules Seghers (c.1590–after 1633): follower, DIA 38.68; imitator, JC 461.

Michiel Simons (died 1673): still life, NOMA 81.280.

Pieter Cornelisz van Slingeland (1640–1691): genre & portraits, (1677) FAMSF; (1688) BMFA 1981.133; (n.d.) SCMA 1958.92; MMA 71.70.

Jan Gabriel Sonje (c.1625–1707): landscape, BMFA 85.254.

Hendrik Martensz Sorgh (1611–1670): genre, portraits & still life, (1641) JBSAM 64.31.31; (1648) JC 531; (n.d.) DIA 38.58; MMA 89.15.7; WAM 1913.45; follower, (1657) AIC 1933.1092; WAG 37.2002.

Pieter Claesz Soutman (c.1580–1657): portrait, attr., SL 139.1922.

Adriaen van der Spelt (c.1630–1673): still life, (1658) AIC 49.535.

Jan Jacob Spohler (1811–1879): PAMP 77.46.

Cornelis Springer (1817–1891): cityscapes, (1851) BMFA 67.671; (n.d.) CAI 857.858.

Willem Steelink (1856–1928): landscapes, (1899) TMA 02.1; (n.d.) BMFA 23.569.

Jan Steen (1626–1679): genre, history, landscapes & portraits, (1662) BMFA 54.102; (1663) NGA 677; (1666) AIC 91.65; (1667) CGA 26.171; (1676) NSM; (n.d.) JPGM 83.PB.388; 69.PA.15; AMAM 57.14; BF; TM 1931.396; FAMSF 62.12.1; NSM (2); RMA 120; MMA 46.13.2; 71.72; 58.89; 1982.60.31; MAG; CMA 64.153; WAM 1954.22; PMA 02-1-21; VMFA 64; NAM 67-8; JC 509; 510; 512; 513; 514; 515; 516; 517; 520; NCMA 52.9.58; TMA 45.32; PAM 74/106; SCMA 1957.36; DIA 39.673; attr., LACM 55.80.1; CAM 1938.105; JBSAM 64.31.25; follower, SDMA 1940.14; AAM; DIA 89.46; JBSAM 64.31.25; (1675) MMA 51.199.2; JC 519; BM 14.583; 34.502; copy, PMA 24-3-37; JC 518.

Jan Jacobsz van der Stoffe (c.1611–1682): attr., WAH 1855.13.

Leopold van Stoll (c.1828–1869): still life, FAM 1969.176.

Matthias Stomer (c.1600–c.1650): history & genre, NCMA 52.9.59; BJU; NSM; MMA 1981.25; AAMCH 79.58.1; HMFA 70.15; RISD 56.177; IUAM 82.47; attr., DAI 135.13.

Dirck Stoop (c.1618–1686): NOMA 81.252.

Abraham Storck (1635–c.1710): seascapes, SMFA 66.10; MIA; NSM; MMA 71.138.

Hendrik van Streek (1659–c.1719): arch. ptg., & still life, TMA 58.05; JC 600; HMAA.

Abraham van Strij (1753–1826): genre, JC 711.

Jacob van Strij (1756–1815): landscapes, WAH 1958.158; PAMP 61.10.2; MMA 91.26.8.

Ernst Stuven (c.1660–1712): still life, MMA 71.53.

Lambert Sustris (1515/20–after 1568): portrait, MMA 49.7.14.

Herman van Swanevelt (c.1600–1655): landscapes, CMA 16.823; attr., MMA 71.146.

Jan Swart van Groningen (c.1500–after 1553): JPGM 71.PB.35; attr., MIA; IMA 59.12.

Michael Sweerts (1624–1664): portraits, history & genre, (1652) DIA 30.297; (n.d.) WAH 1941.595; 1940.198; FAMSF; JPGM 78.PB.259; DMFA 11.1968; FAM 1941.10; AMAM 41.77; WAM 1961.4; MIA 72.65; copies, JC 550; 1178.

Jan Tengnagel (c.1584–1635): history, attr., BM 14.13; RISD; BJU.

Gerard Terborch (1617–1681): portraits & genre, (1653) DIA 44.147; (1658) JC 504; (166[?]) TMA 52.9; (n.d.) LACM M.44.2.7; AIC 91.1; BM L72.7.1; L72.7.2; 34.494; BMFA 47.372; 61.660; CAM 1946.99 1927.421; CGA 26.173; 26.174; CMA 44.93; DIA 65.10; 29.256; FAM 1962.148; 1962.149; FAMSF 52.31; FC 03.1.113; IMA 46.86; IUAM 77.78; KAM AP70.24; AP70.25 (pendants); MMA 49.7.38; 1982.60.30;

1975.1.141; 175.1.142 (pendants); 17.190.10; 89.15.15; 14.40.617; NAM 46-87; NGA 58; PMA 24-3-21; SL 139.1926; TM 1931.398; VMFA 91; 92; JPGM 83.PB.232; attr., AIC 33.1097; workshop, AIC 54.300; 1096; ISGM; copies, WAG 37.341; JC 493; 1177; inv. 377; SDMA 1945.25; SDMA 1950.11.

Hendrik Terbrugghen (1588-1629): history & genre, (1621) CMA 77.2; (1623) NCMA 60.17.66; MIA 65; (1625) AMAM 53.256; (1626) DAI 60.7; (1627) BMFA 58.975; (162[?]) MMA 56.228; (n.d.) CMN 71.2076; JPGM 84.PA.5; SCMA 1957.10; BJU; AIC 1969.3; NAM 64-7; attr., BF; JPGM 72.PA.1; NCMA G.55.5.51; WAH 1942.29; copy, WAG 37.2491.

Lodewyk Tieling (active c.1695): landscape, WAM 1910.33.

Dominicus van Tol (c.1635-1676): genre, WAH 1967.650; JC 547; BMFA 30.503.

Jacob Toorenvliet (c.1635/36-1719): genre & history, (1672) BMFA 01.6218; attr., (n.d.) JC 437; BMA 1954.1.

Cornelis Troost (1697-1750): portrait, (1725) LACM M.71.95.

Johannes Urselincx (died 1664): landscape, WAM 1942.74.

Jan Jansz den Uyl, the Elder (1595-1640): still lifes, WAH 1937.472; BMFA 54.1606; NCMA 52.9.53; follower, WAG 37.1984.

Moses van Uyttenbroeck (1590/1600-c.1647): landscape, TMA 66.113.

Werner van den Valkert (c.1585-c.1627): portraits, (1616) BMFA 06.1909; (1624) JBSAM 63.29.

Adriaen van de Velde (1636-1672): landscapes & history, (1656) JC 602; (1663) CMA 66.12; BMFA 50.864; (1664) AIC 94.1024; (1666) JC 605; (n.d.) JC 603; 606; BMFA 94.169; NCMA 71; NYHS 1867.186; SCMA 1961.17; JPGM 78.PA.208; follower, JC 604; DIA 89.47; style, WAG 37.418; copy JC 1180.

Bram van Velde (c.1895): (1970) CIP 70.63.3.

Esaias van de Velde (c.1590-1630): landscape, history, genre, (1614) NCMA 52.9.61; (1619) MIA 83.122; (n.d.) AMAM 58.42; IMA 57.135; SCMA 1964.4; DIA 45.24; IUAM 60.38; follower, AAMCH 64.26.1.

Geer van Velde (born 1898): NOMA 63.35.

Jan van de Velde II (c.1593-after 1641), landscape, (1615) NOMA 81.270.

Jan van de Velde III (c.1620-1662): still lifes, (1656) BMFA 27.465; (1658) MIA; (n.d.) style, PAMP 61.13.

Willem van de Velde, the Elder (1610-1693): seascape, attr., CGA 26.182.

Willem van de Velde, the Younger (1633-1707): seascapes, (1668) NAM 32-169; (1690) CMA 75.80; (n.d.) SMFA 50.02; JC 590; 591; TMA 77.62; IMA 40.253; MMA 20.155.6; DIA 89.48; WAM 1951.3; FAMSF; attr., CAM 1946.100; 1940.948; follower, WAG 37.321; 37.683; style, RMA 122; copy, JC 585.

Adriaen Pietersz van de Venne (1589-1662): landscape & genre, (1615) WAM 1951.30; (1631) SMFA 69.05; 69.06; (1642) 49.443; (n.d.) JPGM (2); CAMS 1872.698; AMAM 60.94; PUAM 57-68; attr., DIA 58.289; (1624) JC inv. 163.

Pieter van de Venne (active 1618-1657): still life, (1656) DIA 39.671.

Adriaen Verboom (c.1628-c.1670): landscapes, attr., JC 575; DIA 89.49.

Pieter Verelst (c.1618-c.1678): FAM 1968.66; 1968.67; WAG 37.272.

Simon Pietersz Verelst (1644-1721): still lifes & portraits, NOMA 64.5; BMFA 92.202; WAH 1956.782.

Jan Verkolje (1650-1693): history, portraits, genre, (1674) JBSAM 58.3; (n.d.) JPGM 71.PA.66; WAH (2).

Nicolaes Verkolje (1673-1746): genre, TMA 55.39.

Johannes Vermeer (1632-1675): genre, history, portraits, MMA 14.40.671; 89.15.12; 25.110.24; 1979.396.1; 32.100.18; ISGM; FC 11.1.127; 01.1.125; 19.1.126; NGA 53; 694; 693; 1664; style, MMA 47.7.40; copy, JC 497; forgery HC 53.

Jan Vermeer van Haarlem (1628-1691): landscape, PMA 24-3-95.

Jan Vermeer van Utrecht (c.1630–1688): JC 626.

Jan Vermeyen (1500–1559): portrait, MMA 1982.60.26; 1982.60.27; attr., FAMSF.

Lieve Verschuier (c.1630–1686): seascapes, JC 589; 594; SCMA 1966.4.

Hendrik Verschuring (1627–1690): VMFA 96; CMN 71.2231.

Wouter Verschuur (1812–1874): WAH 1905.31; NAM 56-83/1.

Johannes Cornelisz Verspronck (1597–1662): portraits, (1641) NSM; JBSAM 80.21; (1643) BMFA 17.3270; 17.3271; (1645) MMA 36.162.1; attr., SCMA 1964.2; follower, WAG 37.378.

Daniel Vertangen (c.1598–1684): BMFA 16.66; SAM 68.98.

Jan Victors (1620–1676): portraits & history, (1642) FAMSF 59.39; (1649) JPGM 72.PA.17; (1651) BJU; (1652) IMA 79.330; (n.d.) WAH 1958.206; DIA 89.44; MMA 71.170; attr., PUAM 59-193; copy, TMA 28.91.

Abraham Vinck (c.1580–before 1621): portrait, (1610) BMFA 17.3272.

David Vinckboons (1576–after 1632): history, landscape, BMFA 74..3; attr., PUAM 74-14; 71-6.

Simon Jacobsz de Vlieger (c.1600–1653): seascape, history, (1642) DIA 89.50; (165[?]) CMA 75.76; (n.d.) MMA 06.1200; JC 593; FAMSF 1949.20; FAM 1954.58; follower, CAMS 1872.44.

Hendrik Cornelisz van Vliet (1611/12–1675): arch. ptgs. & portraits, (1653) RMA 123; (1656) MAB 39.185; (1659) PMA W'02-1-15; (1660) MMA 1976.23.2; (n.d.) BMFA 17.1411; BCMA 1971.6; WAG 37.1908; 37.1909; NAM 70-17; attr., DIA 89.51.

Willem van der Vliet (c.1584–1642): genre, (1624) DIA 59.449.

Jan Vonck (c.1630–c.1662): still life, FAM 1957.176.

Hendrik Voogd (1766/67–1839): landscape, WAG 37.1806.

Johannes Voorhout (1647–1720): still life & history, WAM 1923.209; BJU.

Cornelis van der Voort (c.1576–1624): portraits, (1617) WAM 1956.16; 1956.17; (n.d.) DIA 89.52.

Daniel Vosmaer (active c.1650–1664): cityscapes, JC 500; VCAG 62.2; DIA 49.7; WAH 1943.96.

Jacob Vosmaer (1584–1641): still life, (1615) MMA 71.5.

Jacob Vrel (active c.1650–c.1670): genre & cityscapes, DIA 28.42; JC 542; JPGM 71.PB.61; 70.PB.21; WAH 1937.489; copy, SDMA 1950.117.

Abraham de Vries (c.1590–1650/52): portrait, (1643) MMA 71.63.

Roelof van Vries (c.1631–after 1681): landscapes, (1652) JC 581; (n.d.) MMA 71.116; PMA 43-40-38; DIA 64.120; 64.119.

Cornelis Hendriksz Vroom (c.1591–1661): landscape, attr., MAB.

Jacob van Walscapelle (1644–1727): still life, attr., WAM 1956.18.

Herman Johannes van der Weele (1852–1930): BMFA 23.566.

Jan Baptist Weenix (1621–1660): landscapes, history, portrait, still life, (164[8]) CMA 64.294; (1649) WAH 1899.6; (1951) NCMA; NYHS 1867.189; PMA E'1984-1-1; WAH 1937.483; AIC 1969.111; YUAG 1960.39; SP; DIA 41.57; 26.22.

Jan Weenix (1642?–1719): still lifes, (1695) MMA 50.55; (1701) PMA W'01-1-3; (n.d.) JC 633; BMFA 41.744; VMFA 93; FAM 1957.45; WCMA 62.2; AMAM 53.3; BC 79.183.

Johannes Hendrik Weissenbruch (1824–1903): landscapes, (1860) DIA 59.55; (1899) TM 1931.452; (1901) TMA 25.878; (n.d.) AMAM 19.9; FAM 1895.709; SL 49.1974; TMA 22.29; 25.46.

Adriaen van der Werff (1659–1722): history, RISD 59.063; FAM 1954.73; AMAM 63.30; attr., RMA 124; DIA 59.17; style RMA 125.

Pieter van der Werff (1665?–1722): history, (1711) DIA 89.53; (n.d.) MMA 71.66.

Abraham van Westerveld (died 1692): WAG 37.794.

Jacob Willemsz de Wet (c.1610–1675): history, (1646) BF; IUAM; style (n.d.) UAMB.

Cornelis Claesz van Wieringen (c.1580–1633): marine, SCMA.

Thomas Wijck (1616–1677): genre, JC 611.

Jan Wijnants (c.1630–1684): landscapes & cityscape, JC 584; CMA 64.419; attr., BM 71.200.4; follower, DIA 09.20; style, CAMS 1872.623; copy, FAM 1945.8.

Abraham Willaerts (1603–1669): marine, (1634) BCMA 1813.26; (n.d.) NOMA 81.267.

Henk Willems (born 1915): PAM 58/124.

Winhold Willemsz (active 1611–1626): portrait, (1641) VCAG 39.7.

Willem Wissing (1656–1687): portrait, MMA 39.65.7.

Jacob de Wit (1695–1754): history & genre, (1723) TMA 74.43; (1742) MMA 07.225.298; (1743) MMA 07.225.301; (1748) SDMA 1975.38; (1749) PMA 44-9-5; (1750) PMA 44-9-6; (1751) PUAM 73-1; (1754) RMA 126; (n.d.) MMA 07.225.257; 07.225.296; PUAM 73-2.

Matthias Withoos (1627–1703): IMA 80.18.

Emanuel de Witte (1618/19–1692): arch, ptgs. & genre, (1651?) DIA 37.152; (1653 or 5) AMAM 43.279; (1657) TAG; (1677) DIA 89.54; BMFA 49.7; (1678) WAH 1947.447; (1685) IUAM 84.21; (1686) DIA 37.1; (n.d.) BMFA 47.1314; AIC 41.1038; AAMCH 73.31.1; CMA 71.1; BF; SMFA 41.06; SAM.

Gaspar van Wittel [called Gaspare Vanvitteli] (1652/53–1736): cityscape, WAH 1946.393.

Philips Wouwerman (1619–1668): horse ptgs. & history, (1653) MIA; (1662) BMFA 1981.78; (n.d.) MMA 1971.48; CMA 67.124; DIA 89.55; 09.19; NAM 31-92; BF; LACM 59.23; WAH 1968.13; PMA E'24-3-40; JC 615; 616; NCMA 52.9.64; NYHS 1867.341; FC 01.1.136; attr., SDMA 1946.21; SCMA 1959.194; NOMA 66.25; FAM 1931.59; HMAA 9360; follower BCMA 1813.28; JC 620; AAMCH 59.14.2; BM 44.222.1; WAG 37.336; HMFA 58-2; style, BMFA Res. 14.29; CAMS 1872.394; 1871.431; JC 617; copy, FAM 1957.138.

Pieter Wouwerman (1623–1682): horse ptg., WCMA 59.22.

Joachim Wttewael (c.1566–1638): history, (1600) NAM F84-71; (1610) RISD 62.058; (1612) BMFA 57.119; (1624) NGA 2610; (n.d.) CMA 74.106; PUAM 75-11; SL 198.1957; JPGM 83.PC.274; LACM M.81.53; follower, WCMA 64.32; YUAG 1964.40; CAMS 1872.453.

Pieter Wttewael (1596–1660): history, CMA 72.169.

Mattheus Wytmans (c.1650–1689): still life & genre, MAB 50.84; WAG 37.382.

Gerrit van Zegelaar (1719–1794): genre, JC 1186; 1187.

Christian Zepp (died 1809): arch. ptg. (1780) DIA.